1989

THE
COLOR
COMPENDIUM

Dedicated to the memory of Faber Birren (1900–88)

THE
COLOR
COMPENDIUM

Augustine
Hope

Margaret
Walch

Introduction by Michel Pastoureau, Centre Français de la Couleur

 VAN NOSTRAND REINHOLD
_____ New York

Printing/binding: The Murray Printing Company

Color printing: New England Book Components

Color separations: United South Sea Graphic Art Co., Ltd.

Typesetting: Dix Type Inc.

Paper: 60# Patina Matte

Sponsoring Editor: Lilly Kaufman

Production Director: Louise Kurtz

Editorial Supervisor: Joy Aquilino

Copyright © 1990 by Van Nostrand Reinhold

Library of Congress Catalog
 Card Number 88-34339
ISBN 0-442-31845-6 (VNR)
ISBN 0-442-00378-1 (CAUS)

Printed in the United States of America

Van Nostrand Reinhold
115 Fifth Avenue
New York, New York 10003

Van Nostrand Reinhold International
 Company Limited
11 New Fetter Lane
London EC4P 4EE, England

Van Nostrand Reinhold
480 La Trobe Street
Melbourne, Victoria 3000, Australia

Nelson Canada
1120 Birchmount Road
Scarborough, Ontario M1K 5G4, Canada

16 15 14 13 12 11 10 9 8 7 6 5 4 3 2 1

**Library of Congress
Cataloging in Publication Data**

Hope, Augustine.
 The color compendium/Augustine Hope,
Margaret Walch.
 p. cm.
 Bibliography: p.
 ISBN 0-442-31845-6 (VNR)
 ISBN 0-442-00378-1 (CAUS)
 1. Color—Dictionaries. I. Walch, Margaret.
II. Title.
QC494.2.H67 1989
701'.8—dc19 88-34339
 CIP

CONTENTS

COLOR SECTIONS

ESSAYS

ESSAYS *(continued)*

FOREWORD

The Coming Century of Color

Color is a phenomenon so vast that it seems rash to attempt a survey in a single book. It touches on most human activity; rare indeed is the area in which it plays no part at all. Physics, biology, perception phenomena, psychology, symbolism, sociology, art, communication, and industry are all concerned with it. It comes as no surprise that such a vast domain, plagued as it is by philosophical and aesthetic considerations, should be hard to pin down. Information on the subject can be culled from an enormous diversity of pursuits, and such a book must consider many of the inevitable specialist applications. The challenge, then, is to collect all the information currently relevant to color and to present this interdisciplinary data in an effective way, and to make the journey through the book's pages pleasurable as well as informative. Rather than treat color's physical and quantifiable aspects in isolation or concentrate only on its subjective and aesthetic dimension, *The Color Compendium* presents a panoramic view, allowing the reader to take his own path.

If our knowledge of color in the coming century is to be extended, attention to its multidisciplinary aspect is vital. If tomorrow's culture is to become more responsive to our human needs, the development of our scientific sensibilities is equally indispensable. For the student as well as the professional, *The Color Compendium* builds a bridge between scientific views of color and our everyday needs for beauty and harmony. The complementary contributions of physicists and philosophers, of color researchers and artists, and the synergy of the communicative, aesthetic, and symbolic aspects of color, are especially worth exploring. Further, this book examines specific areas of knowledge as they relate to color, light, and perception, exploring similarities and differences in color communication and usage around the globe, while providing numerous themes for color ideas and palettes. Ancient and modern approaches, old and new concepts of color science are presented in the belief that no culture is without interest to twenty-first century colorists.

Another initial concern was to chart the revolutionary and phenomenal expansion of color usage in everyday life in the late twentieth century. This growth, overshadowed by the spectacular deluge of innovative technological inventions, may well have been overlooked. Still further, the tidal shift and emphasis on color which characterized painting in the first half of the twentieth century remains to be evaluated in terms of people and communication. In short, so many implicit and explicit models of color reality and

"truths" are in question that the timing for another perspective of contemporary and future attitudes is ripe.

The nineteenth century laid tremendous technical ground for us. There were discoveries of new synthetic dyes and pigments by William Henry Perkin, advances in full-color printing based on the work of Moses Harris, the trichromatic vision theory derived from the independent work of Hermann von Helmholtz, James Clerk Maxwell, and Thomas Young, the research on optical illusions by M. E. Chevreul, and the culminating revolution in painting techniques by J. M. Turner and the French impressionists.

While the nineteenth century was one of large theoretical color advances, the twentieth has been a period of realizing the fruits of these discoveries. Despite the broadened use of color that took place after World War II, people were far from realizing that this ready access to color was changing our ways of perceiving and reacting. Full-color printing, relatively rare throughout the world until this time, was beginning to proliferate. Masterpieces of art, once sequestered in museums and accessible only to a few, were reproduced, printed, and distributed, thus influencing millions. Synthetic dye-stuffs were being efficiently applied to mass-produced fabrics and apparel, making it possible to move away from prevalent gray-black, brown-blue cycles. Motion pictures in color, along with color photography, supplanted black-and-white, heralding the onset of ubiquitous TV broadcasting in color. The sum total of this vastly increased exposure was to irreversibly accelerate and increase appreciation and appetite for color. Already the new generation, clearly unabashed in its use of color, is making unprecedented demands that major academic, professional, and scientific disciplines are only beginning to understand.

Until recently, a common sentiment that color was less important than form prevailed: Modern painters and designers began to enlighten us with pure color. Color is, after all, so elemental to perception, the eye so capable of perceiving and processing color variances and our access to color reproduction now so common, that we often forget about its presence. Color, like air and water, is a part of our universe. Nothing visible can exist without color—without a material form—not architecture, art, design, or fashion. And clearly, "color" is not simply a palette of red, yellow, blue, and green primaries, but the ten million and more subtle shades that the human eye can perceive, as well as the myriad ways these shades interact.

As can be easily predicted, the coming twenty-first century will be dominated by speed and computer-aided global communication. It seems certain that no part of the world will remain in isolation. In the midst of a technology-driven society, there remains one unfailingly emotive force that can add a sense of humanity: color. Color is the quickest, least expensive, and surest way to change appearances. In this way, it is the ultimate democratic gift. There is little doubt that expanding twenty-first century technology will allow the

use of color on new surfaces and in new forms. The question of how to best employ and implement the options opened in a post-industrial era remains.

Running parallel to this period of furious technological advances is the expanding industry of imaging, from the personal image to the package image, from the private to the public domain of urban architecture. No one color mode, either in clothes or environment, is likely to prevail forever. The "ideal package," whether natural or man-made, is constantly being redesigned. Cyclical color is an inevitable part of this process for the simple reason that, as in other facets of life, human beings thrive on variety. Further, with worldwide communication, we shall have to be more conscious of other cultures and color norms, and to meet unforeseen color needs.

On another level, readers of *The Color Compendium* will soon discover that color is one of those rare topics that provides a crossing point between a world of electromagnetic radiations and the world of thought, passing through all stages of perception. Far from being only another "phenomenon" to be dissected in the laboratory and exploited in the marketplace, color is a vital key to understanding our universe. In itself, the realm of color is grand and mysterious, joyful and life-giving, and it is probable that only human beings can comprehend and increase their appreciation of this universe. In a world where most people are concerned mainly with either reproducing or killing each other, something mysterious and wonderful is going on—color!

In short, *The Color Compendium* is a matrix of ideas about color, allowing the reader to propagate any seed that develops. A coherent overview is provided through the main color sections. At the same time, the reader will find that the arbitrariness of an alphabetical order provides unexpected and often poetic conjunctions.

We hope that *The Color Compendium* will fulfill a three-fold aim: First, to give everything related to color a proper foundation of analysis and cross-reference; second, to provide a practical, accessible dictionary; and finally, to herald the coming century of color.

WILLIAM C. SEGAL
Color Association of the U.S.

PREFACE

*E*arly on, when we were preparing a list of subjects for *The Color Compendium*, we were confronted with the question of how to achieve a comprehensive book. There are hundreds of areas of knowledge that touch on color, all interconnected, and many demanding books in their own right.

The wealth of knowledge available today is not a problem peculiar to color; it is symptomatic of a computer age experiencing an information overload. A Bell Telephone Laboratories report states that each day *The New York Times* prints more information than that available to a fifteenth-century man over a lifetime. The difficulty lies in retrieving information and making sense out of it, knowing what is useful, what to discard, and what relates to what.

From the start, we faced a second basic problem: *color* has meant different things to different people over the centuries. To Saint Augustine it was a platonic reflection of God; to Isaac Newton it was light energy; to Wolfgang von Goethe it was a subjective sensation, and to John Locke it was a quality of objects we see. To Alexander Scriabin it was the visual analogy of music; to Ludwig Wittgenstein it was primarily a semantic problem; to Wassily Kandinsky, an expression of the soul. All-embracing, color is intrinsic to how we see the world *and* to how we express ourselves. This much only can we safely say: Color provides humanity with an almost limitless range of subtle and nourishing impressions; it is a prime information-carrier and a powerful tool, important to artist, astrophysicist, and communicator alike. Nevertheless, each aspect must be treated individually.

This book is designed to cover color in all its complexity, but in a straightforward and methodical manner. In each entry, from A to Z, the salient issues are examined, with cross-references provided to related entries. Where the specialist's knowledge was needed, we solicited an essay from a leading practitioner in that field. While *The Color Compendium* functions as a dictionary, we have tried not to limit ourselves to the technical explanation, but to explore the human dimension as well. Thus we hope the reader will be able to find information quickly, and take the time to browse, discovering the curious connections that exist among various disciplines and between what we see and what we feel.

We are grateful to William C. Segal and Marielle Bancou for their extensive support, and to the late Faber Birren and the Color Association of the United States for their generous material help.

Augustine Hope
Margaret Walch

INTRODUCTION

Different cultures define color differently, according to whether they perceive it as a substance, as a fraction of light, or as a sensation. Ethnologists and linguists confront color every day in the course of their research. For them, color is strictly a cultural phenomenon for which no universal, hard-and-fast definition exists. On the contrary, the definition changes with time and space, and its modalities and formulations vary from region to region and epoch to epoch. It is probable, for example, that Western chemists' and physicists' definitions will, within a few centuries, be outdated.

To write a history of color from its linguistic and aesthetic origins to those of the present day would entail considering Western Europe, North America, Africa, Asia, and Oceania, a materially impossible and scientifically futile task. On the other hand, it seems legitimate to concentrate on a single civilization and to study its color problems and traditions over a long period. This a difficult task, which plainly can be accomplished only by teamwork, such as we find in the present compendium, with its focus on Western civilization's historical experience of and relationships through color. With a few examples, I would like to show how the cultural problem of color presents itself to anthropologists and historians.

A "Blue" Civilization

If asked, "What is your favorite color?", half of our readers would probably respond, "Blue." Polls taken after World War II have regularly shown that over half the adults questioned—in the United States, Canada, and Western Europe—claim that their favorite color is blue. Green comes next (slightly less than 20 percent), then white and red (about 8 percent each), while the other colors lag far behind.

Children have a different scale of values. It varies with age and location, and is less stable. But, everywhere and always, red comes out ahead of yellow and white. Only children over eight years old express a preference for cool colors (blue and green), the colors most often preferred by adults. In both cases, however, there are no differences between sexes: The same replies come from both boys and girls, men and women. As shown in studies done since the 1960s, social status and profession have little influence on color choice. The only pertinent difference, then, depends on age: The very young like warm colors, adults like cool ones.

Obviously, strategies in the fields of public relations and marketing have brought about the polls taken in the last fifty years. Results have benefited the history of contemporary taste and sensibility; moreover, they stimulate reflection and, in the long run, inspire a

certain number of questions. What is the basis of the choice of blue in Western civilization? Such inquiries, unfortunately, do not yet exist for all areas of human activity all over the globe. On the contrary, they are narrowly targeted. And sociologists are on the wrong track when they use figures appropriate instead to advertising, sales promotion, and, still more specifically, women's fashion.

The very idea of a preferred color is essentially vague. Can we, in an absolute sense, outside of any context, name our favorite color? And what importance does this question have for research in social studies, notably history? When we speak of blue, for instance, does it mean that we really prefer it in every domain—clothes, interior decoration, everyday objects, political symbols, and art? Or, do we want, ideologically, to line ourselves up with the majority; that is, the majority of blue-lovers? This problem is important. It arouses historians' curiosity all the more in that, during their research, they cover only social activities and sensibilities—clothing, symbols, and so forth—and fail to treat individual psychology and culture.

Most contemporary pollsters do not take detail into account. They deal in absolutes and insist that in order to be "efficacious," persons polled about their color preferences must make "spontaneous"—five- or six-second-long—responses. They give no time for asking, in turn, "Do you mean the color of clothing, or that in a painting?" We may doubt the legitimacy of the reasons for demanding this spontaneity. Any researcher can guess at its artificial character since color is a phenomenon that resists generalization.

Geography of Color

The vagueness of a concept may result in pertinent and productive realizations. This is the case when we see how little change there has been in adults' color preferences with the passage of time. The scarce figures we have for the nineteenth century are close to those quoted above and also similar in various areas. This last point must be underlined: Westerners are almost unanimous in regard to blue. Only in Spain does red come before blue and yellow. In South America, answers are quite different from those given in the West: In Brazil we have blue first, then red; in Chile and Argentina, blue first, white second; in Peru, red first, green second. Western European color values are, in these cases, upset by those of other civilizations and furnish anthropologists with rich and complex cases of chromatic acculturation. Figures are lacking for Eastern Europe, at least in Western publications. I have only the results of two inquiries, one conducted in Hungary in 1963, the other in Poland in 1978. The results are the same as those of France, Italy, Scandinavia, and the United States: blue beats green, and other colors are trailing.

As soon as we leave Europe and North America we find quite a different situation. For example, in Japan—the only non-Western country to provide statistics based on similar questioning—the range of values differs radically. White is the number one choice

(for 40 percent of those polled), black number two (20 percent), and yellow number three (10 percent). This poses a problem for Japanese multi-national enterprises. In devising publicity strategies for posters, folders, and photographic and television images, manufacturers must have two: one for domestic use, one for export. Color is not the only factor involved, but it plays a large part. A company seeking to ingratiate itself on a global scale must deal with the cultural problem of color. A recent example illustrates my point: Three important Japanese manufacturers of cameras and photographic materials (Canon, Nikon, and Fuji) launched the promotion and sale of inexpensive box cameras in three colors—yellow, blue, and red—instead of the usual black. This product was a success in Europe and the United States, but a failure in Japan.

Japan's color preferences emphasize how color is defined and used differently in different cultures. For instance, where Japanese sensibility is concerned, it may be less important to differentiate among blue, red, and yellow than to know whether we are dealing with a dull or shiny finish. As in most Eskimo languages, there are different words for many kinds of whites, and their meanings range from the dullest dull to the most gleaming and shiny. Western eyes, unlike those of the Japanese, seem to be unable to distinguish consistently one from another; emphasizing this, European languages do not have words to designate these differences. Japanese predominance has awakened our sensitivity to distinctions. There is one field in which Westerners have achieved acculturation: photographic paper. When we take our amateur snapshots to be developed and printed we now specify a dull (matte) or shiny (gloss) finish.

Sad Color

The differences we begin to see in Japan, which in some respects is highly westernized, are even more obvious in other Asiatic, African, or Island cultures, where Western definitions of color have little meaning. In most African cultures, for instance, no importance is attached to the borderline between reds on the one hand, and browns, yellows and even greens on the other. Yet, in connection with a given color, we must know whether it is dry or damp, tender or hard, smooth or wrinkled, loud or muted, gay or sad. In this way, color has no existence of its own and has no relation to sight. It is perceived in relation to other sensory parameters, and different tints and shades are considered unimportant. Moreover, in certain West African societies, sensitivity to color and the words used to describe it vary between the two sexes. For example, in certain Fulah tribes, the rich vocabulary for shades of brown in dress differs for men and women.

These social differences are basic, and both anthropologists and historians must keep them in mind. They stress the cultural character of color perception and of the accompanying vocabulary,

underline the role of synaesthesia and the inter-relationship of all the senses and, finally, make for discretion in comparative studies dealing with spatial and time elements of sensitivity to color. A Western researcher may seize on the importance of Japanese concepts of the dull and the shiny but be baffled by the African color world. What, exactly, is a damp, tender, or gay color? Chronological differences are equally important. Historians must remember that differences in the perception, vocabulary, and the social and symbolic uses of color are matched by differences of time. Color also has a history, one that is difficult to master.

We cannot project our own concept and systems of color into the past. For example, since Newton's experiments and the classification of color within the spectrum (from infra-red to ultra-violet), it has been clear to us that the placement of green fell somewhere between yellow and blue. Social customs, everyday practices, scientific studies, and natural phenomena (like that of the rainbow) would seem to prove it. But for the man of the Middle Ages, this relationship made no sense. In medieval color charts, blue and yellow are not shown in the same ranges, and so there can be no connecting link to green for either of them. At this time, green was placed in the neighborhood of black, or else outside of any linear categorization.

And so historians must be wary of anachronistic thinking. They must not project their own knowledge of twentieth-century physics and chemistry onto the past. Nor must they attribute absolute truth to the spectrum's organization of colors and all the theories derived from it. As do ethnologists, historians must view the spectrum only as a symbolic system of color classification. Aristotle, who did not classify colors in the format of our spectrum, nevertheless demonstrated "scientifically"—according to the knowledge of his era with all its methods of proofs—the physical, optical, and ontological value of his own classification. And without demanding proof, what are we to think of medieval man, whose visual apparatus was the same as ours but who saw in the rainbow only three colors: red, yellow–green, and dark?

A final difficulty lies in the very nature of the phenomenon of color: the problem of placing ourselves at every viewpoint, of tackling every domain. Can we carry out a global study of color? We can make separate compartments subsumed by chronology; we must study the mutations, disappearances, and innovations in all the historical arenas of color: the social laws, the vocabulary, the scientific speculation, the chemistry of pigments, the dyeing of materials, and the artist's or artisan's concerns. This is a convenient—though sometimes frustrating—articulation that exists within the diversity of the questions posed by the universe of color. We prefer to generalize, to deal with certainties, to make precise definitions. But color is elusive, and rebels against generalizations and definitions. Color is a dream.

Michel Pastoureau

TO

Aalto, Alvar

1898–1976. Finnish architect and designer and important force in the international modern movement. He is known for the relatively soft finish of his functional bentwood furniture, particularly chairs, which his firm Artek began successfully marketing in 1935 and which became widely appreciated for interior home design. His work in furniture is characterized by the use of light laminate plywood. *See also* Furniture; Wood Colors.

Aberration

The blurring of an image; specifically, the distortion produced by a lens that focuses light imperfectly. Chromatic aberration is a fault inherent in spherical lenses: since each wavelength has its own refrangibility (*see* Refraction), every lens will disperse colors slightly. This distortion is greatest toward the rim of a lens, leading to concentric rings of spectral hues on the edge of an image. Careful control of the lens curvature is essential for a color-corrected lens (*see* Achromat).

Isaac Newton, while a student at Cambridge University, became fascinated with chromatic aberration, and began grinding his own lenses in an attempt to produce a better telescope. From his ensuing research came his revolutionary demonstration that light can be split into the full spectrum of colors. *See also* Newton, Isaac; Prism.

Abraum

A red ocher used mainly to color mahogany wood. *See also* Wood Colors.

Absinthe

The color of a liqueur first made in France in 1797 from wormwood and other aromatic plants. "Absinthe green" is primarily a brilliant yellowish green, although the green liqueur itself will change to a cloudy, opalescent white when mixed with water. "Absinthe yellow," a greenish yellow used by decorators, is not the actual color of the liqueur. The colors were commercially reproducible only with the invention of synthetic dyestuffs.

Absorbance

The ratio of light absorbed to the incident light. This factor varies with the nature and direction of the incident beam, and with the material. Absorbance is sometimes called the absorption factor. *See also* Incident Light.

Abstraction of Color

The emergence of abstract art at the beginning of the twentieth century changed many previously established attitudes toward color. The ground had been broken in the nineteenth century by Johann Wolfgang von Goethe, in his *Doctrine of Colors* (1810), and by Michel Eugène Chevreul in *The Law of Simultaneous Contrast of Colors* (1839), which discusses perception of color and other effects. *See* Afterimage; Color Constancy; Simultaneous Contrast.

One important change was the elevation of color theory to a leading position alongside formal and pictorial considerations in art, a change reflected in the work of the impressionists, who investigated color and perceptual response. Impressionist art, such as the series by Claude Monet depicting the Rouen Cathedral in changing light, directs the viewers to an immediate impression, forcing them to look at colors as they appear in nature rather than those habitually associated with objects. The impressionists' immediate successors, the neo-impressionists gave color considerably more freedom from form by using the play of colored dots and patches to create their overall structures of reality. The fauves reacted against this painting technique, partly because such additive mixture (the mixing of color by the eye—*see* Additive Color Mixing) resulted in softened colors and overall grayed effects. The fauves favored large, flat areas of brilliant hues to create vibrant color effects, resulting in wild paintings that were blatantly removed from everyday reality (*see* Derain, André; Fauvism; Matisse, Henri; Vlaminck, Maurice de).

Since then, there has been considerable interest in the power of pure color. In the 1940s, Wassily Kandinsky, joining the centuries-old search for a grammar of color that

would be analogous to music (*see* Music and Color; Newton, Isaac), drew diagrams to demonstrate the effects of color based on the primary polarity of yellow and blue. He saw yellow as a bold, eccentric, advancing color that moved toward the spectator, while blue was to him concentric and inward looking. With such (by and large subjective) analyses, Kandinsky developed his own language for color—so that even without any figurative elements in a painting, colors could convey a meaning. In fact, though based on the same ideas, the first example of a genuinely abstract painting is Robert Delaunay's *Simultanée* (named for Chevreul's theory of simultaneous contrast)—a series of simple painted disks in expanding circles of color. Kandinsky is notable, however, for trying, as his career continued, to rid color of *all* associative elements, such as its symbolic meanings (*see* Communication and Color).

For further discussions of modern color theory in relation to art and artists, *see also* Aesthetics; Form and Color; Painters, Painting, and Color; *and* individual artists.

Acacia

A tropical tree, some species of which yield lac (a resinous deposit of scale insects used in the production of shellac), catechu (used as a dye), gum arabic, and tannins.

Academic Colors

Since 1893, American universities have recognized officially—and, prior to this date, by custom—a palette of six colors that are used to identify the major faculties. These hues make up part of the scholar's insignia and appear on gowns, braids, or tassels as follows: Scarlet, the color of blood and worn by Christian religious dignitaries as a symbol of Christ's sacrifice, represents theology; blue, emblematic of truth and wisdom, represents philosophy; the purity of white is for the arts and letters; the regenerative quality of green is for medicine; the dignity of purple is for law; and golden yellow represents the light of science. *See also* Communication and Color.

Accent

A touch of additional color, usually small in area, which is used to give interest and vibrancy to a larger area of less brilliant color. Knowledge of how color accents work and how they are most effectively used is vital for the artist and the designer. The principle of harmony of scale (*see* Harmony) applies to accents. A small touch of bright red will enliven an otherwise soberly colored painting, room, or ensemble of clothing, and provide an immediate focus for attention. Accents work on the principle that the more intense the color, the smaller the amount needed for the desired harmony with the larger area. The reverse also generally obtains: If an accent is of lesser intensity, it will likely need to be increased in size to achieve the same desired effect. *See also* Cosmetics and Color; Fashion and Clothing Color; Interiors, Residential; Painter's Eye, The.

Accessory

An extra; any additional element used to complete a clothing ensemble or a decor. Accessories are used frequently to provide a bright accent of color for a larger apparel item or a neutral color environment. Handbags, gloves, hats, scarves, stockings, and jewelry are examples of fashion accessories. Vases and flowers, lamp and bathroom fixtures, and items for school and office desks are the kinds of accessories where the late-twentieth-century color explosion is most evident. The coupling of the 1980s' taste for brighter and more luminous interiors with technology's capability of coloring almost any material in any hue resulted in a selection of ten or more colors for most accessory items. *See also* Accent.

Achromat

A type of modified camera lens that corrects for distortion of colors. An ordinary lens suffers from chromatic aberration: The plane on which light is perfectly focused varies slightly but significantly with each color, causing blurred color images on the flat photographic plate. An achromat is a lens corrected to bring two colors into a common focus—usually blue-violet (all emulsions have a primary sensitivity to this) and yellow or yellow-red (whose wavelengths are the major portion of the brightest image preferred for focusing). Virtually all camera lenses are now achromats.

Achromatic Colors

Black, white, and gray are achromatic "colors"—they have no particular hue. Such colors tend to absorb or reflect all wavelengths of light evenly across the spectrum. A black pigment, in theory, absorbs all incident light; a pure white pigment maximally reflects all wavelengths. Between these parameters lie the grays, which can be produced in pigments by mixing white and black pigments or by mixing complementaries. Light cannot be gray: The "gray light of dawn" is so called because the faint light makes the landscape appear gray (*see* Dark Adaptation [Scotopic Vision; Night Vision]).

"Work on the accent, it will enliven the whole."
—Pierre Bonnard

A curious feature of our visual perception is that we can distinguish among a vastly greater number of light grays than dark ones (see Systems of Color). This has created an enormous variety of different light gray paint choices (with only a handful of dark shades of gray by comparison), making it difficult to match white and light gray paints to previous standards. The slightest trace of black or of a hue in a white pigment will produce warm or cold whites—differing shades of light gray.

Black and white are two of the oldest pigments available to man: In earliest times black was obtained from soot (carbon) and white from lime, chalk, or clay. Partly as a result, they have developed many symbolic associations and linguistic usages, from black magic and blackmail to white feathers and whitewash. See also Black; Colloquial Language, Color in; Gray; White.

Achromatism

Defective color vision—either hereditary or acquired—in which all colors appear as grays. It is also known as monochromatism. See also Anomalous Trichromatism; Color Blindness.

Acid Colors

Acid colors are typified by jarring chartreuse greens, bitter lemony yellows, psychedelic, Day-Glo oranges, or any biting fluorescent shade. In clothing design, acid colors are usually used as accents; for swim, dance, and ski wear, and also in theatrical productions, acid colors are more often used as the principal hues.

Acrylic

A paint in which the vehicle is acrylic resin, a painting done with acrylics, or a fabric of synthetic polymers. Acrylic is a chemical compound—as are other synthetic media, such as polyvinyl—in which small groups of molecules (monomers) are combined into long chains (polymers) in a process called polymerization.

Developed since the 1930s, acrylic paints have been popular with artists because they are water based, while being similar to oil paints in that they are brilliant, opaque, and lasting. The disadvantages of acrylics include drying too fast to allow easy blending and gradation of color on the canvas, and difficulty in obtaining the deep, rich, jewel-like tones of oils. See also Artists' Pigments.

Of all colors, the Adam brothers particularly favored cucumber green.

Adam, Robert and James

The Adam brothers, James (1730–94) and particularly Robert (1728–92), revolutionized the decorative arts in England in the late eighteenth century. "Late Georgian" really implies the work of the Adam brothers. Scottish by birth and an architect by training, Robert Adam traveled extensively in Italy in the 1750s and returned to England to develop a style derived from Greco-Roman ruins and from the villas of Andrea Palladio (1508–80). His light and delicate classical hand can still be seen in some of England's finest mansions, notably Osterly Park and Syon House, both near London.

Color, in all its modulations and applications, played an important part in the Adams' designs; of all the colors, cucumber green, particularly when scaled in value gradations, was by far the most favored. Pastel tints—compatible with classical forms—are most frequently associated with Robert Adam's style. In addition, Adam colors include strong blues, sumptuous reds, and lively lilacs and apricots—often modulated with milky white tints. Although based on classical palettes, the Adam colors generally tend to be slightly cooler, more elegant, "prettier" in the best sense of the word, than are their prototypes. See also Interiors, Residential; Pastel.

Adaptation

See Color Constancy.

Adaption

Alternative (usually British) spelling for *adaptation (see Color Constancy).

Additive Color Mixing

The process by which two or more distinct colors of light are combined to produce new colors. Additive color mixing is used, for example, on the color television screen: Dots of three (additive) primary colors—red, green, and blue—are blended by the eye, which consequently "sees" the full color spectrum. In additive mixing, colored light is *added* together; on the other hand, pigment mixtures *subtract* (or absorb) light to create intermediary colors (see Subtractive Color Mixing).

Until the mid–nineteenth century, there was confusion among color theorists over which were the true primary colors, mainly because those used by painters—red, *yellow*, and blue—are the subtractive primaries. Color offset printing, another example of additive mixing of color dots, uses cyan, magenta, and yellow as its primaries, since the printing ink itself absorbs light.

Research in the 1960s indicated that *two* additive primaries might be sufficient to produce the whole spectrum (see Two-Color Reproduction), but, in general, red, green, and

blue light (which together produce white light) combine for the broadest range of color. Note that a mixture of blue light with red produces a non-spectral color, purple, thus completing the additive color circle (*see* Systems of Color).

Additive color mixing can be demonstrated by placing deep red, green, and blue filters respectively on three separate slide projectors, and overlapping their beams on a white screen. By varying the relative strengths of the beams, different colors can be produced. Red, green, and blue, mixed equally, produce "white" light; red and green mix additively to produce yellow; blue and green produce cyan; red and blue produce magenta. The color resulting from the mixture is always brighter than the contributory colors due to the addition of light beams.

Additive Color Mixing— Mixing Equal Proportions

Primary Colors		Secondary Colors
blue + green	=	cyan
green + red	=	yellow
red + blue	=	magenta
red + blue + green	=	white

The complementaries of the colors of light (which are produced by the additive process) differ from those of pigments (which are produced by the subtractive process). In the former case, the complementary of red (the one that will cancel it out) is turquoise; the complementary of blue is yellow; and of green is purple.

Additive Color Mixing— Mixing Unequal Proportions

Primary Colors	Secondary Colors
2 red + 1 green	= orange
2 green + 1 red	= lime (chartreuse)
1 blue + 1 green + 4 red	= brown

Gray and grayed colors cannot be reproduced as light. When we do see gray on a television screen, it is because our eye adapts to the brightest areas: Less bright areas will seem gray by contrast. *See also* Optical Illusions; Perception; Simultaneous Contrast.

Adjacent Colors
See Analogous Colors.

Adobe
Adobe refers to both the actual thick, irregular, dusty brown brick of straw and clay, wet down and then dried in the sun, and to the soft, undulating architecture constructed of these bricks, found in Arizona, New Mexico, and Texas. Mud huts and rammed earth structures and fortifications have existed since ancient times. Undecorated, they demonstrate how coloration is often determined by the building material that is native to a particular region, and are fine examples of the analogous color harmonies that can exist between buildings and the environment. *See also* Architecture and Color.

An adobe church near Santa Fe, New Mexico.

Color is an effective handmaiden to promotion. Advertising pages in color draw more attention, are more pleasant to read, and enchance recall.

Advertising

The offering of goods, services, or ideas through any medium of public communication. Advertising provides one of the best examples of the use of color in its various functions: to attract attention, as a vehicle for encoding information, and as a rich source of symbolism and evocation. Color, working on a subliminal level, is frequently the first thing perceived in an advertisement and, in a fraction of a second, can establish the content of the image and suggest a range of values to the consumer. Color advertising is prominent in newspapers, magazines, television, billboards, and direct mail.

In newsprint, the first U.S. color advertisement appeared on April 12, 1893, in the *New York Recorder:* It utilized a red star for the retailer R. H. Macy's. This beginning underscored the first and most important concern of advertising color—it must catch the consumer's attention. Since color is used as a visual bait, if it fails to attract, it fails its purpose.

The increasing use of advertising all over the world has brought about new special demands for color effectiveness. In developed nations, the mere insertion of an ad in a newspaper or magazine, or the flashing on the television screen of a color sequence, does not necessarily generate *favorable* viewer/reader attention. Marketing studies on the power of color in magazine advertising, however, indicate that readers rate full-color pages as "more interesting . . . more pleasant to read" and "more exciting." While red is considered the quintessential attention-grabbing color, the *Journal of the Society of Newspaper Design* noted that a page with a small amount of blue was easier to read than one with a spot of red. A study of eye movements indicated that, after the photographs or pictures, readers went first to any color anywhere on a page, even if it appeared below the fold, on the lower half of a large-size newspaper page.

Recall Enhanced by Color

Color has been shown to aid memory retention, and studies indicate that a color ad has four times as much retention value as a black-and-white one. Readers flicking through a magazine spend, on the average, two-thirds of a second on each black-and-white advertisement; by contrast, two seconds are spent on one with color. By drawing the reader's attention to its presence, color interrupts the customary speed at which the pages are turned, and thereby allows an ad to be viewed a second longer, the difference between an ad that is actually read and one that is only seen. The longer the reader pauses, the more likely he or she is to remember, and therefore to buy, the item or service at a future time. On the other hand, a black-and-white ad, which is designed to arouse critical evaluation, may appear to be more straightforward and honest to some readers than a flashy ad in color.

Spot color in newsprint advertising has become more widespread with advanced reproduction and printing techniques. The appearance, on April 11, 1983, of the color-laden newspaper *USA Today* spurred the usage of color in newsprint (*see* Newspaper Color).

Color can be particularly compelling on the large scale—usually 14 by 48 feet—of billboards. These huge advertisements operate in very compressed perceptual time frames and are most frequently seen by viewers passing by at high speeds. To meet the realities of fast-speed presentations, billboard colorations are characterized by simplicity. Similar to the advertising copy that uses a few carefully chosen words, billboard colors must instantaneously convey a given reality.

Calling Attention with Primaries

Advertising color tends to reflect definite segmented markets. Children's cereals, for example, trade on the power of bold primaries. Ads directed at teenagers present trendy, wacky, and quirkily colored images.

Color in advertising is frequently subjective and suggestive. Blue sky (cool), white clouds and white peppermint (fresh), and brown chocolate (taste) all send associative color messages, evocative of fondly remembered past experiences. In the same way, particular hues in given consumer markets tend to represent specific items or qualities. In the soft drink industry red is used to advertise cola, green and yellow to advertise lime and lemon. In the cigarette industry red is equated with full flavor, green with menthol, and white with low tar. In the realm of household products green signals a pine scent and blue and white suggest cleanliness and antiseptic properties (*see* Communication and Color).

The sociological connotations in the use of advertising colors can change over the years. The principle of diminishing effectiveness and of cycles of boredom and interest apply (*see* Forecasting Color). When supermarkets began using white on black to advertise generic, inexpensive goods, this once elegant approach lost some of its cachet, regaining power only when it began to be used in high-fashion apparel advertising.

The greatest development over the last century in color advertising was the introduction of photographic techniques. The use of color photographs was held back for some time since the printed reproductions were often plagued by moiré effects, and color fidelity was uncertain at best and troublesome to correct by retouching (see Moiré).

With the introduction of Kodachrome, the first truly practical color film, in 1935, it became as easy to obtain high-quality transparencies—and therefore better separations—as to make black-and-white pictures.

The success of color photographs was instantaneous, and it is now used worldwide in advertising. This has led, especially in Europe, to something of a reaction against color. An advertisement in black and white that has then been hand-colored, or with a brilliant spot of color applied just to the product, is considered to be highly elegant.

While hand-drawn illustrations are used to provide a softer color look, the cost-effectiveness and speed of photography continue to make it a dominant force. Filters, masks, and special lenses can provide correction or control as well as unusual visual effects. Retouching (now often done by sophisticated computers) and a variety of other reproduction techniques offer additional mechanical ways to obtain the desired final image. It is unusual for colors to be exact matches to the original product; more likely they have been improved and heightened to enhance their suggestive powers. See also Photography.

Aerial Perspective

An artistic and decorative device used to create the illusion of perspective and depth on a two-dimensional surface through the use of color, mainly by representing certain atmospheric effects.

The most striking effect is the blueing of objects seen from a distance, such as mountains. The dust- and moisture-laden air between the object and the viewer tends to diffuse blue light, giving a distinctly blue cast to greens. Leonardo da Vinci, in one of the earliest uses of aerial perspective, achieved a sense of enormous depth by using such a progression in the landscape behind the figure of his Mona Lisa, from deep greens close by to light blues in the distant background. In contrast to blue, anything painted in bright red will appear to dominate the foreground; at a distance, red degenerates into brown and black. In fact, green does not lose its hue immediately as the distance increases, but declines in steps through yellowish green to turquoise and then blue. In addition, far-off brown hills look mauve, while rocky, gray mountains lighten in tone, and blues and purples simply tend to darken as they recede (see Visibility).

A physiological feature of the eye may also contribute to the apparent nearness and distance of red and blue, respectively. Because of chromatic aberration in the lens, red light comes to a focus just behind the retina; it is suggested that this causes red-colored objects to appear to advance toward the viewer. Painters have long used touches of red's brilliance to push objects forward. Blue, with its shorter wavelengths focused in front of the retina, is an apparently retiring color. Builders of Gothic cathedrals often painted the vaults blue to emphasize the height of the building, as well as, associatively, to suggest the infinite depth of the sky. Similarly, the apparent length of the cathedral could be enhanced by using blue stained-glass windows at either end. Such techniques are applicable to all interior design, in which color can be used to increase the apparent size of small living and working spaces.

essay

Aesthetics

A relatively new branch of philosophy, aesthetics deals with the nature of art and the criteria of artistic judgment. It encompasses the fields of poetry, theater, dance, and music as well as the visual or "plastic" arts of painting and sculpture, attempting to outline their means of communication and expression and to explain how art is understood and appreciated—through informed opinion, taste, and emotional response. British art historian John Welchman examines the changing significance of color within this discipline.

Historical Aesthetics

Within so-called classical aesthetics, there is very little specific attention to color. This is, in part, because few texts from antiquity have survived on the art of painting in comparison to the relative abundance of material that exists on literature and music, notably Aristotle's *Poetics* and the *Ars Poetica* of Horace (65–8 B.C.).

Plato's conception of art as a poor imitation of nature—extending even to a proposal to expel poets from his model state—indicates that he regarded color application as an insignificant, sometimes dangerous, and certainly ill-fated attempt to render reality more "real." In his writings, in fact, Plato (428–ca. 348 B.C.) inaugurates the long-standing Western tradition of subordinating color to

"Colors may mutually relate like musical concords for their pleasantest arrangement; like those concords, they are mutually proportionate."
—Aristotle

form and to formal values. In *The Republic*, he attacks the sensuous immediacy of color (and other sensory impressions), declaiming against the seduction of the gorgeous "blazonry of the heavens," "sparks that paint the night," or "mere decorations on a visible surface." Instead, absolute beauty is somehow transcendent, not accessible to the realm of the senses. To balance this, however, he does recognize the nobility of the faculty of sight and begins the articulation of that relation between light and spiritual beauty that was to be of enormous importance to the Christian Middle Ages.

Aristotle's Lost Text

Aristotle concurs with Plato's cautionary words on color, writing in his *Poetics*, "The most beautiful colors laid on without order (that is without cooperation toward a single end) will not give one the same pleasure as a single black-and-white sketch of a portrait." Unfortunately, Aristotle's main writings on painting do not survive, and we are limited to such virtual asides and analogies from his more substantial texts on poetry and music. A result of this is that most writing on aesthetics until the Renaissance and beyond tended to treat the art of painting as susceptible to the "rules" of poetry; there are more analyses of the "colorfulness" of rhetorical and written devices than there are of the role of color in the visual arts. Pliny the Elder (A.D. 23–79), however, does offer a brief technical "history" of painting, which he saw as characterized by a development from mere line drawing to the use of plain red infills followed by the "progress from monochrome to polychrome painting," which was finally achieved in the work of Apollodorus, in the fifth century B.C.

From the time of Plotinus (A.D. 205–70) until the High Renaissance, writers touching upon the arts and mentioning color were forced to wrestle with the troublesome and dangerous question of sensuality. Although colors were perceived through sight—the highest of the senses—they were still a part of the non-celestial substance of which humankind was made. The only way to elevate the colorful, and hence intrinsically sensual, human sense of sight was to celebrate the divine nature of light.

Thus, Plotinus deepened Plato's veneration of the qualities and implications of light; St. Augustine (354–430) called light "the queen of colors"; and Thomas Aquinas (ca. 1224–74) offered a definition of "effulgence," which presumed "bright objects . . . to be beautiful." In a rich tradition continuing up to the time of the poet Gerard Manley Hopkins (1844–89), who penned the famous line

describing the "shining from shook foil," bright colors, luster, reflections, sparkle, radiance, clarity, the golds and lapis blues of medieval mosaics and manuscripts—all that was (literally) "illustrious"—were held as powerful tokens of the divine light that was believed to be their ultimate source.

By the time of Leonardo da Vinci, the golden auras and monochrome backgrounds of the Middle Ages had given way to a much more earthbound, realistic coloration that attempted, with the help of technological advances and new pigments, to render the natural world as though through a mirror. Nevertheless, the formal and perspectival demands of painting still took precedence in the period's treatises and polemics over any detailed consideration of color—except in Venice, where extravagant coloration reached its apogee in the works of Titian and Tintoretto (the only painter to have assumed a name deriving from the word *color*; 1518–94). Leonardo disparagingly described pure color as a "fog" on several occasions, and Giorgio Vasari (1511–74) in his *Lives* stigmatized both Paolo Uccello (1397–1475) and Jacopo da Pontormo (1494–1557) for coloristic excesses.

The brief, jubilant liberation of color in the Mannerist and Baroque periods was followed in the seventeenth and eighteenth centuries by another *rappel à l'ordre*, undertaken this time not in the name of religious piety but on behalf of Enlightenment rationalism. Francis Bacon (1561–1626), René Descartes (1596–1650), John Locke (1632–1704), and others, attempting to define the "rules" of perception, found color to provide only a tenuous link with the real world. Locke, for example, in his "Essay Concerning Human Understanding," lumped together "colors, appearances, and resemblances" as the unstable stuff of "fancy." Sir Joshua Reynolds, in his *Discourses on Art* (1769–89), sought to reveal in pictorial color its appropriate modesty before nature: "Have recourse to nature herself, who is always at hand, and in comparison of whose splendor the best pictures are but faint and feeble." At the dawn of the age of romanticism, nature had taken over from the divine the role of keeper of the splendor and luminosity of light and color.

Modern Aesthetics

Between the mid-eighteenth century, when aesthetics was formally christened as an independent discipline, and the twentieth century, probably the most important systematic attempt to deal with the entire spectrum of aesthetic problems was *Critique of Judgment* (1790) by Immanuel Kant (1724–1804). Despite his confessed difficulties in

finding universal a priori judgments for the category of the beautiful, Kant manages to elaborate a detailed and closely argued system, which he believed to be applicable to all human beings.

At least twice in this volume, Kant deliberately relegates color in painting (along with the "pleasant tones of a [musical] instrument") to the domain of the "charming" (*reiz*) and not of the "beautiful." It is, he says, "the delineation (*Zeichnung*) in the first case, and the composition (*Komposition*) in the second, that constitute the proper object of the pure judgment of taste." He maintained that color, tone, taste, smell, and touch were mere sensations, lacking in form and constituting only "secondary qualities in the experience of the beautiful."

Kant later somewhat softened his approach to allow color the possibility of being perceived as "the beautiful play of sensation," rather than as a wholesome part of "the formative arts" (sculpture, architecture, and painting). However, the potential of color for the disruption of aesthetic feeling, its sensuousness and subjectivity, and its evasion of the controls of ordering and rationalization necessary to any ambitious system of thought, surface as fears and cautions in the writings of philosophers and aestheticians after Kant.

The great connoisseur of the arts Bernard Berenson (1865–1959) responded to color with a flourish of negatives: "As color is less essential in all that distinguished a master painting from a Persian rug, it is also less important in the unmaking of art." Moreover: "Color is subordinated to form and movement; as, for instance, hair on the head, so ornamental and transfiguring, is subordinated to the skull and face." The English formalist Roger Fry (1866–1934) considered color "the only one of our elements which is not of critical or universal importance to life and its emotional effect is neither so deep nor so clearly defined as the others."

While some early-twentieth-century commentators did acknowledge, in the words of Clive Bell (1881–1964), that "the distinction between color and form is an unreal one," Adrian Stokes is one of the few aestheticians to devote a book-length analysis to the subject. His *Colour and Form* (1937) attempts to demonstrate the complex interdependence of form and color, particularly how, in reciprocal relation to form, "colour . . . above all emphasizes for us the outward and simultaneous otherness of space."

Stokes is also critical of one of the major developments in the understanding of color undertaken in the nineteenth century—the scientific, psychological, and mystical analysis of "pure film colors" (*see* Aperture Color). He writes of the "tenuous and rakish mythology of film color" and its "vulgar" connections with "disposition." He is skeptical of the synaesthetic ideas of the symbolists, which were carried over to the theory and practice of early-twentieth-century abstract painting by Wassily Kandinsky, Kasimir Malevich, Piet Mondrian, and others (*see* Kandinsky, Wassily; Mondrian, Piet).

By the middle of the twentieth century, the problematic relation of color to form, to aesthetic pleasure, and even to scientific discourse began to be readdressed. It is not a coincidence, for example, that color experience was the subject of one of Ludwig Wittgenstein's last published works, the remorselessly relativistic *Remarks on Color*; or that several other philosophers of language have used color words to illustrate some of their most complex theories of linguistic reference.

Above all, twentieth-century aestheticians and philosophers such as Rudolf Arnheim and Jean-Louis Schefer have detailed the historical neglect of color and color theory in the writings on painting of the Renaissance, and the subsequent exaggerated rationalization of color in the proliferation of scientific and pseudo-scientific systems during the nineteenth century.
—John Welchman
See also Architecture and Color; Arts and Crafts Movement; Communication and Color; Form and Color; Harmony.

Afterimage

An example of the effect known as successive contrast: Afterimages are "ghosts" of colors that appear when the eye has been fatigued. Focusing for as little as ten seconds on a colored area such as a red spot will fatigue part of the retina to that color and cause a significant shift of sensitivity to its complementary; a pale green spot—the complementarily colored negative afterimage—will then appear for a short time when one looks at a blank, white surface. The afterimage of yellow is violet and the afterimage of blue is orange.

If, instead of looking at a white field, one views a dark or black field after focusing on a red spot, a positive afterimage—or pale red dot—will be seen (though this is not so easily elicited because it is very faint). Successive contrast is also called local adaptation, because it occurs within the stimulated area of the retina and does not spread to immediately adjacent areas, as in simultaneous color contrast (*see* Optical Illusions).

The afterimage of black on white is white on black. Similarly, afterimages of colored patterns appear in complementary hues: the afterimage of red is green; of orange, blue; and of yellow, violet.

Some researchers suggest that the after-image effect takes place in the brain rather than in the eye, and even that it can occur without any light stimulation at all. In one experiment, G. L. Walls, then professor of physiological optics at the University of California at Berkeley, asked his subjects to imagine colors. Color experiences were noted and the subjects even "saw" complementary afterimages, even though their retinas had not been excited. "These were persons who, in the waking state, did not know that there is such a thing as an afterimage—let alone that it should be expected to be a complementary to the stimulus" (Walls 1967).

Agate

See Chalcedony and Jasper.

Aggression

See Baker-Miller Pink; Red.

Agriculture

Analysis of the color of plants or soil samples can be helpful in determining such features as their health or chemical composition, respectively. *See* Appendix for a partial list of color charts for agricultural and horticultural use.

Air Force

See Camouflage.

Airplane Colors

Color is an antidote to claustrophobic tunnel effects suffered on airplanes.

In modern aircraft design, color can minimize an obviously claustrophobic situation and provide visual relief from monotonous design. Color can make airplane interiors appear sturdier and larger and can break the discomforting uniformity inherent in an aerodynamic vehicle. In the case of American aircraft, a sense of substantiality and solidity is achieved with classic design shades, such as light gray, sky blue, oyster, burgundy, beige, terra-cotta, and a variety of whites. Two devices are commonly used to make airplanes look less like airborne tunnels. First, the space can be broken up by arranging seats in alternating blocks of color. Second, it is possible to give the impression of greater height by having the cabin interior colors grow progressively lighter in value from the deep colors, used for carpeting, to light-reflecting creams and whites overhead.

First-class sections of airplanes require special color considerations to match the particular attention such passengers receive in other respects. As in the interior of an expensive automobile, interior color for first-class areas must be non-ostentatious and distinguished by softness, elegance, and coordination of quiet tones. Colors must simultaneously provide a sense of luxury and privacy, evoking the atmosphere of an exclusive club. Thus, popular in the 1980s on transatlantic carriers and other airplanes that make long-distance flights are the cool, clear group of blues and burgundies. However, color preferences do not last forever, and changes must often be made to keep up with the fast pace of color fashion.

When changes are made in color, they should be made throughout the whole color scheme. One major North American airline changed its first-class color scheme, but left the uniforms of the attendants as they had been. The result was a dangerously down-market look, where even the new decor looked old because of the uniforms. A subtle coordination of the entire environment is essential—down to the chairs, pillows, cutlery, plates, signs, and curtains.

Paint used on the exterior of aircraft has two functions. Early airplanes were unpainted to reduce weight, and were left the silver color of their aluminum shell; painted exteriors were reserved for the military, for camouflage and identification. Present-day aircraft, however, tend to be painted to protect the skin of the vehicle from the corrosive action of chemicals in the atmosphere. Painting the outside also helps control the temperature inside. White is now almost exclusively the color for the upper part of the fuselage. Since it reflects most of the sunlight hitting the airplane, white paint can keep an aircraft up to ten degrees cooler than can an unpainted shell. Despite the three tons of paint needed for a jumbo jet, the energy saved on air-conditioning makes up for the added weight. The underneath and wings are usually left uncolored.

White is also often used in airline advertising. While white provides a high-contrast background for an airline's logo, some companies have eschewed this approach in order to be distinctive and to promote certain desired associations: the allover green of Pakistan International Airlines refers to the principal color of Islam, and the new platinum gray for the top of British Airways's airplanes suggests upper-class breeding and tradition, while the overall design keeps within the red, white, and blue scheme of the national flag. *See also* Commercial Color Symbolism; Communication and Color.

Alabaster

The popular name for the highest grade of the mineral gypsum (calcium sulphate), from

which ornamental pieces can be sculpted, but which is also strong enough to be used for structural elements such as columns. Alabaster is commonly off-white in color with a fine graining, although it can also have yellow, red, or gray tinges. Alabaster columns within certain Bavarian Baroque churches are illuminated from the inside, and the translucent material gives off a yellowish glow. Alabaster is soft enough to be easily carved, but it is also too easily broken, soiled, and weathered to be useful for exterior decoration. The oriental ''alabaster'' of ancient Egyptian and Roman tombs is actually marble, a calcium carbonate.

Albers, Josef

1888–1976. Bauhaus teacher, color theoretician, and perceptual painter who played a richly varied role in twentieth-century color history. Albers focused on the relativity, wealth of ambiguity, and emotive content of color relationships that make up the complexities of human visual experience.

Born in Bottrop in Westphalia, then a province in Prussia, Albers's artistic life began to take shape in 1920 when he enrolled at the Bauhaus. As a student there, Albers explored the nature of materials and their forms, colors, and textures. His work in colored glass assemblages was of such interest that in 1922 he was asked to reopen the glass workshop and to teach as a Bauhaus journeyman. In 1923, he was further honored when Walter Gropius (1883–1969) asked him to teach the basic design course (Vorkurs). Albers remained as a teacher at the Bauhaus until the school closed in 1933. During this time, in addition to the basic design course for which he became well known, he taught workshops in furniture design, typography, calligraphy, and printmaking.

Albers's years at the Bauhaus were decisive for his own art. What concerned him was the fundamental perceptual problem—how humans see the third dimension of depth when it is created as an illusion by an artist in terms of only light and color on a two-dimensional surface.

In 1949, Albers began an investigation of color form that he entitled *Homage to the Square*—a series of paintings comprising compositions of three of four squares. Each of the squares nests in another and each is composed of just one unmixed color evenly applied with a palette knife. The series is really an homage to color, because it demonstrates how color can undergo a metamorphosis caused by its environment. Moreover, Albers shows how color acts as a means of plastic organization: Squares move back and forth, in and out, up and down, enlarging and diminishing, all because of color effects. The colors appear stunningly varied and new, but in fact they are generally applied, unmixed, directly from the paint tube, in a single layer without under- or overpainting. Since Albers rarely mixed colors, the chromatic variation is astonishing.

Albers's book *Interaction of Color* (1963) is of major interest to colorists and art educators. This monumental work sets forth Albers's innovative approach to teaching color, based on his perceptual experiments leading to an understanding of color in changing contexts. As a teacher not only in Germany's Bauhaus from 1923 to 1933, but also in the United States—to which he immigrated with his wife, the weaver Anni Albers—at Black Mountain College from 1933 to 1949 and at Yale from 1950 to 1960, Albers educated an entire generation of artists in the appreciation of color as an organizing principle of art. *See also* Bauhaus.

"The aim of our studies is to prove that color is the most relative means of artistic expression, that we never really perceive what color is physically."

"Color is like cooking. The cook puts in more or less salt, that's the difference!"
—Josef Albers

Anni and Josef Albers.

Albers's investigations into variations on the theme of the square gradually evolved into a deepened interest in color. In his book, Interaction of Color, *Albers states that ''color is the most relative medium of art. Any color can be connected with another to produce a well-worked art effect.''*

Albert-Vanel, Michel

1935– French color theorist, artist, and professor at the Ecole Nationale Supérieure des Arts Decoratifs in Paris. Self-taught in the science of color, Albert-Vanel invented a color system, the Planetary Color System (*see* Systems of Color), based on color combinations rather than single, isolated colors. His other work includes a *grande orgue chromatique* (a color organ for mixing sound and color) and a set of tarot cards using the symbolic meanings of colors (instead of images). He has published various articles on the subject of color and in 1987 produced a brochure on color education for the French government, entitled *Des Couleurs pour nos Écoles* (*see* Education, Color).

Albino

An animal or plant congenitally deficient in pigmentation. The albino skin (including hair, feathers, or fur) and eyes lack pigment, the latter appearing pink or blue. In human beings and other animals, albinism is inherited as a recessive trait. Breeding has established albino strains in some domestic animals, such as the Persian cat.

Alchemy

A medieval chemical science and speculative philosophy that searched for the mythical philosophers' stone—a medium with the reputed power to transmute base metals into gold. Alchemy may date back as far as 3000 B.C., when the Egyptians first developed metals from ores.

The search for a means to produce gold had broad and mystical connotations. Gold, the most precious and unsullied of the metals, was associated with spiritual perfection. To learn how to create gold was to comprehend the spirit of creation and to know how to purify and transform the self. The process in medieval times was known as the *magnum opus*, or "great work"—a psychic quest in chemical guise. The philosophers' stone was likened to Christ; transmutation meant faith, the separation of good and evil, the coarse expunged from the divine.

The role of color in alchemy was vital. The different hues that appeared as the alchemist transmuted substances in his vessel symbolized each stage of the simultaneous inner transformation he was experiencing. The alchemic spectrum was green, black, white, red, and gold. Green represented the base metal that the alchemist would transmute, and a state of psychological immaturity and incompleteness. Black signified the death of one chemical and the generation of another, corresponding with a period of melancholy

For Jung, as for the alchemists, color provided a clue to the workings of the mind.

and inward searching. White symbolized the separation of the mercurial, or spiritual, properties of matter from the base or bodily properties. The opposing tendencies—the spirit and the body—in either man or matter were ultimately to be resolved and recombined by the elusive philosophers' stone—symbolized by the color red—whose psychic function could be compared to that of the twentieth-century psychiatrist. In a similar way, the alchemist's "gold" represented not only the metal gold, but also the less tangible brilliance of psychic integration and wholeness.

Although alchemy declined in the seventeenth century with Descartes and the Age of Reason, it experienced a vicarious rebirth with the psychoanalyst Carl Jung (1875–1961). While delving into the psyche of the human being, Jung noted many recurring symbols and colors in the dreams and paintings of his patients, which he explained as common memories—the universal unconscious—handed down from generation to generation. In 1930 he came upon some old alchemical texts and noticed that the symbols and colors describing each step of the alchemist's opus corresponded with the images that occurred in his patients' dreams. He was not persuaded by the pseudoscience of the alchemists, but he recognized that their purpose was the same as his—the purification of the self: "Their experiences . . . were my experiences, and the world was my world. . . . I had stumbled upon the historic counterpart of my psychology of the unconscious." For Jung, as for the alchemists, color provided a clue to the workings of the mind, and using his patients' dream histories he was able to draw a series of parallels between the alchemical process and the psychological growth he deemed indispensable for mental health. *See also* Heraldry; Zodiac Colors.

Alizarin

A vegetable dye originally obtained from the madder plant. Synthesized by German chemists in 1868, alizarin was the first instance of an artificial product of a vegetable dyestuff. In the textile industry, alizarin dyes are mainly used on wool, sometimes on cotton. They produce a brilliant, highly fast turkey red, among other colors. *See also* Dyes and Dyeing.

Almond Green

A standard American shade of green having a grayed-yellowish cast.

Alychne

A term used in colorimetry; it refers to the CIE diagram of 1931, in which all spectral

colors and their mixtures are mapped on a horseshoe-shaped diagram—all the space surrounding this diagram is called the alychne. Alychne is a purely mathematical construct and has no corresponding color. *See also* CIE System and Color Measurement; Colorimeter.

Amaranth

A deep purple or purplish red. The name comes from a plant of the genus *Amaranthus* found mainly in warm regions of the Americas and Africa in the form of herbs, trees, and even vines. Several species contain a lasting red pigment present in the stems and leaves. The amaranth is also an imaginary flower of poetry that never fades.

Amber

Fossil resin originating from now-extinct coniferous trees and used as a gemstone when highly polished. Amber colors range from white to yellow and brown; gem-quality amber is translucent. Its earliest use was as a gem for amulets or, in powdered form, as a medicine. The Greek word for amber is *elektron*, from which the word *electric* derives, because, when rubbed, amber takes a static electric charge strong enough to attract silky materials. Amber is now found chiefly on the coast of the Baltic Sea. Amberlite, a favorite 1940s shade of orangy yellow, is the name of a present-day American textile industry standard. *See also* Gemstones and Jewelry.

American Colors

Standardized American colors go back to 1915, when the Textile Color Card Association (predecessor of the Color Association of the United States) issued the first American swatched color reference for the textile and allied industries. The action was taken in response to the German sinking that year of the British ship the *Lusitania,* which fired red-white-and-blue patriotism because over one hundred American lives were lost. Moreover, the sinking made heads of American textile firms realize that in the immediate future, German dyestuffs would effectively be cut off by the war in Europe and its disruption of Atlantic shipping. Roughly a dozen presidents of U.S. silk and wool textile firms gathered in New York City to establish America's own national color standards. These new color standards were published in 1915 so that American dyers, mills, manufacturers, and retailers could work with a common color understanding without having to depend on Europe.

The first edition of the *Standard Color Reference of America* designated and made available in silk ribbon samples the most popular colors—those that were consistent favorites. Out of some 10,000 to 20,000 major fashion shades, 106 were selected for the 1915 edition, representing the preferred color staples of an ordinary American's chromatic diet. Among the nominees selected to appear in the first edition were gem colors such as emerald, ruby, and sapphire; semi-precious stone shades such as garnet and topaz; college colors such as Yale blue; and colors based on foodstuffs such as apricot, chestnut, eggplant, lemon, olive, and prune; on wines and liquors—burgundy, champagne, claret, and chartreuse; on animals—beaver, fawn, and seal; on birds—cardinal and peacock; on flowers—geranium, lavender, lilac, pansy, violet, wisteria, and wild rose; on plants and shrubs—goldenrod, maize, and sage; on the military—West Point gray and navy 1, 2, and 3; and on precious metals such as gold and silver.

The latest available edition, the tenth, issued in 1981, contains 192 American textile standards and is supplemented with 24 U.S. Army colors. The tenth edition almost doubles the number of colors in the first edition, a fact that reflects the growth of the fashion and textile industry in the post–World War II years. *See also* Athletic Colors; Fashion and Clothing Color.

American Indians

See Navaho Colors.

Amethyst

A variety of quartz that exists in a range of shades of violet from a pale shade to a deep, rich, reddish purple. It was treasured in the classical Greco-Roman world for its reputed magical powers: Dipped in a drink, it was supposed to be a love potion, to sharpen intelligence, and to cure or prevent drunkenness—the name literally means "not drunken" in Greek. The stone became popular for ecclesiastical rings in the Middle Ages, guarding the wearer against unseemly behavior at church banquets. *See also* Citrine; Gemstones and Jewelry; Quartz.

Amorphous Color

A color that is perceived to have no specific spatial location—the blue of the sky being an example, since that blue color is an indeterminate distance from the viewer. *See also* Aperture Color; Surface Color; Volume Color.

Amplitude

The extent of an oscillatory movement (wave) measured from the mean position to

The Color Association of the United States

The Standard Color Reference of America

African Brown 80180
Almond Green 80154
Amberlite 80163
American Beauty 80053
Amethyst 80122
Apple Red 80107
Apricot 80037
Aqua 80133
Arbutus Pink 80016
Ashes of Rose 80094
Autumn Brown 80091
Baby Blue 80010
Baby Pink 80014
Beaver 80190
Beige 80188
Bleached White 80001
Blue Spruce 80155
Blue Steel 80047
Blue Turquoise 80021
Bois de Rose 80149
Bottle Green 80066
Brittany Blue 80130
Bronze 80111
Brown 80167
Burgundy 80186
Burnished Straw 80165
Burnt Orange 80012
Caramel Brown 80168
Cardinal 80081
Castor 80125
Catawba 80095
Chalk Pink 80085
Chamois 80006
Champagne 80169
Cherry 80051
Claret 80185
Cocoa 80092
Copenhagen 80044
Coral 80091
Cork 80170
Cornflower Blue 80074
Crab Apple 80137
Crayon Green 80032
Dahlia Purple 80101
Dark Cardinal 80082
Duckling 80024
Dustblue 80043
Dusty Pink 80088
Ecru 80187
Eggplant 80117
Eggshell 80004
Electric 80104
Emerald 80063
Evergreen 80036
Fawn 80189
Flame Red 80030
Flax 80161
Flemish Blue 80046
Flesh Pink 80013
Forget Me Not 80012
Garnet 80083
Geranium 80079
Gold 80110
Gold Brown 80166
Golden Poppy 80071
Goldmist 80160
Grebe 80096
Grecian Rose 80148
Grotto Blue 80022
Harvard Crimson 80052
Heliotrope 80115
Henna 80114
Homage Blue 80078
Honeydew 80038
Hunter 80064
Hydrangea Blue 80147
Imperial Purple 80102
Independence 80076
Scarlet 80080
Schiaparelli Pink 80049
Sea Pink 80018
Seal 80192
Shell Pink 80027
Shrimp Pink 80106
Silver 80139
Sky Blue 80011
Smoke 80099
Spanish Yellow 80068
Spicebrown 80129
Spring Green 80061
Starlight Blue 80145
Steel 80141
Strawberry 80183
Sunset 80151
Tan 80152
Tangerine 80040
Tarragon 80034
Taupe 80126
Tea Rose 80025
Teal 80135
Terra Cotta 80113
Tigerlily 80029
Tile Blue 80045
Toast Brown 80128
Tobacco 80179
Topaz 80164
Tourmaline 80019
Turquoise 80020
Vassar Rose 80181
Violet 80057
Violine Pink 80050
West Point Grey 80159
White 80002
Yale Blue 80172

"You might think that the invention of aniline dyes changed colours, at least briefly, that were used in painting. But not really. . . . It's surprising to see in the Bronzino portrait of a young man, that he's sitting in front of a curtain which is in fact Schiaparelli shocking pink, which had always seemed to me the last word in aniline colours."
—Howard Hodgkin

an extreme. Amplitude is effectively a measure of the intensity of energy content, as in the case of light waves.

Analogous Colors

Colors that are next to or near one another on the color circle (*see* Systems of Color); also known as adjacent colors. Analogous colors are the basis for a system of color harmony: Colors that are close to one another in hue and saturation will readily harmonize. The best examples of analogous color harmony are found in the natural world, where colors frequently merge into one another from blues to light, medium, and dark greens, through yellows and soft reds. *See also* Harmony.

Analysis, Color

See Jackson, Carole; Personal Color Analysis.

Ångström, Anders Jöns

1814–74. Swedish physicist notable for his study of light, especially in the area of spectrum analysis. Ångström mapped the sun's spectrum and was the first to examine the spectrum of the aurora borealis. The unit of length, ångstrom, used especially to measure wavelengths of light, is named after him (*see* Ångstrom Unit).

Ångstrom Unit

Unit of length (Å), used to measure wavelengths of light, equal to one ten-millionth of a millimeter; named after the Swedish physicist Anders Ångstrom. The ångstrom has been replaced for color and most scientific work by the nanometer (*see* Nanometer). One nanometer equals ten ångstrom units.

Aniline

One of the first synthetic dyes, discovered accidentally in 1856 by an eighteen-year-old English chemist, William Henry Perkin (1838–1907), while he was trying to synthesize quinine from coal tar. At the time, coal tar was a waste material produced in the manufacture of gas. Perkin discovered that, properly treated, it produced a purple color that, when applied to fabric, miraculously resisted fading caused by laundering or exposure to sunlight. Borrowing his father's life savings to manufacture aniline purple and many other aniline-based dyes, Perkin became rich from the dyes' commercial success.

Perkin failed to get a patent on aniline in France, and the French produced their own version of the dye, which they called mauve, after the delicate purple of the mallow

flower. This name has remained as a color designation. In France and England, aniline/mauve became the rage of the fashion world in the 1890s. Queen Victoria herself wore a mauve dress to the International Exhibition of 1862. Perkin's achievement remains a milestone even though today, because of their long dyeing cycle, anilines represent a small percentage of the synthetic dye industry. *See also* Dyes and Dyeing.

Animal Colors

See Zoology and Color.

Animation and Color

See Motion Pictures, Color in.

Anomalous Trichromatism

Technical term for color blindness, a defect of vision in which sufferers cannot recognize one or more of the primary colors of the light spectrum—red, green, and blue. There are three kinds of anomalous trichromatism: protanomalous vision—a reduced sensitivity to red, and some confusion between red and green; deuteranomalous vision—characterized by some red-green confusion and reduced sensitivity to green; and tritanomalous vision—a reduced sensitivity to blue. A test for the defect has the subject try to match a color sample against a mixture of three (red, green, and blue) light beams; he or she is allowed to vary the intensities of each beam until satisfied with the match. An abnormal quantity of one of the three colors used indicates a color vision problem. *See also* Achromatism; Color Blindness.

Antagonism

See Optical Illusions; Stereoscopic Vision.

Anthocyanins

Soluble pigments producing blue to red coloring in flowers and plants. From the Greek *anthos*, meaning "flower," and *kyanos*, "dark blue." *See also* Plant Colors.

Anthracene

A crystalline hydrocarbon to which chromophores are added to produce an intermediate anthraquinone, which is widely used in the production of alizarin dyes. *See also* Chemistry of Colorants; Dyes and Dyeing.

Anthraquinone

A derivative of coal tar, via anthracene, used especially in the manufacture of synthetic dyes. *See also* Chemistry of Colorants; Dyes and Dyeing.

Antimony

An off-white metallic element used as a compound in making color pigments.

Antique White

See Off-White.

Antiquing

Artificial aging of furniture, walls, etc., by use of color. *See also* Trompe L'Oeil.

Aperture Color

A perceived color occupying an area of indeterminate distance from the viewer, which therefore is not seen as belonging to a surface. An example is the color seen in a spectroscope. Aperture colors do not include colors seen on surfaces or as localized within the volume of a liquid (*see* Surface Color; Volume Color). An aperture color exhibits saturation and brightness, but not lightness, since it is viewed as an isolated color.

Apple Green

The yellowish green color of some varieties of apples, notably Granny Smiths.

Application of Color

The coloring of objects varying from glass bottles to clothing, from gases to metals, demands an intricate technology. With the modern proliferation of objects and materials, application of color is a major industrial concern. *See also* Dyes and Dyeing; Enamel; Fabric Printing; Glass; Wood Colors.

Apricot

The fruit—and its color—of the tree *Prunus armeniaca*, native to Asia and, in the United States, cultivated chiefly in California, is characteristically yellowish orange in color.

Aquamarine

An almost flawless variety of beryl, in which the coloring agent is a trace of iron. Aquamarine generally has a transparent bluish green color, but when heated it will turn to the bright blue that is so favored in modern jewelry. The name comes from the Latin *aqua* (water) and *marine* (sea). *See also* Emerald; Gemstones and Jewelry.

Aquarelle

A transparent watercolor paint. Aquarelle was popularized by nineteenth-century British painters, notably J. M. W. Turner. Applied to paper in thin washes, aquarelle yields subtractive color mixes. *See also* Subtractive Color Mixing.

Aquatint

A form of etching, in which the printing plate is etched through a porous resist applied to the surface. The resulting tonal effects on the print resemble those of wash drawings. The technique is said to have originated with the French printer J. B. LePrince in the 1760s. Artists often sharpen the aquatint image by also using other etching methods on the same plate. *See also* Etching.

Aqueous Paints

See Watercolor.

Arabian Art

See Seljuk and Ottoman Mural Ceramics.

ARCHITECTURE and COLOR

Color use in architecture falls into two broad categories: first, color used as an active element, in the form of an applied finish (for example, paint, pigmented whitewash, metal or stone inlays, and decorative brickwork, ceramics, and glass) which is intended to enhance the appearance of a building; and second, a more passive (or neutral) use, where color is derived from the natural tones of the construction materials themselves. Most architectural color use, however, is determined both by site conditions—including climate and lighting—and by the cultural and aesthetic aspirations of the builders. Such color, of course, varies around the world.

Historically, color has often been a luxury, and, with the exception of major civic projects, has usually been determined by the color of building materials—stone, brick, clay, or wood—available locally. Among the advantages of unadorned stone was that it was relatively cheap to maintain, resilient to weathering, and blended harmoniously with the landscape. The perceptive advantages could be substantial: Unpainted medieval fortifications, for example, had the appearance of growing out of the solid rock on which they were built, giving them an additional aura of impregnability before an attacking force. Where paints were introduced, as for protective coatings over mud or stucco, they were generally colored with natural earths found in the vicinity, though sometimes colors were chosen to simulate (unaffordable) local stone. During

the Middle Ages, for example, many Italian towns were painted in distinctive harmonies of local ochers (yellows in Florence, reds in Bologna, and so on), rendering them ruggedly cohesive and in tune with the surrounding landscape (*see also* Architecture: Environmental Color by Jean-Philippe Lenclos, following).

Color for Communication

Where decoration was used, color was an important tool: not only could it be used to enliven a surface, but it could also be used to define space and form (*see* Form and Color; Optical Illusions), to communicate information at a visual or symbolic level about the purpose of a building (*see* Communication and Color). It is largely prejudice against color as an ornamental element that has led to its being downplayed in twentieth-century architecture, since the International Style, with its hard-edged geometries and absence of ornamentation, swept America after the 1920s.

Public buildings of the past, however, have reveled in the use of strong color to celebrate religious or civic power. The ziggurats—artificial mountains of ancient Mesopotamia (modern-day Iraq) and models for the biblical Tower of Babel—are thought to have been richly painted, with a different hue for each actual and symbolic step toward the summit (and innermost sanctuary). While their successors, the pyramidical tombs of Egypt, were not colored—though fine limestone finishes and strict geometry gave them strong contour—color was used lavishly for Egyptian temple walls, columns, and other architectural elements. According to its symbolic content, every color had its place. For example, the green of the Nile valley could be used on columns often carved to represent growing plants, and the blue of the sky was used on ceilings (*see also* Color in Architecture by Michael Graves, following; Symbolism and Color).

With a similar concern with color, the Romans decorated both the interiors and exteriors of their temples with red, green, white, and black marbles, all available from nearby quarries. Brick, the ubiquitous building material, and concrete, a Roman invention, were considered unsuitably colorless as exterior finishes in major projects and were invariably masked by other materials. Nineteenth-century excavations at Pompeii and on the island of Aegina, Greece, showed that the classical tradition went beyond the subtlety of stone colorations. Interiors were covered with polychrome frescoes (*see* Fres-

co; Pompeian Color) and exteriors were decorated with paint in strong primary colors. Subsequent weathering has since all but obliterated the color record.

Nor have stone and paint been the limit of man's ingenuity in the development of architectural colorations. In Mesopotamia, five-thousand-year-old shrines, built of mud bricks, were covered with sheets of copper or decorated with red sandstone, black shale, or mother-of-pearl. In the sixth century B.C., Nebuchadnezzar decorated the entrance (the Ishtar gate) to his temple complex in Babylon with bright, blue-glazed bricks and bas-relief figures in gold-covered ceramic. In a rare example of a primary color becoming endemic to one region, the same blues reappeared in Middle Eastern Islamic architecture nearly two thousand years later. The muslims covered their mosques with glazed tiles in complex mosaics of turquoise, sky blue, and gold, creating (almost literally) oases of spirituality in barren lands. Islam, renowned for assimilating local influences, acquired many other color traditions too, as it spread from the Middle East as far as Europe and India: architectural color ranged from the natural tones of Spain's Alhambra (built 1230–1354), with its spectacular hanging plasterwork that played with light and shade rather than color, to the Mogul palace of Akbar the Great (1542–1605), south of Delhi, India, with its brilliant white and red stonework. *See also* Seljuk and Ottoman Mural Ceramics.

The Christian tradition has generally been ambivalent to the active use of color. When Constantine declared Christianity the state religion of the Roman Empire in the third century A.D., color decoration, then suggestive of pagan temples, was considered inappropriate for the exteriors of the new churches, which were left bare. Instead, color was used liberally within, reappearing in the extraordinarily luminous glass mosaics of such cathedrals as San Vitale, Ravenna, and Hagia Sofia, Byzantium (now Istanbul). *See also* Mosaic.

Color for Edification

Ultimately, Christian builders were unable to ignore the communicative potential of exterior color. During the evolution of Gothic architecture in Western Europe in the tenth and eleventh centuries, it became more acceptable to decorate facades with sculptures and carvings, many painted in brilliant colors, for the illumination of the congregation, most of whom were illiterate. The Gothic aesthetic would come to influence even quasi-romanesque architecture, such as the

A palette of earth pigments collected by Jean-Philippe Lenclos on his travels around France.

Duomo in Florence (Santa Maria del Fiore, begun 1206), with its green and white marble sheathing, and many buildings in Venice with their decorative marble and brickwork.

With the advent of the Renaissance, color use throughout the West became more subdued. Religious authorities discouraged decoration for ecclesiastical structures, though frescoes were a feature of interiors up to and through the baroque period. There are, however, isolated examples of vivid exterior coloration in the Eastern Orthodox tradition. Until the nineteenth century, for instance, churches in Moravia (now northern Rumania) were decorated outside with frescoes in brilliant colors, intended to instruct and edify the congregation's peasants, who were not allowed inside.

Color for Protection
In residential architecture, color, where used, generally has had a functional role. Just as Mediterranean people whitewashed their homes to reflect the heat of the sun, so the characteristic two-toned, half-timbered houses of Tudor England were also a practical response: black pitch protected the woodwork, and the white or ocher-tinged lime did the same for the daub and plaster infills. Similarly, the American colonists took advantage of the newly developed and relatively inexpensive oil paints to protect their predominantly wooden buildings from the elements, with a deep red becoming a popular barn color to conserve heat and as an effective camouflage for rusting nails. In most cases, the choice of exterior paint colors was still based on the availability and suitability of pigments in a local environment and climate; the result has been an almost infinite array of distinctive regional palettes (*see* Fashion: Geography of Color).

In general, the Western tradition has been marked by restraint in architectural color. Major building projects in Europe and America have avoided paint (again used only on

Natural Color

The colors of the landscape can be grafted onto architecture through the simple use of local materials or the application of pigments found in the region.

(Top left) *The colors of Florence—harmonious shades of warm ocher—are derived from natural earth pigments found in the vicinity and form a vital part of the regional heritage. Other Italian cities are variously orange, red, or brown.* (Top right) *An adobe church camouflaged in the New Mexican desert. The undecorated earth provides a smooth transition between landscape and artifice.* (Bottom right) *The weathered shingles and fencing of an eighteenth-century house blend gracefully into the soft colors and misty climate of Nantucket, Massachusetts.* (Bottom left) *A New York City skyscraper sheathed in glass reflects the colors of the cityscape.*

occasion to simulate stone, as in the White House in Washington, D.C., or the cream-colored stucco of London's Georgian houses, a passable imitation of the popular but expensive Bath stone). Remnants of the Puritans' suspicion of color's expressive and emotive force still affect our tastes (and increasingly, through the spread of commercial architecture, the traditionally colorful taste of the Far East). Nevertheless, there have been brief periods of strong architectural color, such as the elaborately painted ironwork and decorative brickwork of Victorian England, and the Art Nouveau and Art Deco movements: Antonio Gaudi's polychrome Sagrada Familia (partially built, 1882–1930) in Barcelona reflects an Art Nouveau sensibility, while William Van Alen's black, gray, and chrome Chrysler Building (1928–31) in New York City, is a superb example of Art Deco at its best. *See* Art Deco Colors; Art Nouveau Colors; Gaudi y Cornet, Antonio; Sources of Historic Color.

Abstract art and the exploration of color as it relates to form have been significant modern influences. The Constructivists, for example, used color to emphasize function and distinguish movable parts, such as doors, from fixed parts, such as walls. Abstract artists, who used color to manipulate space, encouraged the employment in interior decoration of optical effects, such as the tendency of blue to recede or red to advance visually. Similarly, the Dutch de Stijl movement heavily influenced architects such as J. J. P. Oud and Gerrit Rietveld. Its advocacy of bright primary colors, blacks, and whites, and its use of geometric forms dovetailed neatly with modernist theories being developed in Germany and later applied in the United States by Walter Gropius, Le Corbusier, Philip Johnson, and others.

A medieval stone doorway to a church on the island of Rhodes. Whitewashed in the Greek style, the entrance has been highlighted with chevrons in blue (the flag color), visually and symbolically guiding the visitor into the precinct. Photo by John Hope. (Right) Lenclos uses fragments of rock, earth, and paint chips, as well as copious watercolor note, to analyze regional colorations and develop harmonious color schemes for towns and villages of each province. Photos courtesy of Atelier 3-D Couleur, Paris.

Technical developments in the twentieth century have so far played the largest role in determining the form and color of architecture. Reinforced concrete (invented in 1857) has become the primary building material, and for many decades architectural decoration has been in decline. The construction of glamorously decorated skyscrapers, often called the "cathedrals of commerce" with their costly, labor-intensive terra-cotta and glazed tiles, ended with the Wall Street Crash of 1929 (*see* Terra-Cotta). The Bauhaus of the 1920s and early 1930s was particularly successful in disseminating a utilitarian aesthetic, stressing functionalism while minimalizing the use of overt color and focusing instead on the colors of architectural materials. For the first time, concrete was treated as worthy to be used unadorned. Purely formal buildings replaced the elaborate facades of the late nineteenth and first few years of the twentieth centuries. The Seagram Building (Mies van der Rohe with Philip Johnson, 1956–58), for example, was based on visible structural members that provided an austere and abstract form of decoration. The cost-effectiveness of concrete and glass made the Seagram Building a model for a generation of colorless office buildings.

In the 1970s and 1980s, there has been a partial revival in the use of color in architecture by the "post-modernists," for example, the granite and tile facing of Michael Graves's Portland Building in Portland, Oregon, or the brashly colored, exposed pipes of Enzo Piano and Richard Roger's Pompidou Center in Paris. The full return of color, however, probably depends on future attitudes to architectural decoration, and on reintegration of the fine arts into building (*see* Architecture: Interior Color by Theo Crosby).

(Top left) *Radio City Music Hall, home of New York's vaudeville and an early bellwether of twentieth-century glamour, captured in concrete and neon.* (Bottom left) *The red of American commerce has spread throughout the world through advertising and corporate logos.* (Right) *Cesar Pelli's Pacific Design Center in Los Angeles: an uncompromising wall of blue marching toward one of oxide green.* Photo by Ramsey Rose.

Imposed Color: Modern

The international colors of concrete, glass, and bright neon, chosen without reference to the local environment. A universal gray, punctuated by heavy doses of red.

Three Views on Architectural Color

The use of color in architecture at the end of the twentieth century can be examined according to three broad, and often overlapping, tendencies, alongside the still buoyant modernist (predominantly achromatic) tradition: Natural Color, where the emphasis is on environmental harmony; Imposed Color, which explores the dynamic effects of color; and Decorative Color, at present largely confined to interiors. The following three essays discuss some aspects of each case, respectively. (*See also* Fashion: Geography of Color.)

essay

Architecture: Environmental Color

*French color consultant Jean-Philippe Lenclos analyzes "local colors" used in architecture. Len-*clos *and his studio, Atelier 3-D Couleur, have had numerous commissions from regional authorities in France to develop harmonizing color schemes for their towns and villages based on natural colors found in the landscape. Many of his findings have been charted in his book* Les Couleurs de la France *[The Colors of France],* Editions du Moniteur, Paris, 1982.

One of the great riches of any country is the regional diversity of its terrain and of its towns and cities. This diversity, especially in Europe, is an ancient tradition representing a direct, subliminal translation of a culture into material form and an expression of its needs and values. From the warm brick and tile colors of northern France to the gray and white harmonies of Brittany in the west, the architectural styles of all regions are distinguished as much by their chromatic orders as by their forms and volumes.

However, the chromatic quality of both rural and urban habitats is continuously being threatened by the clumsiness of inap-

(Left) *Michael Graves's proposal for an extension to the Whitney Museum of American Art (New York City) repeats the basic form of Marcel Breuer's 1966 structure, but coloristically provides a connection with the adjoining brownstones.* (Top right) *Clad in various shades of granite and tile, the Portland Building (Portland, Oregon) has been decorated to make a symbolic statement out of the simplest architectural form, the cube.* (Bottom right) *Through careful design of color with glazed tiles, Graves reflects the interaction of water and light in the pool room of the Shiseido Health Club, Japan.* Photos courtesy of Michael Graves Architect, Princeton, New Jersey.

propriate developments. The new buildings which are springing up rarely take into account the area into which they are inscribed. Year by year, landscapes are being undermined by veritable visual pollution.

The largest problem is evidently economic: with the unceasing development of new synthetic materials for construction or renovation come savings that are not negligible. But the tendency of these materials toward exaggerated standardization risks promoting a uniformity of character of architecture . . . unless the development of their pigmentation possibilities is put into better service of the expression of the color of the architecture of its surroundings.

Faced by this complex problem—assuring the preservation of the landscape while using new materials and techniques—we [Atelier 3-D Couleur] have developed a new method based on objective observation of color phenomena in a given site and applicable to any kind of architecture. This is not a license to duplicate the past in a sterile fashion, but one to create a new landscape within the old.

The method involves analyzing regional colorations and includes collecting soil samples and paint chips and taking detailed color notes and photographs. Other topographical concerns include determining the main axes of a town, the differentiation of various neighborhoods, the choice of building materials, and the accent of color in key locations, such as for the identification of major construction projects. There are always problems of environment and the integration of site and superstructure.

In France, for many years, color palettes were rooted in the earth: granite from Brittany, ocher from Provence, stones from Fontvieille, bricks from the former territory of the Albigensians. The colors of these materials determine the map of France and the chromatic diversity of its cities. Such colors, shaped by generations, have not always

Post-Modern

A new look in architecture which encourages the use of historical forms and symbols, with the reintroduction of natural materials such as granite.

Decorative Color

A reinvigoration of architecture by means of the decorative arts is a feature of contemporary interiors and exteriors.

The United Airlines terminal in Chicago, designed by Helmut Jahn, recalls nineteenth-century train terminals. Light pours in through the green glass roof, a checkerboard floor breaks up the vast space of the departure and arrivals lounge, and, in underground passages, neon displays lead passengers onto airplanes.

Fashionable shopping complex on Melrose Avenue, Los Angeles, celebrates the industrial architecture and Art Deco style of the 1920s. Photo by Ramsey Rose.

Trompe l'oeil can be so convincing it almost displaces architecture. The monument to Cincinnatus (inspired by Piranese's study for a Roman temple) on the Brotherhood Building in Cincinnati, Ohio, was designed by Richard Haas to remedy the environmental scar left by the demolition of adjoining property. Photos courtesy of Evergreene Studios, New York.

been clearly perceived, nor has their importance been accurately measured. New cities, projected over the last thirty years, have brought out the problem of creating architectural color palettes in all its complexity. Where it had taken centuries to produce a coherent urban fabric, men now presume to create it in ten years.

Big cities have become aware of the importance of establishing their geographical and cultural identities. The enthusiasm—and subsequent mistrust—aroused by new cities have shown that "identification and individuality" are necessary to keep inhabitants and to attract industry and tourists. Throughout Europe, the trend of rehabilitating historical areas and of planning to use color to enhance the urban landscape in a logical and harmonious manner continues. Large cities are revising their plans. This process is not confined to historical centers and fashionable streets, for there is a parallel need to rehabilitate the development projects dating back fifteen or twenty years. These projects are equally interesting because here, too, color plays an essential role. It provides the least confining and expensive way to restore life and dignity to aging housing projects.

Geography of Color

The definition of colors on an architectural support is, of course, dependent upon the shape and function of the architecture, but it also depends essentially on the character of the "local" light.

The geographical location and the climatic characteristics of an architectural site are a determinant of the perception of colors in space. It is, for instance, unthinkable to apply certain harmonies which appear very elegant in Florida or California to many European landscapes.

The sky and natural light, as well as the soil, rock, and vegetation, determine chromatic qualities which are specific and which can be called "local color." Few expressions have been so often and so inappropriately employed as "There is real local . . ." We play up the bowling of southern France, the mantillas of Andalusia, child beggars in Cairo, and the painters of Montmartre in Paris. We forget that "local color," in its true meaning, does exist and plays an important role in defining the cultural identity of nations, provinces, cities, and all other human agglomerations. But it is not where we pretend to see it. Local color is the real color of an individual locality, whether Japan, with its subtle shades of gray and dark brown in old wood, or France, with its palette of earth tones.

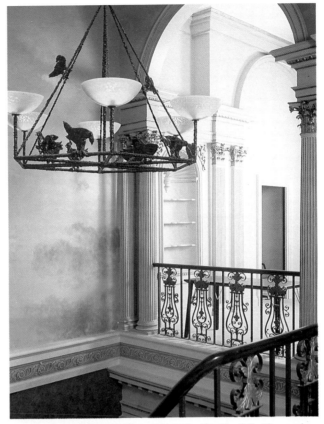

Black wrought-iron and a skyscape mural painted by Polly Hope revive architectural art and bring the great outdoors into a London Georgian townhouse, renovated by Crosby. Photos courtesy of Pentagram Design, London.

Theo Crosby replicates the organic forms of Art Nouveau for a restaurant of the NMB Bank in Amsterdam. His use of pastel colors are contemporary, but they also harmonize with the soft colors of the Dutch landscape.

In houses decorated by the women of the South African Ndebele tribe, strong color is used to enhance architectural detail (such as an entrance) or to create trompe l'oeil effects (such as extra "windows"). It can be used in tight patterns or to cover a broad area. There is a rough format common to all, but artists are free to incorporate symbols and design elements that have personal signfilance, from pure pattern passed down by their families, to stylized representations of heads, or even passing airplanes. Earth pigments have been superseded by industrial-strength synthetic paints.

The local colors of Europe are rich, varied, and distinctive of each region. In France, for instance, the rose tint of Albi is not like the red of Saint-Quentin or the white of Soissons, and the colors of Provence are not those of Brittany or Alsace. Paris has a blond tone, which makes for a mild atmosphere and which projects unique light effects. Every country, every city has its own palette. Holland prefers dark colors, like that of its brown bricks: Amsterdam is a gray and black city in accord with a Protestant temperament; to the south, in Italy, the old sections of Rome are dominated by ocher. The warmth of this last color owes little to man but is, rather, a product of the iron oxide pigments of the soil, carried over into paint

and plaster. Earth nourishes man to a greater extent than is commonly believed and the effects of its colors carry further than mere daubing, just as all color influences us in ways of which we are not aware. It is these natural colors that have to be identified and reintroduced into urban environments.

In addition, despite the spread of industrialization and the conformity of color that it engenders, colors cannot simply be imposed universally. The geography of color makes single communities accustomed to certain ranges of color peculiar to their region. Individuals within a community are attracted to and become "consumers" of these shades. The same color research influences product design and fashion, as well as architecture.
—Jean-Philippe Lenclos

essay

Color in Architecture

Since the early 1970s, American Michael Graves (and his company, Michael Graves Architect, in Princeton, New Jersey) has been at the forefront of an architectural movement covered by the somewhat loose term of post-modernism. *Without abandoning modernism, the post-modernists have explored historic devices, incorporated motifs from past architectural styles, and revived color as a dynamic element in building. Graves here outlines the symbolism of color in architecture.*

I regard architecture, both in form and color, to be derived primarily from symbolic sources. In the classical tradition, form has evolved not only from practical necessity, but also from a metaphorical association with nature and man. In the formal order of architecture, we can also come to recognize the symmetry of our own bodies in the classical tripartite structure: base, or foot; middle, or body; and attic, or head. By these clear totemic references we are oriented within the built context.

The architectural language of color, however, originated in nature, not with man. Colors are often based on building materials initially found in the landscape. It is the architect's use of color which is derived from human understanding. In order to enhance a building's accessibility, the architect uses color to emphasize its figurative content. In my own works, I implement color toward this end in three primary ways: first, by referring to elements found in nature, color may relate the building to its built context as well as to the landscape; second, by deliber-

ately evoking certain building materials, it may represent a familiar frame of reference; and third, by articulating the organization of a building's composition, it may underscore the narrative of its design.

In a time when craft, material, and form were understood to be related to one another more closely than they are now, building materials were reflected by their color. Today, when we no longer build out of "real stuff" but rely on more economical materials such as gypsum board and other veneers, our materials and their final color often have no relation.

We can approach this problem in a limited number of ways. One choice is to leave the material in its natural state, which would result, in the case of gypsum board, in a dull factory gray that was never meant to be exposed. We can also apply, through painting or staining, a decorative covering which would run the risk of extending only a very personal interpretation. There is, I believe, another alternative. We may use color to identify the materials with nature in such a way that anyone can understand and make accurate associations.

These associations are, for the most part, simple. If we use nature as a reference, then the floor can refer to ground, the ceiling to sky, and the columns to trees. Interpretation in color would call for warm, heavy tones at the base of a structure, shades of green in the middle range, and cool, light yellows or blues at the top—colors of ground, landscape, and sky.

Reflecting Water and Light
In the Shiseido Health Club (Tokyo, Japan, 1985), for example, blue tiles in the large swimming pool refer to water. In the niche beside the pool, blue, gold, and white tiles in an expanded checkerboard pattern enhance the marine character by flickering and reflecting light, reinforcing the kinetic quality of the water. The columns enclosing the room are covered with pale green tile, reminiscent of trees one might find near such a body of water in the landscape. Light terracotta was used for the moldings and floors, referring to the earth. The green tile of the columns diffuses upward in a pattern into the yellowish white tiles of the pediment under the vault, suggesting the passage from trees to sky.

Representing a more elaborate interior, the SunarHauserman Furniture Showroom (Chicago, Illinois, 1979) uses the same color framework to accomplish a very different effect. Where a column base is painted terracotta, it lends the room more gravity because

the weight of the room is registered in the foot. It also provides a key to associating the lower course of the interior with the earth or landscape. The column shafts are painted a cast of gray which, while not imitating it, suggests stone. The capitals can also be read as vessels gathering light from the soffit or sky, and directing it along the shaft of the column to the interior below. In these rooms the descriptive aspect of color enriches the forms with greater thematic significance.

Anchoring the Structure
There is no formula for color associations. Each architectural project requires its own palette to assist the viewer in reading the building. For example, in the base of the Portland Building (Portland, Oregon, 1980), green, not terra-cotta, anchors the perceived weight of the structure. This might seem to reverse or invert the patterns already suggested. However, green here refers to the color of the landscape at the level of the ground—in this case, a public park adjacent to the site. Two columns supporting a lintel-like surface seem to rest on the base of the building. Terra-cotta makes this figure appear as a stabilizing structural element against the paler cream color of the facade. On the uppermost story, a pale blue-gray identifies the part of the structure nearest the sky.

Since it is not always possible to build in traditional materials, I believe color performs another vital function by providing architecture with levels of meaning derived from these basic materials. What one might call normal associations of color and construction material would include red and terra-cotta for brick, and cream or ranges of white for limestone or travertine marble.

Although color is two-dimensional, when it is used in this way to replicate nature, we understand it in terms that are three-dimensional. If a surface is painted terra-cotta to allude to brick, our first reaction is to brick, in its full depth. Even though we are conscious that the color is applied to the surface, we see color first as representational. To some degree, therefore, it possesses the quality of an object.

In an early scheme for our proposed addition to the Whitney Museum of American Art (New York City, 1985), we used a gray-red agate granite for the lower portion, similar in tonality and veining to the dark gray, unpolished granite of the existing building by Marcel Breuer. We chose stone of this color and value in order to harmonize with Breuer's building and yet remain distinct, diminishing neither the proportions nor the

object quality of the original structure. The color of the agate granite further refers to the brownstones in the surrounding neighborhood.

In the Clos Pegase Winery (Calistoga, California, 1984), we replicated a more traditional mode of construction. Attempting to root the building in the ground, we used a brick or terra-cotta color to represent earth or brick at the base of the facade. A blue, horizon-like band, or belt coursing, alludes to wainscoting and to one's assumption of it as a transition in materials. The color of the wall above the band is ocher, allowing the stucco to refer to its stone antecedents.

Articulating a Facade

Observers are aware of the location of color and its formal logic. The placement of color reinforces our reading of a building's design by articulating certain elements and organizing them for the viewer. The most basic tripartite composition in figurative architecture can be emphasized with, for instance, green for the base or foot, terra-cotta for the middle or body, and a more ephemeral color for the top or head.

The color scheme reinforces the thematic understanding of the preliminary design for a residential tower above Sotheby's auction house in New York (1988). Color is intrinsic to the composition, emphasizing an emblematic figure at the center of the building, which creates a visual link between the auction house and the residential tower. Primarily a symbolic gesture, the figure is abstraction palazzo and armoire, an allusion to the antique furniture auctioned at Sotheby's.

The gray-green color at the base of the building is repeated in the palazzo-like figure, enhancing the impression that one rests on top of the other. The repetition of this color against the background of pale terracotta increases the perception that the figure exists independently of the midsection of the building. On this section of the tower, a masonry pattern further incorporates color, giving the building an alternate reading. A diagonal grid of gray-green balconies and dark lines against the background of pale terra-cotta accentuate the surface of the architecture. This grid "dematerializes" the building, diminishing any perception of its massive weight and making it appear fragile. The pattern resembles wallpaper, as though the symbolic figure were an artifact on display in Sotheby's.

Similarly, in the Portland Building, the terra-cotta columns of the facade's gateway motif form the passage through the building and support the lintel-like terra-cotta figure, as a clearly separate entity from the beige of the rest of the facade. Here, the tripartite composition is clearly articulated with a base of green, body of beige and terra-cotta, and an upper story of blue.

Color also joins two apparently contradictory elements of the Clos Pegase Winery facade, bringing together the colonnade along the central portion which supports a classical pediment, and the flanking, more houselike elements. The colonnade is a darker shade of terra-cotta and the pediment, cream-colored, continues the composition of terra-cotta base and cream-colored walls in the flanking elements. To center the composition, the blue horizon line of the side elements is repeated on the monumental columns of the portico in exactly the same position. The polychromed wall permits the full range of architecture's thematic significance. When the wall loses its neutrality and takes on material qualities through the elaboration of color, we are able to make the connection between ourselves, the architecture, and nature.

Color invites the viewer's participation by communicating something basic about our building materials, by suggesting architecture's metaphoric properties, and by articulating the narrative content of a building's design. Through the use of color, the materials and forms of architecture have been allowed to take on multiple interpretations. Where the motifs are quite distinct, the articulation of color brings them into meaningful dialogue.

—Michael Graves, with Jennifer Smith and Karen Nichols

essay

Architecture: Interior Color

British architect Theo Crosby is a founding partner of the design firm Pentagram (London, New York, and San Francisco). In recent years, he has been a vocal exponent of the incorporation of the decorative arts in architecture, bringing in artists for projects with public circulation such as the interiors of the ITM bank in London and the huge NMB bank complex in Amsterdam. Crosby analyzes some of the problems and benefits of such collaborations.

First, what is modern? The generation of post-World War II architects knew very well that it was the movement—as defined and clarified by Siegfried Giedion in his book *Mechanization Takes Command* (1948), and powered by Le Corbusier and Walter Gropius—that would bring logic and clarity in-

"Post-modernists . . . see color as an ambivalence, to coat a surface, denying its purist reality."
—Theo Crosby

to our disordered and sentimental lives. It was identified with painter Piet Mondrian's colors, rectilinear geometries, constructivist spaces, and transparencies.

Visionary Color

Architects all over the world proceeded to build according to these theories, and the firm ethical foundations gradually melted away. The heroic period—the white walls and the polychrome interiors with each wall a plangent primary—returned to the safety of the history books along with artist Theo van Doesburg, and the 1960s and 1970s moved into brown. It was a nice masculine brown that echoed Lewis Mumford's diatribe against the Victorians in *The Brown Decades* (1931).

But rescue was at hand in the shape of the post-modernists, who see color as an ambivalence, to coat the surface, denying its purist reality. Candy colors, pink and pale green, floating over hard, tough surfaces now seem to be merely a reflection of the restless, questioning tone of the 1970s and 1980s.

As the 1980s draw to a close, architecture is in its usual position: sofa prone in a state of crisis and filled with rising ambitions in every direction. The technocratic revolution advances in one direction: buildings of steel gray, stainless steel, and reflective glass—an elegant monochrome culture relieved by touches of black. The objects are often spindly (less being more); the surfaces, glass or plastic. Color, for the technocrats, is equated with vulgarity in this world, and thus it has relatively few, though necessarily well-heeled, takers.

Nostalgic Color

In the other direction, traditionalists (or fogeys, as they are labelled in Britain) are determined to restore an almost mythical past, certainly difficult to exhume. Old houses are carefully scraped to uncover the original paints and papers, and dark greens and brown come alive again in candle-lit interiors. Such efforts teach us a good deal, not least the moral glow, but also the effect of dark walls covered with gold frames closely packed, and lit with flickering lights. The importance of atmosphere overrides the nuance of color; the key is in the contrast of dark and gold, and the content, or meaning, is in the effort put into the recovery of a room and of an earlier style. Under the candlelight the well-washed faces glow, the hands worn with toil and sugar soap [a cleaning compound] dispense excellent bean soup.

Between these two extremes, which exemplify the choices for architecture now, there lie two other paths. The first is the appropriation of both moralities in an eclectic mix and match of the fashionable interior, where anything goes. Each period contributes its portion to a rich broth, usually as long as the objects are sufficiently bizarre. Collectors of trivia, such as Andy Warhol, fill their spaces with disparate objects, the fruit of their unique eye and purchasing power. The objects begin to assume the personality of the owner, but for the decorator, the aim must remain a certain, acceptable sweetness. Thus, we have gentle pastels, buffs, pale terra-cottas, pinks, and blues, soft as tissue, comfortable reflections of the unfeminist boudoir.

The Artist's Role

The second path is more difficult and risky. Clients commission artists to create an environment with which they then have to live. In the past, an artist's view of architectural art was somewhat more respectful than it is today. The artist went to the tradesman's entrance, proposing and carrying out decorative schemes with a proper sense of what was fitting to a space. Up to the 1930s, this is how all the best interiors were made—symphonies of well-made elements, the work of artist and architect all fitted together in color harmonies of great invention.

Today, artists have usually not been trained in interior decoration; their contributions, as inventive as ever, may not be harmonious. How could they be, when the main requirement is to make a hit in the galleries? Despite the drawbacks of this last approach, it is the direction of the future because it is here that the real invention is to be found. The problem is to order and tame restive inventiveness to fit the requirements of architectural spaces: calm, orderly, enlivening, but inevitably repetitively used. To achieve these contradictory requirements—discipline and invention—the artist must have a clearly defined role. With a clear brief from the client and a fixed budget, an artist will almost always produce something astonishing, more than one would dare hope or expect. To work in this way—to prepare carefully and then leap into the unknown—is the most rewarding of experiences. Here color and form take on new dimensions: they become not merely a scheme, but a process, an exploration.

—Theo Crosby

Arc Light

See Lighting, Artificial.

Argent

The metal silver; also the name denoting silver or white in heraldic devices. *See also* Heraldry.

Argon Light

See Lighting, Artificial.

Aristotle

384–322 B.C. Greek philosopher whose many works include the renowned *Poetics* (*see* Aesthetics), and to whom is attributed *On Color*, in which the Aristotelian view of the color spectrum is presented as follows:

> Simple colors are the proper colors of the elements, i.e., of fire, air, water, and earth. Air and water when pure are by nature white, fire (and the sun) yellow and the earth is naturally white. The variety of hues which the earth assumes is due to coloration by tincture, as is shown by the fact that ashes turn white when the moisture that tinged them is burnt out. It is true that they do not turn a pure white, but that is because they are tinged afresh, in the process of combustion, by smoke, which is black. . . . Black is the proper color of elements in process of transmutation. The remaining colors, it may easily be seen, arise from blending mixture of these primary colors (Ross 1913).

All colors were thus supposed to be derived from mixtures of white and black—an idea championed as recently as the nineteenth century by Johann Wolfgang von Goethe. Aristotle further reflected:

> The object of sight is the visible. Color is on the surface of that which is visible. Every color is capable of causing change in that which is actually transparent. By "transparent" I mean that which is visible, but not visible in itself or without qualification—but on account of color. Such are air, water, and many solids (Ross 1913).

A Latin edition of *On Color* published in Naples in 1537, with comments by Simon Portius, is said to have heavily influenced Goethe; "We can say [that] white that becomes darkened or dimmed inclines to yellow; black as it becomes lighter, inclines to blue" (*Theory of Colours*, Charles Lock Eastlake, tr., 1840). Goethe asserted, again following Aristotle, that these colors, and others, are produced by the effects of light, fire, and water on white or black objects: For example, water and light easily make white surfaces (paper or fabric) assume a yellow color; iron (black) dissolved in sulfuric acid, and much diluted with water, exhibits a violet color; and the influence of heat on yellow iron ocher gives a strong red.

Isaac Newton's discoveries of the seventeenth century, particularly his demonstration of how to produce the full color spectrum from a ray of white light, are considered to have invalidated Aristotle's theories. Thus, Goethe's championing of Aristotle in the early nineteenth century represents a considerable regression in the field of color science, though perhaps not in the field of poetics. *See also* Goethe, Johann Wolfgang von; Newton, Isaac.

Armed Forces, Color Use in

See Camouflage.

Art Deco Colors

Art Deco is a design style of the 1920s and 1930s that derived its look from technology, popularizing the use of streamlined forms and straight lines for motifs. The name comes from the Paris exhibition of 1925— *L'Exposition Internationale des Arts Decoratifs et Industriels Modernes.*

The Art Deco palette reflects the restrained tones of black, white, silver, and gold, notable particularly in Skyscraper Deco, probably its best-known incarnation. Other influences include ancient Egyptian art, the art of the Native American (Pueblo Deco), cubism, Bauhaus design, and the Russian ballet of Sergei Diaghilev (1872–1929). The Egyptian influence manifested itself in the extensive use of ocher as well as gold, a remnant of which can still be observed in America's fast-disappearing Egyptian-style movie palaces as well as in the zigzag motif that enjoys periodic revivals in art graphics. The Native American influence brought in a vogue for the red of coral beads, the off-white of undyed wool, and Aztec jade green. From cubism and the Bauhaus came a distinct

preference for a limited and basically monochrome palette. From Russian ballet costumes only one hue was adopted—orange—but one used unsparingly.

Variations on the Art Deco palette in the United States can be seen in regional architectural expressions. The color schemes of Pueblo, Tropical, and urban Skyscraper Deco architecture were each born of a particular terrain and embodied reinterpretations of a particular region's favored building style. Pueblo Deco, which fuses the Indian culture of the Southwest with the exuberance of the 1920s, juxtaposes greened and blued turquoises, corals, black Carrara glass, adobe browns, and stucco whites in the zigzag, stepped motifs often seen in Navaho silver jewelry.

Tropical Deco, exemplified in the hotel resort architecture of old Miami Beach, shows a predominant palette of flamingo pink, stucco white, mint green, and scuba diver ocean blue. Overall, the Tropical Deco palette is cooler, befitting the semi-tropical climate of southern Florida. The dramatic use of the mirror image, the thrusts and recesses of two buildings identically reflecting one another, but with complementary colored trims—a melon orange and a grassy green, for example—was a visual phenomenon that Tropical Deco delighted in using.

Skyscraper Deco, especially New York Skyscraper Deco, epitomizes the style's urban, elegant palette, reflective of the Machine Age. Notable examples of the style include the spectacular Chrysler Building (1930; architect, William Van Alen) and the Empire State Building (1931; architects, Shreve, Lamb, Harmon). The first landmark skyscraper, the Chrysler Building, borrowed the theme for its exterior motifs from the company's product line and exemplifies the romance of the new automotive age. For-

merly New York City's tallest building, the Empire State Building employed for its lobby Skyscraper Deco's black, white, silver, gold, and orange in a range of marbleized tones. In addition, there were such examples as Raymond Hood's Daily News Building (1929), remarkable for its soft, smoky off-whites, taupes, grays, and yellowed browns; and the Chanin Building (1929; architects, Sloan and Robertson), notable for its metallic friezes.

Art Deco graphics, under the influence of advertising, particularly billboards, which represented American industry's drive to recover from the Depression, boldly incorporated colored type, mainly sans serif, with floating images borrowed from the constructivists' sense of spatial planes and from the surrealists' humorous surprise use of dismembered elements. The palette was spare: one or two colors plus black and white. Favored colors were sleek: mid-blue, plum purple, deep berry red, melon orange, and browned orange.

Art Deco consumer designs brought the bright palette of the then-new plastics industry to utilitarian housewares and jewelry (*see* Bakelite). In China tableware, notably Fiesta pieces, bright oranges, cherry reds, jade and emerald greens, and periwinkle and sky blues were particularly popular. In the 1920s and 1930s, England's Beatl ware, a new urea formaldehyde plastic, became popular on both sides of the Atlantic. This made even lighter colors than Bakelite possible in a thermosetting plastic.

Industrial designers such as Norman Bel Geddes (1893–1958), Raymond Loewy (1896–1986), and Walter Dorwin Teague (1893–1960) glorified ordinary, household objects like toasters and pencil sharpeners and brought a sense of the gleamingly modern to American homes.

Art Deco shoes.

Art Deco screens in wrought iron by Edgar Brandt. From L'Illustration, October 1925.

Art Nouveau Colors

A style of art, architecture, and the applied arts that flowered briefly, from the end of the nineteenth century to World War I, and was distinguished by its use of organic forms and lines derived from nature. The movement was conceived in part as a rebellion against the harsh linearity of the Industrial Revolution's machine-made products.

As with form, the color used was imitative of the rich and variegated colorations to be found in the natural world, particularly in flowers and leaves. Glass, ceramics, wood furniture, wrought iron, wallpaper, and book design and illustration were among the many applied arts of the style.

Following the groundbreaking work of the impressionists, painters and artisans alike became interested in perception and the dichotomy of form and color. Nature itself was thought to provide the perfect laboratory in which to study the power that lay in pure color. In the words of a leading exponent of the Art Nouveau style, Louis Comfort Tiffany:

It is curious, is it not, that line and form disappear at a short distance, while colors remain visible much longer. It is fairly certain —isn't it—that the eyes of children at first see only colored surfaces—the breast and the face of the mother, the head of the father, a colored ball. . . . Insects are attracted by color (not form) when in search of food. For that reason flowers develop color. . . . And if a plant has flowers that require a visit from a moth or night-flying beetle, then it produces—not a pink or blue blossom, which would not "carry" in the dark, but white or yellow petals that call the favoring insect. . . .

Suitably, Tiffany's motifs were natural forms—flowers, insects, and shells—and the lasting value of his genius is with one material: glass. This he marbled, clouded, and mottled in a range of opalescent and iridescent colors. Tiffany's success coincided with the arrival, initially in the United States, of electric lighting and naturally, being skilled with both metals and glass, he worked bronze and glass together to form lamp-shades made of mosaics, mounting fragments of colored glass in a network of bronze threads, as in the manner of cloisonné enamels.

Art Nouveau's palette was composed mainly of nature's autumnal oranges, browns, and deep greens, the floral shades —jasmine yellows, iris purples, and poppy reds—and deep berry reds. *See also* Gaudi y Cornet, Antonio; Ruskin, John; Tiffany, Louis Comfort.

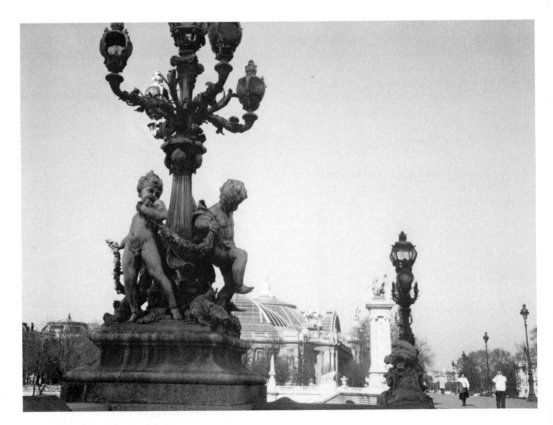

Pont Alexander III (Paris) with bronze Art Nouveau lanterns and cherubs.

Artificial Illumination

See Lighting, Artificial.

Artists' Pigments

Pigments usually used in the production of paints for artists—including acrylic, aquarelle, crayon, gouache, impasto, ink, oil, powder, and watercolor. The following is a selection of the most important pigments used by manufacturers of artists' paints:

Alizarin Crimson: an artificial lake derived from coal tar (dihydroxy anthraquinone). Poisonous. Moderately permanent. Transparent. Cannot be mixed with pigments containing lead.

Bone black (ivory black): carbon and calcium phosphate, formerly obtained by charring ivory chips in a closed retort; now bone (animal charcoal) is used. Non-poisonous. A highly permanent "cool" black that mixes well. Fairly transparent.

Cadmium red/scarlet/orange/yellow/lemon: cadmium sulphate coprecipitated with blanc fixe (artificial barium sulphate), with some selenide added for red and oranges. Poisonous. Permanent. Opaque. Indispensable range, but inferior grades tend to discolor if mixed with copper- or lead-bearing pigments.

Carbon black (gas/furnace/Chanel black): pure, natural carbon, obtained by the incomplete combustion of methane (marsh gas). Non-poisonous. Highly permanent and opaque.

Chrome orange/yellow/lemon: made from lead chromates. Poisonous. Not permanent. Opaque. Chrome pigments tend to fade in direct sunlight; they discolor if mixed with pigments containing sulfur and are advisedly replaced by cadmium.

Chromium oxide green: anhydrous chromium oxide. Poisonous. Highly permanent and opaque.

Cobalt blue: combined oxides of cobalt and aluminum. Non-poisonous. Permanent. Transparent.

Flake white (white lead): lead carbonate, often with zinc oxide added. Poisonous. Highly opaque. A permanent "warm" white that tends to yellow with age and form black-lead sulphate if mixed with pigments containing sulfur or exposed to a sulfurous industrial atmosphere. Advisedly replaced by titanium or zinc whites.

French ultramarine: a calcined compound of silica, alumina, soda ash, and sulfur. Non-poisonous. A permanent pigment of exceptional spectral purity. Fairly transparent. Discolors if mixed with pigments containing copper or lead.

Green earth (Veronese green): natural green earth (glauconite) rich in silicates of iron, manganese, aluminum, and potassium. Non-poisonous. Highly permanent. Transparent. Should not be mixed with pigments containing lead.

Hansa orange: artificial lake derived from coal tar (diazotized toluidine). Poisonous. Highly permanent. Transparent.

Ivory black: see bone black.

Lamp black: pure natural carbon; soot collected by the incomplete combustion of oil or coal-tar products. Non-poisonous. A highly permanent and opaque "cool" black. Used for India ink.

Light red (English red or burnt ocher): natural yellow earth, rich in hydrous oxides of iron and silicon, which has been calcined. Non-poisonous. Highly permanent. Opaque.

Mars red/orange/yellow/violet/brown/black: artificial iron oxides of the same chemical constitution as natural earths. Non-poisonous. Highly permanent. Opaque.

Phthalocyanine blue and green: artificial lakes derived from coal tar (copper phthalocyanine) with chlorine added for greens. Poisonous. Highly permanent. Opaque. Trade names include Bocour blue and green, Monastral blue and green, Phthalo blue and green, and Windsor blue and green.

Quinacra red/magenta/violet: artificial lakes derived from coal tar (linear quinacridone). Poisonous. Highly permanent. Relatively transparent.

Raw sienna: natural yellow-brown earth rich in hydrous oxides of iron and manganese. Non-poisonous. Highly permanent. Fairly transparent. Calcined sienna is called burnt sienna, a permanent dark brown pigment.

Raw umber: a natural brown earth much like raw sienna.

Red ocher (Indian red or Venetian red): natural red earth rich in hydrous iron oxide (hematite). Non-poisonous. Highly permanent. Opaque.

Vandyke brown (Cologne earth): natural brown coal (peat or lignite). Non-poisonous. Not permanent. Transparent.

Vermilion: mercuric sulfide. Poisonous. Moderately permanent. Highly opaque. Tends to darken if overexposed to direct sunlight or if mixed with pigments containing lead or sulfur. Advisedly replaced with cadmium red.

Viridian: hydrous chromium oxide, or a compound of copper phthalocyanine and chlorine. Poisonous. Highly permanent. Transparent.

"Of all the whites, they had the white tripoli of Melos; for yellow ocher, they took that of Athens; for reds, they sought no farther than the red ocher and Sinopie . . . in Pontus; and their black was no other than ordinary vitriol, or shoemaker's black."
—Pliny, describing the four leading pigments used by Apelles and his contemporaries in the ancient world

Yellow ocher: natural yellow earth (limonite) rich in hydrous oxides of iron, aluminum, and silicon. Highly permanent. Highly opaque.

Zinc white (Chinese white): zinc oxide. A highly permanent "cool" white that, unlike flake white, does not discolor. Nonpoisonous. Fairly transparent.

Zinc yellow: zinc chromate. Poisonous. Moderately permanent. Fairly transparent.

See also Acrylic; Fresco; Inks; Pastel; Watercolor.

Arts and Crafts Movement and Color

The late-nineteenth-century English Arts and Crafts movement, a reaction to the Industrial Revolution and the excesses of Victorian taste, reasserted the primary importance of craftsmanship, nostalgically looking back to the Middle Ages as a time when —or so it was thought—the craftsman and his hand-worked products played a significant and socializing role in a community. In reaction to the harsh colors of the new synthetic dyes (*see* Aniline), the movement advocated the use of natural dyes.

The preeminent colorist in the British movement was William Morris. He began as a painter, a member of the Pre-Raphaelite group, but transferred his interest to design, establishing a factory in 1861 that produced fabrics, wallpaper, stained glass, furniture, and tiles. All his papers and fabrics were hand-printed using wood blocks and only natural dyes, often from ancient formulas he found—such as kermes (a red dye made from the bodies of certain insects), a strong yellow made from poplar and osier twigs, brown from the roots of the walnut tree, and blue from indigo.

Morris's prints became very popular for interiors. Their stylized patterns, using fruit, flower, and foliage motifs, in colors that were warm and deeply saturated with a predominance of greens over blues, provided a clear break from the rococo palette of pale pastels and Adam greens.

America's own Arts and Crafts movement, from the 1880s on, also drew its inspiration from Morris, its emphasis being on original shapes rather than elaborate surface decoration. Other influences included European Art Nouveau, clearly evident in Louis Comfort Tiffany's bright and iridescent glass (*see* Art Nouveau Colors; Tiffany, Louis Comfort); the *japonisme* of certain French art and craftwork, leading to the simplified decoration and sophisticated colors of the Rookwood Pottery, founded in 1880 by Maria

William Morris, leader of the Arts and Crafts movement.

Longworth Nichols; and the stylized furniture, using simple stains and oil glazes for decoration instead of inlay or veneer, of the Shakers (*see* Furniture), which heavily influenced Gustave Stickley (1858–1942), who sought commercial exploitation of a growing public demand for what was sometimes termed "art-furniture."

While the Arts and Crafts movement on both sides of the Atlantic reacted against the clutter and meaningless ornament of industrial products, emphasizing the dependence of design on material and process, the simplification of structure and taste for natural color actually made things easier to produce industrially and semi-industrially. *See also* Sources of Historic Colors.

Ash

A light, silvery gray color. *See also* Ceramics and Color; Glaze, Glazing.

Assimilation to Color

See Color Constancy.

Associations and Organizations

See Appendix.

Astrology and Color

See Alchemy; Zodiac Colors.

Astronomy and Color

Classical astronomers noted that the heavenly bodies each had an individual tinge: For instance, the moon was silvery white, but Mars had a definite red aspect—a color like blood—which caused it to be named after the Roman god of war. Modern astronomers have discovered that stars, nebulas, and even whole galaxies can have their own recognizable colors.

In astronomy, all information about stellar systems is derived from the electromagnetic rays that they emit, especially those in the visible spectrum. The light from most stars is too weak to be picked up by the color-sensitive cones of the unaided human retina; stars thus appear white. Through a telescope, even amateur astronomers can begin to see differences in color among stars—from the yellow of the earth's sun, still relatively young, to Betelgeuse, an older, and therefore bright red, star.

The use of photography in astronomy—an innovation of the 1950s—with extremely sensitive emulsions has shown that stars can be of any spectral color. These colors can be analyzed by a spectroscope to provide information about their temperature, age, chemical composition, and the direction in which

they are moving (*see* Spectroscope). For example, the color temperature (a scientific measurement, in which the heat of a glowing object is determined by its color) of a star provides valuable information about its age: The hotter, and thus younger, stars emit more blue light than the cooler, older, and thus redder stars. Detailed information concerning the distribution of wavelengths within the light coming from a star, obtained with the spectroscope, can be used to determine chemical composition. Since various chemical elements emit different wavelengths under the high temperatures on the surface of a star, they can be identified with some accuracy—for example, blue indicates the presence of oxygen; yellow, helium; red, a certain mixture of oxygen, hydrogen, or nitrogen; and ultraviolet, neon. Finally, because of the Doppler effect, electromagnetic rays from stars that are moving away from earth appear to be slightly stretched, causing these stars to look redder. Stars moving toward us appear slightly bluer.

A colorful phenomenon—seen in extreme northerly latitudes—that actually takes place in the earth's atmosphere is the aurora borealis (also known as the northern lights). A similar phenomenon takes place in the southern hemisphere—the aurora australis. These are brilliant patterns of light etched across the sky in polar regions, caused by streams of high-energy particles showering in from space (possibly from sunspots—major eruptions on the sun's surface). The particles shatter the molecules of air in their path, and as the molecules reassemble, they release the energy they have absorbed, some at the frequency of visible light. Oxygen atoms reradiate two wavelengths of visible light—one a brilliant greenish white, the other a deep red.

The most recent application of color in astronomy has been a computer coding—by color—of the images produced from radio telescopes recording invisible electromagnetic rays. By coding the bright areas of intense radio emission in red, the faint areas in green, and by using oranges and yellows for areas in between, an observer can quickly deduce information about the source. An alternative color code used for radio readings shows stars that are moving toward the earth in red and those moving away in blue, while color coding of infrared readings usually shows relative temperatures.

Although color in astronomy now is used mainly for translating information, it will still be significant in color photographs taken from telescopes launched into space—the earth's atmosphere tends to filter out blue light and hide faint stars. If photographs could be taken of stars nearly 18 billion light-years away, they might show numerous blue galaxies undergoing the burst of star formation that occurred soon after the so-called Big Bang, and perhaps help explain how the universe itself was formed.

Athletic Colors

Distinguished by their primary intensity and high visibility, athletic colors include the olympic colors—olympic yellow, flame red, kelly green, royal blue, and old gold—as well as bright ones associated with specific sports such as tennis white or football orange (*see color section* Communication and Color) and, since the late twentieth century, fashion favorites such as black, turquoise, pink, silvery gray, and neon brights. Athletic colors, known in the fashion industry as active-wear brights, are always upbeat and optimistic in feeling. They are preferred by Americans and popular with children around the world. *See also* American Colors.

Atlas

See Systems of Color.

Attribute

A fundamental characteristic or property of sensations. The attributes of color that are generally recognized are quality (hue), intensity, duration, and extensity.

Auburn

A reddish dark brown, usually describing a color of hair. Auburn comes from the Latin word for "white" (*albus*) and in medieval English meant "blond" or "flaxen," but in the seventeenth century the word became confused with *abrown* or *abrune*—both meaning "brown"—and was from then on associated with the color brown.

Auras

The halos and colorful emanations said to issue forth from divine personages. Some people claim to see colored auras emanating from all human beings, purported to reflect a person's health and mental state (*see* Color Therapy). Various occult theories state that color preferences exercised when choosing, for example, a new set of clothes, a car, or a decorative scheme relate to personal auras. The mystics who claim to be able to see these emanations interpret them as evidence for a non-corporeal "body" that permeates the physical body and extends outward in all directions (*see* Synaesthesia).

Between 1909 and his death in 1978,

Forget six counties overhung with smoke,
Forget the snorting steam and piston stroke,
Forget the spreading of the hideous town.
Think rather of the pack-horse in the dawn
And the dream of London, small and white and clean,
The clear Thames bordered by its gardens green.
—William Morris,
The Earthly Paradise

Semyon Kirlian, a Russian technician, developed optical instruments for photographically documenting various effects. He claimed to have demonstrated that a high-frequency electric current would interact with the radiating energy of a living object, such as a hand, resulting in a glow or "corona discharge" that could be recorded on photographic film. This glow could then be analyzed by studying its relative shape and color distribution (see Kirlian Photography). No duplication of this effect has yet been achieved.

Aurora Borealis and Aurora Australis

Spectacular light effects in the sky, seen at extreme northerly and southerly latitudes. See also Astronomy and Color.

Autochrome

The first practical method for making color photographs from a single plate, patented by the Lumière brothers in 1904. The autochrome used a layer of millions of tiny potato starch grains covering the screen, dyed reddish orange, green, and violet in equal amounts. Spaces between the grains were filled with carbon dust so that no unfiltered light could pass through and thus spoil the photographic image. This filter layer was then coated with a panchromatic emulsion.

By 1913, 6,000 autochrome plates were being made every day, and production continued for thirty years. The density of the plates—which transmitted only 7.5 percent of the light reaching them—meant that the necessary exposure times were forty to sixty times those of black-and-white plates; but the color qualities and visible graininess of the images produced an effect reminiscent of the color dots of pointillist painting. See also Lumière, Auguste and Louis.

Automobile Colors

In the automobile business today, color is one of the most important design and marketing tools. It was not always so.

Henry Ford, originator of mass-production techniques, is famous for saying of his Model T, "You can have any color so long as it is black." Until 1923, black was used in about 93 percent of all cars produced in the United States. The process of color application was slow: Cars were hand-painted and hand-rubbed seven times over a forty-five-day period.

The advent of the spray gun and lacquer in the late 1920s improved the process. A car could be painted in one day, with additional time used for buffing to produce a high-gloss

Paint, which represents only 2 percent of the materials used to make a car, has a disproportionate influence in the sales showroom.

finish. Today the job is done in twenty minutes, and buffing is not needed.

After 1923, a wider range of colors began to be used, including blues, greens, and grays. These, however, lacked strong hue or saturation and tended to fade, chalk, and crack. The development of improved finishes and baking ovens allowed the development of some new colorations: The Model A of the 1920s appeared, for instance, in a sporty version—the Phaeton—with black fenders, tan body color, and a convertible roof. Depression-era automobiles, however, continued to appear in restrained colors. The V-8 Fords of the early 1930s came in ten colors only—basically dark shades of green, blue, brown, and black.

It was after World War II that the color explosion began. Pastels, two-tone, even three-tone colors put an end to the wartime olive drab. But the greatest success was white, introduced in 1953. Within a year, sales of white cars ran as high as 35 percent of some automobile lines. Other successes included the new pale silver-blue, introduced by Chevrolet in the late 1950s, as well as the memorable bubble-gum pinks.

The early 1960s witnessed an extensive use of metallic colors and a predominance of blues, aquas, beiges, and greens. But the old standbys, white and black, were still first and second in popularity. In 1962–63, a completely new palette appeared, with colors bearing evocative names such as honey beige, chestnut, pale gold, and black cherry. On luxury cars, the super-elegant "silver mink" took pole position.

By 1964, lime-gold metallic became the most sought-after shade of green, edging out white as the most popular color in the late 1960s. From the green family, interest in car colors moved to the golds, which were introduced in 1968. The golds were followed by their derivatives, the goldenrod yellows and ginger browns, in 1969–70. These were soon even challenging green as the number-one color in automobiles. Since that time, the golds, ginger browns, greens, and all-important earth-toned beiges have continued to dominate the market. In the 1980s, Japanese and European car imports infused a taste for metallics, particularly silver. See also Communication and Color.

Avery, Milton

1893–1965. An American painter, watercolorist, and printmaker, known for his colorful, flat, patterned landscapes and still lifes, expressive and lyrical renderings from real scenes.

Born in Altamir, New York, Avery grew up in Connecticut and in 1925 moved to New York City. His early palette was dark and subdued. He used an impasto knife technique for the application of pigments. By the late 1930s, Avery's palette had lightened considerably. By the last decade of his life, his work had lightened and brightened further, and his color, often pale pastel in value, was thinly applied. In aiming for "the essentials" and for "depth of color," Avery, like Mark Rothko, with whom he worked, achieved at once decoratively abstract and realistically evocative colored surfaces, paintings that in effect were abstractions of real images. His color achievements may be said to parallel those of Pierre Bonnard and Henri Matisse, men whom he admired (*see also* Bonnard, Pierre; Matisse, Henri).

Aviation

See Airplane Colors.

Avicenna

980–1037. Persian philosopher and physician, whose classic text, the *Canon of Medicine* —especially influential from 1100 to 1500— describes ways in which color can signal various illnesses. "In jaundice, if the urine becomes of a deeper red until it is nearly black, and if its stain on linen can no longer be removed, it is a good sign—the better the deeper the red. But if the urine becomes white or slightly reddish, and the jaundice is not subsiding, the advent of dropsy is to be feared." If the skin of the patient changed to yellow, the physician suspected a disorder of the liver. If the change was to white, he said, the disorder was probably of the spleen; a yellowish-green complexion might be attributed to piles.

To Avicenna, however, color could not only provide the diagnosis of an affliction, but also be a cure. For example, innate human temperaments could be classified according to hair color. People with black hair had hot temperaments; those with brown hair had cold temperaments. The tawny- or red-haired person was volatile, possessing an excess of "unburnt heat" and hence a tendency to become angry. The temperament of the fair-haired person was cold and phlegmatic, that of the gray-haired one cold and very dry. By exposure to different colors, excesses in these temperaments could be modified. Red light stimulated the movement of the blood, while blue light slowed it down. The clear light of morning aided nutrition. White was a cooling color that reduced fever, and yellow cured biliary disorders.

Azo Dyes

See Dyes and Dyeing.

Azure

Blue, as used in heraldry; from the French *azur* and, originally, the Persian *lazhward* (*see* Lapis Lazuli). A term often applied to the color of the sky. *See also* Heraldry.

Azurite

An azure-colored mineral, valued as a semiprecious stone for jewelry. Azurite, like malachite, is basically a copper carbonate. In Latin classical writings, azurite was referred to as *caelum cyprium* (literally "sky of Cyprus"), and in the Middle Ages it was called *Alemagna*, or "German," *azure* after the area in which it was mined. It was used commonly for painting and fresco, as a relatively cheap substitute for lapis lazuli, and sometimes also as a dye for textile fibers. Azurite has a tendency to develop a green tinge when exposed to light and air.

Milton Avery.

"Once more I insist that you send someone to Venice to get azure [lapis lazuli], because I will finish this wall during the week and for the next wall I need azure."
—Gozzoli to Piero de'Medici, concerning a pigment that was so expensive in the Middle Ages that the artist's client had to supply it himself

Babbitt, Edwin D.

Edwin D. Babbitt.

1828–1905. Reputed color healer. Babbitt may have been a healer or a charlatan—perhaps both at the same time. Well educated, a teacher, and a dealer in school supplies, in 1878 he published a 560-page book, *The Principles of Light and Color,* which created a sensation in its day, and was subsequently reprinted many times. Today, over a century later, it is still widely quoted and translated, and its doctrines have been acknowledged and followed in scores of later works devoted to chromotherapy, or color healing.

Babbitt was convinced that all human ailments could be cured with colored light, each hue of which had a different meaning. According to Babbitt, red was the center of heat—thus a warming color; yellow was the center of luminosity; and blue was the center of electricity.

Baby Blue, Baby Pink

Baby blue is the palest possible tint of blue. A popular color in the 1950s, it is perennially associated with infant boys. Baby pink, a textile standard since the 1920s, is the softest of the true pinks, a favorite for newborn girls. This shade was also in vogue during the 1950s, when the popularity of baby pink sweater sets reached fad proportions.

Background

The background on which colors are placed can radically affect their luminosity and intensity. The principle involved (*see* Simultaneous Contrast) was extensively researched by Michel Eugène Chevreul (*see* Chevreul, M. E.) in the early part of the nineteenth century. His 1839 book *The Principles of Harmony and Contrast of Colors* is still used to solve problems in color design and presentation.

Generally speaking, light colors decrease in value on a white or light background but increase in saturation, thus reinforcing their tone. On a black background, light colors appear even lighter and more brilliant, while dark colors diminish in saturation but gain in value. Neutral colors (grays) appear darker on a white ground, and lighter on a dark ground.

Of all Babbitt's color remedies, one alone remains in remedial practice: the use of visible blue light to help counteract pathological jaundice in newborn infants.

A color viewed against a colored background becomes more complex and is affected by contrasts in value, hue, and saturation. Value differences in backgrounds affect colors in much the same way as do black and white grounds: A light color will make a darker color seem even darker, and vice versa. Hue contrasts are greatest with complementary colors (excessive contrast can result in distracting dazzle; *see* Dazzle) and least with adjacent hues.

Bakelite

A trademark name of a colored plastic popular in the 1920s and 1930s, Bakelite brought decorative design to inexpensive, mass-produced jewelry, vanities, and objects of all kinds. Imitation ivories and fake ambers, faux jade greens and ruby reds, Depression-era radio browns, kitchen container oranges, and less than fully saturated blacks were all part of the Bakelite palette.

The first thermosetting phenol-formaldehyde resin, produced in 1909 and named for its inventor, Leo Baekeland (1863–1944), Bakelite was first manufactured by the Bakelite Corporation and is still produced by Union Carbide for some product lines, such as umbrella handles. Like cocktails and short hemlines, Bakelite captured a sense of the modern in the post–World War I era, and its vintage pieces now are prized collectibles.

Baker-Miller Pink

A shade of pink, close to American bubble-gum pink, which, when used in an enclosed, interior environment, apparently reduces human aggression. In reaction to a particular pink, actual physical effects—lowered heart and pulse rates—were first reported by Dr. Richard J. Wurtman at the Massachusetts Institute of Technology. According to Wurtman, "I awoke one night from the thought that the suggested pink color might have an effect on human aggression. If my heartbeat, blood pressure, and pulse could be brought down by an environmental variable like color, what effect might this phenomenon have on human aggression?" (*Biosocial,* Nov. 1980).

Wurtman then suggested the use of this pink at an institution to test its effects on

aggressive patients. Two military officers at the U.S. Correctional Center in Seattle, Washington, Commander Ron Miller and Chief Warrant Officer Gene Baker, gave Wurtman a site to test his theories; it was after these two naval officers that the shade was named and subsequently referred to in color annals.

In the experiments, an entire seclusion room was painted the chosen shade of pink, with only the floor left brown. Research began on March 1, 1979, and ran for 156 consecutive days. The report to the U.S. Bureau of Personnel, Law Enforcement and Corrections Division, Washington, D.C., written at the conclusion of the experiments, stated: "Since the initiation of this procedure . . . there have been no incidents of erratic or hostile behavior during the initial phase of confinement." The memorandum went on to support Wurtman's theory that confinees required only a maximum of fifteen minutes of exposure to lessen to some degree their aggressive behavior. Furthermore, the effects of the color lingered for at least thirty minutes after the removal of the subjects from their confinement.

Subsequent testing of Baker-Miller pink's effectiveness on prison inmates and detention-center juvenile delinquents suggested some limits: For example, the color was far more effective in smaller cells or rooms, 8 by 10 feet, than in larger ones, 10 by 15 feet.

Balance of Color

1. Arrangement of colors that follows one or more of the basic laws of harmony; for example, harmony of scale or of contrast. *See also* Harmony. **2.** In photography, color balance is the relationship of the colors in an image to one another and to the original subject. Photographic processes suffer from inherent metamerism (the spectral distributions of a photograph's colors are different from those of the actual colored object, causing color matches to vary according to the ambient light; *see* Metameric Colors), but good color approximations can be achieved by matching the emulsion of the film to the light used for photographing (such as "daylight" or "tungsten" light). To color tinges in the neutrals (the whites and the grays), or to enhance areas of major importance such as skin tones, colored filters can be used on the camera lens or during the developing process. *See also* Photography.

Balas

A variety of ruby of a pale red or orange color. *See also* Gemstones and Jewelry.

Ballet Russe (Russian Ballet)

A highly influential ballet company founded by impresario Sergei Diaghilev (1872–1929) in Paris in 1909 (and merged with Ballet Russe de Monte Carlo, 1931). It featured the designs of Léon Bakst (1866–1924) and Aleksandr Benois as well as Pablo Picasso, Marc Chagall (1887–1985), and André Derain, earning a reputation for use of bright and vibrant colorations. It was unique among modern ballet companies in the way it came to influence fashion in clothing and interiors, as well as to revolutionize theater set and costume design. Bakst's colors—particularly his mustards, violets, yellows, and blues—were startlingly new to fashion, and, with his patterns, exotic and even erotic. Describing the power and evocativeness that color has, he wrote: "There are reds which are triumphal and there are reds which assassinate. There is a blue which can be the color of a Saint Madeleine and there is a blue of a Messalina." Bakst was convinced that through the use of such colors he could arouse emotions in the audience with as much precision as the conductor achieved with his baton. *See also* Derain, André; Music and Color; Picasso, Pablo.

Bamboo

A blond, woody, tropical grass composed of rounded, jointed stalks; used in roofing, furniture, and utensils, and decoratively as both a fresh and a dried plant. In architectural and interior design, bamboo has brought not only a sense of the Orient to the West, but has also lightened many interiors.

Bandanna

A large handkerchief typically featuring figures or patterns on bright backgrounds. The term is derived from the Hindi *bādhná*, meaning "to tie." This refers to a method of tying and dyeing cloth in pinhead-sized sections, creating an intricate pattern of irregular dots. Typically, bandannas are red or blue.

Barberry

A small spiny shrub with yellow flowers and red berries; native to Europe and naturalized in the United States. Its bark is used for the manufacture of yellow dyes.

Baroque

A primarily seventeenth-century style of architecture, sculpture, painting, and interior furnishings, noted for its dynamic thrusts and angularity and elaborate display of saturated contrasting colors; probably derived from the Portuguese word *barrôco,* meaning irregularly shaped pearl.

Nijinski in Après Midi du Faun: *The designers of the Ballet Russe—including Bakst, Picasso, and Chagall—influenced European fashion palettes of the 1910s and after.*

The ornate French interiors of Louis XIII (1601–43) and of Louis XIV (1638–1715), who built Versailles, brought a taste for lavish materials such as rare exotic oriental woods, gilded objects, richly colored velvets and brocades, an abundance of reflecting mirrored surfaces, hanging crystal chandeliers, and a predilection for deep crimsons, damson purples, emerald greens, and, above all, gold. Strong, dramatic color contrasts of dark or bright value were preferred in a court era concerned with designing glittering spaces for entertaining vast assemblages in a regal manner.

Two color techniques for furniture were developed by André-Charles Boulle (1642–1732), a master cabinetmaker to King Louis XIV. Ormolu—gilded brass or bronze—motifs were applied as ornaments, which, besides serving as structural reinforcements, had panels of so-called boulle works, which consisted of marquetry, or elaborate patterns made from sheets of tortoiseshell and German silver, brass, and pewter. *See also* Rubens, Peter Paul.

Base

The principal or essential ingredient, or the one serving as a vehicle for pigments in paint.

Batik

An ancient resist-dyeing technique used for creating patterns on textiles. In the process, the areas of the cloth that are not to be dyed are painted with wax or starch paste to prevent the impregnation of the dye. After dyeing, the wax is removed with a hot iron, leaving the patterns white, while the rest of the cloth is colored. The process must be repeated for each color; as many as twenty different colors may be used to achieve the finished design. Traditional patterns are usually stylized renditions of naturalistic forms. Popular Indonesian batik colors, extracted from vegetable dyes, are blue from indigo, yellow from mangosteen bark, and reds from madder. Batik, along with Ikat, another Indonesian resist-dyeing technique in which the resist is applied to filaments (the warp, or weft, or both) before they are woven, is still popular in the Far East, and periodically returns to fashion popularity in the West. *See also* Fabric Printing.

Three stages in the production of batik cloth: First, a design is applied to fabric with wax, which resists dye. Then, the fabric is dipped in the dye bath. Finally, it is washed in boiling water to remove the wax. The process is repeated for each new color.

Bat Printing

The process of printing on glazed ware with a gelatinous pad upon which a pattern has been stamped.

Bauhaus

Influential school of industrial design and art that flourished in Germany from 1919 to 1933. Established by Walter Gropius (1883–1969) at Weimar, Germany in 1919, the Bauhaus was one of the most important pedagogical and practical institutes in the history of art and design. Gropius intended his school to unite all the arts under the auspices of architecture and to explore new possibilities in the relation between art and design and industrial mass production.

Both color theory and practically oriented applications of color (such as were taught in the wall-painting workshop, for example) were fundamental Bauhaus concerns. During the school's earliest years, many of the most popular ideas were influenced by the largely subjectivistic, mystical, and expressionistic interests of Johannes Itten. These psychological ideas were partly continued by Paul Klee, who arrived at the Bauhaus in 1921, and Wassily Kandinsky, who arrived the year after. But in 1923 Itten was replaced by the versatile Laszlo Moholy-Nagy (1895–1946), whose experiments in film, theater, photography, industrial design, and typography, as well as in painting and sculpture, clearly underscored the constructivist orientation of the school. In early 1925 the Bauhaus was relocated to Dessau in a more industrial area, which further reinforced the school's tendency toward a functionalist approach. In 1928 the institute's new director, Hannes Meyer (1889–1954), formally separated the fine from the applied arts in the Bauhaus's program. During its final, troubled years (August 1930 to April 1933), the Bauhaus was under the directorship of the architect Ludwig Mies van der Rohe (1886–1969), until it was forced to close by the National Socialists in 1933.

Despite the broad scope of the educational program at the Bauhaus, which accommodated divergent, even antagonistic approaches, two basic attitudes toward color can be identified. The first was the subjectivistic approach of Itten and, in part, of Klee and Kandinsky. The second, under the predominant influence of constructivism, considered color more as material than as a sequence of psychological effects.

Probably the most comprehensive investigation of color was undertaken by Joseph Albers, noted particularly for his exploration of the details of chromatic interaction. Albers was also a crucial figure in the dissemination of Bauhaus ideas on color in the United States, where they were influential in the development of color field painting, op art, and aspects of advertising design. *See also* Albers,

Josef; Color Field Painting; Itten, Johannes; Kandinsky, Wassily; Klee, Paul; Op Art.

Bay

Reddish brown or chestnut; generally used to describe horses.

Behavior Modification with Color

See Baker-Miller Pink; Blue; Color Therapy; Education, Color; Red.

Beige

A light brown; one of the first color standards in *Standard Color Card of America 1915,* issued by The Textile Color Card Association of the United States. In women's fashion, beige is considered a basic color for sheer hosiery, shoes, and leather goods.

Benday Process; Benday Dots

A technique used in photoengraving for producing shading, textures, or tones in line drawings and photographs by overlaying a fine screen of dots on the artwork prior to etching; named after the American printer Benjamin Day (1838–1916).

Bengal Light

A chemical compound that produces a bright blue flare when ignited. Used for fireworks and signal flares.

Benham's Top

An invention of C. E. Benham in the 1890s, used to demonstrate how an illusion of color can be created from a flickering black-and-white pattern.

The disk of a simple spinning top is covered with a certain pattern of black lines on a white background. When spun in a clockwise direction at a rate of five to ten revolutions per second, the black lines appear—from the center outward—blue, green, and red. When the top is spun in a counterclockwise direction, the order of colors is reversed. These colors are seen even in monochromatic light (i.e., the light of a very narrow spectrum). The effect is attributed to the different speeds at which the color-sensitive cones in the eye sense color and transmit the signals to the brain. The high-speed black–white flicker exaggerates this discrepancy, leading to an impression of color. *See also* Vision.

Berlin and Kay

See Communication and Color; Language and Color.

Beryl

An extremely hard beryllium and aluminum silicate mineral occurring in crystalline form, often used as a gemstone. The stones, which may be of enormous size, are usually white, yellow, blue, green, or colorless. The most valued variety is the greenish emerald; the blue to bluish green variety is called aquamarine. *See also* Aquamarine; Emerald; Gemstones and Jewelry.

Bezold-Brücke Effect

A color effect, discovered by Wilhelm von Bezold, in which a shift of hue is perceived when the degree of luminance is increased or decreased. The phenomenon, unlike the Purkinje effect (*see* Optical Illusions), occurs at relatively high levels of illumination, wholly within the photopic (light-adapted) range of vision. When luminance is increased, all chromatic colors except a certain invariable blue, yellow, green, and red appear increasingly like blue or yellow and decreasingly like red or green. The four hues that are constant have wavelengths of 474 nanometers (billionths of a meter), 494 nm, 506 nm, and 571 nm, respectively. In effect, as the luminance is increased, the red-yellows and the green-yellows become more yellow, and the red-blues and the green-blues become bluer; or, with decreasing luminance, the red-yellows and the red-blues become redder, while the green-yellows and green-blues become greener.

Bezold, Wilhelm von

1837–1907. German meteorologist and physicist. One of the leading scientists of his time, Bezold was a professor of physics at the Royal Polytechnic School of Munich, a member of the Bavarian Academy of Sciences, and founder and director of the Prussian Meteorological Institute. His book *Theory of Color* was published in 1874, with an American edition appearing in 1876. Bezold devised a cone of pure colors, scaled toward white in the center of the base and diminishing in steps, with black at the top—the opposite of the color organization in the pyramid devised by Johann Heinrich Lambert (1728–77). The phenomenon Bezold describes in his book is similar to the one noted by M. E. Chevreul, in which black or white lines of pattern on pure color tend to darken or lighten whole areas and give the illusion of "spreading" over the other color. *See also* Chevreul, M. E.; Systems of Color.

essay

Bible Colors

Faber Birren, American color expert, discusses the symbolic uses of color in the Bible.

Both the Old Testament and New Testament of the Bible have generous references to color. In the former, red, blue, purple, scarlet, violet, and white are particularly common. The whole color spectrum is used to represent God's promise, in the book of Genesis. After the Flood, He places a rainbow in the sky stretching from earth to heaven, saying: "This is a token of the covenant which I make between me and you, and every living creature that is with you, for perpetual generations" (Gen. 9:12–14). The colors of the rainbow are again depicted in the many-colored coat singling out Joseph as Jacob's favorite son.

In the book of Exodus, God commands Moses on Mount Sinai to "speak unto the children of Israel, that they may bring me an offering. . . . And this is the offering ye shall take of them: gold, silver, copper; violet and purple and scarlet yarn" (Exod. 25:2–3). These represent the most expensive materials then available—purple dyes, extracted in minute quantities from shellfish, being especially valuable—and thus also are designated for the veils enclosing the tabernacle: "Make the Tabernacle of ten hangings of finely woven linen, and violet, and purple and scarlet yarn" (Exod. 26:1). The same colors reappear in St. John's vision of the Apocalypse, in which he mourns the destruction of Babylon: "Alas, alas for the great city that was clothed in fine linen and purple and scarlet" (Rev. 18:10).

Even the priest's breastplate bears symbolic colors in the form of rows of precious stones: "the first row, sardix, chrysolite and green feldspar; the second row, purple garnet, lapis lazuli and jade; the third row, topaz, carnelian and green jasper, all set in gold rosettes. The stones shall correspond to the twelve sons of Israel name by name" (Exod. 28:17–21).

Some of these "jewel" colors are described by St. John the Divine in his vision of the New Jerusalem, its foundations embellished with jasper, sapphire, chalcedony, emerald, sardonyx, sardius, chrysolite, beryl, topaz, chrysoprase, jacinth, and amethyst. The wall of the envisioned city is made of jasper, the streets of gold.

White, symbolizing purity, is the color of the dove released by Noah to find a new and purified earth. In the New Testament, white, being the color of a lamb, is a metaphor for Christ. Again in the book of Revelation,

Christ is described as sitting on a white cloud (14:14), a white throne (20:11), and a white horse (19:11). White robes are worn by the twelve elders on the Day of Judgment, as well as by the martyrs.

Red and black are sometimes used to describe chaos and destruction. In Revelation, with the breaking of the sixth seal, there is a violent earthquake and the sun is described as turning as "black as a funeral pall and the moon all red as blood" (6:12). In the Catholic Church, however, red refers to Christ's blood in the sacrament of communion, and black is worn by priests as a sign of their humble status.

—Faber Birren

See also Catholic Rite Colors; Jewish Rite Colors; Symbolism and Color.

Biedermeier

Style of furniture produced in Austria and Germany during the first half of the nineteenth century, representing design influences from two seemingly incongruous sources—French Empire forms and German painted, wooden folk pieces. Named after a fictional character, Papa Biedermeier, a bourgeois country gentleman, who was known for his strong but incorrect pronouncements about the fine and industrial arts. Like Papa Biedermeier, the furniture was sturdy and comfortable—and often graceless.

Biedermeier colors range from the bright hues of peasant decoration to ordinary farm and orchard woods (birch, maple, pine, apple, cherry, and pear) to the rich browns of mahogany, imported from the West Indies for its color and beautiful grain. The Biedermeier style reached the United States with the German immigration in the 1840s to the Midwest and Southwest, where the simple, solid, and unpretentious pieces were well received. The warm wood colors were appreciated in the long, midwestern winters, and in southwestern interiors the heavy solidity of the furniture was a welcome respite from the relentlessly glaring outdoors.

Billmeyer, Jr., Fred W.

1919– Leading authority on contemporary color technology. A key member of many color societies, including the U.S. National Committee of the CIE (Commission Internationale de l'Éclairage), the Inter-Society Color Council, the American Physical Society, and the Optical Society of America, Billmeyer is the author of more than 260 papers in the fields of polymer chemistry and color science, as well as several books, including *Principles of Color Technology* (two editions, co-authored by Max Saltzman). In addition,

he is founding editor of the journal *Color Research and Application.*

Born in Chattanooga, Tennessee, Billmeyer was graduated from the California Institute of Technology and received a doctoral degree in physical chemistry from Cornell University. From 1945 to 1964, he was associated with the plastics department of E. I. du Pont de Nemours & Co., Wilmington, Delaware, and from 1964 to 1984 he was professor of analytical chemistry at Rensselaer Polytechnic Institute, Troy, New York, where he also taught at and directed the Rensselaer Color Measurement Laboratory. He became professor emeritus in 1984.

Binary Color

See Secondary Colors.

Bioluminescence

The pale green light emitted by various jellyfish, cuttlefish, and squid as well as fireflies and glowworms. Caused by the oxidation of a chemical, bioluminescence is the most energy-efficient light produced, since practically no heat is given off by the chemical reaction. For insects, this cool light is used to attract a mate in the dark, while it is thought that sea creatures may use it to lure their prey.

Bird Colors

See Zoology and Color.

Birren, Faber

1900–88. Eminent scholar, author, and historian, known for his work in the area of human responses to color, with special focus on color preferences and the functional uses of color for improved productivity and safety in industry. Birren became an authority on visual, physiological, and psychological reactions to color, and he served industries across the United States as well as the U.S. Army, Navy, and Coast Guard.

Birren received early training as an artist at the School of the Art Institute of Chicago. After taking a course on color at the University of Chicago, he found the subject harmonious with his nature and decided to devote his life to it. He became an independent consultant and moved to New York to begin his professional life by specializing in the practical application of human reactions to color. "Essentially, the scientist thinks and the artist feels, and around the age of twenty, I realized that I was more of a thinker" (CAUS Newsletter, Oct. 1986). A prolific writer, he was the author of 25 books and over 200 articles on color for general, professional, and scientific publications. Among his most important books are *Color: A Survey in Words and Pictures* (1963) and *The History of Color in Painting* (1981). Having been a historian and bibliophile most of his life, in 1971 he subsidized and presented to Yale University a collection of rare books on color, which today is probably the largest and most authoritative color library in America. Additionally, he resurrected and edited the important works of Moses Harris, M. E. Chevreul, J. C. Le Blon, Edwin Babbitt, Ogden Rood, Albert H. Munsell, Friedrich Wilhelm Ostwald, and Johannes Itten.

Faber Birren.

Birthstone

See Zodiac Colors.

Biscuit

A light grayish or yellowish brown shade taking its name from the color of bread. A low-saturation color, it is sometimes called almond.

Black

The absence of light, or the absence of the reflection or transmission of light by a material, gives rise to the impression of black. Blacks, considered shades of mystery and darkness, range from warm to cool—reddened to blued—as well as tonally from a very pure and achromatic pitch-black to a very dark charcoal gray. Surface characteristics considerably affect the way blacks are seen—a glossy black next to a matte one can make the latter appear to be a dark gray.

No black is absolute. There is a theoretical blackbody (*see* Blackbody), which absorbs all light, but in practice even the darkest materials, such as soot or black velvet, reflect at least 3 percent of incident radiation. A very dark gray may appear black because of the contrast with white or with light colors. A pure black is a rare and dramatic occurrence in the natural world, and early conceptions of black seem to encompass any color that is dark, including browns and blues.

A near, but not perfect, black can be produced by mixing complementary colors or all three subtractive, or pigment, primaries—blue, red, and yellow. For centuries, the darkest black was obtained from charcoal. Vine twigs, burned, then splashed with water and ground into a slurry, constituted the highly esteemed fifteenth-century formula of Cennino Cennini. Cennini's other sources of black were burned almond shells and peach pits. Additionally, his *Craftsman's Handbook* (D.V. Thompson, trans., 1933) mentions burning linseed oil in a lamp "two or three fingers away from a good clean baking dish," thus producing lampblack. Ivory

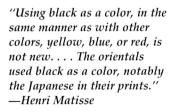

"Using black as a color, in the same manner as with other colors, yellow, blue, or red, is not new. . . . The orientals used black as a color, notably the Japanese in their prints."
—*Henri Matisse*

black, which was made by burning ivory trimmings or old combs, came into use in the seventeenth century. *See also* Inks; Japanese Color; Language and Color.

Blackbody

Term used in physics for an ideal substance that absorbs all and reflects none of the radiant energy falling on it. In practice, on earth, even the blackest object reflects some light. An approximate blackbody is the pigment lampblack, which reflects less than 2 percent of incoming radiation. A study of blackbody radiation led the German physicist Max Planck (1858–1947) to develop his quantum theory in 1900. A later mysterious cosmic phenomenon was the theoretical discovery of "black holes" by contemporary physicists. If these actually exist and are found by astronomers, they will resemble perfect blackbodies, since their titanic gravitational pull absorbs all the light that reaches them, without allowing any to escape.

Black Light

Light consisting of long-wave ultraviolet wavelengths, in the region just beyond the blue end of the visible spectrum. Although they are invisible, these wavelengths can be recorded by film emulsions, and they cause some substances to glow (fluoresce) with unusual colors in the visible range. Incandescent sunlamps, fluorescent and incandescent indoor "plant lights," and BLB (black-light blue) fluorescent tubes are all ultraviolet-rich artificial light sources. Black light became popular in the late twentieth century: It was used in the discotheques of the 1970s; in detergents (the ultraviolet light causes the fluorescent dyes in modern detergents to glow, giving white shirts or other clothes an unnatural luminosity); and in "invisible" fluorescent ink stamps, often used to stamp the hands of visitors to nightclubs or amusement parks who wished to leave and later be readmitted (the stamp becoming visible only under a black light).

essay

Black-to-White Spectrum

Gerhard Lang, American color theorist, provides insight into some of the problematical facets of black, white, and gray.

The black-to-white spectrum is sometimes referred to as a non-color spectrum, or achromatic—meaning without chromatic color, or free of color separation in light refractions. Simply stated, black is the opposite of white and reflects very little light. Gray is the inter-

mediate between black and white—a neutral tone. White is known as the "phantom color" and denotes the absence of all hue. It is difficult, however, to explain to a layperson that white is not a chromatic color. Therefore, describing colors (or non-colors) as progressing from black to white is an inherently paradoxical statement, for neither extreme is a true chromatic color, as are the hues of full-spectrum coloration.

This paradox is further evident in the semantics of the names used to describe the myriad of blacks, grays, and whites available in the marketplace. Is "Chanel black" different from "East Village black"? How is "Dior's forties gray" unlike "elephant gray"? "Charcoal Gray"? "Mouse Gray"? "Dove Gray"? These descriptive names, which represent only a fraction of the terms used over the last few centuries, in no way fix positions along the black-to-white spectrum.

Unfortunately, no one really knows if one has experienced the absolute of black, or of white. Moreover, the thousands of tonal nuances possible between black and white may well be indistinguishable. Variations within this so-called gray scale are limitless. It is doubtful whether any colorist could establish the difference between "elephant gray" and "Dior gray" without the use of a color chip.

The progression from black to white is usually bracketed in 10-percent increments. Most observers can readily distinguish between such increments on the gray scale. People in color-oriented professions can easily recognize gray value scales divided into 5-percent differentials. A few individuals with exceptional training can even discern 1-percent variations. A computer could conceivably decode and print a scale of even further fractional differences, contrasting a 99.999-percent black with a 99.998-percent shade, for example. At the other end of the scale, it could see the difference between 0.002 and 0.001 tonal units. That solution, however, remains in color science's future.

More profoundly in the realm of the future is the discovery of the noncolor that immediately precedes, or is on the other side of the spectrum from, black or white. The question posed is this: What invisible thing (color) is beyond absolute black or absolute white? Or are black and white the finite beginning and ending of this spectrum?
—Gerhard Lang

Absolute (?) white to absolute (?) black.

Black Watch (Royal Highland Rgt.)

Scottish infantry regiment, formed in 1739–40 to watch Scottish rebels and to keep the peace. It became known as the Black Watch because of the dark colors of the regimental tartan (see Tartan).

Blanc Fixe (Baryta White)

First introduced in nineteenth-century France, blanc fixe is an artificial barium sulphate. Finer than a natural baryta white, it is used as a base for the more opaque lakes and as an inert pigment in house paints where, if added in the proper proportions—roughly 10 percent blanc fixe to 90 percent paint—it imparts a good weathering quality. Although of no use in oil paint, in watercolor and in fresco it retains its white color and is permanent.

Blaue Reiter, Der

Literally "the Blue Rider"; a German Expressionist movement active from 1911 until 1914. Named for Wassily Kandinsky's painting Le Cavalier Bleu, the group included, along with Kandinsky, Paul Klee, Franz Marc (1880–1916), and August Macke (1887–1914). The title referred to the position of the members that colors had spiritual significance, particularly blue with its inward-looking, cool, passive character. See also Abstraction of Color; Cubism; Kandinsky, Wassily; Klee, Paul.

Blazon

See Heraldry.

Bleach

To make whiter or lighter.

Bleed

A color is said to bleed when some of the coloring matter of a fabric passes from the fabric into a liquid—usually water—that is in contact with it. A color bleeds into another fabric when the coloring matter of one fabric is transferred to the second—usually white —fabric, through the action of a solvent.

Blind, Color Sensation of the

See Keller, Helen; Synaesthesia.

Blindness, Color

See Color Blindness; Dalton, John.

Blind Spot

Area on the retina of the eye that is not sensitive to light and in which objects seem literally to disappear. The blind spot was discovered toward the end of the seventeenth century by Friar Mariotte, a French student of optics who caused a sensation by showing people at the English court how to make royalty disappear—the image of the personage can be made to fall on the blind spot by staring slightly to the side of him or her with one eye only, and from a certain distance.

The blind spot is where the optic nerve connects to the retina of the eye, a point at which there are no rods or cones to permit sight. The viewer is not conscious of emptiness or blackness because the brain "fills in" the spot with whatever happens to be in the environment. A background pattern or even color will seem to be filled in over the field of vision covered by the blind spot.

X ●

The blind spot can be found by staring at the X drawn above with just the right eye, from a distance of about 1 foot. The black spot to the right will completely disappear. In most instances, with binocular vision, the whole field of view is covered by one eye or the other, and our perception ignores the hole in the visual field. This is a good example of the active part the human brain takes in making sense of what we see or do not quite see, building up a coherent image of the moving world around us.

Blond, Blonde

Fair, light in complexion, as opposed to dark or brunette. The word comes from the French blond, and possibly the old English blondenfeax, meaning "gray-haired." The English printer William Caxton (ca. 1422–91) used the word in 1481: "The rayes of the sonne make the heer of a man abourne or blounde" (Oxford English Dictionary).

Blood Red

The red of blood is a deep blued or oranged red, depending on whether it is venous or arterial. The actual coloring agent of blood is hemoglobin, a pigment protein in the erythrocytes of red blood cells, which are carried in the plasma, a colorless liquid. The myth of the power of blood and hence of the color red goes back to prehistoric times, when primitive man observed life ebbing and ending when blood flowed from a body.

Thus, blood red symbolism has a primitive force: Body painting among African tribes still employs red ocher pigments to promote

health and longevity. Just as a ruddy complexion has often suggested good health, so, too, does the use of rouge and red lipstick emphasize life and even the sexuality necessary for the reproduction of life. In Christianity, blood red symbolism is found in the Catholic ritual of having the faithful drink red wine, which not only represents but actually is Christ's blood—by drinking His blood, Christians partake of His life force. *See also* Communication and Color.

Bloodstone

See Chalcedony and Jasper.

Bloom

Derived from the Middle English for blossom, bloom in color refers to the highest intensity or richness of a shade, as a flower at its freshest and fullest bloom.

Blue

A primary of both pigment and light, and that portion of the color spectrum lying between green and violet, blue is one of the most elusive colors for mankind, despite its preponderance in the environment, especially in the sky and the sea. It has been shown that it is the last primary color to be named by emerging cultures (*see* Language and Color), and it is one of the most difficult colors to produce from natural materials. The ancient Egyptians did have ultramarine from the rare stone lapis lazuli (which they imported from Afghanistan) and Egyptian blue, made by heating malachite with sand chalk and soda (this inexpensive method of making blue was lost since the time of the Romans and rediscovered only during the twentieth century). More common was indigo blue, used, along with madder red, by the Egyptians as early as 4500 B.C. to color the sheets used to wrap their burial mummies.

Since blue is a color that is rarely produced in the natural world, and because it has an amorphous presence in the expanse of the sky, it has been most commonly associated with spirituality, wisdom, and the afterlife. The Romans employed blue in their system of academic robe colors to denote the station of philosopher, as it still does in the American system. Christian art has traditionally used blue to signify spiritual and pacific virtue. Blue was the color of holiness, too, for the Hebrews and for the Hindus, for whom Krishna is exclusively blue. By contrast, for the Japanese, blue historically stood for spring and victory specifically, and it was also used for work and traveling clothes because it was thought to keep poisonous

snakes at bay. In China, blue is associated with the east and in Tibet with the south, whereas the Hopi tribe of Native Americans use blue for the west (*see* Compass, Points of the).

Blue has ambivalent and often contradictory applications in the English language. Usually associated with melancholia, it has been applied to music—the blues—and to severe codes of conduct. (Blue laws regulate private and public conduct and morals, especially Sabbath observance. The term is derived from the blue paper on which some seventeenth-century laws were printed. Most common during Prohibition, blue laws are retained by many states today.) Blue also can suggest licentiousness, as in telling blue stories. It can be used to designate unskilled laborers, as in blue-collar workers; or intellectuals, as in bluestockings (from the blue worsted stockings worn by women at their literary meetings in eighteenth-century London); or even enormous speed, as in comparing fast movement to a blue streak or blue lightning.

Psychology of Blue

Faber Birren (in *Color,* 1963) suggests some psychological characteristics that blue may indicate. He points out that blue is most often chosen as a favorite color (*see* Lüscher Color Test), though more often in communities with higher incomes and levels of education. In other social strata, red, a more primitive color, may be more popular.

Since blue is a retreating color, Birren states that it is the color of deliberation and introspection, conservatism and acceptance of obligations. Those who favor red, either by wearing the color or by choosing it for their environments, tend to be extroverted personalities, seeking the company of others and lively social gatherings. Those people who prefer blue tend to be more withdrawn personalities, favoring quieter surroundings and associates.

Painters and designers have long known that blue can be used to create an increased sense of depth. Leonardo da Vinci first formulated this in his theory on aerial perspective: Objects or landscapes painted in blue will appear to be a great distance away from the viewer. More recently, Wassily Kandinsky speculated that blue is a color that turns in on itself and is best portrayed as a circle, spiraling inward. He suggested further that colors convey tension when shaded toward another color, and that blue added to green or red may be more expressive and evocative than blue on its own. *See also* Aerial Perspective; Language and Color; Symbolism and Color.

"Blue is the only color which maintains its own character in all its tones. Take blue in all its nuances, from the darkest to the lightest—it will always stay blue: whereas yellow is blackened in its shades, and fades away when lightened; red when darkened becomes brown, and diluted with white is no longer red, but another color—pink."
—*Raoul Dufy*

"There are connoisseurs of blue just as there are connoisseurs of wine."
—*Colette*

"Almost without exception, blue refers to the domain of abstraction and immateriality."
—*Wassily Kandinsky*

Blue-Green

A blued green, turquoise, aquamarine, teal, or any off-shade of greenish blue or bluish green.

Blue Moon

A rare occurrence, as in the phrase "once in a blue moon." A blue moon originally referred to a second full moon within one calendar month.

Blueprint

An image in blue tones printed by the cyanotype process, an inexpensive and simple method of printing using light-sensitive iron compounds, producing a white image with blue middletone and shadow areas. The widespread use of a form of this process to reproduce architectural and construction plans established *blueprint* as the colloquial name for all such copies. The term remains even though the process is obsolete and copies can be made with black or brown lines. Some architects and engineers still prefer to reproduce their drawings in blue.

Blues

See Music and Color.

Blue Shift

In astronomy, an apparent shift in color of a stellar body toward the shorter-wavelength end of the spectrum, caused by the body's movement at high speed toward the observer. *See also* Astronomy and Color; Red Shift.

Bluestocking

Denotes a woman of considerable literary and intellectual ability; from the color of the woolen stockings worn by some members of a mid-eighteenth-century London literary circle for women.

Body Painting

Painting different parts of the face and body in tribal society—comparable to the use of cosmetics in contemporary society—is a subject of anthropological interest. Claude Lévi-Strauss (1908–) in his study *Tristes Tropiques*, on the M'baya of South America, writes that the painted face is a sign of human dignity in the individual. Face painting indicates the passage from nature to culture, apartness from the rest of the animal kingdom, and therefore is the sign of the civilized man. In fact, studies of Maori tattooing by other anthropologists suggest that an unpainted face is seen as mute and a purely biological organism—when decorated, it becomes literally and metaphorically a social mask by which a man simultaneously identifies himself with a community and asserts his individual identity.

Color, therefore, appears to serve a vital function as a means of classification or coding. Certain color designs identify the tribe; but subtle variations in application identifies the individual. A modern analogy exists in fashion: A businessman has to wear a suit at work, but, within limits, he can wear his *own* colors (especially in ties).

Color use by primitive cultures is never arbitrary. Each color carries specific connotations—though the exact meaning may vary from tribe to tribe. For instance, red can be a symbol of bad (menstrual) blood that has to be purified by applying white paint to girls at their initiation ceremonies—or it can be a symbol of good blood running through the veins. There are examples dating back to neolithic times of red pigment being rubbed onto corpses—red, according to ancient belief, aided rebirth in the next world.

In *Colour Classification in Ndembu Ritual*, American anthropologist Victor Turner portrays colors—including body paint—as symbolizing the emotional—almost spiritual—side of the more extreme human experiences: birth, puberty, pregnancy, and death. Applied ritually in turn, these colors—the red of blood, the white of milk and semen, and the black of decomposition—give powers that help to control natural events.

Body painting gives an acute example of the power of color when it is used as a symbol. Body makeup is still a fundamental part of group identification and culture, even in the twentieth century. In the Western world, for example, women use cosmetics and some men tattooing. Tattoos, however, are generally a more basic order of symbols—they tend to be representational, recalling past events. As a result, tattoos do not speak of the eternal or transcendental in man in the way that pure colors do. *See also* Communication and Color; Cosmetics and Color; Tattoo.

Bole

Name given to any of several varieties of clay, either white or colored. White bole usually refers to kaolin (china clay), while red bole is a natural, ferruginous aluminum silicate, which was called Armenian in the Middle Ages after the location from which it came; bole has since been found all over Europe. At that time, the high polish that bole takes made it an ideal ground for gilding.

The color of bole is far from uniform. Red

"Face painting indicates the passage from nature to culture; the painted face is a sign of the civilized man."
—Claude Levi-Strauss

bole ranges from warm light pink to deep purplish red. There are also yellow and green boles.

Bolus

A tomato red. Originally used to describe the color of unbleached canvases of Old Master paintings, this brownish red was usually primed with gypsum to provide a suitable, achromatic painting surface. Palettes on which painters mixed their colors were usually plain wood to match the bolus ground, so that colors would seem unchanged when applied to the canvas. With the modern white, bleached canvas, palettes in white or gray are more appropriate.

Bone Black

See Artists' Pigments.

Bonnard, Pierre

Pierre Bonnard.

1867–1947. French painter and lithographer associated with the Nabis and known for his luminous compositions, especially of domestic interiors (*see* Nabis). In contrast to the impressionists' concern with landscapes, changing light and fleeting moments, the Nabis focused on color as a means to create an illusionistic pattern on a flat, two-dimensional surface. Bonnard used a limited, high-value palette containing, in addition to white, eight primary pigments: strontian yellow, cadmium yellow, cadmium orange, cobalt blue, ultramarine blue, emerald green, cobalt green, and cobalt violet.

Like his friend Édouard Vuillard (1868–1940), Bonnard was influenced by the exhibition of Japanese prints held at the École des Beaux-Arts in Paris in 1890. After seeing works by Hokusai, Utamaro, and other Japanese printmakers, he often limited himself to two colors in his lithographs. Delicate, close, analogous harmonies in ivory, pink ocher, orange beige, yellow beige, rose beige, bottle green, and sulfur green appear frequently in his lithographic palette.

Bordeaux

See Claret.

Bottle Green

Term commonly used to describe a deep, dark, lustrous green. The description comes from the green of glass bottles often used for mineral water and beer. Many shades of bottle green exist, ranging from pure greens to olive ambers. Different thicknesses of glass substantially change the nature of the green as more or less light is absorbed. Three bottle greens are generally associated with alcohol: pale aqua for rums, darker green for champagne, whiskies, and scotches. Red wine is usually bottled in green in order to deepen its color and increase opacity, thereby seeming to give it greater body, or fullness and richness of flavor. Historically, bottle green refers to a pale, bluish tint, an aqua, examples of which date from the ancient Egyptians and Romans who perfected the art of glassmaking. *See also* Glass.

Boucher, François

See Rococo Colors.

Boyle, Robert

1627–91. One of the founders of modern chemistry who established proper scientific methods for experimentation. Of Irish birth, Boyle began his career as an alchemist. His extensive writings include a volume on the nature of color, *Experiments and Considerations Touching Colours* (1680), which anticipated Isaac Newton's *Optics* (1704).

Breaking with the long-established Aristotelian theory that all colors derive from black and white, he explained: "I have not found that by any Mixture of White and True Black . . . there can be a Blew, a Yellow, or a Red, to name no other Colour." He proposed that all hues were contained in white light, and that this light was distorted by objects to produce hues. "The Beams of Light, Modify'd by the bodies whence they are sent (Reflected or Refracted) to the Eye, produce there that kind of sensation Men commonly call Colours." These colors were of two different types: atmospheric, as in the sky or the rainbow, and structural, as in rocks or flowers. The former he called "apparent" hues, the latter "genuine." "Genuine Colours seem to be produc'd in Opacious Bodies by Reflection, but Apparent ones in Diaphanous Bodies, and principally by Refraction." His theories thus anticipated not only Newton but also the distinction between additive and subtractive coloration, a fact that was often overlooked for two centuries after his death.

Boyle also had respect for the purely human factors involved in the sensation of color. Hues could not be inherent qualities of objects, since "an apparition of them may be produced from within." His particle theory of light was similar to modern quantum theory: Colors are "produc'd by the Impulses made on the Organs of Sight, by certain extremely Minute and solid Globules." These, he thought, stimulated the eye both by their matter and by the manner in which they

traveled: ". . . the Eye may be Variously affected, not only by the Entire Beams of Light that fall upon it as they are such, but by the Order, and by Degrees of Swiftness, and in a word by the Manner according to which the Particles that compose each particular Beam arrive at the Sensory." *See also* Additive Color Mixing; Newton, Isaac; Subtractive Color Mixing.

Bradford Colour Museum

See Appendix.

Braque, Georges

1882–1963. French painter known for his still lifes and his elegant, restrained palette of black, browns, grayed pinks and blues, and opaque greens and yellows. Born at Argenteuil, where the impressionists had drawn inspiration, Braque began attending the École des Beaux-Arts at Le Havre in 1897. A member of the original fauve group, he turned to cubism in 1908. Exploring space, Braque evolved a palette of soft, velvety contrasts in muted variations of buff, gray, brown, pink, green, and blue.

Along with Pablo Picasso, Braque was a major figure in the cubist movement. By 1911, the fragmented, volumetric, compact style of the movement's analytical phase had resulted in a limited palette of off-blacks and browns. A year or two later, the synthetic phase of cubism began, featuring a greater use of color and larger planes. Frequent subjects of Braque's synthetic cubist works included musical instruments, furniture, wine bottles, and other things typically found in a French interior; to these bourgeois objects he brought a sense of the lyrical through cubist café au lait browns, including walnut and deep chocolate, as well as brownish orange, grayed blues, pinks, and opaque greens. *See also* Cubism; Fauvism; Picasso, Pablo.

Brazilwood

Common name for trees of the *Leguminosae* family; the greatest source of red lake in the ancient and medieval world. Pieces of the wood, when steeped in water with alum, exude a glowing orange-red dye. During the Middle Ages, the name *bresel wood* referred to East Indian sappanwood; however, Portuguese traders used the same name to refer to a similar South American tree, which later gave its name to the country of Brazil.

Brewster, David

1781–1868. Scottish physicist and natural philosopher. His invention of the kaleidoscope was one result of his notable light-polarization studies. He perfected the stereoscope as it is still known today. Among his prolific writings was a major biography (1855) of Isaac Newton. He agreed with Newton that sunlight was composed of different hues. To him there were three essential primaries: "I conclude that the solar spectrum consists of three spectra of equal lengths, viz., a red spectrum, a yellow spectrum, and a blue spectrum" (*A Treatise on Optics*, 1831). This mistaken view was widely accepted, and the red-yellow-blue doctrine became known as the Brewsterian theory (*see* Primary Colors).

Georges Braque.

Brick

A building material made by shaping clay into blocks and hardening them in a kiln. Sun-dried bricks are among the oldest building materials. Examples from 5,000 years ago have been discovered in the Tigris-Euphrates Basin. The Romans faced brick buildings with marble and stone, but Byzantine and later European builders used the brick itself to provide a decorative surface. The term *brick red* is often applied to a medium-dark shade of red. *See also* Architecture and Color.

Brightness

1. Intensity of illumination (of a light source). **2.** High saturation (of a surface color); bright means brilliant, vivid, lively in appearance, the opposite of dull. Sometimes used as a synonym for lightness. Also known as dyer's brightness. **3.** Reflecting power, resemblance to white (especially in paper manufacture).

Broadcasting

See Television.

Broken Color

Term used in painting for a reduced tone achieved by mixing gray into a color; used especially in the chiaroscuro technique for rendering the illusion of shadow. *See also* Chiaroscuro.

Bronze

A metallic brown color varying from warm golden brown to greenish tones.

Bronzy

Having a metallic surface appearance that partly obscures the body color of the material. Bronziness is usually yellowish, greenish, or reddish, and is complementary to the body color. *See also* Verdigris.

Brown

Technically, color produced by the combination of red, black, and yellow. The range of browns is considerable and encompasses the brown of a seal, mahogany, tobacco, coffee, chocolate, a fawn, and autumn leaves. U. S. textile standards include ecru, beige, autumn brown, African brown, oakwood, sandalwood, cork, Champagne, caramel brown, gold-brown, burnished straw, maple sugar, tan, spice brown, toast brown, cocoa, and U.S. Army brown.

Historically, brown has been allied with warmth, comfort, and substantiality. Popular for both men's and women's clothing, brown was the color of choice during the Great Depression because it disguised soiling. *Esquire's Encyclopedia of 20th Century Men's Fashions*, by O. E. Schoeffler, calls brown "the most important color in suits and jackets all during the thirties."

In food, brown suggests homeyness and soundness and is linked with staples such as brown bread, brown eggs, brown sugar, and brown rice. Many provincial bourgeois restaurants in France prefer brown decor because of the solidity and reliability associated with this color.

Brunet, Brunette

Of a dark color or tone; generally used to describe a person with dark hair and usually dark eyes, resulting from high levels of melanin pigmentation.

Buccinum

A shellfish from which a purple-red dye is produced. *See also* Tyrian Purple.

Buckthorn

A thorny shrub (*Rhamnaceae* family) and source of frangulin, which was used histori-cally to dye fibers a greenish yellow or, if used with an alum mordant, green. The coloring matter was squeezed from the plant's small hard fruit, sometimes known as "Avignon" or "Persian grain." In medieval or Renaissance formulas, buckthorn is also called *spinozerbino* or *pomelle de cerbino* and is described as used not only for dyeing but also for painting miniatures.

Buff

A yellowish tan to reddish yellow color, named for the color of buffalo or ox skin. The term derives from the French word *buffle*, meaning "wild ox."

Burnt Pigments

Term used to describe earth pigments that are calcined (roasted) with alumina and silica —as in burnt sienna, burnt umber, or burnt carnelian—which has the effect of dulling the color of the original pigment. Burnt sienna—originally *terra di sienna,* from the Italian city where it originated—has a copper brown color, while burnt umber—from Umbria, an Italian region—is a reddish brown. Yellow ochers also redden when heated, while becoming thicker and denser, resulting in burnt ocher, also a popular artists' pigment. Moderate heating produces yellowish reds; stronger heat results in richer and more saturated colors. Natural burnt-earth red pigments occur in volcanic regions. *See also* Artists' Pigments.

Buttercup

A color name derived from the species of *Ranunculus* bearing golden yellow, cup-shaped flowers, especially *R. bulbous, R. acris,* and *R. repens.*

Byzantine Colors

See Icons.

Cabala (Kabbalah)

A medieval system of Jewish mysticism that influenced the tradition of alchemy (*see* Alchemy) and the eighteenth-century development of Hasidism. Cabala is based on the belief that every word, letter, and number of the Scriptures contains mysteries. One written source, the Zohar (ca. thirteenth century), a commentary on the Pentateuch, contains many discussions on color.

In Cabala, color is used to describe the physical world, and refers to the spiritual only allegorically. For instance, since war involves spilling red blood, red expresses anger and hatred as well as strength; white indicates mercy and peace, since people with white hair (the aged) are usually merciful and do not fight in armies. *See also* Jewish Rite Colors.

Cadmium Light

See Lighting, Artificial.

Cadmium Paints

See Artists' Pigments.

Calcium Carbide Light

See Lighting, Artificial.

Calligraphy

See Typography.

Camouflage

Camouflage is one of the oldest devices in the natural world used by prey to hide from a predator, or by a predator to deceive its prey. Each, through the course of evolution, has been engaged in a continuous upward struggle to improve its camouflage or its powers of discrimination—important factors in the evolution of color vision (*see* Zoology and Color).

Camouflage—the word is derived from the French *camoufleur,* meaning "to hide"—is extensive in nature. Birds tend to be darker on top and lighter underneath, thereby blending with the sky and earth, respectively. Fish are generally colored to match their water environment. Animals, whether hunted or hunter, tend to be marked in ways closely related to their habitat. Biologists call these various camouflage effects "disruptive colorations," indicating that colored markings serve to disrupt the outlines of an animal and conceal it by blending in with its surroundings.

In many instances, camouflage ensures survival. A green grasshopper is hard to find when it's still; a stick insect's shape and immobility would make it conspicuous without the benefit of having the color of a stick. The zebra's strong black and white stripes mimic the effect of moonlight raking down their backs, thus hiding them from nighttime predators. Generally, female birds are less colorful than males, and this is a definite benefit to their remaining unnoticed as they sit on a nest. In the jungle, where nature is colorful, bright feathers are part of a disguise, and this is the case with most tropical birds, female as well as male. In the Bermuda reef, emerald green fish can find refuge near the pink coral because green is the complementary shade, and the fish appears absorbed into the reef's shadow.

Camouflage as part of aggressive acts is very common among hunting animals. A tiger, with black stripes on a coat of tawny orange, hunts among tall grasses and reeds. The light striking the reeds or the grass will cast vivid black stripes of shadow. In such an environment, a crouching tiger disappears.

Camouflage need not be constant. Chameleons are well known for their changing colors and, consequently, their varied environmental blendings (*see* Chameleon).

As in the natural world, military camouflage—the art of hiding people or objects from the enemy—faces a similar endless struggle against progress, in this case of technology. Early camouflage was closely based on nature's techniques. Genghis Khan conquered Asia with mounted warriors mixing shrubbery with their equipment, not unlike crabs with seaweed on their backs. Shakespeare's Macbeth is convinced that he need "fear not till Birnam Wood do come to Dunsinane"—which it obligingly does, with the English army hidden under it.

Two centuries after Shakespeare, the American colonists learned the concealing

security of buckskin browns. The British infantry, known as "lobsterbacks" because of their scarlet uniforms, were easy targets for colonial sharpshooters. (The only advantage for the British of wearing such uniforms was a psychological one: They seemed larger, closer, and more threatening than they really were.) In nineteenth-century India, British soldiers rubbed dirt into their uniforms to hide themselves better. The word *khaki* is Hindi for "dust."

Camouflage against Airplanes

Military camouflage developed fully during World War I. The airplane necessitated the disguising of roads, ammunition dumps, and airfields from aerial spotters and bombers. Aerial photography for reconnaissance demonstrated that the camera was not fooled by pigments of different spectral composition from that of the foliage. Vegetation reflects a great deal of red light, making it appear dark on a black-and-white print. The first camouflage paints reflected only green light and thus appeared in the prints. Infrared photography could quickly identify the real, as opposed to the artificial, foliage.

In response, ground camouflage techniques developed. The tools of the *camoufleur* came to include paints, dyed fabrics, and a variety of other concealing materials. The modern *camoufleur* is probably most concerned about shadows—extremely visible from the air. Shadows appear far blacker than even the blackest paint and are telltale signs of man-made objects, as are all straight lines and right angles. Among the techniques used to counter shadows are a number of nature's tricks. The bottoms of objects can be colored lighter than the tops, offsetting the effect of sunlight, which makes the bottoms appear darker. Another technique is the breaking up of telltale edges of military installations by using broken color patterns.

Sometimes color alone is not sufficient to camouflage an object. If the texture of the camouflaging material is significantly different from that of the surrounding landscape, it will stand out starkly. A transparent (nonreflecting) medium like netting has often proved the best base for camouflaging; on this can be fixed raffia and cloth dyed to the appropriate colors, as well as foliage, to provide the concealment. The texture of this best matches that of natural vegetation.

Glossy surfaces, which can reflect light like a mirror, have to be avoided. For example, the blackest surface, a tarred road, is shiny —from the air, against the non-reflective green of the surrounding natural growth, it appears almost white. Stony surfaces appear darker than smoother areas because the angles of the stones, like the facets of a diamond, reflect light in many directions. Bushes, trees, and tall grass appear darkest because of the shadows created by the densely textured surfaces. (such as conifers) appear darker than deciduous ones—with the latter, the leaves reflect a high proportion of red and infrared light. Camouflage paint, to be effective, has to match the surroundings according to the distance from which the object to be concealed will be seen.

Marine camouflage is just as critical as land-based camouflage. As late as the Spanish–American War (1898), battleships were usually painted white with little thought given to concealment. By the early twentieth century, "battleship gray" was adopted and a system of countershading developed. Parts of the ship that usually appeared dark or in shadow were painted in light colors, and light areas were painted darker.

Marine camouflage changed drastically with the advent of the submarine. Low-visibility paintwork was of no real use, since submarines fired from close range—less than a mile away from their target. Thus, grotesque patterns of advancing and receding colors and geometric patterns with very strong colors were developed as effective means to hide the course of a ship from a submarine. With the development of radar, naval ships have given up camouflage patterns and returned to low-visibility gray.

One camouflage trick that is thousands of years old remains: smoke screens. (Examples from nature include cuttlefish and squid, which squirt ink as a smoke screen to deceive predators.) Smoke screens are still used at sea to hide the exact position of ships from aerial attack, but the method has become somewhat outdated with the use of guided missiles, which have devastating accuracy. The only known camouflage against these are showers of metal foil, which will deceive the missile guidance system as to the position of its target.

Fashion Camouflage

Thus, color camouflage, which belongs to a pre-computer technology, may have become militarily outdated. Its fashion ramifications, however, are very much part of our times. In civilian life, camouflage is subtle and psychological. The blue- or gray-suited businessman is thoroughly camouflaged among his fellow workers. On the other hand, to wear military camouflage gear is a strong fashion statement; its function is completely inverted. During the Cultural Revolution, Chinese citizens wore blue Mao suits to ex-

Camouflage: Nature's tricks for hiding animals can have military applications.

press their conformity; today, as in the Soviet Union, they covet blue jeans, so standard in the Western world that they too are a uniform, a type of camouflage. Buildings are often neutrally colored to blend into the environment; to color them strongly is to create a symbol of power and self-assurance.

Candle (Candela)

A unit of measurement for the intensity of a light source. Originally, a candle of specified composition and dimensions was used as a standard light source for photometry. Today the standard source is taken as 0.16 sq. in. (1 sq. cm) of a blackbody glowing at a temperature of 1,496 K (1,769°C), the point at which platinum becomes liquid. The candle (U.S.) or candela (international) is defined as an intensity equal to 1/60 the intensity of this standard source. *See also* Lumen.

Carbon Black

See Artists' Pigments.

Carbuncle

Name given to almandite (an iron aluminum garnet) when it is cut cabochon, or highly polished and convex but not faceted. Its coloring may vary from a deep red to a violet-red.

Carmine

A rich crimson red, originally made from the cochineal insect. The term is derived from the French *carmin* (cochineal; crimson).

Carnation

A pink or light red, the color of the flower of the same name. The name comes from the Late Latin *carnatio,* meaning "fleshlikeness"; the most perfect shade of carnation, therefore, is a pink flesh tone.

Carnelian

See Chalcedony and Jasper.

Carotene

A yellow, red, or orange pigment found in many fruits and vegetables, and the precursor of vitamin A. Carrots, apricots, squash, and sweet potatoes are some of the fruits and vegetables in which the rich carotenoid color is apparent. Although carotene is also found in many dark green vegetables, its color is obscured by the chlorophyll present in these plants. Currently, carotene is used as a coloring agent in foods. Although a diet containing too much carotene is not harmful, it can result in carrot-colored skin tones.

Carrot

An orange to yellow color, named after the edible root of the plant *Daucus carota* of the parsley family; also a descriptive term of hair coloration.

Cartoons

See Motion Pictures, Color in.

Cast

A tint or tinge of a color or shade with another hue, as in a "green cast" or a "red cast" gray.

Castel, Louis-Bertrand

1688–1757. Inventor of the color organ. Castel was a French natural philosopher, priest, mathematician, and writer on aesthetics who, in his book *La Musique en Couleurs* (1720), proposed the construction of a color organ that would combine color and sound. On December 21, 1734, in Paris, he gave his first demonstration of his "clavessin oculaire," a device consisting of a five-octave keyboard that controlled the raising and lowering of translucent colored tapes, each of which was illuminated from behind by candles or oil lamps.

Castel wrote extensively on music and color; his other principal publications were *Nouvelles Expériences d'Optique et d'Accoustique* (1735), and *L'Optique des Couleurs* (1740). Castel was influenced by Isaac Newton's discoveries in optics and was an early supporter of the three-primary (red-yellow-blue) theory of pigment-color mixture. *See also* Color Organs; Music and Color.

Catechu

A dye and tanning substance produced from the acacia, a tropical tree, some species of which also yield lac (for shellac), gum arabic, and tannins.

Catholic Rite Colors

Roman Catholic ritual today recognizes five colors, prescribed for specific uses: white, red, green, purple, and black. There are a few exceptions: A special rose may be used on Laetare and Gaudete Sundays, while blue is used in some dioceses of Spain for masses celebrating the Immaculate Conception.

The designated ritual colors must occupy the main portion of the religious official's vestments. Borders and ornamental decorations may be added. Although there is no rule specifying the lining of vestments, yellow or gold is generally used. Vestments made of pure gold may be used in place of

red, white, or green; and silver cloth may be used instead of white. No multi-hued garments may be worn.

Comparing Roman Catholic and Jewish rite colors, green seems individual to the Catholic faith and blue to the Jewish. This may be because the Book of Exodus in the Old Testament relates, "Then up went Moses, and Aaron, and Nadab, and Abihu, and seventy of the elders of Israel; and they saw the God of Israel: and there was under his feet as it were a paved work of sapphire stone, and as it were the very heaven for clearness" (Exod. 24:9–11). Thus, blue stands for God in Judaism. In the New Testament, Saint John the Divine declares, "And he that sat was to look upon like a jasper and a sardine stone: and there was a rainbow round the throne, in sight like unto an emerald" (Rev. 4:2–4) Thus, green has come to stand for Christ. *See also* Bible Colors; Jewish Rite Colors.

Cave Painting

See Prehistoric Colors.

Caygill, Suzanne

1911– . Founder of the Academy of Color and originator, in 1942, of the concept of a "color harmony," which correlates coloring of human pigmentation with color systems in nature. Her *Key to Color Harmony* was first published in booklet form in 1946 and provides the process whereby a spectrum of color is developed for each individual based on his or her own seasonal harmony. It was her pioneering work that provided the basis for personal seasonal color analysis, which enjoyed enormous popularity in the 1980s. Caygill created the Carousel of Color—the first portable or traveling color laboratory in the world. Currently being developed is the extension of her laboratory of 20,000 cards on Caucasian pigmentation to include the shadings found among black and Oriental races.

Caygill developed from her theory of the "four seasons" a six-course Color Clinic, which she says has been presented in 36 different cities to over 500,000 clients in nearly half a century. She claims that her method of analysis nourishes an individual's full potential. *See also* Personal Color Analysis.

Celadon

Term applied narrowly to a minty blue-green, and broadly to high-fired stoneware with a grayish or brownish body covered by a transparent or opaque olive or gray-green glaze. The name has its origins in an eighteenth-century French pastoral Romance,

L'Astre, by Honoré D'Urfé, in which the shepherd Céladon is described as wearing ribbons of grayish green. In the late nineteenth century, the term came to describe green or bluish green porcelain ware imported from China.

Green-glazed ware dominated the ceramics of China from 3,000 years ago until the end of the Yuan dynasty in 1368. Celadon was a prized color because of its similarity to jade, the most revered and precious stone of China, and to bronze, a highly valued metal. In Korea, as well as in China, the celadon color elevated the clay wares beyond the mundane world of utilitarian objects.

Early glazes of the Shang dynasty (ca. 1600–ca. 1050 B.C.) are usually thin and greenish yellow or olive-brown. The potters discovered that at high temperatures certain materials liquefy to form a glaze. The first glazes were probably the result of ash accidentally falling on vessels in the kiln, but the potters learned to imitate the process by coating the vessels with ash mixed with clay.

The glaze was aesthetically pleasing as a decorative element, and in later dynasties it was fired to create crackle patterns or incised with designs. The green color is the result of the presence of iron oxides in the glaze, the intensity of color varying according to the amount of iron in the local clay and the heat of the kiln. Different shades also were obtained by varying the amount of oxygen in the kiln. A wide variety of coloration from blue-green to olive and yellow can be found among early celadon wares, even among objects glazed during the same firing, because of the difficulty of controlling kiln temperature. As potters learned to control the heat inside the kiln better, the thick, lustrous green glazes of the Song dynasty (A.D. 960–1279) ware began to be created.

Under the Mongols during the Yuan dynasty (A.D. 1279–1368), the ceramic industry was considerably influenced by foreign trade, and the blue-and-white porcelain industry arose in the fourteenth century in response to outside demand. Both the quality of celadon ware and the volume created declined in the succeeding Ming dynasty years (A.D. 1368–1644), but production never completely ceased and continues in China today. *See also* Ceramics and Color.

Cennini, Cennino d'Andrea

ca. 1365–1440. Florentine painter who was instructed for twelve years by Agnolo Gaddi, son of Taddeo Gaddi, godson and for twenty-four years pupil of Giotto (ca. 1266?–1337). Cennini is known primarily for his book, *Il libro dell'arte (The Craftsman's Hand-*

book), a unique manual and record of the technique and materials of the Quattrocento painter's craft.

The various chapters of the book, even today, can be useful for young painters and feature titles such as: "How to Paint in Oil on Walls, Panels, Iron or Whatever You Please"; "How to Color Gold on Velvets"; "How to Make Impressions in Wax or Paste." An example of particularly delightful writing from the chapter entitled "How to Color Faces, Hands, Feet and Flesh Generally" reads as follows: "Take a little verde-terra . . . and go twice over the face and all the naked parts. But this first bed of color must, when painting the faces of young persons with fresh complexions, be tempered with the yolk of the eggs of a city hen, because they have lighter yolks than those laid by country hens, which from their redness are only fit to temper the flesh coloring of old and dark persons" (*The Craftsman's Handbook*, D. V. Thompson, trans., 1933). *See also* Black.

Ceramics and Color

Ceramics constitute any products made from clay, which, unless the material's natural colors are retained, can be given color by painting or glazing—covering with a fused glass coating. In creating ceramic objects, the clay is shaped while wet and pliant, left to dry, and then hardened by heat ("fired") into one of three main types (depending on the temperature used for firing): porous-bodied pottery, stoneware, and porcelain. At the lowest heat (about 930°F, or 500°C) raw clay becomes porous pottery; stoneware is made by raising the temperature (to about 1,830–2,200°F, or 1,000–1,200°C); and porcelain is created at a still higher heat (about 2,550–2,730°F, or 1,400–1,500°C), making the clay vitrified (glass-like) and especially strong. The type of finish, or glaze, to be used determines the number of firings.

History of Color in Ceramics

Ceramics constitute man's earliest craft form. Fired pots from 6000 B.C. or earlier have been found in Anatolia in modern Turkey. While the earliest pots used the natural colors of raw clay (which when fired can range in color from earth reds to reddish browns, yellows, and buffs), those found in Turkey had evidence of red and yellow ocher, which was used to paint them. Decoration was usually abstract, but human and animal forms began to appear circa 5000 B.C. as ceramic vessels came to be used in ritual ceremonies. Ornamental forms were painted on as slip (diluted clay), which was then fused onto the pot in another firing. Oxides of iron and manganese, graphite, and white clay containing quartz or calcite produced colors ranging from reds to brownish purple to buff, white, and gray.

The invention of the kiln—the closed furnace—about 5000 B.C. was important to the development of color in ceramics. With the kiln, firing temperature could be controlled more easily than it could if pieces were placed on an open fire; variations in temperature changed the color of the pieces. By reducing the amount of oxygen in the kiln drastically, the clay could be made to turn black, the key color of early Greek pottery.

The other method of coloring—glazing—uses the same ingredients as glass—sand, soda, or potash, plus lime. The earliest color, a brilliant turquoise, was probably made by the accidental mixing in of copper oxide. Such glazes were first used on tiny Egyptian steatite beads, dating from the fifth millennium B.C. Transparent lead glaze and opaque white tin oxide glaze were in use in the Middle East by about A.D. 1000. Also in use by then, iron gave a green or yellowish brown tint to glaze; minute amounts of cobalt produced a pure violet-blue; and antimony resulted in a yellow glaze. Red has historically been difficult to produce, but it was discovered in ancient Egypt that copper's blue could be transmuted into red at the right temperatures.

Famous examples of ceramic color include the red-on-black and black-on-red Greek vases of 800–300 B.C.; the Chinese grayish green and sky blue celadon high-fired stoneware tinted with iron oxides and the beautiful ivory white porcelains of the sixth to the thirteenth century A.D. from China; the Islamic pottery and tiles that unsuccessfully tried to imitate imported porcelain and instead reintroduced tin glaze to produce a lustrous, opaque white finish to earthenware; and wares glazed with high-quality cobalt oxide blues and turquoises produced in China. These last were first exported from the Middle East to China, which returned with the classic blue-and-white porcelain of the Ming era, which swept Europe in the seventeenth century, making "china" a household word.

Glazes

Used to apply color and to make pottery waterproof, ceramic glazes are glass—basically silicates—attached to the surface of an object and then fused by heat. Unlike glass, glazes must be of fairly high viscosity, so that they hold their position on the surface of the pottery during firing. This stiffness is achieved by the addition of alumina to the

"When painting the faces of young persons . . . use the yolk of the egg of a city hen, because they have lighter yolks than those of country hens."
—Cennino Cennini

glaze mixture. Glazes fall into a few principal groups:

Alkaline glazes: Discovered by the Egyptians, these glazes are made from soda compounds, which are abundant in the deserts of the Near East. The addition of copper-bearing minerals produces bright blue turquoise glazes.

Lead glazes: Made from compounds of lead, particularly lead sulfide, and producing a smooth, bright, brown or amber-colored glaze. Other lead-glaze colors, discovered by the Syrians and Babylonians, are obtained by mixing copper, iron, and manganese into the lead. Use of these glazes spread to China by 500 B.C., where they became popular. Many lead glazes on surviving pieces of this ancient ware have weathered and become iridescent due to the decomposition of the glaze.

Ash glazes: Discovered by the Chinese, when they improved the design of kilns so that temperatures of about 2,200°F, or 1,200°C, or more could be reached. They found that wood ash (originally from the fire itself) produced strong colors (due to the large quantities of alkalies present, such as potash and soda).

Slip glazes: Glazes made almost entirely of clay diluted with enough water to be painted on the surface of pottery. Some of the most beautiful of the old Chinese glazes are of this type. With the discovery of higher firing temperatures, it was found that some clays, such as the common red earthenware clay, would melt in the kiln to form a glaze (with a brown color, due to the presence of iron). Ashes or feldspar are now added to the slip to make it fuse at a lower temperature than the rest of the pottery.

Feldspathic glazes: Made largely of feldspar, these glazes also require a high firing temperature. They produce a beautiful milky white color, and, with the addition of limestone and quartz, other colors as well.

Color in glazes results from the color in the clay or the underglaze color beneath transparent glazes, or from the addition of metallic oxides. Colors are widely variable, depending on the solution in which the glaze is mixed, the temperature at which it is fired, the quantity of glaze used, and the presence of any impurities. Almost an unlimited range of colors can be produced by adding oxides. The following are some of the most common coloring oxides:

Cadmium and selenium: Used to produce the brightest red glazes, cadmium and selenium are usually used together. The color is fugitive: Pottery must be fired at low temperatures and cooled quickly or the red will disappear.

Chromium oxide: The most versatile coloring oxide, producing reds, yellows, pinks, browns, or greens, depending on the kind of glaze and temperature used. In pure form, the chrome produces a green, but when mixed with zinc, tin, or cobalt oxides, it can produce other colors.

Cobalt oxide: Highly consistent, cobalt oxides produce nearly the same shades of deep blue under many different conditions. At high temperatures, however, and when mixed with magnesia, cobalt oxide can produce mottled effects, marking pieces with splotches of red, pink, and purple.

Copper oxide: Produces a turquoise or blue color in alkaline glazes, although in great quantities it will result in dark and metallic greens and blacks. In lead glazes, copper oxide produces shades of soft, warm greens like those of plants. Mixed with barium, copper can even produce reds, such as copper-red or oxblood red.

Iron chromate: Source of grays, browns, and blacks.

Iron oxide: Present in most earths, iron produces the characteristic browns, rusts, yellows, and grays of clays. Covered with clear glazes, these colors can be modified to include tan, reddish brown, salmon, ocher, or yellowish pink. In general, iron is regarded as an impurity, and great care is taken to remove it from glazes. An iron oxide, however, such as hematite, gives a tan color and is used to tone down and warm yellow, blue, and green glazes (an important technique in celadon glazing).

Manganese oxide: Produces a purple or brown color, becoming a rich plum in highly alkaline glazes, or a violet when mixed with cobalt.

Nickel oxide: Source of most browns and grays, nickel is very unpredictable.

Rutile: An ore containing titanium and iron oxides, rutile produces rich tans and browns. Most useful for giving broken or mottled effects to otherwise smooth glazes.

Uranium oxide: Rare since restrictions on its sale were made in 1942; produces cool, lemon yellows, although reds and corals can be produced if oxide is added to lead glazes.

Vanadium oxide: Produces a rich yellow when mixed with tin.

Other colorants include antimony (which produces Naples yellow), gold (produces

pink, red, and purple), and platinum (an expensive gray). *See also* Celadon; Glass; Majolica; Seljuk and Ottoman Mural Ceramics; Wedgwood Blue.

Ceremonial Colors

See Catholic Rite Colors; Empire State Building Colors; Jewish Rite Colors; Mourning Colors.

Cerise

A moderate to deep red; from the French word for ''cherry.''

Cerulean

A sky-blue shade, of which there are many variations; also known as ciel, from the French for ''sky.'' Cerulean now commonly refers to an artists' pigment.

Cézanne, Paul

1839–1906. Pivotal French painter who became an important figure in the transition to artistic abstraction. Unlike the other great postimpressionists, Cézanne is not usually associated with coloristic innovation. His few remarks about painting and technique, in his correspondence with painter/theorist Emile Bernard (1868–1941) and the painter Charles Camoin, make it clear that Cézanne is more interested in ''a good method of construction (through color)'' (1904) than in its more ''superficial'' aspects.

In a 1904 letter to Bernard, Cézanne advises the younger artist to ''treat nature by the cylinder, the sphere, the cone,'' and he goes on to observe that ''nature for us men is more depth than surface, whence the need of introducing into our light vibrations, represented by reds and yellows, a sufficient blue to give the impression of air.''

Color used to break up and to reorganize pictorial space was Cézanne's lasting contribution to twentieth-century art. By using the cool color schemes typically found in nature (the greens, blues, and light whites) with touches of warm, yellowed tones, he created in his landscapes (and later in his portraits and genre pieces) a formal structure based on colored planes. The fleeting color of the impressionists was thus arrested and held in place by interlocking planes. In this manner, Cézanne prepared the way for the subsequent Cubist investigation of space with color. *See also* Cubism.

Chalcedony and Jasper

The chameleons of the gem world, displaying a bewildering variety of colors, semi-precious quartz stones fall into two groups, chalcedony and jasper, distinguished by their internal structure.

Chalcedony, which includes all agates, carnelian, and chrysoprase, is composed of layers of tiny quartz fibers. Because of impurities present, these layers are often colored: Iron oxides cause the browns in agates and sardonyx and the red in carnelian; apple-green chrysoprase is colored by nickel; while the darker greens of plasma and prase are due to crystals of chlorite and actinolite. Chalcedony is popular as a carving material, and its color banding (particularly of agate, the fine-grained variety of chalcedony) was exploited in classical Roman cameos.

Bloodstone is plasma, or a green chalcedony, that is speckled with red jasper or iron oxide particles. In the Middle Ages, it was said to cure wounds, hemorrhaging, and most disorders of the blood. Legend has it that it derives its color and its power from being stained with the blood of Christ.

Chalcedony is porous and may be stained with a variety of metallic salts. Natural black onyx is rare, and most onyx is made by soaking agate in a sugar solution, then heating it in sulfuric acid to carbonize the absorbed sugar particles.

Jasper consists of a mass of minute, randomly arranged, interlocking quartz crystals. It is opaque and contains large amounts of colorful impurities, mostly red and yellow iron oxides or green chlorite and actinolite. Jasper is used for carvings and in mosaics and inlays. *See also* Gemstones and Jewelry.

Chalk

A mineral (calcium carbonate) pigment. Soft, easily pulverized, and composed mainly of small seashells; the natural chalk white is an opaque white color that was first used in Neolithic cave painting. In classical Greek painting, chalk white was one of the tetrachrome palette, which included two additional mineral pigments, a red and a yellow ocher, and the vegetable charcoal, vine black. Chalk white is used as a ground for textile fabric designs and for priming in canvas painting. In both instances, it increases brightness and luminosity. In painting, it lends an almost fresco-like color quality. Through the addition of coloring matter, chalk of any hue can be made.

Chameleon

An animal of the lizard family with a reputation for fast color changes to blend in with its surroundings, the colors of its skin ranging from brilliant green through dark brown. In fact, the chameleon does not change its color strictly for camouflage—although it

Paul Cézanne.

''There is no light painting or dark painting, but simply relations of tones. When they are done right, harmony appears by itself. The more numerous and varied they are, the more the effect is obtained and agreeable to the eye.'' —*Paul Cézanne*

does generally blend in well with its forest habitat—but in response to various stimuli, including light, temperature, and emotion. The chameleon's colors come from its multi-layered skin: The outside layer has a yellow carotenoid pigmentation; the second layer is not pigmented, but reflects blue light by means of interference effects (see Interference)—these two layers together give the bright, almost turquoise, green; the third layer contains black melanin, which absorbs excess light, and which can be rapidly injected into the other two layers in response to hormonal or nervous activity, progressively darkening the green to brown. See also Zoology and Color.

Chanel, Gabrielle (Coco)

1883–1970. Highly influential Parisian designer whose work was primarily in evidence from the 1920s through the 1950s but whose signature "look" has been continually revived. Chanel was instrumental in advancing simplicity in women's fashions. Her trademarks were boxy, collarless suits and "little black dresses." Her favorite palette included navy, black and white, and flame red. Besides the basic black dress, Chanelisms include pearls, sling-back pumps in beige and white, gold chains, and flame red and navy suit braiding.

Chartreuse

An acid yellow-green shade deriving from the color of the liqueur of the same name, made by French Carthusian monks.

Charts and Atlases

See Sources of Historic Colors; Standardization of Color; Systems of Color.

Chemistry of Colorants

Before 1856, little was known of the chemistry behind color in pigments and dyes. Up to that point, colorants had been synthesized from minerals (for example, lapis lazuli and ocher) or from plant and animal life (red, for example, could be produced from the roots of the madder plant, or from the cochineal insect). Many colors were expensive and, excepting those derived from minerals, impermanent—in a few hours of sunlight, a robe of Tyrian purple made from 20,000 shellfish would fade substantially.

The seminal discovery of 1856 was purely fortuitous. William Perkin, an assistant to an English chemist, was trying to synthesize the organic compound quinine, used to prevent malaria, when he noticed his mixture stained a rag deep purple. Perkin had stumbled on the first organic ("relating to or derived from living organisms") dye to be reproduced chemically: aniline (see Aniline). From this, tens of thousands of other dyes have been developed.

The factor common to all these dyes is the benzene molecule, or one of its close relations, a hydrocarbon found in coal tar and mineral oil. The molecule's virtue is that it has a relatively large number of carbon atoms, a high proportion of which scientists have found to be essential in the production of color. While some other elements will produce color in a compound by themselves (chromium, for example, will usually produce orange, yellow, or green), color more often depends on the particular chemical structure of a molecule; generally the most complex structures are built around the element of carbon.

An example of the transformation of benzene molecules into a viable colorant is provided by alizarin (see Alizarin). Its value to the dye and pigment industry is that it is moderately permanent and is made from what is, these days, a relatively inexpensive substance: crude oil.

The basic structure of the benzene molecule (C_6H_6) consists of six carbon atoms and six hydrogen atoms arranged in a circle; the standard symbol for this is a hexagon. Carbon is a key atom, because it can bond to four other atoms simultaneously, allowing the construction of complex molecules. To increase the proportion of carbon further, three benzene molecules can be bonded together to produce anthracene ($C_{14}H_{10}$), an important base compound in color production.

Up to this point, the substance is colorless. But to this can be added a large number of chromophores (from the Greek terms for "color" and "bearer") to produce, for instance, anthraquinone ($C_{14}H_8O_2$), a slightly colored substance. In all these molecules, the key to creating color is to keep the proportion of hydrogen atoms at the lowest possible level—achieved, in the previous example, by replacing two of them with oxygen.

To produce the full color, a final auxochrome (literally a "color aid") is added to make the compound even more "hydrogen hungry." For instance, a simple addition of an auxochrome to anthraquinone produces the familiar deep red of alizarin ($C_{14}H_8O_4$). Changing the auxochrome will modify the hue slightly. Many other colors can be produced by using the elements nitrogen, aluminum, and sodium, among others, in the chromophore.

The final molecule of a pigment or dye then has the unique characteristic of absorbing certain wavelengths of light energy and reflecting others, giving the color that we

see. This coloring agent then has to be combined with a medium, such as water, oils, or cellulose solutions. This vehicle holds the colored powder in suspension and permits its application in uniform densities to whatever has to be colored. *See also* Artists' Pigments; Colorants; Dyes and Dyeing; Pigment.

Cherry

A deep blue-red hue; the color of the Bing variety of the fruit.

Chestnut

A reddish brown; the color of chestnut wood or of the fruit itself; descriptive name for human hair and the horse of the same color.

Chevreul, M. E. (Michel Eugène)

1786–1889. Color specialist who, through his book *The Principles of Harmony and Contrast of Colors and Their Applications to the Arts* (1839), influenced color theory on a par with Isaac Newton, Johannn Wolfgang von Goethe, and Hermann von Helmholtz. Chevreul had prodigious talents: He became a teacher in his twenties, a member of the British Royal Society by the time he was forty, and eventually a leading world authority on various aspects of chemistry. In 1824 he became director of dyes at the famous French Gobelins tapestry works. It was there that he devoted himself to color and wrote his masterwork.

Chevreul is famous for three unique contributions to color. The first was his statement of the law of simultaneous contrast of colors, which strongly influenced the schools of impressionism, neoimpressionism, and orphism in art. The second comprised his principles of color harmony, which are still taught today. Of final importance were his revelations regarding visual mixtures, which were featured by such painters as Georges Seurat. No other writer has had greater influence in the fields of art and theory of the visual and aesthetic realms of color. Artists such as Eugène Delacroix found new expression for color in these statements, and ever since they were set out, the art of color has consciously or unconsciously paid tribute to the genius of Chevreul.

The following includes some of Chevreul's main principles:

1. Delicate aureoles placed around hues dramatize contrast effects.
2. White placed beside a color heightens its tone.
3. Black placed beside a color lowers its tone.
4. Gray placed beside a color lowers its tone.
5. A dark color placed next to a different and lighter color raises the tone of the first and lowers that of the second.
6. Flat tints of the same hue but different saturation placed next to each other produce a chiaroscuro effect.

See also Harmony; Simultaneous Contrast.

Chiaroscuro

From the Italian for "light" and "dark," chiaroscuro refers to the artist's technique for rendering the three-dimensionality of objects with light and dark shades for the highlights and shadows, respectively.

In describing his chiaroscuro style, Leonardo da Vinci wrote, "The first object of a painter is to make a simple flat surface appear like a relief, and some of its parts detached from the ground; he who excels all others in that part of the art, deserves the greatest praise. This perfection of the art depends on the correct distribution of light and shade, called chiaro-scuro. If the painter, then, avoids shadows, he may be said to avoid the glory of the art, and to render his work despicable to real connoisseurs, for the sake of acquiring the esteem of vulgar and ignorant admirers."

Children and Color

See Color Therapy: The Body Prism; Education, Color.

Chinese Color Symbolism

The Chinese have a traditional love of color and have made abundant use of it throughout the evolution of their culture. Historic ages were associated with color. The royal color of the Sung dynasty (A.D. 960–1279) was brown, the Ming dynasty (A.D. 1368–1644) favored green, and the Ch'ing dynasty (A.D. 1644–1912) preferred yellow, the emperor reserving it for his own exclusive use. In the Ch'ing court, the officials were distinguished according to rank by colored buttons worn on the top of a cap: The first rank wore coral, followed by blue, purple, and white.

After the overthrow of the last emperor, color coding was continued in the first flag of the Chinese Republic—this time with colors designating race. The flag's horizontal stripes included red for the Manchurians, yellow for the Chinese, blue for the Mongolians, white for the Moslems, and a black stripe for the people of Tibet.

Certain color use has transcended political upheaval in China. The bride traditionally wears red—the color of fertility. The color is used for her marriage chair, for her parasol,

M. E. Chevreul.

"In endeavoring to discover the cause of the complaints made of certain pigments prepared in the dyeing laboratory of the Gobelins . . . I saw that the want of vigor complained of in the blacks was owing to the color next to them, and was due to the phenomenon of contrast of colors."
—*Michel Eugène Chevreul*

for the firecrackers exploded in her honor, and for a red cord symbolically tying together two cups from which she and the groom drink the pledge. Similarly, when a new house is built, pieces of red cloth are suspended from the roof to promote joy. It is appropriate, then, that the revolutionary flag is in red, signifying a new age.

China also has an independent alchemical tradition, even older than that of Europe, which is linked to color. There are five elements: earth, metal, wood, fire, and water, whose symbolic colors are yellow, white, blue-green, red, and black, respectively. Each element and color also corresponds to an animal, a part of the body, a season, a planet, and a cardinal point of the compass. The Chinese conceived the elements as dynamic forces: Fire overcomes wood and is overcome by water, for example. This symbolism could be put to practical political use. For example, since metal can "overcome" wood, revolutionaries challenging a dynasty associated with blue-green (wood) thought themselves more likely to triumph carrying a banner of white, the color corresponding to metal. *See also* Alchemy.

Chinese Red

See Lacquer Colors.

Chintz

Term derived from the Indian word meaning "spotted." It applies specifically to a glazed cotton cloth, which is stained or painted with a motif. Chintz fabrics often have bizarre, multi-colored patterns.

Chlorophyll

A pigment produced by plants; used for photosynthesis, the process by which the energy of sunlight is harnessed to manufacture, from water and carbon dioxide, the vital carbohydrates that supply energy to the growing plant and that are used to make fats. Chlorophyll absorbs red, yellow, blue, and violet wavelengths of light, but reflects green light. Chlorophyll always produces the same shade of green, regardless of which type of plant manufactures it, the color being modified by texture and the presence of other pigments. Such other pigments include carotenoids, which may become apparent only when the chlorophyll breaks down, as in the "turning" of leaves in autumn. *See also* Plant Colors.

Chroma

Synonym for saturation; used in the Munsell color system. The Munsell system makes use of three terms: *hue* for chromatic color (as distinct from black, white, and gray); *value*, which refers to the brightness or lightness of a color, in relation to the carefully spaced steps of a gray scale; and *chroma*, which refers to the apparent purity, saturation, or intensity of a color as measured in steps leading outward from a neutral gray. Vermilion, for example, is a color of strong chroma, while rose has a weak chroma. *See also* Munsell, Albert Henry; Systems of Color.

Chromatic Aberration

See Aberration.

Chromatic Adaptation

The process by which the eye adapts to, and hence discounts, the overall color of incident light. *See also* Color Constancy.

Chromatic Colors

Chromatic colors are those colors in which one part of the visible spectrum is dominant, such as red or blue. Achromatic colors, such as black, white, and gray, have no hue because in them all parts of the visible spectrum are roughly equal in intensity and thus no one part is dominant. (A chromatic scale is a musical scale progressing entirely by semitones; for further discussion of color analogies in music, *see* Music and Color.)

White light is a mixture of all the wavelengths of visible light. If one part of the spectrum is filtered out, the complementary color of that part will become dominant, and the light or color will be chromatic. For instance, if red wavelengths are filtered, the light will appear blue-green. It is not possible to have gray or black light, since light always appears to our perception to be fully saturated. The so-called black light used in the cockpits of aircraft or photographers' darkrooms is in fact a deep red that does not affect night vision.

Similarly, surface color will be chromatic if one part of the spectrum is absorbed by the colored object, and only a portion is reflected. The fewer competing wavelengths that are reflected, the purer (more saturated) will be the dominant hue. A glossy surface, which reflects light more regularly with less interference or dazzle, will seem darker and more saturated than a matte surface of the same color. The word *chroma* is used in the Munsell Color System to refer to the degree of saturation of a surface color. *See also* Achromatic Colors; Black Light; Chroma.

Chromaticity

The color quality of a visual stimulus. Chromaticity is determined by the hue and satu-

ration attributes of a color, without taking into account its value, or brightness (*see* Systems of Color). A term used particularly by the International Council on Illumination (*see* CIE System and Color Measurement).

In the case of light, the chromaticity of a color indicates the proportion of any two of the three primary stimuli needed to create it. For example, the chromaticity of a colored light would be specified by saying it could be matched by a light mixture containing 40 percent of a particular red primary and 35 percent of a particular blue primary (there would be no need to specify the third—green—which would make up the remaining 25 percent). The brightness of the light is not a factor in chromaticity.

In the case of surface color, chromaticity corresponds to the hue and saturation of the color perceived by an observer with no color vision deficiencies, under certain conditions of illumination.

Chrome

Bright, silver-colored metal, also known as chromium; a positive photographic transparency; or, in dyeing, the dichromate of potassium or sodium. The term is derived from the Greek *chroma,* meaning "color."

Chrome Yellow

An acid yellow with a greenish cast.

Chromotherapy

See Color Therapy.

Chryselephantine

Ivory and gold figure sculpture, the ivory serving to designate flesh and the gold used for drapery and ornamentation. Popularly used for figurines in Egypt, Mesopotamia, and Crete, it reached its zenith in the colossal temple statues of Greece in the fifth century B.C. Examples of such statues no longer exist but are mentioned in literature of the time. Most famous were the 40-foot colossus by Phidias (ca. 490–430 B.C.) for the Parthenon in Athens, and the statue of Zeus at Olympia. This bichromatic sculpture, which was placed in the interior of the temple, contrasted with the brightly painted sculptures of the outer friezes.

Chrysoberyl

Generally a pale yellow stone. One variety, alexandrite, changes color dramatically from deep green in daylight to red under tungsten light. Chrysoberyl is also pleochroic: It appears red, orange-yellow, and green, according to the direction from which the stone is

viewed. The yellow, green, and brown colors of chrysoberyls are caused by small amounts of iron or chromium (chromium also causes the effect noted in alexandrite). *See also* Gemstones and Jewelry.

CIE System and Color Measurement

The CIE system is an established scientific method used to define and measure color mathematically. It was developed in 1931 by the Commission Internationale de l'Eclairage (the International Commission on Illumination), the initials of which form its name. The following description of the CIE process is provided by American industrial color scientist and founder of Industrial Color Technology, Ralph Stanziola.

In order to obtain an objective description of a colored sample, we must consider the characteristics of the sample itself, the light source under which the sample is being viewed, and the human observer. Each of these elements must somehow be described numerically.

Measuring Color

The Sample. The sample, or object, is described by its interaction with light. This description is called a spectrophotometric curve, or spectral curve (measured by a spectrophotometer). For opaque samples, like paint panels, textiles, or plastics, the curve is a reflectance curve. For transparent substances, the curve is a transmittance curve. These curves show the fraction of the light reflected or transmitted, at each wavelength, from the sample compared with a standard (a suitable white material for reflectance measurements; usually air for transmittance measurements).

The Light Source. Except in rare situations, we do not see color without light. Furthermore, the color we see depends on the characteristics of the light source under which a sample is seen. Under incandescent light, a colored sample may appear yellowish; under daylight, the sample may appear bluish. Because of this, we must have some way of describing the influence of the light source numerically. The light from any source can be described in terms of the relative amount of light (power) emitted at each wavelength. If we plot the relative amount of light as a function of wavelength, we obtain a curve that is called the spectral power distribution curve of the light source.

The Observer. Of the three elements needed to describe the color of a sample, the observer is the most difficult to describe numerically. Light from a test lamp is allowed to

The CIE diagram, showing the relative positions of visible monochromatic wavelengths. Colors progressively blend until, at the very center, they produce white light.

shine on a white screen and can be viewed by an observer. Right next to the spot of light from the test lamp, a spot of light from any combination of a red, green, and blue light —the additive primaries—can also be viewed (at the same time) by the observer. By adjusting the intensities of these primaries, the observer can make the combined colors on the screen match the color from the test lamp. Therefore, the color on the screen produced by the test lamp can be described by the amounts of the three primary colors needed to match it. These amounts (numbers) are called the tristimulus values of the test lamp.

For a more precise procedure with a broader application, we can replace the test lamp with a device (prism and slit type grating) so that white light could be broken up into the visible spectrum one wavelength at a time, to allow each wavelength of light to shine on the test spot. The primary lights could also be made by dispersing white light into the visible spectrum and isolating three single wavelengths of light, a saturated red, green, and blue as the primaries. A comparison procedure similar to the first is used, with each of the single wavelengths matched one at a time with the three primary lights. If this exercise was carried out by a number of normal observers (that is, with no known color vision deficiencies), we could then calculate the average amount of the three primaries needed to match each wavelength. These amounts are the tristimulus values for the spectrum colors.

When these experiments were carried out, it was found that most of the individual wavelengths of light could not be matched with the three primaries. This problem could be overcome by adding light from one of the primaries to the test light, and then matching this new color with the remaining two primaries. In these cases, the test light can be described by combinations of positive and negative amounts of the primary lights. Then, by using a transformation equation (like converting temperature from degrees Fahrenheit to degrees Celsius), the values obtained from real primaries could be converted to values obtained with imaginary primaries. These new primaries were determined so that all of the spectrum colors (each wavelength) could be matched with positive amounts of the three primaries.

The CIE System

In 1931, the International Commission on Illumination (CIE—the initials taken from the French name of the organization) set up an objective description of color by the proper

combination of the elements describing the sample (object), light source, and observer. The CIE provided the elements of standardization of the source and observer data. The CIE also provided the method to obtain the numbers that yield a measure of the color of a sample as seen under a standard source of illumination by a standard observer. These numbers are called the tristimulus values: X, Y, and Z. In 1931, the CIE recommended the use of several sources, which were then defined as standard illuminants when their spectral power distributions were determined. In 1965, some additional standard illuminants were recommended. The most important of these (at least for industrial applications) was D65, an illuminant with the power distribution of typical daylight and a correlated color temperature of 6,500 K (blue-white). Also commonly used is illuminant A, with a color temperature of 2,854 K (yellow-white).

Computation of CIE Tristimulus Values. The tristimulus values X, Y, and Z of a colored sample are obtained by multiplying together the reflectance (R) of a sample, the relative power (P) of a standard illuminant, and the standard observer functions x, y, and z at each wavelength. You now have three columns: RPx, RPy, and RPz. The products in each column are summed up for all the wavelengths to give the tristimulus values X, Y, Z for the colored sample (calculated for a particular standard illuminant and standard observer).

Since the tristimulus values, X, Y, and Z, do not correlate well with the visual attributes of hue and saturation, the CIE recommended in 1931 the use of chromaticity coordinates x, y, and z to define color specification. The chromaticity coordinate is simply the amount of any one of the tristimulus values divided by the sum of all three:

$$x = \frac{X}{X + Y + Z}$$
$$y = \frac{Y}{X + Y + Z} \qquad z = \frac{Z}{X + Y + Z}$$

Since x + y + z = 1, two of the three coordinates are used to plot the familiar horseshoe-shaped curve of the CIE chromaticity diagram. This defines the chromaticity of the color (hue and saturation), but the lightness of the color is defined by the Y tristimulus value. This value is the third dimension of the chromaticity diagram and represents a line perpendicular to the x–y plane. This system is called the CIE Y, x, y system. The color can now be defined by its Y, x, y values, which serve as a useful specification of that color.

If we consider using the chromaticity diagram as a possible means of setting up an objective procedure for color tolerance determinations, we run into serious problems. The physical distance between two samples in one part of the diagram (that is, red) will be different than that in another part (that is, blue), although visually both sets appear to have the same degree of color difference. The chromaticity diagram is not uniform from a perception standpoint.

Over the years a number of attempts have been made to develop linear and non-linear transformations of the chromaticity diagram to form a more visually uniform space. Perhaps it is analogous to plotting the chromaticity diagram on a rubber sheet, and then trying to pull the sheet so that the horseshoe-shaped diagram becomes a circle. In any event, none of the transformations has produced a totally visually uniform color space to date, although some are better than others.

—Ralph Stanziola

Cinnabar

Red sulfide of mercury; the brightest of red pigments known in the ancient world. The chief source for cinnabar at that time was in what is now Spain. The oldest mercury mine there, Almaden, was worked by the Carthaginians and later by the Romans. The pigment was so highly valued that its extraction and trade were strictly controlled by the government, and it was sent in its unrefined form under seal to Rome before it was traded. During the Middle Ages, cinnabar was also known as minium, often being confused with orange lead.

Cinnamon

A bark brown with a red-yellow hue, matching the color of a stick of cinnamon.

Citrine

Composed of quartz, one of the most common minerals in the earth's crust. Both the yellow of citrine and the violet to purple of the related amethyst are caused by the presence of iron; the more iron present, the deeper the color and the greater the value of the stone. Natural yellow citrine is comparatively rare, and most commercial citrine is amethyst turned yellow by heating. At about 850°F, or 450°C, amethyst becomes colorless, turning yellowish brown at about 1,000°F, or 550°C. *See also* Amethyst; Gemstones and Jewelry; Quartz.

Claret

A rich but not too deep red. A term that currently is used in no other language apart from English, *claret* was derived from the Old French *clairet,* a diminutive of *clair* (light, clear). It was originally used to distinguish wines of a yellowish or light red color. The term has been closely associated with the Bordeaux region for so long that English speakers ordinarily use claret to refer to red wines made in the valley of the Gironde and shipped from Bordeaux. *See also* Wine, Color Control in.

Clean, Clear

Free from a tendency to be dull, dingy, gray, dusty, or cloudy in appearance.

Cloisonné

Method of enameling in which enamels are poured into a network or pattern of cells made of thin wire soldered to a surface. This technique was perfected between the sixth and the twelfth centuries among Byzantine craftsmen who worked almost exclusively in gold. The enamels were so intensely colored that the fine partitions of gold, bright as they are, provide a welcome relief between hues that appear too vivid to be comfortably juxtaposed.

The principle of cloisonné was used by designers of stained glass windows from medieval times. They knew that separating colored glass with black leading or with pieces of clear glass would make the colors more vivid. More recently, modern artists such as Henri Matisse have outlined their figures to enhance the vividness of their already strong colorations, a technique that has come to be known as *cloisonnisme.*

Coal Tar

Viscous, dark brown to black substance, obtained by the destructive distillation of coal. Coal-tar derivatives are used to make dyes, cosmetics, and synthetic flavoring extracts. *See also* Dyes and Dyeing.

Cobalt

A silver-white metallic element with a faint pinkish tinge, occurring in compounds whose silicates provide a distinctive blue color for ceramics and glass. The term comes from the German *Kobalt,* originally *Kobold*—a dangerous spirit who supposedly lived in German mines and caused disease.

Cobalt blue is a deep blue to strong greenish blue color, nearly transparent and permanent, also called king's blue or Thenard's

Cloisonné: *Color enhanced by separations.*

"I am crazy about two colors: carmine and cobalt. Cobalt is a divine color and there is nothing so beautiful for creating atmosphere. Carmine [is] as warm and lively as wine . . . the same with emerald green."
—*Vincent van Gogh*

blue. A compound of cobalt oxide, aluminum oxide, and phosphoric acid, it was discovered in France in 1802 and introduced as an artist's pigment in the 1820s. Other cobalt blues are cobalt ultramarine and turquoise.

Cobalt green, also called zinc green, is a medium yellowish green. A compound of cobalt zincate and zinc oxide, it is opaque, bright, and permanent. Discovered in 1780 in Sweden, cobalt green was not introduced as an artists' pigment until the mid-nineteenth century.

Other cobalt colors include cobalt violet (dark and light) and cobalt yellow. Cobalt yellow (aureolin) is made from cobalt and potassium nitrate; it is a bright, transparent, permanent yellow used in glazes and tintings. Discovered in Breslau in 1852 by N. W. Fischer, it was introduced in Paris in the same year and in the United States and England after 1860. Cobalt violet, in both poisonous (cobalt arsenic) and non-poisonous (cobalt phosphate) varieties, are permanent and have been in use as artists' pigments since 1860.

Cochineal

A scarlet red color once widely used to dye silks and wools; now replaced by synthetic colorants. The natural pigment is extracted from the female of the insect *Dactylopius coccus*, which lives on the cacti of Mexico, Central America, and other warm regions.

Coding, Color (Communication)

See Advertising; Astronomy and Color; Communication: Commercial Color Symbolism; Flag Colors; Heraldry; Safety Colors; Symbolism.

Coherent Light

Normal light emissions are naturally chaotic; light from the sun or an electric lamp scatters a mixture of light in all directions. Coherent light, on which principle the first laser was created in 1960, is light that is emitted in a single beam from a specially prepared ruby or hollow tube filled with gas (*see* Laser). The disparate wavelengths then vibrate in harmony, enhancing one another to such an extent that, when focused, this light can drill a hole through a diamond.

Collage

From the French for "pasting," a work of art that is created by the synthesis of various bits and pieces of "found" objects—such as newspaper scraps, wood, textiles, and rope —extracted from their daily roles and integrated onto a painted canvas. This was first

done in 1912 by both Pablo Picasso and Georges Braque in the early stage of their cubist studies.

Picasso's earliest collages, which he called *papiers collés,* such as *Man with a Violin* (1912), were composed of pasted newsprint combined with charcoal drawing. It is only in his second series of *papiers collés* that color as well as other textured elements are introduced. For example, in *Guitar, Sheet Music, and Wine Glass* (1912), he uses wallpaper, a wood texture, and pieces of colored paper.

Since Picasso's and Braque's work, collages have been a popular form of art, especially for surrealist painters such as Max Ernst (1891–1976) and pop artists of the 1960s.

Collimated Light, Collimator

Collimated light is composed of visible wavelengths traveling along parallel paths. Sunlight—and light from any source effectively at infinity—is collimated. A collimator is a lens and light device that produces collimated light; it is used to inspect and adjust optical systems. *See also* Laser.

Colloquial Language, Color in

Color codes colloquial language, often metaphorically. Meanings can often be difficult to pin down—swinging to polar opposites depending on the context. For example, one might be blue-blooded, red-faced, or green-eyed, but one could also be guilty of telling blue jokes, have the red carpet rolled out for him, or have a green thumb. Some color phrases are lost in time; others, still in twentieth-century usage, appear below. *See also* Symbolism and Color.

Red
Red is a particularly strong color that commands attention. Traditionally used on military uniforms, perhaps because it hid blood and because it made armies appear more threatening, it is the color of the planet Mars, named after the Roman god of war. Red was the color of the Russian Revolution, forming the basis for the reference to Soviet Communists as Reds by the Western world, and to Mao Tse-tung's *Quotations from Chairman Mao Tse-tung* as the "little red book."

Red's oldest association is with blood and, by extension, with heat, flesh, and emotions ranging from love and courage to lust, murder, and rage. Thus, in language, red runs the gamut from red-blooded to red alert to scarlet woman and red-light district, to red-handed, as in being caught red-handed in a crime. The ancient Egyptians began the tradition of important, red-letter days by mark-

Cochineal: Beauteous reds from a tiny female bug.

ing new paragraphs, totals of sums of figures, and the names of hostile forces in red ink. In the sixth century, the Christian church used red to mark the rubrics, derived from the word *rubicus*, meaning red in Latin. Thus, since then, the priest is given instructions in liturgical books for mass or for a sacrament in red ink. Similarly, accountants used to write debts in their ledgers in red ink, giving rise to the current financial phrase "in the red." Red tape was used to bind legal documents, and soon the term became synonymous with bureaucratic obstruction. In the Middle Ages, red replaced purple as the color of royalty and aristocracy —for whom the red carpet was rolled out. *See also* Red.

Blue

A cool color that seems to recede from the viewer, blue is correspondingly often considered the color of melancholy. Things look blue when they are bad, and in the American South, slaves sang the blues. On the other hand, the blue ribbon (or riband) has represented the highest honor in many fields since King Edward III of England picked up a blue garter dropped by a lady at court and created the highest order of knighthood, the Order of the Garter. Blue chip, describing a safe investment on the stock exchange, comes from the high-valued blue chips used in poker. Blue blood means high birth and has a Spanish origin: The veins of aristocrats with no Moorish blood looked bluer than those with mixed ancestry. *See also* Blue.

Yellow

The color of sunlight and gold, yellow has most often been associated with enlightenment. Medieval artistic convention portrayed Judas in yellow robes, and the color became associated with those who had "betrayed Jesus." To be yellow became a synonym for cowardice. "The Yellow Kid," a turn-of-the-century cartoon strip, led to the coining of the term *yellow press* to describe unscrupulously sensational newspapers. Yellow journalism publicized the yellow peril in World War II, a scare propagated during wartime against Orientals in general and the Japanese in particular. In trade unions, a yellow dog is a person who crosses picket lines. Today, yellow pages generically refer to information listings—from the Yellow Pages, the business volume of the telephone directory. *See also* Yellow.

Green

Green is the color of both verdure and spring and also of sickness and jealousy. Green is the color most restful to the eye, as its light rays fall most directly on the retina; thus, the green room is where actors relax before and after a performance (though these rooms are rarely actually green today). Green in science fiction represents alien beings—strange, reptilian beasts and weird monsters from outer space. Green indicates illness: green around the gills, or green-eyed with envy and jealousy. In the United States, green means currency in the form of paper dollar bills— greenbacks. *See also* Green.

Orange, Purple, Pink

Secondary colors appear much less frequently in language than do primaries. This is especially true of orange, a color not described until the importation of oranges into Europe in medieval times. For long after, the name was associated only with the fruit. The Protestants of Northern Ireland dedicated to maintaining the union with Great Britain are called the Orangemen, after the orange-colored flowers worn in parades since 1795.

There are also few common colloquial usages of purple beyond purple prose, referring to a particularly florid passage in a book. In American slang, purple passion or heart means a combination of a barbiturate and morphine, and to turn purple is to be very angry or livid. In British newspaper jargon, a purple airway or zone is a route reserved for an aircraft carrying members of the royal family.

Pink describes a person thought to have extremely liberal, socialist, or communist-leaning views, as in the American slang pinko. To be tickled pink is to describe a state of delight; to dream of pink elephants is a hallucinatory experience, generally induced by alcohol. To be in the pink, however, suggests good health and good fortune. *See also* Orange; Pink; Purple.

Black

Black is historically ominous, representing the dark unknown. Its associations are often negative: blacklist, blackmail, blackball, black market, black sheep. However, black does have profitable and sophisticated connotations. To be in the black is to show a profit; to wear black tie is to be in formal attire; and black gold refers to a precious commodity—oil.

Achromatic colors—black, white, and gray or silver—represent the edges of human experience. Black, the greatest darkness, and white, the greatest lightness, are the two extremes. *See also* Black.

The purpura mollusk, found in the Mediterranean, is the source of an ancient purple dye.

White

White suggests purity, and innocence as in white as snow or virginal white. White magic and white lies (as opposed to the black varieties) are considered benign.

Nonetheless, white does have its somewhat negative connotations: The white flag of truce or surrender comes from the white feather (which in the plumage of a gamecock supposedly is a mark of a poor fighter). The burden associated with owning a "white elephant" comes from an apocryphal story about a king of Siam, who used to make a gift of a white elephant to courtiers whom he wished to ruin by the cost of its upkeep. To whitewash is to cover up an embarrassing fact with a veneer of respectability. Other uses of white in language include the White House of U.S. presidents; the Great White Hope of boxing enthusiasts; and the Great White Way, the theater district of New York's Broadway, which is ablaze with light at night. *See also* White.

Gray

Gray usually suggests confusion or lack of positivism: It is neither black nor white. Yet the color gray can suggest intelligence, as in the gray matter of the human brain (neural tissues vary between brownish gray and white in color) or the *éminence grise,* someone who exercises power behind the scenes (the nickname of Père Joseph, confidant of Cardinal Richelieu, the red eminence—named after their respective garbs). Silver is a valuable gray: One is distinguished from the moment of birth with a silver spoon in one's mouth. The glamorous world of Hollywood movies flickers on the silver screen. A cloud with a silver lining suggests a possible brightening after the stormy present. *See also* Gray.

Color

The attribute of a visual sensation or, by extension, an object or light that can be described by such terms as red, green, white, black, and so on. In the narrowest sense, black, white, and gray are not colors, as they are produced by an even balance of all hues or absence of light altogether.

Color can be seen as the quality either of an object that reflects light—surface color— or of a medium that filters light—film color. The color seen on a surface depends on the texture of the surface, the composition of the light reflected from it, the surrounding visual field, and the state of the observer—his or her expectations, the state or degree to which the observer has adapted to a visual stimulus, and so on. Film color is seen in the same way, except that it is not affected by texture.

The qualities of surface color include flicker, glitter, gloss, and other variations in the texture of a surface, but basically, perceived color has three dimensions, or defining attributes: hue, saturation, and value or lightness. Hue is the dominant wavelength (red, blue, etc.); saturation is the relative colorfulness (colors can be pale or bright); and value describes the amount of gray in a color. *See also* Film Color; Hue; Saturation; Surface Color; Value.

Colorado

Name for cigars of medium size and color; from the Latin *coloratus,* meaning "colored."

essay

Colorants

An English painter and educator who has taught at over 100 art schools in Britain, North America, and Australia, Roy Osborne, the author of Lights and Pigments: Colour Principles for Artists, *traces the history of colorants in the following essay.*

Coloring agents used in paints, inks, and dyes, although in general parlance the term may also denote the paints and dyes themselves. Technically, a colorant selectively absorbs a percentage of the light falling on it, and reflects or transmits the remaining light to the eye of the viewer. The distribution of light absorbed usually depends on the chemical structure of the colorant.

Colorants can be divided into two categories—pigments and dyestuffs. A pigment generally consists of a solid material that has been ground to a fine powder, which remains insoluble when combined with a liquid adhesive, known as the medium, vehicle, or binder. A dyestuff dissolves in its medium and combines itself chemically with it. It is also possible to make an insoluble pigment used in dyeing, called a lake—a dye is used to stain a white pigment, which is then held in suspension in water. Lakes are generally brighter but not as colorfast as true dyes.

There are four basic groups of colorant sources: natural earths, natural minerals, organic dyestuffs, and artificial metal compounds. Earth pigments are obtained from native inorganic ores or clays from which, typically, a metal oxide or silicate can be extracted. Mineral pigments are obtained by crushing various inorganic crystals. Natural organic dyes are extracted principally from vegetable sources, though a few come from

animals and insects. The vast majority of organic colorants are now synthesized from coal tar.

Throughout recorded and unrecorded history, man has used his ingenuity to find colorants in nature. Paleolithic cave dwellers at Altamira and Lascaux in present-day Spain and France, respectively, about 15,000 B.C., used red and yellow ochers (hematite and limonite), black manganese dioxide (pyrolusite), and white china clay (kaolin). This selection of colorants—the so-called tetra-chrome palette—remained popular throughout classical civilizations.

History of Colorants

Mineral pigments are known to have been used in ancient Egypt (after 3000 B.C.) and include the arsenic compounds realgar (red) and orpiment ("gold pigment"—yellow); the copper compounds malachite (green) and azurite (blue); and the semi-precious stone lapis lazuli, or ultramarine. Vegetable dyes employed for textiles included henna (dark red), safflower (orange), annatto (orange/yellow), and saffron (yellow). Important ancient man-made pigments included red lead (minium), white lead (flake white, naturally occurring as cerussite), and vermilion (naturally occurring as cinnabar).

The painter's palette of mineral colorants expanded during the Middle Ages to include the brown earth pigments—bole, sienna, and umber; smalt (vitreous cobalt silicate); and verdigris ("green of Greece," a copper carbonate). Vegetable dyestuffs were also made available, among them those extracted from madder (Turkey red), brazilwood (red lake), weld (yellow), buckthorn (sap green), indigo (blue), and woad (a blue similar to indigo). The principal animal sources from which artists' colorants were obtained were the murex shellfish (Tyrian purple), the cuttlefish (sepia), and the insects kermes and cochineal (crimson and carmine).

Artificial colorants were introduced in the seventeenth and eighteenth centuries. The first important man-made pigment was Prussian blue, synthesized in 1704 by Diesbach. Other man-made colorants included the advances in cobalt blue by Louis-Jacques Thenard (1777–1857) in 1802, chrome yellow by Nicolas-Louis Vauguelin (1763–1829) in 1809, and an artificial, or French, ultramarine by J. B. Guimet in 1826. Most significant was the synthesis by William Perkin (1838–1907) in 1856 of the first coal-tar dyestuff—mauveine, or aniline purple—followed by the preparation of artificial alizarin by Karl Theodore Liebermann (1842–1914) in 1869, replacing madder, and of indigo by Adolf von Baeyer (1835–1917) in 1878.

Within one hundred years, more than 4 million coal-tar dyestuffs had been synthesized, making up most of the colorants commercially available today for the painter, printer, and dyer. Important coal-tar dyes introduced in the twentieth century are phthalocyanine blue and green; Hansa, or azo yellow; and quinacridone magenta, or rose—all widely employed as lakes for painters and printers. The most significant pigment to be added to the artist's palette in recent times was titanium dioxide (in 1920), a permanent and non-toxic white that is almost ten times as opaque as the ancient flake white.

—Roy Osborne

See also Dyes and Dyeing; Inks; Paint.

Color Association of the United States (CAUS)

See Appendix.

Color Atlas

See Systems of Color.

Coloratura

Trills, runs, and other florid decorations in vocal music. *See also* Music and Color.

Color Balance

See Balance of Color; Harmony.

Color Blindness

The term *color blind* is somewhat misleading; it covers many kinds of defective color vision. People who are color blind usually can see color but tend to confuse hues that are normally easy to distinguish. The largest group of those who are color blind tends to confuse red with green, but can distinguish blues easily. About 8 percent of all males and less than 1 percent of all females are born with defective color vision. Color blindness can also be acquired through illness or accident. Diseases of the liver and the eye may cause color vision anomalies, as do old age and incipient cataracts, a condition in which the eye lens tends to yellow and thus scatter out blue light. Reduced color discrimination may be a symptom of a brain tumor, multiple sclerosis, pernicious anemia, or diabetes. Industrial toxins or an excess of alcohol or nicotine may cause loss of color vision, which may be restored if intake of these substances is curtailed. There is no known cure for the inherited defect.

Defects are most often inherited by men and carried by women, though it is possible for women to inherit them. A father with defective color vision and a mother with nor-

Modern synthetic colorants number in the tens of thousands, but before William Henry Perkins's discovery of a synthetic mauve in the nineteenth century, organic and mineral color sources numbered only in the hundreds. Listed below are the leading historical colorants:

Buckthorn
Cochineal
Copper acetate
Dyers' rocket
Henna
Indigo
Iron rust
Iron salts
Kermes
Lapis lazuli
Lo kao (Chinese green)
Madder
Malachite
Manna ash
Oak gall
Orange peel
Orchid (violet)
Orpiment (yellow)
Purpura
Saffron
Sandalwood
Sappanwood
Tumeric (Indian yellow)
Verdigris
Woad

mal color vision will tend to have sons with normal vision and carrier daughters. If a carrier of the defect marries a normal-visioned man, half their sons will tend to have defective color vision.

Forms of Color Blindness

An early color vision test, developed by J. G. Huddart in 1777, involved naming colored ribbons, beads, wool, cloth, paper, and glass, but color blindness was not generally recognized until John Dalton (1766–1844; formulator of the theory of the atom) described his own defect in 1794 before Britain's Royal Society. Dalton was unable to distinguish between red and gray. He was a Quaker and is said to have attended a prayer meeting in outlandish red stockings, having mistaken them for his sober gray ones.

Until the 1830s, color naming was the only method available to identify color blindness, a primitive method since it did not distinguish accurately between types and severity of defects. The first test to do this was developed by the German A. Seebeck in 1837. His test required subjects to sort into order 300 colored papers—by comparing the results to those from people with normal color vision, Seebeck could assess those parts of the spectrum where the defective vision was poorest or best.

This test would have identified Dalton as suffering from a form of color blindness that later came to be known as dichromatism, in which only two colors are perceptible·and one color is difficult to recognize. The person with normal color vision—the trichromat—is thought to have three kinds of color-sensitive cones in the eye—red-, blue-, and green-sensitive. The varying stimulations of these three will permit all colors of the spectrum to be seen. Dalton's defect was named protanopia, as it was the first such affliction to be named (from *protos*, the Greek for "first"). He probably lacked red-sensitive cones and thus failed to recognize the color and confused both red and orange with yellow and green. Deuteranopes are those who cannot perceive green, and tritanopes those who cannot perceive blue. Deuteranopes, who tend to confuse green and yellow with orange and red, are the most common—1 percent of men confuse intense, saturated shades of these colors, and 5 percent confuse pale shades.

Color Vision Tests

Since up to one in ten people (especially men) suffer from some form of color blindness, it is necessary that people engaged in professions dependent on color distinctions be properly tested. This is especially true for those engaged in color production and color quality control, and is also important in various areas of communication or transportation where correct recognition of signs and signals is essential.

Color tests have been available since the 1940s. Three types of color vision testing devices exist that are portable and easily used in a laboratory or office (subject only to correct lighting conditions). Each test measures a different aspect of color vision.

Color-Blindness Test Plates. Color-blindness test plates comprised the pioneering color vision tests and are rather crude in their evaluation of the degree of color blindness. These tests quickly detect serious cases of red-green color deficiency, the most prevalent type of defective color vision. Fewer than thirty shades can be distinguished by some such sufferers, yet they often live in ignorance of their deficiency, guessing the correct color name by brightness, for example. The principal tests available are:

Ishihara test: Created in 1917 by Dr. Shinobu Ishihara, then a professor of Ophthalmology at the University of Tokyo, this test efficiently screens red and green defects, but not blue anomalies. It consists of a series of plates that work on the confusion principle—a number or a letter is constructed out of a series of round dots in the appropriate color, and placed on a background of neutral dots of the same value, causing the subject to confuse the figure and ground if he or she is color blind. The test is available in twenty-four- and thirty-six-plate editions.

Tokyo Medical College (TMC) test: Created by H. Umazume in 1957, this test consists of thirteen plates, five for screening red-green defectives and two for tritanopes. Similar to the Ishihara, this test uses small colored dots in a rectangular matrix to distinguish between protanopes and deuteranopes. An additional series of plates, all with orange dots on a yellow-green background, varying only in their saturation, differentiate between mild, medium, and severe defects.

Hardy, Rand, and Rittler (HRR) test: Developed by Legrand H. Hardy, Gertrude Rand, and M. Catherine Rittler for the American Optical Company in 1954, this test was an improvement on the Ishihara. It provided both red-green and blue-yellow tests, incorporating novel features such as cross, triangle, and circle symbols on a neutral background of dots of different size, intensity, and saturation. Now largely replaced by the *Standard Pseudo-*

Isochromatic Plates, developed in 1979 by Hiroshi Ichikawa, Kaitiro Hukami, Shoko Tanabe, and G. Kawakami in Japan, which use uniform-sized dots and figures resembling those on digital displays.

Other, similar tests include the Dvorine Color Vision test and the Bostrom-Kugelberg Plates.

In all of these tests, efforts should be made to ensure that the plates have not been seen before by the subject, who otherwise may memorize the figures; the plates should not be left in light because the colors may fade; and the tests' potential for error should be acknowledged, as it is possible for some people with normal vision to fail a test, and some with "color-weak" vision to pass.

Color Slide Rules. The color slide rule is an apparatus similar in design to a mathematical slide rule but used to match colors. On both the fixed and sliding parts of the rule are affixed either textile or paint chips. The color blind subject has to move the slide, trying to line up identical colors with each other. Color slide rule tests include:

Glenn Colorule: Introduced in the early 1940s by James Glenn, originally a dyer. Strongly metameric dyeings, approximately equal in lightness and having hue and saturation values (chromaticity) along two intersecting lines in the chromaticity plane of the CIE diagram, are mounted on each of two slides. For any observer and with any illuminant, a swatch (or portion of it) on one slide will have a match on the other slide. Uses include comparing color perceptions between two people and comparing the influence of lighting in two different places.

D&H Color Rule: Developed by Davidson and Hemmendinger; similar to the Glenn Colorule. Colorants for one scale are a mixture of orange and blue; those for the second scale are green and violet.

Color Discrimination Tests. These tests are used to identify people with superior abilities in matching or differentiating between colors—even those tested as not being color blind in any way may have trouble seeing fine distinctions between colors. Of the two commonly used tests, the first, the Color-Matching Aptitude Test (developed by the Inter-Society Color Council in 1940) is more useful in the selection of people with excellent color discrimination; the second, the Farnsworth-Munsell 100 Hue Test, is designed to classify people more generally as superior, average, or poor in ability to distinguish barely noticeable differences in shade; it also can be used to detect color blindness.

Color-Matching Aptitude Test: Test apparatus consists of a gray easel displaying forty-eight colored tiles. The subject is given one new tile at a time from a second set of forty-eight tiles and must find the match on the easel. The scoring system (from three, two, and one down to zero points) gives partial credit to close matches. A high score at the end of the test indicates superior color-matching abilities. However, it is possible that a color-blind person could be highly adept at color matching.

Farnsworth-Munsell 100 Hue Test: Published by American inventor Albert Henry Munsell (1906–1971), this test contains eight fixed samples and eighty-five loose ones. The subject is given twenty-one samples, graduated in hue but at a constant saturation and lightness, and told to line them up in order between the fixed samples. Incorrectly placed samples are penalized. The test will identify color blindness and provide a moderately accurate indication of the subject's ability to discriminate between hues. However, it does not test his or her ability to identify value or saturation differences.

Compensation for Color Blindness

Attempts have been made to develop artificial means of compensation for color deficiencies, particularly that of red/green confusion. In the case of one device, a lens that transmits only red light is placed over one eye; this seems to allow discrimination of some confused shades by taking advantage of their differences in lightness to the two eyes. The lens (known as the X-Chrom lens) can be placed over either eye, but is less annoying to the viewer when used over the non-dominant eye. Such devices are not permanent cures for color blindness.

Color Charts

See Systems of Color.

Color Circles

A circular diagram showing all the spectral (i.e., pure) colors in a sequential order of red, orange, yellow, green, blue, purple, and back to red. Complementary colors are placed opposite one another. *See also* Systems of Color.

Color Constancy

As with the optical illusions possible in relation to orientation and size, the mind is ca-

"Colors no longer looked as brilliant to me as they used to do; I no longer painted shades of light as correctly. Reds looked muddy to me, pinks insipid, and the intermediate or lower notes in the color scale escaped me."
—Claude Monet, in his old age

pable of fundamentally altering the color of an object we see in order to improve the quality of our vision. As the human eye is not a perfect optical instrument, the brain must use various tricks, or compensatory techniques, to improve what we see—historically probably a facility on which the survival of the human race has depended.

The range of the eye's adaptation is astonishing. Human vision, for example, is capable of accommodating extreme differences in brightness. We are able to find our way around a room by the very faint light of the moon at night and equally successfully during the day with light literally a billion times stronger. Of significance too is how a piece of paper that looks white by daylight will look equally white by moonlight, not gray, even though there is much less light at night.

One reason for this is that our retinas regulate the amount of rhodopsin being produced so that roughly equal stimuli will be sent back to the visual cortex in any prevailing lighting condition. Yet we seem to recognize a particular color by its contrast with an adjacent color. It has been shown that if the eye is allowed to see only a completely flat area of color, after a short time that color will not be perceived by the observer in his mind's eye, because there is no reference point to which it can be compared and registered. *See also* Afterimage; Simultaneous Contrast.

<div style="text-align:center">essay</div>

Color Constancy in Human and Machine Vision

An expert on artificial intelligence and robotics, Michael Brill enumerates some problems in developing machines that can see. Such machines must be able to adjust to a wide range of lighting strengths and colors and still be able to recognize objects. Consequently, research currently centers on developing a system of color constancy that will approximate that of human vision.

The visual sense has evolved under some, but not all, of the constraints facing designers of computer-vision systems. Both have to deal with vast ranges of lighting conditions —for instance, direct sunlight can be up to 10 billion times as strong as starlight or faint moonlight. The best photosensor (either natural or artificial) can handle a range of intensities on a scale of only 1 to 1,000 before being overloaded. The eye has developed ways to adapt, such as reducing the aperture of the pupil to let in less light, or changing the sensitivity of the retina; the same principles are used in photography, by changing the shutter aperture and film speed, respectively (although it is still difficult to photograph objects in deep shadows because of the extreme contrast with the light areas).

Fortunately, lighting varies gradually in space and time (as when a cloud passes in front of the sun or a shadow lingers), and most surfaces differ in reflectance by factors of less than one hundred. Therefore, a photosensor needs to be sensitive only to relatively small changes of intensity if it is able to gauge the local average (the average strength of the light in the field of vision) as the human eye does. How the eye actually does this, adapting to extremely bright light in just seconds, is something of a mystery. One goal in creating computer-vision systems is to develop a comparable light adaptation. A related goal is to distinguish shadow boundaries between reflecting objects, so that the systems are not fooled by such things as highlights.

To begin, a mathematical model of visual perception has to be developed. It must predict, with some accuracy, what color one sees not only under different light intensities, but also under different colors of lights. In general, the model makers initially have had to ignore such effects of human perception as simultaneous contrast and afterimages. Generic, purpose-directed models are attractive, particularly because the same-colored objects are important to a variety of animals with different visual systems. For example, birds and humans are confused by the same protectively colored insects, and fish and octopi must deal with the same milieu with vastly different visual systems.

One clear purpose of a visual system is to identify important reflecting objects and their color independent of the lighting environment, particularly the color of the light. This phenomenon in human vision is called color constancy.

Our color constancy is fallible, as anyone will testify who has emerged into daylight from a department store with a mismatching outfit that seemed to match perfectly under store light. Even so, the colors we see remain surprisingly stable, considering how much the color of the ambient light can change over the course of a day or under different weather conditions. This stability is undoubtedly vital to evolutionary survival in the animal world, to identify correctly either predator or prey. It can also be vital to the physician who "compares from memory the face color and lip color of someone who stands under one form of daylight with the colors seen an hour ago, a day ago, and

under another form of daylight, and thus detects changes due to blushing or paling or signifying disease such as jaundice (which turns the skin yellow) or anoxia (which turns it blue)" (Brou, Sciascia, Linden, and Lettvin 1986).

R. W. G. Hunt gave an elegant demonstration of the phenomenon. When a color slide of a room interior containing a yellow cushion was covered completely by a blue filter, the cushion looked yellow. When a blue patch was stuck over the cushion alone on the original slide, it appeared vivid green. Somehow, in the first instance, we see the cushion as being yellow because of comparisons with adjacent colors.

Explanations for this phenomenon date back to the nineteenth century, when Hermann von Helmholtz suggested, without offering an explanation, that the eye "discounts the illuminant" when looking at the colors of objects. For some applications, computer-vision systems need to simulate the object-color judgments of human beings. For instance, a robot sorting rock samples on a distant planet would need to be able to do so without sending video signal requests for instruction to an earthbound human observer and waiting for a command to return. One way for the machine to accomplish the task on its own would be to use a narrow-band spectrophotometer and compare the reflected light at several wavelengths with that from a reference white object (whose reflectance is known ahead of time). This is very slow; a faster way would be to use broad-band camera sensitivities (perhaps three, to imitate the trichromacy of human vision). However, simple ratio comparisons of the readings (tristimulus values) would then depend on the color of the light, which would not be a close enough approximation of human color judgment.

It should be noted that the robot *might* be able to sort out the material properties of the rocks *better* than a human; in that case, it would serve a useful purpose even if the human were standing next to it. The illuminant–invariant ability to sort objects according to their light-reflecting properties is a goal of machine color constancy that is independent of simulating human vision.

Another approach to color-constancy modeling stems from early models of chromatic adaptation whereby a white object in the visual field was a standard to which all other object colors were compared (see Brill and West 1986). In the first adaptation model, that of Johann von Kries, the comparison involved dividing out the tristimulus values of the white reflectance. This is actually the broad-band three-component version of the spectrophotometric method described in the previous paragraph. A later model, devised by Dean B. Judd, involved subtracting a white chromaticity from the chromaticity of each colored object.

Three problems remain unresolved. First, it was unclear for which object colors and for what exchanges of illuminants the adaptation models would provide color constancy. Second, there was no explanation for how the visual system attains constancy without a reference object. Third, there was no provision for recognizing the colors of three-dimensional objects, which have highlights and shadows.

The first problem, regarding the spectral constraints for exact color constancy, was addressed by several investigators including the author of this article. Edwin Land's retinex theory dealt with the second problem by proposing a von Kries type of adaptation of a test object color with respect to a "reference" color inferred from the surrounding object colors (*see* Land, Edwin Herbert) A compromise solution to these two problems has been proposed by Brian Wandell and Laurence Maloney. Another approach is to use the "reference-color" theories to recognize multi-colored objects by their illuminant invariants instead of trying to recognize single reflectances.

The third problem concerns, in part, the sorting of object boundaries from illumination boundaries in an image. One popular method of eliminating illuminant shading on an object is to evaluate the ratios of two spectral bands at all positions in the image. This band–ratio method discounts shading on an object under a single light, but is not designed to deal with multiple lights (for example, with sun and blue sky) or with object highlights. However, a simple and elegant theory (Nikolaev, 1988; see review by Brill, 1989 and related work by Shafer, 1985) enables highlighted and shaded objects to be recognized as being uniformly colored, even when they are seen under multiple light sources. Nikolaev's theory is based on the idea that the image of a scene under several light sources is the sum of the images when the light sources are turned on separately. If there are only two light sources and the robot-vision system has three kinds of photosensors, the reflected lights from all parts of a matte object lie on a plane in the robot's color space. This plane characterizes the object, independently of what part of the object is being sampled. When the perpendicular to this plane is computed at various positions on the image, its direction changes only at object boundaries and not at illumination boundaries.

Computer-vision systems aim to mimic the eye's ability to recognize a color in different lighting conditions, and to discount highlights and shadows.

In spite of the time and effort being spent on machine vision and machine color vision, the field is still in its infancy. Currently, industrial robots operate quite efficiently under stringently controlled lighting and viewing conditions. Ideally, we would like robots to operate efficiently in completely uncontrolled environments. In the next twenty years or so, it is likely that there will be robots that can operate in less stringently controlled environments, such as offices and factories, to perform automatic quality control and other sorting tasks. Robotic sorting of varied objects under completely unpredictable lighting, even by that time, may still be a vision for the future.
—Michael H. Brill

Color Control

The technical regulation of dyes, pigments, and finishes so that desired color matches are achieved when colored stuffs are applied to varying materials. A simple example of a color control problem is the handling of a varnish on a silkscreened paper chip so that both shiny and matte surfaces read as the sample color. *See also* Application of Color; Matching Color.

Color Couplers

Term used to describe organic compounds that form dyes during the developing of photographs and in diazo processes. Image-forming couplers in photographic emulsions are colorless until a silver halide image is developed; the compounds then couple with by-products of the chemical reduction to form cyan, magenta, and yellow dyes in proportion to the silver density developed in each emulsion layer.

Other color couplers are used in color negative film to produce color masking dyes, which correct printing deficiencies of cyan and magenta dye images. It is these masking dyes that give a color negative an overall pinkish tan or orange-brown appearance.

Color Cycles

A twentieth-century term used to describe periodic shifts and, occasionally, repetitions of color preferences. In clothing, discernible changes in color taste may occur every twenty-four months; in interior decoration, color cycles may be considerably longer. Prior to this century, color cycles were much longer than they are today. The typical seven-to-twelve-year color cycle for interiors is largely an accommodation to economic reality. Interior furnishings are far more expensive than clothing and, if well chosen,

should wear out before they become outdated in style or color (*see* Sources of Historic Color; Rococo Colors; Victorian Architectural Colors).

Color cycles are of particular relevance to manufacturers of consumer products: If colors do not keep up with shifting public tastes, the product will not sell. Faber Birren noted, "The beautiful colors [in the manufacturer's eyes] are the ones that sell; the ugly colors are the ones that don't" (CAUS Newsletter, Oct. 1986). Thus, in the late 1960s, avocado greens and harvest golds were all the rage in pile carpeting; by the late 1970s, these colors were viewed with such disdain that many real estate agents had difficulty selling residences that were decorated in these shades.

Color cycles generally tend to follow repetitive patterns in the sense that pairs of colors tend to return to popularity. Thus, in apparel, browns and greens were popular in the 1930s; in the 1940s, patriotic blues and reds were dominant; then browns and greens returned in the 1950s.

In applying fashion's color cycles to industrial products, color consultants usually allow for a two- to five-year time lag; a necessary, albeit slight, shade modification; and the influence of perennial best-selling colors. For instance, the kitchen appliance vogue for coppertone and almond of the late 1960s reflected the 1950s yellowed palette, yet white still commanded volume sales, as it had in past cycles and will continue to in future ones. *See also* Forecasting Color.

Colored Hearing

See Keller, Helen; Synaesthesia.

Colored Shadows

The outraged reactions to the impressionists in the nineteenth century was partly due to their uninhibited use of color, which even included painting shadows in purples and blues. Gone was the chiaroscuro technique of toning down background colors with black to create the illusion of shadow. With a fresh eye for color, the impressionists imbued shadows with the complementary color of the prevailing light: Sunlight has a yellow-orange tinge, so shadow areas were painted in complementary blue-purple shades.

The scientific explanation for colored shadows lies in the perceptive experience of simultaneous contrast. The eye becomes attuned to the color of sunlight, thus adjacent areas, on which the light does not directly fall, will take on a contrasting tinge. That the impressionists exaggerated this effect owes a great deal to M. E. Chevreul,

who, writing on harmony, noted that strong contrasts and complementary colors produced the most pleasing effects. *See also* Chevreul, M. E.; Simultaneous Contrast.

![essay]

Colorfastness and Dyeing

Lynn Felsher, curator of textiles at New York's Fashion Institute of Technology, discusses the critical role of colorfastness in the development of dyestuffs for textiles. This discussion is based on the findings of several historians, whose works are listed in the bibliography.

The demand for dyes that will not fade or disappear when exposed to light and water has led to man's quest to develop stable colorfast dyes. The problems of achieving a colorfast dye are complex. Dye chemistry as it pertains to the use of dye substances, dye bath formulas, mordants, and the variations in procedure for the dyeing of cotton, linen, wool, and silk, along with problems of exposure to elements of the environment (light, heat, and humidity), all affect a dye's stability.

The first textile dyes were derived from plants, insects, and shellfish, and are referred to as natural dyes. The aniline dyes, from derivatives of coal tar, were the first synthesized dye compositions.

Indian craftsmen were among the first to perfect the art of adhering natural dyes to the surface of cotton textiles. These fabrics were first brought to Europe in the seventeenth century in the ships of the European trading companies representing Portugal, Holland, England, and France. They used various agents called mordants, which, when applied to textiles, bonded the dye to the cloth in a relatively permanent state. The Indian dyer had a repertoire of mordants which, when combined with a single dye, could produce a range of different colors. Through the manipulation of mordants and different dyes, they were able to create a sophisticated palette of reds, blues, purples, greens, yellows, oranges, browns, and black. During the seventeenth and eighteenth centuries, the Europeans developed methods of printing with mordants, spurred on by the popularity of the Indian dyed and printed cottons. As an example of the high value placed on colorfastness, to distinguish these fabrics as having permanently colored designs the French would print the words *bon teint* or *grand teint* along one side of the cloth.

Chief among the plants that were cultivated for their dyes in India and Asia were *Indigofera tinctoria*, for many shades of blue, and the root of *Rubia tinctorum*, for madder, which produces various shades of red, purple, pink, black, and brown. European dyers knew of other plants and employed woad for their blues, weld for yellow, and dyer's broom for another yellow. The latter, combined with woad, yielded a green.

Still another yellow dye, mentioned in Rita Adrosko's *Natural Dyes in the United States*, was obtained from the bark of the American oak, also known as black or yellow oak, brought to England by Edward Bancroft, who named this dye quercitron. In 1785, the British parliament granted Bancroft exclusive rights to the use of quercitron for the dyeing and printing of cloth.

In Europe, a mordant of iron was used to achieve dark browns and black. One can find early textiles printed in this manner with areas of the design missing. The iron, having reacted with the cotton or linen ground, caused the fabric to deteriorate to the point of nonexistence.

In 1856, William Perkin's accidental discovery in England of the first aniline dye, a coal tar derivative, would alter the dyeing of textiles (*see* Aniline). The aniline dyes of the nineteenth century produced bright, garish colors different in intensity from the range of natural dyes. Easier to use, needing far less preparation to achieve the required results, aniline dyes quickly replaced the natural dyes. Early chemical dyes tended to be fugitive, changing color and bleeding when washed. Still, they were immediately popular.

Arts and Crafts Dyes

There were, however, designers who were not pleased with these new colors. Linda Parry, in *William Morris Textiles*, discusses the designer William Morris's sympathetic attitude toward the use of natural dyes in his own work. Experimenting extensively with natural dyes and collaborating with the textile printer and dyer Thomas Wardle, Morris was able to dye yarns for embroideries and tapestries, solid cotton velvet for hanging, and block-print textiles. The dyes he used were those employed by earlier European dyers and included indigo and woad for blue; madder, cochineal, and kermes (from the dried bodies of insects) for red; weld, quercitron, and fustic for yellows; and the roots from the walnut tree for brown.

In 1881, Morris opened his own dyehouse and factory for printing textiles in England, called Merton Abbey. By 1882, he was successfully using the discharge method for printing with madder and indigo, at a time when most people preferred machine-printed, aniline-dyed fabrics.

"To any white body receiving the light from the sun, or the air, the shadows will be of a bluish cast."
—Leonardo da Vinci, on the colors to be found in shadows

Rubia tinctorum *was cultivated for use in the production of madder.*

During the 1870s, when Morris was hand-printing with natural dyes, a chemical means of altering a textile's surface was being developed. This process, called weighting, involved the treatment of the surface of the fabric with a metallic salt bath. The application of the salt bath added weight and produced a rustling sound, which was fashionable for silks at that time. However, when exposed to light or low humidity, these silks would split or shatter, the metallic salts having weakened the fiber to the point of disintegration. According to *The History of the Silk Industry in the United States,* published by the Silk Dyers' Association in 1927, several weighting agents were used in America. Heavily weighted black silks were dipped in tetrachloride of tin; for colored silks, a tartar emetic and tannin were used. A third method, employed in France, used logwood crystals.

In examining once brightly colored historic textiles, it is apparent that factors other than dye technology have contributed to their colors' changing and fading. Precisely applied colors have bled or migrated to other areas of the design.

A comparison of a textile's right side with a portion which has not been exposed to light, is usually quite revealing. In the case of an eighteenth-century brocaded silk, if one were to carefully separate the silk wefts that float over on the back of the textile and compare the colors with those threads on the surface, the fading of the colors would be apparent.

Differences in color intensity result because some older dyes were more fugitive than others. Oranges and salmons were prone to fade to brownish tones. Another particularly unstable eighteenth-century color was green, achieved by overprinting yellow on blue. The yellow, being fugitive, often faded, leaving the original green segments of the design blue.

The primary cause for the fading of both historic and contemporary textiles is their exposure to ultraviolet radiation, present in daylight and fluorescent lighting. More than any other type of object, textiles are susceptible to damage and deterioration from UV rays. Besides light, heat will also weaken and dry the fibers, causing breakage or splitting. A too-high humidity can cause improperly applied dyes to bleed.

Once a historic textile's colors have faded, the process is irreversible. Deterioration can be retarded, however, by controlling the light source and the amount of time that the textile is exposed to the light. Another solution is to replace incandescent lights with candescent ones, lower the light level to minimize the heat factor, and direct the light away from the textile.

Exhibitions of textiles should be of limited duration so as to minimize fading. Exhibition lighting should be at a low level, directed away from the objects and turned off when materials are not on view. Another important consideration is the storage of textiles. Ideally, this should be away from light, with the textiles placed in a drawer or a cabinet, stored on the shelf, or rolled onto acid-free tubes. Placing textiles in a dark environment with a relative humidity between 50 and 60 percent will help to conserve them and retard further deterioration.

—Lynn Felsher
See also Dyes and Dyeing.

Color Field Painting

Term coined to refer to a broad category of American East Coast minimal art of the 1960s, typically characterized by flatly painted color that dominated form and texture. The large-scale canvases that exemplified this work exhibited uncompromising abstraction, high-chroma color, and simple, regular, geometrical division of the overall painted area. Figure-and-ground division was usually rejected in favor of an allover unification of the painted area, and the painterly expressionism of the 1950s was rejected in favor of an anonymous and nongestural application of paint.

In New York, the principal exponents of Color Field painting were Mark Rothko, Barnett Newman (1905–70), Paul Feeley (1913–66), Ad Reinhardt (1913–67), Jules Olitski (1922–), Ellsworth Kelly, Al Held (1928–), Frank Stella (1936–), Larry Poons (1937–), and Brice Marden (1938–), while a group identified as the Washington Group included Morris Louis (1912–62), Gene Davis (1920–85), Kenneth Noland (1924–), and Thomas Downing (1928–). The critic Clement Greenberg gave the name Post-Painterly Abstraction to the movement, specifically referring to an exhibition of that name organized for the Los Angeles County Museum of Art in 1964. Lawrence Alloway preferred the label Systemic Painting to identify the same trend for an exhibition presented at the Guggenheim Museum in New York in 1966. *See also* Kelly, Ellsworth; Rothko, Mark.

Colorimeter

A color-measuring instrument that compares two colors. Using this instrument, a given color can be analyzed by matching it to another color produced with known propor-

tions of the primary colors. There are two general types of colorimeter: those using the eye as the detector in the comparison, and those using photoelectric detectors. The latter are known as tristimulus (filter) colorimeters (*see* Measurement of Color).

Colorimeters that use human vision as a mode of detection usually display the two colors to be compared on both halves of a circular or rectangular field of view, which may be seen through an eyepiece or directly with the unaided eye. Half of the field contains a comparison color, which may be generated additively or subtractively. In additive colorimeters, this comparison field is produced by the additive mixing of three light beams, usually the red, green, and blue additive primary colors, which allow the widest possible range of color mixtures to be produced. In subtractive colorimeters, the light forming the comparison field is produced by passing white light through three wedge-shaped filters successively, the filter colors being the subtractive primaries yellow, cyan, and magenta. With both additive and subtractive colorimeters, the amount of each of the primary colors can be determined quantitatively by the intensities of the beams or the positions of the wedge filters. The color to be analyzed is placed in the second half of the field, and the observer decides whether there is an exact match with the comparison field. If the match is good, the proportions of the primaries needed for reproduction can be read off the latter. Of course, the results are dependent on the color vision of the observer, especially since the two halves of the field will usually be strongly metameric colors (*see* Metameric Colors).

Color comparison and matching done with the eye is frequently more suitable for the fashion and design industries than are photoelectric colorimeters. The latter are usually insensitive to such characteristics as gloss and texture and are unable to capture ambience and mood or to transfer colors satisfactorily from one medium to another, for example, from paper to textiles.

Color IQ Test

A test measuring awareness of color and sensitivity in combining colors. All color IQ tests have the virtue of approximating one's sensitivity to color, but have the weakness of many IQ tests, that is, of being subjective and uneven in application. *See also* Color Blindness; Harmony; Vision.

Coloritto

A work published in both French and English by J. C. Le Blon in London ca. 1723–26,

which set forth, for the first time, the red-yellow-blue theory of color printing. In this small volume, Le Blon (1667–1741) explains the art of mixing color. He designates the three primaries red, blue, and yellow "primitives," and theorizes how one can obtain the colorations of all visible objects with them. The original edition was illustrated by a series of mezzotint portraits of a young girl. Le Blon described the differences between additive color mixtures (white was a concentrating or excess of light, as demonstrated in Isaac Newton's *Optics*) and subtractive mixtures (black being a hiding of lights). Both kinds of color mixtures, the one by impalpable colors and the other by material colors, he related back to the three primary "primitives." *Coloritto* exists in a modern facsimile edition with an introduction by Faber Birren.

Color Marketing Group (CMG)
See Appendix.

Color Measurement
See Measurement of Color.

Color Me Beautiful
See Personal Color Analysis.

Color Memory
See Systems of Color.

Color Mixing
See Additive Color Mixing; Subtractive Color Mixing.

> essay

Color Organs

An analysis of the function and influence of a peculiarly nineteenth-century invention by America's foremost color theorist, Faber Birren.

Music has an emotional quality that is akin to the appeal of color. For this reason, there have been many efforts to correlate musical notes with the colors of the spectrum—even to the point of making organs that flash colored lights along with the music being played.

In ancient times, astronomers wrote of the music of the spheres. The seven planets they had identified were said to emit sounds as they revolved in their orbits. Plato and Aristotle dealt with this concept, as did Cicero, Pliny, and others. Isaac Newton, in his day, probably in deference to the seven notes of the diatonic music scale and to the seven spheres identified by the early astronomers,

The points of the body where various wavelengths and corresponding colors are thought to be absorbed.

Violet

Blue

Green

Yellow

Orange

Red

chose seven colors for a musical scale: note C was red, D was orange, E was yellow, F was green, G was blue, A was indigo, and B was violet. Thus, poets, if not scientists, have ever since referred to the seven colors of the rainbow.

After Newton, the art of combining music and color gained widespread recognition. In 1844, D. D. Jameson of England constructed an instrument featuring a series of keys that threw light upon glass globes of tinted liquids. In 1845, George Field, also English, developed theories of color harmony based on music. He wrote in *Chromatics* (1845) that "tints, hues and shades of colors, impart mellowness, or melody, to colours and colouring. Upon these gradations and successions depend the sweetest effects of colours in nature and painting, so analogous to the melody of musical sounds, that we have not hesitated to call them the melody of colours."

Again in England, A. Wallace Rimington, using an elaborate contrivance of lights and filters, constructed a color organ in 1893 that became the rage of London. In the United States, Bainbridge Bishop in 1877 built an instrument on top of an organ, which blended colors on a screen. P. T. Barnum, the circus entrepreneur, had a color organ.

Most of these color-music artists allied musical notes to specific hues, but philosophers, scientists, and theorists held varying opinions about the relationships between music and color. Aristotle wrote, "Colors may naturally relate like musical concords for the most pleasant arrangements; like these concords, mutually proportionate" (Ross 1913). Johann Wolfgang von Goethe saw only a vague emotional and aesthetic parallel. The English scientist Thomas Young concluded that any attempt to produce a musical effect from colors must be unsuccessful. M. E. Chevreul of France agreed. Ogden Rood of the United States and Friedrich Wilhelm Ostwald of Germany were also skeptical. Hermann von Helmholtz, the renowned physicist, concluded, "I think, for my part, that the comparison might be abandoned." —Faber Birren

See also Castel, Louis-Bertrand; Michelson, Albert A.; Music and Color; Wilfred, Thomas.

Color Planning Center

See Appendix.

Color Separations

See Separations, Color.

Color Solid

An imaginary systematic arrangement of colors in three dimensions. In a color solid, white and black are invariably placed at the top and the bottom, respectively, of a vertical axis; each color is placed at a height corresponding to its lightness (value), at a distance from its vertical axis corresponding to its saturation, and in a direction from the axis (north, southeast, and so on) depending on its hue. *See also* Systems of Color.

Color Specifiers

See Specification of Color; Systems of Color.

Color Symbolism

See Compass, Points of the.

Color Systems

See Systems of Color.

Color Temperature

Color temperature is a measurement taken in Kelvin degrees of colored light. It is based on the principle that matter—when heated sufficiently—will emit light, and that as the temperature changes so will the color of the light. For example, iron can be heated until it incandesces a pale red; heated further, it will turn white and then blue.

Source	Degrees Kelvin
Match flame	1,700
Candle flame	1,850–2,000
Sunrise or sunset	2,000
40–60-watt household bulb	2,800
100–200-watt bulb	2,900
500-watt bulb	3,000
Studio tungsten lights	3,200
Photo- or reflector floods	3,200–3,400
Fluorescent light (warm white)	3,500
Sunlight one hour after sunrise or one hour before sunset	3,500
Early morning or late afternoon	4,300
Fluorescent light (daylight)	4,300
Blue (daylight) photofloods	4,800
White-flame carbon arc	5,000
Average midday summer sunlight with some blue sky	5,400
Xenon arc projector	5,400
Average daylight	5,500–6,500
Overcast daylight	6,000–7,500
Summer shade	8,000
Summer skylight with no sun	9,500–25,000

Color temperature is based on a theoretically perfect blackbody, which absorbs all the light that hits it. As it is heated, its color, in theory, changes in a regular fashion. At 2,000 K, it will glow red; at 5,000 K it will glow white; and at 10,000 K it will be blue. Light bulbs can be rated against this scale. The color temperature of a 100-watt incandescent bulb is 2,860 K—virtually the temperature of the glowing tungsten filament. A fluorescent light bulb, however, converts ultraviolet energy into blue light without producing heat and so has a characteristically high color temperature of 10,000 K. Sunlight, with an even distribution of wavelengths (white light), can be measured at around 5,500 K. *See also* Kelvin.

Color Tests

See Color Blindness: Color Vision Tests.

essay

Color Therapy: The Body Prism

Color therapy is the practice of using colored light and color in the environment to cure specific illnesses and in general to bring about beneficial health effects. Antonio F. Torrice, a designer who specializes in children's environments, writes of a growing belief in color's healing power, a subject explored in his first book, In My Room, *co-authored by Ro Logrippo. The author is the winner of the 1985 American Society of Interior Designers Human Environment Award and the 1987 Halo Contract Lighting Award for the Children's Hospital of San Francisco Solarium. His unusual concept of the "body prism" may be supported by recent scientific findings. At a 1988 international scientific meeting in New York City on the function of the keratinocytes (cells of the epidermis), it was found that human skin is highly sensitive to colored light and, in fact, does aid in the conversion of spectral colors to chemical reactions within the human body.*

As any sunbather soaking up rays knows, the body takes on color through its skin when light hits it. If one absorbs too much sunlight at a time, sunburn results on the exposed body parts. In everyday situations, whether one is sunbathing or not, the skin acts like a prism, breaking up white light into its constituent colors, and allowing their absorption in different parts of the body.

My research in clinical, hospital, and residential settings has led me to deduce the following:

Red is absorbed in the base of the spine, consequently affecting motor-skill activities.
Orange is related to the circulatory and nervous systems.
Yellow corresponds to the chest, heart, and lungs, affecting respiration and cardiopulmonary activities.
Green relates to the throat and vocal cords.
Blue has an effect on the eyes, ears, and nose, and thus on sight, sound, and smell.
Violet is absorbed through the top of the head, corresponding to brain activities.

Like a prism, the body bends the natural and man-made light that hits it, channeling it through a system of reactions en route to the brain. Along the way, the body is affected—from the spine to the pituitary gland. During this light bombardment, those organs molecularly sympathetic to the corresponding wavelength vibrating toward them will readily absorb it.

The exception to this general principle is the damaged body. If, for instance, a person is deaf, the wavelengths of light commonly absorbed by the body's audio apparatus may find great difficulty in negotiating their normal pathway.

The damaged body compensates for this lack of light to a specific area by reaching out for the deficient color. As I discovered—first by playing a color game of choice with young clients, and later by studying children in colorful pediatric playroom settings I had designed—people with a physical deficiency share a color deficiency. Observations made in hospitals renovated with color revealed that children with specific ailments sought out the playroom color area correlating with their ailment. Those with mending muscles, for instance, opted for a space done in red. Similarly, those with throat problems gravitated toward the green area. The restorative effect of colors was emphasized by the shortening in patient hospital stays following a facility's renovation with color.

Although choosing a specific color may indicate a physical need for that color, it also may indicate that a certain body area is undergoing development. A child may have a propensity for green, the color associated with the throat. Rather than experiencing speech problems, that child may be learning a second language and therefore concentrating on vocal skills.

Each body prism—that is, every human anatomy—responds to color in a different way. A ten-year-old boy in Los Angeles inclined toward blue, for example, may choose a different color there than he would if he were in New York City. What matters is selecting that part of the spectrum that fulfills personal needs at a particular time and place. To allow children, especially, to meet these needs, a young person should be permitted

to determine the exact intensity of the color preferred. This can be done simply by allowing a child to indicate a desired value and shade from sample paint chips in a particular color family. Like a radio station turned up or down, the child will perceive how "loud" or "soft" he or she wishes the color to be. In other words, the child will choose how bright or muted the palette of his or her personal world should be.

Incorporating a child's favorite color into his or her environment may be as easy as covering a bulletin board in a favored color. A simple can of paint or a piece of fabric properly applied can profoundly change a young person's outlook.

Just as we outgrow or change clothes and tastes, so too is it possible to outgrow color at any age. The child who prefers the color blue at age five may or may not opt for blue at fifteen. Both inclination and dislike are quite natural and should never be forced. What matters is that whatever one's color preference, it should be incorporated to some extent into personal surroundings.

As easy as this concept of color choice may seem, it is imperative to understand that these theories cannot necessarily be reversed to achieve a desired result. Filling an environment with green, for example, may not encourage language skills. Flooding a room with blue may not improve sight or hearing. Color cannot be prescribed as if it came as a bottle of blue or a gram of green. Each individual body prism receives and responds to color as light in its own unique way. This fact is all the more reason for adults to ask children what colors they prefer. Each individual child—when given the opportunity—will select the best situation for him or her to live in, by choosing colors that he or she really needs.
—Antonio F. Torrice
See also Medicine and Color; Response to Color.

Color Trends

See Trends in Color.

Color Triangle

See Systems of Color.

Color Vision

Color vision, also known as daylight or photopic vision, results from stimulation of the cones in the retina of the eye. In contrast, the stimulation of the second type of light receptor—the rods—permits night vision or vision in dim light. There are three types of cones, which respond to different wavelengths of the visible spectrum. The cones are bunched near the center of the retina, and only cones appear in the fovea, at the very center of the visual field. At light levels high enough for the cones to be active, the rods are inhibited and play no part in vision.

By contrast, there is only one type of rod receptor; consequently there can be no color vision when the rods are stimulated. This kind of stimulation occurs at light levels so low that the cones are not affected (*see* Dark Adaptation), and produces night vision, or scotopic vision. *See also* Vision.

Color Wheel

See Systems of Color.

Combining Colors

See Harmony; Sources of Historic Colors.

COMMUNICATION and COLOR

Communication by color and color coding is an integral part of the natural world. Color distinguishes members of bird, flower, and animal families: a blue jay, a red rose, a white polar bear—each is immediately identifiable through color, and is thereby recognized by members of the same species, by those of the opposite gender, and by other species in the same ecosystem. Somewhere in the evolutionary process, animals also developed color vision to make these distinctions more quickly and efficiently, and it is perhaps no coincidence that the group of animals with the best color vision—namely, birds—has evolved some of the most striking color arrangements (*see* Zoology and Color).

Humans have also developed color-coding systems. The case for color coding is sound. The essence of effective communication is simplicity: the simpler the code, the easier it is to comprehend the message. Color connects with the viewer more directly than either words or numbers. With traffic lights, for example, the code works because it is quickly grasped, accepted, and generally followed by all drivers and pedestrians. The classified telephone directory exemplifies an arbitrary but successful color code. Readers quickly identify the "Yellow Pages" for commercial listings, "White Pages" for residential listings, and "Blue Pages" for city, state, and federal listings. Similarly, filing systems are often based on arbitrary color codes: one writer, for example, uses yellow folders for copy to be written, pink for lectures to be prepared, white for correspondence, and or-

International colors for road, traffic, and industrial signage follow archetypal color symbolism—green for health and growth, or red for action and danger—with only one arbitrary color code: purple for radiation. All codes use only six basic colors (in addition to black and white): the primaries (red, yellow, blue) and secondaries (orange, green, purple) communicate clearly and directly.

(Below) The colors of road signs indicate what is ahead: Do Not Enter (red —danger); Hospital (blue—quiet); Work area (orange—energy); and Hill Ahead (yellow—caution).

ange for pending material. Such a simplified code can be expanded beyond the desk drawer to shelves and office files.

There are a few basic guidelines for successful color coding. Once a code is established, strict adherence is essential. Clarity is also important. Primary and secondary colors—red, yellow, blue, green, orange, violet —are more effective as codes than either pastels or mixed (complex) colors. Shades such as coral or orchid can be easily misread and create confusion.

Symbolism and Coding

Using a culture's common symbolism also enhances a coding system—color symbolism is always contextual. Max Lüscher, professor of psychology at the University of Basel, Switzerland, compiled the following associations and responses to color throughout western Europe and the United States (1947):

Blue: Trust, but with negative connotations in food.
Brown: Vitality, receptivity, and sensuality; the color of "mother earth."
Dark blue: Peace, security, and contentment.
Green: Regeneration and growth; a color associated with hope.
Orange: Competition; a color of excitability and activity.
Red: Impulse and intensity, blood and sexuality; a youthful and forceful color.
Violet: Magic, imagination, and romance.
Yellow: Philosophical detachment; anticipation (*see* Lüscher, Max).

Safety Coding

In 1948, the U.S. Navy established a mandatory color code based on the Du Pont Corporation's industrial safety code. *Yellow on black stripes* was specified to distinguish strike-against, stumbling, or falling hazards. *Red*, a recognized standard for fire protection, became the color sign for fire-fighting devices. *Orange* designated dangerous machine parts that might cut, crush, burn, or shock. *Green*, the traditional color symbol of the European pharmacist, marked safety items such as first-aid cabinets. *Blue* specified equipment under repair, a designation that was also used for equipment not to be operated without special permission, from blue signs placed on railroad cars that were not to be moved. By the 1970s, a *purple* (or black) *on yellow* propeller symbol was commonly used to warn of radiation hazards.

Very similar to the U.S. Navy code, the Occupational Safety and Health Act (OSHA) code became a U.S. law on 28 April 1971. OSHA red identifies fire-protection equipment, danger, and stopping. Orange designates dangerous parts of machines or energized equipment which may cause injury. Yellow cautions against physical hazards, such as projections. Green is used for designating safety and the locations of first-aid equipment. Blue cautions against the starting, use, or movement of equipment under repair. Purple is for hazardous nuclear energy. Most people know and react correctly to these color designations, with the exception of blue, whose meaning is probably known only to factory workers.

Naval pennants use five fundamental, high-visibility colors—red, yellow, blue, black, and white (green is indistinguishable from blue at a distance, and orange is too similar to red)—in various configurations to communicate from ship to ship in the absence of radio. Each flag represents a letter of the alphabet, a number, or a complete word or message. Colors are chosen more often for strong contrast than for symbolism, though the all-yellow quarantine flag clearly indicates illness.

Through the Coca Cola Company logo and others, red with white (or with yellow, as in McDonald's) has become a symbol of American commerce around the world. Coca-Cola and the Dynamic Ribbon device are trademarks of the Coca-Cola Company and are used by permission.

Communication: Commercial Color Symbolism

Many color symbols in our modern environment have been effectively established by multinational companies. Strong color images have helped to make companies instantly recognizable throughout the world: Consumers know Shell by its yellow and orange logo and Exxon by red and blue, while Heineken brings to mind a predominantly green-and-white beer bottle label.

The colors that are most successful in commercial application tend to be simple and are most often the primaries. Since our color memory is so short—the average person will remember a specific color for only minutes—

subtleties in shades will generally go unnoticed, but people will recall a basic bright color. Few people, however, could accurately choose the precise shade of distinctive red for Coca-Cola, for example, from half a dozen samples, even though the color symbol of this company is globally known. Other factors strongly influence the way we recognize this and other colors; our perception of distinctive red for Coca-Cola is formed as much by the typography, proportions, contrasts, and backgrounds in which the color appears, as by the actual shade.

Continuity and tradition are, nevertheless, important aspects of a successful commercial

Yellow tinged with orange, and accompanied by black and red or other accents, has become uniquely emblematic of Kodak. Reprinted courtesy of Eastman Kodak Company.

color scheme: Texaco Inc., as an example, has carefully chosen the colors for its logos and trademark. The red star and a green "T" (as well as black lettering over a predominantly white or wholly white background) have always been featured in the company's various trademarks and logos, although perhaps not in the precise shade of the red and green used today. The colors are derived from one of the historical six flags of Texas, the state in which Texaco was originally incorporated in 1902.

Texaco's trademark demonstrates excellent use of contrasting color harmony. Since every hue has a mate, or a complementary (red/green; yellow/violet; blue/orange), and a family (its various tints, shades, and tones), effective color relations can be established by coupling similarly modified complementaries. Texaco's orange-red and yellow-green, in simple proportions to the black and white, create an impressive symbol.

Eastman Kodak Company provides a unique example of brand identification based on a specific shade. Kodak yellow, standardized in 1904, is so recognizable that when seen it is immediately associated with the company that invented it. When Kodak briefly changed to a blue packaging in 1914, consumers simply stopped buying the company's film. The shade is basically a primary yellow—normally too weak and desaturated a color to be used as a background. However, Kodak strengthened and warmed it to an orangy yellow, against which black or red type pops out in strong contrast. Green, orange, brown, purple, and blue are used as color keys to identifying various types of film. Kodak yellow has come to symbolize fun, light, and, above all, color film.

Another example of strong color identification is the American Express company's green credit card, introduced in 1958. The card becomes associated with the color of American money. A Roman centurion positioned in the central oval just like the portrait of George Washington on the dollar bill, and the phrase *world service* printed over a series of white globes, reinforce this association and inform us that the card can be used as credit and "ready money."

Companies on occasion will alter their color symbolism to cue the consumer to new phases of their products. American Express did this in 1977 when it issued its GOLD CARD®, and again in 1984 when it extended special membership privileges with the even more prestigious PLATINUM CARD®. Early in the 1970s, white was used (often in conjunction with beige and silver) on cigarette packaging to indicate new, low-tar brands.

Low-calorie beers and diet soft drinks follow the same principle of using white and a lighter value of a chosen hue to designate a sister product of lesser potency than the full-bodied parent item. In the case of Diet Pepsi, not only is the white given extensive play on the can, but also the identifying hues have been tinted or lightened.

In trying to explain the success of certain colors for symbolic use, we naturally turn to psychology. Many people's color preferences may be affected by personal history. For example, a harsh mother who wore green is very likely to have instilled a lifetime of dislike of the shade in her offspring. Multinational companies, obviously, cannot calculate individual color preferences. They can and do, however, take into account broad cultural preferences. Magenta red, for example, is popular in the United States, although it can become unacceptable when diluted with white; yellow-green has an overall lower preference rating; bronze has a still lower acceptance; golden olive elicits a negative response; peach is often preferred to pure orange; and the highest preference rating of all in America is for mid-range blue.

These results may change over a period of years and, although psychologists can chart color preferences (*see* Lüscher Color Test), they cannot project the future success or failure of specific color symbols (*see* Forecasting Color).

Explaining color symbolism after the fact is much easier than actually creating a successful commercial color symbol. Theoretically, the problem is simple: The right hue must be chosen for the right association and be put into an effective relationship with a product,

(Above) *Green, redolent of growth, but cool and trustworthy, is perfectly suited for currency. Copycat color and design assures the financial success of American Express.*

(Below) *The carton colors for Camel cigarettes have been adopted from the yellows and browns of the Middle East. The company has increased the use of white on the packaging for their low-tar brands. White is the color of purity.*

COLORS	1959	1960	1961	1962	1963	1964	1965	1966	1967	1968	1969	1970	1971	COLORS
YELLOW-GREEN	6.00	4.28	4.21	5.45	5.54	3.51	0.00	0.00	0.00	5.73	2.97	2.05	14.85	YELLOW-GREEN
MEDIUM BLUE	9.23	10.48	11.92	11.58	12.68	12.15	12.74	18.16	9.52	13.66	11.42	10.13	11.41	MEDIUM BLUE
COPPER-BRONZE	6.59	3.31	0.00	0.00	6.63	5.04	4.23	4.58	0.00	0.20	0.18	0.55	10.76	COPPER-BRONZE
DARK GREEN	0.33	0.00	0.00	2.77	1.37	1.80	3.09	1.06	0.87	1.75	7.43	8.88	9.80	DARK GREEN
BEIGE	5.16	5.90	6.35	5.32	5.79	6.27	6.00	4.42	6.93	6.60	6.26	8.58	9.08	BEIGE
MEDIUM BROWN-GOLD	4.44	8.63	15.71	14.75	5.27	4.00	3.64	7.45	13.92	19.96	13.19	16.86	6.16	MEDIUM BROWN-GOLD
WHITE	19.10	19.42	19.89	19.05	20.75	14.05	13.02	12.54	13.35	7.84	6.49	5.59	5.67	WHITE
RED-BROWN	0.00	0.00	0.00	0.00	0.00	0.00	0.00	0.00	0.00	0.00	0.00	0.00	4.86	RED-BROWN
YELLOW-GOLD	1.75	2.05	2.24	1.41	0.69	1.68	2.99	3.66	7.83	3.68	3.50	0.00	3.86	YELLOW-GOLD
DARK BLUE	2.82	3.54	1.46	4.80	6.18	7.13	5.56	6.25	3.35	2.90	0.00	0.00	3.54	DARK BLUE
MEDIUM GRAY	6.00	4.57	4.00	3.25	3.60	4.77	5.08	4.97	3.34	4.95	4.28	3.31	3.35	MEDIUM GRAY
BLACK	12.40	9.30	7.20	6.20	6.05	6.70	5.53	4.00	4.08	2.74	3.37	2.26	3.26	BLACK
MEDIUM RED	0.00	0.00	0.00	0.00	3.34	3.64	4.54	4.79	4.62	4.19	3.85	3.05	2.76	MEDIUM RED
DARK BROWN	0.73	1.66	0.60	0.78	0.82	0.00	0.00	0.00	0.00	3.34	6.01	3.60	2.38	DARK BROWN
MEDIUM GREEN	4.78	4.34	2.78	0.00	0.00	1.84	5.59	4.50	5.60	3.20	17.32	14.82	2.37	MEDIUM GREEN
MEDIUM TURQUOISE	11.02	6.75	6.43	9.84	10.25	10.49	11.03	9.45	7.48	7.05	4.39	3.58	1.98	MEDIUM TURQUOISE
DARK GRAY	2.17	2.69	0.00	0.00	0.00	0.71	1.71	0.00	0.56	3.63	0.15	1.50	1.35	DARK GRAY
LIGHT BLUE	1.14	1.19	2.51	1.74	1.82	1.43	0.00	0.00	0.00	0.00	0.26	0.81	1.10	LIGHT BLUE
PURPLE-MAROON	3.48	5.38	5.50	7.32	4.86	8.41	8.84	7.92	6.80	3.83	3.31	3.44	0.82	PURPLE-MAROON
ORANGE	0.00	0.00	0.00	0.00	0.00	0.00	0.00	0.00	0.00	0.00	0.80	0.00	0.64	ORANGE
MEDIUM DARK BLUE	0.00	0.00	0.00	0.00	0.00	0.00	0.00	0.00	8.02	4.75	4.45	6.27	0.00	MEDIUM DARK BLUE
LIGHT BROWN	0.00	0.00	0.00	0.00	0.00	0.00	0.00	0.00	0.00	0.00	0.00	4.72	0.00	LIGHT BROWN
DARK TURQUOISE	0.00	0.00	0.00	0.00	3.30	4.62	4.51	6.25	3.73	0.00	0.21	0.00	0.00	DARK TURQUOISE
ORCHID	0.00	0.00	0.00	0.00	0.00	1.16	1.90	0.00	0.00	0.00	0.16	0.00	0.00	ORCHID
LIGHT TURQUOISE	0.00	1.30	3.45	1.91	0.00	0.00	0.00	0.00	0.00	0.00	0.00	0.00	0.00	LIGHT TURQUOISE
LIGHT GREEN	0.28	2.15	1.46	0.89	0.00	0.00	0.00	0.00	0.00	0.00	0.00	0.00	0.00	LIGHT GREEN
LIGHT RED	2.58	3.06	3.16	2.00	0.00	0.00	0.00	0.00	0.00	0.00	0.26	0.00	0.00	LIGHT RED
CORAL-PINK	0.00	0.00	1.13	0.94	1.06	0.60	0.00	0.00	0.00	0.00	0.00	0.00	0.00	CORAL-PINK

In the postwar era, color and color trends began to be followed seriously by automobile design stylists. A fifteen-year survey (from 1959 to 1971) prepared by Du Pont revealed sharp fluctuations in some car colors and a relatively steady popularity in others. A distinction between functional color use and aesthetic color expression became apparent. Evidence of a link between popular clothing colors and product colors emerged as a result of such studies: Colors that proved popular in the soft goods or fashion markets are frequently successful in hard-goods sectors. Classic examples of the movement of popular apparel shades to industrial products are 1950s pink, 1970s brown and harvest gold, and 1980s black. Illustrating the variable nature of aesthetic communication, red, traditionally associated with urgency and danger, becomes a fashionable auto shade.

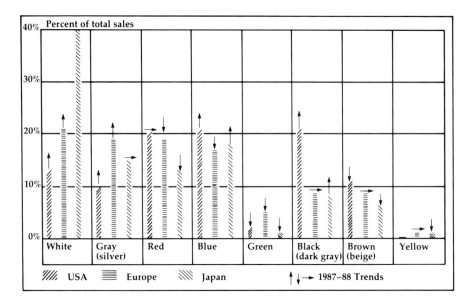

The relative popularity of car colors varies in different countries. Neutrals—black, white, and gray—show particular disparity between West and East.

service, or company. Ultimately, once a particular color shade is chosen for visibility, appeal, and retention, there is no guarantee that the color will attach itself to a product. Conversely, a constant danger is that the color may in fact supersede the message by drawing too much attention to itself. In the final analysis, it is the emotive power of color that makes the evolution of a color symbol more of a subjective art than a science. *See also* Advertising; Symbolism and Color.

Levels of Communication: from Function to Expression

It may not always be necessary to use a color's full communicative potential. In color planning, each design objective should be classified by how much information needs to be conveyed. The following is a list of the roles of color at different levels of communication, from strict function (no message intended) to pure expression:

1. *Strict function:* To use a color's functional advantages; for example, the light reflectivity of white or absorbency of black.
2. *Maximum visibility:* To alert or attract, but not to warn or caution against—black on yellow provides the strongest contrast.
3. *Minimum visibility:* To hide by blending an object into an environment, as in camouflage.
4. *Legibility:* To enhance the visibility of letters, words, or symbols. Here, the background to the type (usually black) is critical.
5. *Identification:* To differentiate between identical objects. Croquet and billiard balls are familiar examples.
6. *Coding color:* To define areas or objects, as in maps and signage.
7. *Color by analogy:* To use color associated with a related object or activity. Fire engine red is derived from the analogous color of fire.
8. *Product variety:* To distinguish grades of variations of a single product. The package's color can be changed while preserving the basic design.
9. *Correspondence/synaesthesia:* To arouse a nonvisual sense (taste, sound, fragrance, or texture); for example, the color orange stimulating the sense of smell.
10. *Pure expression:* To induce moods or suggest ideas. The superior colorist may evoke abstractions such as joy, sorrow, or tenderness.

Rembrandt van Rijn, Self-portrait.

Joseph Binder, Colorform.

Communication and Color

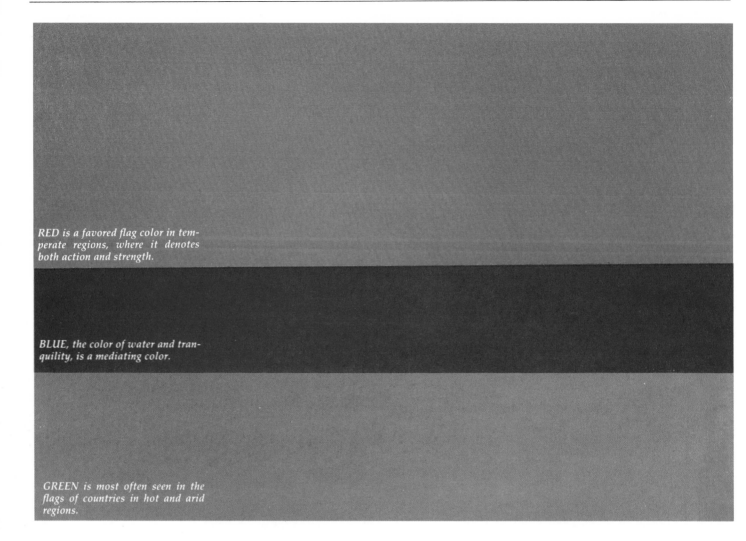

RED is a favored flag color in temperate regions, where it denotes both action and strength.

BLUE, the color of water and tranquility, is a mediating color.

GREEN is most often seen in the flags of countries in hot and arid regions.

Communication:
Races, Civilizations, and Cultures

Is there a relationship between national flags and geography? Red appears as a dominant flag color in the northern hemisphere, while green is included in the flags of many countries in the southern hemisphere. Blue, frequently a mediating flag color, serves as the ground for the flags of both the United Nations and Europe's new Common Market.

Like sound (words or music) and movement (gesture or dance), color is part of a regional or cultural vocabulary. Just as flag colors indicate national identity, or dark mourning clothes speak of loss and death in Western countries, so the color palettes used in fashion and the arts, and even the color words used in spoken language, can be unique to a culture.

There are many ways to categorize and trace the development of these palettes. Some colors are peculiar to religions, as is the case with green in Islam, blue in Greek Orthodoxy, or saffron and maroon in Buddhism. Other colors are aligned with political movements: red can symbolize revolution in Communist nations; red, yellow, and green —for the fight for independence, the sun, and the promise of fertile land, respectively —identify many African countries. Such col-

ors are used repeatedly in political iconography throughout the world to invoke strong patriotic feelings and idealistic values.

Still other colors are determined by climate and terrain alone, as in the misty grays and greens of New England or the ochers and turquoises of the American Southwest. These "regional" palettes, to be found in dress, jewelry, painting, and architecture, are more subtle, but speak profoundly of local culture, and seem connected to their place of origin. *See* Architecture and Color; Fashion: Geography and Color.

Universalists and Relativists
Certain colors, however, transcend cultural and geographic boundaries. Black, red, and white, for example, are colors often associated with primal forces and meanings, appearing in religious ceremonies in many parts of the world; they evoke death, blood, and the purity of light, respectively. As a result, anthropologists studying color in relation to races and cultures are divided into mutually exclusive (if not opposing) groups:

Arctic

Indian

African

Incan

universalists and relativists.

The universalist theory was described by American researchers Brent Berlin and Paul Kay in the 1960s. Recording and analyzing the use of color words in over ninety languages, they were able to show some broad though surprisingly consistent rules in the evolution of color names. For instance, the most primitive languages distinguish between only black and white (or light and dark tones). If and when a third color is named, it is invariably red. Yellow and green follow (in either order), with blue a surprising sixth; then subtler distinctions of pink, brown, and others.

The relativists, while accepting this, in turn point out the disproportionate weight that some languages give to certain colors, arguing that regional and environmental conditions determine the further development of color terminology. The Eskimos of the Arctic, for example, have over 100 words for white: these are necessary to describe the fine gradations of ice and snow that they, unlike dwellers of temperate regions, must

distinguish. Similarly, the hunter-gatherer tribes of the Kalihari in southern Africa have many words for green or brown, but none for blue, while the fishermen of Breton, France have a plethora of words to describe the blues and grays of the Atlantic. *See also* Language and Color.

It would seem that both these positions are valid and that the linguistic wealth of a culture's color words is an indication of relative advancement, if only in a certain direction. In the same way, a culture can often be assessed by the complexity of color use in its arts and crafts; simple color schemes (often determined by available local pigments) are the mark of a primitive, isolated society, while complex and subtle uses of color and nuance indicate a culture with far-reaching trade and communication lines. Between these extremes lie hundreds of intermediate stages of development, and many beautiful and distinguishing palettes through which succeeding civilizations express themselves. For some examples of these palettes, *see* Sources of Historic Colors.

The Relativists: a local bias.

The relativist view holds that environment dictates color vocabulary. Arctic dwellers (top, left) *have many terms for white, while African plains people* (bottom, left) *have many words for colors relating to cattle.*

The Universalists: a world view.

The universalist view holds that as a culture develops, designated colors become more numerous and complex. India's rich spectrum (top, right) *is pictured along with characteristic Inca shades* (bottom, right).

Heraldic shields, forerunners of modern flags, symbols, signs, and trademarks. A herald could custom design an image for his lord using color symbolism: Or (gold) for honor and loyalty; Argent (silver) for faith and purity; Gules (red) for courage and sacrifice; Azure (blue) for piety and sincerity; Sinope (green) for youth, growth, and fertility; Sable (black) for grief and penitence; Tenne (orange) for strength and endurance; Purpure (purple) for royalty and high-ranking officials. These shields and the abstractions (left) show how color and form could be used for modern emblem design.

Communication: Banners and Flags

In the Middle Ages, pennants and heraldic flags enabled allies and foes to recognize each other on the battlefield. Present-day flags, like their heraldic forerunners, usually employ two or three simple colors. For example, Britain's Union Jack combines the crosses of the national saints of England, Scotland, and Wales. The colors, however, refer to primal qualities (as they do in the French and American flags): red for blood and courage; blue for truth and wisdom; white for virtue.

Today, as in the past, color meets contemporary society's needs to communicate. Fast-food services, airlines, and packaged goods are among the facets of modern life capital-izing on the evocative value of flag color allegiance. Most manufacturers and exporters have profited by respecting the fact that citizens of every country identify with their national flag, and that it is advantageous to use flag colors wherever possible. Red and yellow are universally acceptable in Germany, but Brazilians favor yellow and green. Italians tend to focus their affection on green and red. In France, Britain, and the United States, red, white, and blue are winning combinations. American Airlines, the Swedish IKEA, Air France, and Italian Buitoni and Gucci exemplify corporations that have appropriated the colors of their countries' national flags. Color symbols are instruments of compelling immediacy in visual communication.

From the history of stamps, it is clear that the fewer the colors the better the coding. The few stamp denominations (above) could be readily identified by their color. Today, color is of little help in identifying the many mail categories or prices (left). With an excess of classifications, coding by color loses its effectiveness.

Communication: Consumerism

Today, we live with a profusion of color that, increasingly, is independent of national color palettes. Before the 1950s, simple, achromatic colors largely dominated the packaging and treatment of consumer goods. Automobiles, telephones, shoes, and many other objects were black or white. This was partly due to technology and the difficulty of manufacturing in color, and partly due to the "serious" connotations of black and white. The new dyes and pigments available in the postwar boom of the 1950s greatly expanded the consumer's choice of pastel colors.

The 1960s, however, witnessed not only the introduction of color television into millions of homes, but also the challenge of an accepted order in Europe and the United States. Through their rebellion against authority, the youth movements brought a new internationalism to the aesthetics of color. The 1960s color revolution was expressed in the music and graphics of the Beatles, in bright, "mad" clothes, and in the flood of colorful goods, which technology fashioned for popular taste in slick commercial colors. Multiple, psychedelic colors, particularly orange and turquoise blue, symbolized the more abrasive aspects of the era.

In the 1970s, consumer products were routinely presented in at least five different colors. By the early 1980s, color had penetrated practically every arena of daily life. The diversity of colors available creates an equally diverse set of color dilemmas.

The contents of a package are often indicated by the use of appropriate colors. Researchers have found that response to and recognition of a product is frequently enhanced by the use of colors on packaging intuitively related with various tastes. Traditional associations of colors with scents and tastes are based on correlations between fruit plants and their colors. For many people, the sight of an orange evokes an "orangy" smell in the same way that violet and lavender suggest feminine floral scents.

Lemon, Lime

Jams

Salt

Bittersweet Chocolate

Tonics

Vegetables

Mint, Menthe

Syrups

Champagne

Communication: Packaging Images

An example of a small but fully informative package design. Using the colors of fire and flint, the matchbox attracts attention, identifies the product, and suggests its function.

In a consumer society with almost unlimited color use, like that of the United States, the traditional system of symbolism can break down. The powerful signifiers of the past (red for strength or command, for example) are abandoned, and the images of fashion color trends are brought into play. Where a carton of orange juice was once conventionally colored in orange and green—symbols of youth and growth, carrying synaesthetic associations of sweetness—it now assumes a new image in a black container. In this manner, an ordinary drink's package is elevated to a fashionable object, subsumed by the high-tech design movement of its day. On a supermarket shelf, where the competition is packaged in orange and green, the trend- and fashion-oriented black image is distinctly prominent.

To catch the eye of the blasé consumer in a color-saturated era, off-shades and unexpected colors often replace the color norm. For example, Poison, a perfume introduced in the 1980s, was boxed in green, a color traditionally associated with light fragrances and geared to young markets. This particular green corresponded to the shocking impact of the unexpected and daringly named scent. In the late 1980s, American food companies showed a tendency to feature fashion colors —burgundy and violet—in their food packaging in an effort to create a contemporary image. *See also* Synaesthesia.

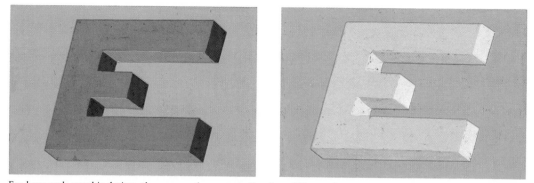

For large-scale graphic design, the essence of communication is grabbing a viewer's attention. This is best achieved by the use of complementary colors; by simultaneous contrast, each heightens the other's apparent strength. Applications include corporate logos to be used outdoors. White and black can also be used for backgrounds to set off any color: white tends to enhance a color's value (relative darkness of a color), while black increases its saturation (depth of color).

Communication: Typography and Graphics

Choosing a color to go with type is an ongoing concern of graphic designers. In addition to legibility, which is usually a primary consideration, credibility, novelty, and the elevation of the message's mood are all considered when making color decisions for either headline or copy text.

Fields of design where color typography or backgrounds are extensively used include magazine illustration, television and print media advertising, book jackets, record covers, corporate reports, graphic systems designs, and exhibition design. The importance of legibility over visual interest depends on the purpose of the design. A book jacket design, for example, usually emphasizes legibility, while a corporate logo stresses visual interest.

In the print media, color graphics strive to attract and hold the reader's attention. Therefore, a delicate balance is sought in color choices for type (and paper) so that sufficient interest is generated, but not enough to cause distraction and make the reading difficult. The type color, moreover, cannot be so overpowering as to create a "hole" on a page. Additionally, type color and background elements, whether for headline or body copy, all need balance for general appeal. *See also* Advertising; Newspaper Color.

The most visible color combination is black type on a yellow page. The most legible, however, is black on white, followed by black on yellow, yellow on black, green on white, and red on white. White on black looks sophisticated on a page, but unless the type is in large, bold characters, it is difficult to read. Good novelty combinations are blue on yellow and blue on white.

The least legible color combinations are red type on a blue background; white on red; black on green; orange on blue; yellow on orange; yellow on white; red on orange; red on green; and green on orange. Strongly contrasting color in large type may stand out well at a distance, but in text-sized print the same combination will tend to establish a flickering effect that is disturbing to the reader. In addition to the color of type and paper, the size and shape of the typeface and the kind of audience being addressed are also important factors to be considered.

On small, textual scales, graphics are more concerned with legibility than visibility. By experimenting with different backgrounds (or types), a designer can evaluate the influence of color. In general, high-value contrast (dark on light) reads best, but high-chromatic contrast (such as cyan on orange) dazzles and disturbs the eye.

Two football teams in similar green uniforms playing on green turf with brown lines would be almost indistinguishable. A degree of emotional excitement for the spectators is also removed. Bold, clashing chromatics add drama.

(Above) *Two opposite or contrasting colors, as on this imaginary tennis ball, have a stronger impact and "read" better than two colors that are closely related.*

(Below) *Ball colors are usually seen at a distance. The optical mixture of many contrasting colors tends toward a neutral gray, as would be the case with a polychrome football.*

Communication:
Sports Stadiums—Temples of Color

Games such as cricket or lawn tennis were first played in all-white dress, and baseball players' uniforms were narrow stripes on white or gray backgrounds. Today's professional sports are played in large stadiums and broadcast to millions of people, which places a special emphasis on color. Color helps fans to identify team members and to follow the swift and complex action. The small television screen calls for vivid, easily identifiable color graphics that help viewers make immediate team and play distinctions. The strong color contrasts of the uniforms of the opposing teams increase the drama and spectator participation in several ways:

1. Color allows for instant identification. Among the outstanding combinations in American football team colors are the classic red, white, and blue of the New York

Giants; the kelly green and white of the New York Jets; the royal blue and white of the Indianapolis Colts; the aqua, orange, and white of the Miami Dolphins; the royal blue, metallic blue, and white of the Dallas Cowboys; and the gold, black, and orange of the New Orleans Saints.

2. Color communicates the flow of the game, so opposing teams must have distinctive outfits. Most teams have two uniforms using the simple principle of color reversal for home and away games. Gold, in combination with black and white, works equally well as a motif or background.

3. Color heightens emotional involvement. Dramatic effects with fully saturated colors are best achieved when a limited number of hues is selected. Including black and white, National Football League uniforms never exceed a total of four colors. Many are successful with only one color plus black or white. For the fullest effect, bold colors work best when given an extensive surface for expression.

Compass, Points of the (and Color Symbolism)

Primitive societies around the world—ancient Egyptians, Celts, Native Americans, and Tibetans, for example—all have shown the same tendency to link color and direction, although rarely with the same colors. A sampling of these associations includes the following:

America: According to Navaho legend, the Navahos' land was surrounded by high mountains that rose and fell, creating day and night. The eastern mountains were white and caused the day; the western mountains were yellow and brought twilight. The northern mountains were black and covered the earth in darkness; blue mountains to the south created dawn.

Mexico: The Ancient Aztec city of Quetzalcoatl (named in honor of a feathered serpent god) had a temple-palace in which rooms facing east were decorated in gold, those facing west in turquoise blue and jade green, those facing south in white, and those facing north in red.

Tibet: The world was looked upon as being the body of a frog from whose navel rose a huge and high mountain, which the Mongols called Sumur. Home to the gods, it was shaped like a pyramid with its top broken off. The sides facing the four points of the compass were hued and shone like jewels: To the north was yellow; to the south, blue; to the east, white; and to the west, red.

China: In Chinese mythology, there were four Heavenly Kings who guarded the four regions of the world. Mo-li Shou guarded the north and had a black face; Mo-li Hung had a red face and guarded the south; green-faced Mo-li Ch'ing guarded the east; and Mo-li Hai had a white face and guarded the west.

Ireland: The early Irish symbolized the north as black, the south as white, the east as purple, and the west as brownish gray, reflecting the colors that surrounded them in their own landscape.

Complementary Colors

Pairs of colors that complete each other and that are found opposite each other on the color circle. As "opposites," they are harmonious and mutually enhancing when adjacent to one another. Additive complementaries, when mixed, produce white light; subtractive complementaries, absorbing all light, produce black. In light, blue and yellow are complementaries, but red and green are not, since they produce yellow light when mixed. In the case of pigments (subtractive colors), red and green are complementary since they effectively absorb all wavelengths when mixed, leaving a dark brown. Indigo blue and yellow, and orange and cyan, display the same kind of complementarity. Complementaries are particularly effective in demonstrations of simultaneous contrast. All afterimages (*see* Afterimage) are the complementary of the original color. *See also* Color Constancy; Harmony; Vision.

Complex Colors

Colors that exhibit variation in texture or even hue; the term also includes colors that change subtly according to the ambient light or the distance of the observer from the surface, as in pearlescent colors. Complex colors can be visually more interesting and dynamic than flat colors (*see* Flat Color). In contrast to simple colors, complex colors include those mixed shades that are usually described by two or more words, as in "greened gray."

Computers and Color

The efficiency of modern methodologies has resulted in a dichotomy in the demands made on color technology. On one hand, consumers demand mass-produced, standardized, high-quality products. On the other, since color is a sensation and is subject to human moods, people look for complexity in color, for natural and sometimes faded looks, and for texture and variety, all of which are difficult for conventional manufacturing technology to supply.

Previous technological advances have been concerned with colorants (particularly in discovering synthetic dyes and pigments, a main thrust of the nineteenth century), automated manufacturing processes, and instruments for color control and matching (such as the spectrophotometer). The result has been an unprecedented range of colors of the highest quality, with great accuracy of reproduction. There have been negative aspects as well—for example, the mechanistic way in which color is produced, or the lack of flexibility. The new technology of computers is addressing such problems and humanizing manufacturing techniques.

Computer-Aided Design (CAD) Systems
Capable of performing logical operations and processing information at high speeds, the computer promises the greatest leap in color technology in the twentieth century. In theory, a computer can reproduce on the moni-

"If we were to imagine an orange on the blue side or green on the red side or violet on the yellow side, it would give us the same impression as a north wind coming from the southwest."
—Ludwig Wittgenstein

tor screen and record about 16 million colors, well beyond what is distinguishable by the human eye; it can show any of these colors in combination and even reproduce the different effects of lighting and texture.

These features are of particular significance to the designer in the textile industry who, using sophisticated programs to manipulate colors and graphic images (called computer-aided design, or CAD), can reduce the time spent on choosing colors and colorways from days to minutes. Computers also obviate the need to graph, dye, or weave prospective samples: High-resolution printers with similar color capabilities to the computer can translate samples to printouts so realistic that they are often mistaken for fabric swatches. In the last stage, computers now can be used to control color directly on looms, in dyeworks, or on printing presses with systems known collectively as computer-aided manufacturing (CAM).

CAD/CAM and the Fashion Designer

A basic CAD system can be used with a personal computer (PC), allowing the designer complete, hands-on control of the design process. The computer uses a high-definition video screen, which reproduces colors additively by creating mixtures of the three primaries (red, green, and blue) and by varying their intensities. A basic design is drawn with a pen plotter, and the computer is then directed to fill in or modify colors according to the designer's wish. Programs simulate the appearance of a color in patterns (from stripes or plaids to figurative designs), in fabrics (such as wool tweed or cotton twill), under different lighting conditions (natural, incandescent, or fluorescent), with different dyes, with different textures (adding three-dimensional depth to color), and on different types of clothing (showing how the finished product will look without having the need to assemble it).

Computers provide the benefit of enormous speed in design coupled with a potential palette of 16 million unique colors.

The CAM system then translates this design into the manufactured object. Computers are linked to automated colorant mixing, dispensing, and dyeing systems equipment. Similarly, coloring can be done by high-speed laser printing or dyeing machines providing comparable benefits in cost and flexibility. One problem that may always remain is the transposing of video monitor colors onto fabric. The laws of physics ensure that dyers and printers will never be able to reproduce accurately every one of the 16.8 million colors produced by the computer (although the reverse is generally possible) —no fabric is regular enough, no dye or pigment consistent enough for the results of color mixing to be completely predictable. While computers can be calibrated so that they will have identical outputs, the actual manufacturing machine requires feedback from the finished article—visual inspection or further computer analysis is needed to control color accurately.

Moreover, some designers have expressed disappointment with CAD systems, because the colors on the screen are produced in light while the results will be in pigments or dyes. Scientifically, the matches may be correct, but perceptually there can be a world of difference. A color that is bright and exciting when lit up on the screen may well be dull and dismal when actually manufactured in cloth. In the same way, color combinations that seem satisfactory on the screen may not be so in real life. The human hand and eye are still needed to achieve desirable results.

Among the main advantages of CAD/CAM systems are their speed, flexibility, and cost-effectiveness, which allow designers to increase experimentation and manufacturers to keep pace with rapid changes in fashion colors. Computer-controlled manufacturing makes it possible to dye or weave short runs, instead of the thousands of yards needed in the past to cover setup costs. In addition, all matching can be done by computer, dramatically improving turnaround times.

Computers and Print Technology

Computers are similarly revolutionizing reproduction techniques. The original technology of mechanical reproduction on paper using lithographs or engravings done by hand was first replaced by photographic methods in the nineteenth century; they are now being augmented or superseded by the application of electronic scanning and computer processing.

At the heart of computer systems is the scanner. This "scans" the image, microscopic dot by dot, evaluating the hue and intensity of the color at each spot; the resulting information is recorded as a digital stream of pulses, which can then be passed either to an electronic printer to make separations (needed for the final reproduction) or to a computer for analysis and modification.

There are two main advantages to digitizing an image. First, all color information is recorded in on/off pulses, so there can be no deterioration of color (for example, by fading or because of low-quality materials). Thus, perfect pictures can also be transmitted over ordinary telephone lines. Second, this information can be manipulated, pulse by pulse, to enhance or tone down color, to improve detail, or even to add new images, quickly

and without the risks inherent in retouching by hand; additionally, changes can be made on a microscopic scale. Collages of elements can be created, shadows added, and damaged areas retouched—all without the labor-intensive remakes and often messy use of scissors and paste or airbrush.

The computer is central to the process. It takes in the digital information from the scanner (recorded on magnetic disks or tape) and begins color evaluation. The scanner, like a camera, is subject to problems of lighting. It can suffer errors in correctly recording color; it also is subject to the judgment of the scanner operator. Other variables, however, are eliminated. The computer contains programs that calculate how to compensate accurately for any color or contrast problem in the artwork. It accurately zeroes in on a desired final color, allowing control standardization to replace subjective operations, such as visual reference to specifier charts.

Major Applications of the Computer

Color correction: This allows for global (overall) or local (defined through a mask) color shifts and the matching of specified tints and samples. At present, a color recipe must first be determined by conventional means for the process-color values (cyan, magenta, yellow, and black), and this is then converted to the corresponding percentage values on the computer console.

Retouching: Often called "electronic airbrushing," this procedure allows erasure, exchange, and enhancement of the original pixels (numerical digits). This might include adding leaves to a tree, removing facial flaws, or trimming off twenty-five unwanted pounds of flesh.

Pagination: Also called electronic stripping, this allows for complex composition or page editing. Numerous picture files may be combined with computer-generated backgrounds, tints, geometric windows, and electronically "cut" silhouettes.

Benefits of computerization in printing are similar to those in textile design and manufacturing: enormous speed and increased possibilities for repeated experimentation by the operator. There are instant zoom or enlargement capabilities, the quality of which depend on the definition that the computer can handle (no computer as yet can improve an image from the regular 512 dots per square inch that a PC can handle to the 93,000-plus dots used by the largest "high-definition" machines), and there are almost no limits to reuse. The computer can record

continuous-tone images as accurately as a camera; its flexibility concerning that is unparalleled.

Disadvantages lie in the application of the color image to the final, "hard" medium, usually paper. No printer can match the definition of high-resolution computers; inks and papers are subject to fluctuations in quality, and no subtractive process exactly reproduces the additive coloration of pure light on the computer monitor.

Computers and Fine Art

In fine art, computer technology has been less responsive to application and less readily accepted than in industry. Initial problems with the earliest generations of computers involved forcing the artist to communicate his or her ideas through a programmer; the free and intuitive way in which artists work did not mesh well with the linear thinking needed to run a computer.

New technology allows the artist, using graphics programs, to work directly with the computer on an electronic board that immediately shows the results on the monitor. He or she can draw a picture or scan a real object, manipulating and coloring the image, rotating it, making it three-dimensional, changing the ambient lighting, and so on in a million different ways. The screen image can then be applied to textiles, wood, canvas, steel, or paper by a variety of techniques, including conventional methods such as lithography or screen printing.

Another way for artists to use the computer as a medium is the "passive system." In this, the artist runs a program telling the computer to do such tasks as drawing an image in a certain style, using specified colors. The computer can be programmed to draw directly from nature—or to manipulate displays of light or the workings of a machine for kinetic art.

Computer art still lacks its own look and language. Graphic applications have tended to imitate processes that are better accomplished by conventional means. While it is possible for computers to produce oil paintings or pastel drawings, there is no improvement over the look of the original hand-drawn methods, except for speed. In fact, colors look mechanical and lack the complexity and texture that make a painting so attractive. All computer graphics have the flat look of pop art or the slick look of photography. Artists complain of not being able to feel or even smell the paints they usually use, thus missing essential synaesthetic aspects involved in painting.

"The painter of the future will be a colorist in a way no one has been before."
—*Vincent van Gogh*

The beauty of computer art lies elsewhere, in styles that are yet to be developed. Artists were quick to employ previous "new" technologies such as printing and photography, and used them to launch art in innovative directions. One promising aspect of computers that is is the video monitor itself. The British artist David Hockney was particularly captivated by the opportunity to "paint with light" and to apply one "wet" color on top of another without any loss of saturation. He compared the new medium to stained glass.

More successful applications of computers are in animation and high-definition video, in color analysis and reconstruction of damaged or deteriorated paintings, and in art history. For example, in 1987 the American art historian Lillian Schwartz used a computer to study Leonardo da Vinci's *Mona Lisa*. She had the computer superimpose a self-portrait by Leonardo onto the face of *Mona Lisa*. She was so struck by the physiognomic similarities of the two faces that she asserted that *Mona Lisa* was an altered portrait of either Leonardo himself or a close relative, probably his mother. While her conclusions may be controversial, her research demonstrates the possibilities for the computer as an art historian's research tool. *See also* Digitization of Color; Laser Printing, Color in; Motion Pictures, Color in.

Conservation of Color in the Fine Arts

Alan M. Farancz is a graduate of Hofstra University. He was a graduate student at the Conservation Center–Institute of Fine Arts at New York University. As a Committee to Rescue Italian Art Fellow (1967), and Fulbright Research Fellow (1968–69), he studied in Florence, Italy. While a Clawson Mills Fellow at the Metropolitan Museum of Art in New York in 1970, he discovered the relationship of the various colors that ivory turns under exposure to heat. He is Fellow of the American Institute for Conservation of Historic and Artistic Works, an Associate Member of the International Institute for the Conservation of Historic and Artistic Works, and a Member of the Association for Preservation Technology.

The craft of fine arts conservation is a complex process entailing the preservation of pigments from further deterioration; the limited restoration of lost colors; and the replacement of discolored varnishes. Many factors have to be taken into account, including the hue and value of the original color, as well as its texture, transparency, and opacity. A further area of concern is the ambience of the area around the lost color.

Conservation: *Even when colors can be faithfully matched, it can be difficult to replicate the application techniques used by the original artist.*

When one views a painting in a museum, dark matte spots or areas are sometimes apparent that are unlike the surrounding areas. These dark areas are the result of retouching done in the nineteenth century or earlier. The oil paints and natural resin varnishes used by the restorers all contained linseed oil, which, when it dries over a period of time, becomes darker and more matte. The result is that the original retouching starts to show.

Conservation of apparently undamaged portions of artworks also presents a problem. The original painters depended on much the same paints and natural varnishes (including mastic and damar), which have discolored long before any attempts at restoration. A modern conservator has to decide how much to clean a painting, when, just by stripping off an old layer of varnish, he can make colors unrecognizably bright.

In general, conservators try to keep restoration to a minimum, preserving the integrity of the artwork and protecting it from further decay. When cleaning a painting, it is of the utmost importance that the colors are as harmonious as the artist intended. The materials used are mostly reversible and could be removed by future conservators without affecting the original colorants. Dry pigments and a synthetic medium (such as a type of acrylic resin) are frequently used.

Where the paintwork has to be restored, various aspects of paint-matching deal with the number of pigmentation layers that the artists have used. The artist could have used a white gesso ground, or a reddish brown ground as El Greco or Rembrandt used; or he or she might have used many layers of glazes (paint that is thinner, containing more medium than pigment). When analyzing color, it is necessary for the conservator to remove pieces of the paint so that it can be examined in cross section with a microscope, as well as to clean the surface completely. As most of the pigment stuffs originally used by the artist were handmade, it is unlikely that the colors can be matched precisely to present-day color chips; instead, they have to be laboriously matched with custom-made mixtures, each layer of the original being matched (often under a microscope) in the new rendering. Even when colors can be faithfully matched, it can be difficult to replicate the application techniques and various brushstrokes used by the originating artist. Since the restorer ultimately wishes to allow later generations to see a work as it originally appeared, he or she must somehow bring even minute details into focus so that the total color effect, including the value level of each color, closely duplicates the original work.

While it is the conservator's job to guard against the damaging effects of the passage of time, it is an onerous and laborious task to bring back the original colors after the ravages of light, heat, and dirt and the natural deterioration of pigments over time have occurred.
—Alan M. Farancz

Constancy

See Afterimage; Color Constancy; Simultaneous Contrast; Successive Contrast.

Continuous Tone

The continuous and unbroken gradation of one tone into another; a term applied particularly to most photographic images, where the gradations from light to dark and from one color to another across the picture are generally smooth and continuous. In contrast, the image produced by offset four-color printing (a halftone image), for instance, is composed of small dots or lines of an ink, which only blend with the background white of the paper to form intermediate tones and an apparently continuous image at normal viewing distances.

A continuous-tone image can be made by photographic means, by varying the density of the image-forming substance: silver in conventional black-and-white, and dyes in color and chromogenic black-and-white images. In continuous-tone photographic emulsions, the image-forming densities are directly dependent on the amount of light to which each area is exposed, thus producing tone variations of a smooth, continuous character. *See also* Moiré; Offset Printing; Photography.

Contrast

For discussion of how the phenomenon of contrast affects how color is perceived, *see* Harmony; Optical Illusions; Systems: Planetary Color ; Simultaneous Contrast; Successive Contrast.

Cool/Cold Colors

Cool, or cold, colors represent half the visible spectrum, namely those colors of short wavelengths, from violet through blue and green. These colors have no perceptible tinge of red in them, which would give a sense of warmth. An icy (pure, light) blue is probably seen as one of the coldest colors.

Copolymer

A synthetic base for paints, made by the polymerization of two monomers.

Copper

Orange-red hue of the metallic element of the same name and similar to burnt sienna.

Copper Acetate

Used in ancient times to make green dyes; prepared as a result of the action of strong vinegar on copper filings. It was seldom used alone, however. Generally verdigris (basic carbonate of copper), alum, and sometimes yellow or green vegetable extracts were added.

Copper Green

Mineral green, or the green tint of weathered copper. Similar to verdigris, the patina on weathered copper or bronze. *See also* Verdigris.

Coral

Any of various deep orange pinks. Coral itself is the skeletal deposit of small sea animals called polyps. It is produced in a range of colors: red, pink, white, and blue, made of calcium carbonate and found in the Mediterranean; black and golden yellow, of the horny substance conchiolin and found off Hawaii, Australia, and the West Indies. In all corals, the skeletal structure is visible as a delicately striped or spotted graining.

Cornflower

A moderate, purplish blue named from the flowering plant; one of the first 106 color standards established in 1915 for the American textile industry.

Cornwell-Clyne, Adrian

1892–1969. English light artist, inventor, and writer; born Adrian Bernard Klein in London. In 1921 he devised a "color projector," which utilized carbon arc lights to project beams of spectral color onto a small screen, which he claimed could exhibit a range of 267 variations of color. He subsequently turned his attention to color in film, inventing the Klein Tricolour Camera. His two informative publications on the subject were *Color Music, The Art of Light* (1932) and *Color Cinematography* (1936); the latter was revised, expanded, and reprinted in 1951. He corresponded extensively with Thomas Wilfred and W. Christian Sidenius (1923–), the two major exponents of projected light as an art medium in the United States. *See also* Wilfred, Thomas.

Cosmetics and Color

Those color alterations to facial skin, eyes, hair, and finger- and toenails, largely

through powders, rouges, eyeliners and eye shadows, dyes, and pigment varnishes used to beautify women and, at times, men. Cosmetic colors are used to create an ideal of beauty that tends to change from culture to culture and from time to time. The ideal created by cosmetics can be so compelling that the images held by succeeding generations are based more often on artifice than on reality. Thus, ancient Roman women created round eyes with deep sockets, and prominent brows with eyeliners and shadow makeup inherited from the Egyptians, and it is these darkened, soulful looks that history records. On the other hand, the fifteenth century idealized the pallid face of expansive whiteness. Women at that time plucked their eyebrows and hairlines and generously applied white powders and pigments to their faces.

Egyptian Makeup

The ancient world had a rich cosmetic tradition, and nowhere was the delight in makeup greater than in Egypt. Five-thousand-year-old lip rouges, stained nails, and cosmetic containers have been found by modern archaeologists. The Egyptians painted their palms and the soles of their feet in a reddish orange henna. Veins on the temples (and often breasts) were accented with blue. Egyptian women even painted their nipples gold. Yellow ocher was used to lighten skin. An orange-tinted yellow was used by both sexes to lighten their skin tones, while only men also used a pure orange for this purpose.

Egyptians lined their eyes heavily with kohl, a powder made from antimony; kohl is still used by Eastern women. The favored colors for kohl were black and gray, but other eyeliner colors included powders of ocher, iron oxide, malachite, chryscocolla, and green copper ore. Powdered kohl was kept in pots, moistened with saliva, and applied with ivory, silver, or wooden sticks. Green-aqua, turquoise, terra-cotta, black, and various shades of brown were commonly used for eye shadow, with green malachite being the most popular pigment. Cleopatra (69–30 B.C.) set the cosmetic style at her time, favoring black on her eyebrows and eyelashes, and blue-black and green eye shadows.

The medieval world, in contrast to the ancient one, shunned bright cosmetic colors. With the Renaissance, paints and washes in brighter hues were revived. Queen Elizabeth I (1533–1603) was particularly lavish with face paint and used coat after coat of white—in this case, poisonous white lead.

Cosmetics: *Ideals of beauty tend to change from culture to culture and from age to age.*

(The image of her white face and red wig is well known.) Elizabeth also plucked away her eyebrows and a good deal of her hairline to emphasize her whitened pallor. The cosmetic practices of hair plucking and facial whitening persisted through Tudor and Elizabethan England.

By the beginning of the seventeenth century, scientists realized the harmful effects of lead-based cosmetics and replaced them with animal fat–based preparations. A form of lipstick appeared made from plaster of paris, colored to the wearer's choice and rolled into a stick. Face powders at this time were generally made from ground alabaster.

The seventeenth century was one of cosmetic extravagances and featured patches of black velvet, in the shapes of moons and crescents, applied to the face. These dramatic beauty marks fitted in with a century given to emphasizing artifice over nature. At the same time, the clergy and other moralists inveighed against face painting as evil—the painted woman was a tainted one.

This attitude, which persisted in the Anglo-American world until World War I, placed all cosmetic colors—but particularly reds, which were largely associated with prostitutes—in the realm of dubious respectability. During the nineteenth century, this position was so strong that the use of cosmetics became somewhat furtive, although women continued to use makeup discreetly. After World War I, the attitude toward cosmetics became more open again. One major change was the acceptance of skin colors other than the porcelain white ideal of the eighteenth-century English beauties.

The Influence of Movies

The twentieth century, with its stepped-up pace, saw a new cosmetic image with virtually every decade. In the years just before the outbreak of World War I, full rosebud lips, dark brown eye makeup, and light skin were fashionable, established by American movie stars Theda Bara and Pola Negri. The first American lipsticks with sliding tubes appeared around 1915, and in the 1920s the flapper painted her lips bright red. This look was succeeded by the 1930s ideal of the sad-eyed female. Greta Garbo's pallid skin, unrouged cheeks, penciled-in eyebrows, and outlined eyelids—emphasizing her soulful eyes—epitomized 1930s glamour. In 1931 Elizabeth Arden promoted a range of lipstick shades in place of the dark, medium, and light that until this time had been a woman's only possible color choices. Paris, always at the leading edge of cosmetic ideas, introduced the idea of opalescent fingernails

achieved by the application of an opaque silver polish to the tops of red enameled nails.

In the 1940s, the American actress Rita Hayworth popularized the image of gleaming red nails and lips. The 1950s, well known for two lipstick shades, "Fire and Ice" and "Persian Melon," gave prominence to the mouth. Movie star Marilyn Monroe, best known for her hourglass figure, established a new norm for the sexually provocative woman through bleached blonde hair and rounded red lips. Even the more refined actresses such as Grace Kelly followed the new cosmetic norm of a strong contrast between brightly colored lips and fair hair. By the 1960s, cosmetics emphasis shifted to the eyes again. Audrey Hepburn, the actress noted for her role as the ingenue in *Breakfast at Tiffany's* (1961), personified the look. Also in the 1960s, the first ranges of cosmetic colors produced especially for black skins appeared.

"Hippie" and ethnic looks in the late 1960s and early 1970s provoked a swing toward natural beauty and, with it, beige, earthtoned cosmetic colors. Foundations were created to match every skin tone. Popular shades for eye shadows and lipsticks were browns and terra-cottas, pinks, and even yellows. Colorless lip glosses also gained in popularity.

The craze for disco dancing during the late 1970s and the early 1980s ushered in glittery eye shadows in silver, gold, and other metallic colors. Nails particularly exhibited the decade's norm of the bright colors, closely paralleling fashion's color-blocking by employing designs of two or more shades on one nail. In 1988, Florence Griffith Joyner, a black Olympic Gold Medal winner, captured the flashy spirit of the decade when she sported nails of many different colors, including red, white, and blue for her country's flag and gold for her own Olympic prowess in the 100- and 200-meter dashes.

The decade's most outrageous cosmetic color expression was found in exaggerated punk hairstyles. These included turquoise and yellow Indian Mohawk cuts; Day-Glo oranges, chartreuse greens, acid yellows, and screaming magentas in quilt patches; and intentionally obvious dyed black or bleached white hair. Worn mostly by East Village habitués in New York, males as well as females, these hair fantasies did a great deal to promote the idea that changing one's hair color was not only all right, but part of a youthful and modern image. Face blushes, eye shadows, lipsticks, and even the tools of cosmetic color applications began to exhibit a faster and faster rate of change by the de-

cade's end. Thus, cosmetics, like clothing, with which it was meant to form an ensemble, evidenced a quickening pace of its normally twenty-four-month color cycle. *See also* Fashion and Clothing Color.

Cranberry

A cultivated and wild fruit, *Vaccinium macrocarpon* or *Vaccinium oxycoccus,* from which a dye is made. The cranberry plant, an evergreen, grows in northern boggy terrains, on the North American continent from Newfoundland south and west to Minnesota; also in northern Europe and Siberia. The colors obtained include a beige (when the cranberries are mixed with vinegar), a pinkish tan (when mixed with alum and tin), taupe (mixed with iron), and gray (mixed with chrome). These dyes are not colorfast.

Crayon, Oil

Soft mold of pigment combined with a small proportion of binder, usually gum arabic, that can be smeared, scraped, or thinned with turpentine. The resulting pastel shades usually have to be sprayed with a fixative to prevent smudging. *See also* Pastel.

Crayon, Wax

Molded stick of pigment held by fat or wax. Uncolored wax crayons are used to paint the resist pattern in batik. The wax is applied to the areas of cloth to remain undyed, hardens when the cloth is placed in cold-water dye, then is later removed with a heated iron. *See also* Encaustic Paints.

Crimson Red

An old color name for a deep red shade derived from the Latin *kermesinus,* crimson was first made from extracts of the insect kermes mixed with lac. Later it was made with cochineal, brought back from the New World by the sixteenth-century Spanish conquistadors. Cochineal was extracted from *Dactylopius coccus,* a minute cactus-dwelling insect, and it is one of the few natural red colorants still used in cosmetics and food. In textiles, cochineal is now replaced by synthetic azo scarlets. *See also* Cochineal.

Cubism

Of all the major twentieth-century avantgarde movements in painting, cubism—as developed in collaboration by Pablo Picasso and Georges Braque from about 1907 to 1911, and thereafter in loose relation to several other artists—was probably the least concerned with color and its effects. Many cubist

pictures are almost monochromatic, featuring brick red and red-brown, often with a gray or gray-green ground, since the color is meant only to be chiaroscuro. This was especially the case during the pioneering years of cubism; the painters' reduced palettes seem all the more remarkable given the rather vigorous attention directed toward color both by Picasso, in his so-called Blue and Rose periods, and by Braque, as a fauvist, immediately before the cubist breakthrough.

The *Demoiselles d'Avignon* (1907; Museum of Modern Art, New York) is generally considered the decisive inaugural work of the cubist epoch. It is clear from this painting that structural concerns did not completely take over the cubists' interests, and not without something of a struggle. The contrast between pale, "iceberg" blues and fiery pinkish reds summarizes Picasso's late coloristic experiments and makes a major contribution to the pictorial effectiveness of the "Demoiselles": The colors are luscious blue, strident yellow, next to pure black-and-white.

After 1909, however, both Picasso and Braque (in his Cézannist landscapes painted at L'Estaque) reduced their palettes almost to monochrome. Most of the major cubist painters after Picasso and Braque never surrendered their colorism as entirely as the masters. For example, art historian John Golding, who wrote a pioneering historical study of the subject (*Cubism: A History and an Analysis*, 1959), claims that Juan Gris (1887–1927) "never discarded color to the same extent as they did, and his use of it is again

more naturalistic and descriptive." The same might be said of Jean Metzinger (1883–1956) who was thoroughly schooled in the divisionist techniques of the late nineteenth century, and certainly Fernand Léger (1881–1955), whose *Contrast of Forms* series represents one of the most convincing investigations of the relation between form and color of any artist in the cubist generation—although Léger properly should be considered a postcubist artist. *See also* Braque, Georges; Picasso, Pablo.

Cultural Meaning of Color

See Communication and Color; Race and Skin Color.

Cupboard Red

A deep, slightly browned, soft red of the American Colonial and Federal periods. Popular particularly in the New England colonies and states, cupboard red was used primarily to color corner kitchen cabinets. Now a decorator's term, it is associated with things unpretentious, practical, and comfortable.

Cyan

A dark blue, from the Greek *kyanos*. While *cyaneous* refers to a deep, cerulean blue, cyan refers to a bluish green to greenish blue color and is one of the three subtractive primaries along with magenta and yellow, used by printers. In additive color mixing, cyan is a secondary color—the mixture of red and blue.

Dali, Salvador

See Trends in Color.

Daltonism

See Dalton, John.

Dalton, John

1766–1844. A famous English scientist who took a strong interest in atomic theory, atomic weights, and meteorology, Dalton—color-blind himself—was probably the first scientist to give an accurate description of the deficiency. His findings were so penetrating that "Daltonism" became, and for long remained, the common synonym for color blindness. In his early years, he attributed errors in judgment to an ignorance of color terms. He discovered later that he saw no color difference between a green laurel leaf and a stick of red sealing wax or a scarlet gown, and once, unintentionally, he attended a Quaker meeting wearing a drab coat and flaming red stockings. The confusion of red and green (deuteranopia) from which he suffered is the most common form of color blindness (*see* Color Blindness).

Damask Red

A dark crimson found in many examples of Renaissance Italian and Spanish damask.

Dark Adaptation (Scotopic Vision; Night Vision)

Vision produced when the eye adjusts to dim lighting conditions. For color vision, sufficient light is needed to activate the retina's light-sensitive receptors, the cones, which have different spectral sensitivities and permit color vision. In darkness or near darkness, the functioning receptors are the rods. Until they can be stimulated by just a few photons, or "dark adapted," the rods become more and more sensitive as the light dims. There are no rods on the fovea, the central part of the retina, so in near darkness the center of the eye is more or less blind. Hence, dim objects of low brightness may seem to disappear if looked at directly.

With night vision, also called scotopic vision, the dark-adapted eye is more sensitive to the color blue, the shorter wavelengths of light, a fact that accounts for the Purkinje Effect. (In 1825, the Czech physician Johannes Purkinje [1787–1869] observed that the reds and blues of signposts seemed equally bright in sunlight, but that at dawn the blue appeared much brighter. In darkening conditions, blue will replace yellow-orange as the lightest part of the spectrum.)

While night vision and daylight vision tend to function separately, it is possible in certain circumstances to maintain both types. For the nighttime pilot of a ship or airplane, who depends on keeping his vision acute in the dark, lighting of a monochromatic (that is, of a very narrow spectrum) red hue is used for the interior of the craft. The rods on the retina are least sensitive to this color, so red light allows rudimentary cone vision without changing the state of dark adaptation. The pilot could also keep his eyes dark adapted by wearing red goggles, but these might filter out light coming from outside, and thus are not used. Black-and-white film or paper that is not panchromatic is insensitive to red light, making this light a common choice for low-intensity lighting in photographers' darkrooms.

Nocturnal animals, including cats, tend to have only rods in their retinas, since this gives them the best vision at night. Purely diurnal animals, such as birds, have principally cone vision, which gives them a wide range of information about the environment but limits them to their roosts at night. Humans, with a balance of rods and cones, have the best of both worlds.

da Vinci, Leonardo

See Leonardo da Vinci.

Dazzle

Effect that occurs when two complementary or near complementary colors of equal saturation are placed next to each other. The eye is fatigued and literally dazzled by the strength of the simultaneous contrast.

Dazzle is best achieved when the following pairs of colors are used: reddish orange with blue; cyan with orange; yellowish red with grayish blue; and red with green. Yellow and blue, although complementary, do

The dark-adapted owl. Owls possess rod vision, which gives them keen sight at night. Almost all other birds have only cone vision.

Edgar Degas.

not produce dazzle because yellow is never as deeply saturated as blue.

Dazzle is principally used as an attention-getting device, most often in advertising, in packaging, and on signs, where the information conveyed must have immediate impact. Dazzle is also called *flicker*.

Dead Color

Color that is flat, lusterless, and often characterized by a high gray content.

Death

See Mourning Colors.

Degas, Edgar

1834–1917. An impressionistic French realist painter, vivid pastelist, and sculptor who is best known for the immediacy and naturalness of his scenes of ballet dancers, horse racing, cafés, and women at their toilette. As a young man, Degas frequently visited Italy, where he was influenced by Italian masters and where he painted *The Bellelli Family* (1859), an unusual informal glimpse into family life. The greened blues, tarnished golds, blacks, and browns are typical of Degas's cool palette and his exquisite sense of tonal distribution.

Degas, a painter of "fleeting moments," exhibited with the impressionists in the historic 1874 show, but remained apart from the main group because of his strong respect for J. A. D. Ingres and the classical tradition as well as his admiration for the romantic colors of Eugène Delacroix. In his own words, Degas was "a colorist with line." Unlike the impressionists, who used pure color straight from the tube and who painted outdoors, Degas favored the intermediate colors—red-oranges, golds, pinks, and grayed blues—and worked in his studio from sketches or photographs.

Influenced, like other impressionists, by Japanese art, Degas sought to employ in his own work the irregular, asymmetrical angles of view and the decorative and graphic color applications found in Japanese prints, becoming increasingly concerned with the fine nuances and gradations of color. Toward the end of his life, however, as his eyesight began to fail, Degas used heavily saturated colors in vivid fireworks of multi-colored hatchings to define his forms. *See also* Impressionism; Japanese Color.

"One never paints violently enough."
—Eugène Delacroix

Eugène Delacroix.

Delacroix, Eugène

1798–1863. Leader of nineteenth-century French romantic painting. Described by Paul Cézanne as having "the greatest palette of France," Delacroix anticipated the impressionists in the use of juxtaposed pure pigments, frequently placing side by side hues from exact opposite positions on the color wheel to effect maximum brilliance.

In 1832, Delacroix spent four months traveling in North Africa, attached to a special French mission to the sultan of Morocco. His exposure to "the devil's sun" extended and intensified his palette as he searched for a way to reproduce the sparkling light effects found in the sub-Saharan climate. His Moroccan notebooks of drawings and watercolor sketches were to provide him with color material for the rest of his life.

The Delacroix palette is striking for its dramatic use of emerald greens, offset by lime yellows, pale blues, orange-reds, and brownish oranges. His *Women of Algiers* (1834) features a deep emerald green offset by luminous white, an almost gaudy gold, and reds from faint pinks to deep madder.

Delaunay, Sonia and Robert

Two twentieth-century artists who worked in Paris and whose paintings, graphics, and textile and costume designs focused on bright geometric patterns and simultaneous contrast effects.

Sonia Delaunay (1885–1979) was born Sonia Terk in the Ukraine. After spending her childhood in St. Petersburg (Leningrad), she moved to Paris in 1905, where she met Pablo Picasso, Georges Braque, André Derain, Maurice de Vlaminck, and Fernand Léger (1881–1955). In 1910, she divorced her first husband and married the cubist painter Robert Delaunay (1885–1941).

Robert Delaunay's initial interest in color is seen in a series of pointillist paintings from 1905 to 1907. Within a short time, the small brushstrokes had enlarged into broad colored areas and into a precocious but mature style. In 1911, he exhibited with the cubists in Paris and with the Blaue Reiter group in Germany, through which his influence spread to Paul Klee, Franz Marc, and Wassily Kandinsky. Though his emphasis was increasingly on color itself as subject matter, he was also interested in the perception of form, as is evident in a series of *Eiffel Tower* paintings of 1910–12 and 1922–28, in which he attempted to accommodate this unique architectural structure, uneasily represented by traditional chiaroscuro and perspective, into its urban surroundings. The earlier series culminated in *The City of Paris* (1912; Centre Georges Pompidou, Paris), a large painting completed in fifteen days, which typically displays his spontaneous and decisive handling of color.

Around 1912, he developed the idea of a type of painting that depended on color alone, and on color contrast. Rather than categorize the work as Orphic cubism, he preferred to use his own, wider term, *simultanéisme,* thereby acknowledging his debt to the optical color theories of M. E. Chevreul. The style is best expressed in his series of *Circular Forms,* 1912–13, in which a lack of central focus is combined with fragmented colored planes to encourage the viewer's attention to explore color comparisons across the painted surface. There is a fine example in New York's Museum of Modern Art.

Sonia Delaunay's excursions into color abstraction may be considered to predate Robert's (for example, in a quilt cover made for their son, Charles, in 1911, and collaged bookcovers for the following year). Her painting *Prismes électriques* (1914; Centre Georges Pompidou, Paris), is evidence that the stature of her work was at least equal to that of her husband's; while Robert remained almost exclusively a painter, Sonia was highly productive in many other media, notably in stage, fashion, and textile design. They worked independently on vast murals for the Paris Universal Exhibition of 1937. Following Robert's death, she worked to catalog and promote his work, prior to the prolific flowering of her own painting, until her death at the age of ninety-five. Her memoirs were published as *Nous irons jusqu'au soleil* (Paris, 1978) and their collected theories were published in English as *The New Art of Color* (New York, 1978, edited by Arthur A. Cohen). *See also* Blaue Reiter, Der; Braque, Georges; Chevreul, M. E.; Cubism; Derain, André; Kandinsky, Wassily; Klee, Paul; Orphism, Orphic Cubism; Picasso, Pablo.

della Robbia, Luca

See Robbia, Luca della; *also* Majolica.

Density

The degree of opacity of a translucent substance; sometimes also indicates the depth and saturation of a surface color.

Deprivation of Color

See Baker-Miller Pink; Color Therapy: The Body Prism.

Derain, André

1880–1954. A French artist who is best known for his fauve paintings, in which vibrant brights, particularly jarring reds and oranges, are juxtaposed in warm and cool harmonies. Born in Chatou, a small town on the Seine west of Paris, Derain's early subjects often revolve around river colors, as in his fauve paintings *Fishing Boats* and *London Bridge* of 1905 and 1906, respectively. He served in World War I and, by 1920, a muted sense of color, involving scales of grays, black, browns, olive greens, and ochers replaced his high-intensity fauve palette of 1906–1908. *See also* Fauvism.

Dermo-Optics

The study of sensitivity to electromagnetic radiation of the skin on any parts of the body; also known as extra-retinal vision. While the eye sees only the limited range of visible light, the skin may be sensitive to other bands of energy and non-visible colors. If this dermic information reaches our consciousness, there is dermo-optic perception. It is thought that fewer than one person in six may be susceptible to a dermo-optic experience, and then only after a period of training, since few people are able to turn their attention from their eyes and, literally, put it at their fingertips. *See also* Auras; Color Therapy: The Body Prism.

de Stijl

Dutch art movement (also called neoplasticism) founded by Piet Mondrian, Theo van Doesburg (1883–1931), and architect J. J. P. Oud (1890–1963), along with other artists, architects, and poets in 1917. Publishing its views in the influential magazine *De Stijl,* the movement propagated a solid Protestant philosophy of sobriety, clarity, and logic, ideals that were soon to be taken up by the international style of architecture with its simple colors and orthogonal lines.

Although not all members of de Stijl were committed to an austere and rigorous approach to color, the designer Gerrit Rietveld was effective in promoting an emphasis on primary colors. His red–blue chair of 1917 is remarkable, in part because of the exclusive use made of primary colors in conjunction with a black linear frame, a color scheme that Mondrian was not to use until 1921.

After a split with Mondrian over his introduction of anti-orthogonal elements—notably diagonals—into his work in the 1920s, van Doesburg gradually became the dominant personality in de Stijl, and the place of color became somewhat ambiguous. In a 1924 essay, van Doesburg stated that painting (and hence color) was completely reduced to industrial and architectural design: "We have established the place for color in architecture, and we declare that painting without architectural construction (that is, easel painting) has no further reason for ex-

The Delaunays—*Sonia: color in stage, fashion, and textiles; Robert: painting that depends on color alone.*

The diamond combines hardness, luster, and fire, and comes in a wide range of colors. Various cuts affect these characteristics.

istence." In this "functionalist" stance, the manipulation of pigment and line in painting was to be condemned as irretrievably bourgeois, individualistic, and anti-modern. *See also* Abstraction of Color; Delaunay, Sonia and Robert; Mondrian, Piet.

Deuteranopia

See Dichromatism.

Diamond

The hardest mineral known to man, diamonds are formed from carbon subjected to intense heat and pressure at great depths in the earth's crust. Diamonds are used in industry as an abrasive for drill heads, and for phonograph needles, but, when cut and polished, they have been particularly valued for their extraordinary diffraction of light, and so used as a gemstone (*see* Gemstones and Jewelry). The diamond is the birthstone of those born under the astrological signs of Capricorn and Aquarius (*see* Zodiac Colors).

Diamonds, in their natural state, vary from colorless, through a range of yellows and browns, to green, blue, pink, and a very rare red. Colorless diamonds, or those of strong or unusual color, are considered the most valuable. Truly colorless stones are rare; most are tinged yellow or brown due to the presence of nitrogen, or blue due to boron.

Diamonds were known and treasured in India as long as 2,300 years ago, valued for their fire—diffraction effects producing the whole spectrum of color. Since diamonds can flash any color, they were often considered in the classical world to have powers greater than any other gemstone to protect from and to cure many human maladies, both physical and mental (*see* Gemstones, Healing and). Until the early eighteenth century, India and, to a lesser extent, Borneo were the major sources of diamonds. In 1725 they were discovered in Brazil and in 1867 in South Africa. Other sources now include Siberia, China, and western Australia.

Other distinguishing features of the diamond, in addition to its supreme hardness, luster, and fire, include the way it is attracted to grease (making it easy to separate from the gravel in which it is excavated) and its tendency to fluoresce blue under X rays (by which means diamonds can be distinguished from cut-glass forgeries).

Dichroic Filter

Filter specially designed to reflect some wavelengths of light and transmit others. A conventional filter, in contrast, absorbs those wavelengths it does not transmit. The dichroic filter has multiple thin-layer coatings on one or both sides that create interference reflections with certain wavelengths. The coatings can be made to transmit much more exact, narrow-band portions of the spectrum than are possible with dyes and other absorptive agents, making dichroic filters valuable in scientific instruments using light, such as lasers. Moreover, a dichroic filter is heat resistant and is not subject to fading under very bright light.

Dichroism

Color phenomenon in which certain fluids or transparent objects change color depending on how deep or thick they are. Red blood, spread in an extremely thin film on a microscope slide, will appear yellow, yet in the quantities that we are used to seeing it, it has a deep vermilion color. Chartreuse liqueur appears green as a thin film around the edge of a glass; a full container of the liquid looks red in color.

Dichromatic, Dichromic

Having or showing two colors.

Dichromatism

A form of color blindness in which a person has trouble recognizing or, in some cases, is completely blind to one of the three primaries (red, green, and blue) seen by people with normal (trichromatic) vision.

The three main types of dichromatic vision are:

1. Protanopia, in which the subject is less sensitive than the normal person to long-wavelength light and so is effectively "red-blind." Reds, oranges, and yellows are confused with greens; colors are matched with mixtures of blue and green only.
2. Deuteranopia, or "green blindness," in which the subject confuses green with red and matches all colors with yellow and blue light. This is by far the most common kind of color blindness, with about 8 percent of the population, usually only men, being sufferers.
3. Tritanopia, or "blue blindness," the rarest form, in which the subject matches all colors with red and green light.

See also Color Blindness.

Diffraction

The spreading of a light wave that occurs when it meets an obstacle or passes through an aperture. This effect becomes significant

when one is working on a microscopic scale. When light passes through a slit in a screen, with an aperture of no more than a few wavelengths, it spreads out on the far side of the screen. The most important feature of this is that the shorter wavelengths are deflected more than the long wavelengths; consequently, the light will be spread out into its constituent colors.

With the use of a diffraction grating—an array of parallel slits—the effect can be magnified thousands of times. A grating will produce a visible spectrum of color, just as a prism does. The points of peak energy of light waves, spreading out from each slit, will be augmented where they meet and combine with the peaks of neighboring light waves. Peaks will be canceled where they coincide with troughs of low energy. The result of this wave interaction is a bright spectrum, which can be seen reflected from a white surface. A diffraction grating produces a spectrum in the reverse order of a prism. It has come to supersede the prism for optical instruments because it produces an evenly spread spectrum, whereas the prism distorts the reds in comparison to the blues. *See also* Astronomy and Color; Interference.

Diffusion

The scattering of light from a more or less uniform path into many different directions. It occurs when light is reflected from an unpolished or matte surface or when it is transmitted through a translucent material. Diffusion has the effect of softening and lightening color, since other wavelengths are randomly mixed with the perceived color, much as if white was mixed into a paint. Diffusion from a surface can be reduced by painting the surface with a gloss varnish (this will tend to deepen the color).

Diffuse light is sometimes used to illuminate paintings in order to reduce the distracting effects of glare, or in photographic studios to soften forms, details, and harsh shadows. Light from the sky (rather than direct sunlight) is naturally diffuse and can be realigned by the use of a polarizing filter (*see* Polarized Light).

Digitization of Color

A modern technique for breaking down a color image into a sequence of electronic signals, which can then be transmitted by wire or through the air (with electromagnetic pulses) to be reproduced by a printer or on a television screen. The optical image is scanned one point—or pixel, short for "picture element"—at a time by a charge-cou-

pled device (CCD), a silicon chip covered with light-sensitive receptors that transmit a digital record of the color and the varying intensities of light onto magnetic tape or computer disks. The color is analyzed through three dissections in which the image is focused in succession through red, green, and blue filters onto the CCD.

The size of the pixel depends upon the scanning system used, although it is generally smaller than 0.01 inch, the size at which the eye can no longer distinguish detail at normal viewing distances. At the same time as it records the color, the CCD also records the brightness or density of light at each pixel. The information is immediately converted to binary numbers—digits. Information in this form can then be processed by a computer for image enhancement, easily transmitted at very high speed over vast distances with no loss of definition, or used to control simultaneous (real-time) reproduction systems.

Digital codes are turned back into optical images in three major ways: on a television screen—an electron gun, controlled by the digital signals, fires electrons at each phosphore dot on the screen, in turn causing them to glow to a required intensity; on photographic prints or films, which are exposed by a scanning laser beam; or by ink-jet printers, which deposit points of ink in replication of the pixel-scanning pattern. *See also* Computers and Color.

DIN-Farbenkarte (Color System)

See Systems of Color.

Discharge Lamp

See Lighting, Artificial.

Disney, Walt

See Motion Pictures, Color in.

Dispersion

The separation of the wavelengths that constitute a beam of light. It is the result of refraction rather than diffraction or interference. Dispersion occurs only with light that strikes a transparent material (such as water or glass) at an angle; each wavelength is bent off course to a different extent as it enters the medium. The result of this is the phenomenon of white light being broken up into its constituent colors. This effect is not marked enough to be visible when, for instance, light hits the surface of a pond. However, a specially shaped glass object like a prism will increase the dispersion to such an extent that a wide spectrum can be seen. The

most familiar type of dispersion is enhanced dispersion, which produces a spectrum when white light is passed through a prism. Lenses also produce dispersion because their curved surfaces ensure that almost all light strikes at an angle; the result is chromatic aberration, causing colored rings to appear on the edges of images, which can be corrected only by adding lenses of opposite curvature. *See also* Aberration; Diffraction; Interference; Prism; Refraction.

Distressing

Artificial aging of furniture or interiors for aesthetic effect. Achieved by reproducing with paint or stains (or even with sandpaper or acid) the normal discolorations that occur over time due to the effects of sunlight, water, and daily wear and tear. *See also* Trompe L'Oeil.

Dominant Wavelength

Describes the wavelength of a pure spectrum color that, when mixed with a particular proportion of white light, matches the color of the object or light source having that dominant color. Since colors can be produced by many different combinations of colored lights (for example, a yellow light can be produced by a mixture of red and green lights), the dominant wavelength of a color may bear no relation to the colors predominantly in its spectral composition, such as those most intensely emitted by, reflected from, or transmitted through it.

Purple light, made by mixing red and blue light, is a special case, since it cannot be matched by the mixture of any spectrum color with white light. It is said to have a complementary wavelength instead of a dominant one. This is defined as the wavelength of the pure spectrum color that, when mixed with purple light, produces white light.

While it is possible to obtain materials that transmit only small parts of the spectrum, eliminating all the rest, in practice this is rare. For example, a yellow glass or pigment will ordinarily transmit the red, orange, yellow, and green rays, and absorb only the blue and violet wavelengths; with green, only red and violet are completely absorbed; and with blue, red and yellow are absorbed. Other wavelengths are only partially absorbed. In general, when one hue is removed from the spectrum of white light, its complementary will become dominant.

Drugs and Color

See Psychedelic Colors.

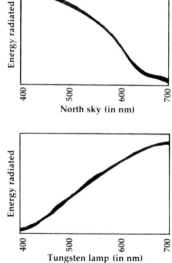

The dominant wavelength is generally in the most intense part of the spectrum: for north sky light (top), it is blue; and for a tungsten lamp (above), it is reddish yellow.

Ducos du Hauron, Louis

1837–1920. French inventor and photographer, born at Langon Gironde and based in Paris and Agen. In 1862, he devised the "mélanochromoscope," an early system of color photography involving the superimposition of three additive primary-color images.

In 1869, in Paris, he published *Les Couleurs en Photographie*, the first treatise to promote a three-color subtractive process:

> Thus one might consider a picture which represents nature as composed of three pictures superimposed, the one red, the second yellow, and the third blue. The result of this would be that if one could obtain separately these three images by photography and then reunite them in one, one would obtain an image of nature with all the tints that it contains.

A very similar solution to the problem of color in photography was proposed independently by Charles Cros, also in 1869. Technical limitations prevented both Cros and Ducos du Hauron from advancing further at that time. Ducos du Hauron experimented with lithographic printing techniques, but eventually produced the first genuine color photograph by the subtractive process in 1877. He subsequently invented a two-color bi-pack system, thereby anticipating almost all improvements in color photography since that time. *See also* Lumière, Auguste and Louis; Photography.

Dun

A dull, grayish color.

Duotone

Term used to describe a single-color photograph that has been converted into a two-color halftone by a photomechanical process. The standard duotone is produced by making two images of somewhat differing strengths of the original photograph, and then superimposing the black image over the first image, which can be printed in whatever second color is preferred. Duotone printing tends to accentuate the highlights, giving the photograph greater depth and three-dimensional quality.

Dyer's Plants

See Dyes and Dyeing.

Dyer's Rocket

An annual plant of the *Resedaceae* family, and source of a yellow dye used in the Middle Ages; it grows wild throughout Europe.

Known also as *herba de Pulea,* dyer's mignonette, yellow weed, or *herba gualda,* the plant contains the coloring substance luteol. It can be applied to wool or silk, usually first mordanted with alum.

Dyer's Yellow

See Reseda.

Dyes and Dyeing

Dyes are coloring agents that dissolve in a medium, leaving no trace of coloring matter. By contrast, pigments are coloring agents that are not soluble in the vehicle or medium with which they are combined to make paints.

In dyeing, the entire support is colored, rather than only the surface, as is the case in painting, varnishing, or analogous processes by which a surface layer is made to adhere to the support, thus covering up the original color of the support itself. Supports that can be dyed include textiles, fibers, paper, and wood.

Not all coloring agents are suitable for dyeing all supports. When the coloring–support system is established, it can be said that a dyeing "affinity" exists. When this affinity or attraction is so pronounced that all of the coloring agent initially present in the dye bath is transferred onto the support, then the dye bath has been "exhausted."

Where there is little or no affinity for a given support, the coloring material can sometimes be fixed onto that support by means of a mordant. Examples of mordants are potassium alum and iron salts.

History of Dyes

Historic Plant Dyestuffs. The earliest known dyes, produced from plants, were indigo, madder, and woad. The woad plant (*Isatis tinctoria*) is one of the oldest sources of blue dye. Thought to have originated in southern Europe, it was, however, also grown in ancient China. It was discovered early that the young woad leaves produced a light blue dye, and that mature leaves yielded a bluish black pigment. Woad was the principal blue dye in Europe until the introduction of indigo in the sixteenth century. Preparation of the dye included pulping the plant, and then drying, powdering, and fermenting the pulp, reducing it to a paste. The indigo plant (*Indigofera tinctoria*) is native to India. The historic origin of the complicated process of fermenting the leaves and reducing and reoxidizing the dye is not known.

Madder, a deep red dye, was used very early in India and was known to the ancient Persians and Egyptians. Cloth dyed with red madder has been found on Egyptian mummies of the pre-dynastic era. The dye is extracted from the roots of certain species of madderworts, particularly "dyer's madder" (*Rubia tinctorum*)—known as *lizari* or *alizari* in Asia Minor, from which the modern name of the dye, alizarin, is derived. Alizarin was produced synthetically in 1869 by Karl Graebe (1841–1927) and Karl Liebermann (1842–1914), assistants to the renowned chemist Adolf von Baeyer (1835–1917), and it completely replaced the natural dye within a decade. Madder tended to produce a dull terra-cotta, unlike the brilliant scarlet obtainable from kermes. An elaborate dyeing process was used in the Middle East to produce a bright red madder known in the West as Turkey Red, but the technique remains a lost secret to this day.

Yellows came from various flowers and were not very fast in color. The ancient Greeks extracted saffron, their main yellow dyestuff, from the stigmas of a fall-flowering crocus. Other yellows came from safflor (also a rose-red, resulting in a "ponceau" or poppy color) and weld. Various other dyes were brought from the New World in the sixteenth century, including the bright red of nine varieties of brazilwood and the deep black of logwood. Logwood is still used to a certain extent today for black, being very rich and colorfast, and, up to a few years ago, for "school red ink"—reddish purples and violets being produced by the addition of alkalis.

Few natural dyes are used today, because of their relative expense and lack of colorfastness. Some dyers, however, most notably the makers of Harris tweed, still prize the uneven and rich color effects obtainable from plants. The traditional Harris colors include orange from ragweed (*buaghalan*), green from heather (*fruoch*) or iris (*seilister*), red from lichen scraped off rocks (*corein*), and yellow from bracken roots (*rainnech mor*) or peat soot (*crotal*).

Historic Animal Dyestuffs. The best-known animal dyes include a mollusk-derived purple and an insect-derived red. The purple dye was extracted from the gland of either the murex or purpura shellfish. Made in Crete as early as 1600 B.C., it became an important product of the Phoenicians in Tyre (after which the dye was named—*see* Tyrian Purple) and was also manufactured in Tarentum and Palermo in Italy. It has been calculated that it took 20,000 shellfish to dye one square yard of fabric, making Tyrian purple enormously expensive and thus reserved for the highest echelons of society since Roman times. Depending on dyeing

Traditional sources of plant dyes.

Indigo plant.

Logwood tree.

Fustic tree.

Safflower plant.

"White-blue, blue-about-to-be-born, pale blue, bleu mignon [delicate blue], Queen's blue, turquin blue, King's blue, guelf blue, greenish blue, aldego blue, and blue of hell."
—List of available dyes, published by French dyer M. Colbert in 1669

time and the type of shell or mixture of shells used, shades varied from deep violet to even a reddish black. This purple was largely replaced by reds from the kermes louse, the cochineal insect, and the madder root in the fifteenth and sixteenth centuries.

Of equal antiquity is kermes, from the insect kermes, or *Coccus ilicis* (called *qirmiz* in Arabic). Long thought to be not an insect but a scarlet berry, kermes was dried and ground to powder and used to dye wool, silk, and leather. In 1464, Pope Paul II decreed that "cardinal's purple" be produced from this source alone, marking the transition to the use of red as the color of the highest in liturgical vestments. Cochineal, also an insect, was brought back by the Spanish conquistadors from Mexico, and quickly replaced kermes.

The following is a list of the most important natural dyes used prior to the invention of synthetic dyestuffs:

Annatto: from the pulpy part of the seed of a West Indian plant *(Bixa orellana);* fugitive orange-red color.

Brazilwood: from the wood of the tree of the same name *(Caesalpinia echinata);* bright red color.

Cudbear: from the lichen *(Lecanora tartarea);* lilac color.

Cutch (or catechu): obtained by boiling the wood of the acacia *(Acacia catechu)* tree; rich brown color.

Fustic (old): from the wood of a tropical American tree *(Chlorophora tinctoria);* gold to yellow in color; still popular for wool dyeing.

Fustic (young, or zante): from the powdered wood of a shrub-like cashew tree *(Rhus cotinus);* yellow to dark olive in color.

Indigo: from the plant of the same name *(Indigofera tinctoria);* blue color.

Kermes: extracted from the body of the female of the tiny insect *(Coccus ilicis);* red color.

Lac: obtained by boiling tree incrustation produced by lac insect *(Tachardia lacca);* bright red color.

Logwood: comes from a Central American tree *(Haematoxylon campechium);* a purple color on wool, a blue-black on cotton, and violet and black on silk.

Madder: from the root of the plant of the same name *(Rubia tinctorum);* red color also known as alizarin (now synthesized).

Orseille: obtained from the lichen *(Lichen rocella tinctoria)* found on the rocks of Mediterranean islands; reddish purple color.

Quercitron: obtained chiefly from the inner bark of the black oak *(Quercus nigra);* brown to yellow colors.

Recent Developments. In 1834, German chemists noticed that aniline, one of the products resulting from the distillation of coal tar, became a bright blue when bleaching powder was added to the substance. A generation later, in 1856, the English chemist William Perkin (1838–1907) synthesized the first aniline dye—popularly known as mauve, after the French name for it—a color so celebrated that it later gave its name to an era (the 1890s). In 1858, Perkin's teacher at the Royal College of Chemistry, William Henry Hofmann, discovered aniline red, referred to as both fuchsine (after the bright blue-red flower fuchsia) and magenta (after a battle fought in northern Italy in 1859). Aniline blue, violet, and green followed quickly.

Soon after, the azoic dyes were discovered by a brewery chemist, Peter Greiss, in 1858 and perfected by Robert Holliday in the 1880s. The last fundamental dyestuff discovery was in the 1950s, leading to the introduction in 1955 of fiber-reactive dyestuffs. For the first time, it was possible to attach a dye to a fiber by chemical bonds far stronger than the physical means previously used.

The following is a list of the major modern synthetic dye groups descended from these:

Basic or cationic dyes: The first synthetic dyes, developed by Perkin and Hofmann from coal tar, use an organic base that is soluble in acid. Colors produced are particularly bright and pure on animal fibers such as wool and silk, but are not very colorfast, so they are used little today except for brightening shades or for dyeing paper, wood, leather, and straw. Some basic-dyeable variants of nylon and polyester developed recently have shown brilliant colors and exceptional fastness with these dyes.

Direct dyes: Successors of basic dyes, these obviated the need for mordants in dyeing cotton. The first, a "sun yellow," was discovered by a Geigy chemist in 1883, and the more important "Congo red" was discovered by a German scientist, Boettiger, in the following year. Although the colors obtained are not so brilliant, they do have better colorfastness under exposure to light and, with certain after-treatments, to washing. Direct dyes are still used on cotton, rayon, wool, silk, and nylon.

Acid dyes: Dyes that have no natural (organic) prototype, these are produced by combining basic dyes with sulfuric and nitric acids. The first was "Bismarck brown" in 1862, followed by many others in the 1870s and 1880s including "Biebrich scarlet," a successful replacement for cochineal. Acid dyes give bright and pure colors, and are

simple to apply to wool, silk, and nylon, but require the use of a mordant for cotton and linen. Important dyes for knitting and rug yarns and for nylon carpeting, their rather uneven colorfastness can be improved by the addition of metallic salts—especially chrome (as in chrome dyes)—in after-treatment. Premetallized dyes are acid dyes that are already complexed with metallic ions to improve colorfastness, for use on nylon and wool.

Sulfur dyes: These dyes provide very deep shades with excellent resistance to washing but not to sunlight. They dye cotton, linen, and rayon, but not brightly. The tendency of sulfur dyes to weaken a fabric can be counteracted by neutralizing the acids within them with alkalis.

Azoic dyes: Used primarily to produce the bright reds for dyeing and printing that cannot be achieved with other dyes, these dyes (also called naphthols), pioneered in the 1880s by Robert Holliday in Huddersfield, England, are actually produced in the fabric—usually produced in two stages, first by treating the cloth with a naphthol solution and then printing with a diazo solution. The oldest azoic dyes are "Para red" and "Naphthylamine Bordeaux," both as bright as Turkey red. Still used, azoic dyes have to be carefully applied and well washed or they have poor fastness to rubbing and crocking. Many bleed in dry-cleaning solvents.

Vat dyes: The best-known type of dye used today, because of its excellent all-around fastness on cotton and rayon, the term derives from the old method of dyeing indigo in a vat. The most successful vat dye was the first synthetic indigo, discovered by Adolf von Baeyer in 1880. Like indigo, vat colors have to be reduced to a soluble form, losing their original color in the process. They regain their color when applied to the fabric and are oxidized. Vat dyes are made from indigo, anthraquinone, and carbazol, and can be used on cotton, linen, rayon, silk, and sometimes nylon. Vat dyes can also be used in the "pigment application process," in which the dyes are reduced only after they have been applied to the fabric, a cheaper process. There are no bright red vat dyes.

Reactive dyes: The most recently invented dyestuff, it was first marketed by ICI under the name "Procion dyes" in 1955. Because these react chemically with cotton, viscose, linen, wool, and silk, they are colorfast during washing. They can be dyed and printed by many methods and, for the first time, the whole spectrum of color can be put onto cloth using just one class of dyes.

Disperse or acetate dyes: Originally developed for dyeing cellulose acetate fibers, these dyes are relatively insoluble in water and are prepared for dyeing by being ground (in a colloid mill) into a relatively fine powder in the presence of dispersing agents. In the dye bath, a colloidal suspension of the dye particle dispersion produces a very dilute solution of the dyes, which are then absorbed by the fibers. Used to dye polyester, nylon, acetate, and triacetate fibers.

As has been indicated above, for proper coloration and colorfastness, the right dye has to be used for each fabric. The following is a list of the major fibers with the class of dyestuff for which each has an affinity:

Acetate	Disperse dyes
Acrylic	Basic dyes
Acrylic (modified)	Acid dyes
Cotton	Direct, sulfur, azoic, vat, and reactive dyes
Linen	Same as cotton
Nylon	Acid and disperse dyes
Nylon (modified)	Basic dyes
Polyester	Disperse dyes
Polyester (modified)	Cationic and disperse dyes
Rayon	Direct and vat dyes
Rayon (modified)	Acid dyes
Silk	Direct, acid, and reactive dyes
Wool	Acid and premetalized dyes

Methods of Dyeing

The method used for dyeing textiles varies according to both the dye used and the fiber being dyed. In general, there are three ways a fabric can be so colored: by dyeing the fiber before it is woven (as in stock dyeing); by dyeing the fabric (as in piece dyeing); or by printing the dyes onto the fabric (as in fabric printing). The following are five methods used to dye fiber or fabric in volume:

Stock dyeing: method used to dye the staple fibers (stock) before they have been spun or blended. It is used for producing mixtures, heathers, and other complex color effects. The expression "dyed in the wool" originated with this technique, and reflects the depth of dye penetration that can be achieved. Originally, the fiber mass was dropped directly in a dye bath and stirred

The Puritan indigo tub.

"For color, the simplest and most at-hand expedient was a dip in the universal indigo tub, which waited in every 'back shed' of the Puritan homestead. One single dip in its black-looking depths and the skein of spun lamb's wool acquired a tint like the blue of the sky. Immersion of a day and night gave an indelible stain of a darker blue, and a week's repose at the bottom of the pot made the wool as dark, in time, as the indigo itself."
—*A description of dyes used in Colonial times (extracted from Wheeler 1921)*

by hand; this has been largely superseded by rotary-drum machines, which hold the fibers while turning them in the dye.

Solution dyeing: man-made fibers dyed while they are still in a liquid state (solution or melt) and before they have been extruded through a spinneret. Color in the form of soluble dyes or pigments is added to the solution. This system offers guaranteed uniformity of color, whereas traditional methods fluctuate in results between dye lots. The best colorfastness can be achieved through the use of pigments.

Top dyeing: method generally associated with worsted cloths. The fiber is combed into slivers and wound into circular tops, then placed in tanks where dyes are pumped over them. The tops can subsequently be blended together to produce special color effects similar to those obtained in stock dyeing.

Yarn dyeing: ancient method of winding yarn into skeins, which are then revolved through a tank of dye solution (now done on a machine resembling a Ferris wheel). Yarn can also be wrapped on perforated spools, through which the dye is then forced. Color-space dyeing, similar to tie dyeing, involves the coloring of yarns at intervals spaced along the yarn length. This technique has long been used in the Middle and Far East; the Javanese, for instance, until recently used tie-dyed yarns for the warp and weft of fabrics to produce a diversity of interesting and popular patterns. Color-space dyeing flourished in seventeenth- and eighteenth-century Europe. Modern techniques include multi-colored, cycle-dyed, or ombré yarns.

Piece dyeing: method preferred today, since converters (companies that buy unfinished or undyed fabric and color them for resale) do not have to invest heavily in pre-dyed fabric, can dye fabric according to their own need, and thus can be more responsive to changing fashions. Techniques of piece dyeing include (1) *beck dyeing,* a continuous process in which the cloth is passed in rope form through a dye bath (dyeing can be repeated as often as necessary to achieve desired intensity of color); (2) *jig dyeing,* also a continuous process, in which the fabric is passed from one roll, through a dye bath, onto another roll, backward and forward until correctly dyed (used for any fabric, such as satin or taffeta, that will wrinkle or show cracks if beck-dyed); (3) *padding,* in which the fabric is passed at full width through rollers, which squeeze dye onto the fabric and then remove excess liquid; (4) *pressure-jet dyeing,* used for continuous-filament polyester yarn (especially in knits), in which the dye is delivered through high-temperature pressure jets.

Two or more color effects similar to those obtained in stock dyeing can be achieved in piece dyeing by either the union or cross-dyeing methods when blends or combinations of different fibers are used. This is in contrast to the unblended fibers, which tend to have an affinity for only one class of dyestuff. Economical means of multi-color dyeing have been aided by the use of nylon, polyester, and acrylic fibers, which dye with different classes of dyes. In the union-dyeing method, dyeing is done in a one-bath process by which the same color can be imparted to the different fibers by using two different kinds of dye in one bath. In the cross-dyeing method, the cloth is passed through two dye baths with different dyes, each with an affinity to one of the fibers. In this way, polyester, for example, in a polyester/cotton blend, can be dyed red with disperse dye, leaving the cotton to be dyed blue with a direct dye. In some cases, this two-color effect can be achieved in a single bath.

See also Fabric Printing.

Dyschromatopsia

General color deficiency in vision. *See also* Color Blindness.

Earth Colors

See Natural Earth Pigments.

Ebony

A deep, lustrous black; from the hard, heavy, durable wood of the same name, of which the most valuable grades are black.

Ecru (also Beige and Greige)

Ecru, beige, and greige (all three French words) originally referred to the color of the cloth in its raw, unbleached state. Ecru comes from the Latin *crudus*, "raw" or "crude," and referred to unbleached cloth of any kind—silk, cotton, wool, or linen. Beige is from an old French dialect in which it means "gray" and referred specifically to woolen cloth, while greige referred to raw silk. These dyehouse terms became fashionable in the nineteenth century. Currently, beige is commonly used, and describes a pale to grayish brown with a tinge of yellow.

Education, Color

In both academic and art schools, color is almost invariably taught only as part of another subject. Initially, a nursery school child learns about color by naming objects or playing with crayons or poster paints. In art schools, the use of color is taught as part of textile, theater, or interior design courses and in photography, graphics, painting, and other studio art courses. A few schools offer fundamental design courses devoted solely to color theory. Teaching color as a subject in its own right is, by and large, very rare. It is for this reason that color education in schools embraces two very different endeavors. In an academic institution, color education is part of the nurturing and the evaluation of the growing child; in an art school, color theory is part of the training of future designers and artists.

Children and Color

From roughly the age of two, even before a child can easily wield a crayon or a paintbrush, color becomes part of his or her life. Educators consider art, of which color is usually the main ingredient, an important element of an individual child's expression and growth. In the pre–grade school years, color choices and manipulations are regarded as sure indicators of a child's future development. Two art therapists who have done extensive studies in the field claim that color, "more than any other aspect of painting, has been of particular value in offering clues to children's emotional life" (Anschuler, Hattswick, 1947).

Very young children express clearly, in the colors of their artwork, color symbolism at a primitive level. Thus, a child under four years of age who favors warm, luminous reds, oranges, and yellows is described as "sympathetic with others," "dependent on others for affection," "cooperative," and "well adjusted." Those children who favor cool blues and greens tend to be "led through intellectual interests," "selfish," "determined," and loners. Using black seems to be a sign of a troubled state in a nursery school child. Red used freely shows an uninhibited love of life, but when applied violently or defiantly, the same red poster paint may reveal either hostility or a desire for affection. Blue seems to indicate a "controlled anxiety," and a household with a new baby in it often results in an older sibling painting in blue. Yellows indicate a happy and carefree child. A child characterized by self-restraint, who is self-sufficient and self-confident and has a high degree of emotional balance, tends to paint in green. Brown, not a popular color, may be associated with the desire to smear. Orange is a favorite with the good adapters, the even-tempered children. There is little interest in purple among very young children, except at holiday time, when it is used for Easter decorations.

Blends Show Spontaneity

Intermingling of colors tends to be done by freer, more spontaneous children. Indiscriminate mixing or smearing, on the other hand, indicates a lack of development. Overlaying of colors is interpreted as an attempt to conceal emotions. Thus, the nursery school child who consistently paints one color over another reflects in the uppermost color his or her overt behavior, and in the underlying hue the feeling he or she wishes to hide.

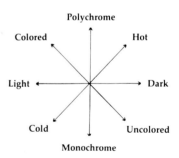

Different aspects of color appearance which need to be taught to children.

Preferences for particular colors usually indicate developmental stages. From four to five years of age, there is an increase in preference for blue and cool colors and a decrease in preference for red and warm colors. This basic shift from warm to cool and from red to blue, plus the use of more secondary colors as well as green, is an indication of greater social conformity and increased intellectual awareness.

Teaching Color

The color experience of a typical grade-school child largely centers on poster painting and cutting and pasting colored paper. By high school, most students will probably have some instruction in a color wheel and some understanding of watercolors and acrylic and tempera paints. The more art-oriented students will receive instruction on how to use colored glazes in ceramics. Color experience for high school pupils is gained largely through studies of still lifes.

It is in art school and interior design schools that a student is most likely to encounter formal color training. Of the Bauhaus instructors, the programs of Johannes Itten and Josef Albers are most often used as models. Itten's *The Art of Color* (1973) is particularly well suited for teaching future designers. The book's color instruction explores various color schemes (complementary, analogous, monotone), chromatic and tonal distribution, and principles and historical examples of color harmonies. The idea is that if a student can manipulate color systematically as set forth in Itten's seminal work, he or she will be able to create particular color ambiences.

The most influential color theoretician for studio art students is Itten's Bauhaus colleague Josef Albers, who himself was an abstract painter. Albers's teachings extended to generations of artists in Europe and the United States, from roughly the 1920s through the 1960s. His color lessons focused on color as "the most relative medium in art." In *The Interaction of Color* (1963), he proposed an experimental, hands-on approach, which subsequently determined in large part how color would be taught in art schools.

Studying color systems was not the issue, Albers claimed. Studying the "innumerable readings" of one and the same color in different contexts was. Instead of applying rules of color harmony, Albers taught his students through color manipulations, by trial and error, to gain "an eye for color." To Albers, such an eye meant seeing how colors related to one another and how the "interaction" of various colors changed the human

perception of a surface. Color demonstrations replaced all theory. To show the relativity of color, Albers led his students through a series of exercises such as making a green or red appear lighter or darker by using different backgrounds (*see* Simultaneous Contrast). He claimed: "This way of searching will lead from a realization of the interaction between color and color to an awareness of the interdependence of color with form and place; with quantity . . . with quality . . . and with pronouncement" (Albers 1963).

Paper as Color Tool

Albers taught with colored papers rather than paint. He preferred paper for practical reasons. Paper provided a ready, inexpensive, and duplicable range of shades and tints. Colored paper, by not exposing a student to the failure of mixtures and imperfect matches, kept a student's interest active. Moreover, colored papers allowed for the use of precisely the same color without the slightest change. To work in paper, Albers pointed out, required only minimal materials —paste, a single-edged razor—and was therefore cheaper, easier, and more orderly. Furthermore, paper eliminated the unnecessary addition of so-called texture and the intricacies of brushwork.

In contrast to Albers's precisely controlled method is that of the nineteenth-century art critic John Ruskin. His approach is still very much a part of traditional art education. Art and color educators are by and large in agreement that nature is an excellent teacher of aesthetics and harmony. Some of the clearest and most elegant statements on how nature instructs in color usage were given by Ruskin. According to him, the power of painting lay in the artist's ability to recover the innocence of seeing: "that is to say, of a sort of childish perception of these flat stains of colour. . . . Colour rendering is really an art of seeing. Very few people have any idea that sunlighted grass is yellow. . . . The quantity of purple and grey in Nature is, by the way, another subject of discovery. . . ." For Ruskin, nature was a superb color guide and ultimately the supreme aesthetic and artistic arbiter.

> No color exists in Nature under ordinary circumstances without gradation. . . . Give me some mud off a city crossing, some ochre out of a gravel pit, a little whitening, and some coal-dust, and I will paint you a luminous picture, if you give me time to graduate my mud, and subdue my dust: but though you had the red of ruby, the blue of gentian, snow for the light, and amber for the gold, you cannot paint a luminous picture, if you keep the masses of those colors unbroken in purity and unvarying in depth (Herbert 1964).

"Not only can color, which is under fixed laws, be taught like music, but it is easier to learn than drawing, whose elaborate principles cannot be taught."
—Eugène Delacroix

Ruskin argued that the discernment of color was the final test of human intellect and culture:

> The man who can see all grey, and red, and purples in a peach, will paint the peach rightly round, and rightly altogether; but the man who has only studied its roundness may not see its purples and greys, and if he does not will never get it to look like a peach; so that great power over colour is always a sign of large general art-intellect (Herbert 1964).

Two Bauhaus teachers, Paul Klee and Wassily Kandinsky, contributed to the less widely accepted notion that color education should concern the psyche and the mystic plane. Kandinsky wrote about color vibrations stirring within the human soul. Red rang inwardly; green lay in quietude and immobility; yellow moved outward; and blue moved in upon itself. According to Kandinsky, color education must encompass the spirit of man as well as the eye.

Color's Hidden Realities

Paul Klee, in *The Thinking Eye* (1961), addressed the idea of color as a pulsating force of opposing energies. Complementaries, opposites on the color wheel, intrinsically have the most dynamic relationships; gray, a shade composed of opposites, represents a resting point of equilibrium. Employing diagrams of the topology of color relationships, Klee depicted the energy of color in forceful line drawings. Like the images in his paintings, textured and slightly askew, the diagrams in *The Thinking Eye* suggest a hidden and fluctuating reality below the surface. His approach, like Kandinsky's, was almost mystical and attracted those given to esoteric teaching.

Color education, running the gamut from the nursery school teacher observer to Kandinsky's spiritual color vibrations, is an incredibly broad and layered subject. Ultimately, color education rests on the cultivating of man's perceptual, linguistic, and aesthetic sensibilities so that the very quality of his life is enhanced. *See also* Bauhaus.

essay

Education, Color: A Frog's Eye View

The following piece by Michel Albert-Vanel examines how an alternative viewpoint can help the student to understand and explore the color world he or she sees but too often takes for granted. It is a relatively simple matter to teach the basic elements of color mixture, but more problematic to develop powers of observation and to communicate the subtlety and complexity of color.

> "It goes without saying that a garden seen by a man and the same garden seen by a frog have extremely different structures. Each of these two beings sees contrasts where the other does not; consequently, they each pick out what is real to them in their own manner, so to speak"—Bernard D'Espagnat, *In Search of the Real*

The garden in the above quotation is a complex structure, which could be represented by many different parameters. Each species, however, sees only those parameters that provide it with useful information. A human being will see trees, grass, and colors; a frog, whose eyes respond above all to movement, will see flying insects and not the static structure of its environment.

One may compare the student to the frog: The student already has a practical conception of color, and is more interested in its beauty, the magic of its combinations, its movement, and its infinite complexity. But the teacher gives him only a theoretical and static point of view, churning out Cartesian formulas—that Holy Trinity of Hue-Value-Chroma, the Munsell or Ostwald systems, the CIE diagram, and so on. These can only puzzle the student.

There is a problem in man's fundamental capacity to recognize but three dimensions at one moment. For example, out of a projected twelve dimensions to the universe, we can only see three: length, breadth, and height (even the fourth dimension, time, seems an abstract idea). With only three parameters, man operates under the illusion of grasping reality.

Color systems, too, have only three dimensions, and generally disregard material, transparency, brilliance, scale, the proximity of other colors, and so on. A classification works if colored samples are chosen in accordance with the system: Fluorescent material, for example, cannot be included. This is akin to the alchemist classifying the world into elements of earth, water, and air, or the naturalist classifying animal species according to whether they walk, fly, or swim. The result is what has been called the failure of the small-square method, the technique using small swatches of color to create color systems and to study color interaction that evolved during the prime Bauhaus years. The student is left with the confused feeling that these systems confine him or her within a very restrictive universe, which in turn does nothing to explain color in all its richness and complexity.

The reality of color could be described, like the garden, as a complex universe in which a great many different qualities interact. A

Eggplant: *One of the richest colors to be found in the natural world.*

workable color-order system would resemble a shapeless, multi-dimensional, cloud-like mass. This could be known as the Planetary Color System (*see* Planetary Color System). Such a system would allow the teacher to select individual criteria from this cloud and combine them as required. Criteria could include the obvious ones—hue, lightness, and saturation—or new relationships—multi-color, transparency, brilliance, and so on. Any three dimensions could be selected to form a recognizable three-dimensional space.

Three principal categories of criteria can be used. Each represents a scale; for example, the gray scale of light to dark:

1. *Strict chromatic criteria*
 Yellow Blue
 Green Red
 Light Dark
 Saturated Neutral
 Polychromatic Monochromatic

2. *Formal association criteria*
 Mixtures Juxtaposition
 Dispersion Concentration
 Diffused Pinpoint
 Eccentric Concentric

3. *Light/material criteria*
 Light Pigment
 Transparent Opaque
 Shiny Dull
 Smooth Grained

To these criteria could be added the context in which they are used: abstract, figurative, or three-dimensional forms. (If the teacher insists on a physical representation, he or she can take any of these parameters, three by three, to create rich and original associations.)

While this system emphasizes the temporary and multi-dimensional status of color, it can never succeed perfectly: Color is never uniform, isolated, or fixed. It is relative—relative to the ambient light, a material, our perception, another color, distance, the weather, and so on. Finally, it is necessary to consider color's powers of communication—the semantic space, wherein color is not an isolated point, but also part of a wider entity, an entity that conveys meaning to us. A painting, an article of clothing, and a landscape are examples of such entities. In each case, color modifies our perception of an object in extremely subtle ways (*see* Communication and Color). It is in representing this mutually dependent relationship that visual art itself can falter. Artists have long since mastered the means of creating an impres-

sion of volume on a flat surface (*see* Chiaroscuro) and even of perspective (*see* Aerial Perspective)—but by doing so, he or she must "imprison" the color in a tight format, with carefully devised harmonious progressions and in pleasing proportions. However, serving only to convey visual effect, color becomes a victim of its own vacuousness.

Blaise Pascal (1623–62) may have been right in saying: "How vain painting is to attempt to portray on a flat surface what exists in real life" (Wright 1852). The teacher can only hope to open the eyes of the student to the world around him or her by breaking down the dimensions of color and studying them one by one. Only then can they be seen as a whole, only then can they be reproduced in all their complexity, and only then can new, unexpected associations be discovered.
—Michel Albert-Vanel

Eggplant

The dark rich purple color of the vegetable eggplant.

Eggshell

A translucent off-white; a slightly warm white; perennially popular for interior decoration. Eggshell blue is a pale blue, with a similar translucent quality, that was popular in the nineteenth century. The color was taken from Chinese imperial wares of the Sung period (A.D. 960–1279), said to be typical of that "blue as the sky after rain seen through the rift in the clouds," as described by T'ao Shuo in an eighteenth-century poem.

Egg Tempera
See Tempera.

Egyptian Colors

The precise colors the Egyptians used 5,000 years ago can be seen today in museums, in palettes carved out of wood or stone and containing six or more wells or pockets to hold pigments with dried colors intact and bright. These colors include blue from turquoise and cobalt, red from madder, vermilion from cinnabar, green from malachite, black from soot, various browns, yellows, and dull reds from soils, and white from chalk, lime, or gypsum. These substances were washed, ground, and mixed with oils. Color was pandemic in Egyptian society—buildings were polychrome, particularly inside, where frescoed hieroglyphs and organic patterns adorned walls, columns, and ceilings, and both men and women adorned their bodies, putting kohl and malachite green around their eyes and rubbing orange

Egyptian color symbolism can be traced through hieroglyphics found preserved in tombs.

and red into their skin to heighten their favored reddish tones.

With the temple and manuscript hieroglyphs now translated, early Egyptian color symbolism can be accurately traced. Purple was the hue of earth. The pharaoh wore a white crown to signify his dominion over upper Egypt; he wore a red crown to proclaim his rule over lower Egypt. Osiris, the god of the underworld, was often portrayed in blue. His wife, Isis, was green, while their son, Horus, was white. Seth, the deity of the north and of evil and darkness, was black. Shu, who separated the earth from the sky, was red. Amen, the god of life and reproduction, was blue. Yellow represented corn and was the hue assigned to Neith, god of the earth.

Amulets of colored gems were carried to preserve life and thwart death. After he or she died, the Egyptian was assured through color of continued life. The Egyptian Book of the Dead states, "And behold, thou shalt make a scarab of green stone, which shall be placed in the breast of a man, and it shall perform for him 'the opening of the mouth.'" This referred to the supposed power of the talisman to restore movement to the jawbones of the corpse, thus enabling the deceased to speak when called upon by the gods.

Elderly, The, and Color

See Color Therapy.

Electrical Code Colors

See Communication and Color.

Electric Blue

A light but intense blue; the blue of an electric spark.

Electromagnetic Energy

Energy that is transmitted in wave form through space, of whose spectrum light constitutes one part. *See also* Spectrum.

Electronics

See Coding, Color; Computers and Color.

Electron Micrography

The photography of minute objects in enlargements of up to 6 million times their original size. The limit of resolution with optical micrographs is a particle size or spacing of about 130 nanometers. The energy beam in an electron microscope is typically about 10 to 1.5nm in diameter, and the limit of reduction is about 0.2nm. Consequently, the image can be magnified up to 3,000 times

more than with an optical microscope. Color, of course, is not possible on scales smaller than visible wavelengths, although the image may be computer-coded with color to provide greater clarity of detail.

Elements and Color Symbolism

A conception of the world as composed of simple elements is perhaps as old as humankind. One of the first references to the elements and color can be found in the Hindu Upanishads, which date back to the seventh or eighth century B.C.

> Of all living things there are indeed three origins only, that which springs from an egg, that which springs from a living being, and that which springs from a germ. . . . The red color of burning fire is the color of fire, the white color of fire is the color of water, the black color of fire the color of earth. . . . Great householders and great theologians of olden times who knew this have declared the same, saying, "No one can henceforth mention to us anything which we have not heard, perceived, or known." Out of these they knew all. Whatever they thought looked red, they knew was the color of fire. Whatever they thought looked white, they knew was the color of water. Whatever they thought looked black, they knew was the color of earth. Whatever they thought was altogether unknown, they knew was some combination of those three beings.

The ancient Greeks glorified the elements and made them a part of science. These elements were identified by hues. While exact Greek designations are not known, from the writings and drawings of later scholars and engravers it can be assumed that the hue of earth was blue, the hue of fire was red, the hue of air was yellow, and the sphere of the deity was white, the unity of all colors.

The Jewish historian Josephus (A.D. 37–95) associated white with earth, purple with water, red with fire, and yellow with air. In Asia, the Chinese of the dynastic eras recognized five elements—earth, water, fire, wood, and metal. Earth was yellow, water was black, fire was red, wood was green, and metal was white. *See also* Alchemy; Astronomy and Color; Chinese Color Symbolism; Compass, Points of the (and Color Symbolism); Leonardo da Vinci; Symbolism of Color.

El Greco (Doménikos Theotokópoulos)

1541–1614. Greek painter born in Crete who emigrated to Italy as a young man and, in 1577, went to live in Spain, where the intense emotionalism of his paintings appealed greatly to the pious fervor of the Spanish.

His depictions of clergy and nobility in elongated and distorted figures and his use of vivid, almost phosphorescent, hallucinogenic colors presaged many later mannerist effects.

In Spain, where the landscape is often monochrome, El Greco's palette was reduced to five colors—ivory, vermilion, yellow ocher, ultramarine, and rose madder—and mixtures thereof, as well as black and white. Through acidic color juxtapositions such as lime green set off with strident yellow, and through mixed shades such as off-white—cool, bluish, and slightly eerie—El Greco's religious paintings achieved a high emotional intensity, which can be seen in dramatic scale in *The Burial of Count Orgaz,* 1586 (Santo Tomé, Toledo). In that painting, shimmering color dramatizes the legend of the miraculous burial three centuries earlier of the benefactor of that church by two saints. The colors of the heavens—the spectral whites and icy ochers, blues, and violets favored by El Greco—take on an expressive independence and in effect narrate the religious story. El Greco's color heritage, his training in Byzantine-Cretan mosaics, his Italian Renaissance and mannerist environment, and the religious temper of Spanish Toledo, which he absorbed, all glow in this painting's color effects.

Ellis, Havelock

1859–1939. English psychologist and author. In his early years, he studied and practiced medicine, but he abandoned the field for other scientific and literary work—including the documentation of colors in literature. In *The Colour-Sense in Literature,* a monograph published in 1931, he recorded the frequency of mention of some seventeen colors in well-known writings from twenty-five sources, trying to find how color expresses poetic emotion and which, if any, color dominated and encapsulated each author's work. He failed to pin down any single color, but his work provides some useful information on the general range of colors mentioned in each case. His general conclusions may be questionable, such as that a poet is likely to be freer with color terms and epithets when young than when old.

These are some examples of his findings: Describing Shakespeare's supremely allegorical use of color, particularly red, white, and black, Ellis noted that "Shakespeare's use of color is very extravagant, symbolic, often contradictory . . . Color seems to become colorless algebraic formulae in his hands. It may be safely said that no great poet ever used the colors of the world so disdainfully,

making them the playthings of a mighty imagination, only valuing them for the emphasis they may give to the shape of his inner vision."

The romantics, in contrast, could be noted for their absence of red, a color that somehow did not have a firm place in their visionary imagination. William Blake favored black, balanced with white, gold, and green. Keats also preferred green, as did Wordsworth, who mentioned it twice as frequently as any other color. On the whole, however, color use by poets over the ages matches the progression in use of color names by any culture, as noted by Brent Berlin (1934–) and Paul Kay (1934–) (*see* Communication and Color). White and black are the most frequently mentioned colors in epithets. Red is next, followed by green, blue, and yellow. More unusual is Ellis's analysis of the colors of poetic predilection: "Here red stands in the lead . . . yellow and golden are second ahead of blue! Blue is tied for third with white and black. Purple is fourth, brown and violet fifth, and pink sixth and last."

Emerald

A variety of beryl used as a gemstone. Minute traces of chromium give emerald its brilliant but velvety green and iron provides the golden yellow of the related gem heliodor, while pink morganite and the rare red beryl are colored by manganese. Perfect emeralds free from fractures and other impurities are rare. They were originally mined in Egypt and Austria, before the Spanish conquest of Colombia flooded Europe with the highest-quality large emeralds in the sixteenth century. Emeralds have been variously credited with giving the power of prophecy to the wearer, sweating in the presence of poison, and curing defects of vision. Emerald is the birthstone for those born under the astrological signs of Libra and Taurus. *See also* Gemstones and Jewelry.

Emerald Green

The shade named after the precious gemstone. In medieval times, emeralds were so highly prized that in English heraldry the word *emeraude* was used to designate green (ordinarily called *vert*) if it occurred in the arms of nobility. Since 1915, emerald has been one of the eighteen standardized greens in the American textile industry.

Empire State Building Colors

Beginning with the 1976 U.S. bicentennial celebration in red, white, and blue, floodlight operations of New York City's Empire State Building began to mark various seasons

and holidays with colored lighting on the building's top thirty floors. The designer was Douglas Leigh. From Halloween to Thanksgiving Day, the Empire State's tower is red, orange, and yellow, and from Christmas to New Year's Day it is red and green. The halo, or pinnacle, lights always remain white.

Special holiday floodlight colors include the following:

Martin Luther King, Jr. Day	Red, black, and green
St. Valentine's Day	Red and white
Washington's Birthday	Red, white, and blue
St. Patrick's Day	Green
Easter week	White and yellow
Memorial Day	Red
Independence and Labor days	Red, white, and blue
Steuben Day	Blue and white
Pulaski Day	Red and white
Columbus Day	Red, white, and green
United Nations Day	Blue and white

Enamel

Enameling, the fusion of a colored glass film with metal, has been practiced for at least 2,500 years to brighten objects from horse trappings to armor and jewelry. Enamel is a comparatively soft glass made from a mixture melted together of flint or sand, red lead, and soda or potash. This produces a translucent glass with a bluish or greenish tinge. Color is added to the mixture in the same way that glazes using iron oxides, copper, cobalt, or manganese are made. The glass is pulverized and washed before being fused to the metal by firing briefly. As with all vitreous materials, the slightest alteration of the mixture or the firing times produces a radically different color.

Since the majority of enamel colors are changed by firing, it is essential that the artisan working in enamel is able to visualize the inevitable modulation of shades. Different colors are fired at different temperatures. Those that can stand the greatest heat, such as brown, blue, and green, are fired first. Certain pinks and turquoises require a lower firing temperature and are thus fired later. Most enameling techniques employ multiple applications and firings.

The art of enameling attained its highest degree of sophistication in France, and the three main types of enamel work are usually known by their French names: champlevé,

basse-taille, and cloisonné. In champlevé, compartments are gouged out of a metal base and then filled with enamel. Basse-taille is similar, but the compartments are usually engraved with patterns, which will then show through the more transparent kind of enamel used. In cloisonné, enamels are poured into a network or pattern of cells made of thin wire, which are soldered to the metal surface. This technique was perfected by Byzantine craftsmen between the sixth and twelfth centuries A.D. The colors used in cloisonné were so intense that the gold wire separating them, and their generally gold settings, provided welcome relief for the eye from simultaneous contrast and dazzle.

Enamels applied as paints, usually on copper, were popular as late as the fifteenth century. The best Chinese enamel work produced during the Ming and Ch'ing dynasties was also masterful, comparable to lacquer work from the same period. *See also* Cloisonné.

Encaustic Paints

Encaustic, derived from the Greek word *enkausikos*, from *enkaiein*—to burn in—refers to colorant made from pigment mixed with melted beeswax, resin, or oil as a binder and fixed with heat; or to any process in which colors are burned into a surface with a hot iron.

Encaustic painting dates to the first and second centuries A.D. at Fayoum, a district in northwestern Egypt, where portraits were made in ground mineral pigments mixed in wax and painted on wood panels. These portraits are remarkable for their brilliance, which has remained over the centuries.

Wax paintings were made until the eighth century A.D., and these works have tended to resist atmospheric action even better than oil. Natural waxes will accommodate any pigment that oil or water will, but is vulnerable to extremes of temperature. Synthetic waxes are more resistant to changes in temperature and are as effective as their organic counterparts in holding pigment.

Notable twentieth-century examples of colored wax paintings and sculptures include works by Diego Rivera, Paul Klee, Jasper Johns, Brice Marden (1938–), and the renowned life-like figures in Madame Tussaud's museum in London. *See also* Crayon, Wax.

The Environment and Architectural Color

See Architecture and Color; Fashion: Geography and Color.

Self-portrait of Rembrandt with fur cap.

Etching

A form of intaglio printing in which a design is incised into a metal plate by means of acids and then inked and applied to paper. In the simplest version of the process, a metal plate is covered with a blackened wax ground. With a steel needle, the lines of the design are traced through the ground, exposing the surface of the plate. The plate is then immersed in a bath of acid, which eats away the exposed metal, forming grooves in its surface. The plate is cleaned and rolled with ink, which is then wiped off with a rag (a "tarlatan"), leaving the printing ink in the furrows. A piece of damp paper is placed on the plate and passed under the roller of the press. The inked design is forced from the plate onto the paper, transferring the design by pressure. Copper is generally preferred for the plates since it is a "sympathetic," easily etched metal, which can be used for printing many times before it wears down.

History of Etching

Etching originated as a way of decorating armor. The earliest dated etching on paper is from 1513, by Urs Graf (1485–1528). Albrecht Dürer (1471–1528) also experimented with the technique. Parmigianino (1503–40) was the first painter-etcher, but it was not until the seventeenth century that etching took firm hold with Guido Reni (1575–1642) in Italy, followed by the Bohemian Wenzel Hollar (1607–77). Hollar specialized in topographical views of important architectural sites—as did Giovanni Piranesi (1720–78)—but he also reproduced drawings by a range of artists from Dürer to Holbein (some of which survive only in Hollar's etched examples). Until the invention of lithography, etching, along with wood-block engravings, was the principal means of reproducing pictures in books and magazines.

Rembrandt, possibly the greatest of all etchers, experimented with different types of inking and papers, including Japanese paper. He was a master of tonal shading and used drypoint in a manner that stretched the technique to its extreme. Later masters of etching include Francisco Goya, James Ensor (1860–1949), and James Abbott McNeill Whistler. There has been a resurgence of interest in etching among many contemporary artists such as Robert Rauschenberg (1925–) and David Hockney.

Methods of Etching

Different methods can be used to apply a design to the etching plate. One such process is the indirect method, using a soft wax coating over the surface of the copper plate—a thin sheet of paper is laid over the wax, which, under pressure from the artist's drawing pencil, is lifted off the plate, later to be etched with acid. In the hard ground process, the plate is simply blackened and the artist etches it directly with a hard needle. A third method, the sugarlift, involves painting directly onto the plate with a sugar solution. When the painted design is dry, the whole plate is covered with a block-out varnish. The plate is later dipped in water, which dissolves the sugar, leaving bare the area where the copper is to be etched. The advantage of this technique is the variety of textures and tonal qualities that can be achieved, as opposed to simply hard lines. By roughing the plate with an instrument called a rocker instead of acid, a mezzotint can be achieved. The plate can then be burnished so that the amount of ink held is reduced (to the point at which it is almost smooth where very light areas are required), to create even softer tones.

Aquatint uses another resist technique. Aquatint is, in fact, a powdered resin that may be painted on or dusted across a whole plate. The particles adhere when a gentle heat is applied, acting as a barrier to the acid. Etching occurs around each particle, giving an irregular grainy texture to the plate. The graininess can be varied by using larger particles, and the depth of color can be changed by exposing the plate longer.

Color can be applied to different parts of an etching either directly to the plate with pads of cotton or with the fingertips, or by using separate plates, each with its own color, applied in sequence, to build up the desired color image. A form of inkless etching, known as embossing, leaves images on paper simply as reliefs, caused by the pressure of the etched plate. Modern forms of embossing are often used for printing stationery and greeting cards.

With all forms of etching, the life of the plate, before it begins to wear down and reduce the quality, is relatively short. Artists are therefore prone to limit editions of their work, usually to 100, numbered in the order in which they are printed; of these the first 10 are generally considered too harsh, and the last 10 too worn, making the middle 80 the most valuable. Once the edition is printed, the plates are often destroyed, or "scratched," to prevent unauthorized copies from being produced subsequently. *See also* Lithography; Relief Printing.

Evergreen

A dark lustrous green, as suggested by the fir tree.

Expressionism

An art movement in Germany before and after World War I that was characterized by a very bold and subjective use of color. Well-known Austrian painters whose visionary color harmonies are expressionistic include Oskar Kokoschka (1886–1980) and Egon Schiele (1890–1918); Russian painters known for their expressionistic color include Aleksey Von Jawlensky (1864–1941) and Wassily Kandinsky. In the 1940s and 1950s, abstract painters in a notable expressionistic color mode include Americans Willem de Kooning (1904–) and Jackson Pollock; in the 1970s, a new generation of German expressionists including Joseph Beuys (1921–86) and Anselm Kiefer (1945–) emerged.

The early twentieth-century German expressionists were architectural students who believed that as painters they could use color to preserve the freshness of their feelings and sensations. Best known among them are Max Beckman (1884–1950), Lyonel Feininger (1871–1956), Erich Heckel (1883–1970), Ernest Ludwig Kirchner (1880–1938), Paul Klee, Käthe Kollwitz (1867–1945), August Macke (1887–1914), Franz Marc (1880–1916), and Emil Nolde. They formed a group in Dresden in 1905, which began to use colored images dissociated from observable reality. Color as an expression of an inner reality was their common point of departure and that of all succeeding generations of expressionist artists. German expressionism has a great emotional range, and color plays a primary role in portraying and evoking pictorial moods such as pity, terror, indignation, frenzy, and chaos.

The expressionist's palette is typically defined by black outlines reminiscent of those in woodcuts and closely pitched warm and cool harmonies. The work of Kirchner, remarkable for its eerie elegance and depiction of the frenzy of large, modern cities, as seen in *Five Women in the Street*, 1913 (Wallraf-Richartz Museum, Cologne), presents often-used expressionistic shades: chartreuse green juxtaposed with greened yellow, olives and browns in close proximity, oranged berry reds, and whitened pinks. By having color accentuate angular forms, the overall effect in the Kirchner painting, as in most expressionist works, is one of distortion and disturbance.

Like the German expressionists at the beginning of the century, the American abstract expressionists of the late 1940s and 1950s used black outline, closely pitched harmonies, and strident hues such as brash oranges and acid yellow. Unlike the German expressionists, the abstract expressionists removed their works further still from a semblance of objective reality. The American abstract expressionist painters used paint pigments extravagantly, at times dripping, pouring, or even throwing paint onto large-scale canvas surfaces.

The term *action painting* describes the physicality of their approach to their inner visions. In the 1970s, a new generation of German painters visually confronted German history—World War II, including the Holocaust and the Occupation—and came up with blackened expressionistic imagery. Notable among the latter-day German expressionists is Anselm Kiefer, whose work embeds actual materials (straw, photographs) as part of the color expression of the painted surface, which is usually a dark brown or black. *See also* Aesthetics; Blaue Reiter, Der; Kandinsky, Wassily; Klee, Paul; Nolde, Emile; Pollock, Jackson; Van Gogh, Vincent.

Eye

Organ with the primary function of sensing light (and thus color), analyzing it according to intensity and frequency, and relaying the information to the visual cortex of the brain (*see* Color Vision; Vision). It basically consists of a lens for focusing light and a retina equipped with light-sensitive cells, the rods and cones (*see* Retina). The colors of eyes themselves, referring to pigmentation of the iris, range from brown and black (due to the presence of melanin) to blue (usually associated with blonds who have no melanin pigmentation—the color is caused by blue light being diffused by the iris, as it is by the sky) and green (the same blue, modified by the presence of yellow pigmentation). It has been suggested that other parts of the body are also sensitive to color (*see* Dermo-Optics).

Roller printing.

Fabric Printing

Application of colors and patterns to undyed or lightly dyed fabrics. Although the color used in printing largely determines the visual attractiveness of fabrics, there are different methods of application that also tend to affect a textile's aesthetic appeal.

Printing techniques for fabrics can be divided into two major categories: the direct application of a colorant to a textile—so-called dry (using pigments) or wet (using dyes or pigment dispersions) printing; and indirect, or heat transfer, printing, which uses dyes.

Dry, or pigment, printing employs an opaque medium, which may be applied to any surface if the correct binder is used. The color tends to sit on top of the fabric, instead of permeating it. The process is popular because it is simple—requiring only heat curing of the pigment—and economical. It is more susceptible to crocking and fading than wet printing, however, especially when darker colors are used, and tends to make the fabric stiffer.

In wet printing, dyes are applied by means of a roller or screen onto a dampened cloth. These dyes are transparent; therefore, color purity depends on the whiteness of the material. Binders are not necessary, but the basic cost of this kind of printing is relatively high. Vat dyes are used with cellulosic fibers, and disperse dyes are used with synthetics.

The following is a list of print technologies available today:

Block printing: A hand method dating back to the eighth century in China and now primarily used only in Asia, in which the design is applied to the cloth by means of a wooden block. One side of the block has the design either cut out or in relief. The printer inks the block from a pad or color holder and then presses it onto the surface of the cloth, which is stretched on a padded table. The design is accurately registered by using small guide points on the blocks, which lie outside the design and leave marks on the cloth. Wood-block printing is favored for the texture and slightly irregular coloration achieved.

Block printing.

Blotch printing: A method by which the background color is printed, rather than piece-dyed. It has been used to imitate costly discharge or resist prints, but can be identified because blotch-print background color will be lighter on the reverse of the fabric. Both blotch and discharge printing permit a very dark background and bright accent colors.

Copper-plate printing: Invented in 1770, the forerunner of modern roller printing. Largely abandoned now, the method is similar to printing on paper with etched plates.

Discharge Printing: Form of printing done on previously dyed fabric. When the design is applied, the ground color is destroyed, or "discharged." For example, a white dot on a blue background can be produced by first dyeing the fabric blue, and then printing the dots with a chemical that destroys the blue color. This is called a white discharge. A color discharge is achieved by mixing the chemical bleach with a colored print paste; both are then applied together.

Flocking: Technique in which, instead of dyes or pigments, particles of colored fibers are applied to a fabric surface that has been previously printed with adhesive.

Foil printing: The application of foil to a fabric surface; similar in technique to flocking.

Heat-transfer printing: Also called thermal transfer printing or sublistatic printing; a method in which the design is first printed on paper with disperse dyes. The printed or transfer paper can then be stored until ready for use. The fabric to be printed is passed through a heat-transfer machine, which brings paper and fabric together face to face and passes them through the machine at about 400°F. Under this high temperature, the dye (and the design) is transferred onto the fabric. This technique is used less than other methods, as color intensity is lacking and motifs tend to have a decal-like appearance. The heat-transfer method is good for pictorial scenes.

Resist printing: Resist printing involves a two-step procedure. The pattern is first printed on a white fabric with a chemical or a with a wax-like resinous substance, which will

prevent the penetration of the dyes. The fabric is then piece-dyed, producing a dyed background overlaid with a white patterned area. The effect is similar to that obtained in discharge printing.

Roller printing: This method is similar to the process used to print newspapers. The design is applied from copper rollers engraved with a pattern. A separate cylinder is required for each color. Extremely fine lines can be printed, allowing details and very subtle gradations, not unlike watercolor effects. Roller printing is used mostly for apparel, as it is an economical method and a high-speed process that permits up to 4,000 yards of fabric to be printed each hour.

Screen printing: Technique that uses a fine-mesh screen, through which a print paste is forced. Screens were formerly made of silk; now they are made of nylon. The pattern is created by making portions of the screen opaque. Complete designs can be photographically transferred to the screen, using a separate screen for each color (a five-color design is known as a five-screen design). There are three principal methods of screen printing:

1. *Hand screen printing.* Process using a long table, with one frame and one color screened at a time. Each color requires a separate application; the number of screens is theoretically not limited. This method results in the most beautiful colors produced by any printing process and allows very large repeat sizes and freely colored patterns. Fall-on effects (a third color obtained by overlapping two colors) are possible because dyes dry slightly between each passage of the screen, creating a richness and variety of colors. The process is used for small runs of expensive fabrics that require great attention to the quality of colors. Lyons's famed silks owe their reputation to this printing method, which is still used for expensive haute couture fabrics.

2. *Automatic, or flat-bed, printing.* Technique similar to that described above, but automated and therefore faster.

3. *Rotary-screen printing.* Developed in the 1950s, this method is continuous, like roller printing, using seamless perforated metal or plastic screens. This process allows extremely accurate registration, and is the most popular method in the printing industry today. The technology of rotary-screen printing surpassed the productivity of flat-screen printing machines and was a challenge to traditional roller printing. New methods for engraving rotary screens introduced in the 1970s, such as laser engraving, have helped cut the cost of such printing substantially.

Certain newer technologies are threatening to render even rotary-screen printing obsolete. For instance, advanced laser printing will allow printing to be operated and controlled directly by a computer, without the need to make relatively costly plates. With an image or pattern in its memory bank, a computer can direct the application of dye pastes onto the fabric through controlled printing jets. With continuous feeding of fabric, and the possibility of instantly changing patterns or colors, the printing machine can be used at maximum efficiency.

Stencil printing: The forerunner of modern screen printing, stencil printing was invented and most fully refined by the Japanese. Designs are cut out of paper (or of thin metal sheets), and color is applied with a brush through this stencil. The technique is still extant today, with an airbrush used to apply the color through the cut-out sections.

Warp printing: Called *ikat* in Indonesia and *kasuri* in Japan, warp printing involves printing or coloring the warp yarns of a fabric before they are placed on a loom for weaving. The fabric is then woven with a solid color filling, often white but sometimes in a color contrasting with that used in the warp print. The resulting design is soft, shadowed, and diffused. The method is laborious and expensive.

Wax resist (batik) printing: Basic resist technique still used by artisans in Java, Sri Lanka, and India. The designs are applied in wax, the cloth is dipped in dye, and the wax then is removed by boiling in water or with a solvent such as benzene. The wax leaves a white design over which new colors and resist designs can be applied. The process must be repeated for each color; examples exist of batiks that use as many as sixteen different colors. The wax can be applied either by hand (*tjanting*) with a small copper "pitcher" mounted on a wooden "pen," or by block (*tjap*) printing.

Fading

Fading is the gradual loss of color in materials because of alterations in their molecular structure resulting from aging, contact with

water (and moisture) or damaging chemicals, or exposure to intense light or extremes of temperature. In contrast, in the words of an eighteenth-century author, "a fabric is fast colored when the color resists the action of water, light, and air."

To minimize fading requires pigment, or dye, permanence, which refers to the property of a coloring agent to resist a modification of its light absorption characteristics. Pigments that resist fading after 600 hours of direct sunlight justify the term absolutely permanent. Such pigments include raw earths, natural mineral colors, and all the carbon-based black pigments.

Organic dyes, on the other hand, were notorious for fading in the sun—often the most expensive ones, like Tyrian purple, being the most vulnerable. Daylight and blue light are potentially more harmful to colors than red light of the same intensity; incandescent filament or "warm white" fluorescent lamps are therefore safer for lighting than the bluer "cool white" sources.

Mixing pigments often reduces their permanence. This is especially true of mixtures of chemically incompatible colors, such as a mixture of a chromium pigment with a sulfur one. Cobalt blue, chrome yellow, and flake white are easily damaged by water or a damp atmosphere. Prussian blue is bleached by an alkaline solution, whereas both genuine and French ultramarine are bleached by acids. Such damage is almost always irreversible, though lithopene (zinc sulfide and blanc fixe) exhibits the photochromic property of darkening as a result of prolonged exposure to light—but regaining its lightness during dark periods. Prussian blue also exhibits photochromism, and chrome yellow reddens if heated but returns to its original when cooled. *See also* Colorfastness and Dyeing; Conservation of Color.

Faience

Glazed earthenware or pottery with highly colored designs; originally from Faenze, in northern Italy.

Farnsworth-Munsell 100-Hue Test
See Color Blindness: Color Vision Tests.

FASHION and CLOTHING COLOR

Fashion in the broadest sense is concerned with change and innovation. The need to express oneself through adornment or decoration, together with the need for new impressions and change, is an integral part of the human experience. "Fashion" can range from a preference for a particular color to a vogue for ten-course dinners to a mania for African sculpture. Essentially a phenomenon of changing taste, fashion is affected by the arts, economic and societal factors, political events, and discoveries and inventions. It can spread quickly within a group or community or throughout the world by means of the instantaneous communication systems and technologies available today.

Change is integral to the definition of fashionable colors. Colors may characterize a historical period without necessarily being considered fashionable. In the 1950s, pastels were popular but not deemed fashionable; their very pervasiveness made them a norm rather than a fashion. In essence, fashion shades are slight—or radical—departures from accepted dress modes, which indicate in the wearer a know-how and a new stance toward the rest of the world. In the 1920s, a flapper announced her liberation from a traditional female role with a flashy short dress and fire-engine-red lipstick. Her glistening colors, like her bobbed hair and overall attitude, were rebellious. In the same manner, the 1930s pink of Elsa Schiaparelli (1890–1973) was shocking in light of pink's traditional association with sweetness and docile femininity. The Italian designer heightened the color's intensity and used it in surrealistic design motifs and perfume packaging, startling the world. The shade came to be called "shocking pink" (*see* Schiaparelli Pink).

Change is so critical to fashion that revivals always vary and reposition a shade slightly so that a color will appear to be new. When "shocking pink" became fashionable again in the 1980s, it was perceived as a soft bright color: Between the late 1930s and the 1980s, neon and psychedelic colors had so intensified the sense of how bright a bright could be that Schiaparelli's favored pink now seemed to be definitely less than shocking. The 1980s revival of the bright shades of the 1960s also intensified each blue, orange, and yellow. The expectation of greater luminosity had been created by the mass media since the 1960s. Television, specifically music television videos and the colored graphics of advertising, had accustomed the public's eye to ever-increasing color intensity.

History of Fashion Colors
Before the twentieth century, fashion colors evolved more slowly and tended to change over decades rather than years. Fashion colors generally need a theater of display, and

the first "audiences" were found in the royal courts. The best records of past color taste are found in historical portraits of rulers and nobility, and from these it is clear that black, red, and white were key fashion shades. Red was a popular color in the Middle Ages and through the Renaissance. Its religious associations with the courage and purity of Christ's sacrifice explain its popularity in an era of the Catholic church's dominance. After the Middle Ages, red appears to have been used in the more modern sense as a signal fashion accent. Red is seen frequently on sixteenth-century men in portraits by Hans Holbein (1497–1543), a German painter of aristocrats and royal families.

Black, even more than red, has dominated fashion annals. Black, a shade that stands out vividly among other colors and disappears among shadows, can make other colors seem insignificant. The Renaissance writer Baldassare Castiglione (1478–1529), in his 1528 *Book of the Courtier*, was one of the first to note the importance of black in establishing individuality without vulgarity. His observation has been appreciated by designers, intellectuals, and rebels, all of whom have worn black to their own advantage.

In the sixteenth century, the taste of the Spaniards for black dominated the western world. This was partly due to the personal taste of the Holy Roman Emperor Charles V (1500–1558), who was known for his sobriety of dress, and partly due to the growing power of Spain. In 1556, when Philip II (1527–98) succeeded Charles V, the Spanish court became the admired model for all of Europe. Even the French king Henry II (1519–59), followed the Spanish lead and always wore black. Philip IV of Spain (1605–65) is known by the portraits of Diego Velázquez (1599–1660), showing him in rich black velvets and satins embellished with gold and silver. Cerise and vermilion reds, excellent accents for black, were also popular.

Historically, black is the all-time most important fashion color. Black sets its wearer apart, proclaiming for him or her a special position removed from life's dalliances. In a little black dress, a woman belongs, no matter where she finds herself. In the 1930s, the French couturier Coco Chanel made the little black dress famous. In the 1950s, Cristóbal Balenciaga (1895–1972) designed all in black, in the Spanish tradition. American movie stars Marlon Brando and James Dean wore black motorcycle jackets in the same decade as a sign of rebellion, and latter-day punk anarchists wore black leather and other black clothing from head to toe. In various ways, black has been thrust to the forefront of the fashion scene.

White, like black, creates drama and attracts attention. The tennis champion Suzanne Lenglen startled her fans in the 1920s by wearing a couturier-designed white pleated short skirt and top. In her Patou-designed white outfit, she probably was a catalyst toward the white-on-white dress and decor of the pre–World War II era. Ivory satin gowns and white fox furs were very popular in the 1930s, and American movie star Jean Harlow created a fad for platinum blonde hair and silver fox.

Fashion colors thrive in societies that possess advanced dyeing technology and are centers of communication. The sixteenth-century Flemish had most of the dyestuffs of the Low Countries, and Flanders was the heart of Europe's dye industry. During that century, new dyestuffs poured in from the New World and from the Orient. The European woad blues of Saxony were supplemented by the deeper indigo blues from India, which came via the Portuguese. Some cities specialized in certain dyes: cochineal, imported from America, in Antwerp; saffron yellow in Basel; and saffron orange in Frankfurt. Also common were the purplish blacks of the logwood dyes from the New World.

Quite naturally, fashion colors have tended to reflect the thriving economy of international trade. Generally, a booming economy has led to a taste for bright colors, to mirror the upbeat mood of prosperity. Fashion colors also reflect technological advances. In the 1950s, for example, the fortuitous discovery of an affordable cotton reactive dye for turquoise by the Bayer Company of Germany led to a veritable fad for this shade. Until then, turquoise dyes had been inferior, suitable only for delicately handled and little-worn garments such as evening gowns. The Acilan blues with a turquoise shade enabled the color to move into sportswear and other less expensive markets. By the late twentieth century, turquoise, like pink, had become a cyclical fashion perennial.

In the nineteenth century, development of aniline dyes and the invention of the sewing machine were largely responsible for the appearance of greater color variety. In London in the 1910s and again in the 1920s, it became the fashion to have the bodice of a dress a different color from that of the skirt and to cut a dress out of two different materials, one patterned and one plain. By the 1930s, technology made color-coordinated ensembles fashion news when it became possible to dye various fabrics and materials (leathers, plastics, and even feathers) in matching colors. Both matching and contrasting colors became one of the strongest selling points of

"Of all the man-made materials, fabric offers the most and best potential for multitudinous profusion of color."
—Jack Lenor Larsen

fashion throughout the years of the Depression. Fashion colors can thrive by accommodating and capitalizing on economic realities. For example, in the 1980s, following a transit strike and a fare increase, walking to work in New York City became a more common practice, not a mere interlude, and flat brown and black shoes with a high capacity to conceal city dirt became fashionable for women.

Influences on Fashion Colors

Fine art is a major influence on fashion colors. The eighteenth-century taste for delicate pastels came about largely through the appeal of the works of the French painters Jean-Honoré Fragonard (1732–1806) and Antoine Watteau and the English painters Thomas Gainsborough and Sir Joshua Reynolds. These painters were themselves influenced by the discoveries of Roman mural palettes. Their fascination with classical ruins ushered in a half century of softly whitened pastels in dress and decor. In the early twentieth century, the painter Sonia Delaunay brought the intense colors of Vincent van Gogh and Paul Gauguin to textile design and clothing. A retrospective of Van Gogh that opened in 1935 at the Museum of Modern Art in New York City drew bigger crowds than major sports events and created a vogue for sunflower prints in yellows and greens in clothing and residential fabrics. Because the Van Gogh retrospective toured for over a year, the exhibition had a tremendous influence throughout the country. In the same way, popular museum exhibitions of treasures from the tomb of the Egyptian pharaoh Tutankhamen (1370–1352 B.C.), shown in London and New York during the 1970s, popularized earth-toned browns and golds in interiors, clothing, and cosmetics.

National culture plays an important part in determining fashion color. The heyday of modern fashion was the highly creative Parisian couture period at the end of the nineteenth and early twentieth centuries. A Charles Worth blue, a Paul Poiret emerald green or an antique or burnished gold, a Christian Dior gray or pale pink, or Coco Chanel's bone, flame red, and navy blue combinations defined women of taste and fashion savoir faire. Readily identifiable, a couture fashion color announced that its wearer moved and mixed in the world of aesthetic refinement and quality. A couture designer such as Poiret made fashion newsworthy when, in the first decade of the twentieth century, he replaced the pale mauves, washed-out pinks, and seafoam greens popular in the nineteenth century

with simple tunics in cerise, scarlet, and apple greens. He was undoubtedly influenced by the postimpressionists and the fauves. The Ballet Russe, which counted among its designers not only Poiret but also Léon Bakst (1866–1924), Sonia Delaunay, and Henri Matisse, was a tremendous color influence from 1910 on. The jewelry of Cartier began to feature Ballets Russes emerald and sapphire combinations, and Mariano Fortuny (1871–1949) used its strong colors in his pleated gowns.

In contrast to the European tradition, the American tradition is typically illustrated by the bright red, white, and blue of American sportswear, often in stripes. The American approach to fashion tends to the practical, straightforward, and comfortable. It was epitomized in the 1940s and 1950s by such designers as Claire McCardell (1905–58), Bonnie Cashin (1912–), Tina Leser (1911–86), and Sidney Wragge (1908–78). Their brightly colored clothes appealed in mass markets because they could be easily mixed and matched, and were more in keeping with the greater number of sunlight hours in the United States and the casual life-styles of Americans.

Of less importance than economics, art, or national culture is politics. Political leaders, by virtue of their powers and visibility, can on occasion elevate colors to fashion status. In the seventeenth century, Louis XIV (1638–1715), the Sun King of France, conducted his own public relations through dress. One design by Charles Le Brun (1619–90) for a Gobelin tapestry shows a diplomatic meeting with Philip IV of Spain in which Louis wears a gold jacket and pants with darker gold, cascades of cherry-colored ribbons, a white shirt, flesh-colored stockings, and yellow shoes with high heels in red. Centuries later, the onetime Missouri haberdasher Harry Truman created a vogue for bright Hawaiian shirts when, as President of the United States, he paraded his taste on his publicized daily walks.

Fashion shades change constantly and thus represent a sense of boredom or disappointment with what exists and a search for a new visual statement. Ultimately, fashion color is a natural expression of the human need for renewed impressions and sensations. A critical part of any fashion color story is the reappearance of perennial fashion shade favorites—black, white, red, and, to a lesser degree, navy and turquoise blues —in varying contexts. While no color under the sun is new, it is the special gift of the designers to make a shade appear so fresh as to be fashionable. *See also* Trends in Color.

Pavement commemorative plaque, on Avenue Montaigne, Paris.

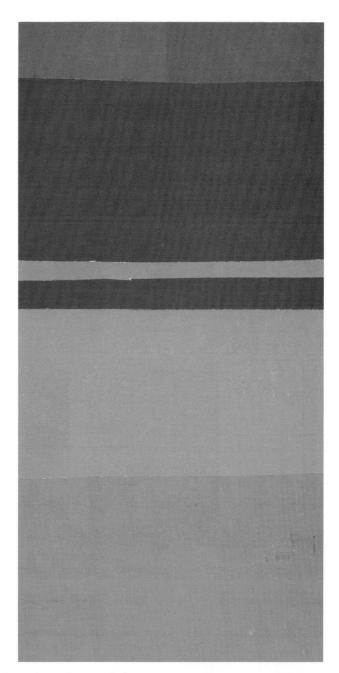

(Above) *Abstractions from a 1990s fashion color forecast, employing contrast and analogous harmonies respectively.*
(Below) *Sonia Delaunay, 1923 color design for woman's vest.*

Fashion: Forecasting Color

Psychologists have noted curves of enthusiasm, satiety, and boredom in color as in other sensory experiences. Studies in the United States indicate ongoing changes in color preference in all design fields. These shifts in color preferences follow definite cycles (*See* Color Cycles) and are similar to the shifts of interest in different foods and cuisines. In fact, taste in food and in color often parallel each other. The taste for spicy, Spanish food in the 1980s, for example, witnessed a concurrent popularity for hot brights in women's clothing.

Color cycles reflect a myriad of elements from a particular era, as well as specifics, such as museum exhibitions and archaeological finds, economics, politics, and psychological moods. Color influences from foreign capitals such as Tokyo, Milan, London, and Paris also add to color design mixes. In the United States, a fascination with black and red in the 1980s, many have argued, was largely the influence of Japanese designers. The continuing popularity of turquoise and

(Left) *An early color card produced by the* Chambre Syndicale des Teinturiers *(Chamber of Syndicated Dyers) in Lyon for the Autumn 1910 season. The complete card includes 720 colors, all dyed on silk yarn.*

(Below) *Extract from the Spring/Summer 1951 color card for the silk-dyeing industry in Lyon. The chartreuse and purple ribbons represent 24 of the 108 fashion colors presented for that season.*

pink in the same decade was in large part due to the elevation of these perennial sportswear favorites to fashion chic by French couture designer Christian Lacroix (1951–).

Forecasting for American consumer markets, as well as color standardizing, emerged as a force around 1915, with the founding of the Textile Color Card Association of America (the predecessor of The Color Association of the United States) by a group of American manufacturers and retailers (*see* Standardization of Color). Faced with the problem of changing color tastes in a consumer-oriented economy, the Association assembled panels of specialists drawn largely from the textile and allied industries to select those fashion shades that would likely be popular at a future time. Selected shades were described in the form of forecast cards, which showed custom-dyed silk or wool swatches.

The first American forecast, issued for fall of 1917, showed forty colors in silk-ribbon form. Of the forty colors, eight—browns and grays—were designated fur colors. The object of the first forecast and all subsequent ones was, on the one hand, to project a color look (for example, bright or dark, grayed or clear, monochromatic or multi-colored) and, on the other hand, to indicate both continually appealing colors and "new," high-risk fashion shades, which would be used in that season as accents or might at a future time command volume sales. From 1917 until World War II, women's clothing was the primary focus of forecasting color. Gloves, hosiery, millinery, and furs were often given special attention in forecast charts. In the 1940s, rayon was used to a limited extent in place of silk and wool swatches.

Since World War II, forecasts have reflected an acceleration of color cycles. In apparel, a season's two or three winning colors tend to change every couple of years. Environmental and interior colors change more slowly, and discernible shifts of taste occur every seven to twelve years.

Color forecasts for the fashion, interior, environmental, and other industries are usually issued to mills, manufacturers, designers, architects, and fashion stylists so that future color preferences can be established among a given population in a given geography at a given time. Obviously, an accurate forecast that is intelligently applied to an appropriate product will result in more sales and happier clients.

With many fashion-influenced products, consumers are sensitive not only to "new"

(Right) *A typical color chart, produced by the Color Association of the U.S. in consultation with leading interior and fashion designers. It projects interior colors twenty-one months in advance of a selling season.*

(Below) *The Standard Color Reference of America (Tenth Edition, 1981), an atlas of the most popular colors for apparel, all dyed on silk swatches. Included among the 192 selected are the exact shades of the American flag, Old Glory Red and Old Glory Blue. Also available are the Armed Forces standard colors.*

colors (a greened yellow, for example) but also to variations of traditional shades. Color directions and changes in shades often begin with a sensitivity to prevailing consumer moods and concerns. The economy is invariably a critical influence on discretionary purchases and thus determines, to a considerable extent, mass-market colors. In economically depressed times, colors tend to be dark. Black was the leading automobile color during the Depression, and throughout the early 1930s a soil-concealing brown was a popular color. In the boom of the 1950s, pastels colored the decade, reflecting a mood of steady tranquillity.

Although change and variation make color more appealing to human beings, there is always a certain consistency of preference for a few rather than many hues. Therefore, color forecasters need to calculate the exact shade in which to render perennially popular volume sellers. Will the red be a blued or an oranged one? Will navy or royal blue be the popular choice of the season? Will peach, pink, or coral be the big volume seller? These kinds of questions as well as others concerning the ongoing or more stable elements of a projection are considered in forecasting for the fashion industry.

In housewares, volume sales tend to rely on even fewer colors. Surveys for the National Houseware Association, for example, indicate that in the late 1960s and early 1970s, popular colors included avocado green, harvest gold, and white. By and large, white in housewares and in appliances has consistently been the leading color. Ob-

viously, a color forecaster must weigh a large measure of practicality in interpreting an interior colors forecast. Turquoise may be the hottest color of the decade, but in appliances it would be unlikely to command more than a fraction of the market.

The twentieth-century trend in product design and in apparel has been to offer more and more colors in a wide variety of lines. The color availability for items ranging from transistor radios to artificial flowers to rubber bands has increased with each decade. Where a product line included five colors in 1930, it was likely by 1980 to include a dozen. Given the proliferation of shades and the accompanying compression of color cycles, color forecasting focuses more and more on how the shades that are perceived as fashionable will perform in different consumer markets around the world. *See also* Fashion and Clothing Color.

(Above) *Eighteenth-century silk kimono. The Kanebo Museum Collection, Tokyo.* (Above right, and opposite) *These two-color combinations, used in silk fabrics for kimonos, indicate the variety of shades and coordinated colors popular in Japan for more than ten centuries.*

Fashion: Japan

(Below) *A Noh theatrical mask that shows the flat white makeup and black and red accents used to denote a female character.*

The Japanese approach to color follows two paths. Shibui, a tradition characterized by broken or grayed colors, is used in combinations that tend to avoid strong contrast of hues. As far back as the tenth century A.D., hundreds of different dyestuffs had been discovered, developed, and cataloged in Japan, and terms describing each of the subtle shades of different colors were in daily use.

The Shibui tradition has survived into the modern era, and is used in kimonos worn by the Japanese in the privacy of their own homes. Combinations are restrained, with the *obi,* or belt, providing a muted accent. Shibui colors, particularly soft browns and greens, are also finding their way into Western fashion.

The second approach uses very bright colors. These colors are frequently seen in the Noh and Kabuki theaters, where the poor lighting conditions of the early theaters demanded strong colorations. Red, black, and white are prevalent.

essay

Fashion: Paris–New York

Françoise Vincent-Ricard, the founder of the French fashion agency Promostyl, is the author of a number of books on fashion, including Clefs pour la Mode *(1987). In this sketch, she touches on the mutual influences of French and American fashion and color industries.*

Since World War I, fashions in clothing have been governed by the exchange and interaction of two opposite but complemen-

tary movements: French haute couture and American ready-to-wear. Linking aesthetic values to mass production is a recent notion which originated in the 1940s in the United States. The American fashion industry introduced the fashion world to "ready-to-wear" clothes that had style, color, and quality.

Two American designers, Claire McCardell and Bonnie Cashin, pioneered casual wear—simple, comfortable, stylish clothes, dubbed "le sportswear" in France—which became international classics. European industrialists and manufacturers visiting America in the late 1940s were impressed by the rationalized operations of a newly conceived, effective fashion industry. They witnessed the coordination of color and form, with apparel produced on a large scale and at a staggeringly fast pace.

Before World War II, manufacturing in France, the United States, and elsewhere,

was geared toward perennial style and lasting quality. These practical, everyday clothes were usually made in basic colors—grays, browns, and dark blues—which would stay in fashion. Elegant high-style originals were the privilege of the wealthy, and seasonal collections of highly sophisticated and expensive creations were presented to these relatively few. These fashions followed the haute couture tradition of rare craftsmanship, begun in 1858 with the opening of the house of Charles Worth (1825–95).

In 1947, the year Christian Dior launched his "New Look," machines were still not used by French fashion houses. His hand-produced Diorama dress required thirty yards of fabric (weighing six pounds) with padding, pleating, and multiple detail refinements. Haute couture had suffered during World War II and, despite Paris's best efforts to promote an international, elitist way of

The Paris Opera at the turn of the century. Photo by Roger Viollet.

dressing, something extra was needed to expand the market, and America led the way. The American press and public gave Dior's New Look an enthusiastic reception, and soon afterward Seventh Avenue, the center of New York's garment industry, found a way to adapt Dior's models and manufacture them at reasonable prices. An exchange of ideas and techniques began between the French and American fashion industries, and became big business. American buyers regularly attended the Paris couture collections to select models for mass production, while a new breed of French industrial stylists rushed to survey New York's department stores and the new suburban shopping centers.

Before long, the French ready-to-wear industry adopted U.S. manufacturing methods, and standardization of color trends on both sides of the Atlantic quickly followed. At the start of the 1950s, manufacturers offered clear, simple color stories. It was the period of the coordinates, of the "go-together" look, of total look: one color from top to bottom. As the world economy grew stronger and a booming junior market developed in the 1960s, stylists began to introduce "violent" tones: fluorescent, glittering colors, optic white "à la Courreges," and star-

tling color graphics became major elements in the fashion dynamic.

In the 1970s, consumer demand and industry response became more complex than ever. Mixed layers of color and multiple combinations brought more intricate color themes. Accessories were used to personalize fashion, and complementary colors were often used to accent an ensemble. A multifaceted fashion industry developed, with the manufacture of belts, gloves, stockings, hats, bags, shoes, shawls, and scarves running parallel to that of clothing. A dynamic play of color took place, pronounced or subtle. In the 1980s, all-black garments became popular, making these accessories even more important.

As consumer tastes have become more sophisticated, color has played an important and complicated role in the fashion business. The fashion industry must mix, juxtapose, play with, and personalize colors. The computer revolution is multiplying possibilities, providing creators of fashion with tools that are radically affecting fashion choices (*see also* Computers and Color). With CAD/CAM systems, swift industrial color realization that responds quickly to market demands is now becoming a reality.

—Françoise Vincent-Ricard

Fashion: Geography of Color

Polly Hope's work as an artist and writer has taken her all over the world. Through her extensive travels, she has acquired an intimate knowledge of the colors that distinguish different countries and regions. Such information can be important in designing fashions and products.

Reading atlases is a luxurious and sumptuous experience, somewhat akin to nibbling all the cakes in the *patisserie:* Each map, like each cake, conjures up experiences. All those brilliantly hued countries leaning one against the other in the glowing pages. To a child, the colors *meant* those countries—France was always green; Italy, yellow; the British Empire, pink; Russia, an indeterminate ocher. Even then it seemed a bit odd, though fascinating: was France really flat apple green all over with its *Départements* dotted in black across its surface? Was all the land in that Empire, on which the sun never set, really carpeted in blossom pink? A ridiculous idea! Yet the atlases are not entirely wrong— countries do have colors; we can feel that and know it from deep within us. What are these colors and from whence do they come?

The colors of countries have emerged and grown over the course of many millenia. The forces of nature have combined with the arts of man in an instantly recognizable mixture from region to region. Every traveller has an instinctive color conception of a place. The French blue of workers' blousons, for example, suggests France; turquoise and silver immediately suggest the American Southwest; the saffron yellow of buddhist robes, and so on. To this add the colors of the earth, sky, and vegetation. Thus we see the colors of central Mexico being, perhaps, the blue of the sky and of lapis stones, the pink of the earth, the gray-green of cacti, and the neon reds and yellows of the marvelous costumes. The unique combinations of these colors and hues shout "Mexico" to us.

Some countries incorporate the colors of their peoples and landscape into national flags. The red and yellow of the Spanish flag is a perfect representation of the passion, blood, and burning sun of that peninsula. The Greeks have a strong preference for blue —their sky, their sea, their flag, which is the color of the Virgin's robe and the color of freedom, all these things at once. Colors, like smells and sounds, are an integral part of a country's personality.

—Polly Hope

Various regions and their characteristic colors by Polly Hope.

Make-up play. Photo by Bernard Chabrol.

Fashion: Cosmetic Colors

Fashion apparel and cosmetic products are related. Color coordination plays an important part in make-up.

Cosmetics are important color complements and accents to clothing and beauty products, and are considered to be quintessential fashion accessories.

The impact of fashion on cosmetics is well recognized. Cosmetics manufacturers follow fashion color forecasts that are designated to provide guidance two or more years in advance of production. Ethnicity, age, peer group, and regionality all enter into color preferences and are taken into consideration in cosmetic color planning.

Coordination of colors used in beauty products is done by specialists. The aim is to enhance individuality and provide allure.

Hair coloring, though part of the beauty products spectrum, is less influenced by apparel colors but sporadically occupies a special fashion niche. (See the next page on culture and sociological influences.)

Eye shadows: Traditionally green, blue, violet —ranges of infinite variety.

Eye liners: Available in blacks, grays, and browns.

Facial powders: From tinted white to cream, beige, and pink shades.

Facial blushes: Stronger than face powders, ranging from beige to red.

Lipstick colors: From pinks to reds to browns, including clear glosses.

Nail colors: Often coordinated to lipstick shades.

FASHION INFLUENCES

A time chart from an American 1990 perspective which links fashion colors and images to their possible influences and sources.

Influence: Hollywood

1910s/1920s—Theda Bara: brunette with pale skin, darkly outlined eyes, and rosebud lips.
1920s—Jean Harlow: platinum blonde.
1930s—Greta Garbo: pallid skin, unrouged cheeks, and soulful penciled-in eye makeup.
1940s—Rita Hayworth: red hair, bright red lips and nails. Ida Lupino: floral prints. Tony Curtis: Hawaiian shirts. Fred Astaire: black and white tails.
1950s—Marilyn Monroe: blonde hair with bright red lips, and body-revealing clothes. Grace Kelly: stylish refinement. James Dean: the black leather motorcycle jacket.
1960s—Audrey Hepburn: dark eye makeup; sophisticated and unprovocatively feminine.
1970s—Television colors: purplish black, maroonish red, and brownish red, for example, to suggest the distant future in "Star Trek."
1980s—Music videos: neon brights.

Influence: Sports

1920s—Tennis: Suzanne Lenglen (France) versus Helen Wills (California) introduced shorter skirts.
1930s—Motoring: soil-resistant browns in dusters.
1960s—Surfing: tropical, California-style swimwear prints.
1970s/1980s—Jogging: brights, pastels, black, and white. Bicycling/Skiing: black, tubular, skin-tight looks with neon for the former, neons only for the latter. Backpacking: book-bag colors, including neon brights against black or brown.

Influence: Couture and Designers

1910s—Paul Poiret: cerise, emerald green, turban gold, and browned orange.
1920s—Madeleine Vionnet: flowing drapery, light and soft pinks and whites, and pearls. Coco Chanel: black, red, navy, and bone white.
1930s—Elsa Schiaparelli: shocking pink.
1940s—Claire McCardell: American Beauty Red and Old Glory Blue. Christian Dior: gray, pale turquoise, and pink.
1960s—Mary Quant: black and white. Zandra Rhodes: neon orange and Indian pinks, yellows, indigo blues, and berry reds.
1970s—Ralph Lauren: hunter green, maroon (burgundy), and other club colors (navy and midnight blues, and midtone grays).

1980s—Stephen Sprouse: neon. Donna Karan/Rei Kawakubo: black. Betsey Johnson: pink. Christian Lacroix: Mediterranean brights, such as pink, fuschia, and magenta.

Influence: Economic and Political Trends

1910s—Sliding lipstick tubes commercially available; color standardization (1915) during World War I.
1920s—White, for airy blithe spirits; black, as the expression of the 1929 Wall Street Crash.
1930s—Blacks and browns continue. Elizabeth Arden lipsticks in ranges of red are introduced.
1940s—Patriotic red, white, and blue; after the war a quick return to bright colors.
1950s—Harry Truman: Hawaiian shirts. Madison Avenue images: *The Man in the Gray Flannel Suit.*
1960s—Prosperity and youth culture: brights proliferate. Jackie Kennedy: pillbox hat pink. Counterculture: Black Panther all-black military dress.
1970s—Southwest earthtones and the Santa Fe look.
1980s—Black becomes a universal favorite. Nancy Reagan: red dresses.

Influence: Cultural and Sociological

1910s—Diaghilev's ballet: Leon Bakst's sets create vogue for oriental colors. Paul Poiret: couture colors.
1930s—Van Gogh: retrospective at Museum of Modern Art (New York) creates interest in floral prints.
1940s—Big Bands and swing music: formal black and white dinner dressing. Frank Sinatra: white shirts, open at the collar.
1950s—Big convertible cars: pale pastel, "candy" colors, particularly sky blue and baby pink. Elvis Presley: blue suede shoes, white suits with studs, and light blue suits.
1960s—The Beatles: psychedelic colors in London's Carnaby Street look. Hippies: Indian prints and tie-dyes. Pop Art: the raw primaries of commercial art and the plastic-chrome culture. Denim. Ivy League: brown loafers, blue button-down shirts, charcoal jackets.
1970s—Southwestern colors. Tutankhamen: plethora of earth-toned browns and golds. Punk rock: punk orange, acid chartreuse, and black, with bleached white or neon-colored hair.
1980s—Retro: a return of 1940s, 50s, 60s, and 70s colors. Jean-Paul Gaultier/Billy Idol: bleached blond look for men.

Surfing colors signal fun and sun.

Couturier colors announce a fashionable person.

Fast Color

See Colorfastness and Dyeing; Fading.

Fatigue

See Safety Colors.

Faunal and Floral Color Names

See Language and Color.

Fauvism: Ordinary French themes, but painted in feral, tropical-colored canvases.

Fauvism

Early-twentieth-century French movement in painting, notable for its use of wild, explosive color combined with distorted form. From roughly 1903 to 1908, the fauves, or "wild beasts," including Maurice de Vlaminck, André Derain, and Henri Matisse, continued some of the pictorial experiments of the postimpressionists, producing outrageous, virtuoso displays of the potent expressiveness of oil paint on canvas.

The neoimpressionism of Georges Seurat and of Paul Signac (1863–1935) prompted Matisse's disposition of smallish dabs of pure color ranging over the whole canvas surface, as in his *Luxe, calme et volupté* (1904–1905), as well as the "broken-touch" fauvism that characterized the earlier work of Matisse, Derain, and Georges Braque. Paul Gauguin's "flat-color" technique dominated fauvism from 1905 to 1906, though many works exhibit a combination of methods, often called "mixed-technique" fauvism.

The relation between color and expression monopolized the conversations of the fauvists and was the primary motivation for the structure of their paintings. Derain and Matisse debated Vlaminck's injunction to paint "with pure cobalts, pure vermilions, and pure veronese"; Derain wrote to Vlaminck in 1905 of his "new conception of light consisting of this: the negation of shadows," of the need "to eradicate everything involved with the division of tones," and of his concern with "things which owe their expression to deliberate disharmonies" (Chipp 1968).

Many fauvist works, such as Derain's *The Pool of London* (1906), are dominated by a powerful clash between primary colors, particularly between sharp reds and deep blues. These bold oppositions were in many ways the essential coloristic contribution of the movement. After about 1908, when the impact of Paul Cézanne became pervasive, a new concern for structure and compositional experiment was substituted for that of effects of the palette. At that time cubism, which disdained bright, stagy color displays and was one of the twentieth century's most important departures in art, was developed by Pablo Picasso and a former fauvist, Georges Braque. *See also* Cubism; Neoimpressionism.

Faux Finishes

See Trompe L'Oeil.

Fawn

A pale and slightly yellow brown; the color of the skin of a young deer. Fawn was a popular shade for women's hosiery, shoes, and other leather items during the 1930s.

Fechner, Gustav Theodor

1801–87. German philosopher and physicist noted for his formulation of the rule known as Fechner's Law, that there is a logarithmic proportion between the intensity of a visual sensation and the stimulus. Educated at the universities of Dresden and Leipzig, he resigned as a professor at Leipzig in 1839, devoting the rest of his life to studying the relationship between body and mind. His most important book is *Elements der Psychophysik* (Elements of Psycho-physics).

Fiber Art

See Tapestry.

Field, George

Circa 1777–1854. English chemist and writer on color. He introduced madder growing to England and became a specialist in the preparation of natural lake pigments. His first book, *Chromatics; or An Essay on the Analogy and Harmony of Colours* (London, 1817) supported the three-primary (red-yellow-blue) principle of pigment-color mixture and proposed theories for the "aesthetic analogy" of color to music, painting, and poetry. It also describes Field's "Metrochrome," an ingenious color-matching device consisting of three gauged glass wedges, respectively filled with red, yellow, and blue liquids. His second and third books, *Chromatography; or A Treatise on Colours and Pigments* (1835) and *Rudiments of the Painter's Art; or A Grammar of Colouring* (1850), consist primarily of information about the origin, composition, and properties of pigments, dyes, and paint media. His books went through several editions, and were widely read, influencing, for example, Bainbridge Bishop and Alexander Wallis Rimington, both of whom were interested in the analogy of color and music. In the art critic John Ruskin's opinion, "If you wish to take up colouring seriously you had better get Field's *Chromatography* at once; only do not attend to anything it says about principles or harmonies of colour. . . ." *See also* Music and Color.

Figure and Ground

See Background.

Filament Lamp

See Lighting, Artificial.

Film Color

Perceived color occupying an area of indeterminate distance from the viewer, and therefore not seen as belonging to a surface. An example is the color seen in a spectroscope. It does not include colors seen on celluloid (properly called *volume color*). Film color exhibits saturation but not lightness and is possibly the purest form of color that can be perceived. *See also* Surface Color; Volume Color.

Films, Color in

See Motion Pictures, Color in.

Finish

Characteristic of pigment colors referring to the presence or absence of a luster, gloss, glaze, or other light-reflecting surface. Finishes largely affect the value (lightness) of a color.

Fixative, Color

Substance used to make a color fast and stable, as in dyeing or photography. A fixative is also sprayed over drawings, especially pastels, to prevent color from rubbing off.

Flag Colors

Flags are the clearest examples of the successful use of colors for their evocative connotations. Flag colors are chosen for many reasons, ranging from abstract and symbolic powers that the colors are deemed to possess to references by the colors to specific historical events or dynasties, but in all cases they provide instant national identity and a singularly strong focus of patriotism.

The progress of flag colors around the world can be used to trace population movements and cultural influences. For instance, the colors of the British flag (a combination of three crosses: red on white for Saint George of England, white on blue for Saint Andrew of Scotland, and blue on white for Saint David of Wales) were carried over into the American flag by a nation dominated by formerly British colonists. The design changed, but the symbolic associations of the colors is classic, going back to the medieval heraldic systems of northern Europe: In this early American icon, red represents revolution and the courage of the American people, white is for purity, and blue for honesty and peace.

Similarly in Mexico, a country colonized by Spain, the favorite colors that evolved into those of the national flag were green for

independence but also white, for the purity of the imported Christian religion, and red, a Spanish national color representing union. In contrast, the colors of the Argentine flag, blue and white with a yellow sun, commemorate an historical event. As the story goes, cockades of blue and white were distributed at a demonstration for independence on May 25, 1810, in Buenos Aires. It had been a cloudy day and when the sky cleared and the sun came through, the colors were taken to be a good omen.

Green is a color particularly favored by Muslim countries, as it commemorates the green turban worn by the prophet Muhammad (ca. 570–632). It became the color of the Fatimid dynasty established by Muhammad's daughter Fatima, and of the first flag of the early Muslims. In the hot, arid regions of the Arab world, it is also a color redolent of vegetation and life. Other colors may recall other dynastic groups or movements, as in the flag of the United Arab Emirates, which includes, in addition to green, red for the Ummayads, black for the Abbasids, and red for the sharifs of Mecca.

Shades can be subject to change. For instance, the blue of the modern Greek flag was originally a medium blue when the country was ruled by monarchs of Bavarian origin from the nineteenth to the middle of the twentieth century. When the military junta was in power from 1967 to 1974, it insisted on a very dark blue, while the latest democratic government has replaced it symbolically with a very light blue. The distinctive maroon that characterizes the flag of Qatar was originally meant to be a bright crimson. However, the effect of the sun on the red natural dyes used forced an official change.

Whether developed in response to the environment or out of respect to cultural roots, the colors of the flag provide a unique means for a nation to signal its character and ideals. The following is a selection of other flag colors and their associated meanings:

Bahamas: Aquamarine blue for the blue waters, yellow for the golden sands of the islands, and black for the unity of the Bahamian people.
Botswana: Light blue for water and sky, sandwiching black and white stripes representing equal opportunity for all races.
Bolivia: Red for the valor of Bolivian soldiers, over yellow for the richness of mineral resources, and green for the fertility of the land.
Egypt: Red for revolution, black for the dark days of the past, and white for a bright future.

The American flag is a symbol recognized instantly around the world.

Finland: Blue and white for the lakes and snows of this Scandinavian country.

Ivory Coast: Orange for the savannas of the north of the country, blue for the virgin forests of the south, and white for peace between north and south.

Gabon: Green for the extensive forests, yellow for the equator bisecting the country, and blue for the sea and its position as a maritime nation.

Greece: Blue for the omnipresent sea and sky and for the color of the Virgin Mary's dress in icons, and white for purity of the country's struggle for independence.

Kenya: Black for the people of Kenya, red for the struggle for independence, green for agriculture, and white for unity and peace.

Libya: All green, representing not only Islam but also the promise by Muammar Qaddafi (1942–) of a "green" revolution transforming Libya into a self-sufficient, food-producing country.

Lebanon: Red for the Kayssites, white for the Yemenites, and green for the famous cedars of Lebanon.

Singapore: Red for universal brotherhood, white for purity and virtue.

Soviet Union: Red and yellow for the continuing revolution.

Panama: Red for the liberals, blue for the conservatives, and white for peace between them.

Venezuela: White for the whites, blue for the blacks, red for the mulattos, and yellow for the Indians.

See also Communication and Color; Heraldry; Race and Skin Color; Symbolism and Color.

Flake White

See Artists' Pigments.

Flame Red

Term applied by designers and colorists to describe a brilliant shade of fiery orange-red.

Flat Color

Color that has been applied evenly, with minimum texture, and with no color variation over large surfaces. Flat color is a feature of lithographic and screen printing processes, in which single, premixed color is rolled over or squeezed through each screen respectively. *Flat* also has the connotation of being without gloss or luster, and so is sometimes used interchangeably with *matte.*

Flavin, Dan

1933– . American lighting artist who works primarily with white fluorescent tubes. Born in Jamaica, New York, Flavin studied at the U.S. Air Force Meteorological Technician Training School in 1953 and at the University of Maryland Extension Program in Korea in 1954 and 1955, which predisposed him toward a highly technological approach to color in art.

In an autobiographical sketch published in *Artforum* in 1965, Flavin criticized conventional art historical studies. The sketch, entitled ". . . in daylight or cool white," implied that in the future the interest in color would focus on color as light, not the "antique mode" of "permanent paint, which no one will ever use again." Flavin's own work includes three aspects: color as a light source, the diffusion of colored lights, and the arrangement of light tubes and fixtures in space. Of great luminosity, his fluorescent tubes are intended by the artist to "punctuate space with incandescent strikes" (*Artforum,* no. 4, December 1965).

Flesh Color

The color of Caucasian skin; a yellowish pink or pinkish cream.

Flicker

See Dazzle; Moiré; Op Art.

Flight of Colors

Many people have noted that after they look at a very bright light source and then close their eyes, flashes of color appear. Centuries ago, Aristotle noted a "flight of colors" upon looking into the sun. In *Physics,* he wrote, "If after having looked at the sun or some other bright object, we close our eyes, then, if we watch carefully, it appears on a right line with the direction of vision, at first with its own color, then it changes to crimson, next to purple, until it becomes black and disappears" (Ross, ed., 1955). Johann Wolfgang von Goethe saw the sequence as brightness first, then yellow, purple, and blue.

If the stimulus is of high intensity, the sequence may begin at green and proceed through yellow, orange, red, and purple, then to blue, fading out in green and black. If the stimulus is weaker, the sequence may begin at purple and proceed through blue and green, into black. Though these hues have no external existence, they are quite real to the senses and will move with the eyes.

Fluorescence

The phenomenon of converting radiation of high frequency into visible light at a lower frequency. Thus, fluorescent paints absorb

ultraviolet radiation, which has a wavelength slightly shorter than the visible spectrum, and reemits some of that energy as visible light. Highly fluorescing materials (phosphores) coated on the inside of glass tubes have produced energy-efficient fluorescent lamps that minimize the amount of energy lost as heat.

Ultraviolet light produces fluorescence in various foodstuffs and organic materials, allowing them to be identified and checked for quality. Butter, eggs, potatoes, skin, teeth, and hair will all fluoresce. Butter glows yellow, while margarine glows blue, allowing as little as a 15 percent adulteration of butter to be observed. Fungi in cheese fluoresce a brilliant green; natural ripening can easily be differentiated from artificial processes that do not use fungi. Healthy potatoes show color, while those affected by ring rot do not. Fresh eggs fluoresce a pale red, while older eggs become more bluish.

Fluorescence also has applications in medicine. Tuberculosis germs in human sputum will fluoresce yellow. A fluorescent dye injected into the bloodstream has been used as an aid to surgery. The bloodstream will carry the dye to the affected areas, making cancer tissues, for instance, glow a vivid yellow. *See also* Fluorescent Brighteners; Fluorescent Colors; Fluorescent Lamps; Lighting, Artificial; Phosphores.

Fluorescent Brighteners

Dyes with fluorescing characteristics are added to modern detergents to counteract the natural yellowing of fabrics that occurs during washing. Up until this century, the yellow tinge was neutralized by the addition of the old-fashioned "blue-bag," a soap containing a reddish blue dye. The resulting reduction of the light reflected by the fabric made it appear a pale gray. The fluorescing dye, on the other hand, actually increases the amount of reflected light by absorbing the invisible ultraviolet radiation in sunlight and reemitting it at a shorter wavelength as blue light. This both cancels the yellow and hides graying, giving rise to the advertising slogan that detergents make fabrics appear "whiter than white."

Fluorescent Colors

Extraordinarily luminous, high-intensity bright shades used to attract attention; the lighting colors produced by fluorescent tubes. In emergencies and in unexpected situations, fluorescent colors are of great value in commanding attention and regulating a desired response. Thus, life jackets are fluorescent orange (not yellow, which at a distance can be mistaken for white wave crests), a color known internationally as "safety orange." Signs, particularly at construction sites, take advantage of fluorescent brightness to alert people to unusual and dangerous situations. Oranges and yellows, naturally high in intensity, are the best warning hues.

In printing, fluorescent colors are used for advertising and in packaging consumer goods for mass markets. Day-Glo or fluorescent color can emanate a certain vulgarity if its inherent brightness is perceived as banally brazen as a result of oversaturation. Heavy roadside diner and supermarket usage, particularly of turquoise blue and orange, established a déclassé character for fluorescent blues and oranges in the aftermath of too much exposure in the 1950s. For a time thereafter, fluorescent colors were rarely used in advertising and packaging when the image desired was one of exclusivity and elegance.

Since the 1960s, with pop art's incorporation and elevation of Day-Glo colors, fluorescent shades have entered fashion fun wear—black wool mittens with yellow fluorescent tips and trendy jewelry accessories are examples. By and large, fluorescent colors have been used only on goods geared toward the young.

Fluorescent white (often forgotten as a fluorescent color) light is used extensively in non-residential interior lighting. Since its development in the 1930s, fluorescent white light has become the chosen form for area lighting because it is extremely cost-efficient. Typically, fluorescent tubes give off a diffuse, shadowless light.

Fluorescent Lamp

Lamp incorporating a glass tube coated on the inside with a powder (phosphore) that emits visible light upon absorbing ultraviolet radiation generated by an electrical discharge inside the tube. The following are some of the common fluorescent lamps, listed with their characteristics:

Name	Color's effect on neutral surfaces	Ambience
Cool white	White	Neutral to moderately cool
Deluxe cool white	White	Neutral to moderately cool
Warm white	Yellowish white	Warm
Deluxe warm white	Yellowish white	Warm
Daylight	Bluish white	Very cool

See also Fluorescence; Lighting, Artificial; Phosphores.

Blue is the one food color that generally does not appeal to adults.

Food Colorants, Artificial

Artificial colorants are used extensively in commercially produced foods. Many of these are derived from synthetic coal-tar dyes; all are subject to regulatory legislation by the U.S. Food and Drug Administration.

Food colorants, despite being potentially hazardous to human health, have been used extensively since ancient times. Color is of prime importance in the evaluation of food, increasing its visual attractiveness. Some products even serve as color guides: for example, *apple* and *cherry* red, *orange* and *apricot* and *melon* oranges, *lemon* yellow, and *pea* green. Some fruits are artificially colored to conform to consumer perceptions of what the "natural" color of ripe produce is. Florida oranges tend to be green when ripe, but this suggests immaturity to the consumer. For this reason, Florida's Valencia oranges, since 1934, have been artificially colored orange. Dairy products also have coloring added to compensate for the difference between consumer expectation and the reality of milk white, which varies seasonally and regionally because cows use beta carotene in differing amounts and at different rates of efficiency. Colorants keep the color constant. Another good reason to use a colorant in a naturally colored product is storage deterioration. Most color additives, however, are in food products that contain little or no color of their own, such as gelatins, margarine, sherbets, ice creams, and sodas.

Food coloring dates back to ancient Egypt; wall paintings from that era depict the coloring of candy. By the late eighteenth and nineteenth centuries, not only was coloring added to make food attractive but it was also used to mask food of poor quality and even spoiled food. A treatise by German chemist Frederick Accum (1769–1838), for example, exposed two lethal practices common in London: one used poisonous copper sulfate to lend an appetizing green color to pickles; the other tinted old tea leaves with deadly black lead to make them appear fresh.

In the United States, an 1886 act of Congress authorized additive coloring matter made from synthetic organic dyes for use in butter. The second recognition of synthetic coloring matter came in 1896 when Congress authorized the coloring of cheese. By the turn of the century, Americans were eating a wide variety of artificially colored foodstuffs, including butter, cheese, ketchup, jelly, candies, and sausages. Among the hazardous color additives then prevalent was Martius yellow, a coal-tar dye, used in imported macaroni. It was outlawed by the Food and Drug Act of 1906. This act, together with a supple-

mentary one of 1907, put an end to known dangerous coloring matters in food. Only seven dyes were listed as acceptable for use: Amaranth, Ponceau 3R, Orange I, Erythrosin (FD&C Red No. 3), Naphthol Yellow S (Ex. D&C Yellow No. 7), Light Green SF Yellowish, Indio Disulfo Acid, Sodium Salt (FD&C Blue No. 2).

The next three decades witnessed a continual growth in the use of food coloring additives. In 1938, the Federal Food, Drug, and Cosmetic Act limited the colorants that could be used, made certification of synthetic color additives mandatory, and extended governmental control beyond food colors to drugs and cosmetics. A 1960 act placed all synthetic dyes under the supervision of the Secretary of Health, Education, and Welfare. Various health scares, principally one in the mid-1970s over red dye used in maraschino cherries, have made the public wary of artificial coloring; by the 1980s, many products are labeled "no artificial coloring" or "no artificial colors" on their packaging.

Food Colors

The color of food has a considerable impact on the taste associated with it. In an apocryphal story, the film director Alfred Hitchcock (1899–1980) served steaks at a dinner party but lighted the dining room only with blue light: The sight of the grayish blue meat, so redolent of disease and decay, sickened all his guests.

Certainly, food producers go to great lengths to ensure that all their products have the appropriate color and shade. Red, for instance, has such an association with ripeness and flavor that yellow or orange-red tomatoes will not sell against the bright red, but generally more tasteless, hothouse varieties. Margarine manufacturers go to great lengths to color their products the yellow of butter, even while simultaneously advertising differences such as health benefits; white simply will not sell.

The most popular food colors with adults tend to be those that are dark, suggesting a strong flavor. Brown is particularly appealing, with its associations with well-cooked meats, breads, and wholesome cereals. Tints of colors are neither as upsetting nor as savory as pure hues. Tinned peas that have been blanched usually have to be redyed green to appeal to the consumer, but the same tint (or so-called candy color) can be relatively attractive in sweets.

Blue is the one color that generally does not appeal to adults, though it will have little effect on children. This may be because many blue, mauve, and black foods are poi-

sonous, a fact that adults have come to recognize. Blue is a natural color for cheese, however, and for the occasional blue corn tortilla chip.

White, which used to be a status symbol, implying processed and refined flour, sugar, rice, and bread, has become less popular in a health-conscious era. In general, white, including the white meat of fish and chicken, is preferred by women more than by men, but the difference is declining somewhat. Dairy products, such as ice cream, are lightly colored to suggest sweetness and flavor, although in some countries sweet products are whitened to suggest the milk that is actually absent.

In packaging food, the best colors are those that are evocative of the colors of the food itself. Just as a brown beer bottle enhances the amber beer, so will a green-and-yellow can for corn attract the consumer to it for the supposed natural flavors it contains. Blue does better in packaging than in food, since it can evoke hygiene and coolness—just as it would in cleaning fluids. As in the food, color coding can be used in packaging to imply strengths of flavor. A white label for beer means that it is a "light." A deep brown package for coffee suggests a strong brand, a color matching the brown to which the beans are generally roasted.

For tableware and the dining room, blue is the one color that stands out. It almost always provides a clean and neutral balance for the color of food.

These are some of the common associations of colors and food types:

Red: Strength and flavor—tomatoes, peppers, fruit, meats (but not fish or fowl), wines.
Orange/gold/yellow/brown: Warmth and sunshine—cereals, breads, pastas, oils, beers, white wines.
Green: Freshness and fertility—best only when applied to vegetables.
Blue: Cool and hygienic—cheeses, some dairy products; good for color coding on packaging to suggest low levels of calories.
White: Refinement and delicacy—flour, sugar, bread, rice, fish, and fowl. Generally too "tasteless" for vegetables or cheeses.

These color associations are conditioned in Western children since birth, but they may not apply to the East: In India, for instance, people are prepared to eat brightly colored food that would be unpalatable for an American. On the whole, recent education on the dangers of artificial coloring is pushing consumers toward "naturally" colored foods, particularly the browns and the yellows, which are suggestive of high fiber content. It is likely to be a long time, however, before people are able to tolerate food that is actually uncolored—perception and taste are too closely intertwined. *See also* Cochineal; Communication and Color; Food Colorants, Artificial; Poisonous Colors; Synaesthesia.

Footcandle

Unit of measurement of illuminance. One footcandle equals one lumen per square foot. *See also* Lumen.

Forget-Me-Not Blue

A soft turquoise, as in the flower (from the genus *Myosotis*, which has clusters of small blue-and-white flowers and symbolizes friendship and faithfulness). The color was particularly popular in women's clothing in the 1920s and appeared as a fashion accent in women's shoes and gloves in the 1930s. In 1941, forget-me-not blue was chosen for the ninth edition of *The Standard Color Reference of America* as an official color standard because of its past popularity. The shade disappeared with the dye shortages of World War II, only to return with other pastels during the prosperous 1950s and remain a textile standard for a pale, green-cast blue.

Form (and Color)

Artistic term describing that element of painting concerned with line and the arrangement of visual space, as opposed to the choice of color. Since the Renaissance and the formulation of the laws of perspective (*see* Leonardo da Vinci), artists have often stressed draftsmanship (thus, form) over color with the exception of only a handful of notable colorists (for example, *see* Turner, Joseph Mallord). The attitude was summed up by Ogden Rood, who wrote in *Modern Chromatics* (1878): "In decorative art the element of color is more important than that of form, whereas just the reverse is true in painting. Here color is subordinate to form." Rood believed color actually undermines the stability of pictures and should be relegated to the province of decoration alone.

However, color can also enhance form, rendering the two interdependent to some degree. Two artistic techniques in particular employ color to create the illusions of depth and shape. One is chiaroscuro, which depends on the representation of highlights and shadows and tonal variations to give the impression of three dimensions on the canvas. The other is aerial perspective, in which

"In my studies of subjective color, I have found that not only the choice and juxtaposition of hues but also the size and orientation of areas may be highly characteristic. Some individuals orient all areas vertically; others stress the horizontal or diagonal. Orientation is a clue to mode of thought and feeling. Some individuals incline toward crisp and sharply bounded color areas, others to interpenetrating or blurred and haphazard patches. Individuals of the latter kind are not given to clear and simple thinking. They may be quite emotional and sentimentally disposed."
—Johannes Itten

"You reason color more than you reason drawing. . . . Color has a logic as severe as form."
—Pierre Bonnard

Chanel perfume.

the artist reduces the chroma and increases the proportion of blue to give an impression of depth to a landscape.

Artists of the past century have variously emphasized form or color. For instance, Pierre Bonnard, in his famous painting of a woman bathing (*The Bath, 1924*), reverses the convention of aerial perspective by painting the foreground (the bath) in blues and the background in a complementary orange. In doing this, Bonnard plays down the representational aspect of the painting, concentrating on the emotive and slightly chilling effect that the blue bather provokes. Going one step further, Piet Mondrian removed representation altogether, standardizing his forms into a set of lines and rectangles, and exploring the effects that the primary colors red, yellow, and blue can produce in various combinations. Similarly, Andy Warhol took pop images and, without altering the basic composition, produced a line of silkscreen prints in varying colors.

The contrasting position, one that standardizes color instead of form, is that of the cubists, such as Pablo Picasso and Georges Braque, who for a time removed all color but the deepest browns and blacks from their canvases while they explored the ways that a three-dimensional object can be broken down into fragments of images.

In each case, there has been an actual or tacit acknowledgment that color *can* profoundly affect the appearance of form, and many of the discoveries of artists have made their way into other disciplines. One example is architecture, in which the ways certain colors can advance or retreat, blend in or stand out, have been used advantageously to control space and proportion in modern buildings, particularly where space is limited. In certain areas, color remains a wholly independent concern. This is the case in packaging, where companies have the opportunity to explore the communicative potential of color while remaining within the basic format of the logo and corporate identity. *See also* Advertising; Aerial Perspective; Architecture and Color; Camouflage; Chiaroscuro; Communication and Color; Kandinsky, Wassily; "Size" of Color; Symbolism and Color.

Fovea

A small depression in the retina's center that lacks rods and that contains a high concentration of color-sensitive cones. With a young, healthy eye, light is brought to the sharpest focus on the fovea, providing that part of the visual field with the clearest detail. *See also* Vision.

"Color, rather than shape, is more closely related to emotion."
—*David Katz*

Fra Angelico

1400–1455. A Florentine painter whose religious works are remarkable for their highly decorative, bright, clear colors. A Dominican monk, Fra Angelico painted only religious subjects. His works retain the bright Gothic colorings and the naive, lyrical aspect of medieval art in spite of a multitude of realistic detailing. The Renaissance painter and art historian Giorgio Vasari (1511–74) gave a description in his *Lives* of Fra Angelico's spirituality that explains the sense of luminosity and clarity of color emanating from the monk's art.

> To sum up, this father, who can never be enough praised, was in all his work and words most humble and sweet, and in his painting facile and devoted, and the saints whom he painted have more an air and likeness of saints than those of anyone else. It was his habit never to retouch or alter any of his paintings, but to leave them as they came the first time, believing, as he said, that such was the will of God (Seeley, ed., 1957).

Fra Angelico's religiosity underlies most particularly his color schemes, which are organized by the light of heavenly presences on earth and therefore show a play of the natural world's clear colors, juxtaposed with the golds and white luminosity of God's manifestations.

Fragonard, Jean-Honoré

See Rococo Colors.

essay

Fragrance and Color

Annette Green, executive director of The Fragrance Foundation and organizer of the historic 1988 exhibition Scents of Time (The Museum of the City of New York), examines the intimate relationship between the smell of a fragrance and its bottle and package color design.

Fragrance has always had a very real relationship to color. In the most obvious sense, it is expressed in packaging. The creative minds behind the bottles and boxes that house fragrant potions literally spend years developing the color messages they want to convey. Behind these decisions, first and foremost is the desire to capture the consumer's attention in a competitive retail atmosphere drenched in color, design, light, and sound. But equally important to the design of both bottle and package is the necessity to use color to express the mood of the fragrance inside the package.

A light, spicy fragrance would never be packaged in a hot red or dramatic black box; the sensory messages would be all wrong. Conversely, more sophisticated and/or erotic fragrances usually are packaged in one or more of the hot colors, or in black, gold, and/or white.

In 1985, The Fragrance Foundation initiated a semi-annual trend forecast, which reviewed apparel fashions for men as well as women and attempted to project future fragrance bottle and packaging colors based on directions in clothing as well as life-style in general. The forecast recognized the close relationship between color and fragrance.

Each season, the interrelationship between clothing fashion colors and fragrances has been clear. For example, when greens have dominated the fashion scene, natural lime and lemon scents have emerged as important. In the late 1980s, when hot colors were combined for startling visual effects in eau de cologne packaging, so were oriental fragrances. When roses bloom throughout the fashion world in their delicate pinks or fuchsias, floral fragrances, in which the rose dominates, also reign.

It is interesting that very little is said about the emotional link between fragrance and color. Fragrances elicit—as do colors—a whole range of emotions. Primary colors can be compared with fragrance classics, which are designed to make the wearer feel secure. Romantic pastels speak to the eternal appeal of gentle, romantic floral bouquets or modern blends of fragrances. Just as cool colors calm us and add to the enjoyment of the summer months, cool fragrances, usually citrus or spicy creations, do the same. We turn to warm colors in winter and to warm oriental scents and rich, jasmine-drenched florals. We use color to express or change our moods.

The relationship between color and fragrance will likely become even more obvious in the years ahead, not only from a fashion/fragrance viewpoint, but also in home decorating. The burgeoning growth of color in interior design has also triggered an emotional need to color the environment with specially formulated scents. In response, the fragrance industry has created and will continue to devise new sensory experiences to complement the environment and conjure up scents that express color and mood in such forms as potpourris, room sprays, candles, and incense. With color and scent, one can control the emotional barometer of a room.

—Annette Green

Fragrance Foundation, The

See Appendix.

Framing

See Mounting and Framing, Color and.

French Ultramarine

A deep blue pigment, a compound of soda, silica, alumina, and sulfur. A good substitute for genuine ultramarine, it is made by grinding the mineral lapis lazuli. French ultramarine was discovered by the chemist Jean-Baptiste Guimet of Toulouse, France, who in 1824 won a competition to produce a less expensive form of the ultramarine pigment.

Frequency

The number of times in a second that a periodic phenomenon such as a light wave repeats itself. The unit of frequency is the hertz (Hz), which is equal to one cycle per second. Each color band of visible light has a different frequency, from red with the lowest frequency to blue with the highest. The frequency of a wave multiplied by the wavelength always equals the speed of light, which is constant. *See also* Light.

Fresco

A painting made directly on damp, fresh lime plaster spread on the surface of a wall. The word *fresco* comes from the Italian, meaning "fresh." In Renaissance Italy, in the fifteenth century, true fresco was called *buon fresco* to distinguish it from *fresco secco*, which is a related technique executed on dry plaster with pigments that have a glue or casein base. Buon fresco pigments are water based, and as the plaster hardens, they are chemically bonded to the wall's surface. Artists must work quickly before the plaster dries, scraping off any unpainted portions at the end of the day. To make the joinings inconspicuous, each day's work must be planned to conform to the contours of figures or objects in the composition.

The fresco technique was first used in Crete, around 1500 B.C. Several centuries later, the Etruscans were using both the buon fresco and fresco secco techniques to decorate the walls of tombs. Dating from the eighth through the first centuries B.C., their frescoes, many of which survive today, were bright and animated, based on a palette of red, black, white, blue, and yellow.

Most pigments were mineral in origin: red and yellow from iron oxides, blue from lapis lazuli, white from chalk, and black from charcoal. Such earth pigments, being resistant to alkalis, are best for fresco painting.

Because not all pigments are compatible with lime, fresco does not permit as large a palette as oil. Nor does fresco allow the freedom of manipulation that characterizes other techniques. These limitations, however, are offset by the clear luminous colors, fine surface, and permanence, all of which are prime considerations in wall painting.

Fresco was revived in the twentieth century by such artists as José Clemente Orozco (1883–1949), Diego Rivera (1886–1957), and David Alfaro Siqueiros (1896–1974). These three Mexican artists gave new life to buon fresco painting with their huge murals, which were created for public spaces in the aftermath of the Mexican revolution. Fresco presented a perfect medium for their pictures: Rivera, in dark, rich, somber tones, represented the history and problems of Mexico; Orozco, with starker and stronger colors, dealt with the dehumanizing confrontation of man and machine; Siqueiros, also depicting revolutionary struggles with characteristic swirling brushwork and dramatic contrasts of light and dark, was the only one to work in a form of fresco secco, innovating the use of pyroxylin paints on masonite. Rivera's work appears in the Stock Exchange and in the Fine Arts Building, San Francisco, though his proposed mural for the Rockefeller Center, New York, was rejected because it included a portrait of Lenin. *See also* Sinopia.

Frosting

Paint term describing a surface that has been altered and whitened. In its positive decorative usage, frosting (commonly called pickling) refers to a flat white paint, usually an oil base, which is used as a glaze. Negatively, frosting refers to the appearance of white spotting on an exterior paint surface and indicates deterioration caused by the combination of the paint's calcium carbonates with acid rain or sulfur-contaminated air. Frosting is most noticeable on dark colors and as a color problem is prevalent in heavy mining and industrial areas.

Full-Color Reproduction

A term used in printing and other forms of reproduction to indicate that the complete range of color is being used. Full-color images can be made with four colors—cyan, magenta, yellow, and black in subtractive processes, or blue, red, green, and black in additive processes. This is known as four-color reproduction; twenty or more colors can be used in other processes, such as wood-block printing. *See also* Additive Color Mixing; Printmaking; Subtractive Color Mixing; Two-Color Reproduction; Ukiyo-e.

Functional Color

During and after World War II, in an effort to increase manpower efficiency, many technical studies were made of illumination and environmental factors, including color. Beyond appearance, problems relating to visual, physiological, and psychological reactions to surroundings were subjected to extensive research.

Some findings had practical applications, especially in the workplace. Warm colors could be applied to walls to compensate psychologically for cool temperatures; conversely, cool colors could be used for warm temperatures. High levels of illumination and luminous colors such as yellow and orange commanded attention and could be used to alert workers to the details of their surroundings. Medium and deeper colors (soft blue, green, beige) lessened the distractions of an environment.

It was also found that the perception of interior space—its size and mood, for example—is affected by the color of surfaces and lighting conditions. Subsequently, the functional-color approach came to be used widely in planning color schemes in the workplace, particularly where a room's dimensions were less than desirable.

Bold color schemes, which contrast in hue and in value, tend to create dynamic interiors, environments engendering movement and activity. Monochromatic schemes, whether in cool or warm tonalities, suggest visual quiet and consequently are better for mental concentration. Light colors such as pastels tend to expand interior space, while dark colors increase the human feeling of coziness, sometimes to the point of claustrophobia. Reds, oranges, yellows, and incandescent lighting generally make a room feel warm, while greens, aqua blues, and fluorescent illumination make it seem cool.

The shape of a room can be altered by its wall colors. A low ceiling will seem higher and narrow walls wider when painted with a cool, light color. A bright hue on a far wall will make a long room seem shorter; conversely, to lengthen a room visually, color a far wall with a cool, dark shade.

Functional color is a major factor in designing for special populations. In facilities for the mentally retarded, convalescent homes, hospitals, and psychiatric wards, for example, color is often used functionally rather than aesthetically to bring a sense of nor-

malcy to potentially dreary environments. The early-twentieth-century hospital, with its white walls, white equipment, white doctors' and nurses' uniforms, and white linen was monotonous and depressingly institutional, increasing a patient's awareness of illness. By the late 1940s, wood furnishings, brightly colored upholstery, light tones on walls, and distinctive signage began to replace such dreary sterile settings. The benefits of color are well documented for the newborn, in industrial environments, and for a variety of deviant behavior.
—Faber Birren

See also Color Therapy; Communication and Color; Industrial Environments and Color; Safety Colors.

Fundamental Color

A general term in color theory used to designate certain hues assumed to be "original" or of more importance than other hues. The significance of the term differs according to the color theory adopted. *See also* Primary Colors; Unique Color.

Fur Colors

The colors of natural animal pelts, skins, and hides; of the bred mutations of minks, foxes, chinchillas, and other furred animals; and of commercially dyed pelts and hides.

Since cavemen discovered the warmth of animal skins, furs have been highly prized, coming to symbolize status, love, power, and beauty. From the Roman Empire of the first century through the sixteenth-century Renaissance, furs enjoyed their greatest popularity, providing comforting warmth in the days of fire-heated houses and snow-covered dirt roads. In interiors and in dress, furs, often in the brownish reds of red foxes, provided pervasive color accents.

Rarer skins and their consequently more prized colors were, in the past, reserved for royalty and later the privileged rich. Notable in this regard are sable (blue-cast brown), ermine (chiefly the white of the winter coat), chinchillas (mottled blue-gray), and Alaska seal (russet brown), all of which were originally worn exclusively by royalty. Edward I of England (1239–1307) forbade commoners to wear hoods trimmed with anything but rabbit or lamb. By 1661, English law limited ermine to high officials and aristocrats, while dyed sable was relegated to the professional classes. In the nineteenth century, Napoleon's empress Josephine (1763–1814) wore ermine, but few others could afford it. In the twentieth century, the movie star Mae West (1892–1980) in white fox (matching her white

satin gowns) continued the tradition of white fur as a badge of the privileged few.

Modern fur-coloring techniques include dyeing, blending, and adding color to the tips of the hairs and printing colored patterns, usually by silk screening or bleaching. As many as 200 new colors and textures have been achieved by controlled breeding. Mink, some types of foxes, chinchillas, nutria, and beaver are among the pelts produced commercially by ranching. The first commercial mink mutation was platinum or silver blue, which appeared in 1931.

Patterned animal colors such as zebra, cheetah, and pony skins have also been prized. As recently as the 1950s, zebra rugs and skin seats were popular in American interiors. By the late 1980s, an awareness of endangered species has made it more acceptable—for many, preferable—to use synthetic imitations of exotic animals. *See also* Zoology and Color.

Furniture

Color in furniture making is derived from various sources: wood, which is left in its natural state or stained; paint, to cover part or all of a piece; and upholstery fabric or other covering material.

Since the seventeenth century in Europe, tastes in furniture color have almost always paralleled color fashions in interiors. In France, for example, painted furniture only gained favor under Louis XIV (1638–1715), and even then it was largely restricted to white paint with gilded details that reflected the prevalent architectural detailing. Similarly, in England during the eighteenth century, the designs of George Hepplewhite (?–1786) combined green, blue, black, and buff with multi-colored decoration. Thomas Sheraton (1751–1806) and Robert Adam favored pastel green, fawn, pink, and mauve, with white and gold enrichment appropriate to their neoclassical architecture.

In America, perhaps the most interesting example of color in furniture occurs in Shaker designs. An isolated religious group, the United Society of Believers, known colloquially as Shakers, made furniture that was spare and unembellished, in keeping with their ideals. Their use of color, however, was often intrinsic to the design, including every coloring technique available. Each element of a case of drawers from 1850, for instance, is of a different wood. The natural colors and grains of tiger maple, bird's-eye maple, cherry, pine, poplar, and walnut alternate in a masterpiece of harmony and geometric design. Stains, used on furniture or hatboxes, were equally subtle, enhancing natural col-

American Shaker furniture is characterized by stains that enhance natural wood colors.

ors of the wood while showing the grain: yellow on butternut, red-orange on pine, and red on cherry or maple. Paint colors were deep, even somber, but of a quiet beauty and depth similar to oriental lacquer ware: dark red-orange, dark red, ocher yellow, blue-green, olive green, and dark blue. Blue, a relatively costly pigment, was saved for "important" pieces such as the trim on woodwork in Shaker meetinghouses.

In the twentieth century, International Style furniture designs relied on chrome-plated metal, black leather, and varnished wood for minimal color. In the 1960s, pop art and later, in the 1970s and 1980s, the postmodernists (especially the Memphis group), revitalized the use of color in their highly ornamental furniture. Bright salmon pinks, turquoises, reds, and brilliant yellow paints cover the entire surface of 1980s furniture and disguise the material. *See also* Adam, Robert and James; Interiors and Color; Lacquer Colors; Memphis; Trends in Color.

Fusion

Optically, the perception of the two images received by both eyes as a single image, of rapid or intermittent flashes of light as a continuous beam, or of dots of color too small to be seen individually as one overall color. *See also* Printmaking.

Futurism

An Italian art movement that celebrated the new world of technology and rejected most historical traditions and values. Poet and editor F. T. Marinetti (1876–1944) outlined this inflammatory movement on the front page of *Le Figaro*, a Parisian newspaper, on February 20, 1909. The predominant concern of the futurists was with dynamism, movement, "force-lines," and energy.

The futurist Carlo Carrà (1881–1966) is explicit about the role of color in painting. Taking as his point of departure the "construction through color" of Paul Cézanne, whose "coloristic sensibility [he claims] surpassed the Egyptians, Persians, Chinese, and even the Byzantines . . . even Titian, Tintoretto, Rubens, and so on," Carrà declared that

> . . . painting must express color the way one senses music though the means are different, that is, analogously. We stand for a use of color free from the imitation of objects and things as colored images; we stand for an aerial vision in which the material of color is expressed in all the manifold possibilities our subjectivity can create . . . form and color are related only in terms of subjective values (Chipp 1968).

For futurists, the compulsive subjectivity of color was exploited most conspicuously as a shock effect: "Before a mysterious grouping of colors, an observer, even if an advanced and well-informed person, gives a scandalized shout" (Chipp 1968).

Gainsborough, Thomas

1727–88. English portraitist and landscape painter who favored a refined pastel palette. He was renowned for his elegant and vivacious full-length portraits, many of graceful women who, like those painted by Sir Joshua Reynolds and George Romney (1734–1802), embody the ideal English beauty of their era. *See also* Reynolds, Sir Joshua.

Galton, Francis

1822–1911. English scientist and founder of the field of eugenics who, in 1883, completed a pioneer study of color associations, published under the title *Inquiries into Human Faculty;* his revelations about color were popular for generations.

Galton noted that the hues of the spectrum may be associated with tastes, odors, or sounds. Red and blue, for example, are thought to be warm and cool colors, respectively. Appetite appeal is said to be found in warm red, orange, "butter" yellow, "lettuce" green, tan, and similar colors, while mustard tones, gray, and black are unappetizing. Pink is a "sweet" color; blue is cool and refreshing. Fragrance is frequently suggested by pale gold tones and sometimes by pastel flower tints (in soaps).

Galton's report was based on the color experiences of friends. He noted that "color thinkers" held no common agreement. Their associations were impromptu and difficult to explain. He concluded that synaesthesia was hereditary and presented several charts in which various color associations were illustrated. *See also* Music and Color; Scriabin, Aleksandr; Synaesthesia.

Garden Colors

The natural hues of flowers and the various greens of growing plants used to create analogous or contrast harmonies in the garden. Color styles in gardening vary considerably according to country and culture: English gardens tend to emphasize nature's disposition of flora, while French gardens often insist on more formal groupings of flora by color, giving great care to the juxtaposition of colors to achieve harmonious effect; Japanese gardens, on the other hand, are char-

acterized by subtlety in the use of color, emphasis on varieties of greens, and the widespread use of stones and water.

The most common effect used in creating garden harmonies all over the world is that of successive contrast. This was exploited by the nineteenth-century British gardener Gertrude Jekyll, who planted gardens with monochromatic progressions of flowers: Pale pinks would merge gradually into bright ones, their brightness being accentuated by the contrast (*see* Jekyll, Gertrude). In another case, Jekyll planted part of a garden in a monochromatic scheme of grayish blue flowers, which would lead into another part with yellow and orange flowers, whose brilliance would be intensified since the eye had been prepared for it (*see* Successive Contrast).

essay

The Gardener: A Green-Thumbed Colorist

The following essay by American landscape designer Jean R. Wells Wallace describes some of the methods that are employed to create color harmony in the modern garden.

Color in gardens is like a living tapestry, with fine, subtle foreground tones moving in stages to a distant vista. Effective color play in gardens, with light shades advancing and dark ones receding, can be achieved in spaces as limited as a bonsai or as vast as a historic English estate.

For example, a grouping of silver-green Russian olive trees, the medium green of weeping willows, and rich red maples against a backdrop of conifers create a fine result. Flowering pink and white ornamental fruit trees, magnolias in bloom, white banked birches, and red flowering hawthorns display well alone or against a background of mature oaks, beeches, hemlocks, firs, or spruces.

For foreground effects, the shrubs of spring are recommended: Forsythia's yellows, rhododendron's mauves, pinks, fuchsias, and lemons, azalea's pinks, salmons, oranges, and reds—all these readily available plants, softened with airy white blooms

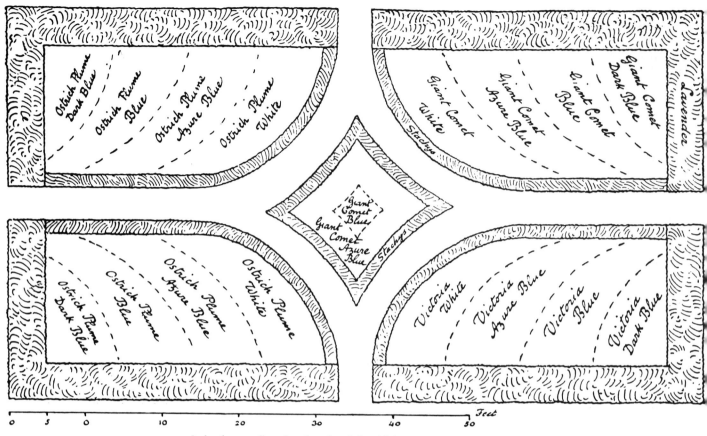

A plan for a small garden planted entirely with lavender and varieties of China asters by Gertrude Jekyll, inventor of the herbaceous border, 1898. The tonal progressions of blues give an impression of depth and perspective. Another favored Jekyll technique was the use of successive contrast effects to prepare the eye for succeeding colors, starting with grayed blues and ending in crescendos of reds and oranges.

of spinea or puffy white fothergilla, provide gardens with a superb palette.

Moving from cool to warm tones in flower beds enriches a garden plot; yet Sissinghurst's all-white garden in Cranbrook, England, with its myriad of different forms, is also highly impressive. Uni- or multi-color, whichever choice is made, the grouping of color masses is essential. For the most part, perennial flower beds must be planned for each of the three seasons in cold winter climates, as annuals are the only reliable source of three-season color.

Winter is a challenge to the gardener. The sight of red osier dogwood against freshly fallen snow is radiant. A Colorado blue spruce melds into a winter sky. Berries and pods—in brilliant yellows, reds, fuchsia blues, and black in season—appear muted and subtle in the light of wintertime.

In cold climates, autumn is a riot of red, orange, coral, golds, wines, and burgundies provided by deciduous trees and shrubs preparing to lose their leaves. Maples, the leader in this group, give the broadest color range. Shrubs and small trees such as *Fothergilla oxydedron* and dogwoods give a fine show.

Through the placement of the myriad shades of green, moods may be established. A driveway lined with dark pines can be foreboding and mysterious, while the same space bordered by majestic light green poplars provides a skylighted entrance.

Whether on desert's edge, in the mountains, at the seashore, on grassy plains, in the tropics, or in temperate woodlands, colorful plants can be used to startle or soothe. Always it is the balance of hues and tones that creates the garden masterpiece.
—Jean R. Wells Wallace

Garnet

The name may derive from the Latin *granatum*, meaning "pomegranate," a good description of its fruitlike red color. Garnet is a group name for the silicate minerals almandite (purplish red from traces of iron), pyrope (blood red from chromium), spessartite (orange from iron), essonite (brilliant green from vanadium), and demantoid (green and more fiery than a diamond, although this effect may be masked by the color-producing chromium impurities). *See also* Gemstones and Jewelry.

Gaudi y Cornet, Antonio

1852–1926. Spanish-Catalan architect who was influenced by the Art Nouveau movement. He worked mainly in Barcelona, where most of his work can be viewed today. Gaudi was revolutionary in his integration of color in the architectural facade. According to him, "Ornamentation has been, is and will be polychromatic: nature does not present us with any object that is monotonously uniform . . . therefore we must necessarily color, partially or completely, all architectonic members" (Martinell, 1975). Gaudi incorporated color into his facades through the use of naturally colored materials such as clinker (red) brick, different colored stones, and small colored tiles, as well as mosaics made of bits of tile, glass, and porcelain.

In the recreational park called Parque Guell, built between 1900 and 1914, color explodes everywhere, along the walks and in all the buildings. Most famous is the serpentine bench bordering the grand plaza, which is covered with porcelain and glass mosaic in bright blues, turquoise, orange, red, yellow, fuchsia, and other colors. Color is used as an accent in the ceiling of the hypostyle hall, which is dotted with medallions of color mosaic that contrast with the white ceiling. On the facade of the Casa Battlo, blues, yellow, and green dominate in glass mosaic, and, from the roof, carefully placed pieces of metal reflect light.

Color is a decorative element that is never lacking in Gaudi's buildings. In his own words, it "has the great value of making outlines and structural planes seem more energetic, and of giving a clearer idea of the object" (Martinell, 1975). *See also* Art Nouveau Colors.

Gauguin, Paul

1848–1903. Leading French postimpressionist painter, woodcut artist, and sculptor. A "weekend artist" until 1885, Gauguin then abandoned a career as a banker and the stability of family life to pursue his interest in painting. His work reflects a deep interest in religious feeling and symbolism, whether it is expressed in the Christian morals of the villagers of Brittany (*Jacob Wrestling with the Angel*, 1888; *The Yellow Christ*, 1889) or in the exotic paganism of Tahiti (*The Spirit of the Dead Watching*, 1892).

Rejecting the color theories of the impressionists—whom he felt "studied color exclusively in terms of decorative effect but without freedom, for they kept the shackles of representation . . . they look for what is near the eye, and not at the mysterious heart of thought"—Gauguin used color to reflect a world of symbolism, not nature's reality.

Not only did Gauguin exploit color's symbolic context, but also he emphasized its purity by isolating it, surrounding it with heavy black lines in a style labeled *cloisonnisme*. This practice, which he introduced, is thought to have been an influence of Japanese ukiyo-e prints, which were popular in France.

Areas of pure, bright, and flat color are a trademark of Gauguin's work, whether using the primaries, oranges, and greens prevalent in his paintings from Brittany or the explosion of tropical pinks, peaches, purples, and warm hues in his tropical palette. He advocated its use in the following way:

> A meter of green is greener than a centimeter if you wish to express greenness. . . . How does that tree look to you? Green? All right, then use green, the greenest on your palette. And that shadow, a little bluish? Don't be afraid. Paint it as blue as you can (Gardner 1970).

Gelatin

Also known as animal jelly, gelatin is obtained from the connective tissue of vertebrate animals (found in hoofs, bones, tendons, ligaments, and cartilage). It is extracted with boiling water or diluted acid. It dissolves in hot water and congeals when cool. Transparent and colorless, gelatin can be used as a binder for paints but is most commonly used, in its highly refined form, as the binding medium in photographic emulsions.

Gemstones and Jewelry

Precious or semi-precious stones used in jewelry making, often valued for their color; stones manipulated for purposes of adornment. The first real jewelry was probably manufactured by the Sumerians circa 2500 B.C., and it has been part of fashion and ritual since then. Modern cutting styles did not begin until the Middle Ages; until then, most stones were polished as they were or rounded into a domed style called cabochon.

The Egyptians were particularly fond of blue, either lapis lazuli, turquoise, or an imitation made of a vitreous paste called Egyptian faience. Green feldspar, amethyst, jasper, obsidian, agate, and crystal were used widely in the Middle Kingdom (2400–1580 B.C.). Certain colors were held to be magical. Green stones, for instance, were often made into heart scarabs, amulets that were placed on the dead to prevent their hearts from testifying against them when they were weighed in the balance by the god Osiris.

Paul Gauguin.

"If you see a tree as blue, then make it blue."
—Paul Gauguin

Greek jewelry, in common with other Mediterranean cultures, emphasized the head, neck, and shoulders, with uncut gems sparkling from settings made of strands of woven gold. Enamels were at least as common as gems in the classical period, until the conquests of Alexander the Great (356–323 B.C.) opened up the vast treasuries of Eastern empires. The Romans imitated much of the restrained beauty of Greek jewelry until the decadence of the later imperial period brought excesses in the number of jewels worn—emeralds, rubies, sapphires, topazes, and pearls—not rivaled again until the Renaissance.

Until the Middle Ages, stones were believed to have the power to sustain the soul in its journey to the afterlife, and they were buried with the dead. With jewelry being worn by more of the merchant middle class, they became more like lucky charms than powerful talismans. Their value still lay as much in their color as in their rarity. They were worn for blood disorders or liver troubles, depending on whether they were red like agate, carnelian, and jasper or yellow like topaz or amber. Superstitions persist to this day: Birthstones are believed to bring good fortune to the wearer through their affinity with the ruling planets—but the big stones of history, such as the Hope diamond and the Koh-i-Noor, are attended by ill luck and even violent death.

Gems appear colored because some of the light traveling through them is diffracted within the mineral structure. Most are also colored by minute quantities of metals, which occur as impurities. Of these, the most important are chromium, iron, manganese, titanium, and copper. Chromium gives both the intense red of ruby and the brilliant green of emerald and of demantoid garnet; iron causes more subtle reds, blues,

greens, and yellows as in almantite garnet, spinels, sapphires, peridots, and chrysoberyls. Blue sapphires are colored by titanium with iron; copper gives the blues and greens of turquoise and malachite; manganese, the pink of rhodonite and orange of spessartite garnet.

Colors vary according to the amount of impurities present and can be enhanced or destroyed by heat or irradiation with gamma rays and X rays. Where the colorant is an essential part of the chemical composition, such as the copper in turquoise and the iron in peridot, the color is very stable, and the color range limited.

Optical effects can also generate color in gems. Dispersion of white light by the diamond gives the so-called fire, those brilliant flashes of color that can be seen within a gem under light. Interference of light in the structure of opals causes their iridescence. Opals with large crystals produce a complete spectrum as the stone is tilted, but small crystal opals generate only blues and violets.

The cut of a gem also affects the color. Round- or oval-cut gems with plain, curved surfaces, cabochons, were among the earliest. This cut is still used to best display the colors in opaque and translucent stones, such as amber, and optical effects in opal such as sheen, iridescence, cat's eyes, and stars.

The faceted styles of gem cutting, first used in medieval Europe, are best for transparent gems on which highly polished flat surfaces act as mirrors. Some light is reflected from the surface of the crown (top) facets, displaying the luster; light entering the gem is reflected from the pavilion (bottom) facets, displaying the color and fire. The angles of the facets are crucial—in badly cut stones, light leaks out through the pavilion so that color and fire are lost.

The typical colors generated in gemstones.

Diamond—white

Beryl—yellow

Ruby—red

Amethyst—purple-red

Emerald—green

Onyx—black

Garnet—deep red

Aquamarine—blue

The brilliant and step cuts are popular facet cuts in Western jewelry. The brilliant cut, with a flat top and both triangular and quadrangular facets, was developed to show off the superb luster and fire of diamond. Step cuts, cut entirely with quadrangular facets, are most effective for emeralds and rubies, where color is the supreme quality. *See also* Amethyst; Aquamarine; Chalcedony and Jasper; Chrysoberyl; Citrine; Diamond; Emerald; Enamel; Garnet; Jade; Lapis Lazuli; Opal; Peridot; Ruby; Sapphire; Spinel; Topaz; Tourmaline; Turquoise.

Gemstones, Healing and

Gemstones, seemingly filled with colored light, have always been held in reverence and were often used, either ground and diluted or dipped in water, as remedies for sickness. Their healing powers were thought to be embodied in their color, often matching the malady of the patient: Yellow beryls were effective against jaundice; blood stones treated hemorrhages and disorders of the blood; prismatic diamonds were cure-alls. Cures thought to be effected by gemstones, and various organic materials also used as adornment, include:

Agate: Brown-colored kinds drove away fevers and epileptic fits.

Amber: The smell of burnt amber aided women in labor; a small lump placed in the nose stopped bleeding; mixed with honey, it was efficacious against earache and failing sight.

Amethyst (purple): Used to cure gout.

Beryl: Green was for eye diseases; yellow, for jaundice.

Bitumen: Prevented bone fractures, headaches, epilepsy, and heart palpitations.

Carnelian (red): The blood stone, thought to restrain hemorrhages and to remove blotches.

Chalcedony (blue or brown): Lowered fever and eased the passage of gallstones.

Coral: Overcame sterility.

Crystal: In powder form, the cure for swelling of the glands, diseased eyes, heart disease, fever, and intestinal pains; mixed with honey, it increased the milk of a mother.

Diamond: Fortified mind and body, and was said to cure everything; when dipped in water and wine, especially efficacious for gout, jaundice, and apoplexy.

Emerald (green): For diseases of the eye.

Garnet (red): Relieved skin eruptions.

Hematite: Cleared bloodshot eyes; stopped hemorrhages of the lungs and uterus.

Jade (green): Assisted in childbirth.

Jasper (red): Helpful in pregnancy.

Jet (black): For epilepsy, toothache, and glandular swellings.

Lapis lazuli (blue): Prevented miscarriages.

Opal (iridescent white): For diseases of the eye.

Ruby (red): To check the flux of blood.

Sapphire (blue): Against disease and plague.

See also Healing and Color.

Genesis of Color

Gerhard Lang, author, graphic designer, and dweller in the southwest barrio of Albuquerque, New Mexico, writes below of a not entirely fictional color genesis from the past to a twenty-first-century Absolute Color Revolution.

When Earth was being configured 4.5 billion years Before Present Time (BPT) it was a *de novo* sphere of achromatism. There was no color. The Blue Planet earth was an orb of whites, grays, and black in sequential noncolorscapes.

During the succeeding cohesive processes of the growth of civilization, the earth acquired a chromatic essence. "Replicate nature's colors" was the goal. Any quoted phrase is an outright anachronism because no one knows what word was used to identify color(s) in that prehistoric era.

Eventually, the new masses of creative intellect used the natural color schemes and enhanced them in what is now suspected to be the forerunner of the principles of primary colors. In other words, humans borrowed from nature the available colorized fluids and pigments and used them in decorative manners. Later, people improvised to create secondary colors not then found in the natural color chain. In isolated enclaves, the domestication of color was developed on an ethnological basis. One tribe's red was not necessarily the same as another's. Standardization was thousands of years away.

To trace color's growth historically, one looks to facets of color applications and usage, improved color formula and color understanding, dissemination of color information and knowledge, and all the attendant facts and data therein. The First Color Facet began a few aeons after the birth of Planet Earth and lasted until 5000 years BPT. During that vast time frame, the color "catechumen" borrowed from or plagiarized the colors of fauna, flora, and earth lamina, and the flesh tones of early *Homo habilis*. Early "colorists" were a combination of alchemist,

The early colorist was part alchemist, shaman, sorcerer, illusionist, and self-appointed priest.

In the Middle Ages, color was the province of emerging chemists, artists, and artisans.

Today, every known discipline adds new form and substance to color use.

shaman, sorcerer, illusionist, and self-appointed priest. All worked from a very limited palette and a limited range of color linguistics. Color by superstition was the vogue of that era.

By 700 years BPT, the color industry entered an era of color usage augmented by a color knowledge explosion. The Second Color Facet was the province of emerging chemists, artists, artisans, ceramists, designers of heraldry colors and symbols, builder-architects, and merchants of consequence. The demands on art and fashion for new colors was financed by the elite of court and church art patrons. It was time for color supersaturation within bounds of known color technologies. Color as a fetish or superstition began to ebb. Inks, dyes, oil paints, and watercolors became viable marketplace commodities. What was once the sole province of artists and artisans mixing their own pigments became a commercial enterprise. It was an age of color determined by accepted usage rather than a craft or artisan studio aesthetic.

For about 500 years, color usage and knowledge were abetted by demands for unified color systems. The pattern of growth was not without resistance. A fanatical, puritanical group lobbied for the return to a world of achromatism. Simply stated, bright color was regarded as somehow suspect, suggesting licentious behavior at worst or vulgarity at best. Eventually, the attitudes of colorists and more forward-thinking designers prevailed. Extensive use of color in all kinds of designs became the new norm. The Third Color Facet began about 200 years BPT, and a new generation of colorists entered the chromatic arena. The neochromatists were scientists, research chemists, lithochemists, spectrochemists, color geneticists, physicists, color psychologists, chromagraphists, color linguists, and master dyers. Later came improved graphic arts, color computerization, ophthalmology inputs, cybernetics, satellite transmission of color images, and the advent of standardization via the Color Association of the United States and its principle of chromatic influence. Every known discipline added new form and substance to the new avenues of color expansion. Color therapy entered the chromatic arena. In short, color was of the neo-essence of the twentieth century, making Earth a more appealing entity.

On the eve of the twenty-first century, the Fourth Color Facet is about to become a color reality. It will be the time of the Absolute Color Revolution (ACR). The finite-neocolorists will look to greater use of electronic color-enhanced computer printouts; real-time colorization; advanced color cybernetics; color info-preneurism—the use of color information for business ventures; optical ranged colormetrics; interplanetary colorism; color compuflex systems—the linking of computerized color graphics; spatial/electro-magnetic disbursement auras—the control of colored light in space; systems for optical color correction modules; and usage of color effects now beyond the comprehension of today's colorists.

In the twenty-first century, science will become a steadfast partner with art in a symbiotic collaboration of new systems of color knowledge and usage. There will also be a heterogeneous coloration of the populations. The "flesh" tones of the Caucasoid, Mongoloid, and Negroid will change with total integration of the races.

Finally, in the twenty-first century, there will be constant reformulation of color principles and methodologies for gaining new insights into color usage. A few of the avant-garde color technocrats are predicting an interplanetary color discovery, which would systematize color principles throughout the universe.

In the twentieth century, color advances were 100 times more than in the nineteenth century and 2,000 times greater than in all preceding centuries before then. In the twenty-first century, one can expect a gain of 2,000 times the gains of the twentieth century. The next enigma: Who will catalogue and name the millions of colors to be made available in the next century? Who will constitute the next generation of color linguists? Fortunately, there is now a solid foundation to build upon in the next century. Colorists' organizations, such as the Color Association of the United States and the Centre Française de la Couleur, joining with centers for color research in Japan, Germany, Italy, Canada, and elsewhere, are ready to lead the colorizational organization.

—Gerhard Lang

Geography of Color

See Architecture and Color; Fashion: Geography of Color.

Gerritsen, Frans

Dutch color scientist, author of *Theory and Practice of Color: A Color Theory Based on Laws of Perception,* in which he attempts, with respect to the human eye's great adaptability, to reconcile the different realities of additive and subtractive color mixtures in one wheel. *See also* Additive Color Mixing; Subtractive Color Mixing.

Gesso

Gypsum or plaster of Paris, prepared with glue and used for coating a surface in preparation for painting or gilding.

Gilding

The covering of a surface with gold, gold leaf, or gold-colored pigment. Colloquially, "gilding" suggests covering an inferior element with a bright veneer.

1. Overpainted layers removed.

2. Missing design drawn in.

3. Undertones painted in.

4. Gilding reapplied.

Gilt was a popular ground for wall decorations in Colonial and Federal buildings of the eighteenth century. Careful restoration can capture the lost grandeur of that historic period. Photos courtesy of Alan M. Farancz, Painting Conservation Studio, Inc.

Gladstone, William Ewert

1809–98. English statesman and prime minister, Gladstone devoted time to studying the Homeric poems and analyzing them for color terms. In eight books of *The Iliad,* he noted references to lightness and darkness and to red, brown, and purple, but none to blue or green. Similarly, the ten books of *The Odyssey* speak of white, black, red, and brown, but again no blue or green. Gladstone therefore erroneously deduced that early man could not see the full range of the spectrum, only the long wavelengths. Of our modern color sense, he effusively wrote: "So full grown is it, that a child of three years in our nurseries knows, that is to say, sees more color, than the man who founded for the race the sublime office of the poet, and who built upon foundations and edifice so lofty, and so firm that it still towers unapproachably above the handiwork not only of common, but even of many uncommon men."

In fact, although early literature may lack color names, the ancients made free use of blue and green in art, symbolism, and ritual. Red, yellow, green, and blue are fundamental sensations in human vision. Nevertheless, the American anthropologists Brent Berlin and Paul Kay conducted a comparative study that showed blue to be the last primary color to be named in any developing language. While the Greek language, at the time when the *Iliad* and *Odyssey* were written, contained a word for blue *(kyanos),* the stories were culled from an oral tradition several centuries older. It is also possible that the reputed blindness of Homer limited his use of color metaphors. *See also* Language and Color.

Glair

A water-soluble vehicle used for paints, glair is made from egg whites whipped into a froth and allowed to stand until liquid again. Because it flowed very smoothly, it was popular with the illuminators of medieval manuscripts. Glair preserves pigment well and does not saturate or surround pigment particles when used in concentration.

Colors applied with glair were sometimes varnished with a mixture of strong glair and honeyed sugar to increase the depth and richness of the color. Glair itself is delicate and brittle, especially when newly prepared. Because of this, and due to a lack of density sufficient to bring out the quality of some pigments, it has often been supplanted by gum arabic since the fourteenth century. *See also* Gum Arabic.

Johann Wolfgang von Goethe.

"The eye sees no form, inasmuch as light, shade, and color together constitute that which to our vision distinguishes object from object, and the parts of an object from each other. From these three, light, shade, and color, we construct the visible world, and thus, at the same time, make painting possible, an art which has the power of producing on a flat surface a much more perfect world than the actual one can be."
—Johann Wolfgang von Goethe

"Whoever is in accord with Goethe finds that Goethe has correctly recognized the Nature of color. And Nature is not what comes from experimentation, but what is in the concept of color."
—Ludwig Wittgenstein

"The more an object is polished or brilliant, the less you see its own color and the more it becomes a mirror reflecting the color of the surroundings."
—Eugène Delacroix, on the effect of gloss

Glass

A manufactured thermoplastic, made from silicates of calcium and sodium (silica, lime, potash, or soda), all of which are abundant on the earth's surface and very cheap. The materials are fused into glass at temperatures of around 2,700°F. (1,500°C).

In glass making, a tank of glass is kept at a high enough temperature to prevent it from "freezing," or hardening. The molten material can be drawn off and fashioned into glass objects by blowing, pressing, drawing, or rolling. Traces of metal oxides (such as iron oxide, manganese dioxide, or cobalt) are used to color the glass or to modify unwanted coloration. Opacity, transparency, or translucency (opalescence) are controlled by the proportion of raw ingredients.

Glass has been used for pictorial art for over 2,000 years. Mural mosaics, comprising small squares of colored glass called tesserae (from the Greek for "four sides"), first appeared in the fourth century. The tesserae were about 2 centimeters square, large enough for the color not to be dulled by the plaster grouting, but small enough to allow for fine detailing. Splendid examples can be seen in early Byzantine churches in Rome and Ravenna. The mosaics in Hagia Sophia, Church of the Holy Wisdom (A.D. 532–37), in Istanbul include some 2,300 different colors. *See also* Mosaic.

Glaze, Glazing

In painting, essentially the use of varnish mixed with a touch of color and applied as an undercoat, body, or final layer to achieve a unifying tonal effect. The repeated application of layers of glazes can build up astonishingly rich, deep color qualities. *See also* Ceramics and Color; Gray.

Gloss

A surface luster or shine, frequently noticed in a paint or a cosmetic lipstick. The word probably derived from the Scandinavian word *glossa*, "to glow," and is akin to the Old English word *geolu*, meaning "yellow." The effect of a gloss surface is to reduce the diffusion of light, causing colors to appear deeper and more saturated to the eye. As in the colloquialism "glossing over," a paint gloss tends to give a deceptively attractive appearance. Deep colors such as garnet red, which in matte paint suggests a dried liver color, are particularly enhanced by a gloss coating. One problem with using gloss is that, because it brings out the pigment color and creates a shiny, highly reflective surface,

it will pick up and accentuate any imperfection in plaster or jointing. Ceilings and large, open wall surfaces are rarely painted in gloss for this reason.

Gobelins Tapestries

See Chevreul, M. E.; Sources of Historic Colors; Tapestry.

Goethe, Johann Wolfgang von

1749–1832. German poet who wrote a famous paper on color, *Theory of Colors*, in 1810. He countered the growing tendency among European thinkers to accept unquestionably Isaac Newton's theories of physics, believing that the field of scientific thought was being endangered by such intellectual ossification.

On a more scientific level, he rejected a prevalent conceptual approach of his time: the doctrine of essentialism, which claimed that the scientifically pertinent sphere of essence and illusory sphere of appearance are separate aspects of a phenomenon. Goethe insisted that such a distinction is invalid, and that the essence of a phenomenon lies in the sum total of its observable effects. He wrote, "We really try in vain to express the essence of a thing. We become aware of effects, and a complete history of these effects would seem to comprehend the essence of the thing. . . . Colors are the deeds [effects] of light." (H. Aach, trans., 1971). Describing how we observe the phenomenal world, he wrote, "The eye sees no form, inasmuch as light, shade, and color that to which our vision distinguishes object from object, and the parts of an object from each other. From these three, light, shade, and color, we construct the visible world, and thus, at the same time, make painting possible, an art which has the power of producing on a flat surface a much more perfect world than the acutal one can be."

In general, Goethe succeeded in redirecting interest towards physiological and psychological modes of color, although his criticism of Newton was largely unfounded. *See also* Systems of Colors; Turner, Joseph Mallord William.

Gold

A precious yellow metal (Au), non-rusting and extremely ductile, widely distributed on earth, commonly found in the form of dust, flakes, or nuggets. Due to its high malleability, it is often combined with other metals, forming multi-colored alloys such as white gold (gold with platinum or nickel), green gold (with silver), or red gold (with copper), which is most commonly used for coinage.

The radiance of this shining metal has given it a unique and mystical significance throughout history, since the artisans of ancient Ur (Mesopotamia) first worked it. Early examples of its religious aura include the funeral masks of such kings as Tutankhamen of Egypt (1370–1352 B.C.) and Agamemnon of Mycenae, as well as the Mayan and Incan gold-sheathed temples of ancient Mexico and Peru. In the Middle Ages, monks illuminated their sacred manuscripts with this luminescent color, church mosaics included glittering gold tessarae—small squares of colored glass—and alchemists dreamed of transforming baser metals into gold.

In recent times, the fervor for gold has not diminished; it has simply become more secular. As the metal of personal adornment, gold is favored for the warm glow it lends to almost any skin-tone, and for this reason it is used abundantly in gold chains, earrings, and bracelets. In packaging, gold conveys immediately the message of luxury and prestige, and so it is used to suggest lavishness by the fragrance and cosmetic industries, in which color psychology constantly comes into play.

Gold Leaf

Gold hammered or rolled into ultrafine sheets, which can then be applied to any tacky surface. Green or brown underpainting can impart distinctive tinges to the gold leaf.

Fragile and expensive, gold leaf is still in use in the twentieth century, largely in picture framing and in a more limited way on furniture. The precious metal adds a historic finish and sense of the past to any wood. In architecture, gold has been used even more sparingly. Architects of the 1930s and late 1980s, particularly the postmodernists, used gold to attract special attention to decorative architectural detailing and to impart a sense of the substantial to entryways and lobbies.

Gothic Color Revival

See Architecture and Color; Victorian Architectural Colors.

Gouache

An opaque watercolor paint. Gouache differs from watercolor in that the pigments are of a coarser ground and in that a large percentage of vehicle is added to the color source to improve its color and textural effects, giving the paint its opacity. The vehicle is always an inert pigment, such as chalk. Gouache also has a gluier base than watercolor, since more binder (gum arabic or honey) is necessary to keep the vehicle and color source together.

Because of its gluey nature, the paint can be applied directly on a surface without much water, with either a brush, airbrush, or pen. Gouache was used by Byzantine, medieval, and Renaissance illuminators and miniaturists, and is still popular with modern graphic designers. *See also* Watercolor.

Goya y Lucientes, Francisco José de

1746–1828. Spanish painter, etcher, and lithographer. Early in his career, Goya painted a series of tapestry cartoons, or preparatory works, for the Royal Tapestry factory. These depict picturesque scenes of court life in bright, gay colors. His later works are predominantly dark both in subject matter and color.

The years of 1794 to 1797 are known as his Silver Period, because of a predominance of silvery gray color. These hues also dominate his famous series of etchings titled *Los Caprichos* (1799). They are macabre critiques of Spanish society and its values. Toward the end of his life, Goya painted a series of murals so dark in tone that they have been labeled his Black Paintings (1820–22). The movement toward darker, moodier color is a reflection of the growing pessimism Goya felt for the world in which he lived.

Gradation

The passing of one tint or shade of a color into another by very small degrees; used in painting, for example.

Graffiti

Any distinguishing decoration applied to buildings or vehicles. Graffiti art reached its apogee on the New York City subway system in the 1970s and early 1980s, from where it was elevated to fine art status in urban galleries. Subway car exteriors are now either all stainless steel or painted in browns or blacks.

Graffito

Italian for "scratched," designating a technique of surface decoration in which a layer of paint is scratched to reveal a different surface and color ground underneath. This technique was especially popular in medieval panel painting, using gold leaf as the underlayer to be scratched through a color. It was also popular in Renaissance fresco work, using two different colors of plaster.

"Granitize"

To paint a surface to resemble granite. Similar to faux marble. *See also* Marbling, Marbleizing; Trompe L'Oeil.

Francisco José de Goya y Lucientes.

"Remember the enemy of all painting is gray: a painting will almost always appear grayer than it is, on account of its oblique position under the light."
—*Eugène Delacroix*

"Better gray than garishness."
—*Jean-Auguste-Dominique Ingres*

Graphite

A soft, blackish form of crystalline carbon, used in lead pencils (named from the Greek *graphein*, meaning "to write"). Graphite gray, a very dark gray, was in the original Standard Color Card of America of 1915 but was dropped from the 1928 edition. *See also* American Colors.

Gray

A surface color without hue (i.e., achromatic); one that evenly reflects or transmits all wavelengths of the spectrum, so that none is dominant.

Grays may be produced by mixing black and white in varying proportions, or by mixing complementary colors. The addition of small, supplementary quantities of red and yellow or green and blue will produce warm or cool grays, respectively. A gray that appears pure in one light may appear colored when viewed under a different light (*see* Metameric Colors).

In oil painting, gray was often obtained by glazing with varnish mixed with a little paint. The beautiful gray tones of the masterpieces of great colorists were produced in this way, by superimposing, on a luminous color, successive layers of glazing taken from the complementary color.

A gray effect is also obtained by placing small areas of complementary colors side by side. They are then perceived, through additive color mixing, as a vibrant gray. Other methods, such as applying closely packed black dots on a white ground, will result in a gray tone. The intensity of the gray varies according to the size and concentration of the dots. Gray goes well with hot, bright colors in graphics and fashion, moderating their strength but not detracting from their brilliance.

Gray derives many of its associations from observations of cloud and shadow. "Gray areas" are shadowy areas that lack clarity; intellectual confusion is often described as seeing issues in "shades of gray." Gray also suggests intelligence (the gray matter of the brain) and age (the gray-haired, wise old person). Gray, in silver and platinum, is a symbol of wealth. As gray dust, the color may also imply decay. More recently, gray has come to suggest the concrete and metal of the urban environment, of business, and of industry. *See also* Achromatic Colors; Additive Color Mixing; Dominant Wavelength; Oxford Gray; Saturation.

Greek Colors

Lacking the favorable dry climate of Egypt, the colors of ancient Greek art and architecture fell victim to the ravages of time and of the environment. It was once thought that Greek architectural ornament and sculpture were unpainted. Archaeological excavations at Aegina in the nineteenth century revealed that, in both architecture and sculpture, colors were liberally applied. The Parthenon of Athens, for example, was decorated both inside and out, and a statue of Diana, found in 1760, had been originally painted with blonde hair and white draperies that had a triple border—one of gold, one festooned with flowers on a purple ground, and one of plain purple. The Greek palette was bold, consisting mainly of black, brown, white, green, purple, yellow, deep reds, blue, and gold.

Typically, Greek marble statues were painted in realistic colors. Most traces of color have long since been eroded.

Modern Greece shows only isolated examples of the ancient taste for polychrome. Most buildings are in white, a color that effectively reflects the heat of the Mediterranean sun, with details such as windows and doors picked out in blue, green, or brown. Blue is a particularly popular color, associated with the sea that is omnipresent and with the cloak of the Virgin Mary, an important religious figure in the Orthodox Church. Recently, the availability of new pigments that can be mixed with whitewash have led villagers to decorate their exterior walls in startling combinations of greens, blues, pinks, and purples. An amber yellow, associated with Fascist architecture in the parts of Greece occupied by the Italians between the world wars, is one color that is generally avoided. *See also* Architecture and Color; Fashion: Geography of Color.

Green

That portion of the color spectrum lying between yellow and blue.

The source of the green of the earth's vegetation is a pigment called chlorophyll. The pigment traps and retains the red and blue-violet parts of the visible spectrum, allowing the green portion to be reflected. Natural sources for green pigment abound. Glauconite, a mineral rich in silicates of iron, manganese, and potassium, is the source of the pigment called terra verte, or green earth. Malachite, a green copper carbonate, produces a minty green pigment when ground. The action of acetic acid on copper creates verdigris, or "green of Greece." Green dye can be extracted from ripe buckthorn berries, ragweed flowers, and iris petals. Artificial green pigments introduced in 1936, with the production of artificial lakes from coal tar, include monastral green, thalo green, winsor green, and bocour green. These pigments are all derived from copper phthalocyanine mixed with chlorine.

Throughout history, green has been associated with vigorous growth, with a tender, unripe state, or with youth's inexperience. In ancient Egypt, the god Osiris painted himself with the "wholesome offering" of two bags of green pigment. In nineteenth-century England, the hero in *Tom Brown at Oxford* is described as "very green for being puzzled at so simple a matter." In America, greenbacks referred to paper money; greenhorns were newcomers or anyone inexperienced or unsophisticated.

Many historical names for different greens have entered the popular design vocabulary. These include: the celadon green of Chinese porcelain, (named for the traditional grayish green costume of a character named Céladon in a seventeenth-century French play); the acid green favored by Italian mannerists of the sixteenth century; American Colonial and Federal-era greens; William Morris woodland greens; and Art Deco jade green.

In American design history, green has enjoyed brief periods of marked appeal, usually during times of economic growth. In 1928, for example, green was the favorite automobile color, while black ranked fifth, according to Chrysler Corporation. By 1933, during the Great Depression, these color positions were reversed. In the 1950s boom economy, light and dark greens were again popular car colors. In American interiors, "institutional green" and avocado green, both of which have fallen from favor, still haunt unrenovated spaces. Considered cooling and calming, "institutional green" was used extensively in the 1930s, 1940s, and 1950s in hospitals and schools, particularly in corridors and lavatories. Like avocado green, "institutional green's" overuse and consequent oversaturation led an entire generation to dislike this color intensely. *See also* Almond Green; Apple Green; Artists' Pigments; Blue-Green; Bottle Green; Buckthorn; Celadon; Chartreuse; Chlorophyll; Cobalt; Colorants; Copper Green; Dyes and Dyeing; Emerald Green; Evergreen; Kelly Green; Malachite; Natural Earth Pigments; Plant Colors; Reseda; Verdigris; Veronese Green.

Green Earth

See Natural Earth Pigments

Greige

See Beige.

Grey

See Gray.

Grizzle

To turn gray, or streak with gray; grizzle also denotes a gray or partly gray hair color (from the Old French *grissel*, identifying a gray animal). Linked with old age, grizzle was used by Shakespeare to suggest aging: "O thou dissembling Cub;/What wilt thou be/When time hath sow'd a grizzle on thy case?" *See also* Gray.

Gum Arabic

The principal binder for watercolor or gouache. Derived from plant gums exuded by trees and shrubs, these gums dissolve and swell in water and produce solutions of only limited adhesiveness.

"In the hierarchy of colors, green represents the social middle class, self-satisfied, immovable, narrow. . . . Absolute green is the most restful color, lacking any undertone of joy, grief, or passion. On exhausted men this restfulness has a beneficial effect, but after a time it becomes tedious. Pictures painted in shades of green bear this out. As a picture painted in yellow always radiates spiritual warmth, or as one in blue has apparently a cooling effect, so green is only boring."
—Wassily Kandinsky

"Green represents the dead image of life."
—Rudolf Steiner

Halftone

A value or color halfway between light and dark; also the photographic reproduction of an image with ink, usually black, which has a single tone strength. All halftone processes divide the image into tiny elements—dots or lines—that vary in size in proportion to the strength of the original image tones. The elements are too small to be seen individually by the eye, which blends them with the underlying white of the paper to create a composite impression of tones. The lightness or darkness of a tone depends on how much white shows through between the dots.

In photomechanical reproduction, the dots or lines are formed by rephotographing the original image through a screen. The exposure may be made directly onto a printing plate coated with a light-sensitive emulsion, then etched in acid, or onto high-contrast lithographic film. For some images, such as of bricks, dappled leaves, or other patterned surfaces, a screen with a random grain pattern may be used to prevent unintentional patterns, (*see* Moiré) from occurring.

An alternative to screening is direct engraving. An electronic image scanner is linked directly to a metal stylus, which cuts the plate as the scanner traces the image. This is faster than photoengraving but does not allow for retouching and cannot achieve as fine a grain pattern. Superior quality can be obtained by using a laser beam to expose the patterned image on a resist-coated plate.

In the halftone pattern formed on a plate for letterpress (relief) or offset lithographic (planographic) printing, the dots or lines vary in size so that ink is laid down over a greater or lesser area. In a plate for gravure (intaglio) reproduction, the "dots" are pits or cells of identical size but varying depths. Thus, the amount of ink they can hold varies. This process provides the best reproduction of tonal variations.

Two other processes use random patterns of dots: In aquatint, a random pattern is obtained by dusting a powdered resin on a plate surface to form a resist before etching; in collotype, a pattern of short, irregular line elements is formed by reticulation of a gelatin coating on the plate. Because both of these processes are best suited to short runs or hand-operated presses, they are used chiefly for art reproductions. *See also* Continuous Tone; Printing.

Halogen Lamp
See Lighting, Artificial.

Hansa Yellow
Among the most permanent of modern synthetic yellow pigments, made from a diazotized toluidine or nitraniline—artificial lakes derived from coal tar. Produced since the 1930s, hansa yellow is a substitute for cadmium yellow as a pigment. *See also* Artists' Pigments; Yellow.

HARMONY

Fundamentally, harmony is a pleasing arrangement of elements or parts, whether they be musical notes, paint pigments, linear patterns, garden plants, or anything else. As simple as this sounds, harmonies, particularly color harmonies, are difficult to define. Harmonies are subjective; those that appeal to some people, repel others. Although the human eye and mind are sensitive and efficient in sorting out, responding to, and creating harmonies of color, it has proven impossible to formulate and establish absolute rules for harmony.

Color systems have been useful in arranging chromatic sequences (*see* Systems of Color). With techniques of colorimetry and of correlating color precisely with vibrations of light, visual identifications have become quicker and easier than in the past. Color atlases and solids based on these systems provide ingenious, mechanistic methods of grouping and matching colors, but they fall short of duplicating the human ability to make subtle, unexpected juxtapositions.

Color is always considered in relation to other colors and to its environment; it is never judged in isolation, except in abstract color studies. Even then, a given color changes as it moves into new surroundings. Thus, an understanding of certain effects, particularly contrast effects, is essential when attempting color harmonies (*see* Optical Illusions; Simultaneous Contrast). In addition, color affects our perception of form and is itself affected by form, scale, positioning, and lighting. Achieving good color harmony largely depends on a colorist's ability to manipulate many, if not all, of these factors.

An artist manipulating the pigments on his palette, a designer concerned with television, theatrical, graphic, or product projections, and an actor applying makeup are essentially searching for color harmony and for ways to minimize discordance. All must understand that colors are malleable; they enhance or detract from a subject depending on the way they are used.

The POWER of RED

The PROBLEM of GREEN

The MOVEMENT of YELLOW

The TRADITION of BLUE

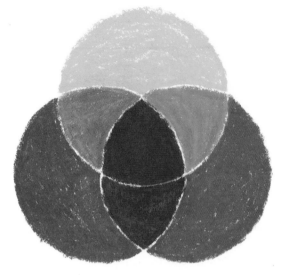

The three subtractive primaries, or primaries of pigments—yellow, red, and cyan-blue—together produce a muddy black.

Harmony: Three Types of Primaries

Many examinations of color harmony begin by exploring the relationships between primary colors. In the study of color, the Bauhaus school, for example, emphasized the importance of the primaries. A number of great colorists, including artists such as Vincent van Gogh, Henri Matisse, and Fernand Léger (1881–1955), frequently favored the use of the primaries, never hesitating to use the oppositional pairs.

To work with primaries, it is essential to identify them correctly. Color sensations in the brain are received from three basic sets of primaries. Each of these corresponds to a different mode in which color manifests itself. Chemistry is involved with the subtractive primaries—red (magenta), yellow, and blue (cyan); light depends on the additive primaries—red, green, and blue-violet; and cognition, the psychological primaries—red, yellow, green, and blue.

The three subjective primaries—red, yellow, and blue—are the best known. They can be mixed in varying proportions to produce all other colors, and they fall in three equal steps around the subtractive color circle. A mixture of all three produces a muddy black. The additive primaries—red, green, and blue-violet—are used on color television screens and in theatrical lighting effects. An equal mixture of the three additive primaries produces white light.

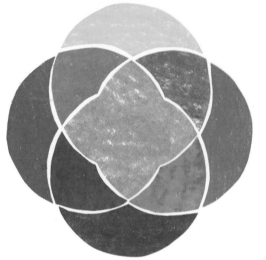

Visually mixed, the four psychological primaries—blue, yellow, red, and green—move toward gray.

Constituting the third set are the four so-called psychological primaries—red, yellow, blue, and green. These primaries of vision are the colors that the human eye recognizes as irreducible and untinged by any other primary. Visual mixtures (accomplished in one way by spinning disks on a color wheel) are medial, and generally tend to work toward a neutral gray.

With these primaries arranged at even intervals on three different color circles, balances of primary (and secondary) colors can be achieved simply by analyzing their spatial relationships. A contrast harmony uses colors at opposite (complementary) points, while analogous harmonies use neighboring colors.

There is another set of primaries: those used in process color printing (with inks) in which tiny dots of color are blended by the human eye. Both a subtractive and additive process, it consists of primaries—magenta, yellow, and cyan—used with black ink. When mixed, they add up to a neutral gray.

The additive primaries—red, green, and blue-violet—combine to produce white light.

Pure primary colors are red, yellow, and blue; secondary colors are orange, green, and violet. Strong contrast harmonies result from juxtaposing colors that are opposite each other.

Mixing colors permits the passage between extremes of opposite colors (Goethe's triangle).

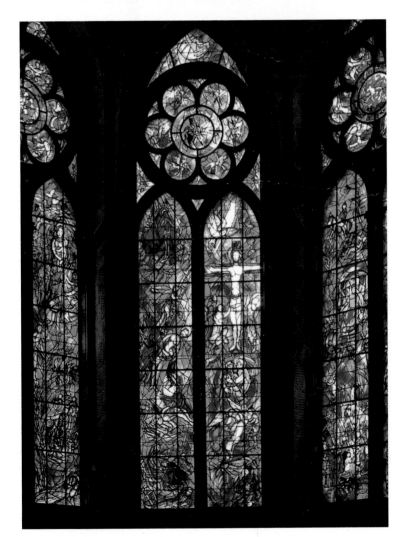

Stained glass windows: the dark outline accentuates luminosity and prevents degradation of color (Reims Cathedral, France).

(Above) *Complementary pairs of colors provide a variety of harmonious chromatic combinations.*

(Below) *According to André Lhote, a French painter and theorist, light is orange, and orange light strikes the eye first. Its complementary shadow is blue. The linking passage from orange to blue is most effectively made through the intermediate red-violet and violet-blue. Violet is a complex color, blending blue, a cool tone, with red, a warm one. Orange has great solidity and is a fundamental tone. Blue (shadow), having the least light, strikes the eye last.*

Harmonies of Contrast

One of the principal reasons that color harmony is difficult to achieve is that colors influence each other considerably. In the fifteenth century, Leonardo da Vinci noted in his *Trattato della Pittura:* "Of different colors equally perfect, that will appear most excellent which is seen near its direct contrary: a pale color against a red; a black upon a white; . . . blue near a yellow, green near red: because each color is more distinctly seen when opposed to its contrary, than to any other similar to it."

These effects are caused by simultaneous contrast, the theory of which was first for-

mulated in 1804 by Michel Eugène Chevreul, a French chemist. Like Leonardo, Chevreul showed that one color will give an adjacent color a complementary tinge. Thus, two juxtaposed complementary colors will brighten each other. But noncomplementary colors will have the opposite effect: A yellow next to a green, for example, will give the green a violet tinge, making the latter appear muddy. This is known as degradation of color. One way to avoid this problem is to use only complementary pairs (red and green, blue and orange, and so on) which heighten each other's brightness. This is the basis of harmonies of contrast and of the

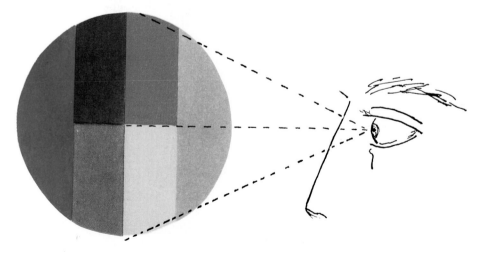

impressionist and other artistic techniques. Since a small spot of strong red will balance a large area of light green, it is also important to consider contrast of scale, saturation, and lightness (value). Working with three or more colors can make it difficult to use any set method, and colorists often resort to an intuitive sense of balance.

A second way to avoid degradation of color is to isolate colors within black or white. As Chevreul noted in his *Contrast of Colors,* "When two colors are bad together, it is always advantageous to separate by White." Moreover, "Black never produces a bad effect when it is associated with luminous colors. It is often preferable to White. . . ." This is the basis for much enamel work (*see* Cloisonné; Isolated Colors) and for stained glass windows.

Harmonies of Nuance

A color will always harmonize with itself and with shades or tints of its own family. This is the basis of harmonies of nuance. Staying within one hue, a designer can create scales of value (by increasing the white, black, or gray content) or saturation, selecting as many or as few colors as are needed for a "monochromatic" color scheme.

Harmonies created with a set value, where all colors are of an even lightness, are similar, but not as predictable in achieving results. While the effects are not obvious at low value levels, simultaneous contrast and successive contrast can occur, which might upset the balance. Harmonies based on even levels of saturation are the most difficult to achieve, mainly because some colors, such as yellow, are naturally very unsaturated, while others, such as blue, are deeply saturated.

In general, harmonies of tints (modifications of pure colors with white to produce lighter tones) provide the best opportunities. A gradual transition of tints is more effective: Variations that are too wide or too abrupt are difficult for the eye to accept. The exception to this rule is when a shock effect of extreme contrast is required.

Artists have never been constrained by laws of harmony and balance. On the contrary, they often see fit to introduce a disharmonious element, much as a discord is used in music, to overcome monotony and to make a specific pictorial point. Just as sudden narrative changes in Brechtian theater shatter an audience's complacency, the contrast between harmony and discord in a painting, magazine, billboard, or television advertisement is also effectively alarming.

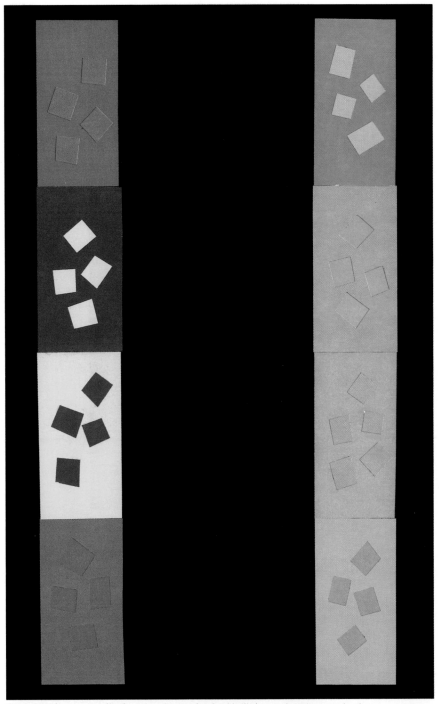

Opposite colors, especially the primaries, tend to lend brilliance and purity to each other.

A gradual transition of tints is more effective than an abrupt arrangement.

(Right) Yellow, used with blue, absorbs some of the latter's density, making it richer and darker.

(Far right) Both green and blue lag behind orange and pink in making contact with the eye.

(Below) Angular, hard edges and warm colors, such as red and orange, tend to suggest a forward movement. Soft, curved shapes in cool colors, such as blue, green, and blue-violet, tend to slow down any forward movement.

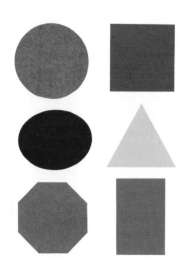

Harmony: Movement and Music

One of the most striking and complex aspects of color lies in its "movement." The eye, scanning a colored surface or a scene, is constantly encountering new and changing harmonies and discords. Even when studying a single, isolated color, one can become aware of a subtle but distinct tendency for that color to vibrate and mutate. This is caused by many factors including the form used, adjacent colors, or the viewer's attention span, emotional state, and color preference.

The exact nature of the movement of particular colors is not easily defined; human color response is too subjective and varied a field. Nevertheless, certain artists have attempted to articulate their own impressions. Wassily Kandinsky, for example, labeled blue a relatively stable color, with a tendency to move inward within itself; red is aggressive, with a tendency to vibrate within the area it occupies; yellow moves outward, making it a difficult color to contain; and

green is a tranquil color which tends to rotate toward its center. Generally, the warm primary colors—reds, oranges, and yellows—are accepted as possessing greater movement than the cool blues and greens. The form through which a color is expressed and its place in the total design of a work of art, together with surrounding elements, contribute greatly to a color's apparent movement. Other adjacent colors, tints, shades, and tones display these basic movements to a varying degree.

Kandinsky also linked colors with the sounds of musical instruments in trying to describe the physical effects of color:

Red: rings like a great trumpet, thunders like a drum
Orange: a church bell or a strong contralto voice
Yellow: a prolonged, shrill bugle note
Green: the middle note of a violin
Light blue: a flute
Dark blue: a cello

Wassily Kandinsky projects a dance of color notes purported to represent the creative relationship and interaction of the primary colors.

Darkest blue: an organ
Violet: the deep notes of woodwinds
White: like the pauses in music
Black: profound and final

As most of our impressions are based chiefly and simultaneously on what we see and hear, it is natural to relate the two senses. A complex picture made of colors resembles a musical composition of notes and chords. In each case, the whole may be different and infinitely greater than the sum of its parts. As with music, some colors and color combinations are animated, some are agitated and disturbing, and some are calm and tranquil.

Olivier Messiaen, a French composer, stated in an interview (in *Musique et Couleur*) that color is linked with music in the works of many great composers. He noted that the color violet and the G-major chord together produce a terrifying dissonance. Asserting that complex colors can be directly related to complex chords and sounds, he further spec-

ulated that the correspondence between color and chords rests on a scientific basis, modified by the personality of the listener.

Color can be considered more architectural than musical—defined and explained in terms of geometric forms and relationships. Again, however, there is a sense that color is dynamic, the product of some human expressive process, not merely passive.

In his studies of subjective color, Johannes Itten in *The Art of Color* discusses the importance of choice and juxtaposition of hues, as well as the size and orientation of areas. He notes that some individuals orient all areas vertically, while others stress the horizontal or diagonal. Orientation is a clue to modes of thought and feeling. There are some designers who incline toward crisp, sharply bounded color areas, others to interpenetrating or blurred and haphazard patches. There is no single classical rule of order and harmony.

(Below) *Blue moves inward, appearing to be fairly stable and fixed. Yellow moves outward; a difficult color to keep within boundaries. Red vibrates within its own area, giving the impression of movement. Green tends to rotate toward its center —a tranquil color.*

Nineteenth-century color pigment jars exhibited at the Musée des Arts et Traditions Populaires in Paris.

Harris, Moses

Active 1766–85. An entomologist, engraver, and color authority, Harris produced the first printed color chart. His renderings of insects and their food plants, reproduced from copper plates, were published for many years in English and French. Some of the early editions were tinted by hand.

Harris's contribution to the history of color was twofold. He published what is probably the first color circle ever shown in full color. Two charts labeled ''Prismatic'' and ''Compound,'' each measuring 10 by 12 inches, showed key or primary hues—red, yellow, and blue; secondaries—orange, green, and purple; and tertiaries—brown, olive, and slate. This choice of terms has been used more or less ever since in the fields of art and color. His *Natural System of Colours* was dedicated to the English artist Sir Joshua Reynolds. Harris declared that he wished to give life to a ''creation . . . which otherwise might have remained forever in oblivion.'' Years later, Joseph Mallord Turner acknowledged Harris's contribution and designed charts based on those of Harris.

Harris's second related contribution was his impressive work *An Exposition of English Insects*, dated 1776. In it, he made one of the first attempts to devise and establish a method for the identification and naming of colors, some seventy-two in all. Harris admitted that while he was ''far from promising this scheme as a complete system,'' nonetheless he hoped it might bring sense and order to an otherwise confusing situation. *See also* Reynolds, Sir Joshua; Systems of Color; Turner, Joseph Mallord.

Hatching

A system devised for heraldry to represent the heraldic tinctures (colors) with black-and-white patterns, thus avoiding the difficulty and expense of full-color reproduction. The associated patterns are as follows:

Tincture	Pattern
Vert (green)	diagonal lines, top left to bottom right
Argent (silver)	plain white
Or (gold)	dots
Sable (black)	grid
Azure (blue)	horizontal lines
Purpure (purple)	diagonal lines, top right to bottom left
Gules (red)	vertical lines

In its modern usage, hatching is a technique in which small, short strokes are used in applying colors or inks; a term used in relation to creating texture through pen strokes; and a term used in the restoration of damaged oil paintings. *See also* Heraldry; Restoration.

Hayter, Charles

1761–1835. English artist who was trained for his father's profession of architecture but instead became a painter of miniatures. He developed a reputation for watercolors and crayon drawings, exhibiting frequently at the Royal Academy in London. He wrote an important book on three-color reproduction entitled *A New Practical Treatise on the Three Primitive Colours Assumed as a Perfect System of Rudimentary Information* (London, 1826), basing his theory on Thomas Young's proposition of the three-color system—red, yellow, and blue—which he applied to light as well as pigment. *See also* Young, Thomas.

Healing and Color

Color has often been connected with the art of healing, particularly in the past. Before the discovery of viruses and the advances of modern medicine, the origins of disease were considered mysterious manifestations of human disharmony with the universe. Cures included many things, from the use of colors, amulets, and gems to body decorations and dances.

Ancient Egyptians practiced various forms of color therapy, drawing on color's symbolic powers. The Egyptian Book of the Dead has many color references. The Egyptian Papyrus Ebers of 1550 B.C. listed, among other color cures, white oil, red lead, testicles of a black ass, black lizards, indigo, and verdigris; the last, a green copper salt, was mixed with beetle wax and used to treat cataracts.

Pythagoras (580–ca. 500 B.C.), the Greek philosopher and mathematician, is said to have cured disease through music, poetry, and colored stones. A Roman physician named Celsus, who lived at the beginning of the Christian era, was said to have prescribed medicines with color in mind, using white or purple violets, lily, iris, narcissus, rose, saffron, and others. The plasters he used to relieve wounds were black, green, red, and white. Of red, he wrote, ''There is one plaster, almost of a red color, which seems to bring wounds very rapidly to cicatrize [form scars]'' (Cox 1831).

During the Dark Ages, from the fifth century to the beginning of the eleventh century, progress in medicine passed from Catholicism to Islam and found its greatest leader in Avicenna (980–1037), an Arab physician. Throughout his *Canon of Medicine*, one

"I have been anointed with the white ointment of the tree of life."
—Galen

Heraldry: *Forerunner of modern signage.*

of the most venerable of medical documents, he discusses color as both a guide to diagnosis and an actual curative. He suggests, for example, that illness can be diagnosed by observing changes in skin color: yellow indicated a disorder of the liver; white meant the disorder was probably in the spleen; yellowish green might be attributed to piles. He developed charts that referred to colors and the elements. As to humors (fluids) of the body, he wrote, "Even imagination, emotional states and other agents cause the humors to move. Thus if one were to gaze intently at something red, one would cause the sanguineous humor to move. This is why one must not let a person suffering from nosebleeding see things of a brilliant red color." He also declared red and yellow to be injurious to the eye. Blue light soothed the movement of the blood; red light stimulated it. The clear light of morning aided nutrition.

Some color cures happened to work. For example, in ancient Greece, the Tyrian purple, laboriously extracted from the murex shellfish and used to dye the garments of emperors, was also a remedy for boils and ulcers; owing to its calcium content, it was often successful. *See also* Color Therapy; Gemstones, Healing and; Medicine and Color.

Heliotherapy

See Suntan.

Helmholtz, Hermann Ludwig Ferdinand von

1821–94. German scientist who researched thermodynamics, electricity, and fluid dynamics. Known also for his pioneering work in physiological optics, he expanded on the theories of Thomas Young who was the first to formulate the theory of trichromatic vision —that the eye has three kinds of color-sensitive receptors, each sensitive to one of three broad bands of wavelengths, representing red, green, and blue light (the additive primaries). *See also* Young–Helmholtz Theory.

Hematite

A hard, compact, and pure natural variety of a hydrous ferric oxide used in the production of a dark red pigment and in the preparation of burnishers for gold leaf in medieval painting. Derived from the Greek, hematite means "bloodlike" and refers to any natural red earth and to all hydrous iron oxides. *See also* Illumination of Manuscripts.

Hemoglobin

See Blood Red.

Henna

A small shrub of the *Lithraceous* family, used now to produce a deep red hair dye or highlighter. Native to Arabia, henna was cultivated in ancient Egypt and other African regions and in Asia Minor and the Far East.

From as early as 2500 B.C., the Egyptians used the plant's dried leaves to extract a yellowish coloring substance, containing alkannin, which on contact with air turns dark reddish. This was and still is used by African and Asian peoples to dye both textile fibers and hair either a mahogany red or reddish blond.

Heraldry

A system developed in the Middle Ages for identifying knights by patterns on their shields, with colors representing specific qualities that the individual supposedly possessed. These color symbols are still used today for ensigns, regimental badges, school and college crests, club insignia, and other identifications.

Painted shields originated in classical times to allow soldiers to recognize friends or foes at close quarters during combat. With the development of armor that completely hid the identity of warriors, the system was standardized to identify men of rank and their escort. Choice of colors and designs for shields and pennants ceased to be arbitrary; the job was entrusted to heralds whose stock-in-trade, as non-combatant messengers, was a knowledge of military leaders and princes, their families, and their lands.

By the mid–thirteenth century, the rules were so well established that heraldry had its own terminology—called blazon. In blazon, colors were called tinctures, comprising two metals, five main hues, and two main furs. The metals are *or* (gold) and *argent* (silver); the hues, *azure* (blue), *gules* (red), *sable* (black), *vert* (green), *purpure* (purple); the furs, *ermine*—actually various patterns of spots—and *vair*, a blue inspired by the belly fur of the squirrel. Two minor hues—*tenne* (orange) and *murrey* or *sanguine* (reddish purple)—also make rare appearances. All heraldic tinctures must be rich and pure colors in accordance with the traditions of chivalry. Gold (and sometimes silver) was for honor and loyalty; silver (or white) for faith and purity; red (of the rose) for courage and zeal (as well as sacrifice, from the Christian tradition); blue (of the sky) for piety and sincerity; green (of grassy fields) for youth and fertility; purple for royalty and high rank; black (of animal fur) for grief and penitence; orange (or tan) for strength and endurance. A metal must have a colored background,

not one featuring another metal, and vice versa.

The notions of heraldry still apply for national emblems, especially flags; the American flag has red to signify the courage of the American people, blue for their sincerity, and white for their purity. The Egyptian flag is green, blue, and gold to represent the fertility of the Nile, tranquility, and the desert sands, respectively. The flag of the United Nations is blue on white as a symbol of purity and peace. *See also* Communication and Color; Flag Colors; Symbolism and Color.

Hering, Ewald

1834–1918. A German physiologist and psychologist, and an outstanding expert on color perception.

In the matter of color vision, Hering paid less attention to the physics of wavelengths than to subjective experiences. Adopting the idea of four fundamental colors (red, yellow, green, and blue), he declared there are three types of visual receptors, which operate in pairs: red/green, yellow/blue, black/white. His theory of color vision has gained increasing acceptance over the years. Psychologists regard his concept of red, yellow, green, and blue fundamental colors as primary in human vision.

Hering devised a system of color organization around a triangle, with pure color at one angle, white at the second, and black at the third, which became the basis of Friedrich Wilhelm Ostwald's color system and of the Natural Color System (NCS) of Sweden.

From the viewpoint of color sensation, Hering said, a person does not "see" actual wavelengths—the experience is a subjective, personal one. As Hering wrote, "Seeing is not a matter of looking at light waves as such, but of looking at external things mediated by these waves; the eye has to instruct us, not about the intensity or quality of light coming from external objects at any one time, but about these objects themselves." James Clerk Maxwell, an eminent Scottish physicist, agreed that "the source of color must . . . be regarded as essentially a mental science" (Maxwell 1890). Hering was the man who first made this clear. *See also* Systems of Color; Vision.

Hickethier Color Atlas

See Systems of Color.

Hiding Power

See Opacity, Pigment.

Highlights

The brightest areas of a subject or image. An area may be light because of the color of the subject matter, such as pale skin or light clothing, or it may be inherently bright, as with lamps or fire. The brightness of an area may derive from reflected light, as is often the case with sand, snow, or water viewed in direct sunlight.

The highlights seen on curved surfaces are essential to our perception of form: We assume that a surface without any highlights is flat; although highlights usually appear white or near-white, our perceptive process automatically discounts them in assessing the color of a surface. *See also* Chiaroscuro.

Hinduism and Color

According to Hindu belief, there are three fundamental constituents of the world and all it encompasses. These are called the *gunas* —*Sattva, Rajas,* and *Tamas*—and each one of these components of the cosmos has a symbolic color. Sattva is the white-colored guna, representing calmness, brightness, and luminosity such as that found in knowledge. Red is the color of Rajas, reflecting activity, passion, and energy; a life source. In Hindu marriage ceremonies, the bride-to-be wears red, heralding the birth of a new creative phase in her life, the role of wife and mother; this custom is based on the traditional association of women with activity—Shakti, the female consort of the great Hindu gods, personifies active creation of the universe— whereas men are associated with a more static manifestation of energy. Tamas, the black guna, represents anger, sloth, and inattention.

Krishna, the second god of the Hindu trinity, is depicted in Hindu painting as blue or, more rarely, dark colored. The use of blue symbolizes his universality, indicating the vastness of the sea and sky. This is related to the Hindu notion that all truth is mysterious and resides in shrouded depths that are not easily accessible. In contrast, the obvious or superficial is seen as light in color.

In many Hindu sects, the monks don saffron-colored (yellow-orange) robes, which symbolize serenity and renunciation.

Historic Color Sources

See Sources of Historic Colors.

Hockney, David

1937– . English artist noted for his colorful abstractions of real subjects portrayed in oil and acrylic paints, crayon and line drawings, and watercolor.

Whether in a still life or a picture depicting people, Hockney's images are always clearly recognizable for their clear, luminous, and highly decorative colors. In a series of swimming pool scenes, much of the unique color decorativeness lies in his treatment of water. In these large, flat areas of color, there are dancing color rhythms that "reflect not only the sky, but also, because of its transparency, the depth of the water" (Stanglos 1977). For the viewer, what appears on the canvas is a blue-and-white color abstraction in which the white lines, representing reflections, give the painting a distinctly linear quality and create colored patterns, making the works at once figurative and abstract.

Hofmann, Hans

1880–1966. German-American painter (born in Germany, emigrated to the United States in 1932), Hofmann, together with Josef Albers, ranks as one of the two most influential twentieth-century teachers of color in the United States.

Both Albers and Hofmann were members of the first generation of modern European artists whose styles influenced young American artists of the 1950s. In his color teaching, Hofmann evolved a concept of pictorial "color space" (derived initially from Paul Cézanne) in which large, painted areas of color suggest advancing and receding surfaces. He described this as "a pictorial reality resulting from the aggregate of simultaneous expansion and contraction with that of push and pull" (Chipp 1968).

The spontaneity of his approach to painting was important in the development of Abstract Expressionism in New York, in particular influencing Helen Frankenthaler (1928–) and Jackson Pollock. *See also* Albers, Josef; Cézanne, Paul; Pollock, Jackson.

Hokusai

1760–1849. Japanese printmaker and painter who revolutionized color in ukiyo-e prints. Originally trained as an engraver, Hokusai was the first artist of his time to cut his own wood blocks for prints. A prolific artist, he produced over 30,000 works of art, his most famous set of prints being *Thirty-six Views of Mount Fuji* (ca. 1820).

Because of the lack of a strong blue for sky and water, Japanese artists had shied away from any serious attempts to depict landscapes. It was the seventy-year-old Hokusai who saw the potential in the newly imported pigment called Prussian blue and used it as the dominant color in his print series. Because of the brightness of this pigment, he found it necessary to upgrade the strength of

After Hokusai woodblock, ca. 1820.

the other colors in his palette, swerving away from the traditional delicate colors of ukiyo-e prints.

In many prints of the Fuji series, Hokusai even replaces the traditional black ink outline with blue. This can be seen in *Fuji in Clear Weather* and *Morning Snow at Koishikawa*. In *The Wood Yard at Honjo Tatewaka in Edo*, Hokusai's emphasis on the decorative use of color is evident in the use of blue on the roofs of the homes. Characteristic of this series is the limited use of color in bold contrast for greater effect. The most famous print of this series, *The Wave*, is done in blue, white, light blue, and tan.

Hologram

A photograph that appears to be three-dimensional; from the Greek *holos* (entire) and *gram* (message). The hologram image of the subject changes in parallax and perspective as the viewing angle changes; objects in a hologram appear to cover or uncover one another, and their relative distances change with the angle of viewing, just as if the viewer was walking past the actual objects. In conventional stereoscopic photography, these changes do not occur as the viewpoint shifts.

Holograms are recorded by means of coherent light (light of essentially a single wavelength in which all waves are precisely in phase, that is, vibrating in unison, and are traveling in the same direction). This light is produced by a laser; the hologram records the standing wave pattern created by interference between two identical laser beams of light (usually a single beam passes through a beam splitter) known as the object and reference beams.

A unique characteristic of single-image holograms is the recording of the interference pattern everywhere on the plate. An entire image can be re-created from any portion of the plate, even a small fragment of a broken plate. More of the plate, however, is needed to produce the perspective and parallax views.

Two kinds of holograms exist: transmission and reflection. The first is made with both the laser's object beam and its reference beam (that which is directed straight at the plate for "reference") striking the emulsion side of the plate. The image is projected by shining laser light through the emulsion side, with the viewer observing the transmitted image from the other side of the plate. A reflection hologram is made with the two beams striking opposite sides of the plate; the image can then be viewed by reflecting ordinary white light off the emulsion side of

the plate. Hologram images can be photographed or projected onto screens, but then they lose the three-dimensional quality.

A full-color hologram can be created, with great difficulty, either by using red, green, and blue lasers, each aimed at the plate from a different angle, and then using matching beams for viewing, or by various single-layer techniques. Hundreds of different images can be recorded on one plate, by slightly changing the plate's angle for each image to be recorded; short motion pictures can be made in such a way and seen by shifting the plate angle during viewing. *See also* Laser.

Honeysuckle

The creamy white of flowers of the genus *Lonicera*.

Hudson River School

Group of American landscape painters of about 1825–75, evolving in the New York State–New England region and consequently labeled "Hudson River" by a derogatory press. Taking direction from the work of such European masters as Claude Lorrain (1600–1682) and Salvator Rosa (1615–73), they produced carefully composed, light-filled landscapes of such picturesque spots as the rivers, streams, and forests of the Hudson River valley, the Catskills, and the White Mountains. This was the first organized group of American artists to portray their native land.

The most prominent figure of the first generation was Thomas Cole (1801–48), whose credo was that "to walk with nature as a poet is the necessary condition of a perfect artist" (Howat 1972). His paintings are notable for their luminosity, lending them a religious aura, as well as for the thick application of his color. Although the latter is basically naturalistic, in certain paintings, such as *Schroon Mountain, Adirondacks* (1838), naturalism is slightly sacrificed for an exaggeration of color that creates a greater emotional effect.

The second generation was led by Asher B. Durand (1796–1886), whose *Letters on Landscape Painting* became the school's manifesto. His paintings reflect a continuing interest in light and atmospheric effects, but his color is less thick and is applied with feather-like brushwork.

Other well-known painters of this school are Frederick Edwin Church (1826–1900)—famed for his views of Niagara Falls—Thomas Doughty (1793–1856), J. F. Kensett (1818–72), S. F. B. Morse (1791–1872) and John Trumbull (1756–1843).

Hue

An attribute of a color by which it is distinguished from other colors and judged to be similar to one, or a portion, of the spectral hues—red, orange, yellow, green, blue, and purple. Thus, crimson, vermilion, and pink, although different colors, are close in hue. Black, white, and gray lack hue. Together with value (lightness) and saturation, hue is one of the three basic color terms. Physically, hue is determined by wavelength. *See also* Color; Saturation; Value.

Hue Cycle

See Color Circles.

HunterLab

See Appendix; Systems of Color.

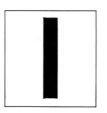

Icons

Religious paintings, characterized by jewel tones, of the Greek and Byzantine civilizations, icons embodied the central beliefs on which medieval Orthodox Christianity was based. While eighth- and ninth-century Byzantine iconoclasts tried to stamp out Christian figurative art in the Eastern Mediterranean, icons are still being made today.

Icon painting both prefigured and ran concurrently with Italian Renaissance painting. Icons tended to be highly stylized, but some of the best artists—including Michael Damaskinos and El Greco (Doménikos Theotokópoulos) in the sixteenth—produced sophisticated amalgams of the two styles.

The form and the graphic expression follow a particular given order and are expressed in a code handed down from painter to painter. As with form, colors are stylized and non-naturalistic. Backgrounds are usually gold leaf, on which appear carefully arranged figures of Christ, saints, or the Virgin Mary, each with his or her own appropriate colors. From icons comes the tradition that the Virgin Mary always wears a blue robe.

Even in icon painting, however, there are no absolute, unchanging colors. Various shades used or harmonies created might be dictated by a master painter or merely attributable to a certain region. The Russian icon painters show some fascinating variety. The fifteenth-century master Andrei Roublev, for instance, used the brightest lapis lazuli to give an impression of intense radiance coming from heaven, and harmonized it with the red of angels' wings and the light brown of faces. The fourteenth-century icons of Novgorod in Russia find their luminescence by contrasting a greenish blue with vermilion, while those of Pskov have a lighter palette of pink instead of red opposite a light green.

In each case, the iconographers are attempting to represent the spiritual ''light'' coming from heaven. To this end, the Russians ignored the shadows present in the occidental view. They did, however, represent the light by means of ''light points''—highlights—usually made on the basis of ceruse white. These light foci are very important, breathing life into a picture—better than all other elements of the icon, they represented the outburst of the Holy Ghost within the personage and the surrounding elements.

Some of the most colorful and interesting icons ever painted were produced in Eastern Europe—Bohemia, northern Austria, Silesia, Moravia, Slovakia, Galicia, Bukovina, and particularly Transylvania—during the eighteenth and nineteenth centuries. Master icon painters came from the ranks of the peasantry, expressing their thoughts and deep faith in the simplest and most instinctive form of art.

Originally, colors were prepared from earth pigments and metallic oxides. White dyes were obtained from limestone, yellow and ocher from clay, red from minium (red mercury sulfide occurring naturally) and from copper and gold salts, brown and violet from manganese, and blue from cobalt salts or natural copper carbonate (azurite).

These colors were later superseded by synthetic pigments, which are denser and more saturated but whose tones are high, acid, and flat. The natural colors produced an interplay of nuances inside the same tones. Since the pigment was unevenly distributed in the binder and the solution was less homogeneous, the colors varied inside the same tones. Sometimes the layers are so thin on the glass slab that, looking at the picture taken out of the frame, one can hardly see them. The dark wooden board at the back of the glass icon gives them a mysterious depth.

A thin gold foil also enters the chromatic composition of these icons. It lends brilliance to halos, armor, ornaments, borders, and sometimes the whole background. *See also* Illumination of Manuscripts; Symbolism and Color.

Icons are embodiments of religious faith, characterized by symbolic rather than representational use of color.

Identification of Color

See Matching Color; Measurement of Color.

Illumination, Artificial

See Light; Lighting, Artificial.

Illumination of Manuscripts

Illumination originally was the art of embellishing and illustrating religious texts for devotional purposes. It was performed usually by monks or other religious persons until about A.D. 1200, when illumination was increasingly provided by secular craftsmen for secular patrons as status symbols. The colors used have been preserved remarkably well because the finished art was on parchment and vellum and bound as a book—well sealed against light and damp air.

Colors used were flexible: Reds could be produced with red lead or kermes, and blues came from woad, ultramarine, or semi-precious lapis lazuli. Verdigris (a copper acetate) and, occasionally, malachite were used for green, while orpiment (arsenic sulfide) and saffron provided light yellows. Ground eggshells were sometimes used to produce a range from white to tan, and ground iris blossoms resulted in vivid greens. The color sources, either pigments or dried lakes (from dyes), were mixed with binders that varied from gum arabic, egg yolk, and glair (egg whites) to boiled-down parchment.

The use of color reflected prevailing tastes. In the earliest medieval manuscripts, such as the sixth-century Rossano Gospels, color was used naturalistically, strongly influenced by the illusionistic style of painting popular in late Hellenistic art. By the twelfth century the influence of Byzantium was felt in western Europe with the return of the Crusaders from the Middle East. Colors, intended to be not naturalistic but stylistic, were chosen for their supernatural connotations. Artists of the period showed a keen sense of contrast, often using red and gold juxtaposed with blue and green, both to emphasize the hues and to define abstract spaces in terms of contrasting color areas (usually lighter on darker).

The parchment folios were used in their natural colors or were sometimes dyed a rich purple—assumed to indicate a royal commission. The inks used for the scripts varied from silver and gold through a range of blues, blacks, and browns. Initials, when not in precious metals, were often done in red or blue ink.

One of the finest illuminated manuscripts, was *The Book of Hours*, commissioned by the Duke of Berry in France and the creation of three Flemish brothers, Paul, John, and Hermann Limbourg. Innovations in realism were achieved with the depictions of shadow (similar to chiaroscuro), the natural coloring of animals, landscape, and architecture, and the use of perspective (skies paling to the horizon). The lettering and costume colors are in gold and vivid reds and blue, a concession to the prevailing taste among patrons for jewels, precious metals, and bright enameling. *See also* Chiaroscuro; Glair; Gum Arabic; Natural Earth Pigments; Symbolism and Color.

Illusions of Color

See Optical Illusions.

Image Enhancement

In photography, changing the look of an image by changing the densities of gray tones or colors, usually by computer-processing techniques. Possible modifications include increasing brightness or contrast; improving color density or saturation; isolating or enlarging details; reconstructing near-original color values from faded images; colorizing black-and-white pictures; or reconstructing images that have been torn, stained, or otherwise damaged.

In digitization, an image is translated into digital data consisting of a set of numbers for each picture element (pixel), representing relative density, brightness, color, or some other characteristic. Enhancement or modification is then achieved mathematically, rather than optically or chemically, by increasing or reducing the numbers. The enhanced image may be displayed on a high-resolution video screen, or the new values can be used to control the intensity of a laser beam or electron beam that exposes photographic material to produce a print, or "hard copy."

Another technique of making image differences visibly clearer is pseudocoloring—coding them by color. Each value of a reference image can be translated into a color. The colors are arbitrarily assigned and have no relation to the original ones (although this is possible if desired). This greatly improves the speed with which an observer can analyze the information on a picture. This process is useful, for example, in astronomical photographs of stars, in which different colors are used to show different temperature bands.

Pseudocoloring is most often performed with black-and-white images, such as those transmitted from satellites or from medical scanners, where there is no objective indication of original colors.

Color Enhancement

Full-color enhancement can be achieved by establishing the standards of the colors that should exist in a picture. A computer will then scan the image; when it discovers differences—resulting from misprocessing,

Illuminated manuscripts: *Colors that have been sealed in the pages of books are well preserved.*

fading, or other causes—the computer derives correction factors for each of the three image dye layers (cyan, magenta, and yellow) and applies them to the color-analysis reading of each pixel. The color factors and balances can also be altered manually by the operator. Such programs are used to color-correct images for photographic reproduction, to correct or restore substandard images, and to create special effects.

Computer color enhancement has been used primarily in surveillance and scientific photography, in advertising, and in photomechanical reproduction. *See also* Astronomy and Color; Computers and Color; Pixel.

Impasto

A painting technique in which a heavy application of paint is made. Once possible only with oil paints, which would not crack when dried, impasto now is very popular with plastic-based paints, in order to create texture. *See also* Acrylic; Van Gogh, Vincent.

Impressionism

An art movement, originating in France in the mid-1800s, which had a profound influence on painters and heralded the modern movement in art. Impressionists sought to capture the essence of natural light in paint. They often worked outdoors, from nature, and used short brushstrokes of pure color, sometimes mixing the paints right on the canvas or juxtaposing dabs of color that would be mixed by the viewer's eyes. Crosscultural influences also affected their use and choice of color. Japanese wood-block printing, which was widely circulated in France in the second half of the nineteenth century, with its flat, unmodulated zones of bright color, found a receptive audience among the impressionists. The impressionist revolution was primarily a technical one, effected above all through the innovative use of color. Artists used a new, brightened palette of machine-ground colors. These had been introduced by about 1860 and produced clearer and brighter pigments than hand-ground colors.

Most impressionists rejected black—the absence of light—altogether. Vermilion was used in its purest form. The greens were viridian, emerald, and chrome, the last a commercially produced mixture of Prussian blue and chrome yellow then widely available. These were considered modern greens—colors of the period. Chrome yellow and lemon yellow mixes were used in the brightest greens (chrome yellow had a tendency to blacken and the impressionists abandoned it by the 1880s). Cobalt violet, the first opaque,

"Three dashes of the impressionists' paintings, aren't they equivalent to Delacroix's hatchings on his great paintings, reduced to proportions of smaller canvases? . . . It is the same procedure with the same goal, light and color."
—Paul Signac

pure violet to be manufactured, was used extensively, leading critics to condemn the impressionists for "violettomania" (indigomania), even quoting doctors' assertions that they suffered from "atrophy of the nerve fibers of the eyes." Cobalt blue, the brightest blue, was frequently used for water. Lead white was used liberally, especially by Claude Monet in his color mixtures. This brought a new overall brilliance and the pale pastel quality to the light tones and minimal light/dark contrasts of his sunlit landscapes.

During the 1870s, Monet, Pierre-Auguste Renoir, Alfred Sisley (1839–99), and Camille Pissarro (1830–1903) continued the exploration of outdoor subjects rendered in vivacious modern colors. Though still essentially studio-based, Édouard Manet (1832–83) and Edgar Degas, under the impressionists' influence, were induced to lighten their palettes. Both Degas and Monet are known to have soaked most of the oil from their colors before use, thus enhancing the paint's richness and luminosity. The impressionists exploited color contrasts and tonal differences and explored intense, light-saturated moments and motifs including reflective surfaces such as water and snow. Eventually these tendencies resulted in an effort to paint light itself.

As neoimpressionism and postimpressionism developed and gained ground in the 1880s and 1890s, both Monet and Renoir were developing their mature impressionist style. Renoir adopted a rich, dense, "feathery" brushstroke, and mixed his colors on the canvas surface itself, producing vibrant, discrete color sensations. Monet, who had developed his technique fully by then, concentrated on challenging subject matter, especially with motifs from the light-saturated south of France and with his well-known "serial" canvases of haystacks and cathedrals, painted at different times and at different seasons and with much variation in the light and color effects. *See also* Chevreul, M. E.; Degas, Edgar; Monet, Claude; Neoimpressionism; Painters, Painting, and Color; Postimpressionism; Renoir, Pierre-Auguste.

Incandescent Light

See Lighting, Artificial.

Incident Light

The illumination falling on a surface; depending on the nature of the material, this may be reflected, absorbed, transmitted, or a combination of these. Measured incident light is called illuminance; it is measured in footcandles (lumens per square foot) or lux

(lumens per square meter). The ratio between the amount of light incident on a surface and the amount reflected or transmitted is used to determine the reflectance, transmittance, absorptance, opacity, and density of a material. Color is seen as a result of some wavelengths of incident light being absorbed by a material, the rest being reflected or transmitted. *See also* Light; Lumen; Measurement of Color.

India

See Communication and Color; Hinduism and Color.

India Ink

A black drawing ink made from lampblack, usually but not always with aqueous binders. Traditional oriental blacks (from China and Japan, as well as India) are complex mixtures; they are made in stick form, which when rubbed with water on stone produces the black ink. It was thought that the quality of the black depended on what stone was used and even the manner of rubbing. India ink is one of the most opaque and permanent colors available to the graphic artist. *See also* Inks.

Indian (Native American) Colors

See Navaho Colors; Sources of Historic Colors.

Indigo

A variable, dark grayish blue originally obtained from the leguminous woad plant, *Isatis tintoria*, used as a dye. One of the most ancient dyes, it was known and widely used in India, Egypt, and Greece. Homer mentions *indikon* in passing in *The Iliad* when he speaks of the (blue) fabrics of Sidon (now in Lebanon).

Oriental indigo, *Indigofera tinctoria*, was more highly valued than woad, the European variety, for its greater yield and purity. In Roman times, it was used as blue pigment for painting; only toward the thirteenth century was the technique of alkalining for fermentation rediscovered and utilized to prepare indigo for fabric dyeing. Indigo dyes produce subtle tones in various gradations and intensities.

Shipments of indigo to medieval Europe were made as early as A.D. 1140. Until the discovery of aniline dyes in the nineteenth century, indigo was the only natural blue dyestuff available for wide use. The first synthetic indigo appeared in 1896, as a result of research by the chemist Adolf von Baeyer (1835–1917). It is this synthesized product that is used in dyeing denim for blue jeans.

To produce a dye, ripened leaves of the indigo plant are left to ferment in vats; the fermenting action releases the ingredient indigofera, which in turn breaks down into indoxyl and indoglucin. This mixture then is beaten to turn the colorless indoxyl into indigo blue. When the natural indigo dye is applied to fabric, the material first turns a green color, but once exposed to air it is transformed to blue. *See also* Aniline; Blue; Dyes and Dyeing.

essay

Industrial Environments and Color

Frank and Rudolf Mahnke, authors of Color and Light in Man-Made Environments, *examine the effect of color in work-related situations.*

Research indicates that people respond to color both psychologically and physiologically. Color may affect activation of the cortex, functions of the autonomic nervous system, and hormonal activity. It may influence our emotional state, producing subjective/objective impressions including mood associations. It also influences our estimation of such things as volume, weight, temperature, time, odor, and noise.

Color design of industrial plants should be approached from both objective and functional viewpoints. If it is taken for granted that correct and adequate lighting already exists, color can be used to create environmental conditions that will counteract premature fatigue, reduce stress, improve visual perception (thereby safeguarding the eyes), minimize possible worker errors, and effectively aid orientation and safety.

Studies, including those conducted in the field of industrial psychology, indicate that incorrect environmental conditions may lead to boredom, resulting in job weariness, lack of motivation, and negative social interaction. Many tasks that are tedious, repetitive, or monotonous, or that expose workers to unusual levels of heat, noise, and odor, or place great demands on vision, undermine worker morale and affect physiological as well as psychological well-being. A negative industrial ambience will have an impact on the quality and quantity of production.

Specific color recommendations for industrial surroundings are difficult to make. Industrial environments are as diverse as the products manufactured in them. Attempting to cover all types of industries with a standard set of color recommendations would be

Studies indicate that incorrect colors lead to boredom, weariness, and lack of motivation.

simplistic. Much depends on the nature of the work performed, the character of material or products produced, the equipment used, the type of lighting, and the dimensions of the plant area.

However, certain principles, having to do with vision, psychological reactions, physiological effects, safety, and functional uses of color, are common denominators for all industrial environments and allow formulation of various guidelines for effective color usage. These guidelines are based on neuropsychological relationships (including many of the physiological effects), visual ergonomics, and color psychology.

Neuropsychological Aspects

Environmental conditions dictate that designers must be aware of research relating to people's general reactions to stimulation—specifically, how information coming from the environment (external information) and from within (mental activity sorting out incoming information) is changed into feelings, thoughts, and actions. People are subjected to many kinds of stimulation, including visual information from the environment, ranging from sensory deprivation on one extreme to sensory overload on the other. Every impulse, whether originating externally or in the mind, produces changes in the individual's emotional state.

Basically, the interior environment must not be so understimulating or overstimulating as to present a set of visual circumstances that are negative in their influence. Studies show that extreme understimulation (monotony) can lead to symptoms of restlessness, excessive emotional response, concentration difficulties, irritation, and other negative reactions. On a practical basis, this indicates that surroundings devoid of a reasonable amount of color variety are objectionable. Unvarying single colors—for example, beige, white, green, gray, and tan—will lose their impact or novelty after a short time and become monotonous. At the other extreme, exposure to an overstimulating environment can cause the same effects, or symptoms, that have been seen in stress research conducted in the 1960s and 1970s—changes in pulse rate and blood pressure, increase in muscle tension, and a variety of psychiatric reactions, probably compounding medical consequences such as coronary disease and ulcers. Overstimulation is distracting and will also interfere with work tasks. Strong color, too much visual pattern, and high brightness elicit voluntary and involuntary misdirected attention.

Striking a balance between these two extremes depends on a designer's knowledge

Color design should avoid monotony and overstimulation.

of color and sensitivity to it. In industry, decisions depend on the nature of the work being performed, and the designer must also understand the general work operation and identify its nature. Workers performing monotonous and tedious tasks will not be helped by monotonous surroundings; conversely, workers involved in tasks requiring a high degree of physical effort and speed would not work most efficiently in an environment saturated with pattern and strong, lively colors. In both cases, the balance consists of variety—within reason.

Vision

Visual discomfort (eyestrain and fatigue) greatly affect performance. Light is the basic stimulus for vision. Just how much light is needed for clear and comfortable seeing has been studied by illuminating engineers for years. Too little light will handicap vision; too much will overtax it. The technical engineering of lighting installations is usually out of the hands of the designer, but he or she will have control over the relationship between light and the quality of the surrounding visual environment.

Environmental space can be designed to maximize visual efficiency and comfort. Eye fatigue is usually the result of tired muscles, not retinal nerves. Just like any other muscle in the body, eye muscles, if subjected to excessive activity, will tire. Glare, constant adjustment to extreme differences in brightness, prolonged fixation of the eyes, and constant shifts in accommodation will tire eyes quickly, causing headaches, tension, nausea, and other disturbances.

Extreme contrast in light and dark will subject the iris muscle to undue stress because the pupil is forced to undergo constant adjustment. Vision should be held to midtones, an ideal light-to-reflection ratio being three to one. This means controlling the light-to-reflection ratios of walls, floors, furnishings, machines, and equipment. Recommended reflectance factors for walls are 50 to 60 percent if floor and equipment are dark, and 60 to 70 percent if most surfaces and areas are light. White and off-white have a reflection ratio of anywhere from 81 to 94 percent and should not be used for walls. However, they can be used on ceilings, where the desired reflectance falls between 80 and 90 percent. Machines, equipment, tables, and desks should have a reflectance of between 25 and 40 percent; floors, approximately 20 percent.

Glare—bright reflection of light from shiny surfaces—also strains the eyes. Direct glare results from insufficiently shielded light sources and unshaded windows. Win-

dow walls should always be kept in a light color. Dark walls adjacent to sunlight entering through windows results in unnecessary brightness contrasts. Reflected glare results from specular reflection of high luminance on polished surfaces. Work surfaces—and walls when possible—should be matte or dull to avoid reflected glare.

Insufficient contrast between the work surface and items being assembled or inspected may cause as much discomfort as too much contrast. For example, it would prove tiring to assemble a green object on a green work surface, because of the extra effort required to differentiate between the two greens. In this case, a neutral gray surface of about 30 percent reflectance would be ideal. If products being assembled are consistently of the same color, the work surface should be in the complementary of that color, but with the proper reflectance and of low saturation. This will also help to eliminate the problems of afterimage—the appearance of the ghost-like complementary color after intense or prolonged stimulation of the eye by a color. Color contrast used to establish an easy-to-see line of division between machines and the material being fabricated can prevent the machine operator from straining to determine this division. For instance, a blue-green would provide good contrast to the yellow-gold of brass, but orange would not do this as well.

Color's Psychological Effects

There are indications that some basic reactions to color may be common to all or most people. Many people agree that some colors are active (exciting) and others passive (calming). Psychologically, the warm color group is generally associated with action, and the cool color group with passive effects. Some effects are more physiological in nature. In one study, R. Gerard found that red stimulated visual cortical activity and functions of the autonomic nervous system more than blue did. Another investigator, M. R. Ali, used electroencephalogram analysis to show that heart rate increased following use of red lighting more than blue lighting. Other studies have similarly suggested that colors richer in longer wavelengths (the warm end of the spectrum) cause more stimulation than those of short wavelengths (the cool end of the spectrum).

Regarding arousal effects, one should be careful not to draw the wrong conclusions. It would be erroneous to think that a red room will have a *continuous* high arousal effect. In fact, although exposure to any single strong hue will cause an immediate and measurable reaction, the effect is not continuous. If a red room, unrelieved by other hues, is found aggravating, then the cause of aggravation will be the limited visual stimulation, not the temporary higher arousal effect. The remedy is a room based on color balance.

Although physiological stimulation may be temporary, certain strong hues (regardless of whether they are warm or cool) may have a troubling psychological impact. A great deal depends on the saturation or strength of a color. For example, in general, red can be considered exciting and green calming; but is a weak red more exciting than an electric green? A cheering yellow becomes irritating if it is highly saturated; a stimulating orange loses its vigor when desaturated. There are numerous such examples. It should be remembered that when a color is modified in intensity or in value, its psychological effect may change.

Apart from personal preferences, some colors are better than others in the workplace. Those that do not work well in any work environment include the following:

White: Psychologically, white and off-white appear empty, sterile, and without energy. White walls, when accompanied by high levels of light, produce high environmental brightness and glare. Too much white may cause eyestrain. The use of white on ceilings, however, is acceptable.

Gray: Environments that are neutral in appearance—as for those in gray—will often appear static, boring, and tedious.

Blue: Blue is a cool color and, if applied in large areas, can make a space seem cold. Pale blue is refracted sharply by the lens of the eye and therefore tends to cast a haze over details and objects in the environment. Medium and deep tones are quite appropriate in incidental areas.

Purple: This color is seldom used in interior spaces except for incidental areas; psychologically it may appear disconcerting and subduing.

Red: Pure red is rarely used except as an accent, or for safety purposes; the color appears aggressive on walls and intruding and heavy on ceilings.

Action of Color

Color may support, conform to, or be in agreement with a given situation; therefore, it has a consonant action. When it counteracts specific environmental problems, it may be said to have a compensatory action. For example, the problem of heat in the environment will be supported by warm colors such as orange and counteracted by the subjective coolness of blue-green. Orange has a consonant action, blue-green a compensatory one.

Colors can have compensatory effects: blue-green cools, and orange-red warms.

Particularly in industrial surroundings, conditions such as noise, heat, odor, dampness, or dryness may become so bothersome as to be a real burden for the worker. Listed below are some problems and compensatory colors that may offset them as dominant wall colors (in all cases, the designer can include subdominant colors in incidental areas to avoid excessive single-color effects within the environment):

Temperature: Blue-green and light green (subdominant colors in incidental areas may be light orange-yellow) will make a warm area seem cooler. Cold areas are offset by warm hues such as orange and light red-orange.

Noise: Compensation can be made through understanding the relationship of color and mental association and choosing appropriate colors. Loud noise is associated with the most active effects of warm colors; the reverse is true for cool colors. People mentally connect a loud red with a high-saturation red; rarely does one speak of a loud blue. High-pitched or shrill sounds tend to be compared with saturated and light hues; these may be offset by olive greens. Muffled sounds appear more so in dark surroundings; lighter colors will compensate.

Smell: Sweet smells are compensated for by greens; red and pink would support them. Narcotic and heavy smells may be offset by orange-yellows, and unpleasantly bitter smells by orange.

Dampness and Dryness: Damp conditions are compensated for by yellow-tan (the color of sand), whereas dry conditions may be offset by blue-green (the color of the sea). Color associations elicit these responses.

Weight/Size: Dark colors appear heavier; light, less saturated ones seem less dense. If hues are of the same value and intensity, then the warmer ones will be perceived as being heavier. Good use of these effects can be made in industry. Bases for machinery and equipment will appear steadier and more solid if they are painted a dark color, while the equipment itself is a light color. Heavy objects designed to be moved, carried, or thrown by human effort will appear less heavy with light, cool colors.

Any color chosen for industries should not be dictated merely by current design trends or idioms, nor by a designer's personal color preferences or opinions. Fashionable color, alone or in combinations, may have little impact on the psychological, physiological, and functional requirements of the industrial environment. Instead, the choice of color should be based on a rational approach, guided by principles derived from human-to-environment research.
—Frank and Rudolf Mahnke
See also Architecture and Color; Communication and Color; Functional Color; Synaesthesia.

Infrared Photography

The recording of wavelengths that are too long to be seen by the human eye. These wavelengths begin just beyond the visible wavelengths in the electromagnetic spectrum, at about 700 nanometers (billionths of a meter), extending to about 0.1 centimeters. Practical infrared photography with ordinary cameras and infrared-sensitive film extends from about 700 to 900nm; specialized films will go up to about 1,200nm. In a color film, the pigment that is normally blue sensitive is made infrared sensitive, and a yellow filter is used to block blue exposure. This is known as "false-color" film and shows green objects as blue, red objects as green, and objects emitting or reflecting only infrared as red. Since most objects reflect some infrared, the colors in the final image are complex and distinctive.

Because vegetation strongly reflects infrared wavelengths, there is a prime military application for infrared film to detect camouflage material, which tends not to reflect infrared so well and so stands out from the surroundings. Infrared photography also allows the detection of heat sources; ordinary photographic film is not normally sensitive to heat waves. Objects emitting heat energy emit a corresponding amount of infrared; heat-seeking heads of missiles can discriminate less than 1.5°C difference in temperature between an object and its background, revealing the presence of a human being or the engine of a tank.

In medicine, infrared photography can be used to detect the presence of internal injury or disease in the human body. Such a defect can produce a drop in temperature in the affected part—or in some cases a sharp rise. An infrared thermograph can record these changes on a photograph, coding the different areas by temperature on a color scale selected to run from white at the hot end, through reds, greens, and violets, to blues at the cold end. *See also* Medicine and Color.

Infrared Radiation

A form of electromagnetic radiation that is continuous with the red end of the visible

spectrum but lies beyond it and is of longer wavelength. Emitted by hot bodies, it will heat whatever it falls upon. *See also* Infrared Photography.

Inks

Pigmented fluids used by artists and printers in their respective work. Black ink originated around 2500 B.C. in both China and Egypt; it was essentially black carbon—soot from oil lamps or, in China, carbon from burnt trees, one favorite being pine—plus water, mixed with a gumlike substance to stabilize the suspension. Because of its rich blackness and permanence, India ink, or China ink, is still used extensively by draftsmen.

The use of a brownish black ink, sepia, from the "ink bag" of the cuttlefish, is also ancient. Sepia is high in tinctorial power—the secretion of one cuttlefish will turn thousands of gallons of water opaque in a few seconds. However, it was not until the eighteenth century that sepia became popular as a drawing ink.

In the Middle Ages, two kinds of black inks were used. One was a suspension of black organic salt of iron; the other used lampblack, a pure form of carbon, preferred for its fineness and flocculence. Modern black and blue inks are most extensively used in writing implements. The black comes from a carbon soot, and the blues are composed of copperas (ferrous sulfate), gallic and tannic acids, and a preservative. These and other colored modern inks contain aniline and other soluble dyes, which allow colors to flow easily, even through ballpoint pens. In contrast, printing and lithographic inks use finely ground pigments in suspension.

The look of an ink depends a great deal on the whiteness and brilliance of the paper (or other surface) to which it is applied. Since most paper has the yellowish cast of wood pulp, which does not provide a good background, it is generally coated with clay white, giving a brighter blue cast to the paper. Absorbency is also critical—the more absorbent the paper, the less intense the coverage of the ink. Gloss, both in paper and ink, is considered desirable for improved contrast and color quality.

There are four colored inks used in printing: yellow (from diarylide), magenta (either lithol rubine or rhodamine Y), cyan (phthalocyanine), and black (carbon). Ideally, these inks are transparent to allow the primary colors to be overprinted and some of the brilliance of the white paper to show through. In practice, all inks are opaque to a degree, and the overall color tends to be skewed slightly to the hue of the last-printed color. In particular, yellow inks shift the color balance noticeably.

All printing inks must balance the relative effects of tinctorial strength, drying speed, cost, toxicity, and so on. Generally, the inks with higher tinctorial strength are preferred because they require thinner films and thus cut down on problems such as resolution. Types of ink are numerous, ranging from silk-screen inks to rubber-based inks, oil, acrylic, fluorescent, and a host of other kinds. *See also* Colorants; India Ink; Printmaking; Process Colors.

Institutions

See Appendix.

Intaglio

Method of reproduction by printing in which the image is cut into a plate: The incised pattern holds the ink, which can then be transferred to the surface of the paper in a printing press. The name comes from the Latin *intaliare,* meaning "to cut into." *See also* Etching; Lithography; Printmaking; Relief Printing.

Intensity

The measurable brightness of a light source. A synonym for saturation. *See also* Lighting, Artificial; Saturation.

Interference

The interaction of wave motions across the spectrum of light, resulting in some colors being intensified and others weakened. Such an effect can occur when light hits a very thin transparent film such as that of oil on water or of a soap bubble. Light is reflected from both the upper and lower surfaces. If the waves of the two reflections are out of step, they will cancel each other out; if in step, they will enhance each other. The colors that are enhanced vary according to the thickness of the film and the wavelength of light. Being conjured out of light, these colors are of spectral purity.

The principle of interference is used to produce a complete spectrum of color from white light by using a diffraction grating. This "grating," in fact, consists of thousands of lines engraved on celluloid or glass film: Light passing through each slit is spread out and interferes either constructively or destructively with its neighbors, the result being a remarkably even progression of color on a reflecting screen.

Similar interference effects are demonstrated by mother-of-pearl. Not naturally

The best inks are still made from soot, or taken from the ink bag of the cuttlefish.

pigmented, the lining of the shells consists of layers of crystals set at an angle in striated patterns. These crystals, much like a diffraction grating, tend to disperse light into the spectrum of colors. Interference from the regular pattern produces the bright colors that we see. Being internal, such coloration is considered purely accidental, serving no known function in the existence or survival of the shellfish. *See also* Diffraction; Iridescence.

Interior Lighting

See Lighting, Artificial.

Interiors, Residential

Interior colors share many of the same functions of exterior colors, mainly in that they are both linked to and partly determined by architectural form. For this reason, interiors are covered extensively in the sections on architecture and industry (*see* Architecture and Color; Industrial Environments and Color).

The distinguishing feature of interior colors for the residential environment is that they are lived in by particular individuals: Colors thus variously determine perceived space, control apparent temperature, and indicate the homeowner's personality. Equally important, they can be—and are—changed at will. Because of the subjective nature of color choice for the home, residential interior colors are the most difficult to analyze. Nevertheless, as in fashion, economic forces and popular cultural trends influence patterns in color usage, which have been documented in annual forecasts since the 1960s by organizations such as the Color Association of the United States and the Color Marketing Group (*see* Fashion: Forecasting Color Preference).

Paint and wallpaper can be used to reiterate colors of furniture, pictures, or even dress, but they can also be used to manipulate the sensory environment. For instance, a large room can appear smaller and cozier through the use of a broken color scheme with both warmer and darker colors. Small, slightly claustrophobic rooms, typically found in modern cities, can be made to seem airier by using light and simple colors. Bright colors tend to foreshorten distances; conversely, blued colors can make walls visually recede. Playing with colors allows subtle but effective manipulation of space: A common Victorian device was to paint walls dark and the ceiling white, thus significantly increasing the apparent height of a room.

Against the background of walls and ceilings, other colored objects such as furniture, lights, and carpets appear as accents. Where monochromatic rooms are ultimately dull, bright and preferably contrasting color touches can provide needed stimulation for the eye. Bright colors all over provide an active environment, more suitable to children than adults. Many designers and consultants recommend that color be used functionally, reflecting the purpose of the room: multipurpose whites and creams for living areas; brown and other darks for places of contemplation such as a den or office; hygienic white and nature's greens and blues for the bathroom; and perhaps a deep blue for the bedroom, approximating the Pompeian taste for sleep-inducing black in their sleeping areas.

Ultimately, paint is the most versatile and least expensive medium for covering large surface areas and for hiding irregularities in wall and furniture surfaces. While over 1,000 hues and shades are available from most large paint manufacturers, it may be difficult to pick exactly the right one from the small sample chips. On average, a color will lighten by 50 percent when blown up to cover a large wall. Also, while some stores will color match to a sample of fabric or old paint, colors will never match as well under lighting at home. It is always best to paint a portion of a wall as an experiment before a decision is made. *See also* Adam, Robert and James; Aerial Perspective; Art Deco Colors; Art Nouveau Colors; Education, Color; Medicine and Color; Size of Color; Sources of Historic Colors; Trends in Color; Trompe L'Oeil; Victorian Architectural Colors.

International Academy of Color Sciences

See Appendix: Color Organizations.

International Association of Color Consultants

See Appendix: Color Organizations.

International Color Authority

See Appendix: Color Organizations.

International Colors

See Fashion: Geography of Color; Flag Colors.

Inter-Society Color Council

See Appendix: Color Organizations.

Invisible Colors

See Black Light; Keller, Helen; Zoology and Color.

Iridescence

An optical effect such as the play of colors seen in soap bubbles, peacock feathers, certain butterfly wings, and elsewhere, often without the presence of any pigmentation. It is usually caused by interference of light, but may also be a result of refraction and diffraction. The term comes from Iris, the ancient Greek goddess of the rainbow.

Some of the brightest and purest colors of the natural world are produced by this effect, as the wavelengths of light reflected by upper and lower surfaces of skin or feathers vibrate in or out of step with each other. Now paints have been developed containing minute flakes of mica or titania, which result in metallic iridescent finishes.

Iridescent colors can be modified by the presence of pigments to produce new colors. The iridescent layer—blue—of the chameleon's skin is superimposed on a layer pigmented with carotenoids—yellow— to produce the characteristic emerald green color. In addition, the chameleon's nervous system triggers the release of brown melanin, which is injected into the yellow layer, enabling the chameleon to change color against different backgrounds.

A feature of iridescent colors is that they change according to the angle of view. Some insects such as the tropical *Morpho* butterfly of South America, which is prized for its brilliant iridescent blue, apparently reflect only one color. But the *Morpho*'s color is bluest when seen from above and deepens into violet when seen from the side. The interference colors of stones such as opals, however, can cover the whole spectrum from red and yellow to green and blue as the stone is rotated. *See also* Diffraction; Interference; Opal; Refraction; Zoology and Color.

Iris

See Eye; Rainbow.

Irradiation

See Bezold-Brücke Effect.

Ishihara Color Test

See Color Blindness.

Islamic Colors

Preeminent among Islamic colors is green. Worn in the headdress of pilgrims going to Mecca, it is the color of the turban of the prophet Muhammad and of fertility and foliage, so rare in desert lands. Green also represents the Fatimid dynasty (ninth century). Each dynasty has its own color: white for the Ummayids (seventh to eleventh centuries), black for the Abbasids, red for the Sharifs of Mecca. These four colors used together are regarded as symbolic of the Pan-Arab movement, and are the basis of most flag colors of the Islamic world. The second major Islamic color combination, turquoise, blue, and gold with green and red, is to be found in architecture and mosaics of the Middle East. *See also* Seljuk and Ottoman Mural Ceramics.

Isolated Colors

Colors that are surrounded by a line or area of neutral tone, thereby enhancing their apparent saturation. The main purpose of visually isolating colors is to reduce or eliminate their interaction with adjacent colors. Such interaction can substantially change the character of a color, resulting in an overall grayed effect or even, in extreme cases, producing dazzle.

Successful applications of color isolation include: stained glass windows, where the thick leading between pieces of glass keeps colors distinct (thus symbolically pure as well); cloisonné, in which metal ridges contain areas of colored enamel, reducing the glare of so many bright colors in close proximity by providing relief for the eye; and modern art, such as the work of Georges Rouault (1871–1958) and Fernand Léger (1881–1955), in which the painter surrounds bold primary colors with black lines of varying thickness. *See also* Chevreul, M. E.; Cloisonné; Dazzle.

Itten, Johannes

1889–1967. Swiss painter and one of the best-known Bauhaus teachers. He taught an intuitive approach to color theory.

Itten's deep interest in color led him as a young man to Stuttgart to study with Adolf Holzel, a German color theorist. Later, he went to Vienna to start an art school, and in 1919 he joined the newly founded Weimar Bauhaus, where he developed a basic course on form and color. His fellow teachers were Lyonel Feininger (1871–1956), Wassily Kandinsky, Paul Klee, and Oskar Schlemmer (1888–1965). From 1924 to 1934, he directed his own school in Berlin, where he evolved the color theories he later published as *The Art of Color* (1961).

As a teacher, Itten stressed spontaneity in color expression. He observed that students, if left to explore color in their individual ways, often made color designs that revealed personality traits suggesting future occupations. For example, in one exercise, a student's painted squares were light violets, light blues, grays, yellows, and whites, with just touches of black, indicating a hard, cold,

Johannes Itten.

"There are subjective combinations in which one hue dominates quantitatively, all tones having accents of red, or yellow, or blue, or green, or violet, so that one is tempted to say that such-and-such a person sees the world in a red, yellow, or blue light. It is as if he saw everything through tinted spectacles, perhaps with thoughts and feelings correspondingly colored."
—*Johannes Itten*

somewhat brittle aesthetic approach. This student, Itten pointed out, ultimately became a successful architect in concrete and glass; his early color preferences had indicated that he had a special affinity for these materials. Another student preferred orange-brown, ocher, red-brown, and some black, while green, violet, and gray tones were absent. This student, Itten claimed, rightly chose a career as a woodworker.

In addition to such subjective, individual studies, Itten formulated an objective color theory of seven kinds of color contrasts: hue, light and dark, cold and warm, complementary, simultaneous, saturation, and extension (or quantity). To explain his theory, Itten used examples from art and nature. He cited, for instance, the manifold variation of hue in illuminated manuscripts as an example of sheer pleasure arising from decorative invention. To understand cold and warm color properties, he suggested visualizing opposites in nature: shadow/sun, transparent/opaque, sedative/stimulant, rare/dense, airy/earthy, far/near, light/heavy, wet/dry. *See also* Bauhaus; Systems of Color.

Ivory

A white to yellowish white color and an organic substance derived from the teeth or modified teeth (tusks) of elephant, mammoth, walrus, hippopotamus, boar, narwhal, and sperm whale. Teeth and tusks are composed mainly of the phosphate mineral hydroxyapatite and organic compounds.

Ivory Black

See Artists' Pigments.

Jackson, Carole

1942– . American color consultant, author of
the best-seller *Color Me Beautiful* (1979), and
head of Color Me Beautiful, Inc. Jackson was
educated at Stanford University and the
State University of New York before opening
her first image consultation business, The
Fashion Studio.

The premise of *Color Me Beautiful* is that
people can be divided into four separate
groups—Spring, Summer, Fall, and Winter
—according to the coloration of their skin,
eyes, and hair. From analyses of such char-
acteristics (called Personal Color Analysis),
the colors most suitable to be worn in cloth-
ing, accessories, and cosmetics can be deter-
mined. Criticized by some for her subjective
and often authoritarian approach to personal
color choice, she continues to be successful
with her follow-up volumes, *Color for Men*
and *Color Me Beautiful Makeup Book. See also*
Personal Color Analysis.

Jade

A naturally occurring mineral named for the
Spanish *piedra de hijada,* a green stone carved
by Central American Indians. The name was
later applied to imported Chinese pieces.
There are in fact two different minerals: neph-
rite and jadeite. Nephrite is generally green
to creamy white, while jadeite varies from
white to green, brown, orange, or, rarely,
lilac. Both minerals are very hard and dura-
ble and have been used since neolithic times
for weapons and tools, and later for delicate
carvings. *See also* Gemstones and Jewelry.

Japan Color Research Institute

See Appendix.

Japan Colors

The term covers pigments ground in quick-
drying synthetic varnish. The paints are
opaque and matte, used where the transpar-
ency of oil paints is unwanted.

Japanese Colors

Japanese colors range from bright and gar-
ish, as in the Kabuki theater, to the most
subtle "non-color" look of *shibui* (subtle,
muted) elegance.

As in neighboring China, color taste in
Japan has varied through the centuries and
dynasties, from the dazzling brights of the
Heian period (A.D. 794–1185), described in
the early-eleventh-century stories of the *Tales
of Genji* by Lady Murasaki (ca. 978–1026) and
Pillow Book by Sei Shōnagon (ca. 966–1013),
to the delicate ukiyo-e prints of the eigh-
teenth and nineteenth centuries, to the con-
temporary black and brown designs of Issey
Miyake.

In each case, the Japanese color tradition is
characterized by equilibrium. This balance is
based on the play of color among the com-
plementaries on one hand and analogous
colors or related tones on the other. Black,
white, and red stand out as the only colors
frequently used as accents.

This balance is well illustrated in an eye-
witness account of the Imperial Court writ-
ten by Sei Shōnagon:

All the High Court nobles were present. They
wore laced trousers and Court Cloaks lined
with violet, through which one could see the
light yellow of their linen robes. . . . Over a
silk robe of dark orange, he [the Captain of the
Third Rank] wore a dazzling white one of
glossy silk. His Court Cloak was lined with
violet and his laced trousers were of the same
color. . . . The summer robes of most of the
men were dyed in magnificent shades, and
together they shone with such luster that it
was hard to single out any particular color as
being the most distinctive.

In Japan, until this century, dark violet
was considered an imperial color since it was
difficult to dye and to obtain. An import
from Egypt, it was very expensive. In Sei
Shōnagon's many detailed costume descrip-
tions, purples of various kinds, grape colors,
mauves, and violets are juxtaposed with yel-
lows and oranges. Colors were chosen to
achieve perfect complementary equilibrium.
A bunch of violets in a spring meadow, for
example, will grow next to the orange-yellow
of a buttercup flower.

During the same period, tonals and off-
monochromatic tones were used together in
clothing. Sei Shōnagon writes, "The lady
had worn a set of dark purple robes over a
violet garb of figured material. Above it all

*Hokusai sketch of woodblock printer
using a* baren, *or burnisher.*

The colors of the Japanese flag—red and white—together with black, are perennial Japanese favorites.

was a thin cloak of dark red." The "set of robes" was an ensemble of lined robes worn by aristocratic women to produce a subtle blending of color. The sleeves of each robe were longer than those of the robe over it, allowing the many layers of related tones to be seen at once.

Colors in nature are also described in detail in the *Pillow Book*: "Snow looks wonderful when it has fallen on a roof or dark, cyprus bark . . . when snow begins to melt a little or when a small amount has fallen, it enters into all the cracks between the bricks so that the roof is black in some places, pure white in others."

In modern Japan, red, black, and white are still favorite Japanese colors. Red (the flag color) is widely used in television commercials and even on public telephones (although pastels are beginning to make inroads into industry). The primary source for the red dye used by the Japanese was the beni-hana flower, used to produce various shades of red. Fabric is dyed several times to achieve the desired shade. The first dye produces light pink; after the second, the color is a little stronger; with each successive dye, it becomes a more saturated-looking color. In ancient times, Japanese women used pink as an underwear color; it was worn next to the skin on the theory that the body requires red for circulation and health.

Indigo, or *ai*, is used in three strengths: dark, medium, and washed out. It is prevalent in working clothes and kimonos—the *yukatas* (bathrobes) of ornate blue-and-white prints.

Kabuki Colors

Kabuki is a Japanese theatrical performance, four centuries old, comparable to a stylized musical comedy. Color, form, and sound are blended with great beauty and artistry. The costumes are bold but refined, based on contrasting colors and geometry of patterns. Western colorists, who may not understand what goes on in the play, are usually impressed by Kabuki's color relationships. Kabuki is red, but Kabuki is all colors. At first glance it looks garish, but it is also subtle. Everything clashes, but all goes well together.

Makeup and its application are critical to Kabuki, and there are intricate rules of face painting, or *kumadori* ("making shadows"). All makeup is exaggerated and stylized, largely consisting of two basic colors, crimson red and dark blue (which, when mixed under the candlelight of earlier times, appeared black). Red symbolizes bravery, justice, and strength. Blue is evil, the super-

natural. Other colors are also used for makeup: black, terra-cotta, bronze, and gold. The face is first covered with a white base, over which these colors are applied.

A light blue is used to indicate areas where hair has been shaved off, such as on the scalp and chin. In the early days, a piece of red-blue cloth was frequently worn to hide the portion of the scalp that all adult males were required to shave. Even now, since Kabuki is an all-male performance, the *onnagata* (male actors playing women's roles) may appear with a blue cloth over their forehead.

To counteract the sameness of all-black hair, there is great opulence and variety in hairstyling. Changes in makeup, hairstyles, and cosmetics are often made directly on stage by *kurogo* (attendants), who wear all-black costumes, including hoods, that render them symbolically invisible, black being the color of non-existence.

The Kabuki curtain, or *maku*, is made of a heavy cotton, usually in wide stripes of dark green, red-brown, and black, especially prevalent in the Edo region (Tokyo). Elsewhere, for example in the Kansai cities (Osaka, Kyoto, Kobe), there may be a variety of colors. The scenery is heavily symbolic: A tree is a forest; a black curtain represents the darkness of a black night and functions as a perfect background for the colors of the actors' costumes.

Fixed characters wear fixed types of costumes. The colors vary in richness and complexity according to the importance of the character. A feudal lord is entitled to different colors than a merchant; the opulence and complexity of his attire place him in a separate visual category. A princess, conventionally, wears an embroidered red costume. Great actors, however, sometimes break with tradition and change hairstyle, color, and pattern of costume.

The overall effect of a Kabuki performance, like that of a ballet, is brought about in part by the repetition and multiplicity of the strikingly patterned and colored costumes worn by most of the actors, whose roles are choreographed to be a background and frame for the star performers. In the succession of tableaux, black plays the same role as the leaded outlines in a stained glass window—basically separating and strengthening the colors.

Two, three, or more actors wearing costumes of carefully chosen harmonious colors move together on stage. There is frequently a bicolor effect in a Kabuki costume with a companion costume, also bicolor. For instance, a khaki and periwinkle blue jacket is often seen next to one of eggplant and pine

green; a neutral tone is often paired with a bright one. Altogether, Kabuki's use of colors is a living source of innovative approaches for chromatists in different disciplines. *See also* Cosmetics and Color; Symbolism and Color.

Shibui

Finally, in contrast to these bright, sometimes garish colors are the *shibui* tones. The vegetable dyes used traditionally in ancient Japan created an ensemble of soft, muted colors: off-whites, beiges, tinted grays, tinted browns, grayed mauves, and subdued greens, which are often harmoniously mixed. Historically, the term *shibui* originated in the tenth century with the Chinese Cha'an (Zen) Buddhist paintings. These works were markedly different from the ornate and lavishly colored designs preceding that time. The gradations of lustrous black ink through all the grays are characteristic, reflecting elegance, subtlety, and economy of means. *See also* Fashion: Japan; Hokusai; Kesa; Mu Chi Gray; Sharaku; Ukiyo-e; Utamaro.

Japanese Wood-block Printing

See Ukiyo-e.

Jasper

See Chalcedony and Jasper.

Jekyll, Gertrude

1843–1932. English artist, embroiderer, gardener, and author, best known for her classic work *Colour Schemes for the Flower Garden* (1908), in which she approaches the landscape like a canvas, plotting in "drifts of color."

Born to a prominent family, she studied at South Kensington School of Art during the period of the Arts and Crafts movement. In the 1860s and 1870s, she painted, traveled, and executed embroidery abroad. In 1889, she met Edwin Lutyens (1869–1944), an architect who in 1896 designed a home for her at Munstead Wood. Thereafter, the two collaborated on hundreds of gardens, and Jekyll became a regular contributor to the periodical *The Gardener*. Her articles are full of descriptive passages in which her trained eye delights in nature's harmonies. In "March Study," she writes: "There is nothing brilliant; it is all restrained—refined; in harmony with the veiled light that reaches the flowers through the great clumps of Hollies and tall half-overhead Chestnuts and neighbouring Beech. The colours are a little 'sad'; as the

old writers so aptly say of the flower-tints of secondary strength." *See also* Garden Colors.

Jet Black

A dark brown or black color derived from fossilized wood, which was easily carved and polished and used in jewelry making. Jet was especially popular in Victorian mourning jewelry. Common imitations include glass, sometimes known as "Paris jet," and vulcanite, a rubber derivative.

Jewelry

See Gemstones and Jewelry.

Jewish Rite Colors

Judaism consists of several denominations, and there is some distinctive color symbolism used in all sects.

The historian Josephus (ca. A.D. 37–100), in *The Antiquity of the Jews*, writes: "The veils . . . declared the four elements; for the plain [white] linen was proper to signify the earth, because the flax grows out of the earth; the purple signified the sea, because the color is dyed by the blood of a sea shellfish; the blue is fit to signify the air; and the scarlet will naturally be an indication of fire."

Among the garments worn by priests described in the biblical Book of Exodus, and used until the time of the destruction of the Temple in Jerusalem in A.D. 70, was a breastplate decorated with twelve stones representing the twelve tribes of Israel. These were arranged in four horizontal rows: In the first row were sardonyx, topaz, and emerald; in the second, carbuncle, jasper, and sapphire; then ligure, amethyst, and agate; and in the last row, chrysolite, onyx, and beryl. Within this system, the four principal colors each embodied a particular quality: Red was a token of love, blue referred to glory, white to purity, and purple to the divine. *See also* Cabala (Kabbalah); Catholic Rite Colors.

Johns, Jasper

1930– . American painter known for his white paintings of archers' targets, American flags, and numbers—images at once recognizable and yet abstract. The era of pop art is often dated from Johns's first one-man show in 1958. His encaustic (wax-based) paint is richly and vibrantly handled, bringing out the interplay between what is illusion and what is reality. *See also* Pop Art.

Judd, Deane B. (Brewster)

1900–1972. American color scientist, best known for his work as a Munsell Research

In the Jewish tradition, red is for love, blue for glory, white for purity, purple for the divine.

Associate at the National Bureau of Standards and for his books *Color in Science and Industry* (1952), co-authored with Gunter Wysezecki, and *Color: Universal Language and Dictionary of Names* (1976), compiled with Kenneth L. Kelly.

A graduate of Ohio State University, where he wrote his master's thesis on *Physical Characteristics of Complementary Pigments*, Judd received his doctorate from Cornell University in 1926. A year earlier, he had published a paper entitled "Computation of Colorimetric Purity" for the Optical Society of America. At the National Bureau of Standards, his work covered color vision, uniform color scales, and prediction of color appearances.

His other significant contributions to color science include papers on whiteness, gloss, textile standards, and color television fidelity. For his lifetime contribution to color, the Inter-Society Color Council established a Deane B. Judd Award in 1975 in his memory.

Juniper Blue

A blue-green, like that of a juniper tree.

Kabuki Colors

See Japanese Colors.

Kandinsky, Wassily

1866–1944. Influential Russian avant-garde painter; one of the principal exponents of expressionism and co-founder, in 1911, with Franz Marc (1880–1916), Alexei von Jawlensky (1864–1941), August Macke (1887–1914), and others, of Der Blaue Reiter (The Blue Rider). This was the only major twentieth-century movement to include a color designation in its name, a clear indication of the expressive potential that these artists felt color forms to possess.

Born in Moscow, Kandinsky studied law, economics, and politics in Russia before moving to Munich, Germany, in 1897. He was influenced by and soon exerted his own considerable influence upon a succession of avant-garde movements, from turn-of-the-century Jugendstil (German Art Nouveau) to expressionism.

From 1911 to 1922, when Kandinsky became a Bauhaus instructor, he explored the realm of abstraction. Works such as *Small Pleasures* (1913) reveal his powers of exuberant polychromatic display, in which color, line, and other formal components are expressive agents in the service of a highly charged and still partly visible apocalyptic imagery. Color itself is seldom subordinate to or bounded by lines, but rather takes on and describes its own shapes and forms.

Color played a strategic role in Kandinsky's complex visionary system of pictorial symbolism and psychological reference. As early as 1911, he developed an elaborate theory of the "Effect of Color" in his *Über das Geistige in der Kunst* (Concerning the spiritual in art). The text distinguishes between the *"purely physical effect"* of color on the beholder and the deeper and more intense *"psychological effect."* The first effect is "superficial" and "limited in duration"; the second, not available to "the average man," is a kind of "spiritual vibration" that Kandinsky conjectures may operate by *"association"* (Kandinsky's italics).

Kandinsky admitted that his associative theory of color response is not necessarily absolute or "universal," but he did make a series of conjectural generalizations concerning the relation of colors to the other senses, particularly sound, taste, and touch. One of his closest friends was the Russian musician Thomas de Hartmann (1885–1956), who composed the "Sound of Yellow."

Whatever the details of the synaesthetic experience, Kandinsky insisted that color directly influences the soul: "Color is the keyboard, the eyes are the hammers, the soul is the piano with many strings. The artist is the hand that plays, touching one or another purposefully, to cause vibrations in the soul." *See also* Blaue Reiter, Der; Mondrian, Piet; Painters, Painting, and Color; Synaesthesia.

Wassily Kandinsky.

Katz, David

1884–1953. Born in Kassel, now in West Germany, Katz was an authority on perceptual color phenomena and gestalt psychology. He became director of a psychological laboratory in Rostock, now in East Germany, but when Adolf Hitler (1889–1945) came to power, Katz moved to England, where he lectured, wrote, and became adviser to various associations. He later occupied a chair of psychology at the University of Stockholm in Sweden.

Katz championed the work of Ewald Hering, a German expert on color perception. He delved into the mysteries of illumination, color constancy, and many of the curious perceptual aspects of color. In his book *The World of Color*, he wrote: "Our interest in color is not the interest of the physicist, nor is it with those aspects of color that puzzle the physiologist. Our concern is with the highly psychological aspects of color." Concerned with visual phenomena related to art and painting, Katz noted several different modes of appearance for color, such as film, surface, and volume, and demonstrated that black was a positive color sensation that followed the rules of simultaneous contrast like any other color, not just a negative experience of absence of light.

In addition, he pioneered the study of color constancy, the process by which human perception recognizes colors in varying

light conditions. *See also* Color Constancy; Hering, Ewald; Modes of Appearance for Color; Simultaneous Contrast; Vision.

Keller, Helen

1880–1968. Blind and deaf from the age of two, she learned to read Braille and speak, becoming a lecturer on blindness and deafness throughout America, Europe, and Asia. She also wrote extensively in books and journals. In her book *The World I Live In,* she gave her views on color:

> I understand how scarlet can differ from crimson because I know that the smell of an orange is not the smell of grapefruit. I can also conceive that colors have shades and guess what shades are. In smell and taste there are varieties not broad enough to be fundamental; so I call them shades. . . . The force of association drives me to say that white is exalted and pure, green is exuberant, red suggests love or shame or strength. Without the color or its equivalent, life to me would be dark, barren, a vast blackness.
>
> Thus through an inner law of completeness my thoughts are not permitted to remain colorless. It strains my mind to separate color and sound from objects. Since my education began I have always had things described to me with their colors and sounds, by one with keen senses and a fine feeling for the significant. Therefore I habitually think of things as colored and resonant. Habit accounts for part. The brain with its five-sensed construction asserts its rightness and accounts for the rest. The unity of the world demands that color be kept in it whether I have cognizance of it or not. Rather than be shut out, I take part in it by discussing it, happy in the happiness of those near me who gaze at the lovely hues of the sunset or the rainbow.

Kelly, Ellsworth

1923– . American painter and sculptor, born in Newburgh, New York and educated at the Boston Music School (1946–48) and Ecole des Beaux Arts, Paris (1948–49). Kelly is best known for his flat colors and juxtapositions of abstract shapes, usually in blown-up scale and high-keyed color intensity.

Kelly Green

A variable, vivid yellowish green. The name *kelly* is from the common Irish proper name, and this bright green color is often associated with the green of Ireland, the "emerald isle."

Kelvin

A unit of temperature, the same as one degree on the Celsius (centigrade) scale, but on a scale whose starting point is at absolute zero ($-273°$C). Thus, 273 K = $0°$C = $32°$F. Color temperature is usually expressed in kelvins. The unit was named after William Thomson, later Lord Kelvin (1824–1907), an English physicist. *See also* Color Temperature.

Kermes

See Crimson Red.

Kesa

Colored silk ceremonial cape, worn by Japanese Zen Buddhist abbots. The color of the *kesa* is largely based on seniority, purple ranking highest, then red, yellow, brown, and green, with black the lowest. One subtemple of the Daitoku-ji monastery in Kyoto has a five-century tradition of wearing only black *kesa* to express the ideal of humility and poverty. *See also* Japanese Colors.

Ketcham, Howard

1903–82. American author and color consultant, born in New York City, who pioneered the application of functional color use for industrial and home products in his work for General Electric, DuPont, Pan American Airways, and Bell Telephone. A graduate of Amherst College, Ketcham served as a lieutenant commander in the U.S. Army and produced films on camouflage principles for the Office of Strategic Services. He wrote extensively and was the author of *How to Use Color and Decorating Designs in the Home* (1949). Beginning in 1946, he wrote a series of twelve articles for *American Fabrics* magazine on how color relates to fashion, cosmetics, lighting, and camouflage. Ketcham initiated the transmission of colors by cable in 1936, and he created a viewing apparatus, which he called "colorcode." *See also* Camouflage; Communication and Color; Functional Color.

Khaki

A tan color or tan-colored cotton fabric used in the military. The term is taken from the Hindi word for "dust." In 1856, during the great Indian Mutiny, a British military officer, Sir Harry Lumsden, noticed that patrol troops whose white uniforms were dusty managed to escape the bullets of Indian snipers. The British soon adopted khaki for their drill uniforms. Outside of India, the first British troops to adopt khaki were a Scots regiment that wore khaki tunics with tartan trousers during the Kaffir Wars in South Africa.

American soldiers wore khaki for the first time in the Spanish-American War of 1898, and by 1915 the color was an American mili-

tary standard. *Chino,* the Filipino word for khaki imported from China, was adopted by U.S. soldiers stationed in the Philippines. Khaki and denim blue are the staple colors of American casual wear. *See also* Camouflage.

Kirlian Photography

A form of electrophotography first reported in the 1950s and named after two Soviet hospital technicians, Semyon Kirlian and his wife, Valentina, who first noticed unexplained spotting in their work and employed photographic materials to explore the phenomenon. The photographic prints appeared to record emanations from the fingertips and other parts of the human body when high-voltage charges were applied to photographic plates. These "flare patterns" could also be recorded from inanimate objects. Colors recorded included blue, yellow, and lavender. *See also* Auras.

Klee, Paul

1879–1940. Painter and theorist born in Munchenbuchsee, Switzerland; noted for the humor (often grotesque), texture, and muted color of his work.

His precocious talents as a violinist and draftsman were evident when he was a child. He settled on art, studying in Munich from 1898 to 1901. From 1902 to 1913, he struggled to achieve an independent voice through exhaustive experimentation in black and white. In etchings, glass paintings, charcoals, and watercolors, he methodically explored the potential of line, tone, and chiaroscuro.

In 1911, Klee joined Wassily Kandinsky in *Der Blaue Reiter* (The Blue Rider movement), becoming interested in the symbolism of color. In 1912, he met Robert and Sonia Delaunay in Paris and recognized in their work an attempt to let color speak for itself without precise reference to objects. To Klee, "abstraction" came to imply "the extraction of pure pictorial relationships . . . light to dark, color to light and dark, color to color, long to short, broad to narrow, sharp to dull, left right" (Klee 1964). Anything was possible with color, so long as a work adhered to the laws of pictorial structure.

In 1914 Klee traveled to Tunis, where, in the Moroccan light, he developed his newfound ability to make color autonomous. He describes the experience: "I now abandon work. It penetrates so deeply and so gently into me, I feel it and it gives me confidence. Color possesses me. It will always possess me. That is the meaning of this happy hour:

Color and I are one. I am a painter" (Klee, ed., 1964).

An important aspect of Klee's work is the unusual combination of media and new techniques. Drawings in ink or oil would be enriched with watercolors, causing random spots and smudges, with unusual results. His principal interest after 1923 was in the planar arrangements of colored squares, allowing him to swell and warp the pictorial surface by the use of color alone. The pitch of colors functioned, he thought, like major or minor keys in music, enabling him "to be able to improvise freely on the chromatic keyboard." His colors were rarely bright, depending instead on subtle color gradations and muted tonalities.

From 1920 to 1926, Klee taught at the Bauhaus in Weimar, Germany, and later at the Düsseldorf Academy. He returned to Bern, Switzerland in 1933 after his expulsion by the Nazis, who exhibited seventeen of his works in the Exhibition of Degenerate Art in 1937. *See also* Blaue Reiter, Der; Delaunay, Robert and Sonia; Kandinsky, Wassily; Language and Color; Synaesthesia.

Kodachrome,® Kodacolor®

Originally, Kodachrome was the two-color photographic printing process involving separate plates, but the name has become identified with tripack (three-layer emulsion) transparency film, first introduced by the Kodak Company in 1935. The color negative film version (for producing color prints), introduced in 1942, is known as Kodacolor. Both films far surpassed all previous processes in accuracy of color reproduction and convenience.

The Kodachrome emulsion is constructed, from top to bottom, of blue-, green-, and red-sensitive layers of silver halides. A temporary yellow filter just below the blue-sensitive layer prevents blue light from affecting the halides below; this dissolves during processing. The unique feature of the Kodachrome emulsion is that it contains no dye-forming color couplers. Kodacolor was the first color negative film that solved the problem of color couplers migrating from one layer to another. The use of couplers had been patented in 1912, but the wandering of coupler molecules when the emulsion was wet with developer led to the graying of the image or creation of spurious colors.

Processing is complex, involving many steps and critical control of time and temperature. A single developer produces the negative silver image in all three layers simultaneously; the couplers are activated, the silver image is bleached, and the emul-

Paul Klee.

sion is fixed, a relatively simple process. One major improvement to the process was the coloring of the cyan and magenta couplers so that those not activated to form dyes remained as a mask (printing filter) that corrected the deficiencies of dye absorption and transmission in these layers. This integral color masking is what produces the overall orange-brown or pinkish tan coloring seen in all processed color negative film. Originally introduced as a 16mm amateur movie film, Kodacolor is now also produced as a 35mm still film. The contrast, grain, and other image qualities are basically still of the highest grade. *See also* Autochrome; Color Couplers; Photography.

Kohl

A mixture of soot and antimony that has been used by men and women in the Near East to darken the edges of their eyelids since the third millennium B.C. Today it is still used in relatively isolated Bedouin societies, where more modern makeup is unavailable.

K'o Ssu

Ancient Chinese tapestry in which thin silk yarns are interwoven with gold threads, creating special color effects.

Lacquer Colors

Lacquer colors come from oleoresins obtained from the sap of trees, in particular *Rhus vernicifera*, a sumac of Southeast Asia. Lacquering was one of the earliest industrial arts of the Orient, dating back to the fourth century B.C. Lacquer ware achieves its depth largely because the lacquer is applied in thin coats—as many as fifteen—each dried and sanded lightly before the next is applied. Lacquer red is an extraordinarily deep color, especially popular in ornamental furniture and ware from the Orient. *See also* Chinese Color Symbolism; Cinnabar; Shellac.

Lakes

Organic dyes combined with a mordant (an inorganic carrier) that has no color response of its own. Lakes are very bright in color, but, being organic, the dyes are not colorfast. An example of a popular medieval lake is Brazilwood, which was combined with alum and used as a source for a bright red in both textile dyeing and as a color source for paints. An example of a modern lake is the range of blues available since 1936 with the extraction of copper phthalocyanine from coal tar. *See also* Dyes and Dyeing.

Lambert, Johann Heinrich

1728–77. Swiss color theorist and originator of an important system of organizing colors. He taught art in Göttingen, now in West Germany, and in Paris and wrote several books, including *On Perspective* (1759), *Photometry* (1760), and *A Description of a Color Pyramid* (1772). Lambert was a contemporary of Tobias Meyer (1728–62), a German mathematician, astronomer, and color theorist whose own color system was a solid composed of equal-sized triangles stacked in graded mixtures from white to black. Lambert's solid has the three primaries in a triangle, with black at the center, but also stacks smaller and smaller triangles, each whiter than the last, with pure white at the apex. *See also* Systems of Color.

Lampblack

See Artists' Pigments.

Land, Edwin Herbert

1909–85. American inventor, best known for his work in instant photography and as the founder of the Polaroid Corporation.

Born in Bridgeport, Connecticut, Land invented a sheet polarizer while studying at Harvard University. His development of a clear plastic sheet that polarized light resulted in a reduction in glare and specular reflections, and greatly improved sunglasses and optical equipment. He gave his inexpensive plastic polarizer the name Polaroid. Land's most famous invention, however, was the Polaroid Land Camera (1947), which offered instant color prints and is recognized as a revolution in photography.

Land introduced a new theory of color perception that disputed classical ideas. He suggested that somewhere in the retina and cortex of the human brain, color information for color perception was produced by a comparison of light from color receptors in the retina. He further postulated the retinex theory: that the determining factor in color perception is the ratio of light values, not the combinations of blue, green, or red light entering the eye. *See also* Perception; Photography; Two-Color Reproduction.

Landscape

See Garden Colors; Fashion: Geography of Color.

Language and Color

The human eye can discern some 350,000 colors of varying hue, saturation, and lightness. Even color-sophisticated languages, however, fall short in describing particular perceived color differences. In English, for example, there are a few basic color terms, such as red, yellow, blue, green, white, and black. These may be qualified in a few basic ways—light blue, dark green, and greenish blue, for example. Such qualifiers are generic and rarely tied to specific colors. Interestingly, the Chinese do not use the terms *light* and *dark* when describing colors, choosing instead the descriptive words *shallow* and *deep*. Other terms for color may be tied to materials or objects that are immediately associated with specific color—such as golden

"The story, the adventure of a novel, is nothing to me. I have in mind, when writing a novel, to bring forth a coloring, a tinge. For instance, in my Carthagene novel, I wanted to do something purple. In **Madame Bovary** *my only thought was of conveying a tone, that color of the mildewed existence of cockroaches."*
—*Gustave Flaubert*

yellow or lemon yellow. Other terms are more tenuously connected: Magenta, for example, comes from the name for a dye discovered in 1856, the year the French defeated the Austrians at the Battle of Magenta.

Today, the word *color* is usually synonymous with *hue*. The oldest color terms, however, seem not to be concerned with hue so much as with quality and total surface appearance. Black and white might be more accurately called *dark* and *light* in translation from primitive languages. Even blue might simply be "dark." When Homer wrote of the wine-dark sea *(oinopa ponton)* in *The Iliad*, scholars attributed it to Homer's fabled blindness, or to a misconception that the Greeks had failed to recognize blue as a separate hue. In fact, they had a word for blue *(kyanos)*, but since it was so omnipresent in the sea and sky and was such a difficult color for man to reproduce, it probably receded in their consciousness before terms that were, for them, more evocative. It is a feature of most evolving languages that blue is the last major color to be named.

As with blue, there can be difficulty naming green, which is occasionally confused with yellow or even white ("light"). Sanskrit, a relatively developed language rich in color words, had only one term for green, *harita*, which sometimes also referred to yellow. Latin, which called green *viridis*, had another word, *pallidus*, but this referred to tints of both green and yellow; *pallidus* evolved into *pallido* in Italian and *pallid* (or *pale*) in English, suggesting absence of color altogether.

As language records some of the basic preoccupations of societies, so color names can give insight into a people's life. No one knows exactly how color terms develop, but environment, culture, and economic growth play a large part. Desert dwellers have a wide range of words for yellows and browns, while the Eskimos have a large vocabulary to describe the various whites of different snow and ice conditions. Maoris have more than a hundred terms to cover the color red. Like many other primitive tribes, they also use color words for the ages and stages of plant growth, which we would describe in terms of time or size, and have some forty color words to distinguish cloud formations.

As languages developed and as color was used in art and decoration, the specific correlation between color names and natural events declined. Names were borrowed from almost any source, especially for colors at the blue-violet end of the spectrum, which rarely occur in nature. Still, many of these, too, are "look-like" words, such as amethyst, peacock blue, and violet; azure comes from the Persian *lazhward* (lapis lazuli) after a blue stone; ultramarine is literally the color imported from "over the sea" by the Venetians; mauve is from *Malva*, a genus of plant known as the mallow; and purple comes from the Greek *porphyra*, the mollusk from which Tyrian purple is made.

Some languages have thousands of color words, making it difficult to decide which are universal basic color terms. Two American anthropologists, Brent Berlin and Paul Kay, have studied ninety-eight different languages and, by showing native speakers a Munsell chart, established that there are no more than eleven basic color terms. Even more surprisingly, they discovered that when a culture has fewer than eleven such names, it can be predicted almost exactly which colors the names describe. They isolated the following constants:

> "If we are asked: "What is the meaning of the words 'red,' 'blue,' 'black,' 'white'?", we can, of course, immediately point to objects of such-and-such a color, but our capacity to explain a meaning of those words does not go far."
>
> "Can't we imagine that some men could have concepts of colors different from ours?"
>
> "There is no criterion by which to recognize what is a color, except that it is one of **our** colors."
> —Ludwig Wittgenstein

Colors in Many Languages

English	Latin	Chinese	French	German	Italian	Japanese	Spanish
Red	Ruber	Hong	Rouge	Rot	Rosso	Akai	Rojo
Orange	Arausio	Juzi	Orange	Orange	D'Arancia	Mikan	Naranjo
Yellow	Flavus	Huang	Jaune	Gelb	Giallo	Ki-iro	Amarillo
Green	Viridis	Lu se	Vert	Grun	Verde	Midori	Verde
Blue	Caeruleus	Ian	Bleu	Blau	Azzurro	Aoi	Azul
Indigo	—	—	Indigo	Indigo	Indaco	Ai	Anil
Violet	Viola	—	Violet	Violett	Violetta	Sumire	Violado
Brown	Fuscus	Hu se	Brun	Braun	Bruno	Kuri-iro	Moreno
Purple	—	—	Mauve	Purpur	Porpora	Murasaki	Purpura
White	Albus	Bai	Blanc	Weiss	Bianco	Shiroi	Blanco
Gray	Canua	Hui se	Gris	Grau	Grigio	Nedzumi-iro	Gris
Black	Niger	Hei	Noir	Schwarz	Negro	Kuroi	Negro
Color	Colorare	Yan se	Couleur	Farbe	Colore	Iro	Color

Compiled by Gerhard Lang

> "Colors speak all languages."
> —Joseph Addison

1. No language has only one color term; it always has at least two. Where there are only two, they are always black and white (dark and light).
2. If there are three terms, the third is always red.
3. If there are four terms, green *or* yellow is added.
4. If there are five terms, green *and* yellow are added.
5. If there are six terms, blue is added.
6. If there are seven, brown is added.
7. If there are eight or more terms, purple, pink, orange, and gray are always added, in any order or combination.

Therefore, the first stage in the evolution of a color language is to identify light and dark, before gradually coming to distinguish a third color, red. The rest follow in the sequence constructed by Berlin and Kay. There are some surprising exceptions to this rule: The Chinese, Japanese, Melanesians, Welsh, and Tamil have no word for brown at all, while the Siamese and Lapps call it "black-red"; in Japanese, the word for blue appears to be older than that for green, possibly reversing the usual evolutionary order. Despite some exceptions, the Berlin-Kay thesis remains substantially undisputed.

Language is hindered by the limited number of specific color names, making it very difficult to convey verbal descriptions of colored objects. The problem is that most people are unable to remember very specific colors for more than about ten seconds. We make do with "look-like" words when describing a color—"a dusty red like faded Etruscan pottery," for instance. For this reason, the Color Association of the United States, which names some 300 colors a year, selects names that are evocative of a place or a mood.

Various attempts have been made to couple names and/or numbers to collections of colors carefully analyzed by wavelength. While these take no account of the richness of perceptual and associative impressions made by color, they serve to specify colors for printers and dyers. None has emerged as dominant, but the most popular in the United States are the Munsell system and the PANTONE®* Professional Color System, each with approximately 1,000 colors. *See also* Colloquial Language, Color in; Symbolism and Color; Systems of Color; Trends in Color.

* Pantone, Inc.'s check-standard trademark for color reproduction and color reproduction materials.

The following are some of the linguistic origins of current English words related to colors:

Color: An entymon or root derived from the Latin *colorare.*
Hue: From the Old English *hiw,* itself derived from the Gothic *hiwi* (form, appearance), the Swedish *hy* (skin or complexion), and the Sanskrit *chawi* (hide, skin, or color, and beauty in general).
Tint: From Old English *tinct* (color) or the Italian *tinta.*
Tone: Derived directly from musical terminology; describes grayed color.
Shade: From *shadow,* describing the somber or blackish quality of colors. Now shade is often confused with tint.
Value: From the Latin *valere* (to be strong, to have worth), it simply describes the strength, worth, or substance of a hue.
Red: The one color with no ambivalent sources; from the Sanskrit *rudhira* and the Anglo-Saxon *read,* both meaning "red."
Yellow: From the Latin *helvus* (light bay) and perhaps the Sanskrit *hari* (a tawny or yellowish color).
Green: From the Anglo-Saxon *grene,* itself probably derived from the old Teutonic root *gro* for "growth" and thus green things.
Blue: From the French *bleu* or the Germanic *blau,* both cognate with the Latin *flavus,* which actually meant "yellow" or "gold." Possibly derived from a Gothic word meaning "to beat," as in the color of a bruise.
Purple: From the Latin *purpura,* the mollusk source of Tyrian purple dye.
White: From the Anglo-Saxon *hivit.*
Black: From the Greek for "burnt" or "scorched"; replaces the Germanic *swart* (now "swarthy").
Brown: From the Anglo-Saxon *brun* and the Sanskrit *bhru;* written *abron* or *abrune* and describing the color of a leather apron, it was confused with auburn (originally meaning white) in the seventeenth century.
Buff: From the French *buffle,* buffalo.
Beige: From the French meaning "raw."
Ecru: From the Latin for "crude" or "raw."
Russet: An Old French diminutive of *rous,* meaning "red."
Crimson: From the Sanskrit *krmija,* after a worm from which a red dye was extracted.
Vermilion: From the Latin word for the same worm, *vermiculus.*
Maroon: From the French word for "chestnut," *marron.*
Taupe: French for "mole."

Vowels

*A black, E white, I red, U green, O blue: vowels,
One day I will tell your latent birth:
A, black hairy corset of shining flies
Which buzz around cruel stench,*

*Gulfs of darkness; E, whiteness of vapors and tents,
Lances of proud glaciers, white kings, quivering of flowers;
I, purples, spit blood, laughter of beautiful lips
In anger or penitent drunkenness;*

*U, cycles, diving vibrations of green seas,
Peace of pastures scattered with animals, peace of the wrinkles
Which alchemy prints on heavy studious brows;*

*O, supreme Clarion full of strange stridor,
Silences crossed by worlds and angels:
—O, the Omega, violet beams from His Eyes!*

—Arthur Rimbaud

"Colorless green dreams sleep furiously."
—Noam Chomsky

Lapis Lazuli

A bright blue derived from lazurite, a blue silicate mineral. Named after the Persian *lazhward*, meaning blue, lapis lazuli is found in Badakhshan, Afghanistan, and elsewhere. It may be combined with calcite and brass-colored iron pyrite, which are abundant in poor-quality lapis lazuli.

As a semi-precious gemstone, lapis lazuli is used for beads and cabochons; it is also carved or used for inlays and mosaics. In medieval Europe, it was crushed to produce the original ultramarine pigment that was used in many sacred paintings and manuscript illustrations. Since 1828, however, ultramarine has been made artificially. *See also* Gemstones and Jewelry.

Laser

A device that can produce either brief, intense bursts of light or a continuous emission of light in collimated (parallel) beams. The light is monochromatic and coherent: Its waves are "in step," unlike those of ordinary light.

The name *laser* is an acronym for Light Amplification by Stimulated Emission of Radiation. It is based on the principle that light can be made to amplify itself to such an extent that a beam can drill a hole through a diamond. The first laser was created in 1960 by Theodore Maiman at Hughes Research Laboratory in Malibu, California. The apparatus consisted of a rod of synthetic ruby (later replaced by a hollow tube filled with gas), which provided an even beam. The internal ends of the rod are reflective, one only partially, like a two-way mirror. The atoms in the medium, gas or solid, are stimulated by an outside source—such as a burst of light from a flash tube—and they bounce backward and forward between the reflecting ends until they fall into a regular or coherent wavelength of great intensity. They are then able to escape from the partially mirrored end.

The color of a laser beam depends on the kind of gas used in the tube. The most familiar is the red light from helium-neon gas. More expensive gases, such as krypton, can produce red, green, blue, or yellow; argon is used for green, though it can be modified to produce a bluish green. Orange lasers have not yet been produced. A second laser chamber filled with dye can be used to modify colors slightly, and it may in time be able to incorporate the three primary colors necessary to create all the colors of the continuous spectrum.

Because laser light can travel a great distance without spreading out, it has become popular for outdoor displays. It is also used in microsurgery, weaponry, and holography. *See also* Hologram; Laser Printing, Color in; Medorachrome Holography.

essay

Laser Printing, Color in

While computers are marching ahead in the field of manipulating color images, the technology for printing on paper lags behind. An expert in such new technologies, Mary Ann Dvonch of Xerox Corporation, looks at the future of color laser printing, which is destined to dominate color reproduction.

With the growing popularity of desktop publishing, the need for color to support presentation graphics and in-house publishing is widely recognized. In particular, the emergence of personal computer systems that allow even casual users to turn out professional-looking documents emphasizes the need for high-quality, low-cost color printers. This is where laser printers are becoming all-important.

Existing color printers are roughly divided into impact and non-impact devices; the impact technology dominates the market of the late 1980s with about 70 percent of all sales. Impact printers press the paper and the ink together, causing a mechanical transfer of the ink to the paper. Pen plotter technologies (which grew out of engineering applications) are the most mature of the impact printers. For pen plotters, an ink-filled pen is mounted in an electromechanical arm that is moved across the paper according to X and Y coordinates defined by the image. However, while they meet the cost and resolution constraints of desktop publishing, they are relatively slow and are limited to a narrow range of pale pen colors. Dot matrix printers are an alternative, but they are noisy, lack bright colors, and also have a limited color range.

Of the non-impact printers, the thermal transfer and ink jet types are of high quality and good reliability, but they have limited resolution (400 dots per square inch) for color graphics. In thermal transfer printing, an ink-carrying sheet is combined with a sheet of plain paper and then passed under an array of heating elements. Ink jet printing requires the generation and control of a stream of ink droplets, which define the image when deposited on the page. The most popular and most advanced non-impact technology for printing in black and white is the laser printer. It provides optimized character processing and a high-resolution output; and it has the ability to mix

text and graphics easily. In three-color laser printing, a full-color image is produced by generating images in each of the subtractive primaries (cyan, magenta, and yellow) and sequentially transferring them to the paper. In a four-color system, a black image is added to the sequence (as it is in regular printing processes). Once the separations are positioned, the paper moves through the developer housing to the fusing station, where the image is fixed on the page.

Certain problems in color laser printing remain unresolved. Since the mechanical system for a color laser printer requires a multi-pass process that allows each primary to be printed in turn, a more sophisticated paper-handling system is required than for a monotone printer. The paper-handler in a color system moves the output media past three or four print heads, instead of the single print head in a monotone printer. Development of dry colored toner (a powder version of ink) is the major problem in the materials area. Since the toner must conform to specific electrostatic properties and must work properly in the developer housing, the range of usable materials is limited. Increased image complexity also calls for high-memory storage devices, and imperfections in the physical nature of the printing process require software for color correction of the image. The proliferation of standards among manufacturers—for page description languages, color encoding, and interconnectivity—is another problem that must be addressed.

Color laser printers are undergoing rapid development and such problems will undoubtedly be solved. Already, at least one printer has appeared with a color laser copier, a five-page-per-minute, four-color device, consisting of a color scanner, color-imaging hardware, and an electronic system that includes image-editing capability.
—Mary Ann Dvonch

Latex Emulsion

Water-bound plastic paints, prepared by dispersing tiny drops of water with the solid pigment and monomer by high-speed agitation. Polymerization occurs as the water evaporates, forming a tough, flexible, and substantially water-resistant film. *See also* Acrylic.

Le Blon, Jacques Christophe

1667–1741. French inventor of full-color printing, Le Blon studied art in Amsterdam, Zurich, Rome, and Paris. Around 1704, while working in Amsterdam on miniatures, he experimented with printing in red, yellow, and blue to reproduce his pictures. Failing to acquire a Dutch patent for his process, the first multi-colored mezzotint, he moved to Paris and eventually to England, where in 1719 he was able to obtain a patent.

The following year in London, Le Blon opened his Picture Office, where he was to use his labor-intensive process to produce some 10,000 prints of works of art before the scheme ultimately failed. In 1727, he attempted to adapt his process to textiles without much success. His work remains the basis of the contemporary four-color printing process that uses magenta (instead of red), cyan (blue), yellow, and black. *Coloritto*, Le Blon's treatise on the three-color process, was published in English and French around 1723. *See also Coloritto;* Printmaking; Systems of Color.

Leonardo da Vinci

1452–1519. Master Renaissance painter. In his famous *Treatise on Painting*, Leonardo recognized objective and subjective factors in relation to color and recorded the following statement:

The first of all simple colors is white, though philosophers will not acknowledge either white or black to be colors; because the first is the cause, or receiver of colors, and the other totally deprived of them. But as painters cannot do without either, we shall place them among the others; and according to this order of things, white will be the first, yellow the second, green the third, blue the fourth, red the fifth, and black the sixth. We shall set down white for the representative of light, without which no color can be seen; yellow for the earth; green for water; blue for air; red for fire; and black for total darkness.

Psychologists would later come to recognize Leonardo's simple colors—red, yellow, green, and blue—as primary in sensation, thus confirming and paying tribute to the painter's insight.

Leonardo was a master of the chiaroscuro style (*see* Chiaroscuro), in which the illusion of three-dimensional form can be created on the surface of a picture by the accurate rendition of highlights and shadows. Long before most other artists, Leonardo saw colors in these shadows: "To any white body receiving the light from the sun, or the air, the shadows will be of a bluish cast." With respect to a white wall standing in the sun:

The shadows of bodies produced by the redness of the setting sun, will always be bluish. . . . The superfices of any opaque body participate of the color of the object from which it receives the light; therefore the white wall,

Original cover (ca. 1723) of J. C. Le Blon's seminal book, Coloritto. Its mezzotint portraits of a young girl were the first ever full-color reproductions using only the three primaries, red, yellow, and blue.

being deprived entirely of color, is tinged by the color of those bodies from which it received the light, which in this case are the sun and sky. But because the sun is red towards the evening, and the sky is blue, the shadow on the wall, not being enlightened by the sky, receives only the reflection of the sky, and therefore will appear blue; and the rest of the wall, receiving light immediately from the sun will participate of its red color.

The phenomenon of colored shadows would one day engage the attention of Johann Wolfgang von Goethe and Hermann von Helmholtz, before being seriously taken up by the impressionists.

In many of his theories, Leonardo touched on, even if he did not fully explain, many visual effects that were to preoccupy later generations of artists and scientists. On the phenomenon of brightness contrast, he wrote, some three centuries before M. E. Chevreul devoted a book to the study of simultaneous contrast (see Chevreul, M. E.): "Of different bodies equal in whiteness and in distance from the eye, that which is surrounded by the greatest darkness will appear the whitest; and on the contrary, that shade will appear the darkest which has the brightest white around it."

Leonardo also wrote about the associations that can be conjured up by colors and forms applied at random to a surface, anticipating in a surprising way Hermann Rorschach's inkblots (see Rorschach Test) and the art of Jackson Pollock (see Pollock, Jackson) as well as the whole abstract movement (see Abstraction of Color):

By throwing a sponge impregnated with various colors against a wall, it leaves some spots upon it, which may appear like a landscape. It is true also, that a variety of compositions may be seen in such spots, according to the disposition of mind with which they are considered; such as heads of men, various animals, battles, rocky scenes, seas, clouds, woods, and the like.

Libraries of Color

See Appendix.

Lichtenstein, Roy

1923– . Along with Andy Warhol, Claes Oldenburg (1929–), James Rosenquist (1933–), and others, Roy Lichtenstein was one of the principal figures in the American pop art movement of the 1960s. Pop art was in part a reaction against the high seriousness of abstract expressionism, which had become ascendant in the 1950s New York art scene.

Like Warhol, Lichtenstein worked for several years as a commercial artist before his first one-man exhibition, in 1962 at the Leo Castelli Gallery in New York. A year earlier, he had made a radical breakthrough by using Benday dots to render skin, sky, and other tones as in enlarged photoengraving reproductions. He described his technique to critic John Coplans:

I project the [preliminary] drawing onto the canvas and pencil it in and then I play around with it until it satisfies me. For technical reasons I stencil in the dots first. . . . Then I start with the lightest color and work my way down to the black line. . . . I work in Magna color because it's soluble in turpentine . . . so that there is no record of the changes I have made. Then using paint which is the same in color as the canvas, I repaint areas to remove any stain marks from the erasures. I want my painting to look as if it had been programmed. I want to hide the record of my hand.

Lichtenstein used this technique to render images from advertising, pulp romances, and comic books; adaptations of works by other artists (including Piet Mondrian); invented "generic" works of "modern art"; classical ruins; land-, sea-, sky-, and moonscapes; and paintings of brushstrokes and explosions. The color effects from most of these works are of a matte, anonymous, commercial finish, with colors sometimes spilling from their boundaries (as they do in printing), and never revealing hand-worked nuances of touch. Lichtenstein makes his point most ironically in his series of brushstroke paintings, which are rendered in the same mechanical way but on a greatly enlarged scale. *See also* Pop Art.

Liebes, Dorothy Wright

1899–1972. American weaver and colorist; born in Santa Rosa, California, she studied at San José Teachers College in California and received a bachelor's degree from the University of California and a master's degree from Teachers College of Columbia University. Later she learned to weave during a summer at Chicago's Hull House, and by 1934 she had founded her own design studio, which became famous for its fabrics of bright color in unorthodox combinations. Liebes was largely responsible for bringing the vivid colors of India to the U.S. textile industry.

In an interview for *American Fabrics* in 1952, she gave her views on color:

Color is a universal language. . . . Love of color is natural and spontaneous with no

barrier of age, wealth or education. We are born with this love, but not always with color taste. . . . Color appeal is emotional rather than solely intellectual. You have to see and experience color rather than discuss it. . . . There is no such thing as a bad color—only bad color combinations.

Color is monumental, it's a magic elixir, it's part of our personality. You can't measure color the way you can temperature, but it's very real. . . . Color is like seasoning. At first you may be timid about it, but as you get used to it you can take more and more of it. . . . It is not a designer's privilege, but a handicap, to have a favorite color. . . . Good color costs no more than bad.

Light

That part of electromagnetic radiation to which the human eye is sensitive. The wavelengths of visible light range from about 400 nanometers (0.4 millionths of a meter) to about 750nm. The invisible wavelengths of infrared and ultraviolet are sometimes also called light, though they can be recorded only by special instruments or photographic plates. If visible white light is separated into a spectrum, each wavelength is seen to correspond to a different color: in order, from longest to shortest, red, orange, yellow, green, turquoise, blue, and violet.

Light is easily absorbed by matter, but its behavior includes reflection by a mirror or other object, refraction by a lens or prism, scattering by small particles, and diffraction as it passes through an opaque object. The extent of these effects often depends on the wavelength of the light: For example, the minute particles of the atmosphere scatter the shorter ultraviolet and blue wavelengths of light, giving the sky its distinctive color, but allow through the longer yellow, red, and infrared wavelengths.

In 1690, Dutch physicist Christian Huygens (1629–95) proposed a theory that explained light as a wave phenomenon, only to be contradicted in 1704 by Sir Isaac Newton, who held that light is composed of tiny particles, or corpuscles, emitted by luminous bodies. The corpuscular theory held sway until experiments done in 1801 by Thomas Young and in 1814–15 by French physicist Augustin-Jean Fresnel on diffraction and interference, which could be explained only by wave theory. The electromagnetic theory of James Clerk Maxwell, presented in 1864, supported the view that visible light is a form of electromagnetic radiation. In 1905, Albert Einstein (1879–1955), in order to explain the photoelectric effect (the emission of electrons by substances, especially metals, when light hits their surface), suggested that light, as well as other forms of electromagnetic radiation, travels as tiny bundles of energy, called light quanta or photons, that behave in a manner similar to particles.

Light thus behaves as both a wave, as in diffraction and interference phenomena, and a stream of particles, as in the photoelectric effect. Einstein's theory of relativity predicts that the speed of light in a vacuum (186,282 miles per second) is the limiting velocity for material particles.

Natural Light

Daylight is the most evenly balanced source of white light available, in that sunlight has roughly an equal proportion of each color of the spectrum, from infrared and red through yellow, green, blue, violet, and ultraviolet. This light, however, never has a constant color, and its beauty comes from the way it is reflected and refracted by the earth's atmosphere, causing it to change throughout the day from the red of dawn to bluish tones of midday, or a deep green just before a thunderstorm. The color of natural light also varies according to geographical location. Temperate countries toward the far north and south appear to have a soft, cool (i.e., bluish) light. The sun is relatively low and the atmosphere fairly humid, resulting in diffuse light and gentle colorations. In the tropics, the sun is directly overhead and the air is often clearer, making colors appear stronger.

In general, natural lighting conditions can be classified into four groups: direct, north-sky, overcast, and moonlight. The color cast of daylight can also be classified according to its color temperature: At sunrise and sunset, light is about 2,000 K; one hour after sunrise or before sunset, the light is 3,500 K; in the early morning or late afternoon, it is around 4,300 K; and at midday, the light can be around 5,400 K. Overcast light is bluer (between 6,000 and 7,500 K), and light from just a blue sky but not direct sun is so blue that its color temperature can be up to 25,000 K (see Color Temperature).

Color Temperatures of Natural and Artificial Sources

In the Northern Hemisphere, most artists prefer studios with windows facing the north. While they receive no bright or direct light to work by, the light they do get is of roughly even intensity and color throughout the day. This light is reflected off dust particles in the atmosphere. The particles are so small that they best diffuse the shortest (blue) wavelengths, making north-sky light slightly cool and bluish.

"Let's go and get drunk on light again—it has the power to console."
—Georges Seurat

By contrast, direct sunlight has a yellowish tinge, which at sunset deepens to a red; the greater amount of atmosphere that the light has to pass through when the sun is low causes all but the red wavelengths to be scattered. Dawn is sunset in reverse, but there are fewer particles in the moist atmosphere of early morning, and the colors tend to be less fiery.

Overcast light—which passes through a cloud—is reflected and refracted many times over from the surfaces of individual water drops (as in a rainbow). In the cloud, its dispersed wavelengths mix additively to form white light. The resulting light of a cloudy day is soft and diffuse, making colors appear grayed. When the atmosphere is heavily laden with water just before a storm, the light is very low in intensity, but it has a pronounced shift toward blue-green. This is the same color seen in shallow waters. Water absorbs red light weakly, so white objects appear bluish green under water.

Moonlight is another example of reflected sunlight. Its spectrum is even, although the light is weak. Like the sun, a rising or setting moon will appear yellow-red to deep red. When low, the moon's light is yellowish, as the shorter wavelengths are scattered. When high, and seen against the backdrop of the dark sky, the moon has a grayish tinge—a result of simultaneous contrast—but the moon's light appears silvery due to its relative intensity. *See also* Diffraction; Lighting, Artificial; Maxwell, James Clerk; Newton, Isaac; Reflection; Refraction; Scattering of Light; Simultaneous Contrast; Young, Thomas.

"Flesh only shows its true color in the open air, and above all in the sun. When a man puts his head out of the window he is quite different to what he was inside. Hence the folly of studio studies, which do their best to falsify color."
—*Eugène Delacroix*

Lightfastness

See Colorfastness and Dyeing; Fading.

Lighting, Artificial

The three principal means of producing artificial light are combustion, incandescence, and fluorescence. Each has distinct color characteristics and, like natural light at different hours of the day, each affects color appearance.

Combustion

The act of burning; a flame is a gas in a chemical combustion, in which the gas combines with the oxygen in the air. As it does so, energy is released, which is sensed as heat and light. Examples of light produced by combustion are fires, oil-burning lamps, candles, and gaslight. The heat of combustion is relatively low, around 1,200 K, so the light is warm and yellow-red. The color can be changed by introducing a chemical element into the flame. Sodium, as in common salt (sodium chloride), for instance, gives a flame a brilliant yellow color; lithium and strontium produce red; calcium compounds, orange; compounds of tellurium or copper, greens; and copper chloride, blue. Combustion-type lamps are inefficient, since a high proportion of energy is given off as heat.

Incandescence

A material heated to a point at which it will give off light is said to be incandescent. Most materials will be quickly burned up, but some, particularly metals, can be heated to incandescence without burning up, by forcing a powerful electric current through them. The most familiar incandescent light is the tungsten filament lamp. Sealed inside a glass globe, a fine-coil filament of tungsten thread is connected to electrodes. When current is applied, it heats rapidly from red to white heat without actually reaching its melting point. Argon and nitrogen, instead of oxygen, inside the bulb prevent the filament from burning away for about 1,000 hours. The temperature is hotter than candlelight, so the color is whiter, but it is still deficient in blue light. Colors of incandescent lamps are altered principally by the use of filters or by painting the surface of the bulbs. An increase in wattage—the power of a bulb—does not significantly affect the color of light emitted.

An incandescent filament lamp with a platinum burner was demonstrated as early as 1820, although it was not until 1879 that a commercially viable lamp was introduced, by Thomas A. Edison (1847–1931). In 1885, Edison collaborated with Louis Comfort Tiffany in the installation of electric lighting at the Lyceum Theater in New York City, and the harsh green glare of gas-burning footlights was soon superannuated.

A highly incandescent alternative light source is the carbon filament lamp which has neither filament nor globe. An electric current uses air molecules as a bridge between two carbon electrodes, which are strongly heated to incandescing temperatures and slowly burned away by the oxygen in the air. The carbon arc lamp is best used when a highly intense light source is required, such as in searchlights and film projectors. Non-incandescent arc lights, known as discharge lamps, are more efficient. The electrodes are sealed in a glass tube in the presence of a gas or metallic vapor. The flow of electrons across the arc excites the element present to emit light. Under high pressures, elements can emit abnormally wide spectra of wave-

lengths. The most familiar discharge lamps are the yellow low-pressure sodium vapor lamp and the bluish white high-pressure mercury vapor lamp used in streetlights in America since 1933. Other low-pressure lamps include cadmium and zinc vapor (red light), neon (orange-red), argon (blue-green), and carbon dioxide (near-white). Among high-pressure lamps is the xenon lamp, emitting light similar in spectral composition to daylight. These lights can be combined with filters to produce other colors of the spectrum. The first commercial discharge lamp, a mercury vapor lamp invented by the American Peter Cooper Hewitt in 1903, appeared the following year, and the neon lamp was invented by French physicist Georges Claude in 1911.

Light emission by a material involving very little heat perceptible to the senses is known as luminescence. Almost all materials capable of luminescence consist of a "host" crystal activated by an impurity. In electro-luminescence, solid crystals are stimulated by an electrical current to give off light. The intensity of the light emitted is generally low, and its color quality depends on the crystals used. Mainly used for the display lights of digital clocks, watches, and pocket calculators, it is becoming favored for the thin screens of computer monitors, and could conceivably be used for a thin color television.

Fluorescence

An ingenious solution to the limitation of mercury vapor lamps, which emit mainly blue, violet, and ultraviolet light, is to combine them with the use of luminescing powders, or phosphores. Coated on the inside of the mercury vapor lamp (usually a tube), the phosphores absorb the ultraviolet radiation and re-emit it at a longer wavelength.

The coated fluorescent mercury lamp, developed by the General Electric Company and introduced in 1938, is highly efficient in operation; a 40-watt fluorescent lamp gives as much illumination as a 150-watt tungsten lamp. It has a typical working life of at least 5,000 hours. Ideally suited to area lighting, the light is diffuse and cannot be focused with lenses to form spotlights. With colors that are predominantly cold, it is more popular in offices and public buildings than in homes.

In the common fluorescent lamp, the blend of luminescent crystals is selected to give white light, the standard commercial grades being warm white, cool white, and daylight. For special purposes, such as theater or decorative lighting, fluorescent lamps can be obtained with coatings emitting red, green, blue, or violet light.

Light is of primary importance to plant growth, being used in the process known as photosynthesis—the manufacture of carbohydrates from carbon dioxide and water in the presence of light, through the energy-storing ability of the green pigment chlorophyll. Artificial lighting is useful for certain areas of agriculture; for instance, by controlling the rhythmic occurrences of light and dark, one can grow onions from seed to seed without the formation of bulbs.

The visible part of the spectrum is most effective for artificial lighting of plants. Carbon arcs, incandescent, sodium, mercury, and fluorescent lamps, and many combinations of these, are being used in growth chambers where humidity, temperature, and air composition can also be controlled. The quantity of light is not as important to plant growth as is the color. Plants respond more readily to red and blue than to other bands of the spectrum; thus, a violet-colored light is the most commonly used.

Lighting of Colors

The most effective lighting is the one that brings out the fullest quality of a color. For selecting or matching paint, fabric, or paper colors, it is best to use natural daylight, which is rich in all the colors of the spectrum. Incandescent lights are deficient in blue wavelengths, and many fluorescent lights are seriously deficient in red and yellow wavelengths, resulting in a high risk of mismatching colors (see Metameric Colors). There are certain exceptions: Small differences in blue, violet, and purple hues are more easily detected under incandescent light than under natural daylight; differences in red and pink are more easily seen under daylight fluorescent bulbs and under natural light.

Reproducing in artificial lighting the fluctuations and changes of natural light is virtually impossible. The best that can be done currently is to reproduce its "smooth curve" characteristics, matching the color of, say, midday light with an even balance of all visible wavelengths.

In general, the curve for the ordinary incandescent light is very strong in the red-yellow range and weak in the green-blue-violet range (making it appear "warm" in color). However, a reasonably close match to natural light can be achieved with filtered tungsten lamps; but they are inefficient in energy used. The color is static, and matches the color temperature of northern-sky daylight—7,400 K (see Color Temperature).

"Yes" I answered you last night,
"No" this morning, Sir, I say,
Colors seen by candlelight
Will not look the same by day.
—Robert Browning

The spectral curves of fluorescent lights (far cheaper to operate) are distinctive by their jaggedness. These lights show abrupt changes for narrow parts of the spectrum; these sudden peaks of energy, exaggerating colors in those parts of the spectrum and diminishing the effect of others, can literally "blast" the eye. Ordinary fluorescent light tends to be strongest in the blue-green region. Daylight fluorescent lamps are corrected to provide more light in the red-yellow region. Another method is to mix incandescent and fluorescent lamps, to produce so-called blended daylight. This is used frequently to examine or match colors, but can be unsatisfactory because of its continued unevenness.

Lighting and People
While it is known that sufficient light is necessary for psychological health and that continuous levels of low lighting (as in some offices) can cause depression, there is no evidence that humans have any color requirements that are not met by a fairly broad-spectrum white light. Nevertheless, there are suggestions that interior light should match the color progression of natural light throughout the day. Noting that people have become attuned to a certain color order as the day brightens (pink, orange, yellow, white, and blue), which changes in reverse order in the afternoon, the Dutch psychologist A. A. Knithof demonstrated what happens when the color-brightness relationship is reversed: Blue light at very low intensity or red light at high intensity appears eerie and surreal. The design implications are that fluorescent tubes, with their blue hue, give an unnatural pallor unless the light is sufficiently intense.

For human comfort, a yellow-cast illumination is the best. It is the color of brightness and midway through the natural progression from cool to warm. A reddish-cast light is most flattering to human skin tones, but will make anything that is colored blue look gray. Blue and violet are the least desirable interior lighting colors. *See also* Color Therapy; Laser; Light; Luminescence; Measurement of Color; Motion Pictures, Color in; Photography; Television.

Light Meter
See Photography; Photometer.

Light, Natural
See Light.

Lightness
A synonym for value, lightness describes how light or dark a color is (in most color

systems, relative to the gray axis). There is a difference between brightness and perceived lightness. Lightness is the attribute of a visual sensation by which material is judged to transmit or reflect diffusely a smaller or greater proportion of light falling on it. For example, although the brightness of a light blue sweater may decrease as the wearer walks out of sunlight into shadow, it will still look light blue (since the observer judges it with respect to the ambient light). Thus, the perceived lightness has remained unchanged. Our recognition of objects in widely changing lighting conditions largely depends on the ability of the perceptive process to maintain the near-constancy of lightness. As the French artist Pierre Bonnard explained, "Almost the whole art of painting consists in lightening and darkening the tones without losing the color." *See also* Brightness; Color Constancy in Human and Machine Vision; Luminance; Value.

Light, Scattering of
See Scattering of Light.

Lilac
A pale purple color named after flowers of the hardy shrub (*Syringa vulgaris*) of the olive family. An American standard color since 1915, lilac is slightly more intense than lavender, but less reddened than violet.

Limonite
See Natural Earth Pigments.

Linseed Oil
A natural binder, drying without any need of an additive. Its use to make oil paints was popularized in the Netherlands in the thirteenth century (*see* Van Eyck, Hubert and Jan); it was favored because it enables the painter to preserve a vividness of color and, as it dries slowly, to employ subtle effects of color blending and overpainting. Other drying oils include those from walnut kernels, hemp seeds, poppy seeds, and lavender (spike oil). Oil paint was not superseded until the invention of synthetic plastics in the 1930s.

Lippman, Gabriel
See Lumière, Auguste and Louis.

Lithography
A graphic reproduction process that is planographic—on a plane surface—and based on the mutual repulsion of oil and water; the word is derived from the Greek *lithos* and

The lilac plant, whose color has been an American standard for most of the twentieth century.

graphos, for "stone" and "writing," respectively. The process was invented around 1794 by Bavarian playwright Alois Senefelder (1771–1834) and is still used today as a direct art medium. Modern commercial reproduction employs photolithography with metal, plastic, or paper-surface offset printing plates instead of stone.

Lithography is distinct from relief or intaglio processes in that the inked areas are on the same plane as the uninked, non-printing areas. A lithographic plate is usually a limestone slab with a flat, polished surface. The image is drawn directly on the slab with a lithographic crayon or with tusche, an oily or soapy liquid applied with a brush. The image has to be drawn in reverse, unless the transfer method is used, in which the drawing is made on special paper and heat-transferred onto the stone.

Oil from the crayon or tusche penetrates the stone, making it receptive to the printing ink in those areas; the whole stone is then dampened, ink is applied with a roller, and the excess is scraped off. The stone is then pressed against the paper in a rolling-pressure or sliding-bed press. The stone must be re-inked for each impression. Multi-colored images generally use a separate stone for each color, requiring accurate alignment of the successive stones—printing inks tend to be opaque, so color mixing with primaries is not possible, and each new color has to be added on with a new plate; some artists use up to fifteen stones. In some cases, a single stone may be inked with different colors in different areas.

Lithography can produce a range of tones from complete saturation through the lightest pastel, as well as completely flat areas of color with no discernible texture or grain. It was especially popular with nineteenth-century artists as diverse as Henri de Toulouse-Lautrec (1864–1901), Francisco José de Goya y Lucientes, Honoré Daumier (1808–79), and James Merritt Ives (1824–95). *See also* Intaglio; Relief Printing.

Lithraceae

See Henna.

Local Color

A term used by artists to describe the "true" color of an object seen close up in average daylight, so that its color is not affected by, for example, atmospheric absorption of the longer wavelengths of incident light, which makes distant mountains look blue, although their local color may be gray. "Local Color" also sometimes describes colorations endemic to the landscape and architecture of a particular region (*see* Architecture and Color).

Logwood

The brownish red heartwood of *Haematoxylon campechianum,* a West Indian and Central American tree, used to make a purple to black dye; sometimes known as campeachy wood. *See also* Dyes and Dyeing.

Lumen

A unit of measurement of the radiant energy emitted by a light source. 12.6 lumens is equal to one candle or candela. *See also* Candle (Candela).

Lumière, Auguste and Louis

1862–1954 (Auguste); 1864–1948 (Louis). French inventors. Working with the French physicist Gabriel Lippman (1845–1921), the Lumière brothers in 1900 invented the autochrome photographic process, the first commercially feasible system of full-color reproduction by photography. The possibility of such a system had long been proposed: by the miniaturist J. C. Le Blon in 1730; by the photographer Niépce de Saint-Victor in 1852; by the French chemists Alexandre-Edmond Becquerel (1820–91), who had photographed the solar spectrum in 1848 with a daguerreotype, and M. E. Chevreul; and by Scottish scientist James Clerk Maxwell, who took the first true color photograph, of a tartan ribbon, in 1861. The following year, the French inventor Louis Ducos du Hauron wrote a treatise on the subject, although he did not take out a patent until 1868. This was the same year that the poet and inventor Charles Gros sent a report to the French Academy of Sciences outlining the theory that color photography required an indirect process necessitating the superimposition of three monochromes.

In 1891, Gabriel Lippman produced direct process, with which he captured the colors of the solar spectrum; he was awarded the 1908 Nobel prize for his work. He inspired the Lumière brothers, who worked with him in perfecting the process. By 1893, the required exposure time had been reduced from between two and three hours to just thirty minutes. In 1900, the Lumières and Lippman demonstrated a stereoscopic system that took merely minutes. Unsatisfied, Louis Lumière continued to work on a system that would allow instantaneous and predictable pictures. After a total of twelve years of work, he finally took out his first patent on the Autochrome process in 1903, and began to market it in 1907.

The photographic plates depended on a surprising ingredient for their emulsions: potatoes. Grains of potato starch (as many as 8,000 to the square millimeter) were the vehicles for three different dyes, spread evenly across the plates. Only light of a matching color was allowed through to expose the underlying light-sensitive emulsion. By 1914, improved techniques of miniaturization had enabled the production of 6,000 plates each day.

This process, with its artisan appearance but professional quality, dominated the photographic market up to 1935—until the introduction of Kodachrome and Agfacolor. These replaced the plate with celluloid film. The vulgarized results were less subtle and louder in coloration, but they satisfied the taste of the average consumer—and were much cheaper. At that time, one million autochrome plates were produced and distributed around the world each year. Because of its availability, for instance, the *National Geographic* was able to publish natural color images of the First World War.

The Lumières were sometimes criticized in France for a certain lack of artistry in their work. In fact, Louis had studied design, sculpture, and music at the Lyons conservatory. He and Auguste left some 1,500 photographs, now collected in the archives of the Château Lumière near Lyons. The brothers published their views on photographic technique in *Instruction for the Use of Lumière's Autochrome Plates* (London, 1926).

Louis Lumière's delicate autochrome photographs, with their iridescent tints, both transparent and light, were clearly inspired by paintings of the period. The granular texture itself resembles the optical juxtapositions of the impressionists Pierre-Auguste Renoir and Georges Seurat. The autochromist had the same eye as the painter, an identical perception of how to mold form and make color flicker, capturing a fleeting moment of time. The photographs have become so redolent of that era that, when recreating a turn-of-the-century rural environment, the French director Bertrand Tavernier (1941–) used the same graininess with deep blacks, brilliant whites, and slightly faded hues in his film *Sunday in the Country* (1984). *See also* Autochrome; Impressionism; Photography.

Luminance

The measured brightness of a surface that is reflecting or transmitting light. This is an objective measurement, whereas brightness is a subjective impression influenced by the color of the light and the adaptation of the eye to particular conditions. Luminance is measured with a photometer in candelas, or candles, per square meter. Illuminance is the measurement of the brightness of incident light. *See also* Brightness; Candle (Candela); Photometer.

Luminescence

The emission of light by bodies that are not hot enough to be incandescent; usually caused by chemical reactions. *See also* Bioluminescence; Lighting, Artificial.

Luminism

A style of landscape painting practiced by some nineteenth-century American painters, notably those of the Hudson River School, that concentrated on meticulously crafted realism and a technically precise rendering of atmosphere and the effects produced by direct and reflected light. *See also* Hudson River School.

Luminosity

The property of a light source that determines the amount of light radiated in a given direction per second. It is measured in candelas, or candles. A source of a given luminosity will appear to have less brightness the greater the distance from which it is viewed. *See also* Brightness; Candle (Candela).

Lüscher Color Test

A psychological and physiological test, devised in 1947 by Swiss psychologist Max Lüscher, that is believed to be capable of universal application and can be self-administered. It is claimed that personality traits, glandular imbalances, and psychic stresses can be determined within minutes by an ordered laying out of colored chips in order of the subject's preference.

In a shortened version, the subject is asked to select from eight chips (red, blue, green, yellow, brown, orange, gray, and black), placing them in order of preference. Each color is assigned a number, resulting in a numerical sequence of eight digits. (The full Lüscher Color Test works with forty-three colored samples.) The numerical sequence is recorded and the process repeated. Because this second ordered color sequence usually occurs more spontaneously, it is considered more valid.

Using the Lüscher functional tables, the color choices can be interpreted. For instance, Lüscher associates dark blue with peace and loyalty; if blue appears as a first choice, it could indicate either a basically introverted and quiet personality or a physio-

logical need for rest, depending on the next color selected. Blue in the last position, conversely, indicates anxiety about relaxation or loyalty, depending on the preceding colors. In the third or fourth position, blue indicates an actual state of tranquillity in that individual's life, while a fifth or sixth position usually suggests an indifference to the color's symbolic issues.

Lüscher believes the four basic colors (red, blue, green, and yellow) represent different biological states (activity, calm, tenacity, and radiant release, respectively). According to him, healthy individuals should place these colors in the first five positions. Their relegation to seventh or eighth position indicates a negative attitude toward life and possible glandular imbalances.

Interpretation of the test is also based on the grouping of colors. Putting red and black in positions one and two means red's normal desirability has become compulsive or been overly dramatized by black. Were the red and the black to appear seventh and eighth, the implication would be of physiological stress arising from an unwanted situation and a psychological state of angry entrapment. Red and black in the third and fourth positions indicate frustrated wish fulfillment; in the fifth and sixth positions, the same colors indicate that the individual's present circumstances are too restrictive.

Color blindness supposedly does not affect the test, because the instinctive response to color can be evaluated in terms of contrast. Thus, if a color-deficient individual is in need of emotional peace and physical regeneration, he or she is expected to choose the darker colors. Were the need to dissipate energy in activity, he or she would prefer the bright colors. *See also* Color Therapy: The Body Prism.

Lüscher, Max

1923– . Swiss psychologist, born in Basel, who became interested in the psychological aspects of color while still a student. He first presented his "color test" in 1947 in Lausanne, Switzerland, and his book *Klinischer Test zur Personlichkeitdiagnostik* (Clinical test of diagnosis of personality) was published in 1948.

Modern English editions of the Lüscher Color Test have been available since 1969. Lüscher has continued to refine his theories, while working as an industrial color consultant in the fields of pharmaceuticals, packaging, advertising, and architecture. *See also* Lüscher Color Test.

Luster

Radiant or luminous brightness or gloss accompanied by a rich depth of color. The best effects of luster are achieved with oil paints or metallic paints. Luster can also be produced in ceramics by the use of a metallic overglaze. Lusterware was popularized by Islamic potters of the ninth century who incorporated copper, silver, or other metals, producing an iridescent luster in their transparent overglazes. *See also* Metallic.

Lux

A measure of the illuminance of a light source in lumens per square meter. *See also* Lumen.

M

Macdonald-Wright, Stanton

1890–1973. American painter born in Charlottesville, Virginia. Active in France, 1907–14, where, with Morgan Russell (1886–1953), another American painter then in Paris, he cofounded synchromism, circa 1912–14. Russell had coined the term *synchromy* in reference to the particular attention both painters gave to color harmonization, intending to achieve an effect analogous to a large musical chord.

From 1913, Macdonald-Wright's use of color became increasingly subjective, reflecting his belief that "color, in order to function significantly, must be used as an abstract medium." Through his association with American illustrator Arthur Burdett Frost (1851–1928) and Patrick Henry Bruce (1881–1936), he became aware of independent but parallel developments toward color abstraction by the artists Robert and Sonia Delaunay.

In 1919, he returned to the United States, settling in Santa Monica, California, and largely withdrew from exhibiting. In the 1920s, he constructed a kinetic color machine and made an early color film (the only copy of which was destroyed by a fire in 1924). His short publication *A Treatise on Color* (1924) promoted a somewhat idiosyncratic theory of color.

Madder

A red dye derived from the plant of the same name, a herbaceous perennial *(Rubia tinctorum)*, originally found in Asia Minor and subsequently cultivated in Europe for the excellent dye extracted from its reddish roots. Madder was replaced by alizarin, a synthetic pigment discovered in 1868.

Madder was known to ancient Egyptian dyers. In ancient Greece, it was called *erythrodanon* by the physician Hippocrates (ca. 460–ca. 377 B.C.) and the naturalist Theophrastus (ca. 372–287 B.C.). From the Middle Ages until the discovery of alizarin, madder was recognized as one of the most important coloring materials, capable of producing solid reds on fibers that had been subjected to alum mordanting, used to fix the dye. *See also* Dyes and Dyeing.

Madras

Cotton cloth manufactured mainly in Madras, India. It is distinguished by the bleeding of the dyes used (usually vegetable, sometimes including synthetic indigo), which gives the checked, plaid, or striped patterns their distinctive blurred edges.

Magenta

A brilliant purplish red, as well as a dye similar to fuchsin or solferino; named in 1859 after a French victory in that year at the northern Italian town of Magenta. One of the earliest synthetic dyes (after mauve) and particularly popular in the Victorian era, magenta is a coal tar derivative. In its crystalline form, the dye has a bright green sheen; but when dissolved, magenta colors animal fibers directly, and vegetable fibers after mordanting, in a characteristically strong but unstable red. *See also* Dyes and Dyeing.

Magic Lantern

An early form of slide projector, using transparencies of still images. In the nineteenth century, it was popular as a toy but was also used for community meetings, lectures, and theater presentations. Hand-painted glass slides were used before the invention of photography but were replaced first by albumen and then collodion glass plates, which often were also hand-colored before being varnished for protection. Adaptations of the magic lantern, with rapid image changing, provided the first, primitive version of projected motion pictures. *See also* Motion Pictures, Color in.

Mahogany

A reddish brown; wood of that color, from a hardwood tree of the genus *Swietenia*, is used in furniture. As a color, mahogany has been an American textile standard since 1915.

Majolica

Earthenware with a tin oxide glaze; named after the island of Majorca and similar to faience. Majolica has been manufactured in Spain and Mexico but is usually associated with the Italian towns of Deruta, Faenza,

and Urbino. Examples of majolica include platters, plates, vases, and low-relief sculpture, most notably those of the Della Robbias, Luca and Andrea (1435–ca. 1525).

Majolica decorations, largely historical and mythological in subject matter, were usually painted on a pink-cast white slip, which itself was applied after the first firing of the earthenware. The piece was then refired with a transparent lead glaze containing tin oxide, giving deep, vibrant colorations.

The color range of majolica was limited due to the difficulty of obtaining pigments that would not burn out during firing. Colors include light and dark blue, reddish blue (such as mulberry), green, and black, often in combination with white. Yellow from antimony was developed by majolica master potters late in the sixteenth century; it became a favored color, with shades ranging from pale whitened yellows to reddened or browned ones.

Makeup

See Cosmetics and Color; Japanese Colors.

Malachite

A green mineral; an important copper ore similar in composition to azurite. It can be ground finely without losing its color, thereby making a saturated and highly permanent pigment. As such, it was produced as early as the third millennium B.C. in Egypt, where it was used as an eye shadow in cosmetics. Malachite takes a good polish and has been valued as a gem and for carved ornaments. The color can be transparent or opaque, and the mineral can have a luster that is variously silky, vitreous, or dull. *See also* Azurite.

Malevich, Kasimir

1878–1935. Russian painter and founder in 1913 of the suprematism movement. After short periods as both a fauvist and a cubist painter, Malevich began dividing the space on his canvas with a limited set of geometric forms (squares, rectangles, circles, and rhombuses) moving in horizontal, vertical, and diagonal directions. These forms were painted in red, yellow, blue, or green against a background of either black or white.

This work represents the first stages of suprematism, the black stage and colored stage, which coincide. In these paintings, the role of color is "to locate spatial structures lying at various distances from each other and to identify the movement of shapes towards or away from the spectator." The final, culminating stage of suprematist painting is the "white stage" (1917–18). Malevich

reached the conclusion that color, not just objects, obstructed the representation of space and movement, so he proceeded to dispense with it. This breakthrough is represented by his famous canvas *White on White* (1917–18). He described it with the following words: "I have ripped through the blue lampshade of the constraints of color. I have come out into the white. Follow me, comrade aviators! Swim into the abyss. I have set up the semaphores of Suprematism. I have overcome the lining of the colored sky" (Malevich 1915).

Malillumination

An extreme case of imbalanced light waves, in which only one color or a narrow band of visible wavelengths is present. This monochromatic lighting condition, in which colors cannot be properly identified (for example, under sodium streetlights), can be avoided when using colored lights (such as neon) by intermingling lamps with complementary hues.

Malraux, André

1901–76. French writer and minister of culture (1959–60) under Charles de Gaulle. His book *Psychology of Art*, published in 1949, shed new light on art history. In it, he claims that "no work of art of the ancient past can be seen as it was originally created, especially its color. We know ancient designs and forms, [but] we are largely ignorant of the colors used. The eyes of statues in Plato's time were red, and Romanesque pillars in churches were bright and cheerful." Malraux argued the symbolic purpose of color, maintaining that Greece, Egypt, and medieval Europe were unaware of art for art's sake, but rather associated works of art closely with their function, such as was the case with (painted) votive figures and icons.

Manna Ash

A small tree of the *Oleaceae* family, from whose bark can be extracted a tannin-based coloring material that produces a range of yellowish to brown to more or less intense grays (through various combinations with iron salts).

Mannerism

An art style of the sixteenth century, dating from 1520 to 1600, originating in Italy and marked by a reaction against the serenity in form and in color harmony of the High Renaissance. A style deliberately marked by restlessness, crowded surfaces, and disturbing colors, mannerism features paintings of defined contours, elongated and often con-

"I ripped through the blue shade of the constraints of color."
—*Kasimir Malevich*

torted human forms, irrational perspectives, and exaggeratedly elegant gestures; harsh colors in bold, jarring schemes characterize the mannerist palette. The Italian mannerist painters included: in Florence, Jacopo da Pontormo (1494–1556) and Agnolo Bronzino (1503–72); in Rome, Parmigianino (1503–40); and in Venice, Tintoretto (1518–94).

El Greco, who was born in Crete, trained in Italy, and worked in Spain, is also considered a mannerist painter, with his glowing, phosphorescent, icy white blues; spectral, chalky grays; and eerie acid chartreuses and emerald green juxtapositions.

Marble

A metamorphic limestone, more or less crystallized, that is prized for its durability, ability to take a high polish, vast variety of colors, and rich patterning or veining; from the Greek marmaros, meaning "spotless stone" or "snow-white rocky mass."

In marble, color increases the stone's ornamental and commercial value. Color is also important from a physical viewpoint; different colors increase marble's resistance to wear, according to the kind and extent of impurities present. These impurities are frequently arranged in veins or patches.

The colors of marble include white (calcites, dolomites, feldspars); gray, brown, and off-black (onyxes); red (hematites); yellow (limonites); green (serpentines); and buff and purple. Some marbles seem to be monochromatic but are actually made up of small, diversely colored, uniformly distributed minerals. Marble that is clearly multi-colored is known as polychrome. Marble colors are most intense when the stone is wetted or polished.

Decorative marbles were first used in the Bronze Age in the eastern Mediterranean region, particularly in sculpture. The architecture of Greece is famous for its marble-decorated buildings, such as the Parthenon, constructed with pentelic marble from Attica. Augustus Caesar (63 B.C.–A.D. 14), the second Roman emperor, boasted of having found Rome brick and left it marble.

For formality and substantiality, marble colorations continue to be favored in state and national court and legislative buildings in the United States. In interiors, marble colors convey luxury and taste. For example, the 1983 AT&T building in New York City, by American architects Philip Johnson (1906–) and John Burgee (1933–), uses black and white marble in the lobby in contrast to the pink granite exterior, emphasizing the intended grandeur of the building.

Marbling, Marbleizing

A decorative, trompe l'oeil effect in which veined or mottled marble is simulated by painting on a wall or other surface. Marbling is highly developed and widely practiced in France and also in Italy, where marbleized papers are a Venetian specialty. See also Trompe L'Oeil.

Marc, Franz

1880–1916. German painter, exponent of Der Blaue Reiter movement. Marc's canvases portray a mystical world of animals, creatures he thought nobler than humans. He glorified animals by depicting them in the intensely bright, clear, expressionistic palette. A famous example of his work is Blue Horses (1912; Walker Art Center, Minneapolis, Minn.). See also Blaue Reiter, Der; Expressionism.

Mariotte, Edmé

1620–84. A French physicist, Roman Catholic priest, and prior of Saint-Martin-sous-Beaune. He wrote Histoire et Mémoires de l'Académie (History and memoirs of the academy; 1733), in which he describes his work on the nature of color, vision, the motion of fluids, and a range of other phenomena. The discovery of the blind spot is attributed to him. See also Blind Spot; Color Blindness.

Maroon

A brownish red, originally derived from a coal tar dye obtained from the resinous matter formed in the manufacture of magenta. Maroon is a standard American textile shade. There are references to maroons in both the eighteenth and nineteenth centuries, clearly coupling the shade with browns. Color psychologists say maroon can be understood as "red under control," and for this reason, it is a favored automobile shade.

Marron Glacé

A yellowish brown with a grayish pink cast, which derives its name from a French sweet chestnut confection.

Matching Color

The comparison of colors within the same or different media, either by eye or by instrumental means, with the aim of reducing irregularities of color between batches or between products. Good color matching is especially important in fashion, where various fabric stuffs are used; in packaging, where colors have to match the product; and in other areas where color standardization is

important. *See also* Measurement of Color; Specification of Color.

Matisse, Henri

1869–1954. French painter, sculptor, lithographer, illustrator; a leader of the short-lived expressionist movement known as fauvism, and one of the most important figures in modern art. Matisse used color as the primary source of pictorial drama. In 1905, he painted *The Green Line,* a portrait of his wife, with a startling chartreuse line running vertically on her face. *Harmony in Red* (1908) revolves entirely around a deeply saturated red surface covering the entire canvas. Accents are yellow, and the work features Matisse's characteristic black and white outlines.

For Matisse, bold, saturated, pure color applied relatively flatly could distill and give the essence of a subject. As early as 1908, Matisse stated that he wished to render the emotion that a subject evoked in him rather than depict its literal appearance. In his *Notes of a Painter,* he wrote:

> I have before me a cupboard; it gives me a sensation of red . . . and I put down red which satisfies me; immediately a relation is established between this red and the whole of the canvas. If I put a green near a red, if I paint a yellow floor, there must still be between this green, this yellow and the whole of the canvas a relation that will be satisfying to me.

Later in his career, he turned to the color medium of paper cut-outs, first used in the Bauhaus color courses. For *Jazz,* published in 1947, he cut forms in paper of vivid colors to evoke memories of circuses, folkloric tales, and past travels. His chosen colors corresponded to printer's inks so that colors could be closely matched. *See also* Fauvism.

Matte

Having a dull, lusterless surface. In contrast with a glossy surface, a matte surface reflects a high proportion of incident light diffusely, thereby lightening the apparent color. Matte paints and photographic papers are an alternative to full gloss, when a less harsh look is required. Metals, paint, or glass can be slightly roughened to give them a matte appearance.

Maurolycus, Francesco

1494–1575. Writer from Messina, Sicily, who pointed out the similarity between the color sequence of the rainbow and the light refracted through a prism. *See also* Rainbow.

Maxwell, James Clerk

1831–79. A Scottish scientist whose work included the formulation of the laws of electromagnetic energy and investigation into the nature of light and color.

During the 1850s and 1860s, Maxwell showed the interrelationship between discoveries in the field of electricity by the English scientist Michael Faraday (1791–1867) and in the field of magnetism by the German physicist Carl Friedrich Gauss (1777–1855). When research confirmed Maxwell's theory that the combined energy is propagated at the speed of light, he deduced the electromagnetic nature of light waves and showed that light is only a small portion of the entire energy spectrum.

His studies of the refraction and reflection of light influenced the work of the German scientist Hermann von Helmholtz and the English physicist Thomas Young. Maxwell also devised the now-familiar triangle diagram to illustrate the theory of three-color additive synthesis and created the Maxwell disk—a circle divided into wedge-shaped segments of various colors that blend into a combined color effect when whirled before a subject's eyes, due to persistence of vision.

In 1861, Maxwell produced the first full-color photograph. He photographed a plaid ribbon separately onto three black-and-white plates, through red, green, and blue filters, respectively. The positive transparencies were projected onto a screen using the same filters at a meeting of the Royal Society in London, and, when registered, the image burst into color. Ironically, the experiment should have failed, since collodion plates were not sensitive to blue light; the dyes in the ribbon, however, reflected enough ultraviolet light, to which the emulsion was sensitive, for the desired effect to occur. *See also* Helmholtz, Hermann Ludwig Ferdinand von; Young, Thomas.

Mayer, Tobias

See Lambert, Johann Heinrich; Systems of Color.

essay

Measurement of Color

The process of describing color quantitatively, either visually or by use of a photoelectric color-measuring instrument is outlined here by Fred W. Billmeyer, Jr., Professor Emeritus of Rensselaer Polytechnic Institute and Founding Editor of Color Research and Application.

Because the eye has a relatively poor mem-

"I am totally engaged with color, because drawing does not interest me anymore. I have done all I could in that field. . . . I am as curious about [color] as one would be visiting a new country, because I have never concentrated so closely on color expression. Up to now I only waited at the gates of the temple."
—Henri Matisse

Henri Matisse.

ory for color, visual color measurement should be limited to comparing two similarly colored samples. One objective can be to describe the color difference between them; another is to assess the appearance of one, the test sample, by comparing it to the colors of similar reference samples taken from a collection or atlas such as the *Munsell Book of Color*, a collection of about 1,600 chips arranged in visually equal steps of hue, lightness (Munsell: value), and saturation (Munsell: chroma). Visual color measurement should be carried out under specified illumination (usually daylight), by an observer with normal color vision, and with the test sample and no more than two reference samples displayed side by side, with minimum spacing between them, on a specified neutral background. Even these precautions —too often ignored—may not suffice to control all the important variables.

There are two types of instruments suitable for color measurement. The more versatile is the spectrophotometer, in which light reflected from the test sample is analyzed, wavelength by wavelength, throughout the visible spectrum. Color coordinates are derived from the resulting spectral data by using the methodology established in 1931 by the International Commission on Illumination (Commission Internationale de l'Éclairage, or CIE). These coordinates describe the color of the sample as it would appear to a specified CIE standard observer, representative of normal color vision, when illuminated by a specified CIE standard illuminant, such as daylight, incandescent light, and so on. The spectral data allow the assessment of metamerism (the tendency of colors to mismatch under different lights) between two samples.

A less versatile (and usually less expensive) color-measuring instrument is the tristimulus (filter) colorimeter, which provides color coordinates for a single type of illumination (daylight) and a single observer—but no information on metamerism. It is best suited for color-difference measurement when it is certain that metamerism is not present (e.g., when the dyes and materials are identical).

Advantages of instrumental over visual color measurement, when the instrument is correctly calibrated and operated, include higher precision (by as much as tenfold over the eye), absolute accuracy, and objective and quantitative results that are repeatable over long periods of time. Some disadvantages are differences between the CIE standard illuminant and the actual light source, and between the CIE standard observer and the actual observer, but these are important

only when metamerism is present. Currently, no account is taken in the CIE methodology of the state of adaptation of the observer's eye or of other subjective ways in which the brain influences the perception of color.

Requirements for the type of sample suitable for instrumental color measurement may at first seem stringent, but in fact even stricter ones are essential for the best visual color measurement. Differences in the geometric arrangements for illuminating and viewing samples exist among various types and models of instruments; these limit the utility of instrumental color coordinates as specifications, and the use of a material standard is still required for the best results.
—Dr. Fred W. Billmeyer, Jr.

See also Metameric Colors; Spectrum; Systems of Color.

Media

See Advertising; Newspaper Color; Television.

Medicine and Color

There is an ancient and widespread faith in looking at color to help diagnose illness. The ancient Chinese read the pulse and complexion in terms of colors. A "red" pulse meant "numbness of the heart"; a yellowish complexion meant a healthy stomach, while a greenish one warned of imminent death. This form of diagnosis was linked with the doctrine of humors—part medical, part mystical—which may have begun with the ancient Egyptians. This doctrine linked the four elements of this world—earth, fire, air, and water—with the four elements, or humors, of human beings—each with its own color, roughly corresponding to that of a body fluid; thus, black bile was linked to earth and produced melancholy; red blood, linked to fire and a sanguine humor; yellow bile or spleen, linked to air and a choleric humor; and the white of water, the phlegmatic element. Imbalance in the humors, and hence in health, was judged by color variations in complexion, urine, or excrement. The Chinese, Hindus, Greeks, and Romans all adhered to the doctrine of humors in one form or another, as did medieval Western Europeans who gained their version from Islam.

Because of its association with high energy, red was considered a particularly good source of bountiful health. The physician to King Edward II of England (1284–1327) directed that everything in a royal room should

be red to thwart smallpox. For a long time, English doctors wore red as a mark of their profession. King Francis I of France (1494–1547) was wrapped in red blankets, and in the same period red cloths were used to cure a variety of sprains, sore throats, and fevers (including scarlet fever) in such countries as Scotland, Ireland, Russia, and Greece.

In modern medicine, analysis of colors of the skin, tongue, eyes, and secretions of the body continues to be a basis of diagnosis. But doctors now know, for example, that purple or blue skin indicates a lack of oxygen in the blood and is probably the result of a lung or heart ailment, and that bright red skin indicates poisoning by carbon monoxide, which combines with hemoglobin more readily than does oxygen. They recognize conjunctivitis and alcoholism by redness of the eyes and diagnose pernicious anemia, due to vitamin B_{12} deficiency, by a yellowed skin and reddened tongue.

The following are examples of color in the diagnosis of maladies:

Anemia: Greenish, waxy skin and pallid lips.
Apoplexy: An ashen gray complexion.
Argyria: The skin becomes bluish gray or a slate color.
Cancer: The color change may not be apparent in early stages, but later the skin may be yellowish, yellowish brown, or greenish brown.
Chlorosis: A peculiar sallow color; sometimes termed *greensickness.*
Chronic alcoholism: Congested face, causing a dusky redness.
Chronic arthritis: Often irregular areas of yellow pigmentation.
Diabetes: Bronzing of the skin in many cases.
Jaundice: Yellowing of the skin.
Leprosy: White patches of skin.
Osler's disease: Superficial capillaries make the face look brick red or plum colored in warm weather.
Pellagra: The skin becomes red.
Pernicious anemia: A peculiar bright yellow tint of the skin, in contrast to that caused by regular anemia, and a red tongue.
Syphilis: A peculiar sallow color, sometimes called *café au lait.*
Tuberculosis peritonitis: Bronzing of the skin, particularly on the abdomen.
Typhus fever: Rose-colored spots turning to purplish rashes.

The colors of blood, urine, nasal discharges, and excrement are likewise important. In addition, the retina of the eye may show patches of white, gray, black, bluish green, or grayish green, depending on various conditions.

Color, allied with technology, also enables examination and diagnosis in the most inaccessible parts of the body. The principle of echolocation, used by bats and dolphins, is employed in sonography to detect tumors, examine the fetus in the womb, and scan a diseased heart. The body is probed with high-frequency waves, and echoes are reflected by soft tissues. These are recorded to produce a gray image that, if computer-coded with color, reveals detailed information about the state of body tissue.

The thermograph is based on the measurement of infrared energy radiated by all matter. A scanning camera records the radiation. A chart is then built up, color-coding the radiation according to the intensity of each. Since every part of the human body has its own temperature range, abnormal readings indicate changes resulting from malfunction or disease.

Some diseases also cause changes in color vision or cause sensations in which the field of view appears weakly or strongly tinted. In jaundice, the world may appear predominantly yellowish. Red vision may follow retinal hemorrhage or snow blindness. Yellow vision may follow digitalis or quinine poisoning. Green vision may be caused by wounds of the cornea. Blue vision has been reported in cases of alcoholism. In tobacco-induced scotoma, vision may be reddish or greenish. Santonin poisoning exhibits the most unusual symptoms, with a preliminary bluish vision being replaced by a second stage of yellow vision, of longer duration, and then a stage of violet vision, before complete recovery. *See also* Color Therapy; Healing and Color.

Medorachrome Holography

A method of projecting two- or three-dimensional space in full color; it relies on the use of interference or Bragg planes, first analyzed in 1891 by French physicist Gabriel Lippman (1845–1921) in connection with color photography. The process, developed in 1987 by the English inventor Michael Medora (1949–), uses a laser to produce these planes in a holographic context. Three interference planes, which essentially reflect the red, green, and blue irradiances of an object or artwork, as well as its spatial location, are encoded onto a holographic emulsion. When the hologram is illuminated by white light, the true or synthesized colors are then re-created by the proportional intensities of the primaries acting on our retinal cone.

The medorachrome process uses red, green, and blue primaries of exceptionally

"I the priest, I the Lord of magic, I am looking for the green pain, I am looking for the yellow pain."
—*Aztec shaman invocation*

high purity and narrow bandwidth, from which the "light palette" is mixed additively. No colorants are used; it is only the selective spacing of the refractive index changing within the emulsion that performs the color discrimination for the primaries. *See also* Additive Color Mixing; Hologram; Laser.

Melanin

A pigment ranging in color from light brown to black, produced in the skin, hair, and eyes of animals and humans. Human skin can produce melanin when stimulated by sunlight—the familiar suntan. It has the beneficial effect of filtering out harmful ultraviolet light that damages the cells of living organisms and causes skin cancer. In tropical zones, melanin pigmentation has become permanent, while races living farther north in limited sunlight have evolved melanin-free skin, hair, and eyes. *See also* Zoology and Color.

Memphis

A school of design founded in Milan, Italy, in 1981 that challenges the Bauhaus concept of modern design as primarily functional and minimal. Full of pattern and ornament for its own sake, the Memphis group's palette runs the gamut from creamy pastels, through salmon pinks, acid greens, and oranges, to glittery primary reds, blues, and yellows, often with metallic finishes that recall electric guitars more than furniture.

Exaggerated color and cartoonlike reinterpretation of known forms define the Memphis look. For color design, however, the most important aspect of the movement is its emphasis on process rather than fixed formal values. This was summarized by its founder, Ettore Sottsass: "Everything we do is dedicated to life and not to eternity" (Horn 1985). *See also* Sottsass, Ettore.

Mercury Light

See Lighting, Artificial.

Metallic

Having a metal-like look or finish. Advanced technology has made it possible to use flecks of metal-like particles to give brilliant, iridescent effects to basic paints.

Metameric Colors

Colored objects or colored lights that appear identical in light of one spectral composition or to one observer, but may not match in light of other spectral compositions or to other observers. Such colors necessarily have different spectral distributions of transmit-ted, reflected, or emitted light, usually as a result of their being produced in different ways, such as with different combinations of dyes or pigments. An example of metameric colors is a pair of fabrics whose colors match under either incandescent or fluorescent store lighting, but not in daylight.

Metamerism is avoided whenever possible in manufactured products that must match in all types of light and to all observers. Because of limitations in the properties of dyes and pigments, it may be very difficult to avoid metamerism when objects made from different materials must match. However, metamerism is fundamental to all color reproduction processes, including photography, printing, television, and painting, in which a wide range of colors is produced by mixing a small number (often three) of lights, dyes, or pigments. Those using these processes are often unaware of metamerism and the need for careful selection of lighting for exhibition to duplicate that used when the original was viewed or created. *See also* Measurement of Color; Optical Illusions.

Mexico

See Fashion: Geography of Color.

Mezzotint

Method of engraving a metal printing plate (usually of copper or steel) in tones. Invented around 1640 by German engraver Ludwig von Siegen (ca. 1609–68), mezzotint (meaning "half-tint" in Italian) came into popularity in Britain in the eighteenth century. The process required the burnishing or scraping away of a uniformly roughened surface on which the picture is then etched in chiaroscuro with a scraper. A pure mezzotint picture, without any line drawing, has a soft look and can show every shade of gray between white and black. Mezzotint was particularly favored for reproducing paintings, such as landscapes and portraits. *See also* Le Blon, Jacques Christophe.

Michelson, Albert A.

1852–1931. German-born physicist who also had an abiding interest in color and looked forward to its recognition as an independent art. Educated in Berlin, Heidelberg, and Paris, Michelson came to the United States in 1892 and was appointed head of the department of physics at the University of Chicago. He gained eminence for his efforts to measure the speed of light. With the American scientist Edward Williams Morley (1838–1923), he conducted experiments, now known as the Michelson-Morley experiments, that contributed to the development

of Einstein's theory of relativity. Michelson was the first to measure the diameter of a star and was the first American scientist to receive the Nobel prize in physics (1907).

His *Studies on Optics* (1924) reflects the creative and romantic spirit of an artist:

> Indeed, so strongly do these color phenomena appeal to me that I venture to predict that in the not very distant future there may be a color art analogous to the art of sound—a color music, in which the performer, seated before a literally chromatic scale, can play the colors of the spectrum in any succession or combination of color, simultaneously or in any desired succession, producing at will the most delicate and subtle modulations of light and color, or the most gorgeous and startling contrast and color chords! It seems to me that we have here at least as great a possibility of rendering all the fancies, moods, and emotions of the human mind as in the older art.

See also Castel, Louis-Bertrand; Music and Color; Wilfred, Thomas.

Minai

An enameling technique used in the making of mural ceramics in the Near East from the third millennium B.C. to the eighteenth century. This technique differentiates between the heat resistance of certain colors (blue, violet, and green) that can withstand a high-temperature firing, and others (such as black, brown, and white) that are painted on the glaze and refired at lower temperatures. *See also* Seljuk and Ottoman Mural Ceramics.

Mineral Colors

See Natural Earth Pigments.

Minimalism

An art movement of the 1960s, largely of American painters and sculptors whose works were distinguished by their reductive and objective tendencies and the anonymity of their serial art forms in monochromatic color. Leading figures of the movement include the sculptors Carl André (1935–), Donald Judd (1928–), and Tony Smith (1912–). Leading painters include Frank Stella (1936–), whose unmodulated paint in stripes, geometrics, and unprimed canvases helped establish the movement; Robert Mangold (1937–), whose precise color surfaces look machine-finished; Agnes Martin (1912–), whose light-colored, rectangular-grid abstracts were inspired by the New Mexican landscape; and Robert Ryan (1930–), who is known for his all-white paintings.

Minium

A term often applied to the color red in general during the Middle Ages. Most specifically, minium refers to orange lead, which was paler and more orange than is red lead today. Cheaper than cinnabar and vermilion, minium was used more often and was often mixed with the other two. It was made by roasting white lead, transforming it chemically into orange tetroxide. *See also* Artists' Pigments.

Modena

An intense purple, used in Seljuk and Ottoman mural ceramics. *See also* Seljuk and Ottoman Mural Ceramics.

Modes of Appearance (of Color)

See Film Color; Fluorescence; Iridescence; Luminescence; Luster; Metallic; Surface Color; Volume Color.

Moiré

In textiles, a cloth with a wavy or "water-marked" surface; the visible interference pattern produced when two unidentical, closely spaced line or dot patterns are superimposed out of register. Because the spacings do not match, at some places the elements in both patterns are close enough to merge visually into a solid; at other places, the elements are aligned one above the other so the spaces between them are visible. The result is a repeat pattern of circles, squares, lines, or other visible elements not present in the individual patterns. Moiré is especially problematical in the halftone printing process; it occurs when the screen-pattern angles are not sufficiently different. Moiré can also occur when photographing architectural detailing, such as a distant brick wall, or fabric texture in a closeup. The effect has been used intentionally by some artists. *See also* Halftone; Op Art.

Mondrian, Piet

1872–1944. Dutch painter who developed a naturalistic style while studying in Amsterdam. On moving to Paris in 1910, Mondrian was influenced by the cubist movement and its geometric forms, evolving his self-described neoplastic style. Neoplasticism, the basis for the de Stijl movement he founded with Theo van Doesburg (1883–1931) in 1917, was characterized by its non-objective (abstract) content, and, from 1921, by his palette, consisting of two triads of elementary color (red, yellow, and blue) and non-colors (white, black, and gray), as well as by the basic compositional units—straight lines

"When you go out to paint, try to forget what objects you have before you—a tree, a house, a field, or whatever. Merely think, here is a little square of blue, here an oblong of pink, here a streak of yellow, and paint it just as it looks to you, the exact color and shape, until it gives your own naive impression of the scene before you."
—Claude Monet

Claude Monet.

and right angles—that he would explore throughout his career.

Like Wassily Kandinsky, Mondrian was influenced by theosophy, particularly the beliefs of M. H. J. Schoenmaekers on the importance of the three primary colors. Mondrian was always more interested in abstract, antimaterialist relationships than in objects themselves. He held that the opposition of vertical and horizontal lines represented the quintessence of the life rhythm.

Mondrian subordinated color to the structural and spatial arrangement of a composition. Color is revealed as an inferior mode of subjective response, permitted, as he would say, for as long as needed, but only as a means to release the universal values: "The rhythm of relations of color and size makes the absolute appear in the relativity of time and space" (Mondrian, 1964). *See also* Cubism; De Stijl; Expressionism; Kandinsky, Wassily.

Monet, Claude

1840–1926. French painter and principal founder of impressionism. Monet's "impressionistic" color effects caught the ephemeral aspects of the changing moment wherein form dissolves into different colors and colored lights, as in his series of paintings of Rouen Cathedral of 1894, showing the cathedral from the same view but in varying times of day and atmospheric conditions. Often he was exasperated because he painted too slowly to achieve that "envelope" of colored light that could unify a scene at a given moment. Black and dark browns were removed from his palette, which consisted of bright, unmixed colors. For heightened color effects, Monet's paintings featured complementaries: red poppies and parasols in green fields; orange sunsets on blue water. *See also* Additive Color Mixing; Impressionism; Neoimpressionism.

Monochromatic Light

Light having a very narrow range of wavelengths, so that it shows only one of the colors seen in the spectrum.

Monochromatism

Technical term for a rare form of color blindness in which hues cannot be recognized at all, only variations in brightness are perceived, and only one primary-colored light is required to match any sample in a color test. Only about one in 30,000 people is afflicted this way, and, unlike other forms of color blindness, it is equally common among men and women. Since the monochromat de-

pends solely on rod vision, visual acuity is low. *See also* Color Blindness.

Moonlight

See Light.

Mordants

Compounds that combine with a dye—either chemically or by absorption—to fix it in place so it cannot migrate or bleed. Some mordants cause the visible color to precipitate as the mordants react with the dye compounds, which are otherwise colorless. The permanent, insoluble compound formed when a mordant reacts with a soluble dye is called a lake. *See also* Dyes and Dyeing; Lakes.

Morris, William

1834–96. English poet, artist, and socialist; a master at enriching a surface with meandering patterns of florals and neo-Gothic clusters of woodland colors. Morris produced furniture, stained glass, books, wallpapers, and printed and woven textiles. He was the exemplar of the craftsman-artist, who combined design with the successful management of a factory from 1861 until his death. As leader of the British Arts and Crafts movement, Morris attempted to make well-designed goods of every kind available to all levels of society.

Morris was an advocate of natural dyes in an era that had just discovered synthetic ones. In his essay "Of Dyeing as an Art," which appeared in the catalog of the Arts and Crafts Exhibition Society of 1889, he wrote that with the discovery of aniline dyes in 1856 there had come about "an absolute divorce between the commercial process and the art of dyeing so that anyone wanting to produce dyed textiles of any artistic quality in them must entirely forego the modern and commercial methods in favor of those which are as old as Pliny, who speaks of them as being old in his time."

Morris did many experiments based on ancient methods. He worked with the four colors—blue, red, yellow, and brown—needed for dyeing. From Greece, he obtained kermes, a red dye made from the bodies of insects; this yielded a particularly fine shade of red. He boiled poplar and willow twigs, which gave, in his words, "a good strong yellow." He extracted brown from the roots of the walnut tree, blue from indigo.

Beginning in 1864, Morris produced more than seventy patterns for wallpapers, chintzes, and woven cloths over a thirty-year period. The warmth and substantiality of his

woodland colors explain in part why his designs were so popular. *See also* Arts and Crafts Movement and Color.

Mosaic

Colored pieces of marble, glass, tile, wood, or other materials that are arranged ornamentally on a surface.

In ancient Egypt and Mesopotamia, furniture and small architectural features were often adorned with inset pieces of enamel, glass, mother-of-pearl, or colored stone. Mosaic floors, probably derived from Greek originals, were common in Rome and Pompeii, as were glass mosaics applied to columns, niches, and fountains. Floor patterns were made either with large slabs of marble in contrasting colors or with small tessarae, or cubes, varying from simple geometric patterns to huge figurative designs.

In the first few centuries after Christ, glass mosaics were used to decorate the broad walls of basilicas and, by the fourth century, to line the domed ceilings of churches, generally depicting Christ surrounded by saints and apostles. The craft reached its peak in the Byzantine empire during the sixth century; the mosaics in the Hagia Sofia (Church of the Holy Wisdom) in Constantinople (now Istanbul) are especially beautiful, with glittering gold backgrounds—a special feature of the Eastern mosaics, which later spread to the West, with outstanding examples to be found in Ravenna, Italy, particularly in the decoration of San Vitale. A gold tessara was produced by applying gold leaf to a glass cube and covering it with a thin glass film to protect it from tarnishing; for the other tessarae, the colors were produced with metallic oxides. The many tessarae of a design were set by hand into damp mortar; the resulting irregularities caused the facets to reflect at different angles and were an essential part of the color effect of mosaics.

The emigration of workmen from Greece to Italy in the eleventh and thirteenth centuries resulted in the beautiful mural works in Rome, Venice (St. Mark's and Torcello), Palermo, and Cefalu. Frequent use was made of gold backgrounds, as well as inlaid marble floors with bands and slabs of marble alternated with tessellated, or checkered, patterns (usually in pink, white, and black, and occasionally green). Mosaics were often applied to architectural elements such as pulpits, thrones, and even candlesticks.

The rise of fresco decoration in the early fourteenth century in Italy superseded mosaic, although it continued to be a popular art form in Greece and Constantinople. *See also* Fresco; Glass; Pompeian Color; Seljuk and Ottoman Mural Ceramics.

Mosaic Systems

The method of producing a full-color image using tiny elements (pixels) in the three primary colors (red, green, blue), which are additively mixed by the eye to produce the whole spectrum of color. The image must be formed by light passing through such a mosaic (as in a television camera) and must be viewed with light passing out from an identical mosaic (such as the phosphore dots on a television screen). Mosaics may be composed of randomly placed dots, as on Autochrome photographic plates, or may be in precise, regular patterns, as in modern offset screen processes. The mosaic system is unsuitable to motion pictures, since the enlargement during projection makes the grain objectionably noticeable.

Mother-of-Pearl

See Pearl.

Motion Pictures, Color in

The history of color in motion pictures dates back to the late nineteenth century, when films such as *Annabell's Butterfly Dance* by the American inventor Thomas Alva Edison (1847–1931) were laboriously hand-tinted frame by frame. Films were short, but even with speeds averaging only 16 frames per second, a full minute involved over 900 individual pictures.

An advance on this method was the stenciling technique developed by the French Pathé company. Pathécolor involved cutting out a stencil image on a duplicate film, through which dye could be applied to the original when the two films were run together. While retouching was still done by hand, this was a step toward mass production. By the 1920s, rising labor costs led to the adoption of various tinting and toning techniques. Tinting involved dipping black-and-white film into dye vats, giving a frame or entire scenes an appropriate uniform color; the poetically named standard dyes included Sunshine (yellow), Nocturne (blue), and Inferno (red). In toning, only the black part of the image was colored, by converting the silver halide into a colored salt (potassium ferrocyanide would convert the silver to blue-green; other reagents produced a variety of reds, yellows, and so on). Both of these methods were doomed by the introduction of sound in the late 1920s; the dyes interfered with sound recorded on the film.

An alternative route to color was the additive color system derived from James Clerk

"The reason why the impression that Byzantine art was repetitive and static prevailed for so long, is simply that its drawing was bound up with a convention, whereas its life-force genius and discoveries were recorded in its color."
—André Malraux

Fragment of a Roman mosaic.

"Suppose that, since the world began, rainbows had been black and white! And flowers; and trees; Alpine sunsets; the Grand Canyon and the Bay of Naples; the eyes and lips and hair of pretty girls!"
—1930 Technicolor advertisement

Maxwell's experiments. Filming and projection were cumbersome processes—either three separate films were made through red, green, and blue color filters—which then required three projectors—or three consecutive frames were shot in each primary color using revolving filters and shutters on camera and projector. The first process caused considerable problems of registration, while the latter required projection at three times normal speed (to prevent flicker), resulting in heavy wear on film.

The only relatively successful additive process, the British Kinemacolor system of 1912, was a two-color process. Using a camera shooting alternate frames through red and green filters at the rate of 32 frames per second, Kinemacolor produced a reasonable range of color through additive mixing by the eye. Briefly successful, this system required extremely bright natural light during filming to produce good color, something that movie studios could not depend on having, and the tiny, but noticeable, time lapse between the "red" and "green" exposures meant that perfect registration of the two frames was impossible when the image was of a moving object.

The future of color film was in subtractive processes, and here Technicolor took an early lead. The first Technicolor system, made in 1915, was in fact additive: It used a beam splitter in the camera to record red and green images simultaneously on separate films. A color film called *The Gulf Between* was made with it in 1917, but it still required two separate projectors; it was soon replaced by a subtractive process. Using the same beam-splitting camera, Technicolor produced red and green records, which could be cemented together and shown with a single projector. This process was used for *The Toll of the Sea*, shown in 1922, but gained greatest notice with *The Black Pirate* of 1926, starring Douglas Fairbanks (1883–1939). A second subtractive process, introduced in 1928, producing a single positive print, allowed for easier mass production. With the incorporation of sound, which this process did not inhibit, releases with Technicolor scenes such as *Broadway Melody* (1929) and *Puttin' on the Ritz* (1930) started a boom in attendance for color movies, only to be set back by the Depression.

Nevertheless, a Technicolor three-color subtractive process was introduced in 1932, recording the blue and red records on a bi-pack negative and the green on a second, single negative, which were then combined into a single print. The cost was high—up to $30,000 for a beam-splitting camera alone—and the process was saved chiefly by the success of the color cartoons of Walt Disney (1901–66), such as *Snow White and the Seven Dwarfs* (1938), and two color features produced by David O. Selznick (1902–65), *A Star is Born* (1937) and *Gone with the Wind* (1939). By the 1940s, color was established, but the risks were still high: In 1948, the show-business newspaper *Variety* estimated that color added 25 percent to a motion picture's earning power; however, the cost of color was at least 20 percent higher than black-and-white.

Technicolor maintained a near monopoly on the market for color film stock until an antitrust case and the introduction of Eastman Kodak's tri-pack negative film (with all three primary colors on one strip) in the 1950s. Since the tri-pack film requires no special camera, the Kodak company has now come to dominate.

Curiously, color was not to be used universally until the mid-1960s, when it had to start competing with color television. Color motion pictures represented only 50 percent of all films made in 1955, a proportion that actually dropped by 1960. This can be partly attributed to the continuing high costs of color production, but it was also due to lingering prejudices among producers and audience alike, who did not associate color with serious dramatic material. The attitude is summed up by Douglas Fairbanks, who, after making *The Black Pirate*, said:

> Not only has the process of [the] color motion picture never been perfected, but there has been grave doubt whether, even if properly developed, it could be applied, without distracting more than it added to motion picture technique. The argument has been that it would tire and distract the eye, taking attention from acting, and facial expression, blur and confuse the action. In short it has been felt that it would militate against the simplicity and directness which motion pictures derive from the unobtrusive black and white (Jump Cut, no. 17).

The longtime general restriction of color to entertainment genres such as the cartoon, Western, musical, or costume romance highlights the paradox that color, while intended to heighten reality, for decades denoted mainly spectacle and fantasy. Color was a tool of the visual, not the dramatic, arts: For instance, visually minded filmmakers such as Rouben Mamoulian (1898–) in *Blood and Sand* (1941), often consciously strove for an Old Master look that recalled such painters as Bartolomé Esteban Murillo (1617–82), Francisco de Goya, and El Greco. The general rule for documentary-type drama was that color should be downplayed. In the

"[Color militates] against the simplicity and directness which motion pictures derive from the unobtrusive black and white."
—Douglas Fairbanks

words of the critic Adrian Cornwell-Clyne: "Color should never attract the attention without carrying a significance necessary for the more complete presentation to the observer of the unfoldment of the drama" (London, 1949).

The advent of television news in full color and the recent explosion of color graphics helped to break down this barrier. Coupled with this came the revolutionary movies of Michelangelo Antonioni (1912–), such as *Red Desert* (1964), in which he explored the various ways color can be used to heighten meaning, particularly in fantasy sequences delineated by intense primary colors. By overt rather than covert use of color, he succeeded in releasing the whole expressionistic and symbolic vocabulary of color.

It was improvements in color film stocks in the late 1960s that destroyed the last technical advantages to be had from black-and-white. Higher color film speeds allowed shooting in low light conditions. Color was also better balanced, reducing the garishness with which it had been associated. The color negative now available is less grainy, is available in very high-speed emulsions, has a great deal of latitude in required lighting, and allows a fair amount of color and tone control in printing.

Thus, the use of black-and-white film stock is severely curtailed today. The cost savings of around 20 percent is offset by the difficulty of finding studios capable of developing black-and-white to a satisfactory standard, and by distribution problems. Nevertheless, some directors still prefer the stark and intellectual aspect of monochrome and the endless subtlety of shading that can be achieved with it, such as in *Stardust Memories* (1980) by Woody Allen (1935–).

Production

There are a number of ways in which a cinematographer can control color in a motion picture. In common with still photography, it is important to choose a film with a color balance that matches the lighting condition. Lighting falls into two major categories: natural and tungsten (that being the artificial lighting source of choice), each of which has corresponding film stock. The camera, unlike the eye, does not adapt to the colors of different light sources, so if a tungsten film is to be used in daylight, the scene will appear preternaturally blue. A warming color-conversion filter (in this case, with a slight salmon color) can be used to counteract this effect. Conversely, filters can be used to imitate the colors that appear under other lighting conditions, such as candlelight, that might be required by the director to create atmosphere.

A choice between reversal and negative film stock also has to be made. Reversal film produces a print without a negative and is cheaper and less susceptible to damage, but with each duplicate print made, the contrast increases and the image looks harder and grainier. Negative film, by contrast, can be duplicated infinitely and is easier for making color corrections at the print stage. Different color camera stocks, in conjunction with their companion printing stocks, afford the cinematographer a range of color saturation.

Each film stock comes with an accompanying chart of its color curve, which represents its sensitivity to red, green, and blue light, respectively, when shooting. With this chart, the cinematographer can see which color is most susceptible to overexposure and which to underexposure. Under- or overexposing only one layer can cause a color cast in underexposed shadow or overexposed highlight areas.

The final choice is of film speed (the sensitivity of the emulsion to light). A high film speed allows shooting in low-light conditions but is often accompanied by increased graininess, which can mask clear tonal separations. Some directors will purposely choose a grainy film: The patchy color produced is reminiscent of the impressionist painting technique of the late nineteenth century, giving a nostalgic or period quality to the motion picture. In general, the filmmaker seeks a balance of grain and speed for the most accurate reproduction of color.

Color Temperature

To be able to control or reproduce a certain ambient color, the cinematographer—the person responsible for the photography itself—has to have a measurement of light known as the color temperature. This is a scale, measured in Kelvin degrees (K)—basically the same as the Celsius scale, but with its zero at −273°C—that describes the color distribution of a light source. (For color temperature of different light sources, *see* Color Temperature.)

Natural and artificial light have different color temperatures. Tungsten lights are preferred for artificial lighting of scenes, since they are incandescent and have a continuous spectrum approximating that of sunlight. Fluorescent lights, by contrast, have an uneven color distribution that can cause erratic color effects on film, often giving a predominantly green tinge. Normally, a two-color meter (recording the intensity of the blue and red components) suffices for measuring the color temperature of light, but for flu-

1890s—Production of the first hand-colored movies.
1920s—Development of the technicolor subtractive process—first two-color only, then three-color (1932).
1950s—Eastman Kodak's tripack film breaks the Technicolor monopoly.
1960s—Competition from color television forces studios to abandon black-and-white filmmaking.

"After all, in making a motion picture, and especially in making a motion picture in color, we are essentially making a series of paintings. What does it matter if we are not painting our picture with water color or oil paint, but with colored light projected on a white screen? What does it matter if our picture moves and speaks? It is still fundamentally a picture."
—Rouben Mamoulian

orescent light, a three-color meter is needed to measure and allow for this problematic green component.

Because of the difference in color between artificial and natural light, a cinematographer has to be careful in interior scenes with, for instance, sunlight coming in through a window. The color temperature difference can be controlled with filters on the camera when it shoots the window, but the preferred method is to cover the window itself with a gel (usually a yellowish orange) to bring its temperature down.

Overt lighting color effects can be achieved by using the wrong type of color film (tungsten film in daylight gives a cool bluish tone; daylight film under tungsten gives a red-brown tone), or by the use of strong filters, such as "warming" filters (usually red or yellow) to imitate sunrise or deep blue (coupled with slight underexposure) to suggest night (a technique known as *day-for-night*). In general, filters cut down on the amount of light transmitted to the film's emulsion, but certain filters help to increase color contrast: UV (ultraviolet) filters cut down the high ultraviolet content of daylight, reducing glare and making colors more intense; skylight filters have a slight pink tone, which helps cut through the bluish color of haze; polarizing filters also reduce glare by screening out scattered light—this will make the sky a darker blue while leaving clouds white, but since the amount of polarization depends on the angle of the filter, it will cause changing depths of blue as a camera pans a skyscape; and diffusion filters increase the scattering of light, giving misty, soft-focus effects with subdued colorations (*see* Photography).

The principal way to control color, in common with all the visual arts, is in the choice of location, sets, and costumes. As a rule, the strong lighting needed for filming will wash out color; the color of sets and costumes, as well as of cosmetics, has to be exaggerated to counteract this tendency. Unlike black-and-white filming, in which strong value contrasts have to be achieved to avoid a muddy look, color filming can depend heavily on contrasts of hue, particularly between the complementaries—red-green, orange-blue, and yellow-violet—to obtain dramatic effect. And as for any field of design, color can be a good means to identify a historical period, not just through the use of sepia tints, as is a current vogue in some films, but through the use of complete historical palettes (*see* Sources of Historic Colors). Colors of sets and costumes can also be varied to suggest different lighting conditions throughout the motion picture, but this causes problems of

Set painting, colored camera filters, and manipulation at the developing stage are three ways to control color balance in movies.

continuity; playing with the gray scale is an exception, as in *Gone with the Wind,* in which fences and even the ground were painted black to deepen the contrasts in order to suggest dawn and dusk.

Ultimately, the color of a motion picture is decided when it is developed and printed. When the original film is sent to the lab at the end of each day's shooting, the director also will send instructions indicating special treatment, such as for purposely blued, day-for-night shots. Once developed, the negative is studied scene by scene by a specialist, who ensures that the color balance of the three primaries—red, green, and blue—is proper and consistent throughout the footage, before a positive working print (the so-called rushes) is made and sent back to the director for viewing. At the editing stage, when the film is cut and reassembled using the best shots, the quality of the color can be checked and the director will request further color corrections to be made for the "answer print" and the "check print," and then for the final "release prints," which will go out to the distributors.

In general, movie projectors all use the same xenon arc light (with a color temperature of 5400 K), though it is theoretically possible to change the color of the projection light. Cost permitting, a possible change on the horizon will be to a laser projection light, allowing better focusing on the screen and thus purer color. Looming closer, however, is the increased use of video projection (as used for in-flight movies), with all the resulting flat and unnatural color looks that the technology currently implies. The transfer of film to video also allows for computerized colorization of old black-and-white movies and television programs, with even greater attendant problems of deadening color monotony, not to mention the infringement on the original color (or non-color) statement made by the director. *See also* Balance of Color; Color Constancy; Color Temperature; Computers and Color; Light; Lighting, Artificial; Maxwell, James Clerk; Technicolor.

Mounting and Framing, Color and

The two processes in which a picture, particularly a drawing or print, is placed on a supporting background (a mount or mat) and suspended within a frame for display.

A picture is often "floated" on a mount, that is, glued on top of it so that the edges of fine paper can be seen. If the edges are not interesting or are damaged, the picture may be covered with a board, known as a mat, through which a window has been cut. In either case, the size and the color of the arti-

ficial border should strike a balance with the image: A large picture will call for a small mount, and vice versa, according to the strength of the image. The aim is to isolate the image from its surroundings, particularly from any conflicting color of paint or wallpaper on the wall behind. The color of the mount is usually neutral or pale, in a hue that follows the overall tonality of the picture or is used as a strong accent. While black borders may enhance the colors of a picture, in most cases it will overwhelm the artwork.

With the picture successfully isolated, frames can be more decorative and better attuned to interior schemes. A gold frame (usually gilded plain or carved wood) is at once lavish and neutral. Modern brushed stainless steel or silver-colored frames provide a similar function. Lacquered wood or metal, available now in the complete spectrum of colors, can provide a strong definition of space around a picture. A simple sandwich mounting of two pieces of glass or plexiglass, fastened with nearly invisible clips, is a neutral and unobtrusive frame for use on walls of appropriate colors, since the framing material is itself transparent. Plexiglass can be obtained in ultraviolet-proof varieties, which will help protect the picture and the pigments used from the most destructive components of sunlight. All pictures, whether paintings, drawings, or photographs, should be kept out of direct sunlight at all times; even a little sun will start to fade the pigments and yellow the paper or canvas. *See also* Artists' Pigments; Colorfastness and Dyeing; Conservation of Color; Harmony; Restoration.

Mourning Colors

Colors associated with rituals of mourning during and following funerals. Mourning colors are worn to express grief after a death or to invoke magical powers that will help the transition from life to death. They may vary according to religion and geography. Mourning provides one of the clearest instances, in secular society, of color being used symbolically in dress.

The most primitive tradition of mourning color is to rub earth pigments into the body at the time of a tribal member's death. Colors used are generally those that are readily available in the vicinity—such as black from soot or charcoal, white from clay, lime, chalk, or ash, and red from ocher—although there are examples of members of some tribes, such as Australian aborigines, traveling hundreds of miles to locate the pigment sought. Red is of particular importance, due to an association with blood. This association

dates back at least 65,000 years, to Neanderthals, who are known to have covered corpses (and presumably the bodies of the bereaved, too) with red ocher as a visible sign of the continuing life-force. Relatively advanced color symbolism can employ two colors: For instance, until recently, a member of the Nandi tribe in eastern Africa who killed an enemy would paint half his body red and half white to protect his blood and his spirit from the ghost of his victim.

Elsewhere, mourning colors and traditions include white or blue worn by the bereaved in Borneo; blue is also used in Mexico (and in some parts of Germany), where it is associated with the heavens to which the soul is migrating. In Guatemala, widowers have been known to dye their bodies yellow, the color of decomposition. White often represents purity and regeneration, and because of its association with the spirit, it is the color of mourning in China (although black, which first appeared at the funeral of Chairman Mao [1893–1976], is now increasingly used). In Japan, white is the color of death, but it is also worn by a bride at her wedding to signify that she is dead to her family and will belong solely to her husband.

The European tradition of mourning colors, from which the American tradition emerged, is complex, with both white and black being predominant. The tradition of white goes back to the classical world, where, symbolizing purity, it was worn by priests of the dominant deities (such as Zeus and Osiris) and by druidic cults. As a result, white was adopted by the early Christians, but by the fourth century this was replaced by black in the West; white, along with gold, purple, blue, and scarlet, became associated with various festivals. Black symbolized "the spiritual darkness of the soul unilluminated by the sun of righteousness" (Hulme 1897). White, however, remained the mourning color of the Byzantine court.

Black and white remained fairly interchangeable at weddings and burials all over Europe until the nineteenth century, though there are certain exceptions. C. C. Rolfe in *The Ancient Use of Liturgical Colors* (1879) mentions that medieval priests officiating at funerals might wear white surplices over blue copes (for "the hue of heaven, which awaits the faithful departed"). Red, or scarlet, was the official mourning color for popes. Purple, the imperial color, was a mourning color for Queen Elizabeth I (1533–1603) of England, and was mentioned by William Shakespeare (1564–1616) in his play *Henry VI*: "See how my sword weepes for the poore king's death. O may such purple

Mourning colors: White in the Far East; black in the West; purple for royalty; scarlet for popes.

Albert Henry Munsell.

tears be always shed from those that wish the downfall of our house." Purple was noted again in the seventeenth century by the English diarist Samuel Pepys (1633–1703), who "saw the king [Charles II] in purple mourning." From the eighteenth century, courtiers went to great lengths to select just the right mauve or softened purple, such as lavender, for the period of half-mourning that lasted up to a year after a royal funeral. In Britain, purple is a color still reserved for royal funerals.

It was the Victorian era that formalized the use of black as the principal mourning color. Queen Victoria (1819–1901) herself wore black from the time of the death of her husband, Albert (1819–61), until her own death. Gray was the accepted color for half-mourning into the twentieth century. The end of the Victorian tradition of black was perhaps heralded by William Morris, who died in 1896. Protesting Victorian etiquette, with all its expensive rituals, Morris left detailed instructions for a coffin of unpolished oak with wrought-iron handles to be laid out in a hay cart painted yellow with red wheels and wreathed in vine, alder, and bulrushes.

Among Western nations in the twentieth century, the custom of wearing black in mourning has all but disappeared, except at the funeral itself. The last vestiges of ancient traditional colors are maintained only by the two extremes of the social scale, the royalty and the agricultural classes of Europe and the Americas. *See also* Communication and Color; Japanese Colors; Symbolism and Color.

Mu Chi Gray

A scale of subtle grays that takes its name from a famous twelfth-century painting by Mu-Ch'i, *The Six Persimmons*, which is typified by the use of tonal variations from dark to light and light to dark.

Mulberry Red

A deep, dark red named after the color of the berry of the mulberry tree, of the genus *Morus*.

Müller, Aemilius

1901– . A Swiss color theorist, Müller started his career as a journalist. In 1941, coming across a copy of Friedrich Wilhelm Ostwald's *U24 Farbentafeln* (U24 color plates, 1934), he developed a lifelong interest in color. Preoccupied with problems of color harmony, Müller produced a number of color products, including a color cube (*see* Systems of Color), color codifiers, several booklets, and, most notably, *Aesthetik der*

Farbe (Aesthetics of color; 1973), a collection of 200 color plates of fabric samples handdyed by Müller himself. *See also* Ostwald, Friedrich Wilhelm.

Munsell, Albert Henry

1858–1918. American artist and color theorist; studied at the Massachusetts Art School and the Julian Academy and Ecole des Beaux-Arts in Paris, winning the Catherine d'Medici scholarship to study in Rome. From 1890 to 1915, Munsell lectured on color composition and artistic anatomy at the Massachusetts Normal Art School. Influenced by Nicholas Ogden Rood's *Modern Chromatics* (1879), Munsell arranged colors into a sphere, which he then expanded into his famous "tree." He produced color charts and school supplies for grade-school teachers to help instruct in color terms and color effects.

In 1915, Munsell's *Color Atlas* was published, and in 1918 he formed the Munsell Color Company. His unique system is based on three visual attributes—hue, value (lightness), and chroma (saturation)—and is arranged in equal visual color steps. The shape is irregular because Munsell wanted to show that not all colors achieve the same degree of chromaticity at the same light/dark value. *See also* Rood, Nicholas Ogden; Systems of Color.

Munsell Color System

See Systems of Color.

Murex

A tropical marine mollusk that yields a purple dye. Valued by the ancients, this purple was restricted to use by the upper classes of imperial Rome. In the Middle Ages, *murex* was the name for a purplish red color. *See also* Buccinum; Dyes and Dyeing; Tyrian Purple.

Music and Color

The linking of color with music dates back to classical aesthetics when some theoretical ties were forged between the two fields (*see* Aesthetics). This history, combined with the tendency of musicians to describe musical experiences in terms of color (and vice versa with artists), has led to a large shared vocabulary; for example, the terms harmony, tone, and scale. In addition, there are numerous instances of people who have synaesthetic experiences in which musical notes and whole compositions give them strong and very real sensations of color.

One of the earliest attempts to make a correlation between music and color was by Ar-

istotle. In *De Sensu*, he wrote: "Colors may mutually relate like musical concords for their pleasantest arrangement; [and] like those concords [may be] mutually proportionate." In 1722, more than two millenia after Aristotle, the English scientist Isaac Newton, while analyzing the color spectrum with the help of a prism, found a progression from violet to red, which, to him, suggested the musical diatonic scale. He arbitrarily divided the spectrum into seven primary colors to match the seven notes of an octave. Describing his theory of color in *Opticks* (1704), he wrote:

> Considering the lastingness of the motions excited in the bottom of the eye by light, are they not of vibratory nature? Do not the most refractive rays excite the shortest vibrations—the least refractive the largest? May not the harmony and discord of colors arise from the proportions of the vibrations propagated through the fibers of the optic nerve into the brain, as the harmony and discord of sounds arise from the proportions of the vibrations of the air?

Johann Wolfgang von Goethe, the German writer, did not support the analogies between sound and light. In his *Theory of Colors* (1810), he wrote:

> Color and sound do not admit of being compared together in any way. . . . Both are generally elementary effects, acting according to the general laws of separation and tendency to union of undulation and oscillation, yet acting thus in wholly different provinces, in different modes, in different elements and mediums, for different senses.

One of the first actual proposals for a system of color music, in which notes and colors appear simultaneously, was by Louis-Bertrand Castel. In his *Esprits, Saillies et Singularités du Père Castel* (Inspirations, salient features, and singularities of Father Castel; published posthumously in 1763), there is a chapter entitled "Clavessin pour les Yeux" (Organ for the eyes):

> At every period light has been compared to sound. But I know no-one who has carried this further than [Athanasius] Kircher [1601–80, a German Jesuit scientist], who was not a man to speak poetically of the comparison. Kircher simply calls sound "the ape of light," and he boldly advances, not without due consideration, that everything that can be made visible to the eyes can be made audible to the ears, and alternatively everything which the ear perceives can be perceived by the eyes. "Why then," following the thread of this analogy, "why not make ocular clavessins instead of auricular?"

Castel created a somewhat arbitrary color-music scale—for a projected color organ that would flash colored lights in time to music—in which C was expressed by the color blue; C sharp, blue-green; D, green; D sharp, yellow-green; E, yellow; F, yellow-orange; F sharp, orange; G, red; G sharp, crimson; A, violet; A sharp, pale violet; and B, indigo.

There is, however, no consensus as to which color "belongs" with each note. In 1844, the English color theorist George Field suggested a quite different order from Castel's. Although he, too, connected C with blue, he felt it would be more suitable to represent D with purple; E, red; F, orange; G, yellow; A, yellow-green; and B, green.

Visual artists have found other confluences. Painters and architects have long been fascinated by music, seeking to match its rhythms, even its forms—the fugue, canon, and so on. The start of the twentieth century witnessed determined investigations of the relationship by the German painters Franz Marc, August Macke (1887–1914), and the Russian painter Wassily Kandinsky. The latter wrote that in "the struggle towards the non-naturalistic, the abstract, towards inner nature . . . the richest lessons are to be learned from music. With few exceptions and deviations, music has, for several centuries, been the art which employs its resources, not in order to represent natural appearances, but as a means of expressing the inner life of the artist. . . . Hence the current search for rhythm in painting, for mathematical, abstract construction, the value placed today upon repetition of colored tones, the way colors are set in motion" (Kandinsky 1912). Kandinsky produced a "synthetic" stage show, entitled *Yellow Sound*, that combined music (by composer Thomas de Hartmann), speech, and an extremely complex lighting score.

Other poets, musicians, and artists similarly combined music and color. Aleksandr Scriabin, the Russian composer, wrote *Prometheus—the Poem of Fire*, a symphonic piece that includes a part for color organ; the French cubist painter Georges Braque painted *Aria de Bach* (1912–13), and later, the Dutch painter Piet Mondrian, in *Broadway Boogie-Woogie*, used yellow, red, and blue with light gray on a white ground in small geometric staccato squares to suggest the sharp sounds and colors of Broadway in New York City. These artists were seeking some sort of "grammar" of color, analogous to musical theory that would provide logical rules for creating visual harmony.

Although color and music show many similarities, the theory that musical harmony can have an exact equivalent in color is not

"The sound of colors is so definite that it would be hard to find anyone who would express bright yellow with bass notes or dark lake with treble. . . . A parallel between color and music can only be relative—just as a violin can give warm shades of tone, so yellow has shades, which can be expressed by various instruments."
—Wassily Kandinsky

"When I hear a score or read it, hearing it in my mind, I also see in my mind's eye corresponding colors which turn, mix, and blend with each other just like the sounds which turn, mix, and intermingle, and at the same time as them."
—Olivier Messiaen

easily supported. In music, notes sounded together are heard simultaneously in blended tone, although perceived as distinct. Color, in contrast, is arranged spatially, whether vertically or horizontally, and is seen sequentially. Nor can mixing colors truly imitate a chord in music.

Musicians, in turn, make loose analogies between music and painting; "orchestral color" is a familiar concept, describing the use of various combinations of instruments to achieve a certain timbre. Color terms provide a way to describe a non-verbal experience such as music. For example, when Franz Liszt (1811–86) was first appointed musical director at Weimar, his instructions puzzled the orchestra at rehearsals: "More pink here, if you please," or "that is too black," or even "I want it all azure here." Ludwig van Beethoven (1770–1827) is said to have called B minor "the black key"; Franz Schubert (1797–1828) likened E minor "unto a maiden robed in white with a rose-red bow on her breast"; of his subtle compositions, Claude Debussy (1862–1918) wrote, "I realize that music is very delicate, and it takes, therefore, the soul at its softest fluttering to catch these violet rays of emotion." Carl Maria von Weber (1786–1826), Hector Berlioz (1803–69), and Richard Wagner (1813–83) described some of their compositions as sound-paintings. Wagner, however, also wrote of meeting "intelligent people with no sense at all of music and for whom tone-forms had no expression, who tried to interpret them by analogy with color-impressions; but never have I met a musical person to whom sounds conveyed colors, except by figure of speech" (Wagner 1879). *See also* Color Organs; Harmony; Kandinsky, Wassily; Scriabin, Aleksandr; Synaesthesia.

Mythology

See Symbolism and Color.

Nabis

A group of French painters including Pierre Bonnard, Édouard Vuillard (1868–1940), Maurice Denis (1870–1943), and Félix Valloton (1865–1925). The Nabis, from the Hebrew word for "prophet," formed in 1889 and by 1891 had their first exhibition at Le Barc de Bouttville in Paris. They embodied the words of Denis, also a theorist and art critic: "Remember that a picture before being a battle horse, a nude, an anecdote, or whatever is essentially a flat surface covered with color, assembled in a certain order."

Influenced by the vivid, flat, and analogous color harmonies of the postimpressionist Paul Gauguin, the Nabis developed a painting style that had a commonality of flat, colorful surface patterns. Each member of this close group (in 1891, Bonnard was sharing a studio with Denis and Vuillard) explored a slightly different color vision. Bonnard loved ranges of yellows, oranges, and violets, often depicting the intimacy of domestic scenes in harmonious, linked colors. Vuillard carried the idea of the flat, patterned surface to its visual limit and in a few of his works color-fused human and environmental forms. Denis employed more delicate colors than the others. *See also* Bonnard, Pierre; Gauguin, Paul.

Naming Colors

See Language and Color.

Nanometer (nm)

One billionth (in Great Britain, one thousand-millionth) of a meter (10^{-9}). The visible wavelengths that make up light are roughly between 400 and 700nm. The nanometer is the recommended term in the metric system (now accepted as standard in every country in the world except Burma, Liberia, and the United States), superseding such older terms as the angstrom unit and millimicron.

National Paint & Coatings Association

See Appendix: Color Organizations.

Natural Color Systems

See Systems of Color.

Natural Dyes

See Dyes and Dyeing.

Natural Earth Pigments

An important group of inorganic pigments derived from mineral sources; also called earth colors or iron-oxide pigments. These are colors from materials dug from the ground that, after simple washing and grinding, can be mixed with a vehicle and used as paint. Generally, earth colors are based on yellow (ocher), red (sienna, red oxide), brown (umber), and, less often, green (terra verde).

Iron oxide is the principal color-producing agent, derived from the four main types of iron ore: hematite, limonite, magnetite, and siderite.

Hematite: A red iron-oxide pigment and the most brilliant and commonly used of the red oxides. It is found principally in Spain (for which it was named Spanish oxide) and the Persian Gulf.

Limonite: A hydrous ferric oxide, it yields colors from light yellow to brownish black. These are known to artists as ocher, sienna, and umber. The strongest limonites are now found in South Africa and India; the European ones are duller.

Ocher: Depending on the amount of iron present, the color can vary from light yellow through orange to reddish brown. The best ochers are found in France, with lesser-quality deposits in the United States, notably in Georgia and Virginia.

Sienna: Originally mined in Siena, Italy, and known as terra di Siena, its colors tend to be more translucent than the opaque ochers, and range from medium to dark yellow. When limonite is subjected to calcination, heating to a high temperature, most of the water of hydration is eliminated and it converts to a red hematite known as burnt sienna.

Umber: Siennas grade into umbers with the addition of manganese oxide. Umber, from the Latin *umbra*—"shade"—is a greenish to yellowish brown earth. When umber is calcined, the ferric hydrate is changed to ferric oxide, and the result,

burnt umber, is a warmer, more reddish material. Umber from Cyprus is considered a standard, with a high manganese and iron content.

Magnetite: A ferric oxide that can be magnetized—in other words, a kind of lodestone. It produces a deep black pigment.

Siderite: Not used as a pigment, calcined siderite can, however, be used to make metallic brown, with shades ranging from light reddish to dark purplish brown.

Vandyke brown: Another earth pigment; it is mostly organic matter. Traditionally, it comes from Germany and has been known as both Cologne and Kassel earth. Often used for wood staining, it can be unreliable as a pigment for artists' paints.

Green earth, or terra verde: A mineral but not strictly an iron oxide. It may include celadonite or glauconite, minerals of complex silicate composition. Colors vary from bluish gray with a green cast (if celadonite is present) to dark brownish olive (if glauconite is present). Greens occur much less frequently than do iron-oxide pigments. When they are calcined (heated), green earths also turn brown. Green earth was popular in the Middle Ages for underpainting flesh tones.

"Give me mud and I will paint you the skin of Venus."
—*Eugène Delacroix*

Earth pigments were used almost universally for decoration and art, with some of the best examples coming from Egyptian tombs and temples in the Nile River valley. Decorative murals used a palette of black, white, green, brown, gray, orange, red, pink, and yellow. The black was some form of carbon; the white was gypsum; some of the reds, yellows, and greens were synthetically produced from copper glazes, crushed and bound with gelatin or albumen. These latter fade considerably with exposure to sunlight. The others are remarkably permanent.

Other examples of superlative use of earth colors include the sculpted and painted Ajanta caves of India west of Bombay (second century). With the exception of green, the artists there used the same colors as the Egyptians. Yellows, oranges, reds, and browns came from earth deposits along the cliffs of the nearby Waghora River; black came from soot; white from gypsum, kaolin, and lime. A natural earth containing glauconite produced green, and many variations of shades were produced by mixing this limited palette. The artists of various Buddhist temple caves of China used the same pigments except for their blue and green, which were derived from the minerals azurite and malachite.

Earth pigments made up the palette of the Minoans of ancient Crete, who, in about 1500 B.C., created some of the earliest frescoes. In the Middle Ages, artists' palettes were fundamentally unchanged. Pigments from mineral sources, especially iron oxides, supplemented by some others from vegetable and animal sources, along with a few artificially made pigments, supplied the needs of artists working in fresco or tempera. Earth pigments in particular show excellent stability and colorfastness when painted on plaster. The same pigments survived the introduction of oil-based paints during the Renaissance, becoming popular for underpainting. Cennino Cennini, however, in the fifteenth century, recorded "a natural color known as sinoper," which, when mixed with lime white, was "very perfect for doing flesh, or making the flesh colors of figures on a wall."

Earth colors were also used for drawing in the form of chalks that were cut directly from earth with sufficient clay to hold them together. Though previously used for outlines, these chalks gained wide use in the Renaissance as a medium for finished work. They could be soaked in oil to stop them from smearing.

Earth pigments are still in use today and are considered among the most permanent colors available. Most are not affected by atmospheric conditions, or by alkalis or dilute acids, and most are non-toxic as well. Iron-oxide paints are used commercially as protection from corrosion on freight cars, roofs, ships, and structural steel. *See also* Artists' Pigments; Fresco; Sinopia.

Natural Light

See Light.

Navaho Colors

The Navaho of the American southwest are among the oldest Indian tribes in the Americas. Their colors can be isolated in their woven blankets and rugs, a distinctive art and decorative craft that Navaho women have practiced for three centuries. Seldom are more than five colors, including black and white, shown. Typical examples of the color boldness of Navaho blankets are the chief-style ones of the classic period (1850–75) in which red, blue, black, and undyed wool appear in geometric patterns. Until the 1870s, the Navaho used only natural dyes: browns from mahogany root and bark; blue from indigo introduced into the Rio Grande Valley from Mexico; reds from the insect sources of lac and cochineal; rose from the prickly pear cactus's fruit; black from sumac and piñon pitch; and creamy white from

sheep's wool whitened with gypsum. After 1875, pink yarn, especially characteristic of the 1870s blankets, was produced by carding white wool fibers with waste material from red-colored commercial cloth, and green from sagebrush was added. In addition to the classic period, Navaho weaving includes a transition period when aniline dyes, in very bright, "eye-dazzler" colors were introduced through Germantown yarns from 1875 to 1890, and a rug period from 1890 to 1920 when "Navaho blankets" were woven commercially on powered looms. From 1920 to 1940, vegetable dyes were reintroduced and hand-weaving returned. During this period, a softer palette was in evidence—pinks, yellows, beige browns, deep corals, and multiple tans. Among the outstanding rugs of this revival period are Two Gray Hills pattern rugs, which feature a monochromatic palette of whites, browns, grays, and black, all from natural wools.

The Navaho also used color extensively in sandpaintings for a kind of temporary altar, where the ritual of curing was practiced. The Navaho word for sandpainting, 'iikááh, means "place where the gods come and go." Five sacred colors—white, black, yellow, blue, and red—were used in the form of pulverized rock to depict highly stylized stick figures (yei gods).

Navy Blue

A dark grayish blue, named after the color of the British naval uniform.

NCS (Natural Color System)

See Systems of Color.

Negative

The exact reversal of an image, in which light areas are seen as dark and vice versa, or in which colored areas are seen in their complementary colors. Negatives of color photographic film tend to have an orangy brown color due to integral masking colors. *See also* Photography.

Neoclassical Color

Distinguished by clear, cool tonalities and airy pastels, the neoclassical palette is best represented by the work of Jacques-Louis David (1748–1825) and Jean-Auguste-Dominique Ingres (1780–1867). Although each artist explored classicism in his own way, similarities can be seen in their approach to color. Their subjects were defined by contours, or crisp outlines, which were filled in with clear, saturated color in midtone ranges. Paint was applied with delicate brushwork and then varnished, producing highly finished canvases. Generally, the neoclassical painters eschewed the heavy layers of color, or impasto, typically found in romantic works of the early nineteenth century. Ingres specifically cautioned against brushstrokes that were apparent, on the ground that these, however skillful, made the artist's presence intrusive and destroyed illusion, showing not the object but the painter's actual hand.

David's neoclassicism openly supported the French Revolutionary cause. A famous example of his propaganda art is the *Oath of the Horatii* (1784), which depicts a conflict between love and duty. In this work, emotion is frozen, and color is contained, restricted to clear contours. There is a hint of color blending or chiaroscuro, and the large areas of solid color result in an uncluttered surface. In *The Death of Marat* (1793), the murdered body stands out in contrast to the stark monochrome of the upper half of the canvas.

Ingres, who considered drawing superior to color, favored soft, muted, cool colors. He was known to remark, "Better gray than garishness," and "Never a color too warm! It is antihistorical."

Neoimpressionism

A movement in French painting of the late 1880s and 1890s, overlapping with post-impressionism and pointillism. A reaction against the intuitive, spontaneous, and above all unscientific aspects of impressionism, neoimpressionism was based on the application of pure colors that were additively mixed. The neoimpressionists—most notably Georges Seurat and Paul Signac (1863–1935)—were particularly influenced by the work of theorists M. E. Chevreul, James Clerk Maxwell, and Nicholas Ogden Rood.

Rejecting the impressionists' tendency to premix or slur complementary colors, the neoimpressionists advocated a palette that was an extended version of the impressionists', but excluded earth colors. For their yellows, they used the cadmiums, from deep through pale; reds were chosen from the alizarin and vermilion lakes. Cobalt violets, ultramarine and cobalt blues, and cerulean blue covered the purple and blue range. They used more greens than the impressionists—viridian greens, as well as two "composed" greens, probably different hues of chrome green, which was a commercially produced mixture of chrome yellow and Prussian blue.

Signac explicitly outlined neoimpressionism's principles, and its divergence from impressionism, in the following table:

Means:
Impressionism
1. A palette composed solely of pure colors approximating to those of the solar system.
2. Mixture (of colors) on the palette, and optical mixture.
3. Brush strokes of comma-like or swept-over form.
4. A technique depending on the inspiration of the moment.

Neoimpressionism
1. The same palette as Impressionism.
2. Optical mixtures (of colors).
3. Divided brush strokes.
4. Methodical and scientific technique.

Results:
Impressionism
By making up his palette of pure colors only, the Impressionist obtains a much more luminous and intensely colored result than [Eugène] Delacroix; but he reduces its brilliance by a muddy mixture of pigments, and he limits its harmony by an intermittent and irregular application of the laws governing color.
Neoimpressionism
By the elimination of all muddy mixtures, by the exclusive use of the optical mixture of pure color, by a methodical divisionism and a strict observation of the theory of colors, the Neo-impressionist insures a maximum of luminosity, of color intensity and of harmony —a result that had never yet been obtained.

The neoimpressionist movement was much criticized for being too scientific, but it had a decisive influence at the beginning of the twentieth century on the renewed colorism of Henri Matisse and the fauves, the color symbolism of Wassily Kandinsky and Paul Klee, and the abstraction of Piet Mondrian. *See also* Additive Color Mixing; Impressionism; Pointillism; Postimpressionism; Seurat, Georges.

Neon

A colorless, inert gas that emits a bright red glow when it conducts electricity in a sealed tube. First introduced in Paris in 1910, neon lighting is used in advertising signs. The name *neon* now covers the use of a wide range of other inert gases, each having a distinctive color: Most popular, after neon's red, are argon's two colors—a brilliant blue, when enhanced with vaporized mercury, and lavender when used alone. Other inert gases—krypton, xenon, and helium—are expensive and rarely used. Over 150 colors can be achieved by mixing gases and phosphore coatings, and still more by manufacturing colored tubing or by painting the exterior of tubing with enamels. A well-made tube will last for around thirty years and will run at a much lower cost than incandescent lighting.

Rising production costs in the 1940s and 1950s drove neon into decline, but it has experienced a revival as neon art since the 1960s. Often used in interiors, neon can provide not only vibrant design accents, but also unusual monochromatic illumination to match the decor, or, with an additive combination of many colors, give a soft and flattering white light. *See also* Flavin, Dan.

Neon Art

See Flavin, Dan.

Neutral Color

A gray, white, or black without identifiable hue; achromatic. Neutrals, such as white and beige, characteristically match well with other colors or shades. Color designers often speak of ''neutralizing'' a color; this refers to lessening the effect of a specific color by juxtaposing it with its complementary in an equal amount and of equal value or weight. *See also* Achromatic Colors; Black; Gray; White.

Newsletters

See Appendix: Color Organizations.

Newspaper Color

A surprisingly resilient legacy of the black-and-white era, newspapers are based on communication by the written word, and black type on white paper has the greatest legibility. Something that appears in print, ''in black-and-white,'' still seems to have a ring of truth. Research done by the Poynter Institute for Media Studies in St. Petersburg, Florida, shows that color does not greatly affect how readers feel about the ethical quality of a newspaper, nor does it strongly affect how important or valuable readers believe a newspaper is.

Color can affect legibility, however. Any color screen or tint will decrease legibility, although the loss can be minimized by using larger type and running only small amounts of copy against screens and tints. Obviously, the darker the background, the less legible the copy. Color newspapers such as *The Register* in Santa Ana, California, have strict rules governing color. For example, they require that combinations of magenta and cyan be no more than 20 percent so as not to print too dark. And they warn against combinations of magenta and black, or cyan and black, in places where text is to be overprinted (*see also* Communication: Typography and Graphics).

Color in newspapers does have a unique drawing power. In *A Poynter Institute Graphics & Design Center Report* (1986), it was found that body copy in a color advertisement was read by 80 percent of the test subjects, compared with only 50 percent for a black-and-white ad. (Another part of the Poynter report acknowledged, however, that for an advertisement's *body* copy, black-and-white beat color in the depth of recall.) A full-color newspaper page was also seen as considerably more interesting than its black-and-white counterpart.

Color photographs can strongly attract the eye. However, having another color on the same page (in a headline slug, for example) seems to reduce the effect of a color photograph; even a weak color tint will move a reader past a secondary photograph. A good balance, therefore, seems to be color pictures and black-and-white type.

Reader surveys by the Poynter Institute indicate that a color newspaper is considered more "modern"; red spot color is seen as "louder" than blue; for "believability," blue moves slightly ahead of red while, interestingly, black-and-white was considered the most "difficult" to comprehend. Few studies have investigated how color appeals to different groups, but in one case, it has been shown that young people like bright colors (suitable for emotional responses) and older people prefer less-saturated colors (considered better for intellectual responses). A host of examples in mass marketing and merchandising at discount price markets suggest that the overuse of brights in multicolored newsprint has the connotation of vulgarity.

Color has been used with success in *USA Today* as well as the London *Financial Times*, long distinguished by its pink paper. Color is used for advertising supplements and inserts about sales in the London *Times* Sunday editions. Before long, most major newspapers may include some color, subdued perhaps in contrast with other forms of print media, in every issue. *See also* Advertising.

New-Tapestry

See Tapestry.

Newton, Isaac

1642–1727. English mathematician and natural philosopher. Newton's activity as an original worker in optics—having read *Dioptrique* by René Descartes (1596–1650)—seems to have begun in 1663, when he was still at Cambridge University. Sent home to avoid an outbreak of plague, he began to grind lenses and to interest himself in the construction and performance of telescopes. In 1666, seeking to remove the chromatic aberration of lenses, he bought a glass prism "to try therewith the phenomena of colors." For this purpose, "having darkened my chamber and made a small hole in my window shuts, to let in a convenient quantity of the sun's light, I placed my Prisme at his entrance, that it might thereby be refracted to the opposite wall" (Newton 1704).

Observing that the length of the colored spectrum was many times greater than its breadth, he was led, after more experiments, to the view that ordinary white light is really a mixture of rays of every variety of color, and that the elongation of the spectrum is due to the differences in the refractive power of the glass for these different rays. "To the same degree of refrangibility ever belongs the same color, and to the same color ever belongs the same degree of refrangibility" (Newton 1704).

His paper on the subject, which appeared in the Royal Society's *Transactions* in 1672, was so fiercely attacked that he was unwilling to publish more for a long time and even threatened to give up research altogether. Nevertheless, *Opticks* was published in 1704 and is still considered the single most important contribution to the science of color. *See also* Aberration; Prism; Systems of Color.

Newton's Rings

The color effect first noted by Isaac Newton when he tried to reproduce the colors of the soap bubble by laying a very thin convex lens on a pane of glass and shining a beam of white light on it. He found that the point of contact was uncolored, but around this point were colored rings: faint blue, then white again, followed by orange, red, dark purple, blue, and green. Not knowing the wave nature of light, he was unable to explain this phenomenon. (The colors are caused by the interference effect of light as it is refracted at various angles by the lens. The effect will also be seen on color slides that are not pressed tightly against their protective glass screen.) *See also* Interference.

Night Blindness

Inability to see well in dim light, a condition caused by a deficiency of vitamin A, which is essential in the production of rhodopsin in the retina. During World War II, it was customary to provide Vitamin A to supplement the diet of aviators who patrolled for submarines and surface vessels at night. This led to the mistaken belief that eating carrots, which are high in vitamin A, will make one

see in the dark. In fact, a normal diet has perfectly adequate levels of the vitamin for all bodily functions. Night blindness may occur, however, in cases of severe malnutrition.

Nippon Color and Design

See Appendix.

Noland, Kenneth

1924– . American minimalist painter. Concerned with the effects of color interactions, Noland uses circles, stripes, and chevrons, often on shaped canvases and on unsized canvases, to explore these relationships. *See also* Minimalism.

Nolde, Emil

1867–1956. A German romantic, expressionist painter, and graphic artist noted for his supernatural imagery and explosive color palette.

Born Emil Hansen, he changed his name to that of his native village in 1902, to mark the beginning of his life as a professional artist. He worked rapidly and applied paint very freely. "The quicker the painting is done, the better it is," he wrote. The approach suited his color abstract style and the use of color for its own expressive force rather than for its definition of form. Nolde used color explosively as he explored religion and the supernatural. His palette, always dynamic, ranges from the clashingly bright and acidic to the dark and melancholic, and depends more on psychic energy than on any reality of the natural world.

Nolde's *Candle Dancers* (1913, Nolde Foundation, Seebull) shows lavender, pink, and red semi-nudes against a Chinese red background with sulfur yellows and dots of unpainted canvas at staccato intervals. His dark palette was used most often in landscapes, where blackened blue water may be set against an acid green sky. "Screaming" is a word frequently used to describe his work, and it is the color that is loudest of all.

Nolde particularly influenced the 1920-to-1940 generation of expressionist landscape painters, including Americans Arthur Dove (1880–1946), Marsden Hartley (1877–1943), Agnes Martin, Georgia O'Keeffe, and Canadians Emily Carr (1871–1945) and Lawren Harris (1910–70), all of whom put a priority on color over form.

Oak-Gall Dye

A medieval dye that produced intense black or various shades of gray. A gall is a pathological growth on the leaves or branches of trees (particularly the oak), providing a casing for insect larvae of the *Cynips* or *Aphis* families. These ligneous growths, often globular in shape, contain considerable amounts of tannin (gallotannic acid). In the Middle Ages and Renaissance, Istrian and Levantine gall were usually used to produce a combination of gallotannic acid and iron salts, which could then be applied to fabrics. *See also* Dyes and Dyeing.

Ocher

A mineral pigment ranging in color from yellow to brown. A compound of iron oxide and clay, ocher was one of the first known earth pigments and was used in neolithic cave paintings. It occurs naturally as yellow ocher, the iron oxide being limonite, or as red ocher, the iron oxide being hematite. Ocher blends into sienna, which has a higher percentage of iron ore and some manganese dioxide; sienna in turn blends into umber, which is darker with still more manganese oxide. The colored earths, or ochers, are found practically ready for use. The best ochers are those formed by weathered iron oxides, which are then finely ground and mixed with a binder and vehicle. *See also* Natural Earth Pigments.

Offset Printing

The most widely used method of photomechanical reproduction. Unlike other printing techniques, the plate carrying the image (text or illustrations) never actually touches the paper; instead, the inked pattern is transferred (offset) to an intermediate surface, which subsequently comes into contact with the paper. Advantages include cleaner impressions than those from letterpress or gravure; the possibility of printing on a wide variety of papers and surfaces from a single plate; shortened setup time; and reduced wear on plates, so that inexpensive materials (paper, plastic) can be used for short runs.

The offset printing technique can be used with letterpress (relief) and gravure (intaglio) plates, but the lithographic process is the most common. By photographic means, the image is transferred to the plate and made grease-receptive to capture the oil-based ink. Non-image areas remain water-receptive and repel the ink. The plate is then mounted on a revolving cylinder, and rollers continuously apply water and ink. The offset image is transferred to a smooth rubber (offset) roller, and the paper is passed between it and another (pressure) roller to receive the image.

In multiple-color printing, the paper continues to further plate and offset rollers, each with a new color. Major problems with offset reproduction include balancing the pressure of all the rollers so that color prints are of equal density, and properly aligning the plates for exact register. *See also* Full-Color Printing; Mosaic Systems.

Off-White

A term used to indicate any of a large and varied range of shades of white. "Dirty" whites or off-whites consist of all the palest tones made by adding a touch of color to basic white. In interiors, yellow or creamy off-whites are used primarily to emphasize architectural features such as panels, moldings, or decorative details. Additionally, yellow or creamy off-whites are preferred to the starkness of true or slightly blued, fluorescent-like, bleached whites in old houses, where the effect of the old lead paints (that changed color over time) is desired.

The most popular off-whites are warm, pearly ones or cool, silvery ones. Warm off-whites are produced by mixing in touches of yellow, red, or a warm brown. Cool off-whites are made by adding a tiny amount of black (ivory or lampblack are commonly used), blue, or a raw umber.

Oil Crayon

See Crayon, Oil.

Oil Paints

Paints with an oil base; used both in artists' paintings and on building and wall surfaces.

Oil paint was described as early as the twelfth century by the writer Theophilus,

but the Flemish painter Jan van Eyck is credited with its first successful development, in the fifteenth century. Among the properties of oil painting that set it apart from fresco or egg tempera are its slower drying rate, allowing easy blending of color on the canvas and a softer merging of one tone into the next; the greater flexibility of its dried films and thus a reduced tendency to crack; and its capacity to produce various color effects such as a gloss surface without varnish, transparency, or opacity.

Techniques for working in oil are many. The paintings of Van Eyck and his brother, Hubert, show the subtle color transitions and gradations from exterior to interior light and a color intensity and realism possible only with oils. In the seventeenth century, Peter Paul Rubens produced surface color of luminous clarity and gloss with resin varnish, thickened oil paints, and Venice turpentine. In the nineteenth century, Pierre-Auguste Renoir used many layers in thin color application to achieve an enamel-like effect.

Any color shift experienced in oil paints once they are dry is negligible. Therefore, oil color fairly dependably reproduces a given color. If not handled properly, however, oil paint will often muddy, or become densely brown. Another disadvantage is that the most common vehicle, linseed oil, tends to darken with age.

In house paints, oil-based paints are used on woodwork, while whitewash and casein are used on less formal and public walls such as plaster work or woodwork in utility rooms. Recently, oils applied to plaster have become popular; in dilute form, they can be rubbed onto bare plaster to give a rich, slightly grainy glaze, creating more complex and more colorful surfaces. *See also* Acrylic; Artists' Pigments; Trompe L'Oeil.

O'Keeffe, Georgia

1887–1986. American painter, a forerunner of modernism in the United States. Her early work (1914–15) took the form of "abstractions" that explored tonal relationships in black-and-white. Only when she felt that she had exhausted the possibilities of black-and-white did she reintroduce color into her work. Beginning in June 1916, color became a central focus, reflected in the titles of many of her paintings (*Music—Pink & Blue*, 1919). Her palette was sparse, using bright, saturated color in limited combinations, as in the orange, red, and black of *Red Poppy* (1937), or tonal variations of the same hue, as in *Black Abstractions* (1927). The colors and subjects of the American Southwest, New Mex-

ico in particular, were a source of inspiration to her from the 1920s until her death (*see* Sources of Historic Colors).

Onyx

A form of quartz having a homogeneous texture rather than external evidence of crystallinity. Onyx is built up of alternating bands that are in planes and parallel to each other; those stones with black and white bands are often used to make cameos.

Opacity, Pigment

Pigment opacity refers to the capacity of a pigment particle in suspension to scatter incident light in order to obscure the ground to which it has been applied.

The general rule is that when light is passing from a transparent medium of low refractive index into one of higher refractive index, the amount of light reflected at the boundary will increase with the difference between the two indices. The property of relative opacity is therefore largely dependent on the difference between the refractive index of the pigment and that of the vehicle carrying the pigment particles.

The refractive indices of most oil and polymer vehicles fall within the range of 1.4 to 1.6 (air has a refractive index of 1). Titanium dioxide (Titanium white) is the most opaque white pigment, since its refractive index is 2.72. At the other extreme, alumina hydrate has a refractive index of only 1.54, little different from its oil binder.

A pigment suspended in a water-soluble vehicle will appear to lighten as the vehicle dries; the spaces occupied by water (refractive index, 1.33) are gradually replaced by air, and a greater proportion of incident light is being reflected. Conversely, the refractive index of linseed oil (1.48) increases as it dries, and pigments suspended in an oil vehicle will appear to darken, until the oil is completely dried. The more transparent the pigment, the more it will be affected by this change. Hence, a pigment such as raw sienna, which is itself very stable, will appear to darken if suspended in oil. *See also* Artists' Pigments; Refraction.

Opal

A mineral that sometimes displays iridescence; the name probably derives from *upala*, Sanskrit for "precious stone." Opals have a regular silicon structure that diffracts light; stones that lack the regular structure are not iridescent but appear in a wide range of flat colors, including red, yellow, green, and blue.

The body colors of iridescent opals are pale in white opal and either black, gray, or brown in black opal. Fire opals—a bright, transparent, or translucent variety—range from yellow to orange and red, and may show no iridescence, while water opals are clear and virtually colorless, but with an internal play of color.

An ambiguous stone, the opal was said to possess both the baleful influence of the so-called Evil Eye and the power to cure eye diseases. Its many colors suggested to some that it combined the powers of other stones. *See also* Gemstones and Jewelry; Interference; Iridescence.

Opalescent

Exhibiting a play of colors and having a milky iridescence like that of the opal.

Op Art

Short for "optical art," op art refers to painting in the 1960s characterized by severe, geometrical abstraction and emphasis on optical illusions of color and movement. Its principal American exponents were the Polish-born artist Julian Stanczak (1928–) and Richard Anuszkiewicz (1930–), both of whom studied with Josef Albers at Yale University.

Parallel developments had been initiated by the Hungarian Victor Vasarély (1908–), whose *Yellow Manifesto* was published in 1955; the Venezuelan Carlos Cruz-Diez (1923–); the English artists Peter Sedgley (1930–) and Bridget Riley (1931–); and artists associated with the Groupe de Recherché d'Art Visuel, founded in Paris in 1960. In America, the movement gained impetus and identity following The Responsive Eye exhibition, organized by William Seitz, at the Museum of Modern Art, New York, in 1965. *See also* Moiré; Optical Illusions.

Optical Fusion

The mixing, by the eye, of two (or more) colors to produce a third, distinct color. This occurs either spatially, when individual colors are too small to be seen as discrete units, or temporally, when colors are flashed in quick succession.

Because it takes a short but definite amount of time for the retina to be stimulated by a light ray, the eye cannot register individual colors when they are flashed at high speed: Colors become fused. The ancient Greeks discovered this principle with their jinx wheel, a precursor to the children's spinning top of today. The jinx wheel was a disk with colored sections on it: When spun by means of two strings passed through its

center, the colors were mixed into new hues.

The color television screen also depends on optical fusion, as does color printing: They depend on the eye being unable to see the small dots (alternating in each of the three primary colors) that make up the mosaic of the pictures. Television is purely additive coloration, while printing is a mixture of additive and subtractive coloration. *See also* Additive Color Mixing; Benday Process, Benday Dots; Fusion; Harmony.

Optical Glass

High-quality, color-free glass with specified refractive properties, which is used to make lenses or other components for optical systems. Flint glass and crown glass are two examples of optical glass. *See also* Aberration.

Optical Illusions

The result of vision and perceptual processes that misinterpret information from the environment. Some optical illusions in color are vital for acute vision; others tend to be visually distracting.

Color itself serves a special function in the processes of vision. Our ability to analyze colors is a result of having three types of cone receptors in the retina, which have different spectral sensitivities. Color vision depends on two processes: the sensing and encoding of light energy by the eye, and the decoding and analysis of the information by the visual cortex of the brain. The eye is not a perfect optical instrument; it suffers from chromatic aberration of the lens, yellowing with age, and variations of sensitivity. Coupled with the brain, however, human vision is exceedingly reliable and constant.

In certain unusual situations, some of the effects that the brain uses to enhance vision (or that are mere by-products of these processes) can be observed. These include afterimage, assimilation, changing color sensibilities, chromatic aberration, light diffraction, persistence of vision, the Purkinje Effect, retinal rivalry, retreating and advancing colors, simultaneous contrast, and the influence of color on apparent size and weight.

Adaptation or assimilation: The tendency of the eye to adapt in a few seconds to most prevailing light sources so that all except the most strongly colored will appear to be white. Because of this effect, the eye can in turn accurately identify colors of objects under changing lighting conditions. Adaptation will be seen by a person traveling in a vehicle with tinted windows; if, for instance, the tint is blue, the landscape outside will at first seem suffused with a

"In 1871, during a long stay in London, Claude Monet and Camille Pisarro discovered Turner. . . . They are first struck by his effects of snow and ice. They marvel at the way he represents the whiteness of snow which up to then they had been unable to achieve with the wide brushstrokes of silver gray. They realized that this marvelous result is obtained not by solid white but by a great number of touches of various colors, painted one next to the other, and reconstituting at a distance the effect wanted."
—Paul Signac

blue cast, but, as the eye quickly desensitizes itself to blue, the view will soon reassume its normal coloration. On exiting, the person will see a complementary orange cast until the eye regains its equilibrium (*see* Color Constancy in Human and Machine Vision).

Afterimage: A negative or complementary "ghost" of a color seen after prolonged stimulation of the eye. An afterimage can be produced by staring at a black spot on a white surface for around ten seconds; shifting one's gaze to a black surface, one will briefly see a floating white spot, the afterimage. The afterimage of a red spot would be green, that of a blue spot would be orange, and that of a violet spot would be yellow.

Changing color sensibilities of the retina: The exact color seen may depend on what part of the retina an image falls on. Color is strongest when one is looking directly at an object and its image lands on the foveal (central) part, which has only color-sensitive cones. Toward the edge of the retina, where there is a higher proportion of rods (which are insensitive to color differences), the eye is increasingly color blind. Accurate color matching depends on keeping a color focused within a narrow part of the retina.

Chromatic aberration: A problem associated with all lenses (including the one used to focus light in the human eye), in which light is refracted by different amounts according to its wavelength. As a result, yellow is the only color perfectly focused by the normal eye, with red focused slightly behind the retina and blue slightly in front. This effect can be seen in a special experiment using the line spectrum of a mercury arc light, in which the green and yellow lines are seen in good focus but the blue and violet are not. In general, chromatic aberration is not directly apparent to humans, but it may contribute to the seeming retreat and advance of blue and red, respectively (*see* Aberration).

Light diffraction: The tendency of light to bend around thin objects, causing a bright aura to appear. Since short wavelengths are bent more than long wavelengths, the light will often fan out into its spectrum of color. The effect can be seen when a spider's web is viewed against the sun; each strand seems to have a halo of different colors sparkling around it. The same colors can be seen playing around one's eyelashes when one is squinting into the sun (*see* Diffraction).

Persistence of vision: The short time that it takes for a light sensation to die down in the retina or visual cortex of the brain means that moving objects, such as a lighted torch waved in the dark, will leave a cometlike trail of light, an effect known as persistence of vision. The effect also occurs with colors. If a watch with luminous hands is swung around in a dark room under a red safelight, the hands will seem to separate themselves from the face (relatively low levels of illumination giving the best results). The reason for this is that different color sensations grow and diminish at different rates: The blue sensation rises very rapidly; red is next; green, third. Under the safelight, a watch with green hands has a red face, and the greenish color is perceived a moment after the red of the face.

The Purkinje Effect: The apparent brightening of blue at dusk. While yellow is the brightest color in full daylight, in dim light the brightest part of the spectrum shifts to blue. The light-sensitive rods, which cannot in general distinguish colors, are in fact most sensitive to short (i.e., blue) wavelengths; as the eye becomes adapted to the dark, blue objects will, for a while, seem to get brighter as other colors get darker. The effect was named after its discoverer, Johannes Purkinje, a Czech physiologist.

Retinal rivalry: Many curious effects may be obtained by stimulating the two retinas, each with a different color. For instance, when blue glass is placed before one eye and a yellow or red one before the other, the two independent monocular fields fight for supremacy; vision appears alternately in one color and then the other, and the brain has great trouble resolving the images. (This is not a problem associated with 3-D motion pictures, because each eye is seeing an image filmed by a different camera through a red and green filter, respectively. The visual cortex of the brain recombines the images into a single image.)

Retreating and advancing colors: Warm and bright colors, such as red and orange, seem to advance, while cooler and darker colors, such as green and blue, seem to retreat. Of two possible explanations for this, the first may be chromatic aberration (*discussed above*). The second reason may be that associative elements come into play: For example, blue may seem to recede because of the association it has in our memory with distance—the sky, sea, or distant mountains. By using blue in the background, painters can thus give an illusion of depth in their landscapes (*see* Aerial Perspective); by contrast, even a

"Look at light and admire its beauty. Close your eyes, then look again: what you saw is no longer there; and what you will see later is not yet."
—Leonardo da Vinci

stroke of red pigment will seem to jump forward, glowing with the heat of a fire.

Simultaneous contrast: An effect in which the contrast between adjacent colors is enhanced by the eye. The effect is particularly strong with a pair of complementary colors, such as red and green or orange and blue. If these colors are put together in tight patterns, the resulting contrast is so strong that flicker will occur and the eye may experience considerable discomfort (*see* Dazzle).

Size of color: Since warm (reddish) colors tend to advance and cold (bluish) colors tend to recede in our visual field, objects painted in red and orange will seem to be slightly larger than those painted in the cool blues and greens. Red cars or buses seem larger than they actually are. Many cities have painted their fleets of buses in sober blues, greens, and silvers in order to play down their impact and make them appear less menacing to drivers of other vehicles.

Weight of color: The value (relative lightness or darkness) of a color affects our perception of the weight of an object. During World War II, it was found that bomb loaders seemed to have less trouble with loads that were painted in light rather than dark colors. There is little evidence that the hue has any effect on our perception of weight.

See also Benham's Top; Camouflage; Color Constancy; Gloss; Matte; Metameric Colors; Op Art; Perception; Simultaneous Contrast; Symbolism and Color; Visibility; Vision.

Optical Mixture

See Optical Fusion.

Optic Nerve

See Vision.

Orange

A secondary color, midway between red and yellow in the color spectrum. Until the seventeenth century, the word *orange* was associated only with the citrus fruit, which had first been imported from India in the tenth century. Orange-colored items were called red, yellow, or gold, as in, for example, red hair, red clay, or goldfish.

Orange is a high-intensity hue recommended for advertising and for signage as a warning and safety color; it is used in a fluorescent version for life rafts and for attention-getting accessories and athletic wear. Probably the best-known orange is International Safety orange, which is used to designate dangerous parts of machines or energized equipment in industry.

When darkened with black, orange becomes brown, the color of autumn leaves, and a common color for the furs and hides of mammals. It is also a common earth pigment, colored by iron oxides such as hematite.

Red (or orange) hair was popular in ancient Rome, where bleach and henna were used to modify dark hair colors. The color was popular again in sixteenth-century Italy, acquiring the name *imbalconata* from a habit owners of houses had of putting their red rosebushes (then a great novelty) out on their balconies—and in England, because of the red-headed queen, Elizabeth I (1533–1603). At some point during the seventeenth century, orange gained a sexual connotation. Nell Gwynn (1650–87) is thought to have seduced Britain's Charles II (1630–85) with the oranges (still rare at that time) she was selling, and both the fruit and the color were used often in erotic paintings. The French custom of throwing orange blossoms over brides symbolized fertility, as few trees are more fruitful than the orange.

An energetic color with practically no negative associations, orange is strongly oriented toward food: It is the color of tangerines, apricots, mangoes, and the flesh of some melons such as cantaloupes; it is used frequently to decorate fast-food outlets, as well as for kitchen utensils and packaging for foods, soaps, and cleansers. *See also* Natural Earth Pigments.

Orange-Peel Dye

The oil of sweet orange peels produces a dye of yellow-orange coloring, which can be extracted simply by boiling. *See also* Orange.

Oricello

A lichen from Mediterranean islands, used to produce a purple dye. Used in ancient Crete and Rome for red-violet or crimson-purple dyes. It was rediscovered in the thirteenth century by a Florentine family, the Oricelli, who gave it their name and made a fortune marketing the dye. The coloring substance (roccellic acid) was extracted through the process of fermentation of the lichen in the presence of putrefied urine.

Oriental Colors

See Celadon; Chinese Color Symbolism; Fashion and Clothing Color; Japanese Colors; Seljuk and Ottoman Mural Ceramics; Sources of Historic Colors.

Orphism, Orphic Cubism

An offshoot of cubism; named in 1912 by the French poet and critic Guillaume Apollinaire (1880–1918) after Orpheus, the mythological Greek poet and musician. The Orphists—Robert Delaunay, Marcel Duchamp (1887–1968), Fernand Léger (1881–1955), Francis Picabia (1878–1953), and the Czech-born Frank Kupka (1871–1957), although the latter was not specifically named by Apollinaire—explored, almost exclusively, the formal and coloristic potential of painting, coming close and perhaps being the first finally to attain to "pure abstraction" or "pure painting."

Of all the orphists, Kupka's ideas were the most mystical and esoteric, drawing on theosophical notions similar to those that influenced Wassily Kandinsky. Kupka's abiding interest was in the abstract representation of movement through the interrelation of color forms. Orphism was a short-lived movement. *See also* Delaunay, Sonia and Robert.

Orpiment

A highly poisonous sulfide of arsenic from which a brilliant yellow pigment of the same name is made; it was used extensively in Old Master paintings.

Ostwald, Friedrich Wilhelm

1853–1932. German physical chemist, natural philosopher, and creator of a famous color system. Born in Riga, Latvia, Ostwald studied at the University of Dorpat (now Tartu) in Estonia and was appointed to the only chair in physical chemistry in Germany, at Leipzig, in 1887. He received the 1909 Nobel prize for chemistry. From 1906, however, he devoted himself to the study of color, particularly to the problem of color standardization. He produced a color system with the form of a squat double cone—similar to some previous theoretical models. His real achievement was in the systematic presentation of all hues in their variations. His model was displayed in the Bauhaus in Dessau, Germany, and his material about it, included in the Bauhaus course of study, was published in 1934 under the title *U24 Farbentafeln* (U24 color plates; a series of twenty-four charts, each showing colors of equal hue). Ostwald wrote *Color Science* (1923, trans. 1931), among other textbooks. *See also* Systems of Color.

Ott, John

See Color Therapy.

Oxford Gray

A dark gray based on a color effect first noted in woolen and worsted cloths: The degree of the shade is determined by the percentages of naturally black and white wool stocks that are used in the weaving. The name comes from Oxford University's preference for dark shades (as opposed to the light shades favored by rival Cambridge), although many different shades of light to medium to dark gray for men's suits are often grouped under the name Oxford gray, which entered fashion's vocabulary in the 1920s.

Packaging and Color

See Advertising; Communication: Commercial Color Symbolism.

Paint

A mixture of pigment (a powdered substance that gives color), binding medium (the "glue" that sticks the pigment to its support), and vehicle (basically, a solvent that dilutes the paint). In oil painting, turpentine is the vehicle; for all other paints, water is used.

The first commercial paint mill in America is thought to have been established in Boston in 1700 by Thomas Child, and in July 1867, D. R. Averill of Ohio patented the first ready-mixed paints. Only after the 1880s were ready-mixed paints universally available. The new latex paints of the 1930s revolutionized the industry. They were fast-drying and easy to apply and store.

Commercial paint finishes include flat or matte, gloss or shiny (which enhances the depth of the color), and semi-gloss, which is in between flat and shiny and tends to make the color appear soft and satinlike, as would a silk-fabric representation of a color. *See also* Acrylic; Casein; Crayon, Oil; Crayon, Wax; Encaustic Paints; Glair; Linseed Oil; Oil Paints; Size Color (Scenic Color); Tempera; Van Eyck, Hubert and Jan; Watercolor.

essay

Painter's Eye, The

French art critic Annette Vaillant gives a personal view of color, as seen through her experiences with some of the masters of painting. Vaillant, whose family published an influential art magazine called La Revue Blanche, *was personally acquainted with many of the impressionists and post-impressionists, was painted by Édouard Vuillard (1868–1940) and Pierre Bonnard, and wrote a seminal book on the latter, entitled* Bonnard.

On Her Childhood. The first color imprinted in the eye of a very small girl was green: a really green green, the green of the linen closet wall, lawn green, the same as in that patch of grass glimpsed beyond the window.

Later on, red was revealed to her, this time on the wall of Papa's study: It was the red pants of a young soldier with a forage cap jauntily askew—in a painting by Renoir.

On the Old Masters. The muted colors of the austere, Byzantine madonnas by Cimabue. The enchanting chromatic harmonies of Piero della Francesca, a poet in color. The gentle touch of Fra Angelico, who gave rainbow wings to his worshiping angel.

On Stained Glass Colors. The miraculous blue of Chartres: that twelfth-century blue that is also the heavenly background of Notre Dame of La Belle Verrière. Its composition has remained a secret for eight centuries, never rediscovered. The stained glass of Chartres and the rose window of Notre Dame of Paris: Shaking up little bits of glass in the tube of the kaleidoscope, we children saw geometrical patterns, uncountable, never repeated—ruby, emerald, sapphire—as brilliant as the cathedral windows.

On Illuminated Manuscripts. Monks bent over parchment, their imagination kindled by their faith, had illuminated—with intense azure, purple, and gold—cities in which legend and daily life were blended: a Gothic Jerusalem, with a medieval Paris—as it was when Jean Fouquet lived there and was not afraid to paint red angels around his immodest Virgin, Agnes Sorel. Great lords out hunting, peasants working in the fields: Protected by thick, costly pages, the *Très Riches Heures* (ca. 1415) of the Duke of Berry, by the brothers Limbourg, still retains all its original brilliance, as does the *Grandes Heures* of Anne of Brittany, painted a century later, in 1507, in which Jean Bourdichon reveals, on an azure ground, the exquisite truth of a thistle, of a ripening berry.

On Flowers and Plants. In the nineteenth and twentieth centuries, Odilon Redon, a master of the fantastic and a virtuoso in black and white, was also inspired by a love of flowers—poppies, delphiniums, anemones—which he idealizes without distortion in pastel, giving them the shimmering fragility of butterfly wings.

On Flesh Colors. The satiny bosom of Helene Fourment, her fair skin caressed by Rubens's brush. The red hair of Titian's beauties. The silky manes flowing from the

Green was the first color imprinted on the eye of the author, followed by red, the red of a Renoir painting.

heads of young lords by Van Dyck, of which Proust was fond.

On the Colors of Fabrics. Tintoretto, Veronese, and Raphael—whose Jeanne d'Aragon, draped in red velvet, seduces the fascinated visitor. The gray-brown rags of Le Nain's peasants, like their own dry bread. The drab homespun robes of monkish figures by Zurbarán, and yet—watch him give peach-colored cheeks to Saint Marguerite, his pretty martyr in a picture hat, crushing a dragon under her tiny foot; and see how the Spanish fondness for lemon yellow comes out in the most frugal, the most beautiful of Zurbarán's still-life canvases. The dark-wine, leaden gray scarf of Saint Louis, king of France, as El Greco painted him centuries later. When the children were taken to church on Sundays, they tended to prefer the full-blown matrons by Ingres, with their Indian shawls and coral necklaces, to the ambiguous figure of the Mona Lisa. At any age, people will be attracted by the satins of Watteau: in the *Enseigne de Geraint*, the *Embarquement pour Cythère*, "the color of time" like Peau d'Ane's dress. And what of the ineffable pink bow crowning the divinely elegant Marquise de Solana, as Goya shows her to us in an effervescence of black tulle?

On Édouard Manet and Olympia. In 1865 came *Olympia* by Manet—and outraged reaction to her startling pose, the black cat, the audacity of the multi-colored bouquet held out by the Negro servant. Greens and grays collide with each other in *Le Balcon*, and the harmonies peculiar to Manet made "the painter's painters shiver with delight," as André Lhote wrote later.

Color and the Time of Day. Early morning or dusk? The time of day is written on the facades—gray, white, blue, brown—of Claude Monet's cathedrals, as it is in the ponds of his garden at Giverny and in the open corolla of his water lilies.

On Eugène Boudin. Boudin's watercolors, where the touches of color serve to bring the white spaces into play on the paper, were for Monet an eye-opener. Whether in watercolor or in oils, Boudin seemed to paint with the greatest of ease. His skies swell with water like the grassy expanses below. Rocks draped in seaweed, at low tide under a rain-washed sky, where the storm clouds are rolling on; the outline of the chalk cliffs at Étretat, with their crowns of crude green; the black shells of boats stranded on the mud; the sea flecked with sails; the wooden huts on the shore of Trouville; and a candy-striped dress under a parasol—the quintessence of impressionism.

On the Impressionists. The impressionists knew better than anyone before them how to make snow serve their purposes. Its whiteness in the paintings of Alfred Sisley, or in those of Monet or (Gustave) Courbet, is never the same. Nor is it in those of Camille Pissarro, who liked to paint roads in all seasons, with slippery ruts; his greens are too many to enumerate, the greens of every kind of tree and grassland. Paul Cézanne, who for some time confined himself to dark blue, greatly admired Pissarro and, at Pontoise in 1872, was initiated by him into the secret of confronting nature, of painting in brilliant colors.

On Edgar Degas. Let us give a special place to Degas. See the colors in his racehorses, the fiery colors of his washerwomen and his bathers, the magical colors of his ballerinas behind the footlights.

On Pierre-Auguste Renoir. Renoir, innocent pagan, painter of youth and of Sunday lovers' outings and, of course, of marvelous landscapes. Renoir, with a passion for full-blown roses, borrowed their blushing shades to bring an ever more rapturous glow to his nudes.

On Vincent van Gogh. The flat colors of Van Gogh, laid on like the patterns in Japanese crepe. Cobalt blue, Van Gogh's blues, which touchingly dramatize his church in Anvers. The thick yellow of his sunflowers—the yellow of which Bonnard declared that "one could never lay on too much of it!" And let us remember his own great mimosa tree—one of the last of his fairylands.

—Annette Vaillant

essay

Painting and Color in the Twentieth Century

American art historian Roger Lipsey examines some of the ways that the art of this century uses color to express the innermost spiritual feelings of artists. This essay is abridged from "Its Own Beauty: Color in Twentieth-Century Art," first published in The American Theosophist, *Spring Special Issue, 1985 (abridged and reprinted by permission).*

In 1947, looking back over his apprentice years at the turn of the century, Henri Matisse remarked: "Color exists in itself, possesses its own beauty" (Matisse 1972). This disarmingly simple phrase is the key to much worth understanding in the art of our time. The perception it embodies was not unique to Matisse; many artists shared in it and explored its truth. Throughout the twentieth century, color has "existed in itself," possessing its own beauty.

In the first decade of the twentieth century, color and design were transformed.

The immediate predecessor of this period was Paul Cézanne, whose work showed both a new, more abstract rendering of nature and a new, intensely psychological participation in the image on canvas. There is an exquisite, almost painful balance in his later work between the motif itself—whether landscape, still life, or portrait—and the artist's keen presence: a questioning, doubting presence, seemingly captured in the brushstrokes and in a certain transparency of color. "I must tell you," he wrote to his son in the last year of his life, "that as a painter I am becoming more clear-sighted before nature, but that with me the realization of my sensations is always painful. I cannot attain the intensity that is unfolded before my senses. I have not the magnificent richness of coloring that animates nature" (Rewald 1976). This passage can help us appreciate that, for the true artist, the study of color and light is not a casual matter. To find a deeply satisfactory rendering takes a lifetime and often remains unattained.

Matisse, who recognized Cézanne as "the master of us all" (Matisse 1972), is generally considered the greatest colorist of our time and the strongest influence in this respect on later generations. He has recounted in detail his search for a fulfilling art of light and color. Rebelling from traditional Beaux-Arts disciplines, Matisse set out "to study separately each element of construction: drawing, color, light, composition." He looked to the past, especially to the impressionists, whose paintings, "constructed with pure colors, made the next generation see that these colors, however much they can serve to describe objects and phenomena in Nature, have in themselves and apart from the objects they describe an important action on the feelings of the observer." He concluded that "simple colors can affect the intimate feelings with all the more force *because* they are simple."

Matisse has recorded that it was not ultimately the example set by other paintings that led him to a new understanding of color, but rather the direct "revelation of light in nature." Although he had studied the science of color relationships with its intricate color wheels and systematic ordering of hue, saturation, and brightness, in later years it provided no more than a convenient vocabulary. "The choice of my color," he wrote, "does not rely on any scientific theory: it is based on observation, on feeling, on the experience of sensibility" (Matisse 1972).

Even so, he stressed the importance of study. "If drawing proceeds from the mind and color from the senses," he wrote, "then one must draw to cultivate the mind to be-

come capable of guiding color down the pathways of the spirit. It is only after years of preparation that the young artist has the right to touch color—not color as a means of description—but as a means of intimate expression. . . . I would like people to know that they must not approach color casually, that a severe preparation is required to be worthy of it" (Matisse 1972).

Matisse's gift to the art of his century was the recognition of pure, radiant color as an aesthetic language that directly addresses the emotional capacity of men and women. His discovery was embraced by succeeding generations; it entered the working vocabulary of modern times.

Cubism: Picasso, Braque

Cubism, the formal language introduced by Picasso and Braque in 1907, is not commonly admired for its treatment of color. On the contrary, in the early and most intense phases of cubism, the full spectrum of color was virtually abandoned in favor of earth tones, white, and black, yielding quasi-sculptural images on canvas in which complex forms are rendered visible by stark highlights and shadows. The brilliant variety of color was sacrificed to form. The austerity of early cubist light and color, however, was memorable in itself—elegant, contained, precise—and it proved to be fruitful for later art. Furthermore, the basic compositional device of cubism (the small rectangular plane) quickly evolved into a simple and effective means of exploring color, its infinite variety restored.

Picasso's colors ranged from the chalky blues and pinks of his early work, to bronze textures of the first years of cubism, and light-filled Mediterranean colors of the later years. He displayed little interest in theorizing about color or in summing up his studio experience at length. After visiting an exhibition of Picasso's work in the early 1930s, C. G. Jung wrote an essay on its psychological content in which he offered a simple but far-reaching formula: Color equals feeling (Jung 1966). These few words capture much of Picasso's implicit perspective.

Cubism Blooming into Color: Delaunay and Klee

"Recently some painters have realized that the brown and white of the cubists does not represent the culmination of all painting and have turned to studying color and to painting colorfully again" (Levin 1978). This comment by Morgan Russell and Stanton MacDonald-Wright, two American artists in Paris, gives a clear sense of a new direction that emerged out of cubism. They were refer-

"The expressive aspect of color comes to me in a purely instinctive manner."
—Henri Matisse

"Remember that a picture before being a battle horse, a nude, an anecdote, or whatever is essentially a flat surface covered with color, assembled in a certain order."
—Maurice Denis

"Color provokes a psychic vibration. Color hides a power still unknown but real, which acts on every part of the human body."
—Wassily Kandinsky

"Color is the most sacred element of all visible things."
—John Ruskin

"Color does not add a pleasant quality to a design— color reinforces it."
—*Pierre Bonnard*

ring to Robert and Sonia Delaunay, among others. In the narrow period, 1912–13, Robert Delaunay created paintings structured by scientific knowledge of color but suffused with an ecstatic sensitivity which all but defied definition. Like many artists of the period, he wrote about and attempted to explain his art: "Light in Nature creates color-movement. Movement is provided by relationships of *uneven measures*, of color contrasts among themselves that make up *Reality*. This reality is endowed with *Depth* (we see as far as the stars) and thus becomes *rhythmic simultaneity*. Simultaneity in light is the *harmony*, the *color rhythms* which give birth to *Man's sight*. . . . *Let us seek to see*. . . . *The synchromatic movement (simultaneity) of light . . . is the only reality*" (Delaunay and Delaunay 1978).

"Let us seek to see"—this simple injunction is at the core of his work in these years. The terms *simultaneity* and *contrast* are drawn from the writings of M. E. Chevreul, the nineteenth-century color theorist on whose thinking Delaunay in part based his extraordinarily vital paintings of 1912–13, a series of essentially cubist works known as *Windows on the City*, and a second series based on circular forms, often with the words "sun" and "moon" in their titles. During this period, Delaunay created dynamic linear patterns glowing with color harmonies and light. In *Windows*, Paris is a vibrant weave of light and air, while the circular studies depict a living cosmos of light and energy. In a letter of 1912 to the German painter August Macke, Delaunay wrote: "Above all, I see the sun always! Since I desire the identification of myself and others, I see everywhere the halo, the halos, the movements of color. And I believe that this is rhythm. To see is a movement. Vision is the true rhythm-maker" (Delaunay and Delaunay 1978).

Further developing the cubist sensibility, during the 1920s and 1930s Paul Klee created some of the simplest and most subtle color studies in the art of our time. He mastered and valued scientific color theory and yet worked with virtuosic freedom. His notebooks document his inquiry into form and color, guided by an integrated aesthetic-scientific perspective.

One of his most characteristic and haunting creations is a series of canvases that resemble patchworks of squares of varying color. In *Blossoming* (1934), the uneven handmade grid contains dark yellows, reds, blues, and browns in outer rows that brighten toward the center of the canvas, as if a light had fallen on them. The work is about color, but it is also about a quickening into bloom and the mystery of the central

and inmost. Klee disguises a scientist's knowledge in a seemingly naive composition to speak of fundamental things. "The interior is infinite," he wrote in his notebook, "all the way to the mystery of the inmost, the charged point" (Spiller 1973).

In contrast, he described elsewhere his exhaustive work to master color as an artistic means: "In color, I have tried all partial methods to which I have been led by my sense of direction in the color circle. As a result, I have worked out methods of painting in colored tone values, in complementary colors, in multicolors and methods of total color painting. Always combined with the more subconscious dimensions of the picture" (Herbert 1964).

Like Matisse and Delaunay, Klee bears witness to the spiritual significance of color in modern art, which coincides with, but is not identical to, its aesthetic power. Color is of this world, and yet more; its harmonies and contrasts, transparency or opacity, are physical notations for feelings and states of being which the artist explores and asks the viewer to experience.

The Serene Emotion of the Universal: Mondrian

Mondrian sought the universal by a process of condensation and simplification that took place simultaneously in his life and in his artistic work. Reducing the confusion of energies in the world to the active and passive, or "masculine" and "feminine" energies, he encoded them on canvas as vertical and horizontal lines. Their intersections and rhythmic balance, in patterns that he described as "dynamic equilibrium," created the variable grid which was the only composition that he employed after about 1921. Within this seemingly simple framework— in fact elaborated in a new way, painstakingly, in each canvas—he admitted only six colors: the three primaries (red, yellow, blue), supplemented by black, gray, and white.

The language of Mondrian's writings is stiff and forbidding, yet its aim is to explain and even justify the purity and almost childlike simplicity of his pictorial work, which was not appreciated by a broad public in his lifetime. "To determine color," he wrote, "involves: first, reducing naturalistic color to primary color; second, reducing color to plane; third, delimiting color—so that it appears as a unity of rectangular planes. Reduction to primary color leads to the visual internalization of the material, to a purer manifestation of light. . . . Primary color simply means color in its most basic as-

"Those who are skilled in painting will live long, because life created through the sweep of the brush can strengthen life itself."
—**The Mustard Seed Garden Manual of Painting**

"Color . . . thinks by itself, independently of the object it clothes."
—*Charles Baudelaire*

pect. . . . The principal thing is for color to be free of individuality and individual sensations, and to give expression only to the serene emotion of the universal" (Holzmann and James 1986).

Mondrian intends the viewer to feel that nothing is missing in his palette—that all colors are implicitly present and concentrated in his few. His movement toward concentration contrasts with Delaunay's ecstatic celebration of the infinity of color and the ubiquity of light. Both approaches grant that color possesses its own beauty, and both artists manifested that beauty in abstract works that have withstood the test of time.

These Unique Beings We Call Colors: Kandinsky

From an early age, Wassily Kandinsky experienced color as a living force. He recalled, "When I was thirteen or fourteen I bought a paintbox with oil paints from money slowly saved up. The feeling I had at the time—or better: the experience of color coming slowly out of the tube—is with me to this day. A pressure of the fingers and jubilant, joyous, thoughtful, dreamy, self-absorbed, with deep seriousness, with bubbling roguishness, with the sigh of liberation, with the profound resonance of sorrow, with definite power and resistance, with yielding softness and devotion, with stubborn self-control, with sensitive unstableness of balance came one after another of these unique beings we call colors" (Herbert 1964).

Drawn from Kandinsky's personal reminiscences, and more intimate in tone than his formal writing on art, this passage nonetheless evokes the sheer responsiveness to color and light that characterizes his art through four decades. By 1912, Kandinsky had made the transformation from the Jugendstil fluency and folkloric charm of his early works to swirling color abstractions. He was ready to articulate the concepts of color that had come to structure his work. In his book *On the Spiritual in Art* he discusses his interest in combining the scientific theory of color with his own perception of the psychological impact of color. He records his emotions and thoughts aroused by specific colors, ranging from superficial associations to religious feelings, and does so in the conviction that his own carefully observed responses are reasonably objective and would occur in other trained observers using the same methods. The drive to develop an aesthetic science, stemming from a desire to order his impressions and convey them to friends and students, remained with him for many years.

One of the concepts governing his approach to color is the notion of the distinct "inner sound" of each color. The concept evokes a living cosmos in which color, sound, and all substances are vibrant and expressive. "The world sounds," he wrote in these years. "It is a cosmos of spiritually active beings. Even dead matter is living spirit" (Lindsay and Vergo 1982). In practice, the idea functions as an effective metaphor, a creative means of translating the subtlety of intimate visual impressions into words that can be shared. For example, on the color yellow, he wrote: "Yellow, when directly observed (in some kind of geometrical form), is disquieting to the spectator, pricking him, stimulating him, revealing the nature of the power expressed in this color, which has an effect upon our sensibilities at once impudent and importunate. This property of yellow, a color that inclines considerably toward the brighter tones, can be raised to a pitch of intensity unbearable to the eye and to the spirit. Upon such intensification, it affects us like a shrill sound of a trumpet played louder and louder, or the sound of a high-pitched fanfare" (Lindsay and Vergo 1982).

The Abstract Icon: Rothko and Reinhardt

In the years after World War II, color field painting emerged as an original and powerful new language in American art. Two of its finest practitioners were Mark Rothko and Ad Reinhardt.

By the late 1940s, Rothko was producing a new, wholly abstract art of color. Over the course of the next two decades, he explored color in hundreds of paintings based for the most part on the same elements: a large canvas (often six by five feet, or larger); two or three great rectangles of vibrant, often contrasting color hovering against a field of color; the edges of the rectangles soft and permeable; the color within them airy, luminous, and subtly mixed. Each canvas differed from the next—one a medley of green, blue, yellow, white; another of red-tinged brown and varied blues; yet another of incandescent reds and yellows. Matisse had taught this faith in color, just as Mondrian had taught the simplicity of form, but the result is not merely additive or logical; Rothko's is a stunning new art.

Ad Reinhardt, Rothko's contemporary, also dedicated himself in later years to painting only a single type of picture (with subtle variations). He described this seminal type, known simply as a Black Painting, in enigmatic but powerful language:

"Color is a matter of taste and of sensitivity. . . . No one can be a painter unless he cares for painting above all else. It is not enough to know your craft—you have to have feeling. Science is all very well, but for us imagination is worth far more."
—Édouard Manet

"Painters who are not colorists produce illumination, not painting. All painting worth its name, unless one is talking about black and white, must include the idea of color as one of its necessary supports, in the same way that it includes chiaroscuro, proportion, and perspective."
—Eugène Delacroix

A square *(neutral, shapeless)* canvas, five feet wide, five feet high, as high as a man, as wide as a man's outstretched arms *(not large, not small, sizeless)*, trisected *(no composition)*, one horizontal form negating one vertical form *(formless, no top, no bottom, sizeless)*, three *(more or less)* dark *(lightless)* no-contrasting *(colorless)* colors, brushwork brushed out to remove brushwork, a matte, flat, free-hand painted surface *(glossless, textureless, non-linear, no hard edge, no soft edge)*, which does not reflect its surroundings—a pure, abstract, non-objective, timeless, spaceless, changeless, relationless, disinterested painting—an object that is self-conscious *(no unconsciousness)*, ideal, transcendent, aware of no thing but art (absolutely no anti-art) (Rose 1975).

Reinhardt seems to negate the succession of color concerns that began with Matisse's pure color. Yet his Black Paintings, which he liked to describe as "the last painting," possess great warmth and depth. Gradually, as the viewer's eyes sweep the painting's surface, a simple symmetrical cross emerges from the uniform blackness, each of its rectangular panels tinted a slightly different black. These are the colors from the last moment of twilight, and like that time of day they infuse a certain inwardness and calm in the observer.

Reinhardt knew his black; he collected and wrote into freely structured litanies his own impressions of black and the meanings it has conveyed in art and in religious literature.

His language is enigmatic and suggestive (Rose 1975):

Diminishing, beyond shapes, colors, "melting away,"
Dematerialization, no-being
"The dark of absolute freedom"
Going from "darkness to darkness deeper yet," *ultimate*
Black, *"medium of the mind"* no distractions, no intrusions . . .
"The Tao is dim and dark" (Lao Tzu)
Ka'aba, black-cube-rock
"The divine dark" (Eckhardt)

Ad Reinhardt's Black Paintings close with concentrated intensity the cycle that began with Matisse's expansive restoration of pure color. *See also* Braque, Georges; Cézanne, Paul; Chevreul, M. E.; Color Field (Painting); Delaunay, Sonia and Robert; Kandinsky, Wassily; Klee, Paul; Matisse, Henri; Mondrian, Piet; Picasso, Pablo.
—Roger Lipsey

Painting, History of

See Abstraction of Color; Aerial Perspective; Aesthetics; Art and Color; Art Deco Colors; Artists' Pigments; Art Nouveau Colors; Chiaroscuro; Egyptian Colors; Fauvism; Harmony; Impressionism; Mannerism; Nabis; Neoimpressionism; Oil Paints; Op Art; Paint; Pop Art; Postmodernism; Prehistoric Colors; Renaissance; Tempera; *and entries on individual artists.*

"Color is nothing unless it is appropriate for the subject. . . . A beautiful color scheme is one that is appropriate to the style of painting. Just as it should form a symphony pleasing to the eye, it should also create a spiritual chord between its character and that of the subject. In such a way the artist predisposes the spectator's soul to the harmony."
—*Eugène Delacroix*

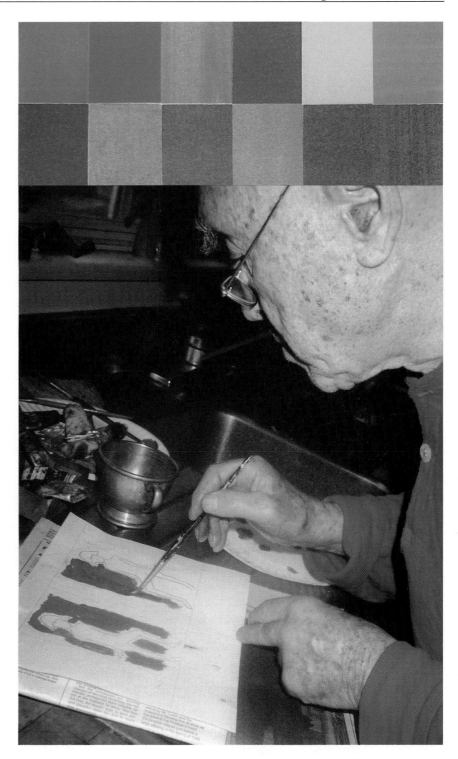

PAINTERS, PAINTING, and COLOR

Different chromatic approaches—the Luminists, the Tonalists, and the Colorists

The artist–painter has always had a special role in relation to color. Painters have investigated their environments intensely, concentrating on visual relationships.

During the nineteenth and twentieth centuries, profound changes have occurred in the artist's approach to color in painting: there has been a shift of emphasis from form to color. In a letter to his brother Theo, Vincent van Gogh said that "the painter of the future will be a colorist in a way that no one has ever seen before." Half a century later, Henri Matisse, writing to his friend André

Rouveyre, said: "I am totally engaged with color because drawing does not interest me anymore." On the other side, art critic and connoisseur Bernard Berenson, in his *Aesthetics and History in the Visual Arts* (1949), declared that love of color emerges in societies where muscle rules, whereas a taste for form is characteristic of societies where the mind rules. The dominance of form was a feature of painting during the Renaissance and Age of Reason.

"The illness of modern man comes mostly from his forgetting the loving and inspiring and creative use of the hands." —*Daisetz Suzuki*

Rembrandt van Rijn, Self-Portrait, 1658. Copyright The Frick Collection, New York.

Rembrandt palette extract

"You, princes, lords, and young men, who aspire to learn, you know without any doubt that the most beautiful animal created by nature is man; that the most beautiful part of man is the head; and, finally, in the head, there is nothing more beautiful and marvellous than the eyes."
—Benvenuto Cellini

"As [Turner] grew older, and particularly after his visit to Venice in 1832, he became more and more ambitious of realizing to the uttermost the fugitive radiances of dawn and sunset. Light, or rather the color of light, became the objective of his painting to the exclusion of almost everything else."
—Sir William Orpen

Georges de La Tour: Not only the source, but the effect of light.

J. M. Turner: Light dissolves forms.

Francisco Goya: Tragic effects rendered by light–dark oppositions.

Velásquez palette extract

Diego de Velásquez, King Philip IV of Spain, 1644. Copyright The Frick Collection, New York.

By the mid-twentieth century, color in painting had become independent of form. At the end of his life, American artist Mark Rothko, a color field painter, could unabashedly declare that "the interaction of chromatic energy patterns has the power to move and reveal the viewer's own inner modulations." Each of his canvases, as varied and monumental in color as they are in size, is complex but unitary in its expressive effect.

Although there are startling differences between Rembrandt and Rothko and those in between, there is also a certain continuity of chromatic approaches of different painters. The luminosity present in Rembrandt's

work, for example, can be seen in Rothko's. Similarly, the vibrant stained-glass colors of the twelfth century are repeated in the intense, juxtaposed color harmonies and contrasts of Matisse, Van Gogh, Marc Chagall, and other moderns.

While attempts to categorize paintings and artists scientifically are futile, an analysis of the specific color orientation of some outstanding artists allows for three rough groupings: luminists, tonalists, and colorists.

Among the artists who can be termed luminist are Rembrandt, Francisco Goya, Joseph Mallord Turner, Georges de La Tour (1593–1652), and James Abbott McNeill Whistler, all of whom evoked light in paint on

"There is no light painting or dark painting, but simply relations of tones. When they are done right, harmony appears by itself. The more numerous and varied they are, the more the effect is obtained and agreeable to the eye."
—Paul Cézanne

Jean-Baptiste-Siméon Chardin,
Still Life with Plums, *late 1750s.*
Copyright The Frick Collection,
New York.

canvas. Luminists emphasized differences of values, of highlight and shadow. By manipulating the subtle gradations between white and black, or between any two colors, the artist conveys the sensation of luminosity. Light is the quintessential element to be rendered, whether expressed in the violent contrasts of the Spanish artist Goya or the restrained but intense grays and exquisite hues of his fellow painter Diego Rodriguez de Velásquez (1599–1660).

The tonalists, such as Jean-Baptiste-Siméon Chardin (1699–1779), Edouard Vuillard (1868–1940), Georges Braque, and Georgio Morandi (1890–1964), work in nuances and tonalities. Their paintings tend to be characterized by a dominant hue, from which colors move in small steps. The effect is to reproduce the harmonies of analogous colors found in nature and thus to simulate the appearance of matter rather than of light. Tonalist palettes range from the rich and variegated browns of Chardin to the desaturated tones used by Braque and Morandi, with local contrasts made in black and white.

Vuillard palette extract

Monet palette extract

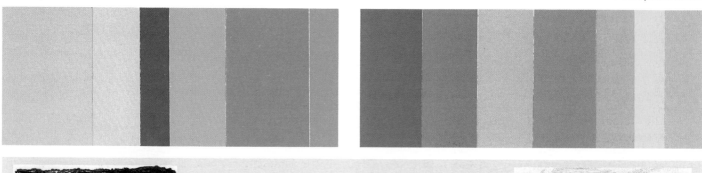

Vuillard: *"Analogous harmonies in small tonal steps."*

Monet: *"Paint it [so that] it gives your own naive impression of the scene before you."*

Paul Cézanne: "There is no light painting or dark painting, simply relations of tones."

Henri Matisse: "I am only interested in colors which give me a certain impression."

Cézanne palette extract

Matisse palette extract

The colorists—Fra Angelico, Eugène Delacroix, Van Gogh, Paul Gauguin, Pierre Bonnard, and Henri Matisse, for example—concentrate on using pure and bright primaries or secondaries, restricting the use of mixed colors. The result is a certain freedom in color use, even a naivete, that can also be found in children's paintings. Gauguin, commenting on the endless permutations possible with a limited number of colors, wrote, "Take as many units as there are colors in the rainbow, add those made up by composite colors, and you will reach a rather respectable number of units. What an accu-

mulation of numbers, truly a Chinese puzzle! No wonder then that the colorist's science has been so little investigated by the painters and is so little understood by the public. Yet what richness of means to attain an intimate relationship with nature."

Obviously, the works of these painters, whether luminists, tonalists, or colorists, like those of numerous others who may be ranked with them, do not fall into such strictly classified categories. Most artists, including those mentioned, cross over and break these boundaries while they explore different modes of expression.

Gauguin palette extract

Van Gogh palette extract

Paul Gauguin: "A green next to a red does not produce a reddish brown, like the mixture of pigments, but two vibrating tones."

Van Gogh: "Colors placed beside each other, producing their effect when viewed from a distance."

Georges Braque, Athenée, *1912. Private Collection.*

Study after Giorgio Morandi's Still Life *(1957).*

Braque palette extract

 essay

Bonnard and Light

An examination of the artist's use of color, with special reference to Bonnard, by David Appelbaum, professor of Philosophy at State University of New York.

What little is known of colorists in ancient Egypt, Babylon, and Persia suggests a concern for combining color to produce in paint an impression of real light. Down to modern times, colorists have searched for a means of passing from the ordinary perception of pigmentary color to one of reproducing pure radiance. Impressionism, fauvism, cubism, and minimalism may be seen as experimental ways, using intuitive, primordial forces, to guide the brain to an unqualified illumination experience. Among the artists of these various nineteenth- and twentieth-century movements, Pierre Bonnard most particularly was concerned with color as light energy.

While science allows us to break up white light into its constituent colors and to measure the intensity and position of each, interior distances "are not the same as ordinary distances" (Paul Valéry). Color measured

Morandi palette extract

solely by optical parameters (wavelength, frequency of vibration, or intensity) gives little indication of the perceptual experience of color. The artist's palette, composed following such principles, conveys merely a partial response to reality. Pigments absorb light and color: the colorist's work is, therefore, but a search for reascendance to an unrefracted radiation.

For harmony in human perception, the correct sequence of colors is essential. Placing colors in a scientific chromatic order yields no radiant effect. Setting orange next to red, yellow next to orange, followed by green, blue, and indigo-violet, fails to produce the juxtaposition necessary for the transformation of color perception.

The stained glass of Chartres represents possibly the best attempt at using the color of light. The radiance that surrounds the clouds of a Titian sky or a Turner landscape manifests the intuitive application of principles governing the inner movement of color. Among twentieth-century colorists, Bonnard offers a fresh look at art based on harmonious color balance.

A good example is Bonnard's painting *Dining Room on the Garden* (1931). The unmistakable radiance flooding the table and spilling into the garden cannot be explained by the use of unmuted juxtaposed pigments. Bonnard's brash color stands in contrast to the quiet awareness it evokes. From the canvas arises an intimation of a white light experience that elevates the color value of a work of art to a sum greater than that of the individual colored parts. At work within the pictorial array of pigments is an interchange of vibrational energy, the movement of which progressively refines the light radiating from the tableau.

Our eye travels to neighboring colors (red to orange, or yellow to green) in the painting through indirect routes. We move, for example, from the red eggcup to the orange rim of the saucer via the yellow inner rim. Similarly, we progress from the blue shadows of the garden to the indigo-violet wallpaper via the true green of the shrubbery. Bonnard's care in spacing and in avoiding certain chromatic continuities deserves notice. Yellow and green, which touch on the spectrum, keep one another at bay—separation marked by the balustrade. Similarly, indigo-violet and red "live" in separate regions of the canvas.

A careful colorist, Bonnard offers an opportunity to appreciate the way colors blend together and are transformed through chromatic opposition and exchange. Through a rigorously maintained sequence of color, he shows the progressive interplay of radiant energies that leads to a refinement of the quality of light.

—David Appelbaum

"Violet in the grays, Vermilion in the oranges, On a chilly day, with beautiful weather."
—*Pierre Bonnard*

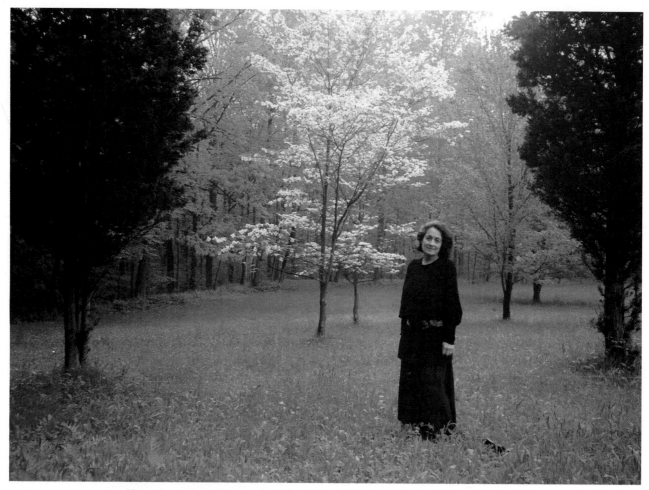

Nature is a subject and source of color inspiration for photographers as well as artists.

Painters, Photography, and Color

"In spring, there is the young, tender, green wheat and the pink apple blossom.

"If the summer is characterized by the contrast of blues with the golden orange of wheat, one could create a canvas expressing the atmosphere of all the seasons by means of all the contrasts of complementary colors (red and green, blue and orange, yellow and violet, black and white).

"In autumn, there is the contrast of the yellow leaves with the violet tones.

"In winter, there is snow with little black figures."
—*Vincent van Gogh*

Advances in color photography have offered new opportunities to explore color harmony. Photographers often work in one of the three modes of color used by painters—luminism, tonalism, or colorism. The luminist-oriented will explore the effects of light, concentrating on contrasts of light and dark areas. This is best achieved with black-and-white film, and by careful control of exposure to ensure deep blacks and pure whites within a single picture. This style is best seen in the work of Ansel Adams, who recorded America's national parks.

The tonalist photographer is more interested in creating a dominant color tonality, for which landscape photography is best suited. Here it is important to capture the dominant color of a place, such as the blues and oranges of Greece or the changing atmospheric colors to be seen at different times of the day. Tinting photographs by hand can help in achieving tonalist effects.

The colorist technique demands a reduc-

tion of the image to simple, almost abstract forms. Photo-collages, such as those by English artist David Hockney, which are made up of hundreds of Polaroid snapshots, use color effectively. Various polarizing and color filters are alternatives available for controlling overall hue within a single photograph. Most important, however, is the deliberate balancing of colors of objects within the image, using the basic complementary harmonies—red and green, orange and blue, yellow and violet. Modern color film, with its strong primary hues, is well suited to this approach.

In the future, the pending introduction of cameras which record the image digitally in a microchip (*see* Photography) will offer almost unlimited opportunities to the photographer. Unlike regular film, the digital image can be processed in a computer to control color in the minutest detail. With this development, it will be more important than ever for the photographer to understand the nature of color harmony (*see* Harmony). *See also* Computers and Color; Fashion: Geography of Color; Light.

Paisley

See Sources of Historic Colors.

Pantone®

See Appendix.

Parra, François

1917–85. French optical physicist, founder in 1977 of both the French Color Association and the magazine *Information Couleur,* and pioneer member of the French Association of Colorimetry. He associated with industrialists, scientists, artists, and teachers, and conducted research into the two domains of color (subjective and objective) and philosophy. In his teaching, he expressed the belief that

> the third millennium starts at a point where the sensitivity to color, one of the strangest of human experiences, moves into a new dimension. On one hand, the scientist has his logic to control his discoveries. On the other, the fabulous domain of color wants nothing of this logic. It means that with color vision we penetrate a totally unknown world where the frontiers of science are not of great help to human intelligence. One needs audacity to go ahead (*Information Couleur,* no. 22, 1983).

Pastel

A color of light value, in contrast to a shade (a color of dark value); a pigment plus a nongreasy binder, usually gum arabic, in stick form; a drawing done in the pastel medium.

Pastel crayons are very suitable for capturing evanescent color effects in nature and are an ideal medium for sketching. One disadvantage of pastels is their highly fugitive character. Unless protected with a fixative spray, pastels can be easily rubbed off a surface with rough handling. Too strong a fixative, however, can eradicate much of a pastel's charm. This is because, in pastel, fine particles of pigment lie irregularly and loosely one over another and thus reflect light from many different angles. The air space between the particles produces a pleasing gray. If the fixative alters the color particle arrangement and creates one smooth, continuous surface, the optical color effects are lost.

Pastels were used in fifteenth-century Italy and were also very popular with eighteenth-century French portraitists.

Patina

A green film that develops on the surface of copper or bronze when these metals are exposed over time to a moist atmosphere or to acids. Patina has also come to designate a surface change through the influence of age, a mellowing in color, in various materials, from wood and marble to rugs.

Peach

A light, pinkish yellow, as in the color of the fruit of that name.

Peachbloom, Peachblow

A delicate purplish pink, usually describing a ceramic glaze.

Peachblow Glass

American art glass of the late nineteenth century, made in various pale colors and sometimes having an underlayer of milk glass.

Peacock Blue

Lustrous greenish blue, as in certain peacock feathers.

Pea Green

Medium or yellowish green, the color of the garden pea.

Pearl

An almost neutral bluish gray, the color of pearls produced by some aquatic mollusks, especially oysters and mussels. Pearls are hardened concretions secreted around an irritant—such as a parasite or sand grain—by the soft internal tissues and built up of aragonite (calcium carbonate) layers, known as nacre. The orient, or iridescent luster, of pearls arises from the diffraction and constructive interference of light reflected from the boundaries of these layers.

Mother-of-pearl is the iridescent lining found in many shells and is especially beautiful in pearl oysters and abalone.

Pearlescent

Having an iridescent luster like that of the pearl. The effect has been reproduced in paints by introducing tiny slivers of glass. *See also* Iridescence; Opalescent.

Pepper-and-Salt

A color that is composed of a fine mixture of black-and-white. It is used to describe hair that is streaked with gray, or cloth with the same effect.

Perception

The perceptual process involved with vision is one of the most mysterious functions of the human brain. It is still not known exactly how crude messages from the lens and color-sensitive retina of the eye, with all their flaws, are converted into an exact and stable picture of the world in our mind.

"Space is filled with electromagnetic radiations, spread through a large spectrum of seventy octaves. Facing the immensity in frequencies of energy, man is given only one octave. He is conscious of this interval of one octave when he looks at a rainbow which permits him to know that his is visually translating this energy into color, from violet to red."
—François Parra

The brain is vital to our perception of color. Stroke victims with partial brain damage to the visual cortex, but with healthy eyes, have been known to fail to recognize color. Other research shows that the brain is probably centrally involved in the process of maintaining color constancy—in which colors are correctly identified in varying lighting conditions. (There is an enormous evolutionary benefit to recognizing predator or prey in the gray light of dawn, the yellow-white of midday, and the red light at sunset.)

The process of seeing color is partly determined by many factors, only one of which is the identification of the wavelengths of light by the eye. Recent theories suggest that the visual system and perhaps other cognitive processes such as the perceptions of form, depth, and movement are carried out in separate areas of the brain. One part may recognize straight lines, another edges, and a third the primary colors. These elements are then combined to give us our picture of the world.

The brain apparently is organized along parallel pathways, a layout that individual computers still have not duplicated. All information that we receive through our senses is processed simultaneously, rather than consecutively—however rapidly—as a computer does. Most intriguing is that there is probably a considerable amount of "cross talk" between pathways. Just how much takes place is in dispute. Nevertheless, each brain area probably has a continuous effect on the others. If the current theories are correct, this will lend credence to centuries-old observations of synaesthesia, in which one sensation gives rise to the experience of another—for example, it is possible for someone to listen to music and "see" colors. It seems possible that our emotional state may even be highly influential in the perception of color.

The way in which the brain processes visual information is in itself highly complicated and not well understood. While there is a correlation between the wavelength sensed by the eye and the color perceived, the relationship is not always direct. For instance, there is no "purple" wavelength; what we see is some mixture of "red" and "blue" light. That the brain is capable of "a high level of inferencing" in processing visual information was shown by Edwin H. Land, founder of Polaroid Corporation, in 1959. In an experiment, he proved that almost every color could be seen without the appropriate wavelength. He took two black-and-white photographs of a still life of flowers, one through a yellow filter and one through an orange filter. These pictures were then projected onto a screen through the same filters and in register. Fantastically, instead of being just yellow-orange, the flowers appeared in their full range of colors—reds, greens, and blues. The brain appears literally to invent the missing colors from the clues in the patterns of yellow and orange light reflected from the screen. Land was unable, however, to produce a satisfactory method of two-color reproduction from these results.

Nevertheless, it is apparent that the colors we perceive are inferences by the brain from messages sent by the eyes, taking into account ambient light and the shape, texture, and depth of an object. Beyond this, there are various visual phenomena that affect how colors are seen together, particularly that of simultaneous contrast. *See also* Aerial Perspective; Color Organs; Fragrance and Color; Land, Edwin Herbert; Music and Color; Optical Illusions; Simultaneous Contrast; Symbolism and Color; Synaesthesia; Visibility; Vision.

Peridot

A magnesium iron silicate, its green color determined by the amount of iron present. The rich "oily" color ranges from pale golden green to brownish green. Possibly named after the Arabic *faridat,* meaning gem. *See also* Gemstones and Jewelry.

Perkin, William

See Aniline.

Permanence

See Colorfastness and Dyeing; Conservation of Color; Fading.

Persistence of Vision

See Optical Illusions.

essay

Personal Color Analysis

Dominique Isbecque is vice president of Look Consulting in New York City and a national trainer for Fashion Academy, Inc.
A theory that four basic color types can be determined on the basis of skin tone and hair and eye color. These color types can then be used to design wardrobes and environments and to merchandise consumer products. The theory's roots can be traced to the Bauhaus artist and teacher Johannes Itten, who noted that an individual often had distinctive color preferences that complemented that individual's coloration.

In the 1940s, a Californian named Suzanne Caygill developed a visual system to determine an individual's best colors and styles according to skin, hair, and eye pigmentation. Gerrie Pinckney (1935–), another Californian, elaborated on the theory by developing elements of style, color, line, texture, and pattern that resemble nature's four seasons. For example, autumn is richly golden, full of textural opulence and detail; an autumn-type person has a coloration warm in pigment base, which will be enhanced by wearing gold-toned earth colors and intricate patterns such as paisley prints. The theory was further popularized by Carole Jackson in 1981, in her book *Color Me Beautiful*.

To determine an individual's color type and hence most flattering colors, the color consultant looks at the individual's skin tone, eye color, and hair color and then chooses the colors that most enhance his or her features. A color analysis can take from thirty minutes to three hours. A variety of techniques—such as draping, painting of skin tone, trying on makeup—are used. An undertone of warmth (yellow) or coolness (blue-pink) is determined by an initial fabric-draping comparison; beginning with the reds (yellow-reds versus the blue-reds), then neutrals (gray versus browns), lengths of fabric are wrapped around a person. The idea is that the "right" colors will brighten skin tone, even the complexion, smooth skin texture, balance the shapes of the features, and make the person appear rested and younger. The "wrong" colors will dull the skin tone and drain an individual's coloring, making it appear sallow.

The four main color types are:

Season	Undertone	Key Visual Identity
Spring	Warm, yellow	Fresh, light, bright, clear, crisp, lively, energetic, animated
Summer	Cool, blue/pink	Gentle, refined, delicate, soft, subdued, blended, flowing, translucent
Autumn	Warm, yellow	Rich, dynamic, earthy, regal, vibrant, strong, opulent, bold
Winter	Cool, blue/pink	Striking, dramatic, winter intense, serene, electric, vivid, contrasting, pure

—Dominique Isbecque

See also Caygill, Suzanne; Color Therapy; Itten, Johannes; Jackson, Carole; Lüscher Color Test; Rorschach Test.

Perspective

The illusion of depth and perspective can be created by the use of color alone. In general, blues and desaturated greens seem to be more distant than reds and oranges when applied, for instance, to the surface of a canvas or the wall of a room. The cause of this is both psychological association of colors with remembered scenes (such as the distant blues and greens of a landscape) and physiological constraints of the eye itself, which has trouble correctly focusing the red and blue extremes of the spectrum. *See also* Aerial Perspective; Optical Illusions; Perception.

Phosphores

Substances that luminesce when hit by light of a certain wavelength, such as ultraviolet light or electrons. Prime-color phosphores (phosphores that glow in one of the three additive primary colors—red, blue, and green) are used to coat the screen of a color television. The term comes from *phosphorus*, the Greek name for Venus or the morning star (literally, "light-bringer"). *See also* Luminescence; Phosphorescence.

Phosphorescence

Luminescence that persists for an appreciable time after the radiation that stimulates it has ceased; or the property of being luminous at temperatures below incandescence. Phosphores, as used in neon tubes and on television screens, produce fluorescence when stimulated. True phosphorescence is the storing of energy and its reradiation in the form of visible light. Some microscopic living organisms demonstrate phosphorescence when disturbed by motion.

Photoengraving

See Printmaking.

Photography

The earliest method of producing color photographs was the hand-coloring of black-and-white prints, a technique used since the mid-nineteenth-century daguerreotypes. It involved applying transparent color, either very thinned oil paint or watercolor, to the surface of the print, allowing the textural outline of the original print to show through. Another method was to print black-and-white images onto colored paper.

Hand-coloring is still done today, mostly for artistic effects, quite unlike true color

photographs. The most commonly used coloring mediums are specially formulated photo oils, watercolors, food-coloring dyes dissolved in water, and acrylics that are considerably thinned. Watercolors and some dyes can leave a dull finish and therefore are best used with semi-matte or matte-surface prints. Application can be with paintbrush, cotton swabs, or airbrush. For a natural effect, shadows are colored in a slightly warmer hue than is desired, to compensate for the cool gray of the black-and-white print.

The first true color photograph was produced by Scottish physicist James Clerk Maxwell in 1861. While demonstrating additive synthesis, he showed that three black-and-white images shot three times through primary-color filters and projected with their respective filters onto a screen would reproduce the full range of color. Taking three shots of the same subject was cumbersome, and color photography did not become commercially viable until Auguste and Louis Lumière of France produced the Autochrome process in 1907. This consisted of a glass plate coated with a mosaic of fine, transparent potato starch molecules dyed orange-red, green, and blue-violet, which was then covered with a photographic emulsion. The emulsion would be exposed only where the dyes, working as filters, let light through. When light was projected through the developed plate, it would show as additive color image. Autochrome plates absorbed much of the light that hit them, but the generally muted, low-key color gave very soft, impressionistic pictures.

Subtractive color photography was to prove more valuable in the long run: Instead of the primaries being mixed in light, they were superimposed as dyes on paper to make prints or on celluloid to make slides. In 1912, German chemist Rudolph Fischer (1881–1957) produced a color film, the first tri-pack, composed of three layers of emulsion, each sensitive to one primary color. He had invented color couplers that would link dyes to the light-sensitive molecules of silver halide, but after developing, the dyes tended to wander, producing blurred images.

By 1935, the Eastman Kodak Company and AGFA had found a way to hold the dyes in place, and they released 35mm reversal color film, which came in a compact roll and finally superseded the heavy plate camera. These early films still produced only slides, but most amateur photographers wanted prints. In 1942, Kodacolor film was released. The big commercial users of screen plates soon switched to tri-pack film.

In 1947, Edwin H. Land, founder of Polaroid Corporation, produced the first "instant" photograph, which had chemical developer combined with emulsion on the film. In 1963, he produced the first instant color film. Since then, developments have focused on increasing the speed of film and with making inexpensive cameras with injected plastic resin lenses.

The quality of color in photography is affected by the light conditions, kind of film, and use of filters. Lighting quality depends on strength and direction. Strong, direct light produces black, sharp-edged shadows and brilliant, defined highlights, with strong modeling of form. Natural light is strongest at noon, at high altitudes, and near the equator. Strong light weakens pale colors, but makes vivid colors more brilliant. Predominant color effects can be achieved by using tungsten film in daylight or daylight film indoors; tungsten film has the bluish cast of artificial light, and daylight film gives a warmer color. There is also a false-color film in which the usual color sensitivities and dye-production characteristics have been altered to achieve distinctive visual images. The most common type is infrared-sensitive color film; the normal sensitivities of the tri-pack film to blue, green, and red are changed to infrared, green, and red. The result is that green objects are seen as blue, red objects as green, and objects reflecting or emitting only infrared as red.

Filters

The use of filters on a camera lens can give great control of the overall color in the final picture. Weak color filters can emphasize warmth or coolness. Strong color filters can add entirely new color nuances. With black-and-white film, yellow filters will absorb excess blue (outdoors), thereby slightly darkening the sky and emphasizing clouds. Green will deepen flesh tones and is used for portraits outdoors and under tungsten light, and for landscapes and foliage. Orange filters render blue tones darker, as in seascapes. Red filters create dramatic sky effects and are used to simulate "moonlight" at midday. They turn foliage white and cut through fog and mist. Dark blue filters accentuate haze and fog.

With color film, each color filter will slightly accentuate its own color while reducing the effect of the rest, especially the complementary. There are several other filters for use with color film, including:

Polarizer: This filter eliminates surface reflections and unwanted glare; it is the only

one that will darken a blue sky and increase color saturation.

Skylight: It can be used at all times outdoors to reduce blue and add warmth to scenes.

Haze: This reduces excess blue caused by haze and ultraviolet rays. Ideal for mountain, aerial, and marine scenes.

UV (Ultraviolet): This filter also cuts out haze, and can reduce blue in shade.

Soft Contrast: It reduces highlights in bright light, which would otherwise be washed out in the picture. Low-contrast filters achieve the same effect by lightening shadow areas, to bring them closer in value to the highlights.

Sepia: This adds a warm brown sepia effect to color imaging, simulating the look of early photography.

Color-correction (CC) filters are used to correct to color balance of light by affecting just one or two primaries, and are sometimes used at the printing stage (usually with color transparency film). CC filters come in the secondary colors of cyan, magenta, and yellow, which absorb red, green, and blue, respectively. They are also available in primary red, green, and blue, each of which absorbs the other two primaries to equal degree. Two different secondary color filters may be used to control two primaries to different degrees. Three secondaries or two primaries cannot be used together, since they will cut out too much light.

Color Film Sensitivities

Color film is designed to be sensitive to all colors of the spectrum in approximately equal amounts. In practice, some colors, such as the blue of the sky, may be much brighter than others, and filters have to be used to prevent overexposure in those areas. Black-and-white film was originally sensitive only to blue light; now almost all general-purpose black-and-white film has a panchromatic emulsion, sensitive to all visible wavelengths. The ordinary ultraviolet and blue sensitivity of silver halide emulsion is extended to the green and red portions of the visible spectrum by dye sensitization during manufacture.

Color Printing

Color prints, unlike black-and-white, are made on paper that is sensitive to all colors of light. For this reason, printing must be done in total darkness. Filters are used during exposure for each of the primary colors. Printing can be done either additively or subtractively. In the additive method, exposures are made through red, green, and blue filters. Most color printing is done by subtractive exposure using cyan, magenta, and yellow filters. The filters can be varied to adjust the color balance required. No more than two filters are used at any one time, or too much light would be filtered out.

There are four kinds of materials for making direct color prints:

1. Negative paper, which is exposed to a color negative and processed in developer, stop bath, and bleach fix solutions.
2. Reversal paper, which is exposed to a positive color transparency and processed in first developer, stop bath, second (color) developer, bleach, fix, and stabilizer solutions.
3. Dye destruction (silver bleach) paper, which is exposed to a color transparency and processed in developer, bleach, and fix solutions.
4. Diffusion transfer films, which are exposed to a color negative or transparency (a different type of film in each case), soaked in an activator solution, and laminated with a print paper until the image has transferred.

There is also one major indirect color-printing method: the dye-transfer process. It is indirect because the print paper is not exposed to a color image. Instead, black-and-white separation negatives are made from the color negative or transparency. These are used to make gelatin-relief matrix images, which absorb dyes and transfer them to the final print sheet.

Fading is a severe problem with color photographs, because the image-forming dyes in most color materials are inherently unstable, whereas in black-and-white photographs colorfastness is primarily a matter of processing procedures.

Images on resin-coated papers are more susceptible to atmospheric attack than those on fiber-based papers; sulfur compounds from rubber cement and other such adhesives will also penetrate paper and attack images. Only color images formed in metallic dyes, such as those used in current dye-destruction materials (e.g., Cibachrome), show virtually no fading. The dyes used in a dye-transfer process are somewhat less fade-resistant but are far more stable than the organic dyes used in virtually all other color films. Fading can be reduced by keeping photographs out of direct sunlight or, better still, in light- and moisture-proof packages. Another conservation method is to make separation negatives of the original image on black-and-white film, which can then be safely stored away almost indefinitely; the

1861—*First color photograph, by James Clerk Maxwell.*

1903—*Autochrome process, by Auguste and Louis Lumière.*

1912—*First tri-pack color film, by Rudolf Fisher.*

1935—*First 35-millimeter color film, by Eastman Kodak.*

1963—*First instant color film, by Edwin Herbert Land.*

Pablo Picasso.

color image can be perpetually re-created. *See also* Computers and Color; Continuous Tone; Kodachrome; Negative.

Photometer

An instrument for measuring light; that is, radiation evaluated according to its visual effect. Historically, photometers required a visual comparison of two lights displayed side by side, or consecutively as with a flicker photometer. Modern usage of the word includes its application to automated photoelectric color-measuring instruments, such as the spectrophotometer. *See also* CIE System and Color Measurement; Colorimeter; Measurement of Color.

Photon

A quantum, or "packet," of light energy. Light behaves under certain circumstances as if made up of invisible packets of energy. For example, light is seen to have mass because it is attracted by gravitational forces. The amount of energy that a photon represents increases with the frequency of the light; a quantum of violet light has about twice the energy as that of red light. *See also* Light.

Photopic Vision, Photopia

The normal process of seeing in bright light with the light-adapted eye, using only—or mainly—the cones of the retina. Because the fovea (the central pit on the retina) has only cones, the greatest visual acuity is achieved with photopic vision during daylight or with sufficient illumination. *See also* Dark Adaptation; Vision.

Photoreceptors

See Vision.

Phthalocyanine Blue, Green

See Artists' Pigments.

Picasso, Pablo

1881–1973. Spanish-born artist and perhaps the greatest innovator in art of the twentieth century.

Picasso's early work was distinguished by his use of the color blue. During this blue period (1901–6), he concentrated on alienated figures. This was followed by a rose period, one of substantial, robust forms and scenes drawn from circus life. A close friend, Luis Miguel Dominguin, summed up the close association he saw between the artist and at least one of his colors when he wrote, "I confess that I can hardly distinguish black

from white, or red from blue. But, in truth, if I concentrate, there is a color I know well. Pink, Picasso pink. Because, when all is taken into account, I say that Pablo Picasso is pink. Pink with the tragedy of black, the power of red, and with more purity than white."

In 1907, Picasso's painting *Demoiselles d'Avignon* catapulted the colors and forms of African primitivism into the European art world, and it was a landmark in the development of cubism.

Picasso's colors primarily served the artist's formal inventiveness. By 1910, his analytical cubist palette of browns and tans—largely monochromatic—appeared. This was later superseded by the synthetic cubist palette of saturated colors spread along a planar surface. In *Three Musicians* (1921), he juxtaposes vivid costumes against a brown background. His *Seated Bather* (1931) uses a subdued palette of tan and blue, while a year later, in *Girl Before a Mirror*, the brights are lavish and bold. In *Guernica* (1937), a severe palette of white, gray, and black reinforces the powerful forms, which depict the devastation of the Spanish Civil War.

In the last years of his life, he employed the primary colors—red with green, blue with yellow, and black with white—with immense power and virtuosity. *See also* Abstraction of Color; Cubism; Painting and Color in the Twentieth Century.

Pigment

A colored substance that is insoluble in, and physically and chemically unaffected by, the medium in which it is dispersed. A pigment is distinguishable from a dye or a stain, in that the latter are soluble in the vehicles with which they are mixed. Pigments are customarily classified or categorized, according to their origin, either as organic (animal, vegetable, or synthetic organic) or as inorganic (mineral or synthetic inorganic). *See also* Artists' Pigments; Natural Earth Pigments; Paint.

Pigment Opacity

See Opacity, Pigment.

Pink

A tint made by adding white to red. Natural sources of pink dyes include brazilwoods and lac, a resinous insect secretion that is the source of shellac. Famous pinks include salmon and shell pinks (important calico colors), Japanese woodcut ginger pink, Williamsburg rose, Pompadour rose, Vassar rose, Schiaparelli pink, Miami deco pink,

and the 1950s baby pink. *See also* Baby Blue, Baby Pink; Baker-Miller Pink; Colloquial Language, Color in; Sources of Historic Colors; Symbolism and Color; Trends in Color.

Pixel

Acronym of "picture element," the smallest element of an image that can be individually processed on a video display system. A pixel is too small to be seen in itself by the human eye at normal viewing distances. Instead, the eye will create the impression of a continuous-tone image over the whole surface. *See also* Computers and Color; Television.

Planets

See Astronomy and Color; Systems of Color.

Plant Colors

Color is a natural by-product of the life processes of plants. The simplest waterborne algae, which appeared around 3 billion years ago, probably contained the pigment phycoerythrin, which absorbed light to give the organism energy. One wavelength, red, is strongly reflected by phycoerythrin, enough to earn the Red Sea its name even today.

Land plants depend on the pigment chlorophyll for photosynthesis, in which light energy is used to manufacture carbohydrates out of water and carbon dioxide; this pigment reflects green light. All other colors found in plants, flowers, fruits, and so on are similarly accidental by-products of basic chemistry that have found some evolutionary use either for defense or in the reproductive process.

Early flowering plants were probably green, developing new colors by genetic mutation. When these colors, contrasting with the background green, began to attract insects, which distribute pollen away from and beyond competition with the parent plant, these plants had a greater chance of survival. Plants most likely then began producing nectar as food for visiting insects, and the symbiotic relationship was established. Primitive flowers were probably white or yellow (daisies and dandelions), but flowers later evolved with colors that attracted those insects best suited to transporting their pollen and seeds.

In autumn, when many herbaceous plants die, chlorophyll quickly breaks down, leaving secondary red, orange, and yellow pigments, the carotenoids, which assist in photosynthesis and protect plants against harmful ultraviolet light rays. These pigments may also play a role in protecting against mineral deficiency: Leaves of orange and apple trees and of cotton and cabbage plants turn brown, red, or purple when deficient in potassium; alfalfa turns red without boron; cotton turns blue-red without magnesium.

Another pigment, anthocyanin (the principal colorant in daffodils, primroses, and tulips), acts as a natural gauge of the acidity of the cell sap in which they are dissolved: Red hydrangeas turn blue in alkaline soil, and back to red in acid, while in neutral soil they are violet. The same pigment, anthocyanin, is a vital tool for fruit- and berry-producing plants. Before ripening, fruits are well camouflaged in the green foliage. On ripening, the sugar level quickly rises, and anthocyanins produce high-contrast reds, yellows, and blues, making the fruits irresistible to birds and animals, which will carry the seeds in their stomachs, to be later deposited far away, covered with their excrement, a natural fertilizer. To enhance survival, seeds themselves are an inconspicuous dull brown.

The spectrum of plant colors are thus often tied to the feeding patterns of particular animals. Bees are most attracted to blue and ultraviolet and can detect six different colors: ultraviolet, violet, bee-purple, blue, bluish green, and yellow. Flies, by contrast, prefer white, pink, yellow, or green. Flowers adapted for pollination by beetles, which have poor eyesight, tend to be large, conspicuous, strongly perfumed, and colored white. In other flowers, nectar is produced in elongated floral tubes, which can be reached only by butterflies or hummingbirds (with their long beaks). Butterflies have good color vision and are attracted to flowers that range in hue from pink to gold and bright blue. Flowers adapted to the poor sense of smell of sunbirds and hummingbirds are particularly bright, with red, orange, and yellow being the most common colors.

Some plants, such as the phlox family, shift the colors of their blooms from dark to light to encourage different pollinators, depending on the time of year. Scarlet gillia plants, with their trumpet-shaped flowers, produce more muted shades of their deep red color in mid-August, about halfway through their blooming season—after the hummingbirds, which, like that color, have left. The secondary pollinators, hawkmoths, prefer the light reds, ranging from pinks to almost white.

Some flowering plants are specifically adapted to the area in which they grow. Plants have discovered the benefit of group coloration—called Müllerian mimicry, after German scientist Johannes Müller (1801–58): Arctic and subarctic plants have a high pro-

"You have to observe flowers in order to find the right tones for the folds of clothes."
—Jean-Auguste-Dominique Ingres

"I love to study the many things that grow below the corn stalks and bring them back to the studio to study the color. If one could only catch that true color of nature—the very thought of it drives me mad."
—Andrew Wyeth

"Why is grass green and why is blood red are mysteries which no-one has reached into."
—John Donne

portion of white flowers, making the most of the weak sunlight; desert dwellers tend to be yellow, while those high in the mountains, where there is a greater proportion of ultraviolet light, are usually blue.

Non-flowering plants may also have strong color identities: Venus flytraps mimic the red of flowers to lure their live prey; pebble plants hide themselves from predators with color patterns identical to small stones; poisonous mushrooms or toadstools are often a brilliant carmine, an unambiguous signal of danger. *See also* Zoology and Color; Appendix: Color Atlases.

Plastic

From the Greek *plastikos* (to mold), the word plastic denotes anything malleable. In art, the plastic arts are those based on modeling, primarily sculpture, or, more generally, any of the visual arts, as opposed to the literary or performing arts. The word *plastic* is also applied to the large group of synthetic polymers that can be formed into objects.

The first commercially successful but only partly synthetic plastic was celluloid, which was formulated in the late nineteenth century. A malleable material, celluloid was first produced in white and brown, to simulate the natural plastics ivory and tortoiseshell, for which it was an inexpensive substitute.

The discovery of Bakelite in 1909, a thermosetting resin that was the first *entirely* synthetic plastic, could and did add a deep faux gemstone color range of bright "jade" greens, "ruby" reds, and "sapphire" blues. Bakelite, a phenol-formaldehyde resin, gains its color by the combination of a synthetic pigment and what is termed a filler: wood flour, cotton flock, asbestos, mica, or ground walnut. During the 1920s, the radio brought Art Deco plastic colors such as case brown, knob orange, and dial black and yellow into practically every American home. Depression-era pins, buttons, buckles, ring boxes, and costume jewelry of Bakelite display a remarkable range of subtle colorings.

By the late 1920s, the successful substitution of urea (ammonia and carbon dioxide) for phenol in the formaldehyde formula resulted in a new thermosetting molding powder, which led to an expanded color range, including a pure white, pale pastels, and more stable saturated hues.

Post–World War II plastic colors expanded to include strong primary reds, yellows, and greens, as well as clearer and more delicate pastels. In the late 1940s, Tupperware food-storage bowls of milky white, pale sky blue, and soft melon oranges were described in a *House Beautiful* magazine advertisement as

"art" for the incredibly low price of "thirty-nine cents."

In the 1960s, Olivetti, the Italian manufacturer, introduced black, red, and yellow plastic typewriters, which transformed drab office machines into personal accessories. Also in the 1960s, international clothing designers used colorful plastics in sequined and vinyl miniskirts and accessories.

The plastic laminate furniture of the 1950s diners, in the hands of postmodern designers, became an art form in the 1980s. Brought into fashion were a plethora of pale turquoises, mint greens, bright yellows, black, and white, along with faux surface finishes and mass-produced accessories in outlandish bright colors. From toys to telephones, from vanities to kitchenware, plastic colors reflect each decade of the twentieth century. *See also* Bakelite; Memphis; Trends in Color.

Platinum

Both a light gray with a bluish tint and a pale, bleached yellow, as in a platinum blonde; also a silvery white metal, highly lustrous and ductile. The name originates from the Spanish word for silver, *plata*. Platinum never appears in nature as a pure metal but as an alloy with other metals of the platinum group—copper, gold, and nickel.

Pleochroism

The property in some crystalline substances, such as opal, of exhibiting different colors when viewed from different directions under transmitted light. *See also* Dichroism; Gemstones and Jewelry.

Pliny the Elder

23–79. Roman naturalist, whose one surviving work, *Historia Naturalis* (Natural history), consists of thirty-seven volumes that deal with the nature of the universe, geography, anthropology, zoology, botany, and mineralogy. He also struggled with the mysteries of color. Pliny related colors to nature:

> I remark that the following are the three principal colors; the red, that of kermes [an insect], for instance, which, beginning in the tints of the rose, reflects, when viewed sideways and held up to the light, the shades that are found in Tyrian purple; . . . the amethystine color, which is borrowed from the violet; . . . and a third, properly known as the "conchyliated" color, but which comprehends a variety of shades, such, for instance, as the tints of the heliotropium, and others of deeper color, the hues of the mallow, inclined to a full purple, and the colors of the late violet.

Plum

A dark reddish purple like that of the fruit of *Prunus* trees. *See also* Purple.

Pointillism

In its broadest sense, a method of painting pictures by methodically applying small dabs of paint. More specifically, a method of picture-making, also known as divisionism—one of several styles collectively known as neoimpressionism—that employs such an approach to obtain variations of color by optical mixing.

In conventional color mixing by painters, two colorants may be combined on the palette to obtain a subtractive color mixture, which usually incurs the absorption of a large proportion of incident light. The theory of pointillism proposes that if the same colorants are laid side by side, and then viewed from a distance, the light reflected from both will fuse in the eye of the viewer to give a single color impression, an "optical mixture," absorbing a significantly smaller proportion of light and, therefore, appearing more luminous.

The effect was first systematically studied in 1839 by Michel-Eugène Chevreul during his search for principles underlying the optical mixture of color by weavers at the Gobelins Tapestry Manufactory in Paris. In 1879, Nicholas Ogden Rood combined Chevreul's findings with those of Thomas Young (1807) and James Clerk Maxwell (1855) to realize that the color theory for interwoven threads of a piece of cloth or the mosaics of painted dots was essentially the same as that for color fusion by spinning disks. While such optical color mixing does not involve the physical combination of light beams from separate light sources, it does appear to correspond to the red-green-blue theory of additive primary-color mixture, whereby, for example, a mosaic of red and blue points of paint, or sectors of a disk, will fuse optically and appear magenta or purple when seen from an appropriate viewing distance.

Rood's 1879 book, which was translated into French in 1881, provided the scientific basis for initial experiments by the young French painter Georges Seurat, whose best-known pointillist work is *A Sunday Afternoon on the Island of La Grande Jatte* (1884–86). Seurat is also known to have read an 1867 reference to color mixing by Charles Blanc that states that, when a pattern of narrow stripes is alternately colored red and green, "it will happen that the red and the green mingle with and destroy each other by their apparent mixture, optical mixture, and the panel will appear gray and colorless."

Other notable pointillists include Henri-Edmond Cross (1856–1910) and Paul Signac (1863–1935), although there were few important painters working in Paris between 1885 and 1915 who did not experiment, however briefly, with some variation of the pointillist method. *See also* Chevreul, M. E.; Optical Mixture; Seurat, Georges.

Points of the Compass

See Compass, Points of the (and Color Symbolism); Fashion: Geography of Color.

Poiret, Paul

1879–1944. French couturier who epitomized the lavish chic of pre–World War I Paris. He was influential in curtailing in dress the pervasive use of the washed-out blues and pinks, overly "dusty" or grayed mauves, and funereal, somber blacks of the late nineteenth century. Poiret advocated the use of brilliant colors. His clothing designs used reds, often in combination with purples, gold, emerald and lime greens, and deep blues in supple, soft fabrics. From 1903 to 1914, Poiret's colorful outfits did much to encourage the world of haute couture to choose a lavish and vivid color range. *See also* Fashion and Clothing Color.

Poisonous Colors

Colors may be poisonous either because the pigments from which they are made contain toxic substances such as lead, arsenic, or radioactive materials (as in fluorescent paints used on watch dials) or, psychologically, because they are perceived as being so ugly that they are deemed to be commercially "poisonous."

Physically poisonous pigments include flake white (from lead carbonate), Naples yellow (when made with lead ammoniate), the chrome yellows and greens (from lead chromate), and Veronese and Paris greens (from arsenic compounds). Since 1975, reports have called attention to possible dangerous effects of pigments containing cadmium, chromium, manganese, and mercury. These include the cadmium reds, yellows, and oranges, viridian and chrome opaques, manganese blue and violet, burnt and raw umber, and vermilion (mercuric sulfide), quinacridone colors, and Realgar (arsenic sulfide). Pigments and the chemicals they contain can enter the human body through the mouth, via skin abrasions, and through inhalation.

In 1971, in response to the number of cases of lead poisoning among children in urban areas who ingested paint chips, the federal government passed legislation to limit the

Paul Poiret.

manufacture of lead-based paints. Subsequently, mercury, like lead, has been outlawed, except in industrial use. Legislation curtailing the production of pigments with either lead or mercury pertains to both commercial and artists' paint pigments. *See also* Artists' Pigments.

Polarized Light

Light waves that vibrate in one direction only are said to be polarized. All light sources (except laser) produce naturally chaotic light: To produce light that is vibrating in only one plane, a beam of light is passed through a slit with an aperture less than a wavelength in width. In this case, only those light waves going up and down in the same plane as the slit will be able to pass through.

Since much of the light is cut out, the intensity of the beam is reduced. However, polarized light produces no glare, so colors appear more saturated. Polarizing lenses on cameras and sunglasses deepen the blue of the sky and intensify the colors of the landscape by cutting out dazzling glare.

A common material for polarizing light is the plastic film known as Polaroid, which has myriads of needle-shaped crystals arranged with their long axes parallel. Each crystal acts like a slit in a screen. If two Polaroid filters are used in conjunction, with one rotated by 90 degrees, all light will be cut out. By varying the angle of rotation, the amount of light filtered out can be controlled.

Several substances, if placed between two crossed Polaroid sheets, will cause light to be transmitted again by the second sheet. Sheets of cellophane and mica, flax, cotton, white hair, and wool fibers frequently show such optical properties, due to their double refraction of light. They will create beautiful and varied color effects when rotated between crossed Polaroids.

Polaroid® Instant Photography

See Land, Edwin Herbert.

Pollock, Jackson

1912–56. American painter and leading abstract expressionist, who pioneered the "drip" technique and "action painting."

Pollock tacked large canvases to the floor and dripped, splattered, or even threw paint on the surface while he himself moved around the edge—hence the name *action painting.* Like Wassily Kandinsky, Pollock viewed artistic expression as inward, directed by mysterious psychic forces. The random fall and spatter of pigment was part of the painter's striving and had the power of

unplanned immediacy—the technique was an intrinsic part of the creation of an artwork. Pollock was among the first abstract artists to emphasize the "process" element in the making of a painting, and the use of paint pigment in an expressionistic and highly textured manner. He often employed a primordially minimal palette of black and white accented with red, and in this way brought a primitive color sensibility to modern abstract painting. *See also* Abstraction of Color; Expressionism; Kandinsky, Wassily.

Polychrome, Polychromatic

Having or exhibiting many different colors; multi-colored.

P'o Mo

Chinese term for ink wash, a monochrome ink painting considered superior to a color painting, which many Oriental artists denigrate as being a mere imitation of outward appearances. Some Chinese and Japanese connoisseurs maintain that the "life breath" of a painting depends on the manner of applying the ink wash (to give the picture maximum luminosity). P'o mo is sometimes called "splashing ink," meaning that the brushwork is free and spontaneous. P'o mo was developed by Tang-dynasty artists (618–907) and taken up by later painters.

Pompadour Rose

A delicate pastel pink named after Madame de Pompadour (1721–64), mistress and confidante to King Louis XV of France (1710–74). There is a similarly delicate blue, and both colors are seen in the work of the painter François Boucher (1703–70), whom she patronized, and in the porcelains from the Sèvres factory, which she supported. *See also* Rococo Colors.

Pompeian Color

Pompeii, an ancient Roman city, was buried by the eruption of Mt. Vesuvius in A.D. 79. Excavations in the eighteenth century revealed much about Roman life and architecture, including glimpses of Pompeian taste for color. The Pompeians decorated everything: the walls of their rooms, the facades of their buildings, their floors, pavements, porticoes, statues, and shrines—in contrast to the prevailing Roman taste for simple marble facing.

Pompeian wall painting evolved through several successive styles. In the early stages, the wall painting consisted basically of a dado—decoration applied to the lower part of a wall—above which were panels, and above these a frieze representing the open

air. The illusion of perspective was created through painted, simulated architecture: painted columns and cornices, "behind" which were other decorative paintings, giving trompe l'oeil effects of open spaces beyond the wall, often as elaborate as landscapes and garden scenes with trees, shrubs, fountains, and flowers.

By the first century A.D., the Pompeians turned away from the illusion of three-dimensional space and concentrated on purely decorative formal schemes. There was an increasing emphasis on fields of color and pattern, and architectural detail became mainly a frame for the picture. Wall surfaces were covered with delicate, decorative fantasies: trailing vines, slender candelabra, animals, or abstract geometrical motifs. A typical color scheme was black dado, a green middle area with black verticals, and white upper areas.

Birds and other animals, especially marine life, figured prominently in smaller panel painting. Uncovered are charming garden scenes featuring storks, a pet dog, and a lizard, as well as the exotic Egyptian bird the ibis (perhaps part of the popular cult of Isis). Fruits and vegetables, probably native to the region—grapes and vines being common symbols, because of the town's prosperous wine trade—are painted in incredibly soft, subtle tonalities: delicate pinks, rosy tones, luminous golden beiges.

Strongly Hellenistic, but less refined and exquisitely wrought than Greek art, the Pompeian style owes its greatest charm and brilliance to the light, sketchy, freehand manner of its execution, the broad, impressionistic technique favored by Pompeian artists. See also Sources of Historic Colors.

Pop Art

An American art movement of the 1960s, characterized by a glorification of the commonplace. Partly as a reaction to abstract expressionism, pop artists offered super-realistic depictions of American advertising, billboards, comic books, and other forms of commercial art, rendered primarily in the flat colors of screen printing. Roy Lichtenstein, for example, enlarged benday dots in raw primaries to reconstruct in giant scale the banality of comic-strip romance and adventures. Andy Warhol produced multiple silkscreened representations of Marilyn Monroe, Campbell's soup cans, and Coca-Cola bottles, while Claes Oldenburg (1929–) celebrated the slick, wet bright colors of the plastic age in vinyl sculptures of gigantic lipsticks and kitchen appliances. Jasper Johns found inspiration in the American flag, arabic numerals, and bull's-eye targets.

The American pop palette favored chrome gray, turquoise, flesh tones, and primary yellow, orange, and red. See also Johns, Jasper; Lichtenstein, Roy; Sources of Historic Colors; Warhol, Andy.

Pope, Arthur

1880–1974. American art educator, writer, color theorist, and director of Harvard University's Fogg Museum. He studied under Denman Waldo Ross (1853–1935), a champion of fixed palettes and organized color scale in painting. To Pope (and to Ross), good order assured good color expression. Not to be knowledgeable in matters of color theory was to be aesthetically illiterate.

Pope developed a system of color and a color solid that has been greatly admired by artists and highly praised by scientists. It was based on red, yellow, and blue key hues and was organized in terms of different-shaped triangles that made allowance for colors of different values and intensities.

Pope wrote several books and extensively described the color choices of Renaissance masters and the fact that many of their works omitted certain pigments.

Positive

An image in which the relative brightnesses or colors of various areas correspond directly to those of the original subject.

Posterization

A photographic technique for reproducing the look of a poster with its flat areas of tone and color. By translating a continuous-tone image into three or four tone steps, a photographer can achieve a graphic boldness and simplicity. The maximum effective number of tonal steps is five; otherwise the image is increasingly seen as continuous tone.

Tonal separations are made from either prints or transparencies on a high-contrast film, one for each tonal step. For a three-tone black-and-white image, three negatives are made exposing highlights, middle values, and dark areas in turn. When superimposed, the additive effect of exposure makes the shadows darkest, the middle tones a lighter single tone, and the highlights the lightest single tone.

Color posterization is achieved by filtering the exposing light; any color may be used and the filters changed for each exposure. By deft manipulation of positives and negatives, the color separations can then be produced for the printer. Three-tone separation is usually the practical maximum in color posterization; the ability to change both colors and

exposures in the various steps makes a great number of variations possible.

Postimpressionism

An art movement originating in France in the late nineteenth century in reaction to the impressionist movement. Postimpressionism dates to 1886, the year of the eighth and last impressionist exhibition in Paris. The impressionist painters, whose works were criticized as crude and unfinished, were beginning themselves to feel that too many traditional, formal, and structural elements were being neglected in the search for the momentary sensations of color and light. Since postimpressionist work varies enormously, while still retaining the impressionists' bright palette, the name denotes the chronological sequence more than any one particular style.

The postimpressionist painters include the neoimpressionists and pointillists Georges Seurat, Alfred Sisley (1839–99), Paul Cézanne, Paul Gauguin, Vincent van Gogh, and, by some definitions, Edgar Degas. *See also* Neoimpressionism; Pointillism; *and entries on individual artists.*

Postmodernism

A late-twentieth-century movement primarily in architecture, interior design, and literature that, in reacting to the sameness and anonymity of white, black, and gray modernism, returned to historical forms for sources in the visual arts. In architecture, the most influential notables include Michael Graves (1934–), born in Indianapolis; Robert A. M. Stern (1939–), born in New York City; and Robert Venturi (1925–), born in Philadelphia. The colorful exteriors of their, and other, postmodern buildings are often in a pastel palette of pink granite and marble surfaces, combined with mint green and aqua blue glass; interiors are even more dramatic in their color articulation of architectural members, particularly classical columns, faux finishes, and other theatrical effects in the movement's high-value colors. *See also* Architecture and Color; Memphis; Sources of Historic Colors.

Pre-Columbian Colors

The colors used by the Incan, Mayan, and Aztec civilizations, in their "books," textiles, frescoes, featherworks, and other artifacts made prior to the invasion of Central and South America by the Europeans, at the end of the fifteenth century and afterward.

Pre-Columbian Aztec colors, which are preserved in mineral and vegetable dyes on bark and on deer and jaguar hides in the form of written "books," exhibit a distinct range of deep reds, clay browns, vivid straw and lemon yellows, turquoise blues, deep emerald greens, and grays and black. In one of these early "books," *Codex Borgia*, which depicts religious scenes of the death of a god and goddess on a moonlit night, the colored images are so bright, and the animals—rabbit and cat—so realistic that they appear modern, almost out of a comic strip.

Color harmonies are readily seen in textiles. With native cotton and wool from the domesticated llama and alpaca and the wild vicuña, the Incas had an advanced hand-weaving industry. Thanks to the aridity of the coastal climate of Peru and the total absence of groundwater, many examples of their work survive. Dyes came from vegetable, mineral, and some animal sources, most notably cochineal (for the reds), making up a palette of some 190 identifiable colors. Natural shades of off-black and off-white wools and cottons further extend the range. Multiple combinations of colors—up to twenty-two in a single fabric—are unique to early Peruvian textiles.

Both the Incan (A.D. 1100–1530) and the Tiahuanacoan (also Peruvian, A.D. 600–900) cultures are noted for their use of lively abstractions and warmly colored patterns of puma gods, birds' heads, cats, llamas, and fish. Recurring analogous harmonies include blood–red, llama–straw, desert sun–orange, and wool–white. A sparer use was made of dark brown, indigo blue, and turquoise. In luxury or ritual items, feathers were woven into the textiles for embellishment. Favorite bright colors came from birds of the Amazonian jungle: parrots (yellows and oranges), macaws (blues), and Muscovy ducks (greens and shiny blacks). The colors of these feathers have remained remarkably bright through the passage of time.

A discovery in 1946 of an eighth-century classic Mayan polychrome floor-to-ceiling fresco at Bonampak, Mexico, made it clear that pigments of mineral origin, particularly the iron and copper oxides, were all in use. They were almost always diluted, never applied pure. Even color modeling is to be seen in these ancient Mexican wall paintings.

The multi-colored decorative ceramics of Peru were developed after Paracas pottery from circa 1000 B.C., which tended to be monochrome. By the Nazca period (ca. 200 B.C.–A.D. 600), the ceramics were fully polychrome: blacks, reddish brown, rust red, bone white, tan yellow, and cream.

The colors of Incan pottery: black, reddish brown, white, tan-yellow, and cream.

Prehistoric Colors

Colors found on cave walls of archaeological sites such as those in Lascaux, France, and Altamira, Spain, dating back to Paleolithic times; predominantly a palette of mineral reds and blacks.

Over 20,000 years old, Paleolithic paintings have endured because of the constant temperatures and humidity of the limestone grottoes in which they were painted. The rock walls exhibit friezes of ibexes, bulls, horses, birds, and occasionally human figures. The Paleolithic palette included red and yellow ochers from iron oxide; grays and black from burnt bones and black manganese oxide; and white from china clay or kaolin.

Reds and blacks, perhaps symbolizing life and death for primitive humans, were the colors consistently used and favored. Archaeologists speculate that prehistoric humans believed that, by drawing the images of animals, they could capture their spirits. In this way, painting could ensure a successful hunt—and life itself. Cave paintings are among the first extant examples of human power to think beyond immediate needs. *See also* Symbolism and Color.

Prendergast, Maurice

1859–1924. Born in St. John's, Newfoundland, an American painter known and favored for his idyllic scenes of beaches and gardens, parasols and merry-go-round ponies in blotchy decorative surfaces of muted colors. In 1908, Prendergast joined Arthur B. Davies (1862–1928), William Glackens (1870–1938), Robert Henri (1865–1929), Ernest Lawson (1873–1939), George Luks (1867–1933), Everett Shinn (1876–1953), and John Sloan (1871–1951). The Eight, as the group came to be known, never exhibited together but later challenged many style conventions in the representation of color by using freer, bolder, more patterned, tapestry-like color than was taught or thought appropriate in American and European art academies.

Pre-Raphaelites

A brotherhood of English painters and poets formed in 1848 to elevate art by rejecting the materialism of industrial England and returning to the simplicity of medieval times. Principals included Edward Burne-Jones (1833–98), William Holman Hunt (1827–1910), William Morris, and Dante Gabriel Rossetti (1828–82). The painters set out to emulate the innocent style of the Italian artists prior to Raphael (1483–1520). The result was somewhat mannered work in a bright decorative palette. Auburn reds and forest greens are abundant and lend a unique color tonality to Pre-Raphaelite work. *See also* Morris, William.

Preservation of Color

See Conservation of Color; Restoration.

Primary Colors

Simply stated, primary colors are ones that cannot be mixed or formed by any combination of other colors. A balanced mixture of all three primaries adds up to black (when mixing pigments) or white (when mixing lights). By varying the proportions of primaries, every conceivable color can be produced.

Today, three sets of primary colors are generally recognized in the fields of art and science. Oldest by tradition are the red, yellow, and blue colors long adopted as primary for artists. Printers, however, depend on the intermediate colors between additive primaries, namely, magenta, yellow, and cyan. Because paints absorb light, a mixture of these subtractive primaries will add up to a black in theory, though in practice, since no pigments are pure enough, they produce a dark brown.

The second set of primaries as recognized by scientists comprises the additive or light primaries of red, green, and blue (or blue-violet). When combined, lights of these colors will produce most other hues: Red and green light rays will form yellow; red and blue light will form magenta; blue and green light will form cyan. All three, when mixed, will form white. These three colors are additive and will be found on television screens as emitted by three phosphores.

The third set of primaries consists of colors recognized in the fields of vision and psychology: red, yellow, green, and blue. These are elementary visual sensations and are known as the psychological primaries. In human vision, there is a definite tendency to simplify and hence to clarify visual experience. Thus, although we see many shades of color, we encode relatively few and tend to try to relate colors for organizational purposes. Thus, even though red and violet are in fact at opposite extremes in wavelength, they are psychologically related through purple (itself not a spectral color but a blend of red with violet or blue). *See also* Additive Color Mixing; Process Colors; Subtractive Color Mixing.

Prime-Color Phosphores

See Phosphores.

Printmaking

The earliest European woodcuts appeared about 1400, at around the same time that paper became cheaply available. These prints were commonly single sheets depicting biblical scenes intended for inexpensive sale at religious shrines. Most consisted of single-color impressions (usually black) onto which colored paints were brushed or stenciled by hand.

The earliest known multi-colored woodcut was produced in 1482 by Erhard Ratdolt (1462–1523), a German printer working in Venice, who mastered the necessary skills of printing separately inked blocks in accurate alignment. By 1510, Lucas Cranach (1472–1553) had begun to produce high-quality chiaroscuro woodcuts, consisting of a key outline block with additional blocks for highlights and shaded areas, printed on tinted paper. A similar technique, introduced independently in 1516 by Venetian printer Ugo da Carpi (ca. 1480–ca. 1525) omitted printed outlines; it was perfected by Hendrik Goltzius (1558–1617), who used it in the depiction of landscape. In Japan, an alternative approach to color woodcut, using different colors for each block, was invented by Suzuki Harunobu (1724–70) and later employed by Kitagawa Utamaro in figurative prints and by Katsushika Hokusai in landscapes. In England, a method of obtaining subtly colored wood engravings, by combining up to twenty separately inked blocks, was patented in 1835 by George Baxter (1804–67).

Though copperplate line engraving did not lend itself readily to the production of multi-colored prints, a method of full-color picture reproduction by mezzotint, based on the red-yellow-blue theory of primaries, was patented in 1719 by J. C. Le Blon. The same color mezzotint principle was successfully transferred to the medium of lithography by Godefroy Engelmann (1788–1839) in France in 1837 and subsequently used with newly available photographic processes to form the basis of modern trichromatic halftone printing, introduced by Frederic Eugene Ives (1856–1937) in the United States in the 1880s.

The first artistic application of multi-colored lithography was by English artist Thomas Boys (1803–74) in a topographical publication dated 1839. The invention of lithography in 1798 by Alois Senefelder (1771–1834) had already enabled the printmaker to combine freely painted gesture with large, unbroken areas of transparent color in prints. Henri de Toulouse-Lautrec (1864–1901) and Edvard Munch (1863–1944) are examples of master lithographers.

In the twentieth century, a variety of color stencil printing known as Pochoir was introduced in France and employed by Henri Matisse, among others. It was directly succeeded by the extensive development of silkscreen printing, employed widely by the American pop artists of the 1960s, notably Andy Warhol.

Contemporary developments in color printing include the ink jet (1985), which produces "impressions" composed of tiny jets of trichromatic inks released in response to signals from a digital computer screen, and the laser printer, which, rather like a photocopier, fuses color images to paper. See also Coloritto; Computers and Color; Etching; Halftone; Japanese Wood-Block Printing; Laser Printing, Color in; Lithography; Newspaper Color; Relief Printing; Silkscreen Printing; Ukiyo-e.

Prism

A transparent glass or plastic block, usually triangular in cross section, that separates light passing through it into the spectrum of colors. Prisms can have other cross-sectional configurations and can be used as highly reflective mirrors in cameras and binoculars.

The principle of the prism depends on the refraction of light as it enters or exits the denser medium. Light passing through a side at an oblique angle other than perpendicular is bent off course, with the shorter wavelengths being deflected more than the longer. At too narrow an angle, the light will simply bounce off the surface. In 1666, Isaac Newton, using a prism and observing the phenomenon of refraction, was led to propound the revolutionary theory that white light is not simple, but rather a mixture of different "particles," each producing a different color. See also Newton, Isaac; Refraction.

Process Colors

The three subtractive primary colors generally used in printing by photomechanical reproduction processes. These have been standardized internationally to those needed for subtractive synthesis: cyan, magenta, and yellow—which do not add up to black. The dots of color on a printed page absorb light, but it is because our eye optically blends them that we see the entire range of color. As a result, these primaries are medial, and add up to a neutral gray. A fourth plate —black—is needed by a printer to make black.

Process colors are referred to as "process blue," "process red," and "process yellow."

Some ink and printing concerns define other key or reference colors by specified mixes of two or three process colors; these are some-times—inaccurately—also called process colors. *See also* Primary Colors; Subtractive Color Mixing.

Proofing Color

The checking of photographs or other repro-ductions for validity of colors before the final prints are made. "Proofs" of three- or four-color photomechanical reproductions are prepared by making separate exposures from the separation negatives on transparent cyan, magenta, and yellow diazo materials; these are assembled in register to provide some indication of color quality. Another method uses wipe-on liquid emulsions, which are exposed and processed in register, one after the other, on a single sheet of base material. Proofing is vital to color reproduc-tion for publication, since colors are rarely correctly reproduced or balanced on the first attempt, and require visual correction. *See also* Matching Color.

Protanopia

See Color Blindness.

Psychedelic Colors

A palette consisting of very intense, fluores-cent colors, associated with the 1960s and the use of psychedelic drugs such as lysergic acid diethylamide (LSD) and mescaline. One of the effects of these mind-altering drugs is on the perception of color. In describing an experience with mescaline, the English writer Aldous Huxley (1894–1963) noted that it "raises all colors to a higher power and makes the percipient aware of innumerable fine shades of difference, to which, at ordi-nary times, he is completely blind" (Huxley 1963). Psychedelic colors—fluorescent or-ange, blue, and green, especially—were meant to give the viewer the visual sensation of such a drug without actually ingesting it. The colors were widely used in discotheques and poster art in the 1960s. *See also* Fluores-cent Colors; Subjective Colors.

Psychiatry, Psychology (Color and)

See Color Therapy; Education, Color; Re-sponse to Color.

Public Space

See Architecture and Color; Communication and Color; Industrial Environments, Color in.

Pucci, Emilio

1914– . Italian couturier who brought vivid color back into fashion after the drab colors of the Depression and post–World War II years. In 1948, after photographing underwater life off Capri, he persuaded Ital-ian chemists to re-create the clear shades of green, blue, violet, and pink in fabric dyes. He used this brilliant palette for silk dresses, ski clothes, stretch body suits, Capri pants, and upholstery fabric. Pucci often used up to fifteen colors within a print and put together daring combinations such as dark brown and purple, coral red and turquoise blue, or bright red-orange and chartreuse green. *See also* Fashion and Clothing Color.

Purism

An art movement of 1918–25 that was in-tended to take cubism to its proper conclu-sions. Its two main proponents, Amédée Ozenfant (1886–1966) and Charles-Édouard Jeanneret (Le Corbusier; 1887–1965), pro-duced several key texts, including *Apres le Cubism* (1918), *La Peinture Moderne* (1925), and the magazine *L'Esprit Nouveau* (1920–25). Their ideas of "clarity and objectivity" were summed up in the slogan "the call to order." In their manifesto, *Le Purism* (*L'Esprit Nouveau* [1920]), they designate color as the last of the elements of composition:

> In the expression of volume, color is a perilous agent; often it destroys or disorganizes volume because the intrinsic properties of color are very different, some being radiant and pushing forward, others receding, still others being massive and staying in the real plane of the canvas, etc.; citron yellow, ultramarine blue, earths and vermilions all act very differently, so differently that one can admit without error a certain classification by family.

They recognized three "scales" of color: the "major scale," "dynamic scale," and "transitional scale." The major scale in-cluded ocher, yellows, reds, earths, white, black, and ultramarine blue, which they called "strong . . . constructive colors. . . . It is these that all the great periods em-ployed; it is these that whoever wishes to paint in volume should use." The dynamic scale consisted of citron yellow, the oranges (chrome and cadmium), vermilions, Vero-nese green, and light cobalt blues—colors that were "animated, agitated . . . and 'dis-turbed.' " Finally, the transitional scale com-prised the madders, emerald green, and all the lakes, "which have the properties of tint-ing, not of construction."

The purist contribution to color in the modern world amounted to recommendations to avoid excess and, instead, to regulate and control color.

Purity

Synonym for saturation.

Purkinje Effect (Purkinje Shift)

The changing relative brightness of colors seen in different lighting conditions, observed by Czech physiologist Johannes Purkinje (1787–1869). In the brightest lighting conditions, the eye sees yellow as the most luminous color; in dim light, blue appears to be the most luminous because the rod vision of the dark-adapted eye is most sensitive to the shorter (blue-violet) wavelengths of light. *See also* Optical Illusions.

Purple

A color intermediate between red and blue, and thus not existing in the spectrum of light; the complementary of yellow; from the Latin *purpura* and the Greek *porphyra*.

Archaeological research has placed the discovery of purple dye in the Bronze Age (ca. 1250 B.C.), several hundreds of years before the Mediterranean trade in the Phoenicians' Tyrian purple. The color was one of the first to be synthesized artificially and became popular in the Victorian era. In daily life, purple's various tints are frequently identified by the flowers and fruits in which they occur: plum and eggplant, for example. *See also* Aniline; Eggplant; Mourning Colors; Plum; Tyrian Purple.

Purple Bacteria

Purple to purplish brown bacteria that grow in water; unusual in that photosynthesis (the use of light energy to make fats) is carried out without oxygen (used by most vegetable matter), employing the pigment bacteriochlorophyll.

Purple Heart

A U.S. military decoration, originally established by George Washington in 1782 at Newburgh, New York, for extraordinary military merit and fidelity, and later revived in 1932 for any member of the armed forces wounded or killed in action. The heart-shaped medal features a bust of George Washington, on purple enamel with a gold border, and a ribbon with white trim. The choice of the purple probably relates to the extraordinariness of the military effort.

Purple of Cassius

A purple pigment produced from gold chloride, stannic acid, and stannous chloride used to color ruby glass, ceramic glazes, and enamels; named after a seventeenth-century German physician, A. Cassius.

Purple Passage (Purple Prose)

A piece of writing, either a whole book or a passage within an otherwise unremarkable book, distinguished by a particularly ornate or hyperbolic use of language. The color purple suggests a richness of content and the exaggerated sentiment that the author is trying to instill in the reader.

Purpure

A deep reddish purple; from the plum color as used in heraldry. *See also* Heraldry.

Quantum Physics, Quarks

Study of the smallest units of energy or matter that constitute the universe, such as atoms, photons, and quarks. Quarks are hypothetical particles that have been categorized by quantum theorists into three "colors" (or groups)—red, green, and blue. The strong nuclear forces always bind these particles together in combinations that are without color. A red quark is always joined to green and blue quarks, and this triplet constitutes either a proton or neutron, the basic building blocks of the atom. The combination of quarks is analogous to the mixing of the three primaries of light together to make white. Other "colorless" combinations are produced by quarks with antiquarks—red with antired, blue with antiblue, green with antigreen—much as complementary colors of light produce white light. The unstable products of these combinations are called mesons; quarks and antiquarks tend to annihilate each other, producing electrons.

Quartz

One of the most common minerals available, and the basis of many semi-precious stones. Quartz displays a profusion of colors, patterns, and optical effects—ranging from the transparent colors of amethyst and citrine, to the silky sheen of tigereye and the intricate banding of agate. Colors arise from the presence of impurities: Iron produces the yellow of citrine and the violet of amethyst; titanium and iron, rose quartz; aluminum, smoky quartz; flakes of green mica, brown iron oxide (producing the streaks of tigereye), and asbestos (producing the blue streaks of

hawk's eye) give rise to many other colors. *See also* Amethyst; Chalcedony and Jasper; Citrine; Gemstones and Jewelry.

Quartz-Iodine Lamp

See Lighting, Artificial.

Quetzal

A brilliantly colored bird (genus *Pharomachrus*) native to South and Central America. The quetzal is generally golden-green and scarlet. The bird was emblematic of Quetzalcoatl, the feathered serpent god of the Aztec and Toltec civilizations, who was supposed to have come from the east, and for whom Cortez was mistaken when landing in 1519.

Quinacridone Red

An extremely fade-resistant synthetic red pigment. An artificial lake derived from coal tar, quinacridone red comes in both yellowish (scarlet) and bluish casts; it was first manufactured in Germany in the 1930s and further developed by DuPont in the 1950s. The other quinacridones (violet and magenta) are less outstanding, though sufficiently lightfast to qualify in the group. The quinacridone pigments are poisonous, highly permanent, and slightly transparent.

Quran (Koran)

See Architecture and Color; Islamic Colors; Seljuk and Ottoman Mural Ceramics.

Quth-al-din (al Shirazi)

1236–1311. Arabian writer, among the first to attribute the rainbow to the refraction and reflection within individual water drops.

Race and Skin Color

In the past, as now, skin color has been a strong source of cultural jingoism and of racism. In his book *The Descent of Man* (1871), Charles Darwin (1809–82) wrote: "We know that the color of the skin is regarded by the men of all races as a highly important element in their beauty." Certainly, extreme whiteness of skin among northern peoples, extreme yellowness or goldness among Orientals, and (rarely) extreme blackness among those of African descent have at various times become emblems of the ideal racial type and cultural superiority.

Human beings have easily divided and categorized themselves by skin color, the merest tinge meriting the label of being such-and-such a hue. The basic coloration of skin is either white, from unpigmented skin cells; black, from melanin, produced in the skin under stimulation by ultraviolet light from the sun; red, or ruddy, from blood vessels present under and in the skin; or yellow, caused by a slightly thicker layer of skin, which masks the red blood vessels.

Prejudice based on skin color dates back thousands of years—at least to the ancient Egyptians, who recognized four "races": They constituted the red race and were proud of it, to judge from the frequent application of red and henna to their hair; yellow symbolized the Asiatic peoples; white was the color of the people from the north across the Mediterranean; and black was the color of Nubians and people in the rest of Africa.

Black—with its suggestion of exposure to the sun and, to many, primitivism—has often been considered to be at the bottom of the list, even among native Africans; the Fulani of Central Africa, for example, revile subservient tribes as *black,* even though it is doubtful how much darker their skins actually are. In the West, the prejudice developed long ago, at least to when the fair-skinned Saxons fought and defeated the dark-skinned Celts for control of Britain. To this day, *fair* has the connotation in English of, not just *white,* but also *good* and *beautiful.* The Arabs, similarly, with their two categories, saw themselves as ruddy and the rest of the world as black. In the Orient, the Hindu caste system, divided into four *varnas* (Sanskrit for "colors"), labeled the priests (who were rarely exposed to the sun) as white, the soldiers as red, the merchants as yellow, and the *sudras*—the serfs—as black. The distinctive skin color of "black Americans" remains a prominent cause of their lack of integration into a generally diverse and tolerant society.

Rainbow

An arc or circle made up of bands of the spectrum colors. A rainbow occurs when opposite light hits a cloud of water molecules, either in a mist or in a shower of falling rain, and is refracted and reflected by the droplets, which act like prisms. Light, hitting raindrops at the right point, will be refracted by the outer surface and will penetrate the water, bounce off the opposite side, and be refracted again as it reenters the air, with the result that it is deflected from its original path by almost exactly 42 degrees. The combination of millions of drops along the curved path in the sky that is at 42 degrees between us and the sun produces the brilliant hues of the rainbow.

In strong sunlight, a secondary rainbow can sometimes be seen. In this case, light entering at a point near the bottom of a droplet is reflected twice internally and emerges at an angle of between 52 degrees and 54 degrees, according to the wavelength, thus creating a bow below the first, with its colors in reverse order. Since some light escapes at each internal reflection, it will be much fainter than the first bow.

When the sun is low, rainbows will be tinged with a reddish cast of sunset or sunrise. The droplets in a mist are sometimes so fine that the colors recombine additively to produce a pure white bow.

essay

Rainbows: The Bow of Iris

French color theorist Philippe Fagot examines the mythological status and the changing scientific understandings of the rainbow throughout the course of history.

> *"I am white, I am black, I am yellow, I am brown. . . . There is nothing wrong with this reality. In order to make harmony between peoples, the basis is diversity. It is from different types and different races that harmony may come."*
> —The Dalai Lama

Most cosmologies include creation myths that describe the separation of a fundamental unity into two parts—earth and heaven. Linking, even mediating between, these elements are the natural forms of trees and mountains, whose verticality finds architectural parallels in the pillars, megaliths, and totem poles that humans have erected all over the world. Of all the mediating symbols, the rainbow was the greatest. It partook of a certain contemplation, bound up with silence, with changes of the microclimate, with the mystery of its perfect shape, spectral colors, transitory presence, vertical sweep, and energizing effects. Thought to have been conceived in a moment of ecstasy, an expression of earth's enjoyment following its fecundation by rain, the rainbow carried the hope of a good harvest. Often, too, it was equated with the body of a serpent, a symbol of fertility.

Perfect in geometry, the rainbow was yet curiously incomplete. Its lower half was swallowed up by Earth. Despite this hidden arc, the rainbow was assumed to be a complete circle, half of it lying in the underworld, the place of darkness and death.

This bow/serpent, fragmented or whole, with or without color bands of the spectrum, appeared in many myths as a path between two worlds. From the underground serpent, the Greek river Styx, where the goddess Iris went to tear a lock of hair from the heads of the dying, to the bow employed in the birth of Buddha, to the arc of urine shed by the Goat to allow the African blacksmith to reach the territory of humans, the rainbow is a potent symbol. In European folklore, it was believed that treasure could be found at its foot, the point where three elements—water, fire, and earth—met and were transmuted into precious stones.

The rainbow figures strongly in religious art, from Tibetan mandalas to the sand carpets of the Hopi and Navajo Native Americans. Even in religions based on the written word, rare were the mystic visions described that did not include the rainbow as metaphor for God: "And I saw . . . as the appearance of fire . . . from the appearance of his loins even upward, and from the appearance of his loins even downward. . . . As the appearance of the bow . . . in the cloud in the day of rain. . . . This was the appearance of the likeness of the glory of the Lord" (Ezek. 1:27). The rainbow also figures in the New Testament: "Behold a throne was set in heaven, and one sat on the throne. And he . . . was to look upon like a jasper and a sardonix stone, and there was a rainbow round about the throne, in sight like to an emerald" (Rev. 4:2–3).

Religious and mythological concepts long influenced rational investigations into the rainbow, resulting in research that bordered more on alchemy than true scientific inquiry. Until the late Middle Ages, the most acute observations on the rainbow were left over from the classical era, made by the ancient Greeks in the course of their studies of optics. Aristotle, in his *Meteorology*, theorized that "the rainbow is a reflection of the sight of the sun." In addition, while experimenting with artificial spectral bows, he observed: "We get a rainbow when we scatter tiny drops on a place turned toward the sun in a position such that the Sun lights up one part and keeps the rest in shadow. If we water the interior of such a space a person standing outside perceives a rainbow whereas at one place where the sunrays leave off there is shadow."

Medieval Advances

Not until the twelfth century were there any advances in pure scientific research, in this case by Arab scholars. As the Muslim world expanded, its scientists acquired knowledge of Western teachings, including Greek texts such as Aristotle's. Arab scholars brought new, empirically based research techniques, making rigorous observation and experimentation the basis for the development of mathematical models.

One of the founders of Arab optics, Ibn al-Haytham (or Alhazen; 965–1039), well known for his experiments with physiological optics, made a significant contribution with his introduction of the measurement of the indices of refraction. However, it was a Franciscan monk, Robert Grosseteste (ca. 1175–1253), who applied this knowledge of refraction to describing the origin of the rainbow. Roger Bacon (ca. 1220–92) repeated al-Haytham's experiment on the path and deviation of a ray of light through a sphere consisting of a glass bowl filled with water, to show how a rainbow was formed.

Much of this kind of research was fiercely opposed by the theological authority, which was averse to scientific study of the symbol of God's promise to man, the rainbow. When Dietrich of Freiburg (?–1310) posited a fourth primary in the spectrum of the rainbow, it conflicted with the perfect number three of the Trinity. According to church dogma, the primary colors of the spectrum were *either* red, green, and blue *or* red, yellow, and blue. Considered theologically indefensible, the whole text of Dietrich's *De Iride* was banned, not to be rediscovered until the nineteenth century.

In the *Divine Comedy*, Dante (1265–1321) includes various versions of the mythologi-

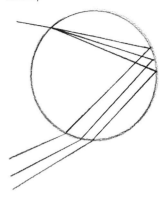

Light refraction and reflection in a raindrop.

Primary bow.

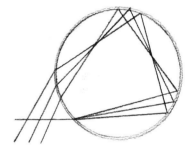

Secondary bow.

"If you disturb the colors of the rainbow, the rainbow is no longer beautiful."
—Denis Diderot

cal, scientific, and spiritual aspects of the rainbow: "As sweep over the thin mist two bows, parallel and like in color, when Juno maketh behest to her handmaiden, the one without born from the one within in fashion of the speech of that wandering nymph whom love consumed as the sun doth the vapors, making folk here on earth foreknow, in virtue of the compact God made with Noah, that the world never shall be drowned again" (*Paradise* XII.10ff.). He describes a double rainbow: "In the profound and shining being of the deep light appeared to me three circles of three colors and one magnitude. One by the second as Iris by Iris seemed reflected, and the third seemed a fire, breathed equally one from one and from the other (*Paradise* XXXIII.115ff.).

In the seventeenth century, there was a renewed interest in the rainbow independent of any religious associations. It became an important part of dioptrics, the study of the nature of light. Francesco Maurolycus of Messina, treating problems of atmospheric geometry (such as the shape of the rainbow), hypothesized the existence of a light ray (*Photismi de lumine et umbra ad perspectivam, et radionum incidentiam facientes,* 1611). René Descartes (1596–1650) promulgated, in his *Discourse on Method* (1637), his theory of "efficient rays" by which we observe natural phenomena. When explaining the rainbow's geometry, he failed, however, to explain colors properly.

The breakthrough in understanding the rainbow was made by Isaac Newton, who, unlike his predecessors, including Descartes, was a rigorous empiricist. Using a prism to split light into its spectrum, Newton discovered in 1666 that every light "ray" (a wavelength, in modern terminology) corresponded to a specific color and was endowed with a particular degree of refractibility. "A certain color," he wrote in his *Opticks* (1704), "depends on the degree of refrangibility [refractability] and vice versa. Red rays are the least refrangible, violet the most. With colors we can compose white and all the colors between white and black. The whiteness of sunlight is composed of all the primary colors—red, yellow, purple, violet—but also orange, indigo, and an infinite number of intermediary shades, mixed in the right proportions."

Newton's theory of light helped to explain the origin of the rainbow from sunlight passing through raindrops that behave like miniature prisms. His observations paved the way for the capital discoveries of the nineteenth century. Thomas Young applied his theory of luminous interference to the rainbow. He confirmed the path that light takes within a raindrop (one refraction, one reflection, one refraction). As the light spreads out after each refraction, he correctly proposed that interference of the waves in their constructive phases (summits on summits) produces the supernumerary bands of the primary bow, and that in their destructive phases (summit on hollow), the waves are canceled out.

Indirectly, from studying the rainbow, Young was able to unravel one of nature's greatest secrets—what light actually is. He proved that light has less speed in water than in air and, by showing the (inversely

Symbol of the god of the rainbow as conceived by the Zuni Indians of New Mexico. Photo courtesy of the American Museum of Natural History.

proportional) relationship between the speed of light and the index of refraction, he was able to state that light was propagated in wave form, not as a particle (as Descartes's corpuscular theory would have it). From Young's work evolved the theses of several great color technicians of the nineteenth century, Hermann von Helmholtz, James Clerk Maxwell, and Ewald Hering.

Art and the Rainbow

As scientists began to understand the rainbow, artists were reinterpreting its function as a pictorial element. Around the time Descartes was working in the field of physics, Peter Paul Rubens was developing an interest in the rainbow, leading him to make a radical break in the iconographical history and the symbolic attributions of the rainbow in the West. His first rainbow representation appears to have been the frontispiece for a treatise on optics by the Jesuit Franciscus Aquilonius in 1611.

Rubens's most important portrayal of a rainbow, however, comes in a series entitled *Shepherds and Shepherdesses with a Rainbow*. In one particular version, to be found in the Louvre, can be seen two double rainbows whose special feature is their crossing each other. This is probably a preparatory version, because the bow directed toward the center is obviously a second thought—which implies a considerable evolution in iconographic analysis of the rainbow. The rainbow's religious symbolism was shaken off. Rubens's depiction implied a meteorological phenomenon divorced from any sacred meaning, to be used for plastic balance in the construction of a painting. Previously, in Last Judgment scenes by Rogier van der Weyden (ca. 1399–1464), Hans Memling (ca. 1430–94), Albrecht Dürer (1471–1528), Matthias Grünewald (ca. 1455–1528), and Hieronymous Bosch (1450–ca. 1516), the rainbow has a conventional representation, wrapped up with its signifying form—it is the essence of light to be associated with its direct opposite, darkness.

After Rubens, the rainbow appears again and again as a purely pictorial element in secular paintings, particularly by romantic painters, who were encouraged to observe nature. Pierre-Henri de Valenciennes (1750–1819), an initiator of landscape painting, is noted for his scrupulous reproduction of the colors of the rainbow.

Joseph Mallord Turner used the rainbow, notably in his later studies of the Reichenbach Falls in Switzerland, to study the representation of light and of light within light —though he paid little attention to the color effects themselves.

John Constable (1776–1837) was haunted by the rainbow in the last years of his life. Respectful of nature's creation and drawn to the scientific spirit of his contemporaries, he wrote, "Landscape painting is scientific as well as poetic. Imagination alone has never produced and never will produce works that can stand comparison to reality. Painting is a science and should be conducted as an investigation of the laws of nature."

Constable, however, was also interested in the rainbow for its iconographic content. While his 1829 version of *Salisbury Cathedral from the Meadows* contained no rainbow, it played a majestic role in that of 1831. Similarly, in the *Stonehenge* series, his representation of the rainbow enhances the sacred nature of the atmosphere. The temporary appearance of human beings is cut out, leaving space only for megaliths (the great stones) and the rainbow, contrastingly representing eternity and the passing moment.

In an 1811 painting by Pierre-Narcisse Guérin (1774–1833), the goddess Iris is depicted on a mission to Morpheus, illustrating a passage from the *Aeneid* by Virgil (70–19 B.C.). Only a fragment of rainbow identifies the goddess, just as in other mythographical works such as the portrayal by François Le Moyne of Juno, Iris, and Flora (early seventeenth century). Guérin's painting, as far as we know, is the last depiction of Iris appearing as a rainbow.

Nineteenth Century

The German painter Caspar David Friedrich (1774–1840) is notable for his use of the rainbow as icon. His few paintings featuring the rainbow have a spiritual imprint. His *Landschaft mit Regenbogen* (Landscape with rainbow) portrays a walker leaning against a rock and gazing at a lunar rainbow amid a mountain scene. To the meditating person, the rainbow appears as a luminous incarnation of some higher reality, just as it did to primitive people of other cultures. In *The Cathedral* (1817), Friedrich depicts human consciousness passing through the rainbow and finding rest in the anteroom of the angels before ascending to the inner temple.

Romanticism was the apex of a tradition in which the rainbow represents a journey from a phenomenal universe of the scientists to a mythological world of those more spiritually inclined. Romantic thinking aimed at strengthening the relationship between a sense of humanity and a search for wisdom, and the rainbow marked out the path toward knowledge outside the realm of everyday perception.

Few works stand out for their examination of the rainbow during the second half of the

nineteenth century. The painting *Printemps* (Spring, 1863–73) by Jean-François Millet (1814–75) in the Musée d'Orsay in Paris is meteorological in character. But the impressionists ignored the rainbow, as did the symbolists. There are some furtive musical evocations, such as by Richard Wagner (1813–83), and a few poetic examples. Then it reappears in the work of Fernand Léger (1881–1955); in the series *Noah to the Rainbow* from the *Biblical Message* of Marc Chagall (1887–1985); in *The Rainbow* by D. H. Lawrence (1885–1930); in the prismatic paintings of Sonia and Robert Delaunay; and in many other places.

Rainbows seem to be everywhere—in advertisements, logotypes, gadgets, objects, clothes, and elsewhere—experiencing a renaissance for promotional purposes on behalf of all sorts of products and services. The multiplication of its images renews its symbolic content but also carries the seeds of a regression of meaning, culminating in devaluation.

Abusive materialization, however, does not eliminate the emotive potential that contemplation of the real thing awakens in us. Seeing an actual rainbow reconstructs our mythology. Swept away are conjectures, mathematics, and the complexities of reflection and refraction. Instead, at the depths of our consciousness we experience the cumulative feelings of Aristotle, Ibn al-Haytham, Descartes, Halley, the Hopi shaman and rainmaker, Turner, Wagner, Hesiod, Ovid, Schiller, Noah, Buddha, and Ezekiel, and all who wondered at the rainbow. At this instant, the works of heavenly mechanics are displayed.

At this moment, there comes silence. The ephemeral image of immobile eternity.
—Philippe Fagot

Raw Pigments

Naturally formed inorganic pigments, including the siennas, ochers, and umbers. Raw sienna is a yellow earth pigment named for the Italian city of Siena, or Sienna, from which come the best grades of the pigment-bearing clay. Like yellow ocher, sienna is a hydrated ferric oxide with alumina and silica, but it is slightly darker, warmer, and more transparent than yellow ocher. Because of its transparency, it has often been used by artists as a glaze. Raw sienna is also used in wood staining and for giving the appearance of wood grain to faux finishes.

Raw umber is a brown earth pigment (although common, it came originally from the Umbria region of Italy), similar to ocher and sienna, but containing manganese dioxide as well as hydrous ferric oxide. The best umbers are a warm, reddish brown color with a greenish undertone. The color is determined by the quantity of goethite present; the grains are finer (thus more opaque) and darker yellow-brown than in raw sienna and yellow ocher. Raw umber is very stable and colorfast in oil paints. *See also* Burnt Pigments; Natural Earth Pigments.

Realgar

A bright orange-scarlet pigment that, like orpiment, is a sulfide of arsenic and highly poisonous; the name is derived from the Arabic word *rahj al-ghār*, or "powder of the mine."

Red

In pigments, a primary color; in light, the longest visible wavelengths, some 650 to 700 nanometers (billionths of a meter). Red's presence in prehistoric cave paintings, along with black and white, makes it one of the oldest colors used by man. Red ocher, an earth pigment, was the ancient world's most widely used coloring stuff. The Egyptians used it to color their bodies, fabrics, and walls.

Additional sources of red pigment in the ancient world were the kermes louse, for crimson, and the cochineal insect, for carmine. In addition to these natural animal sources, the ancient world also extracted red dyes from many plant sources, including roots, berries, flower heads, barks, and leaves. One of the oldest and the most important historically was madder, extracted from a root. True madder (*Rubia tinctorum* or dyer's madder) grows prolifically in any tropical and temperate zone. However, it was only in the sixteenth century that the plant came to be cultivated in large quantities. (Holland and France set the highest standards for production.) Other natural plant sources of red dyes are brazilwood, beetroot, cranberry, safflowers, and oricello, or orchil. In addition to these natural animal and plant sources, the classical world, since the third century, knew how to extract vermilion pigment by roasting cinnabar.

Synthetic sources of red include alizarin, first discovered in 1869 by the Germans Carl Graebe and Carl Liebermann; the mars reds, synthesized in the nineteenth century; cadmium red, synthesized in 1907; and cadmium-barium, synthesized in 1926 in the United States.

Red is a signaling, attention-getting color: It is universally recognized as a stop signal in traffic lights (except in China, where red is a national symbol of communism, and

where green means stop and red means go); red is also used for warning lights. In fact, so traditionally is red linked with an alert generally and with a fire hazard specifically that an attempt to change the color of fire trucks in the United States to yellow, a color of higher nighttime visibility, was squelched by irate Americans. Surprisingly, although red cars are highly visible in daylight hours, insurance company records show that more red cars are involved in accidents than cars of other colors. For this reason, red cars are outlawed in Brazil and Ecuador. *See also* Advertising; Colloquial Language, Color in; Commercial Color Symbolism; Healing and Color; Heraldry; Historic Color Sources; Lüscher Color Test; Medicine and Color.

Red Eye

The glowing of the pupils of many animals' eyes, when a strong light is shone into them at night. This "red eye" effect is caused by the reflection of light from a layer of blood vessels on the inner surface of the eye. It occurs mainly in dim light, because the pupils are fully open.

Red Ocher

See Venetian Sumac.

Red Shift

An apparent shift in color of celestial bodies toward the longer wavelengths as they move away from the observer. *See also* Astronomy and Color.

Reflection

The return of a light wave from a surface it strikes to the medium through which it has traveled. The law of reflection states that the angle of reflection will be equal to the angle of incidence. On a glossy, smooth surface, light is reflected regularly, but on a rough, matte surface, light is diffused in all directions, making colors appear less saturated and duller. *See also* Surface Color.

Refraction

The bending of light rays as they pass from one medium to another. In a vacuum or empty space, light will travel at a constant speed (186,282 miles per second) and in a straight direction. In general, as light passes into a denser medium (into earth's atmosphere, or from air into glass), it is slowed down and bent toward the line that is perpendicular to the interface (and vice versa when passing out again).

An important feature of refraction is that rays of shorter wavelength (toward the blue end of the spectrum) are bent more than those of longer wavelength. A suitably shaped transparent object, such as a prism, will break up "white" light into its component colors to form a spectrum.

The density of the transparent medium determines how much the rays will bend off course. The denser the material, the higher the refractive index. Air has one of the smallest refractive indices, followed by water and glass. A material with a greater refractive index than glass, such as carbon disulfide in a prism-shaped bottle, increases the separation of the rays. However, this also exaggerates a distortion, a tendency of prisms to spread the violet rays out more than the red rays. This can be overcome by using a diffraction grating.

The laws of refraction are important in understanding the optical behavior of paints and printing inks. These are composed of vehicles in which innumerable fine particles of an insoluble substance called a pigment are suspended; the greater the refractive index of the pigment in relation to the vehicle, the greater the opacity. For instance, because of different refractive indices, particles of ground glass mixed into linseed oil can produce a highly effective white paint.

Refraction is the basis of lens construction. By using a curved surface, the light can be focused in toward a fixed point. However, a given type of glass does not have the same refractive effect on all wavelengths. A major design concern in correcting this chromatic aberration in lenses is to select types of glass and shape their surfaces so that the dispersive characteristics of various elements cancel one another. *See also* Aberration; Diffraction; Dispersion; Light; Paint; Prism.

Refractive Index

The ratio of the speed of light in empty space to its speed in some transparent medium. Any transparent medium is classified by its refractive index, giving an indication of how much a ray of light is refracted on entering it —the denser the transparent medium, the higher the refractive index, and the more light is bent off course on entering the medium. The refractive index of air is a fraction over 1; the index of glass is 1.33. The refractive index of a diamond—over 3—accounts for its spectacular light and color effects.

Relief Printing

The oldest form of printmaking, achieved simply by cutting a design into a flat surface; when that surface is inked and pressed onto paper, only the uncut, inked part will touch

"It's been a long time now since we've seen the unadulterated reds with which both Florence Knoll and Cecil Beaton made direct, decisive statements. . . . Of all the hues, reds have the most potency. If there is one electric blue, a dozen reds are so charged. Use them to punctuate white, burn into bronzes, or dynamite black."
—Jack Lenor Larsen

"I tried to express through red and green the terrible passions of humanity."
—Vincent van Gogh, on his **Night Cafe'**

"As he grew older, he simplified his palette more and more. . . . Each nuance is obtained by using paints from different tubes. . . . Renoir used eight or ten colors at most. They were arranged in neat mounds around the edge of his scrupulously clean palette. From this moderate assortment would come his shimmering silks and his luminous flesh tones."
—Jean Renoir, on his father

the paper, thus transferring the design in relief. Woodcut, wood engraving, photoengraving, mezzotint, and linocut are the most familiar kinds of relief printing. The Japanese developed another kind of relief printing, known as Ukiyo-e. *See also Coloritto;* Etching; Lithography; Mezzotint; Printmaking; Ukiyo-e.

Rembrandt van Rijn

1606–69. Renowned Dutch painter, who painted mainly in Amsterdam and whose works are greatly admired for their chiaroscuro, the delicate play between light and shade that serves to heighten the introspective quality of his work. Noted for a golden tonality in such paintings as *The Night Watch* (1642) and *Supper at Emmaus* (1648), he also used clean and intense color in many earlier paintings, such as *The Angel and the Prophet Balaam* (1626); with its bright purples, yellows, and greens, this is characteristic of Rembrandt's early work at Leiden, under the wing of Pieter Lastman. *See also* Chiaroscuro.

Renaissance, Color and the

An important period in art history, from about 1400 to 1600, during which oil-painting, chiaroscuro, and advanced techniques of one-point or linear perspective were developed, and, among other innovations, movable type and forms of relief printing were invented.

The Renaissance palette included burnt sienna, yellow ocher, cobalt blue, Venetian red, vermilion, lead white, real ultramarine, malachite green, and ivory black. A remarkably wide range of color effects was possible with this palette, less than a dozen colors in all. Unlike fresco or tempera paints, oil paints could be applied thinly, thickly, opaquely, or transparently. The manipulation of the medium itself yielded rich, luminous, lifelike paintings. *See also* Chiaroscuro; Leonardo da Vinci; Painters, Painting, and Color; Van Eyck, Hubert and Jan.

Renoir, Pierre-Auguste

1841–1919. French impressionist painter. Although he, along with Claude Monet, developed the broken-color technique of impressionism in the 1870s and 1880s, Renoir was more interested in rich color effects and in the solidity of color-rendered form, preferring figure painting to landscape. By the 1890s, his style was marked by diffused light effects and dazzling opalescent colors, which he used to depict voluptuous nudes, radiant children, and lush landscapes. After 1903, Renoir's palette became extremely sensuous and lush; in his very late paintings, his

colors are almost garish. *See also* Impressionism; Monet, Claude.

Reseda

A European plant that was once called dyer's yellow, and is used on wool or silk that has been mordanted with alum; also, the greenish yellow color of the dye.

Response to Color

The psychological reaction of a viewer to seeing a color or combination of colors. Such reactions may be expressed in terms of preference for certain colors in clothing, interiors, and so on. Scientific attempts to analyze other, generally subconscious, responses in human beings to color have been largely discredited in reports such as *The Human Factors of Color in Environmental Design,* a critical review undertaken by Barbara Krysa Wise and James A. Wise for the National Aeronautics and Space Administration (NASA) in 1987. As that report states: "There are no 'hard-wired' linkages between environmental colors and particular judgmental or emotional states. Specifying colors on the basis of spaces being 'active,' 'contemplative,' 'restful,' or whatever to be congruent with the mental or behavioral activities they enclose is simply unjustified."

While there is no evidence of a one-on-one relationship between color and a person's mood, color does, however, have a continuous, though changing, effect on perception of such qualities as temperature, size, relative value, and ambience through associative connotations (*see* Communication and Color; Symbolism and Color). Certain companies attempt, with some success, to link these effects to specific colors, but they are inevitably superannuated by changing fashion. For instance, an ocher that elicited a negative response in the mid-1980s, according to the Wagner Institute for Color Research, became a fashionable—hence, desirable—color, known as mustard, in the late 1980s. Color charts ranking human responses have authority only if updated annually.

Certain analyses of color response made by examining people's color preferences are still considered valid (*see* Lüscher Color Test). These show a surprising consistency in the choice of favorite colors. In the Eysenck Study (1941), 20,000 people were asked to list the prismatic colors in order of preference. Without taking account of age or sex, the study ranked them in the following order: blue, red, green, violet, orange, and yellow. The tendency to place blue first is a phenomenon of Western nations, and it should be noted that other countries have

Pierre-Auguste Renoir.

different color preferences (for example, red is the favorite color in Japan).

Although it used to be assumed in America that the determinants of color choice were sex (e.g., blue for boys, pink for girls) and income categories (e.g., complex colors for the wealthy, simple primaries for the economically disadvantaged), color forecasters now specify age and geographic location as the most important influences on a person's color preference (see Education, Color; Fashion: Geography of Color). Color responses based on biological development are independent of fashion. Newborns at first perceive only the differences between light and dark, but the first hue to be recognized and favored by an infant (gauged by the amount of time spent staring at it) is yellow, probably because it is the most luminous color. In young grade-school children, yellow begins to give way to red and blue as preferred colors. With maturity, preferences shift toward hues of shorter wavelengths (blue, green); with advanced yellowing of the eye's lens, many old people describe themselves as ''blue-hungry'' and will wear that color predominantly. Preferences within geographical regions are also reasonably consistent and predictable, generally revolving around complete palettes and accepted historical color traditions. See also Advertising; Music and Color; Rainbows; ''Size'' of Color; Sources of Historic Colors; Synaesthesia.

Restoration

The repair of damaged artwork, including retouching or renewing faded or destroyed colors, and replacing missing areas.

Over the centuries, there have been different approaches to restoration: Up until the eighteenth century, restorers would often not only repair damage but also repaint freely, sometimes according to their own taste. Today, however, restoration is generally done with a rigorous faithfulness to the original. Widespread use is made of different photographic techniques, X-ray scanning, and colorimetric analysis to establish the original colors. Retouching is then done by hand, for which there are a number of methods, each appropriate to a different artistic style. The Rome Institute, for instance, teaches a process known as *trateggio,* which is suitable for primitive paintings. This seeks to reproduce the original method of hatching, capturing the vibrancy and transparency that the artist originally achieved by alternating lines of pure colors with their complementaries. A second method, used for later paintings, follows the natural flow of the brushwork, giving authenticity through faithful adherence to the original style. For frescoes, a method of retouching with neutral tones permits the damaged parts to recede in relation to adjoining painted surfaces.

Efforts are not always made to use exactly the original pigments: On one hand, the original pigments may have been too impermanent or delicate; on the other, the actual paint recipes (often the artist's own secret) may be lost. In general, restorers will use paints that can easily be removed by future restorers, that do not damage the existing paint or supporting structure, and that will not fade easily. At the Brussels (Belgium) Institute, reconstituted tempera-based materials are used for retouching. They are usually a shade lighter than the original, so that the observer can distinguish the old part from what is repaired. A final oil glazing completes the work. The Italians use water-based paints (watercolors or acrylics), also adding a final oil glaze. Restoration methods and techniques are different throughout the world; for authentic palettes, these differences are of less importance than the thought processes governing their use. *See also* Conservation of Color.

Retina

The internal, rear surface of the eye, which, being covered with rods and cones, is sensitive to light and to individual colors. *See also* Vision.

Retinal Rivalry

See Optical Illusions.

Retreating and Advancing Colors

See Optical Illusions.

Reynolds, Sir Joshua

1723–92. English portrait painter; first president of the Royal Academy (1768). Conservative in his views, he thought little of the color expression of his day, writing, ''There is not a man on earth who has the least notion of coloring; we all of us have equally to seek color . . . as at present it is totally lost to the art'' (Wark 1959).

Reynolds admired the golden tones of Old Masters such as Titian, and he is remembered for a controversial—and erroneous—color formula he presented in his *Discourses on Art:* ''It ought, in my opinion, to be indispensably observed that the masses of light in a picture be always of a warm mellow color, yellow, red, or a yellowish-white; and that the blue, the gray, or the green colors be kept

*''When I was thirteen or fourteen I bought a paintbox with oil paints from money slowly saved up. The feeling I had at the time—or better: the experience of color coming slowly out of the tube—is with me to this day. A pressure of the fingers and jubilant, joyous, thoughtful, dreamy, self-absorbed, with deep seriousness, with bubbling roguishness, with the sigh of liberation, with the profound resonance of sorrow, with definite power and resistance, with yielding softness and devotion, with stubborn self-control, with sensitiveness, with unstableness of balance, came one after another these unique beings we call colors.''
—Wassily Kandinsky*

almost entirely out of these masses, and be used only to support and set off these warm colors." Thomas Gainsborough, Reynolds's chief rival at the time, supposedly painted *The Blue Boy* (totally cool in effect) to refute Reynolds's mistaken conviction. *See also* Gainsborough, Thomas.

Rhudira

The Sanskrit word for "blood" or "red" (hence, *ruddy*), said to be the first color word in the parent language.

Ridgeway's Color System

See Appendix: Color Atlases.

Rietveld, Gerrit Thomas

1888–1964. Dutch architect and designer who is best known for his sticklike wooden furniture painted in primary colors. In 1917, he presented a "red and blue" wooden armchair: red slab back, blue seat, and black members with yellow accents. It anticipated Bauhaus designs of the 1920s, as well as postmodern furniture of the 1980s.

Rietveld also pioneered the use of natural wood colors in his designs for inexpensive furnishings. His 1920s lighting fixtures of bare tubular bulbs set in black wood and his zigzag chairs of the 1930s were early twentieth-century sculptural forerunners of functional color design, which derived both its colors and its high-tech aesthetic from industrial materials. *See also* Bauhaus; Memphis; Sottsass, Ettore.

Rikyu Gray

A light to medium gray named after Senno Rikyū (1522–91), a Japanese artist and Zen master. The earliest reference to Rikyu gray is thought to be the following passage from *Choandoki*, the tea writings of Kubo Gondayu (or Choando; 1571–1640), head priest of the Kasuga Shrine in Nara, Japan:

From the time that he came to serve as tea master to Lord Hideyoshi, everyone began to learn Soeki's [Rikyū's] way of *chanoyu*. Thus did Soeki's distaste for colorful show achieve a widespread following, as did his verses advocating *wabi* austerity. Practitioners were instructed to wear cotton kimono sumi-dyed to a neutral hue, and to outfit themselves with new sashes, footwear, and fans. Hosts were advised that it was befitting in manner to serve simple dishes such as bean broth and vinegared shrimp and vegetables. From then on, the color gray enjoyed great popularity, and large quantities of gray cotton twill (*ayaori*) and broadcloth (*toromen*) were imported from China.

It was this "sumi-dyed neutral hue" that came to be known as Rikyu gray. During the Edo period (1590–1688), it was a popular color, along with brown and indigo. Other grays also became popular—silver gray, indigo gray, scarlet-tinged gray, lavender gray, grape gray, brown gray, and dove gray, as well as plain gray. All shades of low color saturation, permitting the enjoyment of subtle variations in tonality and color balance, these grays were the hallmark of aesthetic sensibility from the Genroku era (1688–1704) through the Temmei era (1781–89). *See also* Achromatic Colors; Fashion: Japan; Japanese Colors.

Rimington, A. Wallis

See Color Organs.

Robbia, Luca della, and Family

Ca. 1399–1482. Florentine sculptor and ceramist. His sculptures were of tin-glazed terra-cotta, breaking the barrier that had previously existed between ceramics and other arts. His family workshop was well known for its medallions of white-glazed Madonnas and infants against a rich, sky-blue background. This color combination was sometimes garnished with touches of gold or garlands of polychrome fruits or flowers. The style of his work was continued by his nephew Andrea della Robbia (1435–ca. 1525), who used clay and glazes for entire altarpieces.

Rocellic Acid

The active chemical ingredient of a dye extracted from a lichen, which yields a crimson purple color and was used in the period before the Renaissance. *See also* Oricello.

Rococo Colors

The rococo style was popular in the eighteenth century, especially in the France of Louis XV (1710–74). It is characterized by refined, curved lines in art and interior decoration and by a palette of delicate pastel colors. The name comes from the French *rocaille* (rock) and *coquille* (shell), referring to the artificial grottoes, complete with cockleshells, then in fashion. During the eighteenth century, rooms became smaller and more specialized in function than in previous centuries. To create a feeling of warm intimacy, the rococo palette was used. Popular shades were gold, soft rose, pale pinkish yellow, turquoise blue, and yellowish green. *See also* Pompadour Rose.

Rod Vision

See Dark Adaptation.

Rood, Nicholas Ogden

1831–1902. American chemist and physicist who conducted research into physiological optics. In 1879, he published his *Modern Chromatics* to wide acclaim. In it, he wished to "present in a simple and comprehensive manner the underlying facts upon which the artistic use of color necessarily depends," with the idea that "a certain amount of rudimentary information tends to save useless labor." His color solid showed hues around the circumference, and white to black scaled through the solid. In this, and in his stressing of the need for standardization of color, he led the way for many later color theorists, including Albert Henry Munsell and Friedrich Wilhelm Ostwald. *See also* Munsell, Albert Henry; Ostwald, Friedrich Wilhelm; Systems of Color.

Rorschach Test

A test devised by Swiss psychiatrist Hermann Rorschach (1884–1922) in 1921 and based on a subject's response to ten symmetrical inkblots. Its purpose is to aid in analyzing a subject's personality and diagnosing psychological disorders. Some of the inkblots are shaded black and gray, while others are designed with patches of color. The test is administered in two parts. The subject is first shown each of the inkblots by the interviewer and asked to describe what he or she sees. Then the examiner questions the subject about the responses. How the subject relates to color is an essential part of the test. A subject describing a blot primarily in terms of color is thought to reveal an emotional, impulsive personality. A subject who defines a blot almost exclusively in terms of form would be considered more cerebral than emotional.

The examiner also considers the subject's response to certain specific colors. A subject's strong reaction to the color red, for example, could indicate feelings of anger, while a subject seeing primarily gray might be suffering from depression. Since the test relies upon the examiner's insight and analysis, many psychiatrists consider it unreliable, and it is generally used only as one in a series of tests and interviews. *See also* Education, Color; Response to Color.

Rose

Any of various reds reduced in value; named after the flower of the genus *Rosa*. There are seven rose colors on the list of American textile standards in *The Standard Color Reference of America*: Ashes of Rose, Bois de Rose, Grecian rose, Old Rose, Rose Beige, Tea Rose, and Vassar Rose. Other rose colors include Pompadour Rose, English Rose, and Victorian Rose.

Rothko, Mark

1903–70. American expressionist painter; along with Clyfford Still (1904–80), an originator of color field painting. Rothko worked oil paint thinly—often, unfortunately, with inferior, fugitive pigments. His large-scale canvases exhibit floating abstract rectangular shapes of undefined edges, and it is from these that a chromatic glow, an autoluminism, emanates.

Rothko's actual palettes vary widely: In the collection of the Museum of Modern Art in New York City, for example, can be seen a brightly colored work of 1949, *Magenta, Black, Green & Orange;* a 1958 work entitled *Red, Brown & Black,* in which the mixed colors are distinctly murky and somber; and a 1970 monochromatic work of black and gray. In a 1971 tribute to Rothko at Yale University, then-president Kingman Brewster said, "[Rothko's] paintings are marked by a simplicity of form and a magnificence of color. In them . . . he has attained a visual and spiritual grandeur, whose foundation is the tragic vein in a human existence . . . (his) influence has nourished young artists throughout the world." In his total elimination of imagery and exploration of the oblique radiance of drifting color and the cool depths of maroons, charcoals, plum purples, carmine reds, and murky yellows, Rothko posited a shadowy dimension to abstract expressionism. *See also* Color Field Painting; Expressionism; Painters, Painting, and Color.

Rubens, Peter Paul

1577–1640. Flemish painter whose art is characterized by a vitality and passion that captures the grandiose baroque style. For his dynamic, heroic paintings, he developed a palette of rich purples and deep yellows, offset by lavenders and pinkish yellows. He was a master at achieving the nuance of red, blue, white, and yellow that make up the flesh tones. *See also* Rainbows: The Bow of Iris.

Ruby

A very hard gemstone; a red variety of the mineral corundum. Pure corundum is colorless. The rich red of ruby is caused by the presence of chromium, which also provides

a red fluorescence. All other gem corundum is called sapphire. The Moguk area of Burma has been the major source of rubies for centuries, the best stones displaying a color described as "pigeon's blood." *See also* Gemstones and Jewelry; Sapphire.

Runge, Philip Otto

1777–1810. German classical painter, who in 1810 designed a color sphere that included all distinguishable colors and on which Albert Henry Munsell later based his work. Runge's sphere was originally published in *Die Farbenkugel* (Color globe), a treatise appearing the same year as his death and as Johann Wolfgang von Goethe's *Farbenlehre* (Theory of colors). *See also* Systems of Color.

Ruskin, John

1819–1900. English graphic artist, writer, and influential art critic of nineteenth-century England. In his multi-volume work *Modern Painters* (1840–60), he supported James Mallord Turner's then-controversial use of color in painting. He also supported the Pre-Raphaelite brotherhood, praising Dante Gabriel Rossetti (1828–82) and William Holman Hunt (1827–1910) for their use of color. Ruskin listed seven painters whom he considered to be the greatest colorists: Titian, Giorgione (ca. 1477–1511), Paolo Veronese (1528–88), Tintoretto (ca. 1518–94), Correggio (1494–1534), Sir Joshua Reynolds, and Turner.

In *The Elements of Drawing* (1857), Ruskin wrote in part on color and composition. His theories on color, developed in art classes given at the Working Men's College, London, emphasize uncompromising accuracy of color matching and a distaste for all artificial systems of color harmony. Parts of the text were quoted by Nicholas Ogden Rood in *Modern Chromatics* (1879).

Russet

Reddish brown, probably named after a coarse, homespun woolen cloth also called russet. The color is described in a fifteenth-century book on liming with directions for mixing: "If you will mingle a little portion of white with a good quantity of redde, you make thereof a Russet, or a Sadde Brown, at your discretion" (Oxford English Dictionary). The color is associated with the reddened browns of autumn. The nineteenth-century Scottish author Robert Louis Stevenson (1850–94) describes an autumn sky, "touched here and there with certain faint russets that looked as if they were the reflections of the colour of the autumnal woods below" (Stevenson 1905).

Russian Avant-Garde

A loosely linked group of Russian artists active from about 1900 to 1925 and particularly experimental and innovative with color. They absorbed and developed, in just a few years, the advances generated by the impressionists, postimpressionists, symbolists, fauves, expressionists, futurists, and orphists. At first, Russian avant-garde artists merely produced works derivative in form (though perhaps more vigorous in color) of these movements. But around 1910–12, Mikhail Larionov (1881–1964), Natalya Goncharova (1883–1962), Kasimir Malevich, and others began to develop a distinctive "primitive" idiom influenced by vernacular peasant art and medieval icons. They used stylizations in the manner of peasant embroideries and popular wood engravings (*lubki*), with patterns of flat color in the manner of folk art.

The conspicuous color patches of these works gradually modulated from rugged, expressive, fauve-like blotches to the more disciplined, but animated, color surfaces that characterized Malevich's cubo-futurist paintings of 1912 and 1913, such as *The Woodcutter* (1912) and *Woman with Buckets* (1912).

Around 1912–14, Larionov and Goncharova developed in "rayonism" (sometimes known as rayism or luchism) their own interpretation of the futurist theories that had become popular in Russian avant-garde circles. Rayonism was a two-dimensional composition of crisscrossing lines of color (devoid of specific representation), conveying dynamic and temporal interaction of light and matter. The greater reliance of rayonism on color effects (in comparison to futurism) is signaled by the presence of color designations in many rayonist titles, such as *Rayonism: Domination of Red* (Larionov 1912–13) and *Rayonism: Blue-Green Forest* (Goncharova 1913). *See also* Futurism; Malevich, Kasimir.

Rust

A metallic oxide widely used as a coloring agent. Iron rust, or ferric oxide, has been used since ancient times to produce yellow or brown textile dyes, and is also the coloring agent in earth pigments such as umber and sienna. Since the early 1800s, iron oxide has been used to produce the synthetic inorganic mars paints, with colors ranging from red, yellow, and orange to brown and black. *See also* Artists' Pigments; Burnt Pigments; Natural Earth Pigments.

Sabattier Effect

See Solarization.

Sable

A deep, lustrous brown suggestive of the fur of the sable, a small mammal related to the marten. In heraldry, the term is used for black. *See also* Heraldry.

SAD (Seasonal Affective Disorder)

A syndrome discovered in the late twentieth century whereby human beings suffer from lack of natural (full-spectrum) light during winter months and grow irritable, anxious, sleepy, and socially withdrawn.

Safelight

A low-wattage light that provides darkroom illumination without "fogging" (exposing) photographic paper. All color films and most black-and-white films are panchromatic, meaning that they are sensitive to the full color spectrum of light; therefore, no lighting is possible during actual film developing. Black-and-white contact and enlarging papers are sensitive only to blue and some green wavelengths, allowing them to be handled and processed under the familiar red safelight illumination.

Safety Colors

Specific colors designated by the Occupational Safety and Health Administration (OSHA) to indicate industrial hazard points. Their use was mandated by U.S. law in 1971.

Saffron

A strong, slightly reddish yellow of high brilliance, originally derived from the pistils of the saffron plant *(Crocus sativus)*. The dye was used by the ancient Greeks and Romans and was also cultivated in Persia. From there it found its way, via the Mongol nomads, into China, where it was used in dyeing carpets. In the Middle Ages, it became one of the principal articles of trade, for it was used not only as a dye but also as a spice and drug. *See also* Dyes and Dyeing.

Sappanwood

See Brazilwood.

Sapphire

A gemstone variety of the mineral corundum in colors other than red—notably, a transparent blue. (Red corundum is called ruby.) The sapphire derives its color from the presence of iron and titanium, but the additional presence of chromium can give colors ranging from pinkish orange to golden. Improvement of color by various forms of heat treatment has become common in recent years. Major sources of sapphires of all colors include the gem gravels of Sri Lanka. Fine cornflower-blue sapphires come from Kashmir, and Australia is at present the most prolific source of blue and golden sapphires. *See also* Gemstones and Jewelry; Ruby.

American Safety colors and the Color Association of the United States (CAUS) equivalents.

Safety Red (Pimento 80042)	Fire protection equipment, danger signals, and stop signs.	Safety Green (Mintleaf 80062)	Safety areas and the locations of first aid equipment.
Safety Orange (Tangerine 80040)	Parts of machines or energized equipment that may cause injury.	Safety Blue (Oriental Blue 80176)	Against the starting, use, or movement of equipment under repair.
Safety Yellow (Lemon Yellow 80090)	Physical hazards such as projections, low pulley blocks, and cranes.	Safety Purple (Purple Orchid 80100)	Radiation hazards.
		School Bus Chrome (Spanish Yellow 80068)	For vehicles transporting children.

Prométhée.

Fragment of the "Prometheus" score by Aleksandr Scriabin.

Saturation

Term used to describe the intensity of a color: the greater the saturation of a color, the higher the proportion of pure chromatic color, free from white, black, or another color. Usually, the pure spectrum color (or the purest possible purple) is considered the pure chromatic color, also known as *chroma* in the Munsell system (*see* Systems of Color).

Scattering of Light

The reflectance of light in all directions by fine particles suspended in a transparent medium. The wavelength of the reflected light approximates the diameter of the particles. Most commonly, the color is blue, though violet and green are sometimes also scattered. This occurrence is often referred to as Tyndall scattering, after John Tyndall (1820–93), the Irish physicist who first noted the effect.

Particles in the earth's atmosphere—molecules of nitrogen, ozone, oxygen, water, carbon dioxide, dust, and trace elements reaching some 50 miles above the earth's surface—are responsible for the blue color of the sky. They tend to absorb and reradiate blue and violet light. City skies are usually a paler blue than elsewhere because the particles of pollution, of many sizes, scatter all wavelengths in all directions and thus dilute the blue of the upper sky with white.

Scent of Color

See Fragrance and Color; Synaesthesia.

Schiaparelli Pink

An intense color made popular by Italian designer Elsa Schiaparelli (1890–1973). This special "hot" pink was also known as shocking pink, which describes its initial effect on the fashion world. However, over time, it has become an acceptable color. *See also* Fashion and Clothing Color.

Schopenhauer, Arthur

1788–1860. German philosopher who took a special interest in color. In 1813, at the age of twenty-five, he met Johann Wolfgang von Goethe, then sixty-four. Becoming friendly with him, he borrowed Goethe's prisms, equipment, and instructions, and set out to study color effects. Later, taking exception to Goethe's color theories, he wrote a pamphlet, *On Vision and Colors,* which enraged Goethe and brought their friendship to an abrupt end.

Schopenhauer interpreted color by emphasizing vision rather than the physics of light. He also studied the mechanism of the human retina but failed to note its relation to the brain. He accepted the idea that white is the unity of hues; in this, he defied Goethe. By dealing with color in humanistic terms, Schopenhauer encouraged that personal attitude so essential to the understanding and use of color in the service of life. *See also* Goethe, Johann Wolfgang von.

Scotopic Vision

See Dark Adaptation.

Scriabin, Aleksandr

1872–1915. Russian composer who allied color with sound and prepared scores with color accompaniment. His sense of color hearing was natural and real to him. Writing of this strange faculty, Dr. C. S. Myers, a British psychologist, said: "Scriabin's attention was first seriously drawn to his colored hearing owing to an experience at a concert in Paris, where sitting next to his fellow countryman, the composer Rimsky-Korsakoff, he remarked that the piece to which they were listening (in D major) seemed to be yellow; his neighbor replied that to him, too, the color seemed golden" (Myers). Scriabin, in composing his *Prometheus,* adopted a color scale using an association of color and musical notes that seemed harmonious to him. This scale follows:

Note		Color
C	=	Red
G	=	Rosy orange
D	=	Yellow
A	=	Green
E	=	Pearly blue
B	=	The shimmer of moonshine
F sharp	=	Bright blue
D flat	=	Violet
A flat	=	Purple
E flat	=	Steely, with the glint of metal
F	=	Dark red

Prometheus, the Poem of Fire was one of the first musical scores to include a part for the color organ. This part, called "Luce," headed the page and was an effort to blend the hues of the color scale with the concords of the music itself. Later, the music was presented in America, where the performance took place in darkness, with colored lights thrown upon the screen as the orchestra played. *See also* Music and Color; Synaesthesia.

Seal

Various grayish or yellowish browns and other colors named for the pelts of fur seals.

The Alaska seal, for example, is prized for its particularly fine fur which ranges in color from brown through blackish brown. Other seal colors include the white and blue of the Hair seal, the blue and brown spots on silver ground of the Saddler seal; and the patterned rings on dark ground of the Ring seal.

Seasonal Color Theories

See Personal Color Analysis.

Secondary Colors

Colors obtained by mixing two primary colors. Examples of secondary subtractive colors (i.e., of pigments) are orange (red plus yellow), green (yellow plus blue), and purple (blue plus red). The secondaries of additive colors (of light) are cyan (blue plus green), yellow (green plus red), and magenta (red plus blue). Variations on these secondaries can be achieved by different proportions of the primaries used. *See also* Primary Colors; Tertiary Colors.

Selective Absorption

The physical event in which a colored material—such as paint—absorbs some wavelengths of light and reflects or transmits others. Generally, the wavelength that is reflected the most determines the apparent hue (red, yellow, green, blue, or violet). Neutral colors (black, gray, or white) absorb and reflect all wavelengths of the spectrum evenly.

Selective absorption of light occurs at the atomic level. Matter consists of atoms, each having a positively charged nucleus balanced by a varying number of orbiting satellites, the electrons (basically, packets of energy with negative charges). The latter can combine with incoming photons (light) of similar energy, absorbing the minute quantity of energy and jumping to a new, higher-energy orbit. At that point, they pause before eventually returning to the original orbit, releasing the absorbed energy as heat. Photons of other wavelengths, and thus of higher or lower energy levels, are reflected or pass through, and it is these that allow us to "see" the substance. *See also* Dominant Wavelength.

Seljuk and Ottoman Mural Ceramics

Traditional style of decorating buildings with glazed mosaics, popular for major public and religious buildings in Muslim-dominated Asia Minor from the eleventh century until the collapse of the Ottoman Empire in 1918. The wall ceramics of the Seljuk and Ottoman Turks represent high points in the relation of color to both exterior and interior architectural space.

Mural ceramics, in which the Turks excelled, can be dated to the Babylonian and Assyrian cultures of the third millennium B.C., when a protective single-color glazed façade was often applied to the front of palaces and other major structures. By the twelfth and thirteenth centuries A.D. and during the rise of the Ottoman Empire, a range of designs and patterns had been developed to supplement monochrome tiling. The principal motifs included zoomorphic designs *(rumi)*; floral motifs *(hatayf)*; geometric and arabesque patterns; and various calligraphic scripts. The predominant colors were light and dark blue, modena (an intense purple), turquoise, white (mostly of the mortar backgrounds), some manganese black, and gold. Pigments were mostly applied directly onto the tiles and then covered with a transparent blue tint glaze. The *minai,* or enameling technique, differentiates between the heat resistance of certain colors (blue, violet, and green) that can support a high temperature, and others such as black, brown, and white that are painted over the glaze and refired at lower temperatures. (The full details of the Seljuk Turks' luster technique were kept secret for centuries by its practitioners, and are still not fully understood.)

Ceramic art was revived by the Ottoman Turks, especially during the classic period in the sixteenth century, when architecture and decoration were developed in coordination. Color boundaries were kept crisp by the *cuerda seca* (dry cord) process, whereby a color unit was edged with string that would burn and disintegrate in the kiln, and by delicate temperature regulation.

Coloristic innovations included the appearance of bolus, a bright orange-red "obtained from a ferruginous earth containing a little uranium . . . this earth produced a temper thicker than oxide-based glazes, and was thus used in slight relief. It was first used, very unobtrusively, in the Suleymaniye Mosque, Istanbul" (de Corcaradec 1981). During the second half of the sixteenth century and the first two decades of the seventeenth, this red became very abundant, deep emerald green was substituted for pale yellow-green, and yellow and gold fell almost completely out of use.

In 1585, following a rebellion by Persian workers, the workshops at Iznik were completely shut down by the orders of Murad III's vizier, Osman Pasha. An attempt was made by Turkish assistants to continue the tradition in the town of Ktahya, but stan-

Sepia: *Detail of a sepia drawing by José Clemente Orozco.*

dards of quality fell, never to recover. The colors became duller, less well defined, and more restricted in hue. *See also* Architecture and Color; Ceramics and Color; Islamic Colors; Mosaics.

Semiotics of Color

See Wittgenstein, Ludwig.

Sensitometry

Photometric analysis of the performance of light-sensitive emulsions, such as those used on photographic papers.

Separations, Color

In color reproduction, the separate images made showing each of the primary colors and black, respectively, which are recombined at the printing stage to produce the full-color image. Separations for color printing were formerly etched by hand on stone or metal (lithography and etching) or painted on fabric (silkscreen printing). Today they are usually made on photographic film, which can then be translated onto printing plates. Reproduction of colored subjects directly from film separations (offset printing) is a relatively new development. Film separations are made by photographing the image through three filters of the additive primary colors (red, green, and blue). Each of these films gives a record of the complementary colors—cyan, magenta, and yellow, respectively—which are the most suitable primary colors for printing. A fourth—black —separation is needed to give proper tones and deep blacks, and is usually made from a yellow filter. *See also* Etching; Lithography; Offset Printing; Silkscreen Printing.

Sepia

A brownish color, originally from an ancient dye found in the ink bag of the cuttlefish or squid. In photography, sepia tones refer to brown print shades; first manufactured in the late eighteenth century for inks and watercolors, not oils, sepia brown continues to lend a feeling of history to a drawing or photographic print.

Serigraphy

See Silkscreen Printing.

Setting

A term applied to the process in which colored textiles are heat-set to prevent color fading, running, or crocking (where colors can be rubbed off).

Georges Seurat.

Seurat, Georges

1859–91. Neoimpressionist French painter who developed a methodical technique of painting that he labeled divisionism, but which is now better known as pointillism. He covered his canvases with tiny dots of pure color so that the viewer would optically blend neighboring tones into a single hue. Seurat's palette consisted of four fundamental colors and their intermediates: blue, blue-violet, violet; red, red-orange, orange, orange-yellow; yellow, yellow-green; green, green-blue. The pure colors were never mixed with each other, although white could be added to an individual color; the juxtaposition of each pure shade was supposed to enhance the brilliance of the bordering one (*see* Simultaneous Contrast).

Seurat's major paintings are the *Baignade* (1884) and *Un Dimanche à la Grande Jatte* (A Sunday afternoon on the island of La Grande Jatte; 1886). In the former, he began to apply the principles of French color theorist Michel Eugène Chevreul, using color in clean and separate strokes to promote optical mixture, and rendering shadows in complementary colors to the light. With the *Grande Jatte*, Seurat eliminated earth colors and black as contributing elements to pigmentary mixtures and as components in the large color areas. He developed brushstrokes more uniform in size and shape—the pointillist technique, which was to be most fully realized in *Les Poseuses* (1887–88). By using pigments at full intensity, he hoped to produce bright color more like that produced by a mixture of light than of pigments. In fact, the cumulative effect of all optical mixtures tends to be a gray, not a white—it was this tendency of Seurat's colors to muddy, when seen at a distance, that the fauves reacted against in the 1900s. *See also* Additive Color Mixing; Fauvism; Neoimpressionism; Pointillism.

Shade, Shading

Specifically, the modification of a pure color by the addition of black. The usage of the word *shade* has been broadened to include any small variation of color. Shading means representing the effects of shadow on flat surfaces or three-dimensional forms by gradations of gray or color. *See also* Chiaroscuro; Colored Shadows.

Shadows

See Colored Shadows.

Sharaku

A Japanese artist of the late eighteenth century, best known for his exquisite, delicate

portraits of famous Kabuki artists, some 150 in all, executed in color wood–block prints (ukiyo-e). They are striking because of the expressionistic use of color. Most of the actors' costumes correspond to *shibui* (subtle) colors of everyday life more than to historical attire. The multiple tones of tinted beiges, golds, rusts, and red-browns (all warm earth tones) are accented by blue or soft green, and always black. The effects are of unique quality and originality. *See also* Japanese Colors; Japanese Wood-block Prints; Ukiyo-e.

Shellac

A lac resin that is yellow, orange, or red, according to how pure it is; it is white when bleached. The darker the shellac, the less dilute it is. The resin is mixed with an acetone or alcohol solvent and is applied to surfaces in this form. The solvent evaporates, leaving the surface covered with a thin insulating film.

Shibori

A Japanese dye process similar to tie-dyeing, but instead of knots, designs are stitched into the fabric; the areas that are sewn resist the dye. *See also* Tie-Dyeing.

Shocking Pink

See Schiaparelli Pink.

Siderites

See Natural Earth Pigments.

Sienna

See Burnt Pigments; Natural Earth Pigments; Raw Pigments.

Signals

See Communication: Color Coding; Safety Colors; Symbolism and Color.

Signs and Semiotics

See Communication and Color; Symbolism and Color; Wittgenstein, Ludwig.

Silkscreen Printing

The popular name—because silk was used originally—for a printing technique called serigraphy, which consists of a fabric (silk or nylon) screen on which a resist image has been painted and around which ink of any color is then forced. Silkscreening can be done by hand in any of several methods, producing quality, flat color images, or by rapid printing machinery. Colors are built up using separate screens. In addition to art prints, posters, and other flat images, it is used to print drapery fabrics and clothing, beverage containers and bottles, signs and notices, and many other kinds of objects. *See also* Printmaking.

Silver

A whitish, lustrous gray color, such as that seen in the precious metal; like gold, the metal silver can be beaten into "leaves" and attached to paper, a picture frame, or a furniture surface to impart a metallic polish; silver pigments are found in acrylic and oil artists' materials, bottled inks, crayons, markers, and gouaches, as well as house, commercial, and industrial paints.

Silver Halide

A crystal that is highly sensitive to light and is used in photographic emulsions. Silver forms these crystalline compounds with the halogens—chlorine, bromine, iodine, and fluorine. The most common compounds, silver chloride and silver bromide, are used individually or in combination in photographic emulsions. The chloride produces prints with a blue-black tone, the bromide a brown tone. Halides are most sensitive to ultraviolet and blue light but can be sensitized to longer (red) wavelengths. By combining them with color couplers, it is possible to reproduce a color image. *See also* Color Couplers.

Simple Color

A color characterized by uniformity of tone and hue over the whole colored surface; also another term for primary color. *See also* Complex Color; Primary Colors.

Simultaneous Contrast

The mutual influence of two adjacent colors, causing each to enhance or reduce the other's saturation and even substantially altering their respective hues. This visual phenomenon is also known as color irradiation.

Artists have long used this effect to improve coloration in their work; it was written about at least as early as 1550, when the Italian art historian Giorgio Vasari (1511–74) observed in his *Lives* that "a sallow color makes one that is placed beside it more lively, and melancholy and pallid colors make those near them very cheerful and of a certain flaming beauty" (Vasari 1550).

The first methodical study of simultaneous contrast was made by Michel Eugène Chevreul at the Gobelins tapestry works in Paris during the early nineteenth century. He had been called in to determine why some colors of the fabrics did not appear as saturated as they should, and he concluded that these

Two complementary colors will make each other appear more saturated and vivid. A tomato appears bright red against a green background; against a red background, it can appear red-brown.

unexpected visual shortcomings, rather than being the fault of the dyes, resulted from the irradiative effect of colors in proximity to each other. He called the effect *simultaneisme*, or simultaneous color contrast. It results from the automatic heightening of contrast on the part of the perceptive process that allows the observer more easily to distinguish colors that are simultaneously present in the visual field. Two complementary colors together will make each other appear more saturated and vivid. With noncomplementaries, each color will tinge the other with the complementary of the former: The influence of this tinge may desaturate the second color, by adverse additive mixture.

Chevreul devoted considerable attention to the artistic application of the contrast effect. The publication of his researches (1839) would eventually encourage the impressionist painters to explore the influence of juxtaposed colors, opening the way to pure abstraction. At the time, it was a revelation to see, for instance, the relationship between a red-orange parasol or poppy against a green field as a contrast principally between two complementary hues, not two different objects.

The effect of simultaneous contrast is greatest at the edges between colors, or on patterns of a small scale. It can best be avoided by encasing colors with black or neutral lines (*see* Cloisonné; Isolated Colors).

The heightening or dulling of color has ramifications in many fields of human enterprise. For instance, a tomato appears bright red against a background of green leaves, but against a red background it becomes a faded reddish brown color. Knowledge of such effects is important when choosing colors for display areas or advertising. *See also* Albers, Josef; Chevreul, M. E.; Dazzle; Optical Illusions; Successive Contrast.

Sinopia

A natural red earth pigment procured from sinopite, a red ferruginous clay; named for the Turkish town of Sinope on the Black Sea, where sinopite is mined. Sinopia was used extensively by Italian fresco painters until the mid–fifteenth century to outline their compositions. In fact, the pigment is so closely connected with early Renaissance painters that art historians refer to rough sketches from that period as "sinopia drawings." *See also* Fresco; Natural Earth Pigments.

Sixties Colors

See Op Art; Pop Art; Psychedelic Colors; Trends in Color.

"Of different colors equally perfect, that will appear most excellent which is seen near its direct contrary: a pale color against red; a black upon white . . . blue near yellow; green near red: because each color is more distinctly seen when opposed to its contrary, than to any other similar to it."
—Leonardo da Vinci

"In order to change a color it is enough to change the color of its background."
—Michel Eugène Chevreul

"Size" of Color

The ability of some colors to seem to affect the size of an object. In graphics, particularly, colored surfaces appear a different size than they really are: A white square on a black ground seems bigger than a black square of the same size on a white ground; on a chessboard pattern, the white squares appear larger than the black; similarly, with three squares, one yellow, one green, and one blue, the yellow will seem to "irradiate" and expand beyond its edges, while the blue seemingly develops a concentric movement and shrinks.

More light is reflected by bright colors than by dark ones, resulting in excess stimulation of the eye. This excess causes the edges of an object to be perceived less sharply, making bright objects seem to bulge outward. If there is also simultaneous contrast of hues, the effect is further increased. On average, against a variety of backgrounds, a three-dimensional red object will appear largest, followed by yellow and then green.

The phenomenon of advancing and retreating colors also contributes to apparent size. A yellow disk hung on a black wall and viewed from a distance of a few yards will appear to be some six inches away from the background. The same occurs, but to a diminishing extent, with orange on black, red on black, green on black, and blue on black, respectively. Violet on black does not appear raised at all. On a white ground, a blue disk will appear to be six inches behind the ground, with a reverse order down to yellow on white being practically level.

There are several explanations offered for this effect, although none has been proved. Blue and red/yellow light are refracted differently by the lens of the eye—blue slightly behind the retina at rest and red in front, causing an adaptation of focusing. Much also depends on irradiation and the relative luminosity of color and ground—colors with luminosity similar to the background are less protrusive. Finally, we habitually associate blue with distance (sky, distant mountains), and red/yellow with near objects. *See also* Aerial Perspective; Optical Illusions.

Size (Scenic Color)

Water-soluble paint made with hot glue size, a solution of gelatin. It results in a quick-drying but brittle paint film, used almost exclusively for theatrical scene painting. Soft-bound distemper, consisting of pigment in cold glue size, is occasionally used as an inexpensive paint for interiors.

Skin Coloring

See Body Painting; Race and Skin Color; Tattoo; Zoology and Color.

Slate

Dark, bluish gray, similar to the stone used primarily in roof and terrace tiles.

Snow Blindness

A temporary abnormality of the color sense, in which all objects are tinged with red. It is caused by long, continued exposure to very bright light, as in arctic exploration, on glaciers, in telescopic observation of the sun, or in watching welding operations.

Sodium Vapor Lamp

See Lighting, Artificial.

Solarization

The partial reversal of tone in a photographic image, caused by overexposure in the region of 1,000 to 10,000 times. Solarization was first noticed in daguerreotypes in the 1840s. The blue-sensitive surface of a plate required substantial exposure times, and bright areas such as the sky would solarize and become dark, giving the images the appearance of being negatives. Solarization is rare in modern film, but a similar effect, known as the Sabattier effect—after Armand Sabattier, the French scientist who discovered it in 1862—was used by the American artist Man Ray (1890–1976) to produce dramatic reversals of color: By flashing a bright light in the dark room during film exposure, he caused colored areas to build to densities far greater than normal, with the result that their printing value or visual appearance is reversed.

Solid Color

Uniform color showing no variations; also known as flat color. *See also* Complex Colors.

Sottsass, Ettore

1907– . Milanese designer and architect; founder of the group of designers called Memphis. In the 1960s, Sottsass designed an orange-red Olivetti typewriter, known as the Valentine, which featured black keys with white letters and bright yellow spindels. This marked such a departure from traditional drab office machinery that it came to be considered a personal color accessory (*see* Plastic).

In the late 1960s, Sottsass became a father figure to those who challenged the idea that furniture should be traditionally designed.

His style of bold, brassy, oversized furniture became distinct for its juxtaposition of colors and materials. As many as five different Italian marbles and five multi-colored laminates can be found in a single piece. The multiplicity and ambiguity of his materials and his emphasis on color over form have made him a key figure in postmodernism. *See also* Memphis; Postmodernism.

Sources of Historic Colors

See Sources of Historic Colors *color section*, page 321.

Specification of Color

A method of communicating color information between design and manufacturing stages. Techniques include supplying a sample swatch of fabric or other colored material, matching the color to a chip or swatch in a specifier system (such as The Standard Color Reference of America, the Munsell Book of Color, the PANTONE®* Professional Color System, or the Colorcurve® System), or providing identification codes (such as CIE tristimulus values, CIELAB values, or a specifier system's own notation).

In color specification, the accuracy of the final color depends on the method used (*see* Measurement of Color). Some companies, like Munsell, provide color tolerance sets, giving the maximum color differences permissible for each of the three visual attributes (hue, value, and chroma). However, it is often not possible or even practical to reproduce an exact color, particularly when working in different mediums—even with standardized lighting, our perception of a specific color can change dramatically according to the size of the color chip, surface characteristics such as texture (gloss or matte), and contrast effects with neighboring colors. Although there is often a need for strict accuracy, as in the reproduction of safety colors or in multi-component products, this may have to be balanced with economy. In fashion or interiors, for instance, a variation of 5 percent (on a hue circle of 100 steps) may be unavoidable due to fluctuations in dye quality, paint mixing, or colorfastness.

Customized hue specification charts showing acceptable tolerances are produced for various industries in which the product undergoes color changes, such as the cooking of food or the ripening of fruits and vegetables. Gray scales help maintain pho-

* Pantone, Inc.'s check-standard trademark for color reproduction and color reproduction materials.

tocopy quality in office copiers and are also used in the photographic and graphic arts to control value gradations. *See also* Colorfastness and Dyeing; Computers and Color; Gloss; Matching Color; Matte; Measurement of Color; Optical Illusions; Proofing Color; Simultaneous Contrast; "Size" of Color; Systems of Color; Vignelli, Massimo and Lella.

Specifier System

A guide, usually with a sample color chip or fabric swatch and a number, by which colors are matched or designated; each industry has a specifier that shows color in its particular medium and with either pigment or dye color stuffs. *See also* Systems of Color.

Spectral Colors

The colors that make up the spectrum of visible light: red, orange, yellow, green, blue, indigo, and violet. Purples are not spectral colors since there is no dominant wavelength for purple; it can be produced only by mixing red and blue light.

It is variously estimated that the human eye can distinguish 100 to 120 different spectral colors. These colors are perfectly saturated and are vivid over most of the spectrum; they do not include browns, purples, pinks, or grays. *See also* Spectrum.

Spectral Curve

A representation drawn on a graph based on measurements of the intensity of light at each wavelength across the spectrum. The curve is a useful way of showing the overall color characteristics of a light source (an emission curve). *See also* Color Temperature; Light; Light, Artificial.

Spectral Line

A line of color that appears when light from a source with uneven emission characteristics is passed through a prism. In contrast, the spectrum produced from sunlight is continuous. Spectral lines produced from matter heated to incandescence are a helpful indication to scientists of the chemical composition of a substance. *See also* Astronomy and Color; Spectroscope.

Spectrograph

See Spectroscope.

Spectrometer

See Photometer.

Spectroscope

An optical instrument for producing spectral lines and measuring their wavelengths and intensities, used in spectral analysis. In the simple prism spectroscope, a collimeter, with a slit at the outer end and a lens at the inner end, transforms the light entering the slit into a beam of parallel rays. A prism or diffraction grating disperses the light coming from the collimeter, and the spectrum formed can be viewed through an eyepiece. If a photographic plate is used to record the spectrum, the instrument is called a spectrograph. *See also* Measurement of Color.

Spectrum

An arrangement of the components of an emission according to some varying characteristics such as wavelength, energy, or mass. In the case of light, the visible spectrum is the tiny fraction of electromagnetic energy to which our eyes are sensitive—with wavelengths from 400 to 700 nanometers (billionths of a meter).

All electromagnetic energy is the same throughout the spectrum, differing only in wavelength and its inversely related characteristic, frequency. Long wavelengths are produced by electric current running through wires, such as radio antennas; progressively shorter wavelengths are produced by molecular and atomic motion, by movements of charges within atoms (light), and by action within the nuclei of atoms (gamma rays).

Each part of the spectrum has its own useful characteristics. Light, being easily reflected or stopped by matter, has become the basis of animal vision, a means by which human and most other animal species can gather information about their environment without actually touching it. The whole visible spectrum seen together constitutes white light; this can be broken down by a dispersion or by selective absorption by matter into its constituent wavelengths, which the highly evolved eye can distinguish as separate colors. *See also* Diffraction; Prism; Selective Absorption; Vision.

Spotty Color

Non-uniform color covering small areas; mottled color.

Spreading Effect

See Bezold-Brücke Effect.

Stained Glass

Glass that has had metallic oxides fused into it or colored pigments fired onto its surfaces. Fusion occurs when the metal oxides are added to molten glass—pot-metal glass. Otherwise, the oxides are suspended in a

gum solution and painted onto the glass, which is then refired to fuse a coated design. When this painted glass is kiln-fired to about the melting point, the vitreous paint becomes part of the glass itself. Additional firing results in further color enrichment. The coloring agents are mainly metallic oxides such as cobalt, copper, selenium, gold, and silver salts. Ruby and rose tints are derived from gold; a luminous yellow is obtained from silver salts.

Stained glass is the most permanent man-made color medium. Although it acquires a patina over the years, it resists fading for centuries. The most brilliant of color materials, it transmits spectral color directly from sunlight.

Earliest examples of stained glass include the windows of Hagia Sofia in Constantinople (Istanbul), and the Church of St. Martin (Tours, France). By 1400, the glaziers of France led the world with their windows at Le Mans, Bourges, and Chartres, the latter cathedral exhibiting the finest examples. Its rose and blue windows are the quintessential examples of stained glass art.

The continuity of the stained-glass art tradition is demonstrated in the relatively new

installations in Reims Cathedral, France. To replace a number of windows shattered during the war when the cathedral was bombed, the church authorities commisioned designs from Marc Chagall (1887–1985). Contemporary stained glass ateliers in the neighborhood of Reims executed the designs with much the same techniques used for the originals some seven centuries earlier.

The process involves drawing full-sized cartoons with thick black lines for the leading and the structural and reinforcing bars. From these, the patterns for each individual piece of glass are made. The glass is cut with diamond-tipped cutters and soft iron pincers known as groziers. The glass shards are assembled temporarily with beeswax, and are then each decorated with metallic pigments mixed with finely powdered glass (which is then fired on). The final stage involves assembly using lead beading with an H-shaped

cross-section to hold the glass in place.

Stained glass was taught at the Bauhaus by Johannes Itten, Paul Klee, and Josef Albers. Modern usage can be seen by Marc Chagall at Nice University (1968) and in the Synagogue of Hadassah building in Jerusalem (1966–69). *See also* Glass; Isolated Colors.

Standard Color Reference of America

See Standardization of Color.

Standardization of Color

The creation of a universally recognized list of colors and their names within the color industry of the United States. In 1915, after the outbreak of World War I in Europe, it became difficult to obtain reliable dyestuffs from overseas; the presidents of silk and wool companies joined together and founded The Textile Color Card Association, subsequently known as the Color Association of the United States (CAUS). Standardization of textile color was their paramount concern. According to Frederick Bode, the first president of the board of directors, "The idea was conceived that we should begin by creating a Standard Color Card, which would embrace all colors commonly demanded and largely suggested by objects as they appear in nature, and the name of the color should be the name by which the color is known, so that the name would at once suggest the color. The only question was how to limit the number of colors and yet present all of the so-called staple shades in use."

In 1915, the first list included 106 "staple" colors as standards in the United States. Selection was based on the fact that "a large consumption fell upon a very few colors, and that the demand for a large variety of shades was comparatively small." The names adopted for the first standard reference were commonly known names of jewels, animals, and flowers, such as emerald, otter, and violet. *The Standard Color Reference of America* has been periodically updated and is supplemented by special U.S. military cards that show approved and accepted military shades. *See also* Appendix: Color Atlases; Forecasting Color; Trends in Color.

Stars

See Astronomy and Color.

Steiner, Rudolf

1861–1925. German philosopher, scientist, and educator who had a strong interest in color. In 1922, he gave a series of lectures on color, which are still influential. He recog-

Stained-glass windows.

Reims.

Chartres.

nized that although color concerns the physicist, "it also concerns . . . the psychologist, metaphysician . . . [and] above all the artist" (Steiner 1977). He had a particular interest in a flesh tone that he called peach-blossom, which he said "represents the living image of the soul." Of other principal colors, he said, "green represents the lifeless image of the living . . . white or light represents the soul's image of the spirit . . . black represents the spiritual image of the lifeless."

Stella, Frank

1936– . American painter known for his large-scale, shaped canvases—unmodulated and geometric striped abstracts. Stella pioneered the 1960s minimalist art movement, beginning with black-striped paintings. He used alkyd commercial paints, even at times motor vehicle paints, and the large brushes of the house painter, and he left lines of unprimed canvas between his favored motif, stripes. By the early 1960s, his works were in full-spectrum and even fluorescent colors. In 1970, the Museum of Modern Art in New York City exhibited a Stella retrospective, making him the youngest living painter so honored at that time. *See also* Minimalism.

Stereoscopy

The perception of a three-dimensional image. Human vision is stereoscopic; with slightly different angles of view coming from two eyes, the visual cortex of the human brain combines the two images into a single one, simultaneously imbuing the image with apparent depth and perspective.

There are also various stereoscopic processes and devices that give the illusion of depth from two-dimensional images or reproductions, such as photographs or motion pictures. The main method of creating this effect is by photographing a subject from two slightly different angles simultaneously; when the images are viewed together, a single image is seen but with the appearance of depth of relief. In the 3-D movies of the 1960s, the red and blue images, respectively, were projected on the screen; the audience was given special spectacles with one red and one blue plastic eyepiece, allowing each eye to see only one of the images. The overall color effect, however, was that of black-and-white. *See also* Aerial Perspective; Holograms; Optical Illusions; Vision.

Streaks

Dark or light marks running lengthwise on a painted or glazed surface (or warpwise on a fabric).

Striated

Marked with stripes, furrows, streaks, or flutes. Striation was an important part of the moiré effects created by op artists of the 1960s. In such art, alternating lines of varying thickness and curvature give extraordinary illusions of movement and three-dimensionality as the eye strives to make sense of what it is seeing. *See also* Moiré; Op Art; Optical Illusions.

Strike-Off

In textile industry vocabulary, the strike-off is the initial sampling of a printed fabric, made at the plant before initiating full production. It is the equivalent of the color proof in printing, and an important stage in which a designer or stylist makes certain that the pattern transposed onto the fabric is as close as possible to the original artwork, mainly in color. Several samples, called patches (about a yard of cloth), may be required, with color correction on each one, before a reasonable match is made. Most apparel patterns are roller printed and have an average of three to six colors. Interior fabrics, printed on a flat bed or on rotary screens, use many more colors.

Structural Color

Color that is not due to the presence of some pigment or other coloring material, but solely to the action of light upon the geometry of a transparent medium. Examples are the iridescent colors of an oil film and the thin scales of a butterfly's wings, which change color depending on the angle of viewing. *See also* Interference; Iridescence.

Subjective Colors

Colors that are not dependent upon light for their perception. Isaac Newton, aware that color sensations could be experienced without the influence of light, wrote in his major work *Opticks*, "I speak of Colours so far as they arise from Light. For they appear sometimes by other Causes, as when by the power of Phantasy we see Colours in a Dream, or a Mad-man sees things before him when they are not there; or when we see Fire by striking the Eye, or see Colours like the Eye of a Peacock's Feather, by pressing our Eye's in either corner."

There are many other examples of subjective color. For example, afterimages may be experienced in darkness some time after exposure to small areas of illuminated hues. Experiments with hallucinogenic drugs have shown heightened sensations of brilliant hues that far exceed the intensity of colors

"Color is but a sensation and has no existence outside the nervous system of living beings."
—Nicholas Ogden Rood

seen in normal life. Persons suffering from mental disorders sometimes describe color visions that are purely subjective. *See also* Afterimage; Flight of Colors; Op Art; Optical Illusions; Psychedelic Colors.

Subtractive Color Mixing

One of two basic methods—the other is additive color mixing—of reproducing images showing the whole spectrum of color through the combination of only three or four colors.

Paints, dyes, inks, and natural colorants create color by absorbing some wavelengths of light and reflecting or transmitting others. A subtractively colored image absorbs different parts of the spectrum in different areas, giving us the full-color pictures we are used to seeing in color photographs or photomechanical illustrations.

The principle is based on a characteristic of human and other highly evolved eyes to perceive colors by means of three types of cones, with different spectral sensitivities, in the retina. Our perceptive process then combines the information garnered by each type of cone into signals describing color. Because of this, various combinations of two or three primary colors of dyes, paints, or inks (in addition to black) will produce all intermediate colors.

The colors used for scientifically exact subtractive color mixing are actually cyan, magenta, and yellow (the complementary colors of the primaries of additive mixing), although artists conventionally use blue, red, and yellow. A colorant that absorbs one of these colors reflects the combination of the other two. Two complementaries in equal strengths produce an additive primary color because each absorbs a primary; for example, magenta and yellow absorb green and blue, respectively, leaving red to be seen. Combinations of unequal subtractive strengths produce intermediate colors from white light: Full-strength yellow absorbs all blue, while half-strength magenta subtracts half the green; the remaining green combines with the unaffected red to produce orange. The combination of all three complementaries (subtractive primaries) subtracts all light evenly, and therefore produces black (full strengths) or gray (lesser equal strengths). *See also* Additive Color Mixing; Maxwell, James Clerk; Primary Colors; Young-Helmholtz Theory.

Successive Contrast

A contrast effect that occurs when colors are seen in quick succession—unlike simultaneous contrast, which occurs when colors are seen simultaneously, especially along the edges between contiguous colors. Both kinds of contrast can serve to heighten color.

The successive contrast effect depends on the eye being able to adapt to a single color; such an adaptation affects the perception of other colors seen immediately afterward. Successive contrast can be quite startling and will alter the character of broad areas of color when the eye moves from one to another, especially if those colors are complementary.

Adaptation of the eye can easily be seen in the case of afterimages. Staring at a red dot on a page for ten seconds, for example, will cause the corresponding portion of the retina to adapt to it; when one then looks at a white surface, the same color will persist for an instant, followed by a "ghost" (afterimage) of the original dot in its complementary color—in this case, green. The effect also occurs with light and dark contrasts.

Painters have to be particularly conscious of successive contrast. When viewing a painting, the eye scans it continuously with saccadic (rapid, jerky, stop-start) movements; each time the eye sees a new color, it is also seeing an afterimage of the previous color, and it perceptually mixes the colors. A yellow afterimage from a blue portion will make a yellow portion even brighter, but a red portion more orange. Landscape architects and others involved in designing with color also make use of successive contrast. *See also* Garden Colors; Isolated Colors; Simultaneous Contrast.

Sunlight

See Light.

Suntan

Darkening of the skin caused by exposure to the ultraviolet rays of the sun or special lamps. Melanin, a dark brown pigment, is produced under stimulus from ultraviolet radiation. An uneven distribution of melanin can result in freckles; an absence of melanin is a feature of albinism. *See also* Race and Skin Color.

Surface

A diffusing surface or medium breaks up the incident light and distributes it in a chaotic fashion; for example, rough plaster or opal glass.

A redirecting surface or medium changes the direction of the light in a definite manner; for example, a mirror or a prism.

A scattering surface or medium redirects the light into a multiplicity of separate rays by reflection or transmission; for example, rippled glass.

"A billiard table—go into a billiard hall. When you have concentrated on the green cover for a while—look up. How wonderfully reddish everything will seem. The gentleman dressed in black now wears a crimson red suit —and the hall has reddish walls and ceilings. . . . If you want to paint an impression with a billiard table, then you must paint in crimson red."
—*Edvard Munch*

Black and white, or dark and light, are the first colors to be named in all languages.

Surface Color

A color perceived as belonging to a surface, as compared to a volume color or an aperture color. A surface color usually appears to be illuminated by an outside source of light; that is, it is not self-luminous, as are aperture colors. *See also* Aperture Color; Gloss; Matte; Volume Color.

Swedenborg, Emanuel

1688–1772. Swedish scientist, religious teacher, and mystic who wrote extensively on religious matters and had a special regard for the significance of color.

Despite his friendship with Isaac Newton, Swedenborg adopted the view of Aristotle and declared that colors were derived from white and black. "For any color to come forth there should be something dark and snowy, or black and white, in which colors come forth when the rays of light from the sun fall into them, according to the varied tempering of the black and white, from the modification of the influent rays of light. Some of these colors derive more or less from the black, some more or less from the white; hence their diversity" (Birren 1941). *See also* Aristotle; Newton, Isaac.

Sweet Pea

An alliance of red and violet colors, as in the flower of the sweet pea *(Lathyrus Odoratus)*.

Symbolism and Color

The practice of using colors of the spectrum as symbols or codes to represent experiences, emotions, status, deities, and diverse other types of information that cannot be easily formulated in spoken or written language. An example of a color symbol is the use of the rainbow to represent the presence of God in Judaism, a religion that forbids making images of, or even giving a name to, the supreme deity. Color symbols can be used either pictorially or linguistically.

Symbols in general are considered to be an integral part of the human experience, and color symbolism reflects how people think, communicate ideas, and develop culturally. Just as language itself is a system of symbols (people use words to conceptualize their environment and to share information with others), color, a visually oriented symbol, can carry information but is generally less exact in its signification. However, being both a visual experience and a symbol, color has been presumed by many to bridge the gap between the conscious and the subconscious, and between the known world and a mysterious, hidden world beyond it.

Color, a visually oriented symbol, carries more information than words, but is less exact in its signification.

Color Archetypes

There is some evidence, through the work of the Swiss psychologist Carl Jung (1875–1961) and others, of the pre-linguistic existence of archetypes in human consciousness and subconsciousness. This can be corroborated in the use of color by early human beings: Neanderthals whose skeletons were found at La Chapelle-aux-Saints, France, and elsewhere had been strewn with red ocher and black manganese dioxide before burial. Red ocher, probably through its association with blood, was apparently being used to suggest life and to represent a renewal of life beyond the grave.

Similarly, red and black as symbols of life and death were used for body painting by primitive humans and in the hunting scenes painted in such caves as Lascaux in France and Altamira in Spain. Various theories have been put forward to explain the cave paintings, from ritualistic use in "blessing" the hunt to a basic human need for artistic expression. Certainly many artists today argue that the power, impact, and meaning of color cannot be defined systematically—that color lies in the province of intuition and the emotions, and is a primordial way to convey human hopes and fears. The fact that color partakes of light itself makes it a magical tool.

Color Language, Color, and Art

Something of the archetypal force of color continues into the era of language and verbal communication. Color enters the realm of symbols and metaphors used in the language (and pictures) of mythology, saga, religion, ritual, poetry, and the arts. A study of the earliest myths and creeds reveals that people have connected their deities from the very beginning with the source of the light that illuminated the earth and dispelled the formless darkness, the chaos of primordial night. This applies to such ancient cultures as the Indian, Chinese, Mesopotamian, Persian, Mayan, and Aztec, as well as to the sagas of the Norsemen and Druids in Europe. Black and white (or simply dark and light) were the first colors to be given names in all primitive languages, followed closely by red, indicating the symbolic importance of this trio of colors.

In the ranking of color symbolism, yellow, the color of the sun, stands out as a "sacred" color, especially in the Orient. It was sacred to Brahma, the highest Hindu deity, and to Buddha. In China, yellow was the attribute of the Yellow Emperor, the only one among the "Seven Immortals" who was believed to have been reborn as an aged sage, Lao-tzu.

His pupil, Confucius (551–479 B.C.), likewise gave preference to yellow. As the meaning of color was gradually refined, yellow came to be associated with particular gods or human qualities: In Greek mythology, "yellow-haired" Helios emerges from the waves, wrapped in a brilliant yellow robe; yellow also became associated with Athena, the virgin goddess of wisdom, and her Roman counterpart, Minerva.

Color symbolism continues into monotheistic religions as well, with generally the complete spectrum (or sometimes white light) used to represent the godhead. In Judaism, it is believed that when a fresh start was made after the Flood, the colors of the rainbow appeared over the earth as a sign of the covenant of a new order between God and man. The rainbow reappears in Christian writings, notably the revelations of St. John, as a metaphor for God.

Individual colors do have their own symbolic meanings. Some of these color symbols evolve and change over time: The Green Man of celtic mythology in Britain, who was the god of fertility, is probably the basis for the red-clothed Santa Claus (red, for Christians, representing suffering and regeneration). Other color symbols have never changed: In Christian art of the Middle Ages, the Virgin Mary is always depicted in a blue robe, blue being a symbol of truth and justice that adorned the breastplates of ancient Egyptian priests (as well as the modern American flag).

From these religious origins, much of the symbol-laden use of color in the English language originated. Meanings may be directly derived from earlier traditions, such as the gardener with the "green thumb," the "true-blue" politician, or "red-letter days" (religious holidays marked in red on calendars). Other meanings may have been twisted and inverted: Green, the color of youthfulness and hope, is used derogatorily in "greenhorn"; "blue laws" suggest puritanical restrictive legislation; the "bluestockings" are women whose erudition is gained at the price of forgoing female charms; and red, so spiritually majestic in the robes of cardinals, is now more commonly associated with the "scarlet" woman and the "red-light district."

Color and Culture

As colors are appropriated by different cultures, they can also have different connotations attached to them. These color symbols may be dependent on the archetypal use of color in language and religion, but they can also evolve new meanings and uses for sociological or political reasons, and are thus more variable and complex. As civilizations developed, people discovered the usefulness of color simply to code their fellow humans beings, and so developed uniforms. Like the primitives who identified themselves with the colors of tribal body paints, armies marched under colored banners and in colored costume. The height of this tradition was reached in medieval Europe, when a complex system of heraldry was developed, with shields identifying the followers of each nobleman.

The colors, however, were never arbitrarily chosen: Each conveyed very exact symbolic meanings, exemplifying real or hoped-for qualities of the leader. For instance, red stood for love and martyrdom, purple for majesty, blue for piety, green for contemplation, and yellow for wisdom. The direct descendant of this tradition can be seen in modern company logos and images. The green of American banknotes recalled not only the uniforms of the Revolutionary soldiers, but also the rise of a youthful new order from British colonialism.

Flags, also derived from heraldry, are the most potent symbols of cultural homogeneity. Japan, seeing itself as the first country in the world—"the land of the rising sun"—chose the red of the sun breaking over the horizon for its flag, and the dominant symbol of red still suffuses its culture. While blue has been emblematic for centuries of workers' uniforms (dyed in indigo) and of the Chinese peasants universally dressed in blue, red has been the symbol of danger and revolution, for which reason the communist Soviet Union and China both use red flags. Red in the American flag similarly suggests revolution and courage, but is mitigated by blue and white for honor and purity.

National flags, derived from heraldic banners, are the most potent of color symbols.

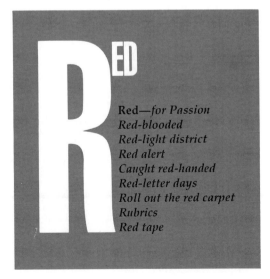

Red—*for Passion*
Red-blooded
Red-light district
Red alert
Caught red-handed
Red-letter days
Roll out the red carpet
Rubrics
Red tape

Color and Fashion

The use of color in fashion is based on the most complex system of color symbolism. At work are not just cultural norms in color use (for example, the wearing of specific colors restricted to certain classes), but also personal symbolic and associative meanings. Moreover, questions of harmony between colors, and between color and skin, hair, and eyes, particularly affect the way colors are combined and used.

Again, certain colors show remarkable consistency in meaning over time: Blue, gray, and black have long intimated sobriety and trustworthiness in the businessman; red nails and lips are powerful sexual symbols. In general, however, fashion color symbols are ephemeral, since modern fashion itself is based on change. Where in previous centuries dyes were few and fashion colors could last for decades and have deep associations, today's multiplicity of synthetic colors has prompted changes almost from season to season, making it increasingly difficult to pin down meanings. Much work has been done by color consultants on the most flattering colors for various color types, but not enough has been done on personal color symbolism through clothing.

Modern Color Symbolism

These are some of the modern symbolic associations of color in Europe and the United States, which have applications in the fields of advertising, architecture, design, graphics, fashion, and interiors.

Yellow. The nearest color to white and the most luminous color; suggestive on one hand of the life-giving sun and the wealth of gold, it can be associated on the other hand with the yellowing of leaves and the discoloration of white. Psychologically, yellow most often symbolizes hope, a bright future, and wisdom, just as the gold of Byzantine mosaics and icons suggested spirituality. A lemon yellow tint, however, can represent illness, as in jaundice and the color of quarantine flags, and suggest cowardice and treachery (from the medieval convention of portraying Judas Iscariot in yellow robes) as well as heresy: Sixteenth-century victims of the Inquisition were made to wear yellow armbands, as were Jews in Nazi-dominated Europe.

Red. The color of fire and blood, and a primordial symbol of activity, power, and aggression; the complementary of green, with all of that color's suggestions of the immobility of vegetation. Red is sometimes counterpoint to black: In China, red suggests the active (yin) force and black the passive (yang) force; similarly in the West, red and black represent war and priesthood, respectively. Psychologically, red has two distinct but related valences: On the positive side (which might be represented by a blued red), it is energy, warmth, talent, and courage; on the negative side (perhaps a yellowed red), it conjures up violence, passion, fire, and war.

Green. The most ambivalent color, easily associated with vegetation, growth, renewal, and thus immortality, it can deviously attract opposite connotations more appropriate to red: The Greek goddess of love, Aphrodite, was symbolized by green (her metal, copper, was red but that soon acquired a green patina); in medieval Europe, a sexually active man was considered "green"; the predomi-

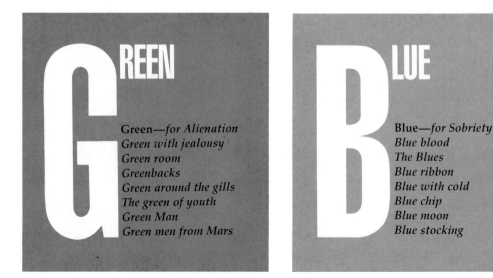

Green—*for Alienation*
Green with jealousy
Green room
Greenbacks
Green around the gills
The green of youth
Green Man
Green men from Mars

Blue—*for Sobriety*
Blue blood
The Blues
Blue ribbon
Blue with cold
Blue chip
Blue moon
Blue stocking

nant use of green in Jan van Eyck's *Giovanni Arnolfini and His Bride* both suggests the sanctity of love and points to the fact that the woman is obviously pregnant; green is so ambiguous that the Dutch artist Piet Mondrian expunged it from his palette altogether. Modern connotations of green suggest both immaturity and freshness or health.

Blue. Naturally dark, blue is a strong, reliable color that has for centuries suggested the depth of the sky and the mystery of the sea. It is the sine qua non color of Western twentieth-century cultures, of their flags, of their conservative political parties, and even of the uniform of their youth, blue jeans. Blue is tranquillity and truth and cannot be subverted, though it may be melancholy (as in the blues) and cold.

Purple. An imperial color in ancient Rome and, since then, a mystical and religious color worn by priests presiding over the ancient Greek mysteries at Eleusis, purple partakes of both the integrity of blue and the power of red. In Christianity, it symbolizes both the shed blood of Christ and the power of the Spirit. Being the first aniline dye color to be produced, purple was popular with the Victorians at large, yet it still carries a suggestion of aristocracy and snobbishness. Purple, expressing self-esteem, is a favorite of people fond of the arts, philosophy, and music, and a phobia of people with a particular aversion to pretentiousness, vanity, and cultural conceit. Today, associations of purple slide between faith or spirituality—a deep purple—and dreams or superstition—a light lavender.

White. Uncompromising, pure, and the non-color of light, the associations of white have always (and in every part of the world) bounced between death and salvation. The symbol of surrender (as in the white flag), it also represents a point of purification and transmutation (as in the white dove of peace, or the ashes of fire out of which comes new growth). Beginning with the seventeenth-century white flag of the Bourbons, white has often symbolized a purportedly legitimate cause. A notoriously difficult color to reproduce, bleached white often slips toward other hues with other meanings: Pinkish whites are warming, bluish whites are chilling, and yellowed whites suggest aging and decay.

Black. Denoting the absence of light and color, black is the end of a cycle, implying depth, corruption, and death. It is nevertheless a forceful color in clothing: The most common color of mourning, when worn by priests it symbolizes total self-abnegation; yet its very mystery caused it to become the fashion color of the twentieth century. Black is the perfect foil of color, both strengthening it and holding it in check. Black is authoritative and calm, but its undertones of horror and loss give it an erotic touch. If it slips toward gray, however, black becomes neutral and passive.

See also Advertising; Architecture and Color; Colloquial Language, Color in; Communication: Commercial Color Symbolism; Communication and Color; Fashion and Clothing Color; Heraldry; Language and Color; Motion Pictures, Color in; Mourning Colors; Personal Color Analysis; Rainbows.

YELLOW

Yellow—*for Hope*
for Despair
Yellow alert
Yellow back
Yellow bellied
Yellow dog
Yellow jacket
Yellow journalism
Yellow pages
Yellow rain

WHITE

White/Black—*for*
Good and Bad
White magic
White lies
White elephant
Blackball
Black sheep
Black market
Blackmail

Synaesthesia

The response of one sense to a stimulus applied to another sense. The most common example of synaesthesia is so-called colored or color hearing (also known as synopsia), in which sounds seem to have characteristic colors.

Examples of sounds affecting sight occur in all the arts (synaesthetic responses to other sensations are less common). The French composer Olivier Messiaen (1908–) constantly links color and sound, saying that he feels colors inside himself that move like music. One of his compositions, *Chronochromie,* concerns the way color manifests the discontinuity of time. In a conversation with French musicologist Claude Samuel, Messiaen described the way in which he simultaneously experiences color and sound within his own imagination: "But it's extraordinary that, having [not] absorbed [mescalin] . . . I am all the same affected by a kind of synopsia, found more in my mind than in my body, which allows me, when I hear music, and equally when I read it, to see inwardly in the mind's eye, colors which move with the music, and I sense colors in an extremely vivid manner."

In another form of synaesthesia, more relevant to the advertising and marketing of food products, some quite well defined colors are associated with fundamental and popular odors and tastes. It is thought that less than 1 percent of the population will make clear associations, but many of us are susceptible to inferring non-visual sensory information from colors. Many correlations are based on direct experiences with fruits, flowers, and foodstuffs: Looking at orange evokes in many people the smell of the fruit; lilac, violet, orchid, and lavender colors evoke floral scents; while many greens and browns suggest outdoorsy, earthy smells.

Value is critical. A shade is often perceived as heavy, ponderous, and dark in mood; a tint is usually seen as light and delicate. Thus, plum and maroon suggest a heavier, weightier scent; lilac and pink, the lighter colognes.

The material used is also of prime significance. While black in fabric may be viewed as elegant, in a liquid it may suggest tar. White suggests a slightly sweet, ethereal scent in liquid form, while gray may seem metallic, smoky, and musty.

In a study of the association between color and various odors and tastes, the French color theorist Maurice Deribère of the Centre Français de la Couleur, Paris, used a questionnaire to ascertain color associations. Of the 3,000 responses returned, he found 100 examples of repeated associations between color and smell or taste, of which eleven, listed below, showed striking consistency. These responses were based on individual and personal experiences; such cross-sensory color associations may change from individual to individual and over time.

Basic Odor	Associated Colors
Camphor	White or light yellow
Musk	Red-brown or golden yellow
Floral	Rose
Mint	Green
Ethereal	White or light blue
Acrid	Gray or brown
Putrid	Black, dark green, or brown

Basic Taste	Associated Colors
Salty	Blue-green or gray-white
Sweet	Red or pink
Sour	Yellow to yellow-green
Bitter	Brown-maroon or olive green

Recent neurological studies of the structure of the brain suggest that scientific evidence of synaesthesia may be established in the future. There are some indications that the centers for processing sensory information are linked to each other, leading to a certain amount of "crosstalk" between the five ostensibly separate senses. *See also* Advertising; Castel, Louis-Bertrand; Color Organs; Communication and Color; Kandinsky, Wassily; Language and Color; Music and Color; Scriabin, Aleksandr.

Synchromism

An avant-garde twentieth-century art movement begun by two American painters, Morgan Russell (1886–1953) and Stanton Macdonald-Wright (1890–1973), who first called themselves synchromists in 1913 exhibitions in Paris and Munich. In their nonobjective compositions, they explored harmonious arrangements of pure color—like the Orphists, followers of a concurrent movement. Macdonald-Wright wrote *Treatise on Color,* describing how "form translates itself as color. When I conceive of a composition of forms, at the same time my imagination generates an organization of color that corresponds to it. . . . Each color has a position of its own in emotional space and possesses a well-defined character. I conceive space as a plastic entity which in painting can only adequately be expressed by color. Thus I envisage this space as though it were a spectrum extending from my eyes

into measureless depth" (Macdonald-Wright 1924). *See also* Orphism, Orphic Cubism.

Synopsia

See Synaesthesia.

Synthetic Colors

Man-made dyes and pigments as opposed to mineral, vegetable, or animal colorstuffs; synthetics are often characterized by greater brilliance, intensity, and permanence.

The milestone in the development of synthetic colors was the accidental discovery of the first aniline dye—mauve or Perkin's Purple—by the nineteen-year-old William Henry Perkin in 1856. While attempting to synthesize quinine (a preventative medicine for malaria) from coal tar, Perkin noticed that a particular compound stained silk a deep and permanent purple. He then gave up his research position and, with his father, founded a factory to manufacture and market his discovery. Further work with coal tar, particularly in Germany by the chemist Adolf von Baeyer, soon led to the synthesis of indigo and other vat and basic dyes, and the discovery of direct dyes by Geigy in 1883, from which most of the early-twentieth-century dyes evolved. The most significant of recent dye developments was the discovery of reactive dyes by ICI chemists in 1955, where chemicals react with fibers to produce the most permanent colors available. The following tree shows some of the early developments in dye synthesis:

Adolf von Baeyer, the chemist who first achieved the synthesis of indigo dye, leading to many new discoveries.

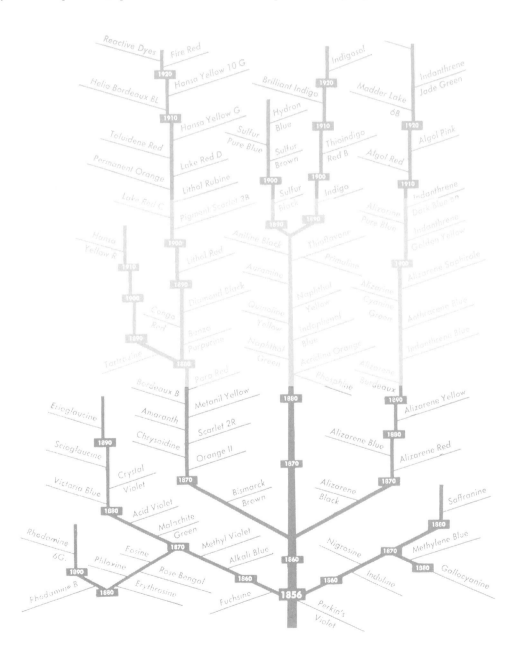

(At left) *Early developments in color chemistry.*

French chemist Michel Eugène Chev-
reul's lasting contribution to the field
of color was his masterly study of the
phenomenon of simultaneous color
contrast, published in Paris (1839)
under the title De la Loi du Con-
traste Simultané, *quickly followed by*
a German edition (1840) and later an
English edition (1854). Chevreul was
honored by the French government
with a special anniversary edition on
the occasion of his hundredth birthday
(1889). Still a classic analysis of the
interaction of color, the latest edition,
edited by Faber Birren, was published
in 1987 under the title The Principles
of Harmony and Contrast of Col-
ors.

SYSTEMS of COLOR

The arrangement of color in sequential order, notated with a number or letter code, which facilitates the visual identification, matching, and reproduction of colors, while providing an effective method of finding harmonious color groups.

A color system can be invaluable in design situations, given that human color memory is poor: By some estimates, the trained eye can distinguish up to 10 million different colors (making it 20 times more sensitive to sensory stimuli than the ear). But we can remember specific colors for only two to three seconds. Moreover, the spoken language is notoriously deficient in accurate color names; only very general color information can be conveyed orally (e.g., red, light blue, greenish blue, and so on). Various attempts have been made to produce a standardized system of colors, replacing names by letter and number codes and thus allowing every conceivable color to be systematically tagged and retrieved for use at any time and in any part of the world. So far, no one system has achieved universal acceptance.

The accompanying illustrated section describes the development of color systems, from Isaac Newton's early arrangement of spectral hues in the form of a circle to contemporary three-dimensional systems showing the whole gamut of color. Obviously, no color system can economically handle 10 mil-

lion colors: All systems use representative ranges of color (to date, the largest has 7,000 samples). A major problem in creating any system is that the accurate reproduction of color samples can be extremely difficult. Different surface textures, printing materials, or lighting can change the appearance of a color (*see* Metameric Colors).

A good color system works in three ways: First, all the colors are produced on a standard material, providing both gloss and matte samples. Second, all the colors are arranged sequentially and notated for easy reference. Third, the notation shows the colorist how to reproduce a given color, and indicates complementary and harmonious color groupings.

Note that color systems (or atlases) show colors only in isolation. They do not take into account the perceptive changes associated with differences of scale, or with the effects of simultaneous and successive contrast (*see* Optical Illusions). An exception to this is the Planetary Color System of Michel Albert-Vanel.

essay

Systems: Planetary Color

An approach to representing color space in multi-dimensions, using paired contrasts. Modern mathematics has broken with Cartesian geometry,

which held that the whole universe can be described in three dimensions: length, breadth, and height. Beyond the fourth dimension of time, scientists now believe that there are a further eight dimensions. Similarly, it is no longer satisfactory to describe color in the three dimensions of hue, saturation, and value. Michel Albert-Vanel, president of the French Color Center, describes a color order system in which color can be accurately tagged using at least three more dimensions, taking into account the way colors modify each other in a visual field.

In order to capture color in everyday life, it is necessary to take into account everything that falls into the observer's field of vision. In this field of vision, a color is never alone and isolated, but always confronted with other colors. Each one of these component colors is relative in time and space; the eye does not appreciate any of these as a color itself, but only with reference to the relationship or difference between these colors. From this juxtaposition are created the effects of contrast, smearing, and fusion, which modify our perception of colors.

In this manner, "groups of colors" are produced, which are perceived as a whole, reaching far beyond simple color associations. These groups of colors are characterized by more or less strong prevailing colors and internal contrasts that oppose each other on antagonistic axes. Consequently, a group of colors will be more or less warm or cool, more or less saturated or desaturated, more or less clear or dark, more or less fused or contrasted. From this opposition on antagonistic axes, it is possible to quantify a group of colors according to linear scales.

The oppositions between prevailing colors and color contrasts conform to the principle of contrast in Ewald Hering's theory: opposition of yellow and blue, of green and red, and of black and white—but equally of yellow-blue-green-red to black-white (*see* Hering, Ewald). In the same manner that prevailing colors have three dimensions, three kinds of color contrast exist (i.e., contrast of hue, saturation, and value). There are thus six scales, running from 0 to 10, that make it possible to characterize a group.

When the three color contrasts attenuate, the differences between the color areas also attenuate, and the group appears to be a single color. When these three color contrasts are neutral, when there is no color contrast at all, then we see a uniform flat color. A uniform color is an exception, however, and groups of colors are the general rule, because there are always some color contrasts. A color system that takes colors in isolation is an abstraction; the reality is found in the complexity of interacting colors. Any group of colors, such as in a painting or a piece of fabric, falls somewhere between extreme contrast (as between primaries in Hering's theory) and total fusion.

The three color contrasts can be represented by a dihedral rectangle. To take all three prevailing colors and three color contrasts into account, however, would require a space with six dimensions, which cannot be represented in conventional systems. It is possible, though, to represent the three contrasts in the form of a three-dimensional "solid," as is usually done with the three primaries (*see* Systems of Color).

The system is similar to one found in quantum mechanics, where two orthogonal spaces must be correlated between each other. In actual fact, a three-dimensional representation is already complex and unwieldy. Thus, it is better to represent these six dimensions simply, in pairs on a two-dimensional diagram.

There are three categories—colors, tones, and values—that correspond to the classic categories of painting. A work of art is usually filed in one of these categories (*see* Painters, Painting, and Color). The three dimensions of contrast become increasingly secondary as the general prevailing color tends toward monochromatism. Consequently, for saturated colors the contrasts of saturations and values are least important, whereas the contrasts of hues are primary. Inversely, the contrasts of saturations and hues are negligible for a set dominated by black and white, while the contrast of values will be important for it. A group of colors can be defined in a single point on the diagram of contrasts, if one is satisfied with an approximate value. But it will require three points on this diagram to designate a group of colors with precision.

While color combinations may have an infinite number, our perceptions of color are centered around a few principal groups that constitute large "planets," around which finer and finer variations gravitate as "satellites," or moons.

The most complete color system would have to incorporate not only scales showing hue, value, and saturation, and contrasts of hue, value, and saturation, but also scales showing the oppositions of pigment and light, opacity and transparency, and matte and gloss surfaces. It would be impossible to represent all these dimensions of color within one diagram, but the color theorist could take any two or three dimensions to show as a two-dimensional diagram on paper or as a three-dimensional solid.

—Michel Albert-Vanel

Chronology
c. 1500—Leonardo da Vinci expounds his theory of primaries.
1666–Isaac Newton analyzes light by means of prism.
1731—J. C. Le Blon defines the nature of pigment mixture.
1745–1772—Tobias Mayer and J. H. Lambert design color solids with triangular cross-sections.
1766—Moses Harris devises the first full-hue chart.
1810—Philip Otto Runge's sphere presages Ostwald and Munsell.
1839—Michel Eugène Chevreul's system springs from necessity to solve dye idiosyncracies.
1868—William Benson devises the innovative color cube.
1876—Wilhelm von Bezold designs a color circle based on human perception.
1878—Ewald Hering's system further expounds on the
Young-Helmholtz theory of vision and on perceptive experiences of color.
1915—Albert H. Munsell gears his three-dimensional system to contemporary needs, taking into account visual perceptions of color's multidimensions.
1917—Wilhelm Ostwald designs a double cone that makes it simple to plot geometric progression.
1931—CIE system provides mathematical precision in relating different colors.
1940—Alfred Hickethier's color cube provides a neat graphic solution for color space.
1958—Hunter system corrects visual distortions of CIE.
1979—Natural Color System (NCS) is introduced for modern use.
1983—Albert-Vanel outlines his Planetary color system.

Early Theorists

The modern development of chromatic systems began during the period of scientific inquiry in the Renaissance. Around 1500, Leonardo da Vinci recognized yellow, green, blue, and red, as well as white and black, as primaries, showing that all colors could be mixed from these. Isaac Newton, experimenting with light (but not pigments), was the first to arrange hues into a circle, but found no place for black (the absence of light) and white (the entire spectrum of light). Newton's work was continued by Jacques Christophe Le Blon, a Dutch printer who defined the nature of pigment mixture with red, yellow, and blue as primaries, and English engraver Moses Harris, who published a complete color circle produced with the same three primaries. These systems of organization have become the basis of many modern two-dimensional representations of color space, such as atlases (*see* Appendix).

A true color system, which necessitates a three-dimensional model, was first conceived by German mathematician Tobias Mayer (1728–62) in 1758, from which evolved the color pyramid of Swiss theorist Johann Heinrich Lambert. From this it was a short step to the hemisphere of French chemist Michel Eugène Chevreul and the American Albert H. Munsell's distorted sphere, one of the most successful color systems to date. Other designs include a double cone designed by the German Nobel Prize-winning chemist Friedrich Wilhelm Ostwald in 1917, and a cube, first designed by English architect William Benson in 1868, and perfected by German color printing expert Alfred Hickethier in 1952.

Circles of Color

Systems of color were first represented in two dimensions, showing the progression of pure colors from one to another. The circle was the most accommodating shape, as colors progress from red into yellow, then green into blue and finally, with the introduction of purple, back to red. This organization of the color spectrum evolved from Isaac Newton's discovery (1666) that white

Light refracted through a drop of water—an elegant demonstration of Newton's experiments with the spectrum.
Photo by Philippe Fagot.

light can be dispersed into its constituent colors. Newton had been experimenting with convex telescope lenses and was puzzled by rings of color (*see* Newton's Rings). Using a prism, he duplicated the effect, producing the regular ordered spectrum that is seen in the rainbow. By recombining the colored light back into white light with an inverted prism, he theorized that all colors are contained in sunlight.

Newton's spectrum showed a consistent and gradual color progression identical to the rainbow: from red into orange, yellow, green, blue, indigo, and violet. His proposal that the spectrum be represented in the form of a circle arose from the observation that the two ends of the spectrum—red and violet—are perceptually similar and naturally blend into each other. Strictly speaking, the circle is incomplete since violet-red (purple) has no corresponding wavelength. The choice of a circle is also significant since it is a mystical symbol of unity, portrayed by the alchemists of the period as a snake devouring its own tail. The circle remains the most efficient way

to arrange pure colors. Note that, in subsequent circles, while the color order is invariant, the exact location of each color on the diagram depends on the number or type of principal colors chosen.

Newton expected color to be part of a harmonious universe and to have a mathematical structure that could correspond to a musical scheme. He arbitrarily chose seven principal colors, which he then associated with the seven notes of the diatonic scale, and even the seven known "spheres" (the sun, moon, and five planets). Thus, red represented the note C; orange, D; yellow, E; green, F; blue, G; indigo, A; and violet, B (*see* Music and Color).

Variations on Newton

Less than a century after Newton, around 1731, J. C. Le Blon analyzed the primary nature of red, yellow, and blue in pigment mixtures. The discovery that these colors could be used to mix all others made it sensible to place them in the form of a triad (an equilateral triangle) on the color circle, with all

Facsimile (above, left) and abstraction (right) of Moses Harris's prismatic color circle (c. 1766). Using Newton's arrangement of the light spectrum to produce a continuous cycle of hues, Harris published the first circle in full color. His major innovation was the use of the three subtractive primaries ("prismatic" or "primitive" colors) of pigments.

With red, yellow, and blue, Harris was able to produce all other hues—the "mediate" colors (secondaries), orange, green, and purple, and the "compound" colors (tertiaries), olive, slate, and russet. Shades were made by overlaying black lines, increasing in density toward the center.

(Above) *The triangular glass prism used by Newton in 1666 to show that white light can be split into a full spectrum of rainbow colors. The phenomenon results from the varying refraction of different wavelengths.*

(Below) *Newton noted that the color sequence, as in the rainbow, is fixed. Observing that violet blends into red, Newton represented the spectrum as a full circle, with red (rubeus), green (viridis), and indigo blue (indicus) at equal steps.*

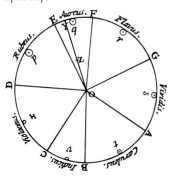

other intermediate colors of pure hue at even intervals between these points. In 1766, some thirty years later, the first color chart featuring this arrangement was published by Moses Harris, an English engraver. Subsequently, it was used by early nineteenth century color theorists such as Johann Wolfgang von Goethe, Michel Eugène Chevreul, Philip Otto Runge, and later by Nicholas Odgen Rood.

For a time there were disputes over which were the "true" primaries, with many color researchers, including Wilhelm von Bezold, advocating red, green, and blue as primaries. This confusion was a result of the differences between surface (pigment) color and spectrum (light) color; colors mix differently in each case. As Hermann von Helmholtz and James Clerk Maxwell realized, red, green, and blue are the primaries of light, in which color is combined additively (*see* Additive Color Mixing; Subtractive Color Mixing).

Color circles locate complementary colors diametrically opposite one another. On cir-

cles with pigment primaries, red is opposite its complementary, green; on the circle with light primaries, red has a different complementary, turquoise blue.

A third kind of color circle is derived from the physiological aspects of the eye. The eye recognizes four primaries—red, yellow, green, and blue—as being irreducible, totally distinct from their neighbors. For example, while orange and violet resemble red, red does not seem tinged with either of these two colors. The circle, with the four "psychological" primaries placed in the form of a square, was developed by Ewald Hering, a German physiologist, and used by Friedrich Wilhelm Ostwald as a basis for his own color order system.

Color circles use only the purest, brightest hues, just as we see them in the rainbow. Colors modified with black (shades) or white (tints) need a more expansive system.

Color Solids

The spatial representations of the position of colors in relation to each other make it pos-

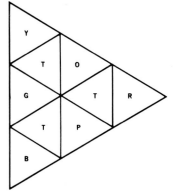

(Above, left) *Wilhelm von Bezold's color circle (1876). A less arbitrary arrangement, closer to perceptive experience. Bezold spaced the hues according to apparent differences, giving increased weight to green. As in previous circles, complementaries were located opposite one another, but his was the first to show that harmonic triads could be found at the apexes of equilateral triangles. A direct precursor of Munsell's system, it suffers, however, from exaggerated emphasis on the blues and violets.*

(Above, right) *Ewald Hering's circle (c. 1878) is strictly based on perception, rather than pigmentary mixtures. Hering identified the four psychological primaries as the four colors (red, yellow, blue, and green) that are "unitary" and have no visual resemblance to each other. While his circle is in accordance with the Young-Helmholtz theory of vision, it is considered too simplistic to be useful in identifying colors and harmonies.*

(Above) *An outspoken opponent of Newton's color schema, Goethe emphasized the primacy of red, yellow, and blue (similar to the subtractive primaries) in his triangle of 1810.*

sible to indicate progressive passages of one color to another with a minimum of ambiguity. Unlike the color circle which presents only pure colors (hues), the color solid can be used to plot variations of color, commonly known as tints (lightened with white), shades (darkened with black), and tones (grayed colors). Attempts to chart all these color attributes on a single two-dimensional surface are bound to fail.

The breakthrough in system design was the analysis of color according to three parameters: *hue* (determined, in pigments, by mixtures of red, yellow, and blue); *value* (or brightness, showing the amount of white or black in a color); and *saturation* (the strength, or purity, of a color). These three variables made it necessary to project a diagram of color in three dimensions—a color solid.

In 1745, Tobias Mayer developed a color solid based on a triangle with red, yellow, and blue at its points. Secondary colors ran along the edges and tertiaries across the middle. He then added other triangles, working up toward white and down toward black.

The first relatively satisfactory solid was that of Johann Heinrich Lambert in 1772. He realized that mixtures were "subtractions" (as they are in pigments) and that they tended when mixed to darken toward black. A base triangle with red, yellow, and blue on its angles was shaded toward a black center. The lighter colors were shown on subsequent planes, growing progressively smaller in size, rising vertically to a white apex.

In 1810, Philip Otto Runge, a German painter, conceived of the first color sphere (described by Johannes Itten as "the elementary shape of universal symmetry") in which the pure colors ran along the equator, while the tints scaled upward to a white north pole, shades scaled downward to a black south pole, and tones scaled inward toward the gray axis.

Chevreul's Color Hemisphere

The color hemisphere outlined by Chevreul in *The Law of Simultaneous Contrast of Colors* (1839), although flawed, is important. In conjunction with his original research into

(Below) *That red, green, and blue are the (additive) primaries of light was first recognized around 1790. These form the basic triad of Nicholas Ogden Rood's circle of 1879. Note that the complementary (or opposite) of red is green-blue.*

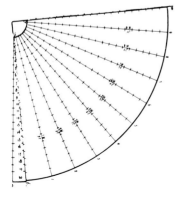

Facsimile (above, left) *and abstraction* (right) *of Michel Eugène Chevreul's color circle (1839). The (subtractive) primaries and secondaries of dyes were arranged on the circle in complementary pairs of red-green, blue-orange, and violet-yellow. There were seventy-two hues gradating into white (0) at the center and out to black (20) at the*

perimeter. The position of the pure ("normal") colors was determined by their natural "luminousness"—pure red was at 15, yellow at less, blue at more. This circle was the base of his color solid: the vertical axis was white to black, and the fins showed colors progressively "broken."

(Above) *The finned hemisphere of Chevreul's color solid, constructed with hand-dyed fabric swatches. Although never completed, it remains the first attempt to represent color physically in space.*

(Below) *A sample fin from Chevreul's color solid, showing the base colors increasingly "broken" with black in ten equal steps. The notation indicates dye proportions: 9B/1C means 9/10ths black and 1/10th of the chosen hue. Lighter colors (tints) are obtained by reducing the strength of the solution.*

color harmony and contrast effects, it represented the first systematic attempt at both a color notation and full scientific method to find harmonious progressions.

Chevreul asserted that his system "appears remarkable for its simplicity" but it was criticized by Ostwald for representing a considerable retrogression on what Mayer and Lambert had accomplished. He pointed out its major failing: that it duplicates shades. It also fails to show enough tints, or lightened colors.

Pragmatically concerned with the operation of the Gobelins Tapestry Works, France's state textile factory, Chevreul appreciated the need for good color organization. He identified four main advantages of color order: to have a readily available representation of "all modifications resulting from mixing colors"; to have "the means of knowing the complementary of every color"; to be able to visualize the order without the need of rendering in detail; and "to make apparent to all artists who employ colored materials of a given size the relation of number which exist between the tones of different scales when worked together."

The Munsell Color System

Albert H. Munsell's system, still one of the best, was intended as a "simple and practical notation, or method of writing color" (Munsell, *A Color Notation*, 1905). He suggested that it is very difficult to identify colors beyond five principle hue names: red, yellow, green, blue, and purple. Having a deep aversion to naming a color after an object, such as orange or violet, Munsell developed a system using numbers and letters outlined in *A Color Notation*. By 1915 he had constructed the *Atlas of the Munsell Color System*, a collection of charts built up from hand-painted color chips in scales of equal visual steps.

From his charts a color solid could be constructed—a distorted sphere with colors accurately located according to their three variables: hue, value, and chroma (saturation). The equator is the basic circle of pure colors. The perpendicular axis is the black-to-white scale. All the grayed colors (tones) fall in the interior of the solid.

Munsell's system arranges each attribute of color into orderly visual steps: 100 hue steps (labeled "H"), based on the five major colors and five intermediaries, each with ten

(Above) *Munsell's original black-and-white drawing of the ten-branched "tree," showing the numbering system used to identify colors by value (against the trunk) and saturation (out along the branches). Hues are identified by letters.*

Albert H. Munsell's color tree (1915). An imaginative representation of Munsell's three-dimensional color space. The trunk represents the gray scale—the roots are black and the top is white. From this extend branches representing the hues, with neutrals appearing near the trunk and the pure colors at the tips.

steps; ten value steps (labeled "V"); and an open-ended chroma scale (labeled "C") that could reach 12, 14, or more, depending on the strength of a colorant. The complete Munsell notation for a chromatic color is written symbolically: H V/C. Thus the notation for vermilion might be 5R 5/14, and for rose, 5R 5/4.

The updated version of Munsell's atlas, the *Munsell Book of Color*, by his son Alexander, is still in use. According to critics, the major defect of his system (and any system rotating out from a central axis) concerns the visual differences: there are large differences between hues of high chroma but a vanishingly small difference as the chroma approaches zero. Consequently, there are too few chips illustrating high-chroma colors which are industrially more important than those of low chroma.

The Ostwald Color System

Friedrich Wilhelm Ostwald, a German Nobel Prize–winning chemist and contemporary of Munsell, also constructed his system by means of equal visual steps. His notation,

however, indicates the percentages of white, black, and a hue in each color.

Studying first the achromatic (neutral) colors, he noted that while grays differ in proportion to the amount of white light that they reflect or absorb, white is visually dominant and its influence increases exponentially. A gray of 42.5 percent white is not the visual mid-point between black (5 percent) and white (80 percent); in fact, a 20 percent gray is the mid-point. The percentages of white needed for equal gray steps are a geometric progression (the accompanying letters identify the percentages in his notation): 89 percent (a), 56 percent (c), 36 percent (e), 22 percent (g), 14 percent (i), 8.9 percent (l), 5.6 percent (n), 3.6 percent (p). Effectively, "a" is a pure white and "p" a pure black.

Ostwald then divided a color circle of pure hues into twenty-four equidistant steps with eight principal hues (yellow, orange, red, purple, ultramarine blue, turquoise blue, sea green, and leaf green), each with three steps. The arrangement conforms to Hering's circle with four psychological primaries. The color solid, a double cone, has the gray scale as the central axis, with colors increasing in pu-

(Below) *A portion of the Munsell color solid, showing the relative lightness (value) and saturation (chroma) of a particular red, yellow, and blue. The central axis represents the black-to-white scale. Yellow is a naturally light color and reaches its greatest saturation at level 7 or above. Red and blue, however, are darker and reach full saturation at lower values.*

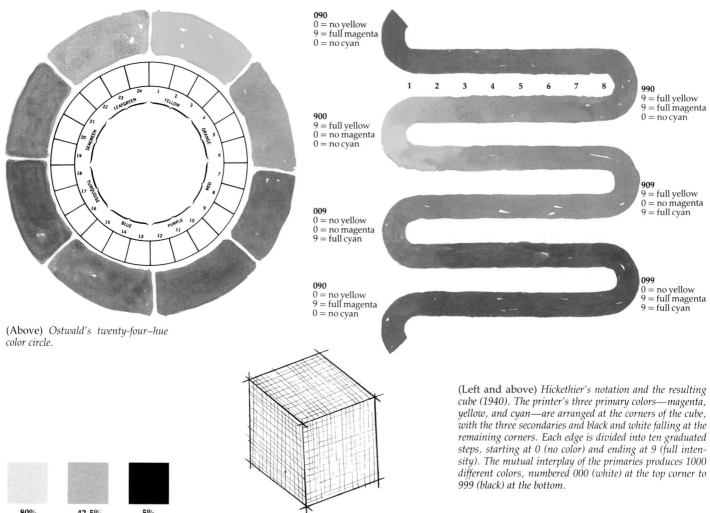

090
0 = no yellow
9 = full magenta
0 = no cyan

1 2 3 4 5 6 7 8

990
9 = full yellow
9 = full magenta
0 = no cyan

900
9 = full yellow
0 = no magenta
0 = no cyan

009
0 = no yellow
0 = no magenta
9 = full cyan

909
9 = full yellow
0 = no magenta
9 = full cyan

090
0 = no yellow
9 = full magenta
0 = no cyan

099
0 = no yellow
9 = full magenta
9 = full cyan

(Above) Ostwald's twenty-four–hue color circle.

(Left and above) Hickethier's notation and the resulting cube (1940). The printer's three primary colors—magenta, yellow, and cyan—are arranged at the corners of the cube, with the three secondaries and black and white falling at the remaining corners. Each edge is divided into ten graduated steps, starting at 0 (no color) and ending at 9 (full intensity). The mutual interplay of the primaries produces 1000 different colors, numbered 000 (white) at the top corner to 999 (black) at the bottom.

| 80% | 42.5% | 5% |

| 80% | 20% | 5% |

Ostwald's two gray scales (with percentages of white content). A true midgray (as in the second row) requires an uneven mixture of black and white.

(Below) A segment of Ostwald's solid. The letters indicate the proportions of white and black respectively in the color.

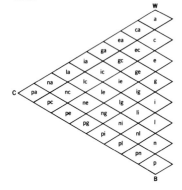

rity toward the equator. In his notation, a color such as rose would be given as "9ea," showing a red ("9") hue, with 36 percent white ("e") and no black ("a"). The top surface of the solid shows the tints, which Ostwald called "light pure colors" (colors with no black), and the bottom surface shows shades, "dark pure colors" (with no white). Colors inside the solid were "muted colors" (grayed), with both black and white.

The solid is presented as a regular double cone so that color harmonies can be plotted by fairly simple geometry. However, strict mapping, allowing for the natural luminosity of yellow and the darkness of blue, would result in a solid with an irregular shape more like Munsell's.

Chromaticity Diagrams
Mathematical representations that relate to color-matching properties of the eye help to ensure exactness and to eliminate distorted representations caused, for example, by aging or fading. Such chromatic diagrams have an objective basis of analysis, free of

visual limitations.

The CIE system, or "Standard Valency System," was recommended by the Commission Internationale d'Éclairage (CIE) in 1931, and is important to scientists who use colorimeters and need a mathematically precise system that correlates color to the properties of the eye and the wavelengths of light. The system is based on additive color mixture (of light), and the original experimental primaries were monochromatic radiations or wavelengths, called standard valencies: blue, with a wavelength of 435.8 nm (nanometers, millionths of a meter); green, at 546.1 nm; and red, at 700.0 nm. After transformation to ideal but hypothetical primaries, the locations of the colors are plotted as a graph on a flat plane: on the edge of the graph are the fully saturated monochromatic hues, and inside the hues blend together toward white at the center. Further planes below can be used to represent colors of decreased luminance.

The advantage of the CIE system is that the position of any color in relation to each primary is calculated and can thus be accu-

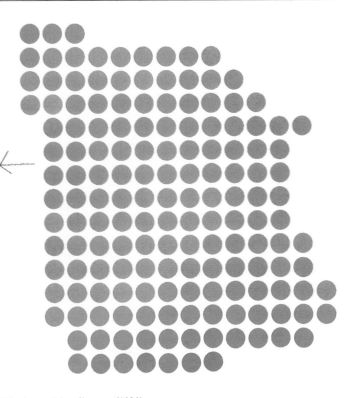

(Above, left) *The CIE chromaticity diagram (1931), a purely mathematical construct, based on the color matching properties of the eye. The center of the diagram represents white light. Further levels can be plotted showing the darkened colors (shades).*

(Above, right) *A color atlas, the Colorcurve™ System presents 1,228 sequentially arranged color chips in the form of a book. The system is based on the opponent-color solid devised by the CIE, with each page showing a different lightness level (level 65 shown here).*

rately noted. The disadvantage is that the distances between hues are strongly distorted in parts of the spectrum. Green, for example, dominates the graph, but to the eye is only a small part of the visible spectrum. *See also* CIE System and Color Measurement.

Chromatic Atlases
Two-dimensional renderings of chromatic spaces are known as chromatic (or color) atlases and are presented in the form of books. Easy to manipulate and comprehend, atlases have the advantage of being more tangible, through the use of actual color samples (chips or swatches.)

The color atlas developed in 1988 in the United States by Colorcurve™*Systems, Inc. maps some 1,228 colors arranged in eighteen charts (pages) by equal levels of lightness. A separate gray and pastel atlas brings the total

available colors to 2,360. All colors have been mixed from only eight base colorants, in order to reduce the effects of metamerism. Additional (intermediate) colors can also be produced on request, and all colors can be ordered in large 14- by 22.5-inch sheets.

The colors are preselected mathematically using the CIE system, with some modification to individual colors to promote equal visual steps. Colorcurve has its own notation but each color is correlated with standard reflectance values, CIE tristimulus values, and mathematically transformed CIELAB values so that manufacturers can accurately reproduce the colors. The first enables the system to be used with most current computer color technology, while the other two are useful to manufacturers who depend on the simpler colorimeters.

The Colorcurve system, with its adaptability to modern manufacturing processes (*see* Computers and Color), promises the accuracy of color identification that will be demanded by colorists in coming decades. *See also* Appendix.

* Process color reproduction of Colorcurve color communication system colors may not match solid color standards. Accurate identifications and color matching can be achieved only through the use of authorized Colorcurve reference manuals.

Planetary System

Designed by Michel Albert-Vanel in 1983, this is a new breed of color system that allows for effects of color perception. Arguably, colors are not abstract concepts, but real sensations; they tend to be seen in groups of two or more, not in isolation. Thus, effects like simultaneous contrast can change a color's appearance. Other factors to be considered are lighting, texture, and even size.

New parameters are added to describe the context in which a color is seen. These fall into three groups:

Chromaticity—the conventional scales of hue, value, and saturation of single colors.

Contrast—three new scales which describe groups/mixtures of colors: one for hue, stretching from monochrome (zero contrast) to polychrome (full contrast); and one each for value and saturation, similarly stretching from flat color to complex color (as in a dappled surface).

Material—three further scales: from active (light) to passive (pigment); from transparency to opacity; and from matte to glossy.

Any three scales can be used as the axes of a color solid. This system can be used to map color in complex color impressions, such as paintings, landscapes, or architecture. An infinite number of colors can be plotted simultaneously, although in practice the eye can only see about twenty colors at a time.

Albert-Vanel represents the system as spinning planets in primary colors, orbited by moons of secondary colors. *See also* Systems: Planetary Color.

Taiga

Distinctive Japanese painting style of the Momoya period (1573–99), particularly associated with the artist Kano Eitoku. He disdained monochromatic ink and evolved a monumental (*taiga*) style, using broad, sweeping brushwork against a gold background, with earthtones and greens for nature scenes on multiple-fold screens. *See also* Japanese Colors.

Tan

A light brown, usually of yellowish cast; the name is derived from the practice of tanning the leather from animal hides, an American textile standard since 1915.

Tanagra

From the ancient, clay-rich town of Tanagra, located in the Boeotia area of Greece, came graceful little female statuettes, which were personalized by individual treatment of color after firing. To eliminate repetition in color, each figurine was retouched by hand with blue, red, green, dark brown, pale purple, or yellow. All ornaments (earrings, bracelets, necklaces) were accented by a touch of gold. Hair would become Venetian brown-red. Faces were delicately made to seem alive with blue eyes, carmine lips, pink cheeks, and a rich black underlining the eyebrows.

Tanning

See Suntan.

Tantric Colors

Colors emphasized in the Tantra, a mystical Buddhist scripture. In the tantric tradition, three colors have special significance: Gold represents omnipotence, red stands for strength, and blue means victory over all evil forces and influences.

Tan T'Sing

Red and green; originally the literary term used in China for painting.

Tapestry

A heavy, hand-woven textile, used for wall hangings, curtains, or upholstery. The art of tapestry weaving is ancient, although the finest examples are generally considered to be those pieces made in Europe during the Middle Ages.

Many of these tapestries were made out of soft wool yarns with silk, linen, and gold threads woven in. Color was dyed in the yarn or thread, with no more than twenty clear colors used. Two color schemes predominated: reds with pinks, and blues with blue-greens and greens, providing warm and cool ambience, respectively. The soft pinks and pinkish oranges of the *Apocalypse d'Angers*, one of the first great weavings of the fourteenth century (made by Nicolas Bataille of Arras), are still vivid in their harmonies.

Tapestry weaving gradually became a means of reproducing paintings. As many as 36,000 different shades were developed, although at the end of the nineteenth century, Michel Eugène Chevreul reduced the number to 14,000, both in his chromatic circle and in the Manufacture Nationale des Gobelins, which he directed.

Many twentieth-century artists have designed tapestries, including, in France, Georges Rouault (1871–1958), Georges Braque, Jean Lurçat (1892–1966), Pablo Picasso, and Joan Miró (1893–1983). After 1950, an explosion of a new kind of tapestry occurred. Often inspired by the non-classic weaving techniques of ancient Peru, artists throughout the world experimented with different fibers, synthetic colors, and mixed techniques. The results have been variously called "textile art," "fiber art," and "new-tapestry."

Tartan

A plaid textile pattern originating in Scotland. The tartan symbolizes family loyalties and patriotism. The system of marking cloth with distinguishing spots and stripes may date back hundreds of years, although the modern code was not developed until Victorian times, when it became fashionable to wear tartan at Balmoral Castle, the Scotland residence of Queen Victoria (1819–1901).

Different tartans belonged to different clans; even within a clan, differing sets, or patterns and colorings, were used for differ-

District checks: The Shepherd Check was first worn by shepherds in the form of a plaidie, *or shawl. It was generally black and white (the two natural colors of wool), and, when colors were introduced, they were restricted to reds, russet browns, and soft greens.*

ent occasions: Hunting tartans, for example, were generally more subdued in color than dress tartans. They were meant to blend unobtrusively with the vegetation of the surrounding countryside.

Tartan colors, obtained from native vegetable dyes, were soft. Tartan green came from gorse bark and brown knapweed; red from rock lichen; yellow from bracken and heather; blue from bilberries, alum, and moss; black from the bark of the alder tree; violet from wild cress; and brown from dulse, or seaweed.

* * *

Distinctive check patterns and colorings, these originated in the Highlands of Scotland and were popular, along with tartans, in Victorian England.

The distinctive character of their "protective" color effects were used to camouflage the gamekeepers on the sporting estates. The first authentic "Districts" appeared in 1848 and was known as the Glen Urquhart check: The original plaid was navy blue and white, but it was ultimately superseded by the black-and-white version. Others followed, and there is now a list of twenty-six checks accepted as authentic Districts. The most famous is the black-and-white "Shepherd check," which was first worn by shepherds in the Cheviot Hills in the form of a *plaidie,* or shawl, for warmth. *See also* Dyes and Dyeing.

Taste of Color

See Synaesthesia.

Tattoo

To mark or color the skin permanently by injecting natural dyes and pigments beneath the surface. In Japan, tattooing has been raised to an art form, although it is linked with the criminal underworld known as *yakuza,* whose male and female members adorn themselves, sometimes from head to toe, with elaborate decorations that are considered highly sensual. The tradition is thought to have come from islands of the South Pacific, where the inhabitants cover themselves with body painting; the word *tattoo* is of Tahitian origin.

Teal Blue

Usually known simply as teal, this is a deep greenish blue like the feathers of the teal duck.

Technicolor

Trade name for what was originally a two-color motion-picture process introduced in

1915; in the 1930s, it became a three-color subtractive process.

The first film in the new Technicolor process was the animated *Flowers and Trees* (1932) by Walt Disney (1901–66). The first live film entirely in three-color Technicolor was *Becky Sharp* (1935); *Trail of the Lonesome Pine* (1936) was the first shot outdoors. For some twenty years, a bulky camera was used to accommodate beam splitters and filters that made simultaneous separation negatives directly on a bi-pack (two-emulsion) film and a mono-pack film.

In 1953, the system switched to conventional cameras and integral tri-pack film, from which separation negatives are made; these are then individually dyed cyan, magenta, and yellow and placed in contact with the print film emulsion to transfer the color. This emulsion also carries a moderate-density silver image to add definition and richness, especially in shadow areas and blacks. Exact registration is important, since every deviation is magnified at least one hundred times on projection. *See also* Motion Pictures, Color in.

Television

Color television uses the principle of additive light mixing. Filters in the recording camera separate the primary-color information (red, blue, and green). In addition to hue, the camera records the luminance (brightness) of all colors—the sum of the luminance components of all three primaries supplies the finer details of the color TV image. A special auxiliary signal cell called the "color burst" synchronizes the processing of the primary colors. The information is then broadcast and is picked up by each television set's receiver, which decodes the signal and fires streams of electrons from three electron guns within the vacuum tube. These hit phosphores dotting the inside of the screen, which glow briefly, reproducing the visual image. Each dot is subdivided into areas of red, blue, and green phosphores. The beams from the three electron guns are controlled in such a way that the beam from the gun using a given color signal strikes the phosphore of the same color.

When viewed, the dots are combined by the eye into coherent and continuous images, with the full range of spectrum colors. The illusion of grayed colors (normally a property only of reflecting surfaces) is a result of simultaneous contrast with brighter surrounding colors.

Color television's commercial appearance dates from December 1953, when a modified version of RCA's "compatible," all-electronic

(dot sequential) system was approved by the Federal Communications Commission. This system was subsequently adopted by Japan, Canada, and Mexico. Nearly three-quarters of all foreign television services use rival color systems, either PAL (West German) or SECAM (French), although direct-broadcast satellite services are considering a common digitized color system known as MAC (multiple analogue component).

Color television's acceptance by the public was very quick. Some twenty years after its development, the majority of American homes had color TV sets. By 1986, 96 percent of all American homes had color television. With the color graphics and expanded channel range of cable television, and the enormous number of daily hours of viewing by an average adult (reported to be 4 hours 19 minutes in 1987), color television can be described as the major source of all color information and color entertainment.

There are few restrictions on colors appropriate for color television recording. If a program is "chroma key," a technical process permitting a combination of separate images without the transparency of double exposure —and this is the case with many newscasts and commercials—then the color of the key, usually a blue, sometimes a green, must not be worn. This is because the blue or green chroma-key screen makes those parts of a person that are clothed in the key color disappear. This effect is often used in commercials; for example, the viewer sees only disembodied moving hands, because the rest of the body has been chroma-keyed out, by covering it with the color of the screen used.

Additionally, very bright yellows and white are not good wardrobe choices for television, because the details of the garment will be lost within their high reflectance. Intricately patterned materials, such as herringbone, small checks, and sharkskin, are also discouraged, because such complicated designs appear in distracting shimmering color on the TV screen. *See also* Advertising; Communication and Color; Computers and Color; Motion Pictures, Color in.

Tempera

Paint made of finely ground pigment mixed with a vehicle such as albumen (raw egg) or thin glue. Tempera produces clear, pure colors that resist oxidation.

Lighter pigment colors do better than darker ones because as the egg dries, there is a tinting of the color generally, plus a loss of richness in the darker shades. Most recommended for tempera painting are titanium white, cadmium lemon, yellow ocher, cadmium red, alizarin crimson, burnt sienna, Indian red, raw and burnt umber, French ultramarine, cerulean blue, and viridian. Due to the danger of poisoning, the lead-based pigments, such as flake white and Naples yellow, and the chrome colors are to be avoided.

Tempera paints are extremely stable, easy to apply, and beautiful in surface quality. If good pigments are used, there will be minimal fading and, if painted on good-quality wood panel (preferably primed with gesso), no cracking. Another advantage is that the surface will dry within a minute or two, allowing rapid overlaying of paint. Disadvantages are that it cannot be applied thickly or it will fall off the surface, and, although its surface dries quite quickly, the paint film is tender for weeks, requiring some six months to cure fully.

Whereas watercolor relies on a single layer of rich color to achieve its best effect, tempera attains its characteristic quality from a buildup of several layers of translucent paint put on thinly, each layer modifying but not obscuring the layer underneath. Pale tints are obtained by dilution, since the use of too much white can produce chalky tones. Even in the palest tones, overlays of ten layers of tempera are commonly used and can give a jewel-like quality. *See also* Artists' Pigments; Glair.

Terra-Cotta

Reddish brown, like the color of low-fired clays known by the same name; from the Latin *terra*, "earth," and *cotta*, "baked." The clays are used for pottery and in the decorative arts, often with colorful glazes.

A low-cost, lightweight material capable of assuming almost any shape, terra-cotta was ideal for architects to decorate the first of New York City's skyscrapers. Favored facade and roofline colors in the early twentieth century were yellow, orange, purple, lime green, pink, and cobalt blue. Metallic lusters of gold, silver, and copper were also often used. The Great Depression of the 1930s brought an end to the American terra-cotta industry on a large scale, as color and ornamentation in architecture became too labor-intensive to be affordable.

Tertiary Colors

A painting term for colors formed by mixing secondary colors. Examples include reddish brown and yellowish green. *See also* Secondary Colors.

Textile Art

See Tapestry.

Textiles

See Dyes and Dyeing; Fabric Printing; Tapestry; Tie-Dye; Toile de Jouy.

Theophilus

Pseudonym of the author of *De Diversis Artibus,* an early-twelfth-century treatise on painting—the first to deal with it as a comprehensive whole rather than a haphazard compilation of recipes, or descriptions of pigment mixtures. The treatise discusses the making of pigments, paints, and varnishes, as well as the techniques of painting on such varied surfaces as parchment, wood, and metal. It is divided into short, concise chapters such as "How to Prepare Green Earth," "How Colours are Prepared for Books," and "Grinding Colours with Oil and Gum." It offers detailed instruction on such subjects as the appropriate colors for the Madonna's robe and the different colors that should be used to render hair at different stages of life.

Thirties Colors

See Trends in Color.

Tie-Dyeing

A dye process and one of the earliest methods of decorating cloth. Portions of a piece of fabric are gathered up and tied into tight knots or bunches. The cloth is then dipped into the dye. The tied areas of cloth resist the dye, creating a design on the fabric. Developed in the Far East, this technique became extremely popular in the United States during the 1960s, along with bright color schemes. *See also* Batik; Fabric Printing; Shibori; Trends in Color.

Tiffany, Louis Comfort

1848–1933. American jeweler and glassmaker famed for his stained glass production, especially lamps. In 1887, he founded Tiffany Studios and the Tiffany Jewelry establishment in New York City. *See also* Art Nouveau Colors.

Tincture

A shade or a tinge of color. The term is used in heraldry to denote any of the colors, metals, or furs used for coats of arms. *See also* Heraldry.

Tint

Any color lighter (that is, of higher brilliance) than median gray, the modification of a hue (pure color) by the addition of white. Tints such as pink and lavender will appear to have both pure color and white in their makeup. To tint a photograph or a painting is to give the white areas of the image a faint hue by applying a thin, transparent wash of pure color. *See also* Harmony of Colors; Shade, Shading; Systems of Color.

Titanium White

See Artists' Pigments.

Titian

Ca. 1488–1576. A Venetian painter, born Tiziano Vecellio, whose realism, golden tonality, and color subtleties in the oil medium influenced succeeding generations. Titian's technique, which is also that of the Venetian School, was to work in a combination of oil and tempera paints. In place of the medieval practice of white grounds on panels, he used dark grounds on canvas. The Italian painter and art historian Giorgio Vasari (1511–74) commented on Titian's "ripe method of coloring" and his deserving "the praise of being the best imitator of nature in the matter of color of our time."

Titian is known for his use of few colors and many glazes. Like many great colorists, his palette consisted of a limited number of pigments: lead white, genuine ultramarine, red madder, burnt sienna, malachite green, red ocher, yellow ocher, orpiment, and ivory black. Linseed oil, nut oil, and Venetian turpentine were all used in the numerous glazes, sometimes as many as forty in all.

Titian's late work is largely monochromatic. In his final color work, he anticipates the seventeenth century and Rembrandt's naturally glowing colors.

Toast

A pale to medium brown color, like that of bread heated on both sides.

Toile de Jouy

Printed cottons in simple flower patterns and other decorative motifs, manufactured in Jouy, France, from 1760 to 1830. Toile de Jouy is particularly associated with Christophe Philippe Oberkampf (1738–1815), who, elevating textile printing to a fine art, made it a leading industry of France. As an employee in his father's factory in Wiesenbach, Germany, he experimented with dyeing and colorfastness. Toile de Jouy fabrics are often distinguished by characteristic beetroot reds and indigo blues.

Tone

A pure color that has been modified by the addition of black (a shade) and white (a tint). In common speech, the word *tone* has come

A Tiffany lamp.

to be synonymous with *hue* or any slight variation from a hue—as in "a tone of blue" or "blue with a greenish tone"—as well as the shades and tints. Examples of genuine tones are rose and beige. *See also* Systems of Color.

Topaz

A mineral, specifically an aluminum silicate that contains up to 20 percent fluorine or water; its physical and optical properties vary according to the proportions present. Pink and golden brown topaz contain more water, while fluorine-rich topaz is colorless, pale blue, or yellow. The usual gemstone topaz is yellow, although colors can vary from pale blue and colorless to orange, brown, and pink. The pink stones so popular in Victorian jewelry were produced by heating the yellowish brown topaz from Brazil. Today, a vivid blue topaz is produced by irradiating and then heating the colorless mineral. *See also* Gemstones and Jewelry.

Toulouse-Lautrec, Henri de

1864–1901. French postimpressionist painter and lithographer. The colors he used reflect his choice of subject matter—the world of Paris nightlife, clubs, cafés, and bordellos, peopled by singers, dancers, prostitutes, and other social outcasts. The colors are antinaturalistic, strident, and brassy. This is strikingly evident in *The Salon at Moulin Rouge* (1891), for example, in which the stark white faces of the reclining prostitutes contrast with the harsh colors of their makeup.

As a lithographer, Toulouse-Lautrec elevated the poster to an art form, using color as silhouette. Color is freed from a descriptive function and takes on a purely decorative role. He uses a limited palette of bright, clean primaries, orange, and green, contrasted with black, white, or gray, for dramatic effect. *See also* Neoimpressionism; Postimpressionism.

Tourmaline

A mineral of varying color; in fact, of all the gemstones, tourmaline shows the greatest color range—almost any shade seems possible, although pink and green stones are the most popular. Many tourmaline crystals exhibit polarity: The color may be pink at one end and green at the other end of the same crystal. Although most gem tourmaline is lithium-rich, there is no simple correlation between chemical composition and color. *See also* Gemstones and Jewelry.

Translucence, Pigment

The property of being partially transparent, allowing a certain amount of light to pass through a surface but diffusing the rest, so that the material behind the surface is not completely distinguishable. In medieval paintings and illuminations, different tones or hues of translucent color were painted in layers, one over the other, creating a richer, deeper surface. Translucent color was achieved through the use of such binders as glair, gum arabic, and gum water. *See also* Illumination of Manuscripts; Opacity, Pigment.

Transportation, Color in

See Airplane Colors; Automobile Colors; Safety Colors.

Trends in Color

Color tendencies or directions in clothing, interior, and exterior design, which have come to be recognized in the twentieth century as cyclical in nature; for whatever reason, the color design cycles align, more or less, with each decade of the twentieth century.

In the United States, color cycles began to be charted during World War I, in 1917, when the first silk and wool textile forecast was issued. The forecast itself was a highly successful attempt at coordinating color manufacturing throughout the textile and other allied industries. The 1917 forecast incorporated bright couture colors, particularly those of the avant-garde designer Paul Poiret: Royal purples, emerald greens, and peacock blues were featured. The colorful look was appropriated by the 1920s flapper, who wore multi-colored, sequined short dresses and painted her nails and lips bright red to announce her independence.

In interior design, two opposite color directions marked the 1920s: One trend was the Art Deco full spectrum, one of emerald greens, polished chrome, Indian corals, and black and red lacquer for furniture and screens; the other derived from the Bauhaus influence and featured white walls with one or two bold primary-color statements in furnishings. The designers Alvar Aalto, Marcel Breuer (1902–81), and Gerrit Rietveld were highly influential, and their color design innovations were to be seen in the 1920s and throughout the twentieth century.

In the midwestern and southwestern United States, meanwhile, warm oak colorations, reflecting the influence of Frank Lloyd Wright (1869–1959) and his prairie-style interiors of exposed reddish brown brick fireplaces, ocher plastered walls, and oak paneling and furniture, gave many an interior a substantial dignity. Ultimately, reds and oranges, pinks and apricots, and blues and greens in analogous color schemes came

"Very bright colors used to belong—when there were such people—to the truly plebeian and truly aristocratic. Perhaps it's partly to do with the enormous rise of the middle classes that we use muted colours."
—Howard Hodgkin, to David Sylvester

1920s—*Art Deco brights.*

1930s—*Depression and soil-resistant browns.*

1940s—*Hollywood fantasy pinks and other pastels.*

1950s—*Eisenhower and Hawaiian shirt colors.*

to be accepted in all levels of interior design. Light and bleached woods, like clear glass and metallic finishes, were used to suggest "the modern" by interior designers.

In the 1930s, there was a general tendency toward color coordination, and bright couture colors were introduced into mass markets, such as the cyclamen red of cosmetician Elizabeth Arden (1891–1966). Bakelite wares inaugurated the distinctively colorful palette of the modern plastics industry.

As it became possible to dye-match colors in all textiles and non-textiles (leathers, plastics, and even feathers), color coordination became fashion news. In the early 1930s, whites and off-whites, both warm and cool, were popular for women's clothing. Elsa Schiaparelli (1890–1973) introduced a warm "parlor pink" in 1936. In 1938, in a slightly bluer version, this became the famous then-shocking color known as Schiaparelli pink.

Color selection in the 1930s was directly influenced by political events. In 1937, for example, the coronation of Edward VIII (1894–1972) in England made royal purple popular. As the decade progressed and war sympathies gained momentum, navy blue, cadet blue, khaki, earth browns, and olive drab greens became popular in clothing. Dark, soil-resistant browns were pervasive in men's clothing.

Art also had an effect on colors. Surrealism, particularly the collaborations of Schiaparelli, Jean Cocteau (1889–1963), and Salvador Dali (1904–88), and the dismembered images of Man Ray (1890–1976), established that fashion color and form could stand outside reality and be extraordinary, even rambunctious. Heliotrope purples, parrot blues, emerald greens, golden yellows, and cream and mocha beiges were, in addition to pink, some of the colors they popularized.

Hollywood and Pre-War Colors

Hollywood and the film industry, a bright spot in the Depression era, had a large impact on style, including color. Movie idols such as Greta Garbo (1905–) and Jean Harlow (1911–37) wore flowing white dresses and costumes. Director Busby Berkeley (1895–1975) choreographed spectacular dispositions of choruses in 1930s musicals, adding to the glamour of black and white.

The 1940s comprised two color periods: World War II and post–World War II. During the World War II period, from 1939 to 1945, pigments and dyes were withdrawn from consumer goods, and textiles were demanded for wartime uniforms, blankets, and tents, while nylon went to parachute mak-

ers. Large, festive hats, often with outrageous arrangements of fruits, birds, or flowers, were one of the few acceptable feminine color extravagances. The Brazilian film star Carmen Miranda (1904–55) gave full expression to multi-colored hat fantasies. Prevalent colors for women's clothing during those years were navy blue, cadet blue, khaki, earth browns, and olive drab. All of these shades were considered supportive of the European war effort. Red was also worn, particularly in the form of little, entirely red jackets.

Post-War Colors

Most women found the return of color a welcome relief from the duller military palette. Following the war, fashion turned to more feminine looks and colors. Notable was the 1947 "New Look" of designer Christian Dior (1905–57), featuring an abundance of fabric and a more vivid palette including pale turquoise, pink, and gray. In ready-to-wear, fluorescent orange and hot pink bathing suits, as well as purple angora sweaters complemented by chamois yellow moccasins, were popular with teenage girls. Older women treated themselves to colorful suits in striking chartreuses and purples.

After 1945, paint companies offered many more color choices, making their various shades available in flat, eggshell, or glossy finishes. This, like the technology in the textile industry of man-made fibers and dyes, prepared the way for consumer expectations of a greater number of color choices. The plastic parts of small appliances such as toasters, mixers, and coffee makers first showed the manufacturers' response to the new demand for flame reds, chartreuse, and forest greens.

The colors popular in the United States in 1953–61, during the presidency of Dwight D. Eisenhower (1890–1969)—which was generally associated with the conservative 1950s—were principally sweet, uncomplicated pastels. The perennial American favorites, cherry red and navy blue, were also popular again.

In interior design, baby blue, baby pink, aqua, pale turquoise, orchid purple, silver chrome, and a yellowed green—used so extensively that it subsequently became known as bathroom-tile green—marked the era. Women's clothing featured dyed-to-match sweater sets, often worn with pearls; the popular colors for these sets were baby pink, baby blue, and the slightly more saturated sky blue. Saturated blued reds and navy blues were the favored "establishment" colors in suits, jackets, and coats. For men, in

addition to conformist gray—as documented by Sloan Wilson (1920–) in his best-seller *The Man in the Gray Flannel Suit*—traditional navy, soil-resistant brown, and briefcase tan made up the limited number of mass-market shades available.

The fashion industry promoted color glamour by giving exotic names to popular pastels and by pairing them in such two-tone combinations as the following: Roman Turquoise and Indo-Peacock, Dawn Aqua and Deep-Sea Turquoise, Frost Lime and Rustic Moss, Bois de Rose and Mahogany, Ecru Beige and Pink Putty, and Brandied Apricot and Cognac. By romanticizing familiar pastels with catchy names and then teaming them with related shades, designers aroused new interest.

Two-tone combinations marked the decade's distinctive showiness and encouraged an optimistic mood in potential customers, which probably led to more purchases. Color ostentation and the mania for two-tone looks reached its fullest expression in car colors, in which a plethora of pastels and shades was available. In 1954, for example, Chrysler Corporation offered a choice of fifty-eight exterior colors; these were available alone or in eighty-six two-tone combinations. Two very popular combinations in the mid-1950s for Chrysler's Pontiac Catalina were a yellowed green and ivory white and a cinnamon and beige brown. Car color variety and extravagances of the 1950s become particularly notable when compared with the limited number of exterior car colors available some thirty years later.

Fifties Colors

Fifties colors, like fifties design styles, have enjoyed continuing popularity among succeeding generations. Undoubtedly, the restfulness of the decade's sweet pastels reflected the psychological and economic stability of the post–World War II era and thus plays a part in the nostalgic revivals of the 1980s.

The 1960s was a decade distinguished in fashion, art, and industry by fluorescent colors associated with the youth movement and psychedelic drugs. Hippies in denim blue jeans, Beatlemania, mini-skirts in hot colors, white leather boots, and acid yellow and funky purple were all a part of the scene.

In interiors, the soaring sales of orchid-colored bathroom tiles, brightly colored paints, kitchen appliances in green-cast whites, gold- and copper-toned yellows and oranges, and olive green pile rugs established a new norm of color marketing.

The 1960s also marked a basic change in how color actually was understood. Up to that time, color was always defined in terms of light; it was assumed that without light, there would be no color. Hallucinogenic, mind-affecting drugs made it clear that in human experience, color could be generated internally.

Brown dominated the 1970s. In fact, brown shades were so much in evidence that interior designers refer to the decade as suffering the influence of a beige syndrome. The interest in a range of earthy, clay browns was largely derived from a focus on the American Southwest. Many 1960s college graduates romanticized the region, a place they considered the last frontier, and migrated to the states of Arizona and New Mexico, where they wore silver and turquoise Native American jewelry, patched brown corduroy skirts, and plenty of decorated and embellished blue denim. Long manes of hair for men as well as women established the natural look; lips were only lightly colored. The end of the decade was signaled by a new color direction when bright body colors in the obviously dyed hair and exaggerated eye and lip makeup of the "punks" appeared.

Eighties Colors

The 1980s were noted for a veritable explosion of color in fashion and design. The trend toward exotic wood treatments was one indicator of the taste for colorful effects. Italy's Memphis designers and New York City's East Village crafts makers applied aniline dyes, creating "punked" wood. Because light woods could be colored more easily, ash and bird's-eye maple gained favor.

In clothing, athletic wear, particularly tennis shoes, attracted the decade's fashionable bright colors, including chartreuse, acid orange, magenta purple, pink, and turquoise blue. Attention-commanding reds were given media exposure initially by being the favorite color of the first lady, Nancy Reagan (1921–); later, reds were mass-marketed in scarves, hats, coats, and suits. By the decade's end, the American designer Geoffrey Beene (1927–) could jokingly comment, "Don't you think orange is the new red?" (*The New York Times*, January 17, 1989).

Under postmodernism's influence, urban architecture captured in full-scale the era's desire for luminous colors: Mint green and pale sky blue glass, pink marble and granite, and black in every material were popular exterior and interior architectural colors. Philip Johnson (1904–) and John Burgee (1933–) designed the American Telephone and Telegraph Headquarters in New York City, an

1960s—Psychedelic, acid colors.

1970s—Southwest browns and turquoises.

1980s—Nancy Reagan red and Issey Miyake black.

1990s—Complex and blended colors.

"Distressing" paint to give a textured surface; an important faux finish.

early 1980s example of the use of more and brighter exterior as well as interior colors in public buildings. Of all the 1980s colors, though, none was as pervasive as black. There were black dresses, of course, and black appliances and electronics equipment, black eyeglasses, black towels, and even all-black weddings in which the entire party —including the bride—wore black.

A definite color trend in the 1980s was using paint to transform appearances. Trompe l'oeil and faux finishes changed dull surfaces (brick walls or ordinary wood furniture), relieved their monotonous uniformity, and rendered them theatrical. Classical facades, supermarket displays, and entire turn-of-the-century storefronts, as well as tortoise-shelling and marbleizing, all suggested the possibility that perhaps color could triumph over the limitations of form and space. *See also* Architecture and Color; Art Deco Colors; Forecasting Color; Op Art; Poiret, Paul; Pop Art; Psychedelic Colors; Rietveld, Gerrit Thomas; Trompe L'Oeil.

Trichromatism

Normal color vision, in which any color can be matched by an appropriate mixture of primary colors. Defective color vision is known as anomalous trichromatism, of which there are several types. *See also* Color Blindness.

Tristimulus Colorimeter

A color-measuring instrument that provides color coordinates for a single type of illumination (daylight) and a single observer, but no information on metamerism. It is best suited for color-differential measurement when it is certain that metamerism is not present (for example, when dyes and materials are identical). *See also* Measurement of Color; Metameric Colors.

Trompe L'Oeil

Literally "to deceive the eye" (from the French), trompe l'oeil covers various decorating techniques in which an artist can make two dimensions appear to be three and paint objects to simulate other materials. The technique was developed in Pompeian wall painting, in which landscapes and representations of plants and animals were painted on interior walls to give an illusion of space. A modern trompe l'oeil includes painted "carpets" on floors, painted architectural detailing, and faux finishes, such as imitation marble or granite.

Trompe l'oeil depends heavily on the extensive use of color to create the illusion of reality. However, the simplest methods employ a monochrome or only slightly tinted palette: In a technique reminiscent of grisaille and chiaroscuro, solid form and perspective can be suggested with different shades of one color only. This is a popular way of creating details such as paneling on woodwork, or the appearance of stone or brickwork on exteriors.

Trompe l'oeil in color extends the range of possibilities enormously, the best examples of which are realistic mural landscapes and still-life paintings that use shading to suggest three-dimensional form (*see* Fresco).

Faux Finishes

Faux finishes seek to simulate natural materials such as stone or to change the apparent quality or age of an object through the use of paint alone. All faux finishes also enliven a flat surface and hide any irregularities such as flaking paint or uneven plastering. Among the techniques used are:

Antiquing: Artificially aging an object by means of paint. Techniques include shading with neutral, earth-colored washes, spattering with brown and black dots, dulling brash new gilding, and rubbing over hard painted lines and stencils. A wash of raw umber is the standard antiquing color, because it ages and softens almost every other hue without muddying it. Raw sienna adds a warmer tinge when applied over cold colors only. Tints of washes used are a couple of tones darker than the base color.

Distressing: Texturing a paint surface while it is still wet to give it greater depth and variety. The effect of distressing is to make the surface uneven, thus breaking up the reflection of light and creating an uneven pattern of lighter and darker tones. Techniques include dragging the surface with a dry brush, rubbing a glaze or wash over with a paint-laden cloth, stippling with a stippling brush, ragging with a dry cloth, and sponging to create a mottled surface.

Graining: Painting a surface in imitation of wood grain, including knots; similar to tortoiseshelling and marbling.

Japanning: Imitating oriental lacquer work by painting or gilding household objects or furniture and then covering them with numerous layers of shellac or varnish to simulate the depth and richness of the original technique. Dark colors are preferred, especially deep reds, browns, and blacks, with detailing in gold or bronze powder.

Marbling: A fantasy effect that suggests the luxurious and rich colorings of natural marble, of which there are at least nine varieties—brecciated, serpentine, traver-

tine, crinoidal, unicolored, variegated, laminated, statuary, and alabaster—and as many different colors. The most common ground colors are a pale gray-green, a red-umber, and a white. On this is painted "veining" in black, gray, and white, depending on the background.

Density of texture can be varied for light and heavy looks. Imitation granite—granitizing or spattering—is achieved by speckling paint on the ground instead of veining; this is an easy way to create a textured surface with a complex color look. Since the color is broken up into tiny particles, it never looks heavy or clumsy. Unusual color combinations of ground and speckles can be used for the sake of interest or to match furnishings. The laws of texture apply: Viewed from close up, detailing will be seen, but from a distance, the colors will blend optically to produce a new overall color, with a richness and variety beyond that of any flat-painted surface. Complementary colors, if of equal density, will neutralize each other at a distance. Best results are obtained with a fine speckle, which will not obscure the base color.

Tortoiseshelling: Reproducing the circular pattern of a tortoise's shell, this is a rich finish, preferred in confined or small spaces. There are blond, leopard-spotted (in translucent browns or ambers), and red tortoiseshells (with a great deal of dark red-brown and black).

Tungsten Light

See Lighting, Artificial.

Turmeric

An East Indian herb *(Curcuma longa)*, the pulverized rhizome—or subterranean stem—of which produces a yellow dye for textile fibers. Turmeric is still used as a spice in cooking and as a yellow coloring material for rice.

Turner, Joseph Mallord

1775–1851. English romantic landscape painter whose freestyle use of color anticipated elements of impressionism and abstract art.

After a visit to Venice in 1819, light and its color effects became a central subject, as is attested to by the titles Turner assigned to his work: for example, *Light and Color: Goethe's Theory,* or *Sun Rising through Vapor.* Turner's subjective presentations of what he actually saw in nature, such as a luminous yellow sky at sunset, surprised and disturbed his contemporaries.

In his late paintings, his palette plays on a sequence running from tint to grayish tone. Light colors are pure, and deep colors are neutralized or grayed. The overall quality is hazy, and this creates a field upon which his pure tints and pastels shine radiantly. Key colors in Turner's palette are white, a luminous yellow, and pure and muted variations of pink, orange, green, and blue, plus medium and deep grays.

Turquoise

A variable greenish blue or bluish green, similar to the color of the mineral turquoise, or "Turkish stone." The mineral's color, produced by copper, was greatly admired in the Middle East, where it was first mined over 6,000 years ago. It was believed to have preventive and healing powers over an assortment of dangers and illnesses. The finest turquoise today comes from Nishapur in Iran; most turquoise is produced in the southwestern United States and set in fine Indian jewelry.

The color of turquoise stones deteriorates if it absorbs skin oil and cosmetics—one reason it was thought able to detect illness—and it can sometimes fade on exposure to air. It can be "color stabilized," however, by bonding it with plastic resins or silica. *See also* Gemstones and Jewelry.

Two-Color Reproduction

The production of full-color images using only two primary colors. Such simplicity and economy are obviously attractive, but there has been only limited success in two-color reproduction. In a subtractive mode, the two colors used are orange and a near-cyan. Color reproduction is quite acceptable when the image has little significant blue content, but cyan and orange cannot produce a blue free of a large amount of green. The first subtractive-color amateur motion picture films, introduced in the 1920s, used two-color synthesis. Interiors lit with incandescent lighting that is blue-deficient could be reproduced quite well, but in outdoor scenes the sky took on a greenish tinge. Two-color photomechanical reproduction with orange and cyan plus a gray (derived from the cyan separation) was better, although again only if the subject had little blue in it.

In the early 1960s, Edwin H. Land, president of the Polaroid Corporation, successfully produced images by a two-color additive process. The method used two black-and-white transparencies photographed through red and blue filters, respectively. When projected in register on a screen, with only a red filter in front of the red record, the whole color spectrum could

be seen. If the red filter is used with the green record, reversed color is seen. The reason for these effects is not yet understood but is thought to show high-level inferencing on the part of the brain (rather than the eye), by which it infers the missing colors. No means of re-creating this effect in photographic prints has yet been discovered. *See also* Land, Edwin Herbert.

Tyndall Scattering

See Scattering of Light.

Typography

In general, the symbolic and synaesthetic content of color has little direct relevance in typography. Nevertheless, the background or type color can be varied to striking visual effect.

Black type on a white background has the greatest legibility, but black type on a yellow background provides the strongest visual contrast. In a large body of text such as a book, black on yellow places too great a strain on the eye, but it is very effective as an attention-getter: in advertising, packaging, and display, for example, and on automobile license plates. Where "recall value" is more important than simply catching the eye, blues, purples, and greens may serve more effectively.

Small yellow type on a black background is wasted, since it appears white. Yellow on white is difficult to read, because there is no contrast. However, yellow type is considered cheery and has been often used successfully in large type against a colored background on such products as candy wrappers.

Green type is highly legible on a white background and is one of the most inherently stable colors. In a test of colors for gas station signs, when viewed at 600 feet, beyond the distance of readability for any of the signs, a bright green with blue undertone was distinguishable by its color, while the others were not. Green-on-white signs also came into focus sooner than other colors. For clarity, blue can be as successful as green, but even at short distances, it is soon indistinguishable from black.

The combination of red on white is difficult to read because of lack of contrast and the tendency of red to "vibrate": While it may be stimulating when painted on large areas, red can cause fine type to seem to jump. Red lettering is best suited for very short messages that need to be emphasized, or simply for names and logos.

Colors chosen for type from a sample swatch of the color alone will appear to be considerably different when printed, due to the small scale of type. The end color can be correctly ascertained by masking all but a fine line of the color on the sample swatch and checking it against a white background. A white background greatly deepens a color, because of the effect of simultaneous contrast (*see* Simultaneous Contrast).

Small modifications of print color can have a large cumulative effect when seen as a whole on a page. Grayed colors, particularly putty greens and greenish browns that are almost neutral in tone, can successfully be used in printing text to give a feeling of richness, without suffering from the effects of illegibility or excessive contrast. *See also* Advertising; Communication and Color; Newspaper Color; Visibility.

Tyrian Purple

A deep purple favored in imperial Rome, produced from the *Murex* mollusks and supposedly discovered in ancient Tyre (in present-day Lebanon), although traces of the dye have been found on material from Crete of 1500 B.C. and earlier. Since it took up to 20,000 shellfish to dye one square meter of fabric, it was enormously expensive and was therefore reserved for the use of the highest-ranking nobility—and, later, high ecclesiastic officials.

Writing in the first century, Pliny the Elder gives an informative account of the production of purple dyes in the classical world. According to his *Historia Naturalis* (Natural history) mollusks were caught in baited wicker baskets. Their flesh, which contained the dye-producing gland, was placed in an open pit and allowed to decompose for three days. These remains were then kept in stone or lead vats for another ten days, at which point the dyestuff could then be separated. It took eighty pounds of mollusk flesh to produce five pounds of dyestuff. *See also* Buccinum; Murex.

Ukiyo-e

Japanese wood-block prints. The process originated in China and was introduced to Japan in the early seventeenth century, probably by Matahei Otsu. *Ukiyo-e* translates as "pictures of the fleeting world," reflecting the typical subject matter—everyday life.

The production of wood-block color prints involves three craftsmen: the artist, the engraver, and the printer. The artist traces the lines of the original picture onto several sheets of thin paper. He applies the colors that will be printed, using a different sheet for each color. The engraver carves a wood block for each color; the printer mixes the colors, matching the originals prepared by the artists. The blocks are printed over each other, one by one, beginning with the lightest color. The blocks themselves are usually of cherry wood, and the prints are made on rice paper—made from mulberry bark.

The earliest ukiyo-e prints were done in black outline and hand-colored. By 1740, two additional blocks of color were used, and the maximum of twelve printed colors—the *nishiki-ye*, or "brocade print"—was achieved in 1765. One of the first and most famous artists to use the full-color palette was Suzuki Harunobu (1724–70).

The pigments available for the printing of color were not strong; therefore, the colors of the ukiyo-e prints were traditionally muted and soft. Emphasis was placed on flat areas of clean, delicate colors that were harmoniously combined.

A revolution in the color of ukiyo-e prints was brought about by Katsushika Hokusai. He used a newly imported pigment from Europe, Prussian blue, and brightened up the traditional palette for use in landscapes, causing many to label his work vulgar.

Ukiyo-e prints reached Europe in the mid-nineteenth century, greatly influencing the postimpressionists. *See also* Hokusai; Japanese Colors; Sharaku; Utamaro.

Ultramarine

A deep blue pigment for artists, made initially from lapis lazuli imported by Italy from Persia (now Iran); the name is derived from the Latin *ultra*, or "beyond," and *marine*, or "sea." Before being produced synthetically, this blue was so rare and expensive that it was the custom in Italy for a patron of a painting to supply the blue pigment. *See also* Lapis Lazuli.

Ultraviolet

Invisible electromagnetic radiation, with wavelengths between that of X rays and visible violet light—about 4 to 400 nanometers (billionths of a meter). Ultraviolet (UV) radiation can be detected in several ways: by special instruments; by the fluorescence it induces in certain substances; and by its blackening of photographic film. *See also* Black Light; Fluorescence; Light.

Undertone

A pale or subdued color applied beneath other colors and visible through them. Undertones impart depth and richness to the surface coloring.

Unique Color

A color that is not describable psychologically by reference to any other color. The seven unique colors are red, yellow, green, blue, black, white, and gray. *See also* Fundamental Color; Primary Colors.

United States, Color and the

See American Colors.

Utamaro

1753–1806. Japanese ukiyo-e printmaker and painter, one of the first to become well known in Europe; his work influenced such artists as Edgar Degas, Henri de Toulouse-Lautrec, Vincent van Gogh, and James Abbott McNeill Whistler. He used clear, fresh colors for his depictions of tall, elegant women with small, delicately modeled features, and was the first Japanese artist to use silver mica, a silicate of aluminum with a silvery luster, as a major background color. *See also* Japanese Colors; Ukiyo-e.

Detail of a print by Utamaro. The soft yellow background sets off the bright colors used for robes and features.

Vincent van Gogh.

Value

The relative lightness or darkness of a color, measured against a scale from black to white, with white having the highest value. *See also* Systems of Color.

Vandyke Brown

See Natural Earth Pigments.

Van Eyck, Hubert and Jan

Ca. 1370–1426 (Hubert); ca. 1390–1441 (Jan). Flemish brothers and painters noted for their magnificently colored microscopic realism and their artistic development of the oil-painting technique.

Their exacting realism was achieved with a fairly limited palette, which is thought to have included a brown (used mostly for outlining and shadowing), red madder, ultramarine blue, yellow ocher, an earth green, and black.

Color variety came from the fact that the underpainting was itself varied by the addition of a little yellow or gray or green. When a glaze of a certain red, for instance, was laid over a differentiated white, it showed a variation of shade. The Van Eycks apparently covered the entire panel with a layer of chalk and animal glue. This white preparation was smoothed and treated with great care so that it would be a good reflecting surface, onto which layers of color could be added. Translucent coating, similar to glaze retouches, modulated a base layer that constituted only the fundamental element of color, which was enriched by subsequent superimpositions. The effect is a tactile realism rendered primarily by enamellike masses of color, with red, blue, and green seeming to be in a pure state.

Van Gogh, Vincent

1853–90. Dutch-born postimpressionist painter, whose work has been widely influential. Except for his earliest art, which is characterized by a darkish, heavily impastoed technique and by a green-brown chromatic range, Van Gogh used a palette of intense, extremely vibrant colors, notably yellow. The three most important factors

shaping his attitude toward color were his move to the south of France in February 1888, where he was impressed by the luminous effects; his admiration for the romantic painter Eugène Delacroix; and his fondness for Japanese prints.

Van Gogh believed strongly in the emotional immediacy of color sensations, while still studying color as a system or science. He described a bedroom painting where "the walls are pale violet. The floor is of red tiles. The wood of the bed and the chairs is the yellow of fresh butter, the sheets and pillows very light greenish citron. The coverlet scarlet. The window green. The toilet table orange, the basin blue. The door lilac." (Van Gogh 1858). Nevertheless, the intention is "to express absolute peacefulness through all these various colors, you see, where the only white mote is given by the small spot of the mirror with its black frame (so as to cram yet the fourth pair of completaries into the painting)." Elsewhere in his writings, he debates whether black and white should be considered as colors and reveals some anxiety at his own lack of "system." In the end, however, the artist's temperament always brought him back to the landscape and figure, which he interpreted through "personal sensations" and rendered in "suggestive color."

Vanilla

A pale, warm yellow or yellowish white, named after the pods of the vanilla plant.

Van Rijn, Rembrandt

See Rembrandt van Rijn.

Variegated

Characterized by a variety of color; marked with patches or spots of different colors.

Varnishes

Varying liquid solutions of natural resins (from trees, insects, and fossil deposits) or synthetic resins (acrylic, vinyl, ketone, alkyd) that, when dry, give a continuous, hard, lustrous, transparent, and largely colorless coating. According to the actual composition of the solution, the resulting

"Have you seen a study of mine with a little reaper, a yellow wheatfield and a yellow sun? It's not successful, but still in it I have tackled that devilish problem of yellows again. I mean the one with a heavy impasto done on the spot, not the duplicate with hatchings, the effect of which is weaker. I wanted to do the first one entirely in sulphur."
—*Vincent van Gogh, to Emile Bernard*

film exhibits differing qualities of gloss, protection, reversibility, and durability.

Painters use simple varnishes ("spirit varnish" or "cold cut varnish") and cooked oil varnishes. Lacquers and enamels, coatings of high gloss that are usually pigmented, have many of the qualities and serve many of the purposes of varnishes, but because they are colored by pigments other than the yellowish tinge of resins, they are not varnishes. An example of a simple solution varnish is shellac in alcohol; an example of a cooked oil varnish is linseed oil–copal (fossil resin).

Simple varnishes dry by evaporation; theoretically, their dried films are reversible and can be reliquified by using the original solvent. This makes the work of the conservator much easier. One color problem with simple varnishes (particularly of damar, from the damar fir tree, in gum turpentine) is that their film darkens and yellows as it ages. The use of cooked varnishes has elicited some controversy because they contain heated oil that tends to darken and embrittle.

Varnishes applied to existing artworks are mainly used to protect paintings from atmospheric deterioration. Artists who apply varnishes to their works do so for protection but also to impart a lustrous finish or to give a tinted glaze effect. The degree to which an artist originally intended the tinting has resulted in many color controversies surrounding restoration work involving varnishes, as in the ceiling of the Sistine Chapel (Rome), where it is uncertain whether Michelangelo intended such bright colors as have been uncovered beneath the varnish. *See also* Paint.

Vehicles and Binders

See Paint.

Venetian Red

A red ocher color; an iron oxide with a brick red color. Occurring naturally, it is now obtained principally by calcining a mixture of copperas (ferrous sulfate) and whiting (calcium carbonate). The best Venetian reds have a high proportion (up to 50 percent) of ferrous oxide. The pigment is highly permanent and opaque, and is non-poisonous. *See also* Natural Earth Pigments; Titian.

Venetian Sumac

A woody-stemmed shrub (*Cotinus coggygria*) of the Terebintheceae family, and the source of a yellow dye; also known as young fustic. When the yellow principal fisetin, found in the wood, is infused with hot water, it produces a yellow liquid, which in turn becomes brown when exposed to air for some time.

As a yellow dye, Venetian sumac has been known since Roman times; it was widely used from the Middle Ages through the nineteenth century. When combined with iron salts, it produces gray-green and brown dyes.

Verdigris

The most ancient of the manufactured green pigments, literally translated as "green of Greece." A transparent blue-green, verdigris is a compound that results from the treating of copper with acetic acid.

Recipes for the making of verdigris can be found in manuscripts of the sixteenth century and even earlier. By the early seventeenth century, verdigris was among the pigments that were commercially manufactured, particularly in Montpellier, France. Ordinary verdigris is slightly dirty. A preferred refined verdigris is a neutral copper acetate. This was prepared by dissolving ordinary verdigris in distilled vinegar, filtering it, and evaporating the liquid to recrystallize the pure pigment.

Vermilion

A bright red pigment derived from manufactured sulfur of mercury; poisonous, moderately permanent, and highly opaque. The original source of this pigment was native cinnabar, a mineral and primary ore of mercury, which was well known to the ancient Greeks and Romans, was called *minium* by Pliny the Elder, and was widely used in Pompeian murals. By the eighth century, vermilion had replaced the less reliable cinnabar. The medieval painters intensified vermilion by balancing it equally with bright blues, greens, and yellows. Vermilion has a tendency to discolor over time, and by the 1920s it had been replaced by cadmium red.

Verona Green

A bluish green; a high-quality green earth (glauconite), one of the natural earth pigments, rich in silicates of iron, manganese, aluminum, and potassium. Popular in Italy from classical times, especially for fresco and tempera painting, it is a non-lead pigment, non-poisonous, permanent, and transparent. *See also* Natural Earth Pigments.

Veronese Green

A term loosely applied by paint manufacturers to a variety of greens, including emerald green, Verona green (glauconite), and chrome green; named for Paolo Veronese (1528–88), a Venetian painter.

"Those women dressed with the luminous colors of the anemone, wearing blue dresses that the Chinese called the blue of the sky after the rains."
—Edmond de Goncourt

"Any color works if you push it to the extreme."
—Massimo Vignelli

Victorian Architectural Colors

Popular exterior paint colors of the period 1839–1901 in Britain and the United States: The most prominent were light, medium, and dark grays; fawn colors, browns, bronze greens, blue-greens, and dark slates; terra-cottas, buffs, ambers, and straws; and Indian reds, with blue as a strong accent.

Color styles in America developed alongside architectural taste, and can be roughly divided into the following periods: early Victorian (including Gothic and Italianate revivals), 1840–70; high Victorian (including a quintessentially American "Queen Anne" style), 1870–90; and Colonial Revival, 1890–1920. Prior to the enormous advances in paint technology during the 1860s, buildings were usually light tints of fawn, straw, plain gray stone, slate, brown stone, and shutter green. Builders after 1870 began using the newly available rich tertiary colors—gold, olive, terra-cotta, plus dark grays, dark browns, and dark olive greens. The Colonial Revival style brought back a vogue for clear, light colors (light blue, gray, and yellow, plus ivory).

Victorian exteriors—trims, roofs, sashes—tended to be carefully schemed. One complex 1886 palette is known to have included pale yellow and terra-cotta for body colors, brown stone color for trims, and amber for the sash. Exterior colorations were chosen to set a house off from the landscape, without being too strident; white was attention getting, and therefore considered to be in poor taste: "There is one color," says American architect and landscapist Andrew Jackson Downing, "frequently employed by house painters, which we feel bound to protest against most heartily . . . this is white. . . . The glaring nature of this color, when seen in contrast with the green foliage, renders it extremely unpleasant to an eye attuned to harmony of coloring" (Downing 1842). *See also* Sources of Historic Colors.

Vignelli, Massimo and Lella

New York–based Italian designers, noted for simple graphic design using flat areas of primary color and bold lettering, and for interior designs with extensive use of colored lighting. In one recent project, they reworked the map of New York City's subway system using color coordination. In specifying chromotypes (the identifying colors) of company logos, signage, and letterheads, they use principally the primary colors—Vignelli red (a bright, orangy red), yellow, and green being most common. The intentional mis-matches that occur between the colors of the envelopes, letterheads, labels, signs, and so on provide interesting gradations of tone and monochromatic harmonies, while the basic color of the company is still easily identifiable.

Violet

A secondary color, the complementary of yellow; in light, the shortest wavelengths (around 380 nanometers, or billionths of a meter) of the visible region of the electromagnetic spectrum, between blue and ultraviolet.

The term *violet* is derived from the Old French *violete,* or *violette,* a plant or flower of the genus *Viola,* particularly *V. odorata,* whose flower is this color. In common language, as in the textile industry, violet is a reddish purple and is used to qualify other colors, such as a violet black (describing a "black" tulip, for example) or a violet blue (to indicate one with a strong cast of red).

In clothing, violet, like the darker, bluer purple, is widely used. In interiors, because of associations with mourning or religious vestments, and because of its yellow afterimage, violet is not recommended for reflective wall surfaces or over large areas.

The French painter Eugène Delacroix, and later the impressionists, made particular note of the alliance of violet and yellow, the commingling of golden shade in violet shadows. The nineteenth-century chromotherapist Edwin D. Babbitt viewed violet as capable of cooling nerves and having cold, electrical, contracting potencies. The twentieth-century expressionist painter Wassily Kandinsky described violet as a red "withdrawn from humanity" by blue. And a violet light in a landscape can indeed cast a frightening atmosphere. In discotheques, especially of the 1960s, ultraviolet-rich lights, or black lights, were frequently installed; they caused the bleaches in white clothing to fluoresce. *See also* Babbitt, Edwin D.; Black Light.

Viridian

See Artists' Pigments.

Visibility

Distance causes color to change dramatically, influenced by the scattering effect of the atmosphere, by dazzle, or by the overwhelming influence of an adjacent color. These color shifts give a visual clue as to how far one is from a distant object. Mountains seen from afar will appear blue, the tinge caused by the intervening atmosphere scattering the shorter wavelengths and thus effectively drawing a bluish veil over the view. A tree,

whose leaves appear yellow-green from close up, may register as blue-green at a distance. Similarly, seen from afar, the addition of blue to yellows tends to produce neutral grays; pale yellows become pale gray or white. Blues tend to darken before losing their hue: Blue-violet shifts toward dark gray and then black. As a rule of thumb, only reddish orange and bluish green do not change at a distance; warm colors will tend to shift toward the first, and cool colors toward the second. Artists, long aware of these color shifts, use a technique called aerial perspective to give the illusion of depth.

In signs and signals, used in controlling traffic or as warning lights, tests have shown that red and blue-green are the most distinctly different from white. Yellow tends to look white at a distance, so the two colors lose effectiveness when used together. Blues and violets also give unreliable results unless they are extremely bright.

Dim light has an effect similar to distance on our perception of color. Red and blue-green lights are the most visible at dusk. With pigments, blue becomes the brightest color in dim light because of the Purkinje effect: As the eye becomes dark-adapted, it becomes increasingly sensitive to the short (blue) wavelengths.

Fluorescent colors, particularly orange, are used when visibility is crucial. Fluorescent orange appears brightest at twilight and gives the greatest contrast with the blue of the sea at any distance. Its brilliance increases because there is a greater proportion of ultraviolet light at dawn and dusk, which emphasizes the fluorescent properties. Orange is used for life rafts; both fluorescent and non-fluorescent versions are preferred to yellow, which, though brighter, makes the raft indistinguishable from the white crests of waves at a distance.

With combinations of colors, a contrast of value appears to have more readability than a contrast of hue or saturation, because colors, seen from afar, tend to wash and fade.

While designers may avoid colors that shift dramatically at a distance, they may prize this characteristic in the case of natural materials. Marbles and wood veneers, for instance, have grains of different scale and contrast, which become effective at different viewing ranges. Similar variation and interest can be created with multi-colored brickwork or textiles, where subtleties of color and texture apparent from close up become fused when seen from afar but produce intermediate patterns at in-between distances. *See also* Aerial Perspective; Dazzle; Safety Colors; Scattering of Light; Simultaneous Contrast.

essay

Vision

W. D. Wright was a lecturer in color vision, and held the chair of applied optics at Imperial College of Science and Technology, University of London, 1931–73. He was president of the International Colour Association (ICA), 1967–69, and his awards include the Mees Medal of the Optical Society of America, the Judd-AIC Medal of the ICA, and the Newton Medal of the Colour Group (Great Britain). He is the author of, among others, The Measurement of Color *(1944; 4th ed., 1969),* Researches on Normal and Defective Colour Vision *(1946), and* The Rays are not Coloured *(1967).*

To explain how color vision works, we will suppose that we are in an art gallery viewing a painting. We will then consider the color vision process under the following headings: lighting; the painting; the image on the retina; neural response; the mental image; perceived colors.

Lighting

One type of lighting differs from another in its spectral composition. Tungsten lighting is acceptable in the home because of its warm color, due to its high percentage of energy in the red end of the spectrum and its low percentage at the blue and violet end. Daylight, especially north-sky light, is generally regarded as the ideal illuminant. Its particular merit is that all the wavelengths in the spectrum from the red to the violet are well represented in its spectral composition. It therefore gives a well-balanced color rendering. Fluorescent lighting varies in color depending on the phosphores used in the production of the lamps, but special fluorescent lamps are available if required. In the art gallery we are considering, we will assume that we are viewing the painting under daylight illumination.

The Painting

A painting can be described in many different ways: the realism of a Jan van Eyck, the subtle gradations of a Claude Monet, the shrewd characterization of a Pieter Brueghel (ca. 1525–69), the rich coloring of a Titian. To understand just how we see color, however, we need different information. What is the spectral composition of the light that the eye receives from each point of the painting? This depends on the lighting, of course, but mainly on the spectral reflectance of the pigments used in the painting. A typical red pigment, for example, has a high reflectance for the red and orange wavelengths and a

fairly low reflectance for the remainder of the spectrum; a typical yellow pigment has a very high reflectance for all the wavelengths from the red to the green, with a very low reflectance in the blue and violet; and so on. To follow the color vision process, we will consider as an example how the color-sensitive receptors in the retina respond to the light from a yellow area of the painting.

The Image on the Retina
There are two types of light-sensitive receptors in the retina: rods and cones. The rods operate at low light levels and give us achromatic (colorless) vision. The cones function at the higher light levels and give us our color vision. The proportion of rods to cones increases as we go from the center to the periphery of the retina, with a rod-free area called the fovea at the axial center of the retina. The cones are very closely packed together at the fovea, so our visual acuity (the ability to see fine detail) is at the maximum at the foveal axis. When, therefore, we look at the painting, we see it in detail by making a series of fixation pauses as our eyes scan from point to point across the picture.

Our color perception originates in the cones through the existence of three types of cone, each having its own light-sensitive visual pigment and its own spectral sensitivity curve. These sensitivity curves are broad overlapping curves, one with its maximum toward the long-wave—red—end of the spectrum, the second with its maximum in the middle—green—region, and the third with its maximum at the short-wave—blue—end.

As an example to show how the cones respond, suppose we fixate on a yellow area of the painting. A typical yellow pigment has a high reflection for wavelengths from red to green, with a very low reflection for the blue and violet. This means that the first two sets of cones—for convenience we will label them as the red-sensitive and the green-sensitive cones—will give a strong response when the yellow light strikes the cones, while there will be little or no response from the blue-sensitive cones. This is the start of the color perception process and is analogous to color photography (when the red-, green-, and blue-sensitive layers of a color film are exposed to the yellow area of a scene being photographed).

What is going on in the retina is incredibly complex. There is an almost infinite amount of detail and color information that the retina has to record as the eye scans across the painting. Yet we see the picture in all its detail and color without any conscious effort on our part.

Neural Response
Once the light has been absorbed in the cones' visual pigments, a very intricate sequence of chemical changes occurs that controls the flow of sodium ions through the plasma membrane of the receptor. The electrical responses that this process generates in the three types of cones are then analyzed and coded as they traverse the neural network of the retina (which functions much like a computer). The coded signals then travel along the optic nerve to the lateral geniculate nucleus (a kind of relay station) en route to the visual cortex at the back of the head.

The Mental Image
Much fascinating research is in progress in laboratories around the world to try to unravel the mystery of just how an image (in this case, the image of the painting) is reconstructed in the mind from the signals arriving in the visual cortex. We can do little more than just note two points about this stage of the color perception process: The signals themselves are not the colors. Somewhere, somehow, there must be a kind of subjective palette of colors in the brain, which can be stimulated by the signals arriving at the cortex. Also, although the mental image and its colors are generated within us, we do not see a subjective image of the painting at the back of our heads. What we see is a real painting hanging on the wall of the art gallery, and we see the colors in the picture as part of the material substance of the objects that are portrayed in the painting, and not as some subjective overlay. How the mental image within us is projected into the objective world outside us is another of the unsolved problems of the visual process.

Perceived Colors
It is widely accepted that there are six unique subjective primaries, namely red, yellow, green, blue, black, and white, and that the appearance of all other colors can be described subjectively in terms of those six. We owe this concept to Ewald Hering, but we do not yet know just how these primary color perceptions are stimulated in the subjective color palette within us.

Accepting the fact that there are only three additive primaries—red, green, and blue—and three subtractives—magenta, yellow, and cyan—we must remember that these operational primaries are not directly concerned with the subjective appearance of colors. We also have to recognize that the visual process from eye to brain is a living, moving biological system, not a static one.

Although the spectral composition of the light entering our eyes is all-important in determining the colors we see, there is not a fixed relation between the two. Color appearances can be affected by changes in the color adaptation of the eye and by contrast effects. Also, while a change in the lighting, for example from daylight to tungsten lighting, will modify the spectral composition of the light entering our eyes, the changes in the color appearance of the objects in the scene are not as great as we might expect. There is a large measure of color constancy in the scene as a whole, which can be attributed in part to our eyes adapting to the new illuminant and to the fact that we see colors of objects in relation to one another.
—W. D. Wright

Vision, Animal

While research in the field is in its infancy, recent findings indicate that some species see brightly hued landscapes in colors invisible to human eyes, whereas others see only drab colors or none at all.

Apart from man and primates, most mammals probably have only two types of light receptors, called cones (see Vision), and generally have relatively poor color vision. Insects, however, are probably closer to humans in their color vision, in that they can record and compare light intensities in three regions of the electromagnetic spectrum. But what a person sees and what a bee sees can be vastly different. Being sensitive to ultraviolet light, a bee zeroing in on a black-eyed Susan sees a bull's eye pattern in what, to human eyes, are uniformly yellow petals. Because the bee's eye cannot see red, a white blossom will look blue-green.

Cats are not, as it was once thought, totally color blind. But they, at best, have only a pale copy of our trichromatic vision. The color vision of dogs is believed to be no better than that of cats.

Pigeons have an extraordinary ability to discriminate between almost identical shades (wavelength differences of only a few billionths of a meter). In contrast with the triple system of human color perception, pigeons use a combination of photosensors and light filters that may record as many as five different spectral bands.

Some daytime feeders, such as hummingbirds, can perceive the ultraviolet part of the spectrum, which humans cannot; it may help them locate flowers or ripe fruit. *See also* Plant Colors; Zoology and Color.

Visual Field

The totality of visual stimuli that act upon the unmoving eye at a given moment. The central part of the visual field is seen in color, while peripheral vision is in black-and-white. *See also* Optical Illusions.

Vlaminck, Maurice de

1876–1958. French painter and close friend of the fauve André Derain. Vlaminck most admired the work of Vincent van Gogh and adopted his short, choppy brushstrokes and color dynamism, including exaggeration by a painterly impasto. After 1915, Vlaminck moved toward greater realism, and his later landscapes exhibit tonally subdued color in diametric contrast to his well-known fauvist period. *See also* Derain, André; Fauvism; Van Gogh, Vincent.

Vodka White

An off-white, lightly tinted with yellow. *See also* Off-White.

Volume Color

A transparent, three-dimensional color experience, such as looking at a colored liquid. *See also* Aperture Color; Surface Color.

Von Helmholtz, Hermann

See Helmholtz, Hermann Ludwig Ferdinand von.

Vision and color: An interaction of light, pigment, and perception.

Walnut

A hardwood tree of the *Juglans* genus, which includes the butternut, or white walnut (*Juglans cinerea*), the nut of which yields a dye used in colonial times for homespun cloth. The fabric of uniforms worn by Confederate soldiers in the American Civil War was known as "butternut cloth." The hardwood colors vary according to species—black walnut ranges from dark to medium brown; butternut is a yellowish gray—and the wood is valued for furniture, paneling, and musical instruments.

Wandering Afterimages

See Optical Illusions.

Warhol, Andy

1928–87. American artist; a central figure in the pop art movement of the 1960s. Warhol extracted such common images from mass communication and media as Coca-Cola bottles (*Green Coca-Cola Bottle*, 1962), bright red Campbell's soup cans (*Campbell's Soup Can*, 1965), and even movie stars (*Marilyn Monroe's Lips*, 1962). These images were hand-painted and then silkscreened, sometimes as a single image but most often as multiplications of the same image, perhaps in allusion to the repetitiveness of industrial techniques of reproduction.

Warhol's color is taken from the highly depersonalized palette of America's commercial culture. He used bright, raw primaries, as well as such popular advertising colors as orange or a shiny chrome. Although, for example, in his painting of Campbell's soup cans, his colors remain true to the image's source, in *Marilyn Monroe's Lips* he plays with color by varying the intensities and areas of pigment so that no two faces on the painting are the same. *See also* Pop Art.

Warm/Hot Colors

Those colors that are from the longer-wavelength—red—end of the spectrum, as well as related non-spectral colors such as reddened blues; by some definitions, everything that has yellow in it is a warm color. Such colors have been assumed to have a warming, brightening effect. Hot colors include fluorescent or extremely bright versions of red, yellow, orange, and pink. *See also* Cool/ Cold Colors.

Watercolor

An aqueous paint medium; the technique of using such a medium; the work produced. The paints are made with a water-soluble vehicle (usually gum arabic, gelatin, or dextrin) and are used in both transparent (aquarelle) and opaque (gouache) forms. Tempera and fresco are also forms of watercolor. *See also* Fresco; Tempera.

Watermelon

A hot pink like the color of the inside of the fruit of the same name. Watermelon pink was particularly favored by the Mexican painter Rufino Tamayo (1899–).

Watteau, Antoine

1684–1721. French artist of the rococo period and outstanding colorist best known for lyric, sensuous, often wistful canvases. Watteau's palette, distinctively eighteenth century in its use of soft pastels but seventeenth century in its yellow glow, is unique for its warm tints of graded greens and yellows. His palette is more in keeping with a gilded boudoir—often the setting for the scenes he depicted—than an actual landscape. For this reason, Watteau's work suggests the intimate flutterings of interior rooms, although the scenes are actually set in nature. *See also* Rococo Colors.

Waves

See Light.

Wax Crayon

See Crayon, Wax.

Wax Paint Colors

See Encaustic Paints.

Wedgwood Blue

A chalky pale blue associated with a kind of pottery made by Josiah Wedgwood and Sons, Limited, of Staffordshire, England since the eighteenth century.

Weight of Color

See Optical Illusions.

Whistler, James Abbott McNeill

1834–1903. American painter known for his impressionistic juxtapositions of lights and darks. Color balances are the essence of Whistler's harmonies, which are essentially monochrome, tonal, and concerned more with the alignment of value planes than hues. His work is also unique in that he often adopted a long vertical rectangle for full-length portraits, departing from customary horizontal color plane perception.

Many of his compositions were influenced by the sense of abstraction found in the works of the Spanish painter Diego Velázquez (1599–1660) and in Japanese prints circulating in Paris, where he lived in the 1850s and 1860s. The non-descriptive titles of his own works, such as *Arrangement in Grey: Self Portrait* (1871) or *Nocturne in Blue and Green: Chelsea* (1871), attest to this.

In 1877, the art critic John Ruskin described Whistler's *The Falling Rocket* as a painting by a "coxcomb" charging 200 guineas "for flinging a pot of paint in the public's face." Whistler sued, but went bankrupt in the ensuing legal proceedings. Leaving London for Venice, he was reduced to doing pastels on dark brown paper. He returned to London in 1880, however, and was subsequently elected president of the Society of British Artists in 1886, where he established the policy of more spacious hanging of art, instead of the customary floor-to-ceiling method. *See also* Ruskin, John.

White

An achromatic color produced by the reflection, transmission, and emission of all kinds of light in the proportion in which they exist in the complete visible spectrum. White is without sensible absorption and therefore fully luminous and devoid of any distinctive hue.

The human eye is enormously sensitive to the slightest change of white's purity, which can be lightly tinted to produce literally thousands of warm or cool whites. The word *white* is used to designate anything approaching white, from a pale yellowish white, as in white bread, white wine, or vinegar, to a bluish white, as in snow white or milk white.

Pure white has been a notoriously difficult color to produce. Artists often achieve whites (especially in watercolor) by "reserving" the white paper or white plaster ground; that is, by leaving a portion of the surface unpainted. Some whites have been obtained from chalk, kaolin, or ground seashells, but most white pigments have been based on the highly poisonous lead or flake white (lead carbonate), the principal ingredient since its discovery by the ancient Egyptians. In artists' pigments, flake white was eventually superseded by Winsor & Newton's Chinese white, made from zinc oxide and introduced in the early 1800s. Zinc oxide is non-poisonous and is a by-product of brass founding. Titanium dioxide, discovered in the 1920s, has made brilliant white paints commonplace; it is also used in paper manufacture. *See also* Cosmetics and Color; Fashion and Clothing Color; Language and Color; Symbolism and Color.

White House, The

The official residence of the president of the United States, situated on Pennsylvania Avenue in Washington, D.C. It derives its name from the fact that its gray, smoke-tarnished walls were painted white in 1814 (after the burning of the nation's capitol by the British). *See also* American Colors.

White Light

Light composed of equal proportions of all visible wavelengths, as in sunlight. Although light from the sun is considered to be white light, its character may change throughout the day. In the morning or evening, when the sun is low, much of the blue light is filtered out by the atmosphere, and the sunlight appears tinted red and yellow. At midday, when the sun is directly above and passes through only a few miles of atmosphere, it has a much more balanced color, but is still not truly "white." *See also* Light; Lighting, Artificial.

Whitewash

A combination of lime and water or of whiting, size, and water; used for whitening walls or woodwork.

Wilfred, Thomas

1889–1968. American exponent of mobile color. Born in Denmark, he studied painting in Paris, where he began to experiment with color and light. At the age of twenty-seven, he moved to the United States, where he began to develop color organs and music to which he gave the name *lumia* (kinetic color). An elaborate projector, which he called the Clavilux, was composed of floodlights, spotlights, rheostats, and special filters, and was capable of projecting majestic visual effects on a screen in tandem with musical pieces.

"I don't think there is any other century which has its own colour, but this one has. And that is white. White before this century, was a luxury. . . . White has [now] become a sexy color. . . . Once everybody decided that black is beautiful, and therefore brown is beautiful, then white began to come into its own as a very, very sexy colour for clothes. But white is not a sexy colour to wear if your skin is white."
—Howard Hodgkin, to David Sylvester

Wilfred's color art is independent of sound, although music was frequently used in conjunction with it. Describing the projected color harmonies, he wrote:

The even color which floods the screen is called the accompaniment. In the center of this is the solo figure. This figure may be square, it may be circular, it may be a combination of various figures, as, say, a combination of pyramids, which will turn, and twist, and stretch upwards like arms. The solo figure is always opening and closing, approaching and withdrawing.

I have no pet color. The whole spectrum is my favorite. No special color has an especial meaning. Green is generally considered a restful color, but green has a thousand qualities. It may be stirring rather than restful. Blue may mean one thing when applied to a square and another thing when applied to a circle (Wilfred 1948).

See also Castel, Louis-Bertrand; Color Organs; Michelson, Albert A.; Music and Color.

Wine, Color Control in

Because color is one test of a vintage wine's maturity, stable color is a primary goal in extended production of a given vintage. Color control is essential. Work done in France, particularly on champagnes, has been concerned with how to characterize the color of wine. Three basic measurements are taken:

The amount of light absorbed at two points of the spectrum, 420 and 520 nanometers (billionths of a meter). This indicates the opacity of a one-centimeter-thick layer of wine.
Color intensity and nuance (or hue) of the wine. The intensity represents the sum of the two readings taken to measure light absorbance. The nuance is the ratio of the reading made at 420 nanometers to that made at 520 nanometers.
The exact proportion of light—composed of red, green, and blue—transmitted by the wine. This is determined from tristimulus coordinates. Relative luminosities are then examined.

Color is the first stimulus that the consumer perceives, resulting in an immediate evaluation of the product. From a marketing standpoint, it was proved important to find a descriptive characterization of wine color that will match the instrumental measurements. The best scientific measurements of the color of wine were found to be the tristimulus coordinates, defining its chromaticity and luminosity.

Winsor & Newton

Pioneering manufacturers of artists' pigments; founded in 1832 by William Winsor (1804–65) and Henry Charles Newton (1805–82), inventors and makers of oil and watercolor paints. This was the first British firm to make and sell paints in collapsible tubes; previously, paints were sold in bags made out of pigs' bladders. The convenience of portable tubes gave a real impetus to British landscape painters, made feasible the impressionists' on-site painting, and encouraged the emergence of untold numbers of amateur painters.

Winsor & Newton developed many new pigments, such as Chinese white, the first reliable opaque white in watercolor, and were the first manufacturers to realize the importance of categorizing and publishing the relative permanence and opacity of each pigment. *See also* Artists' Pigments.

Wittgenstein, Ludwig

1889–1951. Austrian-born philosopher who analyzed the use of language and argued that philosophical problems arise from the illusions created by the ambiguities of language. In *Bemerkungen über die Farben* (Remarks on color), he deals directly with perception of color.

In a series of short propositions, interrogations, and hypotheses, he examines color from many perspectives—including physical laws, phenomenology, psychology, and the relation of color to language structures—and invents challenging questions and scenarios to help understand what we mean by *color*. He shows that the word has an extraordinary complexity in terms of its "natural" properties, its modes of perception, its conditioning by human language forms (or "games"), and that it is always determined by its "relativity" to these and other constructs.

Several times, Wittgenstein concedes "the indeterminateness in the concept of color": "When we're asked 'What do the words red, blue, black, white mean?' we can, of course, immediately point to things which have these colors—but our ability to explain the meanings of these words goes no further! For the rest, we have either no idea at all of their use, or a very rough and to some extent false one."

Elsewhere he notices: "If there were a theory of color harmony, perhaps it would begin by dividing the colors into groups and forbidding certain mixtures or combinations and allowing others. And, as in harmony, its rules would be given no justification."

While evidently familiar with, and in some

ways dependent on, Johann Wolfgang von Goethe's theory of color, Wittgenstein remains suspicious of Goethe's phenomenological impulse—his attempt to articulate the "nature," "character," or essence of color. In one place, this suspicion amounts to a sweeping condemnation of its inadequacies: "Goethe's theory of the constitution of the colors of the spectrum has not proved to be an unsatisfactory theory, rather it really isn't a theory at all. Nothing can be predicted with it. It is, rather, a vague schematic outline of the sort we find in [William] James's psychology. Nor is there any experimentum crucis which could decide for or against the theory."

Instead of searching for the constituents of color, Wittgenstein investigates its different modes of existence and its relationality. He discusses primary colors, color purity, intensity, mixing, transparency, and opacity, and makes an important contribution to the problem of color blindness. Instead of attributing to color a set of immutable scientific properties, he demonstrates the inadequacy and reductiveness of such universalizing tendencies, preferring to emphasize color's dependence on context and its subjective apprehension in most human experience. *See also* Language and Color; Symbolism and Color.

Woad

An herbaceous plant *(Isatis tinctoria)* from which a blue dye is derived. It was known in antiquity, and Julius Caesar (100–44 B.C.) noted during his invasions of Britain in 55 and 54 B.C. that the early Britons stained their bodies blue with woad to make themselves appear terrifying in battle. Although considered an inferior form of indigo (both contain indican), it was cultivated intensively in Europe from the Middle Ages until the seventeenth century. Indican is extracted from woad by first macerating the dried plants, then adding to the resulting aqueous extract either lime milk, fermented urine, or ash lye. *See also* Indigo.

Wood Colors

The range of colors of natural timbers, including whitish blonds, yellows, reds, light and dark browns, and off-blacks. Nearly all fine woods are obtained from hardwoods or broadleaf trees such as oak, walnut, maple, and birch.

The natural color of wood can be altered with dyes, stains, or bleach.

Dyes: Standard fabric, carpet, and leather dyes, applied to bare wood, rubbed with mineral spirits or vinegar and water, and varnished.
Stains: A pigment mixed with water, alcohol, oil, varnish, or wax. Stains penetrate more deeply into wood than dyes. Colors range from pale blond to dark brown-black, as well as bright reds, greens, blues, and yellows. New wax stains give a rich glow to wood.
Bleach: Regular, extended scrubbing and scouring with soap and zinc white will whiten wooden floors and furniture. A mixture of linseed oil and zinc white simulates the look of natural bleaching without making the wood appear worn and weathered. Tinted white paint, softened with raw umber and ocher, is also used, and usually rubbed off so that only a residue is deposited in the cracks and pores of the wood.

See also Trends in Color.

Wright, Frank Lloyd

1869–1959. An American architect whose writings and work pioneered and promoted open planning in both residences and offices and the close relationship between buildings, furnishings, and sites. Wright's palette was invariably derived from the "natural" terrain of a building. Whether using substantial brown oak wood and cream plaster for the interior of the prairie-style Robie House (Chicago, 1990), or pink and orange mesa rock for facades at Taliesin West (Scottsdale, Arizona, 1936), or off-white, reinforced cement in the Solomon R. Guggenheim Museum (New York City, 1959), Wright was committed to the hues inherent in his chosen materials and their accord with the edifice's surroundings.

Wyeth, Andrew

1917– . American painter known for landscapes and portraits taken from the environments of Chadds Ford, Pennsylvania and rural Maine. His style is naturalistic; using the media of watercolor (dry-brush technique) and tempera, his paintings are dominated by earth tones, particularly terra verte, ochers, and reds.

This window by Frank Lloyd Wright is characterized by natural woods and colorless glass, but with intense accents of the purest colors.

Frank Lloyd Wright.

X Y Z

X Ray

A form of electromagnetic radiation, similar to light but of a shorter (hence invisible) wavelength. It is capable of penetrating solids and ionizing gases. Photographic emulsions can be made sensitive to X rays; these are used for photographing stars and in medicine for taking pictures of bones, since X rays penetrate flesh but are weakly reflected by bone matter.

Yale Blue

A royal blue associated with Yale University.

Yellow

The most reflective and luminous of the primary colors. Yellow retains its character only in its lightest, most saturated state; the addition of even a small quantity of black gives it a greenish hue.

Yellow light gives the human eye its greatest visual acuity. Thus, sodium light, though it tends to discolor other colors, is in fact the most efficient for seeing.

American yellow textile standards include Goldmist, Flax, Old Gold, Gold, Leghorn, Lemon yellow, Jasmine, Spanish yellow, Maize, and Chamois. *See also* Symbolism of Color.

Yew Green

A bluish green. The yew is an evergreen tree or shrub.

Young-Helmholtz Theory

A theory, later confirmed, proposing that there are three groups of cones in the retina of the eye with spectral sensitivities, responsible for trichromatic—normal, three-color-based—color vision. Proposed by Thomas Young, the theory was expanded upon by Hermann von Helmholtz. *See also* Helmholtz, Hermann Ludwig Ferdinand von; Trichromatism; Young, Thomas.

Young, Thomas

1773–1829. English physicist, physician, and Egyptologist who helped decode the Rosetta stone. He also formulated the theory of trichromatic vision, later known as the Young-Helmholtz theory. Reviving the wave theory of light, Young used it to explain phenomena of diffraction and dispersion. *See also* Young-Helmholtz Theory.

Zebra Stripes

A black-and-white, or black-and-yellow, stripe pattern used as a warning signal, particularly on city streets at crosswalks. Its name is taken from the African zebra, whose stripes actually serve not to attract attention, but to conceal. *See also* Zoology and Color.

Zinc White

A white pigment based on zinc oxide and used since the early 1800s in artists' paints. It is a brilliant cold white, somewhat whiter than white lead. A non-poisonous pigment, zinc white is very stable. Its one disadvantage is that it dries very slowly (especially in comparison to flake white). It is used principally in all *prima* painting—in which only one layer of pigment is applied—or for finishing coats. Its slow drying time and relatively brittle film qualities make it less desirable for underpainting than other paints. *See also* White.

Zircon

A mineral gemstone, usually gray-green or brown in color. Lustrous blue zircon can be produced by heating colorless zircon in an oxygen-free atmosphere; to turn it from blue to a similarly permanent golden color, the stone is then heated in air. *See also* Gemstones and Jewelry.

Zodiac Colors

Colors associated with each of the twelve signs of the Zodiac along with corresponding planets, metals, and stones. With only seven "planets"—including the sun and moon—known to ancient astronomers, and only seven principal hues, several signs had to share the same color. These are the correspondences used by medieval alchemists

(modern associations of birthstones and astrological signs may vary):

Cancer—White (moon, silver, pearl)
Leo—Yellow (sun, gold, topaz)
Capricorn and Aquarius—Black (Saturn, lead, diamond)
Libra and Taurus—Green (Venus, copper, emerald)
Pisces and Sagittarius—Blue (Jupiter, tin, sapphire)
Virgo and Gemini—Purple (Mercury, quicksilver, amethyst)
Aries and Scorpio—Red (Mars, iron, ruby)

The linking of color in this way, with planets, metals, and precious stones, was a way of suggesting that some mysterious benefits might be derived from their colors. A ruby was believed to possess something of the power of the red planet, Mars, and to impart the strength of iron, for example. The virtues and qualities of heraldry were later included in the scheme: White stood for purity, gold for happiness, black for penitence, green for love and hope, blue for piety, purple for majesty, and red for courage. This provided a simple way of classifying the world, of relating different areas of experience (*see* Communication and Color).

The symbolic hues of the zodiac were carefully embodied in frescoes for temples, on coffins of the great, and in fine art: Green, for instance, the color of Venus and therefore of love, was traditionally worn at weddings in Europe, where it symbolized fertility, and was used ironically in Jan Van Eyck's *Giovanni Arnolfini and His Bride* (1434), in which the pregnant bride is wearing green. *See also* Alchemy; Symbolism and Color.

Zones, Chromatic

Regions of the visual field that have different characteristics relating to chromatic response. For most individuals, the central portion of the field shows full chromatic response, while red and green responses disappear at a moderately peripheral position, and blue and yellow fail in the extreme periphery. The exact boundaries of any zone depend upon the extent, intensity, and chromaticity of the stimuli used; they vary also with the individual. *See also* Optical Illusions; Vision.

Zoology and Color

In the animal world, color plays many diverse roles. It is linked to evolution and survival, to courtship and reproduction, and to many daily activities. The actual color of animals is derived from several sources, notably from hemoglobin and melanin. Hemoglobin in the blood colors it red and can give human or animal skin a pinkish color. Melanin is brown to black and protects skin from the dangerous ultraviolet rays of the sun. It gives many animals their dark color and is found in such substances as the ink produced by squid and octopus as a protective screen when threatened by predators.

The next most common pigment in the animal world is carotenoid, the substance that gives the carrot its color. Carotenoid can be red, orange, or yellow. It is an important source of vitamin A, which is essential to vision. It cannot be synthesized but must be obtained from a food source. Without their diet of carotenoid-rich shellfish, flamingos would be white. It is also carotenoid that colors the feathers of the goldfinch, the red wingcase of the ladybug, and the yellow beaks of many birds.

Blue and green pigments are rarer in the animal world. The emerald green of the chameleon, for example, is actually a combination of three types of pigments in three skin layers: a top carotenoid layer that is yellow, a middle layer that is blue because of the scattering of light, and a third layer that contains melanin. Fluctuations in the amount of melanin, triggered by the nervous system, account for the changes in the chameleon's color. Melanin is injected into the blue and yellow layers, producing a progressively darker green until the blue is obscured altogether and the chameleon becomes a dark brown.

Color has been intrinsic to the survival of many species. For instance, color vision in some animals may have evolved in relation to their primary food source. One chronology suggests just such a link between flowering plants and insect pollinators 150 million years ago. Insects, with primitive vision most sensitive to long wavelengths of light, were attracted to blue flowers, it is believed, and therefore the blue flowers were the most successful survivors.

Color and Survival

Among animals, color can provide a warning important to more immediate survival. In some cases, bright colors signify danger. The red of the poisonous coral snake, for example, or the high-visibility yellow-and-black stripes of the bee and wasp warn away predators. Often, this is a learned response after an unpleasant encounter. Mimicry of these warning colors by other animals also can occur. The non-poisonous king snake, for example, closely resembles the coral snake, and there are non-stinging wasp beetles that

The zebra's contrasting stripes, replicating the effect of moonlight, provide perfect camouflage at night.

Color is an intrinsic part of the evolution and survival of species.

have the same coloration as the stinging varieties. Predators avoid these along with the dangerous look-alikes. Such resemblances act as protective coloring.

In other examples, animals may so closely resemble their environment that they are almost invisible. The walking stick insect, for instance, has the same angular shape and brown color as the twigs among which it stalks its insect prey. The Borneo crab spider matches the color of the guano eaten by the insects that are its primary food source. The seagull's mottled gray back and head are perfect camouflage when the bird is sitting on its nest, while its white underside makes it difficult to distinguish against the bright sky, so that it is inconspicuous to the schools of fish upon which it preys.

Taken out of context, some patterns seem very conspicuous, but they are actually very good camouflage in the animal's natural environment. The zebra's vertical, tapering stripes, for instance, exactly replicate the effect of moonlight on their backs, making them almost invisible at night, when many predators are active. The tawny and black stripes of the tiger match the stripes of grass and shadow in the savannas where they hunt, while the spots of the leopard match the speckled light and shadow of the forest floor.

Color Changes

Some animals change color over the course of a lifetime; others, in response to environmental changes. The young of many species, birds and mammals alike, have temporary colors or patterns that allow them to blend in with the background during a very vulnerable time in their lives. The dappled back of a fawn, for example, looks like sunlight filtering through the trees onto the leaves of the woodland floor. Many animals change color radically in relation to seasonal changes in the environment. The brown stoat becomes the white ermine in winter. Similarly, the coat of the arctic fox turns white in winter.

In other species, changes are almost constant. Flatfish such as flounder, for example, assume the coloration and markings of the mud or gravel upon which they rest. The mechanism that triggers this change in flounder is based on signals that originate in the eye and cause melanin-producing cells to expand or contract. Chameleons, too, change color and pattern as they move about, hunting or resting. Their most spectacular coloration—black with a wide-open bright pink mouth—is reserved for frightening off predators and for courtship displays. In many species, color is important in courtship and reproduction. The blue face of the male mandrill and the iridescent feathers of the crested peacock help each species attract females, for example.

In studies of two types of duck that interbreed, the mallard and the black duck, it has been found that the flashier colors of the mallard help it to win mates. It is theorized that the green head, white neckband, dark chestnut breast, violet wing feathers, and orange red legs and feet make the male mallard appear bigger and more aggressive, thus a better choice for the female as a protector of the vulnerable nest. The number of purebred black ducks seems to be in a slow but irreversible decline in North America as the process of natural selection takes its toll.

The study of animal behavior is relatively new, and much is yet to be discovered about the relationship between color and behavior. *See also* Camouflage; Iridescence; Plant Colors; Vision, Animal.

SOURCES of HISTORIC COLORS

From Ancient to Pop and Post-Modern

Civilizations and nations, like cultures and individuals, tend to develop color harmonies and combinations in distinctive palettes. Availability of pigments, as well as instinctual and psychological biases, enter into and influence particular choices. In these pages, selected palettes from different eras have been chosen. Each ensemble forms a chromatic cluster with historical authenticity; the distillation of key colors of each period.

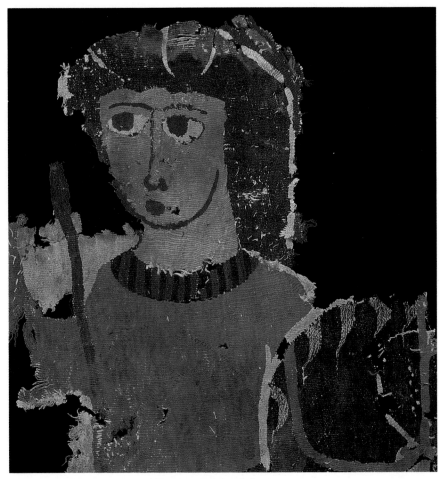

Coptic textile. Photo courtesy of Kanebo Museum Collection.

Ancient Egyptian Colors

From the pharaonic paintings that have survived, the range of Egyptian colors can be deduced. The blue of the backgrounds and the green used for foliage were both derived from copper frit (calcinated material used in glass making); black (from soot) was used for rendering the characteristic hairstyles, or, mixed with white, for producing the soft grays. In the Rameses epoch (thirteenth to twelfth century B.C.), a gold-yellow replaced blue as the background color, and other more vivid colors were introduced. *See also* Egyptian Colors.

Coptic Textile Colors

Bold colors reinforce the powerful designs of Coptic textiles; a very deep purple was used extensively. The pervading tonality is brown, however, as the Copts (Christian Egyptians) relied upon the decorative effects achieved by opposing one brown against another. The scale ranges from an orange to a deep, almost black, brown.

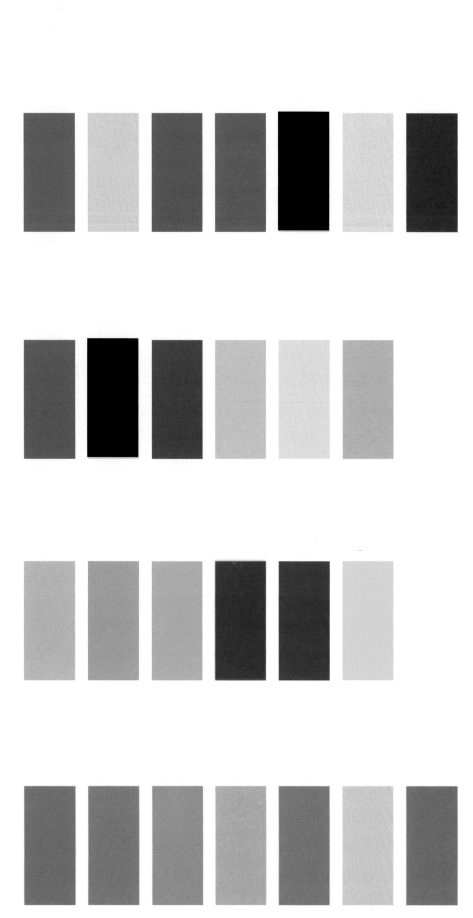

Greek Pottery Colors

Knowledge of ancient Greek colors, now that the paint that decorated the temples and statues has disappeared, is limited to the surviving colors of Greek pottery. The black-figure style came to maturity at the start of the sixth century B.C.; figures drawn in black silhouette contrasted strongly with the natural red of the Attic clay, the latter often enhanced with red ocher. About 520 B.C. the introduction of the red-figure style reversed the colors of figure and ground. About 400 B.C. tempera colors—reds, yellows, blues, purples, greens, mauves, and pinks—were applied after the pottery had been fired. Today these can be seen only in severely faded examples. *See also* Ceramics and Color.

Pompeian Colors

Pompeii was a flourishing city when, in A.D. 79, an eruption of Vesuvius buried it. The layers of ash preserved it until the eighteenth century, when excavations began. The fresh colors of the wall paintings give us a unique view of painting in antiquity and provide a rare source of information. The Pompeian red and its complementary blue-green are often used in modern palettes. Black, next to this red, has a strong decorative effect. *See also* Fresco; Trompe L'Oeil.

Islamic Tile Colors

The zenith of Islamic tile decoration was during the Seljuk and Ottoman Empires from the twelfth to the sixteenth centuries. Tiles were used to decorate the entrances and sacred niches of their otherwise austere architecture, and for the interiors of palaces and mosques. Colors were mostly applied directly onto the tiles, then glazed with a blue tint. As a result, the predominant colors were light and navy blue, modena (an intense purple), and turquoise, with white (usually of the mortar), some manganese black, and gold. *See also* Seljuk and Ottoman Mural Ceramics.

Persian Miniature Colors

The most frequent color combination in Persian miniature painting and book illustration was a gold ground and a blue sky. Three shades of Persian blue—deep azure, gray-green blue, and a pale whitish blue—and two tints of gold—pale yellow and deep gold—are all used in the sumptuous manuscript produced for Prince Baysunghur, the *Shahnama (The Book of Kings)*, a national epic by Firdawsi, an eleventh-century poet.

Chinese Porcelain Colors

The Chinese formulated glazes for their high-fired porcelains in a wide range of colors. One of the most prized is celadon, the outstanding porcelain tone of the Sung period (A.D. 960–1276). The term *celadon* can include many greens, from yellowish green to a gray-blue green. Celadon, ivory white, and a special blue applied by blowing powdered cobalt through a bamboo tube, constituted the most popular trio of early Chinese porcelain colors. In striking contrast to the celadons were the large variety of red glazes, ranging from pale pink to the deep purplish pink of the Ming period (A.D. 1368–1644). *See also* Celadon; Chinese Color Symbolism.

Pre-Columbian Colors

The great pre-Columbian cultures of Peru, Tiahuanaco and Inca, and of Central America, Maya, were notable for their exuberant use of warm harmonies. Due to the extreme aridity of certain coastal areas of Peru, an accurate color record was found when tombs were excavated. The recurring color harmony was blood red, warm yellow, orange, brown, and white. Combinations of colors, sometimes as many as twenty in a single fabric, are unique to Peruvian textiles.

Romanesque Mural Colors

Romanesque artisans produced few paintings, but some murals made in the tenth and eleventh centuries in France are of special interest. The Saint Savin frescoes, for example, were executed with relatively few colors, mostly earth tones, with red, yellow, and green ochers (mixed with black and white) predominating (there are no blues). A characteristic reddish brown shade and a countering pale green emerge as two thematic tones. With this simple binary color approach, light tones alternating with dark ones interplay to produce vivid contrasts and original harmonies. *See also* Tapestry.

Empire Colors

The deep and intense luminosity of Empire colors reflects the power and optimism of France's First and Second Empires. Along with white and gold, Empire green was a vivid color favored by Napoleon. Complementing this green were pearl gray, amethyst, and rosy red. Gray-blue and pale ivory are also part of the Empire palette.

Paisley Shawl Colors

The dominant colors of the paisley shawl—a warm range of reds, oranges, and browns—have come to be associated with England in the eighteenth and nineteenth centuries. The original design is thought to have originated in ancient Babylon, where the teardrop shape was used as a symbol for the growing shoot of the date palm. The use of this symbol spread through Indo-European civilizations, although it survived only in India. Kashmiri shawls with these patterns were brought back by soldiers of the British Empire in the mid-eighteenth century. It became so popular that British and French manufacturers soon imitated it. This distinctive pattern is named after the Scottish town of Paisley.

Persian Carpet Colors

Persian carpet colors owe their beauty both to their complexity of design and to the skills of individual dyers. In the sixteenth century, each dyer was responsible for just one dye. To be a dyer of blue or red carried the highest status. Madder, sheep's blood, grape leaves, ivy, and myrtle were used. Noteworthy and unusual was padshah blue—dark, deep, and translucent.

Indian Textile Colors

India's textile colors are characteristically intense: deep gold-yellow, orange, and pink, along with hot magenta and turquoise. In India, these colors quickly mature, fading to softer hues in response to the sun. For more than two thousand years, India's dyemakers have used madder or lac for red, indigo for blue, pomegranate rinds for green, tumeric or saffron for yellow, and iron particles bathed in vinegar for black. *See also* Dyes and Dyeing.

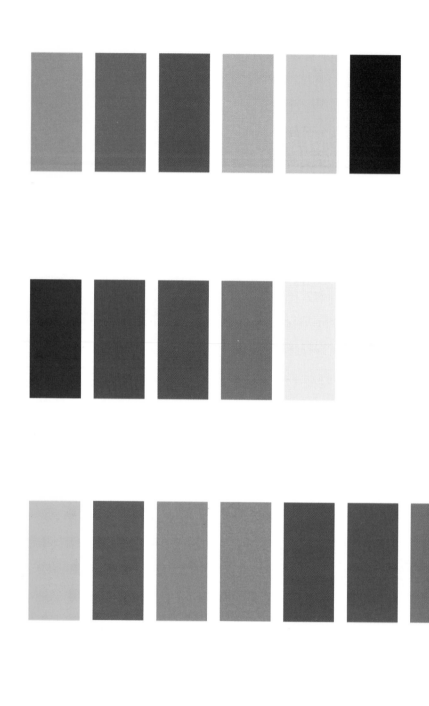

Batik Colors

Batik is the Javanese word for fabric dyed using a wax resist, a process that is at least two thousand years old. The colors most often used in Java were blue from indigo, yellow from the bark of mangosteen, and red from madder. *See also* Batik.

Bayeux Tapestry Colors

The Bayeux tapestry is technically an embroidery (of worsteds on canvas) that narrates the Norman conquest of England by William the Conqueror in 1066. The tapestry is attributed to his wife, Mathilda, and her atelier, but is more likely to be the work of Englishwomen. Medieval English needlework (known as *Opus Anglicanum*) was of such a high quality that it was exported to all of Europe, and the colors have become emblematic of that era. Very few colors were used: a red-brown, a paler tint of the same, two greens, two blues, tan, and black.

Aubusson Tapestry Colors

The Aubusson tapestry works, founded near the end of the thirteenth century and staffed by immigrant weavers from Flanders, reached the height of its creative activity toward the middle of the eighteenth century. A cool green and blue were frequently used to balance warm earth red and yellow. In later Aubusson tapestries, especially those designed by François Boucher and Jean-Baptiste Oudry, a myriad of dyes greatly extended the Aubusson color range.

Gobelins Tapestry Colors

The original tapestry works was established in Paris in the fifteenth century. It was taken over by Flemish weavers named Gobelins in 1662, and became famous for its royal upholsteries and huge figure work tapestries, which are typified by clear, warm shades. The Gobelins' fame reached its zenith in the mid-eighteenth century, and it is from that period that the shades of soft browns, browned red, carnation pink, and aqua blue were selected. *See also* Chevreul, M. E.

Poiret's Haute Couture Colors

Golden yellows and deep reds, purples, and greens marked the palette of the ultra-chic French couturier Paul Poiret (1880–1944). Influenced by the Orient, his designs featured turban hats, flowing evening wraps and gowns, and dresses of mixed patterning in luminous shades. Poiret's unusual color combinations—bright yellow or violet silks, for example, with emerald green satin or brown fur—have become a hallmark of pre- and post-World War I couture. *See also* Fashion and Clothing Color.

Southwest Native American Colors

The rich colors of the Arizona and New Mexico deserts infuse the geometrically designed fabrics of the Indians with vitality. In the finest Navaho blankets, a palette of five colors was often used: black or white (undyed wool), with green, deep red, dark blue, and bright yellow. Similarly, the Hopi artisan used blue, green, white, and black, with a touch of red. *See also* Navaho Colors.

Williamsburg Colors

The restoration of colonial Williamsburg, begun in 1928, involved intense research into historical paint colors. Most colonial paints were imported from England in dry form to be ground and mixed with oil by the users. Only by painstakingly stripping away layer upon layer of paint and wallpaper, allowing for oxidation, searching for areas of paint that were covered by furniture or applied woodwork, and cross-checking these with colonial American and early Georgian examples have the original Williamsburg paint colors been duplicated.

Colonial and Federal American Colors

The interior colors of colonial America were strongly influenced by the eighteenth-century British preference for green. Generally, the shades were lighter than their British counterparts. A pale yellow-green became part of a unique early American palette, as well as a shade of red that was used on many cabinets regardless of the wall color. *See also* Cupboard Red.

Tiffany Glass Colors

The glass of Louis C. Tiffany is one record of American colors popular at the turn of the twentieth century. Tiffany established a glass factory in Long Island in 1893, where he produced a blown glass known as Favrile, distinguished by pearly, unconventional colors. *See also* Art Nouveau Colors.

Victorian Colors

Color schemes in a typical Victorian interior connected the function of a room with its hues: dining rooms were decorated in warm hues considered suitable for eating; libraries were usually papered in somber tones; halls and stairways in cool colors; and parlors and drawing rooms in light, bright hues. Particularly popular in the late nineteenth century were mauve (Perkins's first aniline dye), and two brilliant purple-pinks—magenta and solferino (named after two battles in the Austrian-Italian war of 1859). Other historic examples of these potent dyes are Victorian blue, Victorian green, and Victorian orange. *See also* Aniline.

Adam Greens

Greens in subtle gradations were favored by English architects Robert and James Adam, whose neoclassical taste dominated the decorative arts of the late eighteenth century. Based largely on colors derived from Pompeian frescoes, the Adam colors tended to be slightly cooler and more elegant than their prototypes. Light green and Adam green still survive in a number of England's late eighteenth century mansions. *See also* Adam, Robert and James.

Wedgwood Colors

Josiah Wedgwood, born in 1730, founded a family of potters and established a palette of colors that have become known around the world and dominated by the so-called Wedgwood blue. In addition to the Wedgwood blue were lilac, cane yellow, pale avocado green, warm brown, and a group of jasper (quartz) colors, including brick red with a pinkish cast. *See also* Wedgwood Blue.

William Morris's Nature Colors

William Morris, a leader of the British Arts and Crafts Movement, was dedicated to reinvigorating craftsmanship in the wake of the Industrial Revolution. Eschewing synthetic materials, he used only natural dyes to produce chintz, wallpapers, and woven cloth in warm, woodland colors that became the standard of taste among the middle classes of both Britain and the United States. *See also* Arts and Crafts Movement and Color.

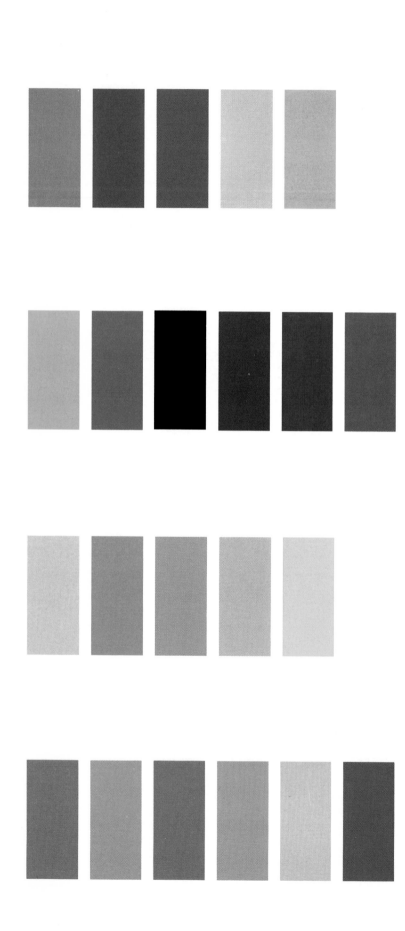

Art Deco Colors

The Art Deco palette of bright, saturated colors characterized fashionable design in the late 1920s and 1930s in both the United States and Europe. Named after a 1925 exhibition in Paris, *L'Exposition Internationale des Arts Decoratifs et Industriels Modernes,* Art Deco color designs strongly reflected the technological advances following World War I and the association of modernity with bright coloration. By the end of the 1920s, manufacturers of consumer goods had the ability to render an increasing variety of products in primary oranges, reds, greens, and blues, and to effect clearer whites and blacks. *See also* Art Deco Colors; Bakelite.

Bauhaus Colors

Primary colors in opposition with white and, to a lesser degree, black, clearly distinguish the architecturally bold Bauhaus chromatic statement. Primary red and yellow and secondary orange were used in residential facades; "seasonal mood" (fall, winter, spring, and summer) combinations were also explored by Bauhaus teacher Johannes Itten and his students, and later published in Itten's *Theory of Color* (1961). *See also* Bauhaus; de Stijl.

Pop Art Colors

The pop art palette is composed of colors of two orders: a group of raw primaries, such as those seen in Andy Warhol's Brillo box paintings and in many of Roy Lichtenstein's comic strip paintings; and the colors of a plastic- and chrome-dominated society, as in the palette shown here: chrome, turquoise, yellow, and baby pink. *See also* Lichtenstein, Roy; Warhol, Andy.

Post-Modern Architecture Colors

Post-modernism, which in part represents a strong reaction to the color austerity of Bauhaus-inspired modernist architecture, began with the pop art palette, preferring a melon pink and coolly classical pale and mint greens, alongside subtle color gradations of natural stone, from buff, through pink granite, to a soothing gray-blue. *See also* Architecture and Color.

APPENDIX I
COLOR
ORGANIZATIONS

The following is a list of color organizations arranged alphabetically by country name.

GRUPO ARGENTINO DEL COLOR LIC.
R. D. Lozano
INTI Division Optica
Cas de Correo 157
1650 San Martin Buenos Aires
Argentina

COLOUR SOCIETY OF AUSTRALIA
Dr. B. Powell
P.O. Box E 184
St. James
N.S.W. 2000
Australia

ARBEITSKREIS FARBE DER OVE-OLAV
Dr. F. Rotter
Fachgruppe Messtechnik
Arltgasse 35
A-1163 Wien
Austria

CENTRE D'INFORMATION DE LA
 COULEUR BELGIQUE
Mme. J. Verschueren van Helden
S.A. Levis N.V.
171 Leuvensesteenweg
B-1800 Vilvoorde
Belgium

CANADIAN SOCIETY FOR COLOR
Dr. A. R. Robertson
National Research Council
Division of Physics
Ottawa K1A 0R6
Canada

CHINESE COLOUR COMMISSION
Prof. Shu Yuexin
Shandong Textile Engineering College
Dept. of Colour Science
Qingdao
China

CENTRE FRANÇAIS DE LA COULEUR
Dr. Robert Seve
15 Passage de la Main d'Or
75011 Paris
France

THE COLOR GROUP
Dr. M. R. Pointer
Kodak Ltd., Res. Div.
Headstone Drive
Harrow, Middlesex HA1 4TY
Great Britain

NEDERLANDSE VERENIGING VOOR
 KLEURENSTUDIE
Dr. C. H. Kleemans
Zuidlaan 22
NL-211 GC Aerdenhout
Holland

HUNGARIAN NATIONAL COLOUR
 COMMITTEE
Dr. A. Nemcsisc
Technical University of Budapest
Muegyetem rkp. 3
H-1111 Budapest
Hungary

COLOUR GROUP OF INDIA
Dr. N. S. Gangakhedkar
Compute Spectra Pvt. Ltd.
1, Manisha, Malviya Road
Vile Parle (E)
Bombay 400 057
India

ASSOCIAZIONE OTTICA ITALIANA
Prof. L. R. Ronchi
Instituto Nazionale di Ottica
6 Largo Fermi
I-50125 Firenze
Italy

COLOR SCIENCE ASSOCIATION OF
 JAPAN
A. Kodama
Japan Color Research Institute
1-19 Nishiazabu 3 Ch
Minato-Qu
Tokyo 106
Japan

NORSK FARVEFORUM
U. Willumsen
P.O. Box 1714 Hystad
N-3200 Sandefjord
Norway

POLISH COMMITTEE FOR
 STANDARDIZATION
Prof. Dr. Sobczak
ul. Elektroralna 2
PL-139 Warszawa
Poland

SOUTH AFRICAN COLOUR SCIENCE
 ASSOCIATION
A. N. Chalmers
P.O. Box 36319
Menlo Park
Pretoria 0102
South Africa

SVENSKA FARGGRUPPEN
Th. Hord
Swedish Colour Centre Foundation
P.O. Box 14038
S-10440 Stockholm
Sweden

INTERNATIONAL ASSOCIATION OF
 COLOR CONSULTANTS
Frank Mahnke
11 Quai Capo d'Istria
Geneva 1205
Switzerland

SCHWEIZERISCHE LICHTTECHNISHE
 GESELLSCHAFT
A. O. Wuillemin
Postfach
CH-8034 Zurich
Switzerland

AMERICAN ASSOCIATION OF TEXTILE
 CHEMISTS AND COLORISTS
William R. Martin
P.O. Box 12215
Research Triangle Park, N.C. 27709
U.S.A.

AMERICAN INFORMATION CENTER FOR
 COLOR AND ENVIRONMENT
Mrs. Erna Haynes
3621 Alexia Place
San Diego, Calif. 92116
U.S.A.

COLOR ASSOCIATION OF THE UNITED
 STATES
Dolores Ware
343 Lexington Avenue
New York, N.Y. 10016
U.S.A.

COLOR MARKETING GROUP
Ms. Nancy Burns
4001 North Ninth Street
Suite 102
Arlington, Va. 22203
U.S.A.

DRY COLOR MANUFACTURERS
 ASSOCIATION
J. L. Robinson
206 N. Washington Street
Alexandria, Va. 22320-1839
U.S.A.

INTERNATIONAL ASSOCIATION OF
 COLOR CONSULTANTS
Rudolf Mahnke
730 Pennsylvania Avenue
San Diego, Calif. 92103
U.S.A.

INTER-SOCIETY COLOR COUNCIL
Mrs. Joy Turner Luke
Studio 231
Box 18, Route 1
Sperryville, Va. 22740
U.S.A.

NATIONAL PAINT AND COATINGS
 ASSOCIATION, INC.
Larry L. Thomas
1500 Rhode Island Avenue, N.W.
Washington, D.C. 20005
U.S.A.

DEUTSCHER VERBAND FARBE
Dr. G. Geutler
Institut fur Lichttechnik, TU
Einsteinufer 19
D-1000 Berlin 10
West Germany

APPENDIX II
COLOR SPECIFIER
SYSTEMS

The following is a list of specifier systems/ atlases of the last three centuries arranged chronologically by date of publication, ranging from simple palettes showing the colors of animals or of historical periods to complex systems exhibiting the entire color space with accurate notation. All are available at the Faber Birren Collection of Color Books at the Art and Architecture Library, Yale University, New Haven, Conn.

Discourse on Light and Colours, F. Malebranche, 1700. Printed in England, this relatively unknown work was part of Father Malebranche's treatise on nature.

Observations and Remarks, Moses Harris, 1776, Robson & Co., London. This rare work named some 72 colors drawn from a hand-tinted color circle of pure hues, tints, shades, and tones, with accompanying text in English and French. It was one of the earliest efforts at color identification and naming.

Werner's Nomenclature of Colours, Patrick Syme, 1814. Published by James Ballantyne & Co., Edinburgh, for William Blackwood, John Murray, and Robert Baldwin. An early, key work designed chiefly for naturalists. Its 13 plates with 108 color samples are named and numbered in terms of animal, vegetable, and mineral colors. (This elaborated on an earlier system by A. G. Werner, a Scotch mineralogist.) Another pioneer work in its field.

Des couleurs et de leur applications aux arts industriels à l'aide des cercles chromatiques, M. E. Chevreul, 1864, J. B. Ballière, Paris. A magnificent work containing a beautiful fold-out spectrum and a color circle of continuous tones, both of which are remarkable lithographic reproductions for their time. Eight plates, each with 60 steps, scale spectral colors from purity to blackness. Further, 12 color scales show the value steps of principal hues.

A Nomenclature of Colors for Naturalists and Compendium of Useful Knowledge for Ornithologists, Robert Ridgway, 1886, Little, Brown & Co., Boston, Mass. This is a rare and highly significant work. It preceded Ridgway's later well-known presentation, *Color Standards and Color Nomenclature*, by some 26 years. A total of 190 colors were hand-applied to ten plates. Color names were given in English, Latin, German, French, Spanish, Italian, and Norwegian-Danish. Ridgway was curator of the Department of Birds for the United States National Museum.

Répertoire chromatique, Charles Lacouture, 1890, Gauthier-Villars, Paris. Contains a series of 28 beautiful color plates based on some 1,300 optical mixtures. Different tones were achieved through the use of fine lines —at the time, a new technique.

Répertoire des Couleurs, Société Française des Chrysanthémistes, 1905. A well-known and important system for color identification in horticulture, it contains over 1,400 printed colors in two volumes. Widely used for the identification of color in flowers, foliage, fruit, and so forth.

The Mastery of Color, Charles Julius Jorgenson, 1906. An interesting work which has 22 thick die-cut plates with air-brushed gradations. All colors are named. A separate 83-page booklet accompanies the volume of plates. Designed as a "Simple and Perfect Color System . . . for Educational Purposes."

Color Standards and Color Nomenclature, Robert Ridgway, 1912, published by the author, Washington, D.C. Ridgway's work was highly important in scientific circles and has become a classic in the field of color notation. It has 53 plates with 950 samples of coated paper. All colors are named.

Ostwald Color Album, Winsor & Newton, 1933, London. Contains 11 color charts with about 900 mounted chips. Published originally to accompany *Wilhelm Ostwald Colour Science*, Parts I and II, Winsor & Newton, 1933, London.

Dictionary of Colour Standards, British Colour Council, 1934, London. A boxed collection of

240 samples of dyed silk ribbons used for color identification and color names in the textile industry. (Also published in wool yarns.)

British Traditional Colours, British Colour Council, 1937, London. Published for the coronation of King George VI and Queen Elizabeth, dyed samples of heraldic colors, standards for the Union flag, robes, knighthood ribbons, tartan colors, and standards for the army, navy, and air force are contained in the volume.

Historical Color Guide, Elizabeth Burris-Meyer, 1938, William Helburn, New York. Contains 150 color samples mounted on 30 plates and devoted to colors used in ancient and modern times. A useful reference.

Wilson Colour Charts, British Colour Council, 1938, London. Two volumes contain 800 printed, named color samples, for use in horticulture. (Identical to *Horticultural Colour Charts,* 1942, London.)

Standard Color Card of America, originally issued in 1941 by the Textile Color Card Association of the U.S. Two hundred sixteen colors in dyed satin are presented on 18 hinged charts. This has been one of the most widely used sources of reference, both for colors and names, by the U.S. Government and American textile industry. (An edition was published in 1980 by the Color Association of the U.S., New York. Later editions have also been issued.)

Horticultural Colour Charts, British Colour Council with Royal Horticultural Society, 1942, London. Two volumes with 800 printed color samples, for color identification in horticulture. (Identical to *Wilson Colour Charts,* 1938.)

Munsell Book of Color, Munsell Color Company, 1942, Baltimore, Md. A small, two-volume edition with 41 plates. The colors included are based on the 1929 abridged edition. It represents an early historical Munsell work.

Schweizer Farbenatlas (Swiss Color Atlas), Dr. Aemilius Müller, 1945, Winterthur. A large, handsome volume, 24 charts hold over 1,000 samples of dyed paper in small envelopes. Follows the principles of Wilhelm Ostwald.

Plochère, Color and Color Names, 1946, Los Angeles, Calif. A large and impressive book of color standards, to be used for identification purposes and for color names. Contains 64 charts with 1,536 mounted chips.

Atlas de los Colores (Color Atlas), C. Villalobos-Dominguez and Julio Villalobos, 1947, Buenos Aires. English text by Aubrey Molyn Homes.

Color Harmony Manual, Egbert Jacobson, Walter C. Granville, and Carl E. Foss, Container Corporation of America, 1948, Chicago, Ill. This third edition is a boxed loose leaf, with about 900 removable chips. Includes a descriptive color names dictionary edited by Helen B. Taylor, Lucille Knoche, and Walter C. Granville, 1950. (Later editions of the *Manual* were issued.)

Dictionary of Colours for Interior Decoration, British Colour Council, 1949, London. Three hundred and seventy-eight color samples are displayed in two boxed volumes, showing gloss and flat paint and pile fabric. Includes a separate index of color terms and names.

Designer's Color Guide, E. I. Du Pont de Nemours & Co., 1950, Wilmington, Del. An impressive collection of 1,600 samples of dyed yarns, arranged in analogous order and featuring Du Pont dyes. Compiled for textile designers and stylists.

Dictionary of Color, A. Maerz and M. Rea Paul, 1950, McGraw-Hill Book Co., New York. A bound volume containing 7,000 samples of printed color, with color names based on historical origins and current usage.

Dictionary of Colour Standards, British Colour Council, 1952, London. Boxed collection of 240 samples of dyed wool yarns. Used for color identification and color names in the textile industry. (Also published in dyed silk ribbons.)

Dutch Boy Color Gallery, c. 1952, New York. An elaborate system, well-organized, for interior and exterior paints. Contains 41 charts of 60 swatches each, for a total of 2,460 mounted colors.

Farbenordnung Hickethier, 1952, Verlag H. Osterwald, Hanover. Hickethier, a color printer, developed an unusual and interesting system of color organization. This beautiful work is replete with excellent color plates and color charts, which exhibit some 999 different color variations.

Hesselgren's Colour-Atlas, 1953, Stockholm, Sweden. This system consists of an atlas with 507 small samples on 26 charts. A well-devised, general color order system.

Colorizer Paint System, 1955. Developed by Faber Birren, there are 51 separate charts, and a total of 1,812 individually coated chips mounted on removable strips. Includes Color Harmony Selector. (Also refer to the

Colorizer Paint Systems issued in 1970 and 1980.)

Duo-Color Guide, edited by Zane Bouregy and Samuel Tankel, 1955, Graphic Publishing Co., New York. This is a standard reference work on two-color reproduction with printing inks. Contains 76 charts of color-and-black combinations, and 24 charts of color-and-color combinations. Each chart has 42 graded steps in halftone.

Inter-Society Colour Council–National Bureau of Standards (ISCC–NBS) *Method of Designating Colors* and *Dictionary of Color Names*, National Bureau of Standards, 1955, Circular 553, Washington, D.C. This book established a system for the naming of colors. Simple color names are included using the Munsell system. There are cross-references to colors derived from a number of color order systems, such as Ridgway, Maerz and Paul, Plochère, and others. The later edition is dated 1976.

RAL Farbregister 840 R, 1955, Muster-Schmidt, Gottingen. A German system of color for purposes of standardization and identification that contains 94 standards.

Scandinavian Colour Book, 1956, Nordisk Textile Unions, Copenhagen. Three striking loose-leaf volumes contain 1,728 samples of dyed felt in systematic order.

Pflanzenfarben-Atlas, Prof. Dr. E. Biesolski, 1957, Musterschmidt-Verlag, Gottingen. An interesting series of color charts with 375 mounted chips. Designed for the notation of flower colors.

Nickerson Color Fan, Dorothy Nickerson, 1957, Munsell Color Co., Baltimore, Md. Contains 37 strips exhibiting 40 hues of maximum chroma, with six or seven steps to each strip. Used for color identification by the American Orchid Society and the American Horticultural Council. Follows the *ISCC–NBS Method of Designating Colors.*

Four-Color Process Guide, 1960, Graphic Publishing Co., New York. Using the standard process colors—magenta, yellow, cyan, and black—25 pages of charts show 5,600 different color patches, important for work in the graphic arts. Fourteen pages of explanatory text in English, French, German, and Spanish are included.

The Friel System: A Language of Color, Edward Friel, 1961, privately printed, Seattle, Wash. With color plates. Discusses the relationships of existing colorants (pigment dyes) and orderly color organization.

Reinhold Color Atlas, A. Kornerup and J. H. Wanscher, 1961, Reinhold Publishing Co., New York. A small, unique book of color standards, with 30 double-spread charts both showing and naming 1,440 printed color samples. Its purpose is to provide a source of standards for matching, naming, and identifying color. (See *Methuen Handbook of Colour*, 1978, which repeats the Reinhold version.)

Color for Interiors, Historical and Modern, Faber Birren, 1963, Whitney Library of Design, New York. Includes 16 charts with 248 mounted chips. Charts present ancient and period colors: Egypt, Greece, and Rome, and Renaissance, French, English, American, and Victorian period colors. Colors for schools, hospitals, factories, offices, stores, and foodservice are also suggested. All chips are named.

Pantone Color Specifier, 1963, Pantone, Inc., Moonachie, N.J. A widely used system, particularly in the graphic arts. Some 563 printed colors are presented on coated and uncoated stock in loose-leaf sheets with tear-out swatches.

Plochère Color System, 1965, Los Angeles, Calif. This system consists of a boxed set of 1,248 colored cards. It has been successfully used over the years and carries a considerable reputation as an American color system.

Advanced Ink Mixing System (AIMS), 1968, Danish Paint and Ink Research Laboratory, Copenhagen. Six plates, showing 1,200 color variations used in an ink mixing system, are also used for color description and identification. The foreword is in several languages. Devised by Andreas Kornerup (see *Reinhold Color Atlas*, 1961 and *Methuen Handbook of Colour*, 1978).

Federal Standard No. 595a, Colors, 1968 edition, issued by the Federal Supply Service, Washington, D.C. Some 26 charts have 437 coated and mounted samples of color in gloss, semi-gloss, and lusterless finishes. The colors are those officially recognized by all branches of the U.S. Government and are to be used as standards by suppliers of colored materials.

Colorizer Paint System, Totalcolor Concept. Faber Birren, 1970, for a group of American paint companies. A total of 1,740 individually coated chips are mounted on removable strips. There are 58 separate charts. (Refer also to the *Colorizer Systems* developed by Faber Birren in 1955 and 1980.)

Color Mixing by Numbers, Alfred Hickethier, 1970, Van Nostrand Reinhold, New York. An abbreviated edition of Hickethier's commendable color order system. The 384 die-

cut color chips may be pasted on charts for color training. There is also a good review of historic color solids.

JIS Color Code for Investigation, 1971, Japan Color Research Institute, Tokyo. A system for color identification and naming, it contains 600 mounted chips. Twenty-eight charts, 2 fold-out charts, a set of bound black-and-white charts, and a descriptive booklet of color names are included.

I.C.I. Color Atlas, 1972, Imperial Chemical Industries, London. This novel color system contains a series of charts with 1,379 individually imprinted color swatches all graded from pure hue to white. Modified shades and tones are then visualized through the use of 20 neutral gray filters to be placed over the color swatches. Identification and notation are provided.

Color, Origin, Systems, Uses, Harold Küppers, 1973, Van Nostrand Reinhold, New York. Fourteen charts show 1,400 gradations of colors. Diagrams of early color systems—those of Lambert, Rünge, Ostwald, and others—are also included.

Princeton University Press Color Kit, 1973, Princeton University Press. A series of 18 plates demonstrate two-color effects, using 16 inks on color stock. Practical for visualizing the influence of colored papers on colored printing inks, solid impressions, and screen combinations.

Chart System of Color Names, 1974, Japan Color Research Institute, Tokyo. Two hundred and eighty-six mounted color chips are identified with common color names. An accompanying 32-page booklet refers to other color-naming systems and identifies the colors on the large charts in their terms.

Hickethier Color Atlas, 1974, developed by Alfred Hickethier of Germany, Van Nostrand Reinhold Co., New York. An impressive collection of 1,000 color standards mounted on 40 die-cut charts. Designed chiefly for the purpose of color identification and notation.

Manual of Color Names, 1974, Japan Color Research Institute, Tokyo. With a color circle of 24 hues, along with other charts, the work is used to identify and name (in both Japanese and English) some 400 different chips of color tones. There are black-and-white sketches of flowers, birds, fish, vegetables, and fruits. This is an extremely practical reference for anyone endeavoring to associate different colors with common names. (The equivalent in the United States is the *ISCC–*

NBS Method of Designating Colors, which does not include color chips.)

Uniform Color Circles of the Optical Society of America, 1974. An authoritative collection of 552 colors, each 2 inches square, held in individual clear plastic pockets on 30 charts. With loose chips, six entirely different color scales can be arranged. In all cases, equal color differences are noted. The binder includes various reprints of articles related to the scales, a history of their development, colorimetric data, and so forth.

Color Data Manual, 1975, Japan Color Research Institute, Tokyo. About 90 charts include color chips and word identification, mostly in Japanese but some in English. Practical use requires a knowledge of the Japanese language.

Color System, 1975, Japan Color Research Institute, Tokyo. Produced for color education in Japan. While the text is in Japanese, color identifications and names are also made in English. The color order systems of Lambert, Rünge, Chevreul, Von Bezold, Helmholtz, Rood, Hofler, Munsell, Ostwald, and others are reviewed. A series of 21 exquisite charts, containing over 1,000 color chips, illustrate three major color systems: Practical Color Co-ordinate System (P.C.C.S.), Munsell, and Ostwald—a feature quite unusual in one volume.

Harmonic Color Charts, 1975, Japan Color Research Institute, Tokyo. This is a digest of the Japanese P.C.C.S. and is meant for educational purposes. Included is a large fold-out chart, on which about 100 chips of color are mounted; duplicates of these 100 colors are filed loose in a separate folder having plastic pockets. Two descriptive booklets (in Japanese) are also included.

Munsell Book of Color, glossy finish collection, 1976, Macbeth-Munsell Color, Baltimore, Md. This is the most widely known color system for the notation of color, authoritatively developed by color scientists. Contains 22 charts, with about 1,500 removable plastic chips.

Chroma Cosmos 5000, 1978, Japan Color Research Institute, Tokyo. This is one of the most elaborate, beautiful, and complete color systems ever issued. Contains 5,000 individually coated and mounted color chips on 23 charts, with a twenty-fourth volume of explanatory text. All 5,000 chips also identified in terms of the Munsell Color System and have further designations to agree with the *ISCC–NBS Method of Designating Colors.*

DuMont's Farben-Atlas, Harald Küppers, 1978, DuMont Buchverlag, Cologne. A paperback edition of a color atlas containing 46 charts of basic color standards. Based on an intriguing geometric concept of color order.

Methuen Handbook of Colour, by A. Kornerup and J. H. Wanscher, 1978, Eyre Methuen, London (third edition). This is a British adaptation and duplication of the original Kornerup-Wanscher work. It introduces names used by British paint- and printing ink manufacturers, and is otherwise well recognized by British organizations concerned with color. (See *Reinhold Color Atlas,* 1961.)

Color Source Book, Margaret Walch, 1979, Charles Scribner's Sons, New York. This attractive work contains a series of 48 charts with 103 mounted color chips showing actual, tipped-in samples of historical and period colors, textile and pottery colors, the palettes of famous artists, and so forth. The book repeats a group of boxed charts originally issued through *American Fabrics* magazine in 1970.

Colorizer Paint System, Colorizer Plus, Faber Birren, 1980, for a group of American paint companies. A total of 988 individually coated and named chips are mounted on removable strips. There are 27 separated charts. (Refer also to the *Colorizer Systems* developed by Faber Birren in 1955 and 1970.)

Natural Color System, Color Atlas, 1980, Scandinavian Colour Institute, Stockholm, Sweden. A color system based on the theory of Ewald Hering and developed by Anders Hård. Some 1,412 colors are available in various forms. The atlas has 42 charts with mounted chips. A color notation is provided.

Chromaton 707, 1982, Japan Color Research Institute, Tokyo. A color system containing 7 fold-out charts with 707 mounted color chips. An extra set of swatches is also included. All colors are identified by number as well as by notations of the U.S. Munsell Color System and the ISCC–NBS Method of Designating Colors.

Color Atlas, Harald Küppers, 1982, Barron's, Woodbury, N.Y. An English paperback edition of an earlier German publication. Exhibits over 5,500 printed color swatches drawn from 18 basic inks, and includes a description of a hexagon color order system devised by Küppers. (See *DuMont's Farben-Atlas,* 1978.)

DIN-Farbenkarte, glossy collection, 1982, Beuth Verlag Gmbh., Berlin. A highly technical, well organized color system and standard for color identification. Over 1,000 removable plastic chips are carefully notated in scientific terms. (The Yale *DIN* collection is incomplete and includes only three out of 25 charts: yellow, blue, and green.)

BIBLIOGRAPHY

Adrosko, Rita J. *Natural Dyes in the United States*. Washington, D.C.: Smithsonian Press, 1968.

Albers, Josef. *Hommage to the Square: Ten Works by Josef Albers*. New Haven, Conn.: Ives-Stillman, 1962.

————. *Interaction of Color*. New Haven, Conn.: Yale University Press, 1963.

Alberti, Leone Batista. *Della Pittura*. Florence: G. C. Samsoni, 1436.

Ali, M. R. "Pattern of EEG Recovery under Photic Stimulation by Light of Different Colors." *Electroencephalography and Clinical Neurophysiology* 33 (1972).

Allen, Jeanne. *Designer's Guide to Color I, II, and III*. San Francisco: Chronicle Books, 1986.

Alloway, Lawrence. *Lichtenstein*. New York: Abbeville Press, 1983.

Alschuler, Rose H., and La Berta Weiss Hattswick. *Painting and Personality*. Chicago: University of Chicago Press, 1947.

Amber, R. B. *Color Therapy: Healing with Color*. New York: Santa Barbara Press, 1967.

American Cinematographer Manual. Hollywood, Calif.: ASC Press, 1986.

American Society of Photogrammetry and Society of American Foresters. *Color Aerial Photography in the Plant Sciences and Related Fields*. Falls Church, Va.: American Society of Photogrammetry, 1979.

Amster, Arnold A. "The Evolution of Color as a Primary Element in Painting 1850–1970." Master's thesis, New York University, 1971.

Anderson, Mary. *Color Healing: Chromotherapy and How It Works*. Wellingborough, England: Thorsons, 1975.

Apollonio, Umbro, ed. *Futurist Manifestoes*. London: Thames & Hudson, 1973.

Aristotle *De Coloribus Libellus*. Florence: Ex officina Laurentii Torrentini, 1548.

————. *Physica* (in Greek) Edited by W. D. Ross. Oxford: Clarendon Press, 1955.

Arnheim, Rudolf. *Art and Visual Perception*. Berkeley: University of California Press, 1954.

Astrua, Massimo. *Manual of Colour Reproduction for Printing and the Graphic Arts*. Kings Langley, England: Fountain Press, 1973.

Audsley, William J. *Color in Dress: A Manual for Ladies*. Philadelphia: G. Maclean, 1870.

————. *Polychromatic Decoration as Applied to Buildings in the Medieval Style*. London: Sotheran & Co., 1882.

Babbitt, Edwin D. *The Principles of Light and Color*. New Hyde Park, N.Y.: University Books, 1967.

————. *The Principles of Light and Color*. Edited by Faber Birren. New York: Citadel Press, 1967.

Bagnall, Oscar. *The Origin and Properties of the Human Aura*. New York: E. P. Dutton & Co., 1937.

Bamford, G. R. *Colour Generation and Control*. Amsterdam: Elsevier, 1977.

Barasch, Moshe. *Light and Color in the Italian Renaissance Theory of Art*. New York: New York University Press, 1978.

Barthes, Roland. *Le Systeme de la Mode*. Paris: Le Seuil, 1987.

Battersby, Martin. *The Decorative Twenties*. New York: Macmillan, 1969.

Baty, Thomas. *Academic Colours*. Tokyo: Kenkyusha Press, 1934.

Bayer, H., W. Gropius and I. Gropius, eds. *Bauhaus, 1919–28*. 1938. Reprint. New York: Museum of Modern Art, 1952.

Beck, Jacob. *Surface Color Perception*. Ithaca, N.Y.: Cornell University Press, 1972.

Belt, Forest H. *Forest H. Belt's Easi-Guide to Color TV*. Indianapolis: H. W. Sams, 1973.

Benaim, L. *L'Annee de la Mode*. Paris: La Manufacture, 1987.

Berlin, Brent, and Paul Kay. *Basic Color Terms: Their Universality and Evolution*. Berkeley: University of California Press, 1969.

Berlyne, D. E., and P. McDonnell. "Effects of Stimulus Complexity and Incongruity on Duration of EEG Desynchronization." *Electroencephalography and Clinical Neurophysiology* (1965).

Bezold, Wilhelm von. *The Theory of Color in Its Relation to Art and Industry*. Boston: L. Prang & Co., 1876.

Billmeyer, Fred W., and Max Saltzman. *Principles of Color Technology*. New York: John Wiley & Sons, 1966.

Binder, Joseph. *Colour in Advertising*. London: The Studio, 1934.

Birren, Faber. *Color Dimensions: Creating New Principles of Color Harmony*. Chicago: Crimson Press, 1934.

————. *The Printer's Art of Color*. Chicago: Crimson Press, 1934.

————. *Color in Modern Packaging*. Chicago: Crimson Press, 1935.

————. *Functional Color*. New York: Crimson Press, 1937.

————. *The Wonderful Wonders of RYB (Red-Yellow-Blue)*. New York: MacFarlane, Warde, 1937.

————. *Monument to Color*. New York: McFarlane, Warde, McFarlane, 1938.

————. *Character Analysis Through Color*. Westport, Conn.: Crimson Press, 1940.

————. *Selling with Color*. New York: McGraw-Hill, 1945.

————. *Color and Your Self: The Significance of Color Preference in the Study of Human Personality*. Sandusky, Ohio: Prang Co., 1952.

————. *New Horizons in Color*. New York: Reinhold, 1955.

————. *Selling Color to People*. New York: University Books, 1956.

————. *Color, Form and Space*. New York: Reinhold, 1961.

————. *Color Psychology and Color Therapy*. New Hyde Park, N.Y.: University Books, 1961.

————. *Color for Interiors, Historical and Modern*. New York: Whitney Library of Design, 1963.

————. *Color: A Survey in Words and Pictures from Ancient Mysticism to Modern Science*. New Hyde Park, N.Y.: University Books, 1963.

————. *The American Colorist: A Practical Guide to Color Harmony and Color Identification*. Norwalk, Conn.: Silvermine, 1966.

————. *Light, Color and Environment*. New York: Van Nostrand Reinhold, 1969.

————. *Principles of Color*. New York: Van Nostrand Reinhold, 1969.

————. *Itten: The Elements of Color*. New York: Van Nostrand Reinhold, 1970.

————. "Color and Man-Made Environments: Reactions of Body and Eye." *A.I.A. Journal* (September 1972).

————. "Color and Man-Made Environments: Reactions of Mind and Emotion." *A.I.A. Journal* (October 1972).

————. "Color and Man-Made Environments: The Significance of Light." *A.I.A. Journal* (August 1972).

————. *Color Perception in Art*. New York: Van Nostrand Reinhold, 1976.

————. "The 'Off-White Epidemic': A Call for a Reconsideration of Color." *A.I.A. Journal* (July 1977).

————. *Color and Human Response*. New York: Van Nostrand Reinhold, 1978.

————. *The Textile Colorist*. New York: Van Nostrand Reinhold, 1980.

Bloy, C.H. *A History of Printing Ink, Balls, and Rollers*. New York: Sandstone Press, 1967.

Blunden, Maria and Godfrey. *Impressionists and Impressionism*. New York: Skira/Rizzoli, 1973.

Boll, Marcel, and Jean Dourgnon. *Le Secret des Couleurs*. Paris: Presses Universitaires de France, 1946.

Boller, Willy. *Masterpieces of the Japanese Color Woodblock*. London: Elek Books, 1957.

Bond, Fred. *Color, How to See and Use It*. San Francisco: Camera Craft, 1954.

Borelius, Birgit. *Oscar Wilde, Whistler and Colours*. Lund, Sweden: Gleerup, 1966.

Bouma, Pieter. *Physical Aspects of Colour: An Introduction to the Scientific Study of Colour Stimuli and Colour Sensations*. London: St. Martins, 1971.

Bowlt, John, ed. *Russian Art of the Avant Garde: Theory and Criticism 1902–34*. New York: Viking, 1977.

Boyle, Robert. *Experiments and Considerations Touching Colours*. 1670. Reprint. New York: Johnson Reprint, 1964.

Boyton, Robert M. *Human Color Vision*. San Diego: Holt, Rinehart & Winston, 1979.

Bradley, Milton. *Elementary Color*. Springfield, Mass.: Milton Bradley Co., 1895.

Breathnach, A. S. *Melanin Pigmentation of the Skin*. London: Oxford University Press, 1971.

Brewster, Sir David. *A Treatise on Optics*. Philadelphia: Carey, Lea & Blanchard, 1835.

Brill, M. H. "Object-based Segmentation and Color Recognition in Multispectral Images." *Image Understanding and the Man-Machine Interface II*. Edited by Eamon B. Barrett and James J. Pearson. Proc. SPIE 1076, 97–109 (1989).

British Colour Council. *Colour and Lighting in Factories and Offices*. London, 1946.

————. *The British Colour Council Dictionary of Colour Standards*. London, 1951.

Brown, M. W. *The Color Kittens*. New York: Golden Press, 1958.

Bruno, Vincent J. *Form and Color in Greek Painting*. New York: Norton, 1977.

Buckley, Mary. *Color Theory: A Guide to Information Sources*. Detroit: Gale Research Co., 1975.

Burch, Robert M. *Colour Printing and Colour Printers*. 1910. Reprint. London: I. Pitman, 1983.

Burnham, Robert W. *Color: A Guide to Basic Facts and Concepts*. New York: John Wiley & Sons, 1963.

Burris-Meyer, Elizabeth. *Color and Design in the Decorative Arts*. New York: Prentice-Hall, 1935.

Bush, Donald. *The Streamlined Decade*. New York: George Braziller, 1975.

Callen, Anthea. *Techniques of the Impressionists*. New York: Orbis, 1982.

Campbell, Ann. *Let's Find Out About Color*. New York: Watts, 1975.

Carnt, P. S., and G. B. Townsend. *Colour*

Television: The N.T.S.C. System, Principles and Practice. London: Illife, 1961.

Casselman, Karen L. *Craft of the Dyer: Colour from Plants and Lichens of the Northeast.* Toronto: University of Toronto, 1980.

Castel, Louis B. *L'Optique des Couleurs.* Paris: Briasson, 1740.

Cennini, Cennino. *Il Libre dell'Arte* (The craftsman's handbook). New York: Dover, 1954.

Cerwinske, Laura. *Tropical Deco.* New York: Rizzoli, 1981.

Chakravarti, Tapo N. *The Universe of Color: Modern Western and Ancient Indian Perspectives.* Calcutta: Putul Chakravarti, 1978.

Chamberlin, Gordon J. *The CIE International Colour System Explained: For the Non-Technical Reader.* Salisbury: Tintometer, 1951.

Chambers, Bernice G. *Color and Design: Fashion in Men's and Women's Clothing and Home Furnishings.* New York: Prentice-Hall, 1951.

Chatelet, Albert. *Van Eyck.* Bologna: Capitol Editions, 1979.

Cheskin, Louis. *Colors: What They Can Do for You.* New York: Liveright, 1947

————. *Notation on a Color System: For Color Planning, Color Identification, Color Mixing-Matching, and Printing with Color.* Chicago: Color Research Institute of America, 1949.

————. *Color for Profit.* New York: Liveright, 1951.

————. *Color Guide for Marketing Media.* New York: Macmillan, 1954.

————. *How to Color-Tune Your Home.* Chicago: Quadrangle Books, 1962.

Chevreul, Michel E. *The Principles of Harmony and the Contrast of Colors.* 1854. Reprint. New York: Reinhold, 1967.

Chipp, Herschel B. *Theories of Modern Art.* Los Angeles: University of California Press, 1968.

Clark, William H. *Gardening for Color.* Boston: Little, Brown & Co., 1954.

Clarke, Ronald. *Food Colours.* Leatherhead, England: British Food Manufacturing Industries Research Association, 1952.

Cleland, Thomas M. *A Practical Description of the Munsell Color System: With Suggestions for Its Use.* Boston: Munsell Color Co., 1921.

Coe, Brian. *Colour Photography: The First Hundred Years, 1840–1940.* London: Ash & Grant, 1978.

Cogniat, Raymond. *Georges Braques.* New York: Harry N. Abrams, 1980.

Cohen, Arthur. *Sonia Delaunay.* New York: Harry N. Abrams, 1975.

Cohen, Robert. *The Color of Man.* New York: Random House, 1968.

Collins, Judith, John Welchman, et al. *Techniques of Modern Artists.* London: Macdonald, 1983.

Color. New York: Time-Life Books, 1976.

Colt, Priscilla. *Color and Field, 1890–1970.* n.p., 1970.

Conroy, Ellen. *The Symbolism of Colour.* London: William Rider & Son, 1928.

Cook, Kristina, ed. *National Paint & Coatings: Celebrating a Century, 1887–1987.* Washington, D.C.: National Paint & Coating Association, 1987.

Crewdson, Frederick M., *Color in Decoration and Design.* Wilmette, Ill.: Frederick J. Drake and Co., 1953.

Crisp, Quentin. *Colour in Display.* New York: Chemical Publishing Co., 1938.

Dalton, John. *Extraordinary Facts Relating to the Vision of Colours with Observations.* Manchester, England: Member Literary and Philosophical Society, 1798.

Danger, Eric P. *How to Use Color to Sell.* Boston: Cahners Publishing Co., 1969.

————. *The Colour Handbook.* Aldershot, England: Gower Technical Press, 1987.

Daniels, Harvey. *Printmaking.* New York: Viking Press, 1971.

da Vinci, Leonardo. *A Treatise on Painting.* London: G. Bell & Sons, 1877.

da Vinci, Leonardo. *The Notebooks of Leonardo da Vinci.* New York: Reynal & Hitchcock, 1939.

Davis, Derek C., and Keith Middlemas. *Coloured Glass.* London: Jenkins, 1968.

De Angelis, Rino. *Il Colore nella Divina Commedia.* Naples: Loffredo, 1967.

de Carcaradec, Marie. *Mural Ceramics in Turkey.* Istanbul: Redhouse Press, 1981.

De Fiore, Gaspare. *Drawing with Color and Imagination: The Techniques of the Old Masters.* New York: Watson-Guptill, 1985.

Degas, Edgar. *Degas by Himself: Designs and Writings.* Edited by Richard Kendall. London: Macdonald Orbis, 1987.

Delacroix, Eugène. *The Journal of Eugène Delacroix.* New York: Covici, Friede, 1937.

Delaunay, Robert and Sonia. *A New Art of Color.* New York: Viking Press, 1978.

Delbourg-Delphis, M. *Le Chic et le Look.* Paris: Fayard, 1978.

De Mare, Eric S. *Colour Photography.* Harmondsworth, England: Penguin, 1973.

Dennys, R. *The Heraldic Imagination.* London: Barrie & Jenkins, 1975.

Déribéré, Maurice. *La Couleur dans les Activités Humaines.* Paris: Dunod, 1959.

————. *La Couleur dans la Publicite et la Vente.* Paris: Dunod, 1969.

————. *The Relationship between Perfumes and Colors.* Vol. 3, No. 3, of *Color.* New York: John Wiley & Sons, 1978.

Deslandres, Y., and F. Muller. *Histoire de la Mode au XXième Siècle.* Paris: Somogy, 1987.

DiNoto, Andrea. *Art Plastic Designed for Living*. New York: Abbeville Press, 1984.

Dodson, Margaret. *An Easy Guide to Color for Flower Arrangers*. New York: Hearthside Press, 1956.

Doerner, Max. *The Materials of the Artist and Their Use in Painting: With Notes on the Techniques of the Old Masters*. New York: Harcourt, Brace & Co., 1934.

Doig, Allen. *Theo van Doesburg, Painting into Architecture, Theory into Practice*. London: Cambridge University Press, 1986.

Don, Frank. *Color Your World*. New York: Destiny Books, 1983.

Downing, Andrew J. *The Architecture of the Country House*. 1850. Reprinted with an introduction by George B. Tatum. New York: Da Capo Press, 1968.

Eastlake, Charles L., trans. *Goethe's Theory of Colours*. London: Cass, 1967.

Eastman Kodak Company. *Color as Seen and Photographed*. Rochester, N.Y.: Eastman Kodak Co., 1972.

Eauclaire, Sally. *The New Color Photography*. New York: Abbeville Press, 1981.

Eaves, A. O. *The Color Cure*. London: Philip Wellby, 1901.

Elderfield, John. *The "Wild Beasts": Fauvism and Its Affinities*. New York: Museum of Modern Art, 1976.

———. *The Cut-Outs of Henri Matisse*. New York. George Braziller, 1978.

Ellinger, Richard G. *Color Structure and Design*. New York: Van Nostrand Reinhold, 1963.

Ellis, Havelock. *The Colour Sense in Literature*. London: The Ulysses Book Shop, 1931.

Engdahl, David A. *Color Printing: Materials, Processes, Color Control*. Garden City, N.Y.: American Photographic Book Publishing Co., 1977.

Eraclius. *De Coloribus et Artibus Romanorum*. Biblioteca Pubblica di Valenciennes, c. 1000.

Evans, Ralph M. *Eye, Film, and Camera in Color Photography*. New York: John Wiley & Sons, 1959.

Evans, Ralph M. *The Perception of Color*. New York: John Wiley & Sons, 1974.

Eysenck, H. J. *Fact and Fiction in Psychology*. New York: Penguin Books, 1965.

Faulkner, Waldron. *Architecture and Color*. New York: Wiley-Interscience, 1972.

Favre, Jean Paul, and A. November. *Color und/and/et Communication*. Zurich: ABC Editions, 1979.

Favre, Louis. *La Musique des Couleurs et la Cinema*. Paris: Presses Universitaires de France, 1927.

Fazio, Beverly, ed. *The Machine Age in America, 1918–1941*. New York: Harry N. Abrams, 1986.

Feininger, Andreas. *Basic Color Photography*. New York: Amphoto, 1972.

Ferrarp, Pat and Bob. *The Past in Glass*. Sparks, Nev.: Western Printing Co., 1964.

Field, Gary G. *Color and Its Reproduction*. Pittsburgh: Graphic Arts & Technical Foundation, 1988.

Field, George. *Rudiments of the Painter's Art: Or a Grammar of Colouring*. London: J. Weale, 1850.

———. *Field's Chromatography: Or Treatise on Colours and Pigments as Used by Artists*. London: T. W. Salter, 1869.

Finch, Karen, and Greta Putnam. *Caring for Textiles*. New York: Watson-Guptil, 1977.

Foote, Kenneth E. *Color in Public Spaces: Towards a Communication-Based Theory of the Urban Built Environment*. Chicago: University of Chicago, Department of Geography, 1983.

Forgden, Michael and Patricia. *Animals and their Colors: Camouflage, Warning Coloration, Courtship and Territorial Display, Mimicry*. New York: Crown, 1974.

Fox-Davies, Arthur C. *Complete Guide to Heraldry*. London: T. Nelson & Sons, 1909.

Francis, F. J. *Food Colorimetry*. Westport, Conn.: AVI, 1921.

Franklin, Colin and Charlotte. *A Catalogue of Early Colour Printing*. Oxford: Home Farm, Culham, 1977.

Friedman, Joan M. *Color Printing in England, 1486–1870*. New Haven: Yale Center for British Art, 1978.

Friedman, Joseph S. *History of Color Photography*. New York: Focal Press, 1968.

Friedman, Julius, and Nathan Felde. *Consider Color*. Louisville, Ky.: Prinaire Lithographing Corp., 1976.

Furst, Jill and Peter. *Pre-Columbian Art of Mexico*. New York: Harry N. Abrams, 1980.

Gage, John. *Colour in Turner: Poetry and Truth*. London: Studio Vista, 1960.

Gall, L. *The Colour Science of Pigments*. Ludwigshafen-am-Rhein: B.A.S.F., 1971.

Galton, Francis. *Inquiries into Human Faculty*. New York: E. P. Dutton, 1908.

Garcia, Mario R. "Color: How to Use It, How Readers Perceive It." In *Contemporary Newspaper Design: A Structural Approach*. Englewood Cliffs, N.J.: Prentice-Hall, 1987.

Gardner's Art Through the Ages, 5th ed. Edited by Richard G. Tansey. New York: Harcourt Brace & World, 1970.

Gartside, M. *An Essay on Light and Shade in Colors and on Composition in General*. London: The Author, 1805.

Gass, William H. *On Being Blue: A Philosophical Inquiry*. Boston: David R. Godine, 1975.

Gatz, Konrad, and Gerhard Achterberg.

Color and Architecture. New York: Architectural Book Publishing Co., 1967.

Geerlings, Gerald K. and Betty F. *Color Schemes of Adams Ceilings*. New York: Scribners, 1928.

Gerard, R. "The Different Effects of Colored Lights on Physiological Functions." Ph.D diss., University of California at Los Angeles, 1957.

Gerritsen, Frans. *Theory and Practice of Color: A Color Theory Based on the Laws of Perception*. New York: Van Nostrand Reinhold, 1975.

Gettens, Rutherford, and George Stout. *Painting Materials: A Short Encyclopaedia*. New York: Van Nostrand, 1942.

Gilliatt, Mary. *The Mary Gilliatt Book of Color*. Boston: Little, Brown & Co., 1985.

Gittenger, Mattiebelle. *Master Dyers of the World*. Washington, D.C.: The Textile Museum, 1982.

Gladstone, William E. *Studies in Homer and the Homeric Age*. Oxford: Oxford University Press, 1858.

Glendinning, Peter. *Color Photography: History, Theory, and Darkroom Technique*. Englewood Cliffs, N.J.: Prentice-Hall, 1985.

Godlove, I. H. *Bibliography on Color*. Rochester, N.Y.: Inter-Society Color Council, 1957.

Goethe, Johann Wolfgang von. *Goethe's Color Theory*. Edited by Rupprecht Mathaei. Translated by Herb Aach. New York: Van Nostrand, 1971.

Golding, John. *Cubism: A History and an Analysis 1907–14*. London: Faber, 1959.

Goosen, E. C. *Ellsworth Kelly*. New York: Museum of Modern Art, 1973.

Graves, Maitland E. *The Art of Color and Design*. New York: McGraw-Hill, 1938.

———. *Color Fundamentals: With 100 Color Schemes*. New York: McGraw-Hill, 1952.

Gray, Camilla. *The Great Experiment: Russian Art*. London: Thames & Hudson, 1962.

Gree, Eleanor. *Maurice Prendergast: Art of Impulse and Color*. College Park, Md.: University of Maryland Art Gallery, 1976.

Green, Ben K. *The Color of Horses: The Scientific and Authoritative Identification of the Color of the Horse*. Flagstaff, Ariz. Northland Press, 1974.

Green, Christopher. "Purism." In *Concepts of Modern Art*. Edited by Tony Richardson and Nikos Stangos. London: Thames & Hudson, 1981.

Greenwalt, Mary H. *Nourathar: The Fine Art of Light Color Playing*. Philadelphia: Westbrook Publishing Co., 1946.

Gregory, R. L. *The Intelligent Eye*. London: Weidenfeld & Nicholson, 1971.

Grender, Iris. *You and Your Child Playing with Colors*. New York: Knopf/Pantheon, 1975.

Griffiths, John. *Colour and Constitution of Organic Molecules*. New York: Academic Press, 1976.

Gunn, Fenja. *The Artificial Face*. London: David & Charles, 1973.

Halse, Albert O. *The Use of Color in Interiors*. New York: McGraw-Hill, 1968.

Hamilton, William J. *Life's Color Code*. New York: McGraw-Hill, 1974.

Hardy, Alexander Charles, ed. *Colour in Architecture*. London: L. Hill, 1967.

Haring, Elda. *Color for Your Yard and Garden*. New York: Hawthorn Books, 1971.

Harley, Rosamond D. *Artists' Pigments, 1600–1835*. London: Butterworths, 1970.

Harris, Moses. *The Natural System of Colors*. 1766. Reprint. New York: Whitney Library of Design, 1963.

Haskins, Ilma. *Color Seems*. New York: Vanguard Press, 1973.

Hay, Roy. *The Color Dictionary of Flowers and Plants for Home and Garden*. New York: Crown, 1972.

Head, Sidney, and Christopher H. Sterling. *Broadcasting in America: A Survey of Electronic Media*. 5th ed. Boston: Houghton Mifflin, 1987.

Helmholtz, Hermann von. *Treatise on Physiological Optics*. Rochester, N.Y.: Optical Society of America, 1924.

Heran, Ivan. *Animal Coloration: The Nature and Purpose of Colours in Vertebrates*. New York: Hamlyn, 1976.

Herbert, Robert L. *Neo-Impressionism*. New York: Solomon R. Guggenheim Museum, 1968; distributed by Van Nostrand.

Herrick, Clyde N. *Color Television Troubleshooting*. Reston, Va.: Reston Publishing Co., 1976.

Heusser, Albert H., ed. *The History of the Silk Dyeing Industry in the United States*. Paterson, N.J.: Silk Dyers of America, 1927.

Hicks, David. *On Decoration*. London: Frewin, 1966.

Highland, Harold J. *The How and Why Wonder Book of Color*. New York: Grosset & Dunlap, 1963.

Hilda, Simon. *The Splendor of Iridescence: Structural Color in the Animal World*. New York: Dodd, Mead & Co., 1971.

Hirschland, Ellen B. *Henri Matisse, Jazz and other Illustrated Books*. Huntington, N.Y.: Heckscher Museum, 1979.

Hollander, Anne. *Seeing Through Clothes*. New York: Viking, 1978.

Holmberg, Lennart. *Size Estimations and Color Vision Dimensions*. Lund, Sweden: Lund University, 1971.

Homer, William Innes. *Seurat and the Science of Painting*. Cambridge, Mass.: MIT Press, 1964.

Hope, Sir William Henry St. John. *English Liturgical Colors.* London: Society for Promoting Christian Knowledge, 1918.

Horn, Richard. *Fifties Style; Then & Now.* New York: Tree Books, 1985.

———. *Memphis.* Philadelphia: Running Press, 1985.

Howard, Constance. *Embroidery and Color.* New York: Van Nostrand Reinhold, 1976.

Hubert, Joan E. *The Kline Guide to the Paint Industry.* Fairfield, N.J.: Charles H. Kline, 1978.

Hunt, Robert W. G. *The Reproduction of Color.* Kings Langley, England: Fountain Press, 1975.

———. *The Reproduction of Colour in Photography, Printing & Television.* Tolworth, England: Fountain Press, 1987.

Hunter, Richard S. *The Measurement of Appearance.* New York: John Wiley & Sons, 1975.

———. *The Reproduction of Color.* New York: John Wiley & Sons, 1975.

Indow, Tarow. "Colour Atlases and Colour Scaling." In *Colour 73.* Edited by R. W. G. Hunt. London: Adam Hilger, 1973.

Innes, Jocasta. *Paint Magic.* New York: Pantheon, 1987.

International Colour Association. *Colour 73.* Survey lectures and abstracts of the papers presented at the second congress of the International Colour Assoc., University of York, 2–6 July 1973. New York: John Wiley & Sons, 1973.

International Colour Association. *Proceedings of the Congress, 1969.* Gottingen: I.C.A., 1969.

International Museum of Photography. *Color as Form: A History of Color Photography.* Rochester, N.Y.: International Museum of Photography at George Eastman House, 1982.

International Symposium on Natural Colours for Food and Other Uses. Sponsored by Roche Products. London: Applied Science Publications, 1981.

Ionides, Basil. *Colour and Interior Decoration.* London: Country Life, 1926.

Irwin, Aleonor. *Colour Terms in Greek Poetry.* Toronto: Hakkert, 1974.

Irwin, John, and Katherine Brett. *Origins of Chintz.* London: Her Majesty's Stationery Office, 1970.

Ishihara, Shinobu. *Tests for Colour-Blindness.* Tokyo: Nippon Isho Shuppan Co., 1951.

Itten, Johannes. *The Elements of Color.* New York: Van Nostrand Reinhold, 1970.

———. *The Art of Color.* New York: Van Nostrand Reinhold, 1973.

Jacobs, Michel. *The Art of Colour.* Rumson, N.J.: Prismatic Art Co., 1956.

Jaensch, Erich R. *Eidetic Imagery.* London: Kegan, Paul, 1930.

Jones, Owen. *Color in Architecture and Decoration: An Apology of the Colouring of the Greek Court in the Crystal Palace.* London: Bradbury & Evans, 1854.

Judd, Deane B. *Colorimetry.* Washington, D.C.: U.S. Government Printing Office, 1950.

Justema, William. *Weaving and Needlecraft Color Course.* New York: Van Nostrand Reinhold, 1971.

Kanazawa, Hiroshi. *Japanese Ink Painting: Early Zen Masterpieces.* New York: Kodansha International, 1979.

Kandinsky, Wassily. *Concerning the Spiritual in Art.* New York: Wittenborn, Schultz, 1947.

Kandinsky, Wassily. *Point and Line to Plane.* New York: Guggenheim Foundation, 1947.

Kaplan, David G. *The World of Furs.* New York: Fairchild Publishing, 1974.

Katz, David. *The World of Color.* 1935. Reprint. New York: Johnson Reprint, 1970.

Kelly, Kenneth L. *Colorimetry and Spectrophotometry: A Bibliography of NBS Publications.* Washington, D.C.: U.S. Government Printing Office, 1974.

Kelly, Kenneth L., and Deane B. Judd. *The ISCC-NBS Method of Designating Colors and a Dictionary of Color Names.* Washington, D.C.: U.S. Government Printing Office, 1955.

Kelly, Kenneth L., and Deane B. Judd. *Color: Universal Language and Dictionary of Names.* Washington, D.C.: U.S. Government Printing Office, 1977.

Ketcham, Howard. *Color Planning for Business and Industry.* New York: Harper, 1958.

Kettlewell, Bernard. *The Evolution of Melanism.* Oxford: Clarendon Press, 1973.

Klee, Paul. *Paul Klee: The Thinking Eye.* Edited by Jurg Spiller. New York: George Wittenborn, 1961.

Klee, Paul. *The Diaries of Paul Klee.* Edited and with an introduction by Felix Klee. New York: University of California Press, 1964.

Klein, Adrian B. L. *Color Music: The Art of Light.* London: Crosby, Lockwood & Son, 1930.

———. *Colour Cinematography.* London: Chapman & Hall, 1936.

Knight, Richard P. *The Symbolic Language of Ancient Art and Mythology.* New York: J. W. Bonton.

Kobayashi, Shigenobu. *Book of Colors: Matching Colors, Combining Colors, Designing, Color Decorating.* New York: Kodansha Int'l., 1987.

Kober, Alice E. *The Use of Color in the Greek Poets.* New York: W. F. Humphrey, 1932.

Koblo, Martin. *World of Color: An Introduction to the Theory and Use of Color in Art.* New York: McGraw-Hill, 1963.

Koch, Robert. *Louis Tiffany: Rebel in Glass.* New York: Crown Publishers, 1964.

Koehler, Walter. *Lighting in Architecture: Light and Color as Stereoplastic Elements.* New York: Reinhold, 1959.

Koffel, Martin. *The Impact of Colour Television in Australia.* Melbourne: Commission for Economic Development of Australia, 1970.

Kornerup, Andreas J. H. W. *Methuen Handbook of Color.* London: Methuen, 1963.

Kuehni, Rolf G. *Color: Essence and Logic.* New York: Van Nostrand Reinhold, 1983.

Kuller, Rikard. "The Use of Space—Some Physiological and Philosophical Aspects." Third International Architectural Psychology Conference, Universite Louis Pasteur, Strasburg, France, June 1976.

———. "Psycho-Physiological Conditions in Theatre Construction." Eighth World Congress of the International Federation for Theatre Research, Munich, Germany, September 1977.

———. "Non-Visual Effects of Light and Colour." Annotated bibliography. Document D15:81. Stockholm: Swedish Council for Building Research, 1981.

Kumagai, Kojiro. *Fashion and Color: Total Fashion Coordinate.* Tokyo: Graphic-sha, 1985.

Kuppers, Harald. *Color: Origins, Systems, Uses.* London: Van Nostrand Reinhold, 1973.

Landi, Sheila. *The Textile Conservator's Manual.* London: Butterworths, 1985.

Lanier, Graham F., ed. *The Rainbow Book: A Collection of Essays Devoted to Rainbows.* San Francisco: Fine Arts Museums of San Francisco, 1975.

Lapiner, Alan. *Pre-Columbian Art of South America.* New York: Harry N. Abrams, 1976.

Lartigue, Jacques H. *The Autochromes of J.H. Lartigue.* London: Ash & Grant, 1981.

Laurence, Frederic. *Color in Architecture.* New York: National Terracotta Society, 1924.

Laurie, Arthur P. *The Painter's Methods and Materials.* London: Seeley Service, 1960.

Le Blon, Jacob C. *Coloritto.* 1720. Reprint. New York: Van Nostrand Reinhold, 1980.

Le Corbusier and A. Ozenfant. "Purism." In *Modern Artists on Art.* Edited by R. L. Herbert. Englewood Cliffs, N.J.: Prentice-Hall, 1964.

Lee, Welton L. *Carotenoids in Animal Coloration.* New York: Halsted Press, 1977.

Leene, Jentina E. *Textile Conservation.* Washington, D.C.: Smithsonian Institution Press, 1972.

Leland, Nita. *Exploring Color.* Cincinnati: North Light, 1985.

Lenclos, Jean Philippe and Dominique. *Les Couleurs de la France.* Paris: Editions du Moniteur, 1982.

Lerner, Marguerite R. *Color and People: The Story of Pigmentation.* Minneapolis: Lerner Publication Co., 1971.

Levengood, Sidney L. "The Use of Color in the Verse of Pleiade." Ph.D. diss. P.U.F., Paris, 1927.

Levine, Bernard. "R&D Target: Color for Desktop Publishing." *Electronic News* (May 4, 1987).

Lewinske, Jerge. *Colour in Focus.* Kings Langley, England: Fountain Press, 1976.

LeWitt, Sol. *Geometric Figures and Color.* New York: Harry N. Abrams, 1979.

Libby, William C. *Color and the Structural Sense.* Englewood Cliffs, N.J.: Prentice-Hall, 1974.

Lidstone, John, ed. *Reinhold Visual Aids for Art Teaching.* New York: Van Nostrand Reinhold, 1968.

Lilien, Otto M. *Jacob Christoph Le Blon, 1667–1741: Inventor of Three- and Four-Colour Printing.* Stuttgart: A. Hiersemann, 1985.

Lindberg, David C. *Theories of Vision from Al-Kindi to Kepler.* Chicago: University of Chicago Press, 1976.

Lindsay, Kenneth C., and Peter Vergo, eds. *Kandinsky: Complete Writings on Art.* Boston: G.K. Hall, 1982.

Linton, Harold. *Color Model Environments: Color and Light in Three-Dimensional Design.* New York: Van Nostrand Reinhold, 1985.

Little, Clarence C. *The Inheritance of Coat Color in Dogs.* New York: Howell Book House, 1967.

Loef, Carl. *Farbe, Musik, Form: Ihre bedeutenden Zusammenhange.* Gottingen: Musterschmidt, 1974.

Luckiesh, Matthew. *The Language of Color.* New York: Dodd, Mead & Co., 1920.

———. *Color and Its Application.* New York: Van Nostrand, 1921.

———. *Light and Color in Advertising and Merchandising.* New York: Van Nostrand, 1923.

Luckiesh, Matthew, and A. J. Pacini. *Light and Health.* Baltimore: Williams and Wilkie, 1926.

Luckiesh, Matthew, and Frank K. Moss. *The Science of Seeing.* New York: Van Nostrand, 1937.

Luescher, Max. *The Luescher Color Test.* London: Cape, 1970.

Lumière, Auguste. *Lumière: Les Premieres Photographies en Couleurs.* Paris: Andre Barret, 1974.

MacAdam, D. L. *Color Measurement: Theme*

and Variations. New York: Springer Verlag, 1981.

Mackinney, G., and A. C. Little. *Color of Foods*. Westport, Conn.: AVI, 1962.

Maerz, Aloys J., and M. Rea Paul. *A Dictionary of Color*. New York: McGraw-Hill, 1950.

Mahnke, Frank H. "Color in Medical Facilities." *Interior Design* (April 1981).

Mahnke, Frank H. and Rudolf H. *Color and Light in Man-Made Environments*. New York: Van Nostrand Reinhold, 1987.

Malin, David, and Paul Murdin. *Colours of Stars*. New York: Cambridge University Press, 1984.

Malraux, Andre. *The Voices of Silence*. Princeton, N.J.: Bollingen Series XXIV, 1978.

Mannoni, Luciana. *Marble: The History of a Culture*. New York: Facts on File, 1985.

May, Julian. *Why People are Different Colors*. New York: Holiday House, 1971.

Mayer, Ralph. *A Dictionary of Art Terms and Techniques*. New York: Thomas Y. Cromwell Co., 1969.

Mayer, Ralph. *The Artist's Handbook of Materials and Techniques*. 3d. ed. New York: Viking Press, 1970.

McClung, Robert M. *How Animals Hide*. Washington, D.C.: National Geographic Society, 1973.

McLean, Ruari. *Victorian Book Design and Colour Printing*. Berkeley: University of California Press, 1972.

Mellinger, John J. *An Investigation of Psychological Color Space*. Chicago: University of Chicago Press, 1956.

Merik, Boris. *Light and Color of Small Lamps*. Cleveland: General Electric, 1971.

Mitchell, Bob. *Color Printing*. Los Angeles: Petersen Publishing Co., 1975.

Mondrian, Piet. "Plastic Art and Pure Plastic Art." In *Modern Artists on Art*. Edited by R. L. Herbert. Englewood Cliffs, N.J.: Prentice-Hall, 1964.

Montgomery, Florence. *Printed Textiles: English and American Cottons and Linens 1700–1850*. New York: Viking Press, 1970.

Morgan, Alan, ed. *All You Need to Know about Color*. London: Laurie Larson, 1974.

Morris, William. *William Morris by Himself: Designs and Writing*. Edited by Gillian Naylor. London: Longmans, Green, 1988.

Moss, Roger W. *Century of Color: Exterior Decoration for American Buildings, 1820–1920*. Watkins Glen, N.Y.: American Life Foundation, 1981.

Moss, Roger W., and Gail C. Winkler. *Victorian Exterior Decoration: How to Paint Your Nineteenth Century House Historically*. New York: Henry Holt, 1987.

Munsell, Albert H. *A Color Notation: An Illustrated System Defining All Colors and Their Relations by Measured Scales of Hue, Value and Chrome*. 1905. Reprint. Baltimore: Munsell Color Co., 1947.

———. *A Grammar of Color*. Edited by Faber Birren. New York: Van Nostrand Reinhold, 1969.

Murray, James A.H., ed. *The Oxford English Dictionary*. Oxford: University Press, 1933.

Museum National d'Histoire Naturelle. *Les Couleurs des Fruits Anthocyannes & Flavones*. Paris: Museum National d'Histoire Naturelle, 1952.

Nath, R. *Colour Decoration in Mughal Architecture*. Bombay: D. B. Taraporevala Sons, 1970.

Naylor, Gillian. *The Bauhaus*. London: Studio Vista, 1968.

Newhall, Sidney M., and Josephine G. Brennan, eds. *Comparative List of Color Terms*. Washington, D.C.: Inter-Society Color Council, 1949.

Newton, Sir Isaac. *Opticks*. 1704. Reprint. London: G. Bell, 1931.

Nickerson, Dorothy. *Horticultural Color Chart Names with Munsell Key*. New York: Optical Society of America, 1957.

Nikolaev, P. P. "Monocular Color Discrimination of Nonplanar Objects under Various Illumination Conditions." *Biofizika 33*, 140–144, 1988 [in Russian].

Nochlin, Linda, ed. *Impressionism and Post-Impressionism, 1874–1904*. Englewood Cliffs, N.J.: Prentice-Hall, 1966.

Oney, Gonul. *Turkish Ceramic Tile Art*. Tokyo: Heibonsha, 1975.

Optical Society of America. *Committee on Colorimetry: The Science of Color*. New York: T. Crowell, 1953.

Osborne, Roy. *Lights and Pigments: Color Principles for Artists*. New York: Harper & Row, 1980.

Ostwald, Wilhelm. *Color Science: A Handbook for Advanced Students in Schools, Colleges and the Various Arts, Crafts, and Industries Depending on the Use of Color*. London: Winsor & Newton, 1931.

Ostwald, Wilhelm. *The Color Primer*. Edited by Faber Birren. New York: Van Nostrand Reinhold, 1969.

Padgham, C.A., and J. E. Saunders. *The Perception of Light and Colour*. London: Bell, 1975.

Palmer, Samuel. *A General History of Printmaking*. 1733. Reprint. London, 1972.

Paritsis, Nicholas C. *A Cybernetic Approach to Color Perception*. New York: Gordon and Breach Science Publishers, 1983.

Parker, G. H. *Animal Colour Changes: A Survey of Investigations 1910–40*. Cambridge: Cambridge University Press, 1948.

Parry, Linda. *William Morris Textiles*. New York: Viking Press, 1983.

Pascal, Blaise. *Thoughts & Letters of Blaise Pascal.* Edited by O. W. Wright. New York: Derby Jackson Publishers, 1852.

Paschel, Herbert P. *The First Book of Color.* New York: F. Watts, 1959.

Pasco, Allen H. *The Color-Keys* to A la Recherche du Temps Perdu. Geneva: Droz, 1976.

Patchett, G. N. *Colour Television with Particular Reference to the P.A.L. System.* London: Norman, Price, 1969.

Patton, Temple C., ed. *Pigment Handbook.* New York: John Wiley & Sons, 1973.

Perry, Robin. *Creative Color Photography.* Garden City, N.Y.: American Photographic Book Publishing Co., 1974.

Pfeiffer, Henri E. *L'Harmonie des Couleurs: Cours Theorique et Pratique.* Paris: Dunod, 1961.

Phillipps, Lisle M. *Form and Color.* New York: Charles Scribner & Sons, 1915.

The Physical Society (Colour Group). *Report on Colour.* London: The Physical Society, 1948.

Pincus, Edward, and Steven Ascher. *The Filmmaker's Handbook.* New York: New American Library, 1984.

Pliny the Elder. *Historia Naturalis.* Edited by Roger French and Frank Greenway. Tottowa, N.J.: Barnes & Noble, 1986.

Plochere, Gladys and Gustave. *Color and Color Names.* Los Angeles: Fox Printing Co., 1946.

Podendorf, Illa. *Color.* Chicago: Childrens Press, 1971.

Poling, Clark V. *Bauhaus Color.* Atlanta: High Museum of Art, 1975.

Pope, Arthur. *An Introduction to the Language of Drawing and Painting.* Cambridge, Mass.: Harvard University Press, 1929–31.

Porter, Tom, and Byron Mikellides, eds. *Color for Architecture.* New York: Van Nostrand Reinhold, 1976.

Portmann, Adolf, et al. *Color Symbolism: Six Excerpts from the Eranos Yearbook 1972.* Dallas: Spring, 1977.

Potet, L. Robert. *La Couleur das l'Histoire du Costume.* Paris: L'Officiel de la Couleur, 1951.

Prang, Louis, et al. *Color Instruction: Suggestions for a Course of Instruction in Color for Public Schools.* Boston: Prang Educational Co., 1893.

Pratt, A.E. *The Use of Color in the Verse of the English Romantic Poets.* Chicago: University of Chicago Press, 1898.

Prentiss, Stanton R. *Basic Color Television Course.* Blue Ridge Summit, Pa.: G/L Tab Books, 1972.

Priestley, Joseph. *The History and Present State of Discoveries Relating to Vision, Light and Colours.* London: J. Johnson, 1772.

Rainwater, Clarence. *Light and Color.* New York: Golden Press, 1971.

Reed, C. R. G. *Principles of Colour Television.* London: Pitman, 1969.

Reed, Kay. *The Painter's Guide to Studio Methods and Materials.* Englewood Cliffs, N.J.: Prentice-Hall, 1983.

Reinhold, Meyer. *History of Purple as a Status Symbol in Antiquity.* Brussels: Latomus, 1970.

Relxild, John. *The History of Impressionism.* New York: Museum of Modern Art, 1973.

Rewald, John. *History of Impressionism.* London: Secker & Warburg, 1973.

———. *Cezanne: A Biography.* New York: Harry N. Abrams, 1986.

Reynolds, Sir Joshua. *Discourses.* Chicago: A. C. McClurg & Co., 1891.

Rimington, A. Wallace. *Color Music: The Art of Mobile Color.* London: Hutchinson & Co., 1912.

Robinson, Stuart. *A History of Printed Textiles.* Cambridge, Mass.: M.I.T. Press, 1969.

Rolfe, Clapton C. *The Ancient Use of Liturgical Colors.* London: Parker & Co., 1879.

Ronchi, Vasco. *The Nature of Light: A Historical Survey.* Cambridge, Mass.: Harvard University Press, 1971.

Rood, Nicholas O. *Modern Chromatics: Students' Textbook with Applications to Art and Industry.* 1879. Reprint. New York: Van Nostrand Reinhold, 1973.

Rorschach, Hermann. *Psychodiagnostics: A Diagnostic Test Based on Perception.* Berne: Hans Hubert, 1942.

Rose, Barbara. *The New Aesthetic.* New York: Museum of Modern Art, 1967.

Rosenblum, Robert. *Cubism and Twentieth-Century Art.* New York: Harry N. Abrams, 1961.

Roth, Alfred. *The New Schoolhouse.* Zurich: Edition d'Architecture, 1966.

Rubin, William, ed. *Cezanne: The Late Work.* New York: Museum of Modern Art, 1977.

Ruskin, John. *The Art Criticism of John Ruskin.* Edited by Robert L. Herbert. New York: Doubleday, 1964.

Ruskin, John. *The Elements of Drawing.* New York: Dover, n.d.

Russell, John. *The Meanings of Modern Art.* New York: Museum of Modern Art, 1975.

Ryan, Roderick T. *A History of Motion Picture Color.* New York: Focal Press, 1977.

Sachs, Viola. *The Myth of America: Essays in the Structure of Literary Imagination.* The Hague: Paris Mouton, 1973.

Salemme, Lucia A. *Color Exercises for the Painter.* New York: Watson-Guptill, 1970.

Sargent, Frederick L. *A Working System of Color for Students of Art and Nature.* New York: H. Holt & Co., 1927.

Sargent, Walter. *The Enjoyment and Use of Color*. New York: Dover, 1964.

Saxby, G. *Holograms*. New York: Focal Press, 1980.

Schaefer, Dennis, and Larry Salvato. *Masters of Light*. Los Angeles: University of California Press, 1984.

Schaie, Klaus W. *Color and Personality: A Manual for the Color Pyramid Test*. Berne: H. Huber, 1964.

———. "Scaling the Association Between Colors and Mood-Tones." *American Journal of Psychology* (1961).

Schopenhauer, Arthur. *Ueber das Sehen und die Farben*. Leipzig: J. F. Hartknoch, 1816.

Schrift, Richard. *Cezanne and the End of Impressionism: A Study of the Theory, Technique and Critical Evaluation of Modern Art*. Chicago: University of Chicago Press, 1984.

Selz, Peter. *Emil Nolde*. New York: Museum of Modern Art, 1963.

Shafer, S. A. "Using Color to Separate Reflection Components." *Color Research and Application* 10, 210–218, 1985.

Sharpe, Edmond. *Four Letters on Colour in Churches, on Walls, and in Windows*. London: Spon Co., 1870.

Shaw, Kenneth. *Ceramic Colours and Pottery Decoration*. London: Maclaren, 1962.

Sheppard, Joseph J. *Human Color Perception: A Critical Study of the Experimental Foundation*. New York: Elsevier, 1968.

Sherman, Paul D. *Colour Vision in the Nineteenth Century: The Young-Helmholtz-Maxwell Theory*. Bristol: Hilger, 1981.

Simon, H. *The Splendor of Iridescence*. New York: Dodd, Mead, 1971.

Slawson, Wayne. *Sound Color*. Berkeley: University of California Press, 1985.

Smith, Hugh M., and Robert E. Frye. *How Color of Red Delicious Apples Affects Their Sales*. Washington, D.C.: U.S. Department of Agriculture, 1964.

Southall, J. P. C. *Introduction to Physiological Optics*. New York: Dover, 1961.

Spate, Virginia. *Orphism: The Evolution of Non-Figurative Painting in Paris, 1910–1914*. New York: Oxford University Press, 1978.

Spears, Charleszine. *How to Wear Colors: With Special Emphasis on Dark Skins*. Minneapolis: Burgess, 1974.

Sproson, W. N. *Colour Science in Television and Display Systems*. Bristol: Adam Hilger, 1983.

Stangos, Nikos, ed. *Pictures by David Hockney*. New York: Harry N. Abrams, 1977.

———. *Concepts of Modern Art*. London: Thames & Hudson, 1981.

Steiner, Rudolf. *Colour: Three Lectures Given in Dornach (May 6–8, 1921)*. London: Rudolf Steiner Press, 1970.

Stokes, Adrian. *Colour and Form*. London: Faber & Faber, 1937.

Storey, Joyce. *Textile Printing*. London: Thames & Hudson, 1974.

Sturzaker, Doreen. *Color and the Kabbalah*. Wellingborough, England: Thorsons, 1975.

Sze, Mai-mai, trans. *The Mustard Seed Garden Manual of Painting*. Princeton: Bollingen Series, 1978.

Tanaka, Ikko and Kazuko Koike, eds. *Japan Color*. San Francisco: Chronicle Books, 1982.

Teevan, Richard Collier. *Color Vision: An Enduring Problem in Psychology*. New York: Van Nostrand, 1961.

Thomas, David B. *The First Colour Motion Pictures*. London: H.M.S.O., 1969.

Thomson, C. Leslie. *Colour Films: The Technique of Working with Colour Materials*. London: Focal Press, 1971.

Thompson, Daniel V. *The Materials of Medieval Painting*. London: G. Allen & Unwin, 1936.

———. *The Materials and the Techniques of Medieval Paintings*. New York: Dover, 1956.

Thrower, Percy. *Guide to Color in Your Garden*. London: Colligridge, 1966.

Todd, Holis N., and R. D. Zakia. *Color Primer I & II*. Dobbs Ferry, N.Y.: Morgan & Morgan, 1974.

Trimble, Lyne S. *Color in Motion Pictures and Television*. Hollywood, Calif: n.p., 1954.

Tucker, Marcia. *The Structure of Color*. New York: Whitney Museum of American Art, 1971.

U.C.L.A. Dept. of Art. *Color: Ron Davies, Ellsworth Kelly, Morris Louis, Kenneth Noland, Jules Olitski, Frank Stella*. Los Angeles: University of California Press, 1970.

Ukiyo-e Society of America. *Life and Customs of Edo as Portrayed in Woodblock Prints of the 17th through 19th Centuries*. New York: Pratt Graphics Center and the Ukiyo-e Society of America, 1978.

Upright, Diane. *Ellsworth Kelly: Works in Paper*. New York: Harry N. Abrams, 1987.

Using Filters. Rochester, N.Y.: Kodak Workshop Series, 1981.

Van Gogh, Vincent. *The Letters of Vincent Van Gogh*. New York: Atheneum, 1963.

Van Zanten, David. *The Architectural Polychromy of the 1830s*. New York: Garland, 1977.

Varley, Helen, ed. *Color*. Los Angeles: Knapp Press, 1980.

Vasari, Giorgio. *Lives of the Artists*. Edited by E. L. Seeley. New York: Noonday Press, 1957.

Verity, Enid. *Colour*. London: L. Frewin, 1967.

Veronese, Luigi. *I Colori*. Milan: M. A. Denti, 1945.

Vincent-Ricard, Françoise. *Clefs pour la Mode.* Paris: Seghers, 1987.

Wakeman, Geoffrey. *The Production of Nineteenth Century Colour Illustration.* Loughborough: Plough Press, 1976.

Walch, Margaret. *Color Source Book.* New York: Scribner's, 1979.

Walker, John A. *Glossary of Art, Architecture and Design Since 1945.* New York: Clive Bingley, 1973.

Walls, G. L. *The Vertebrate Eye and Its Adaptative Radiation.* Bloomfield Hills, Mich.: Cranbrook Institute of Science, 1942.

Walls, Gordon L., and Ravenna M. Matthews. *New Means of Studying Color Blindness and Normal Foveal Color Vision.* Berkeley: University of California Press, 1952.

Wasserman, Gerald S. *Color Vision: An Historical Introduction.* New York: John Wiley & Sons, 1978.

Watson, William. *Textile Design and Colour.* London: Longmans Green, 1948.

Webber, Lucille R. *Japanese Woodblock Prints: The Reciprocal Influence between East and West.* Provo, Utah: Brigham Young University Press, 1979.

Weigle, Palmy. *Ancient Dyes for Modern Weavers.* New York: Watson-Guptil, 1974.

———. *Color Exercises for the Weaver.* New York: Watson-Guptil, 1976.

Weyl, Woldemar A. *Coloured Glasses.* London: Dawson's, 1951.

White, Palmer. *Elsa Schiaparelli: Empress of Paris Fashion.* New York: Rizzoli, 1986.

Whitford, Frank. *Bauhaus.* London: Thames & Hudson, 1984.

Whiton, Sherrill. *Interior Design and Decoration.* New York: J. B. Lippincott, 1974.

Wilson, Jose, and Arthur Leaman. *Color in Decoration.* New York: Van Nostrand Reinhold, 1973.

Wilson, Robert F. *Colour in Industry Today: A Practical Book on the Functional Use of Colour.* London: G. Allen & Unwin, 1960.

Winter, Ruth. *A Dictionary of Cosmetic Ingredients.* New York: Crown, 1974.

Wittgenstein, Ludwig. *Remarks on Color.* Berkeley: University of California Press, 1977.

Wolf, Martin L. *Dictionary of the Arts.* New York: Philosophical Library, 1951.

Wright, Richardson L., ed. *House & Garden's Book of Color Schemes.* New York: Conde Nast, 1929.

Wright, William D. *Researches on Normal and Defective Colour Vision.* St. Louis: Kimpton, 1947.

———. *Photometry and the Eye.* London: Hatton Press, 1949.

———. *The Measurement of Color.* London: Hilger, 1958.

———. *The Rays Are Not Coloured: Essays on the Science of Vision and Colour.* London: Hilger, 1967.

———. *The Basic Concepts and Attributes of Color Order Systems.* Color Research and Application. New York: John Wiley & Sons, 1984.

Wurtman, Richard J. "Color, Light and Energy," *Biosocial: The Journal of Behavioral Ecology* (November 1980).

Wyatt, R. C. *The Symbolism of Color in the Drama of German Expressionism.* Ann Arbor: University Microfilms, 1956.

Yeatman, John N. *Judging Quality of Tomatoes for Processing by Objective Color Evaluation.* Washington, D.C.: U.S. Department of Agriculture, 1958.

Zarchy, Harry. *Color and the Edgar Cayce Readings.* Virginia Beach, Va.: A.R.E. Press, 1973.

INDEX